STRAND PRICE
$5.00

BEYOND GENIUS

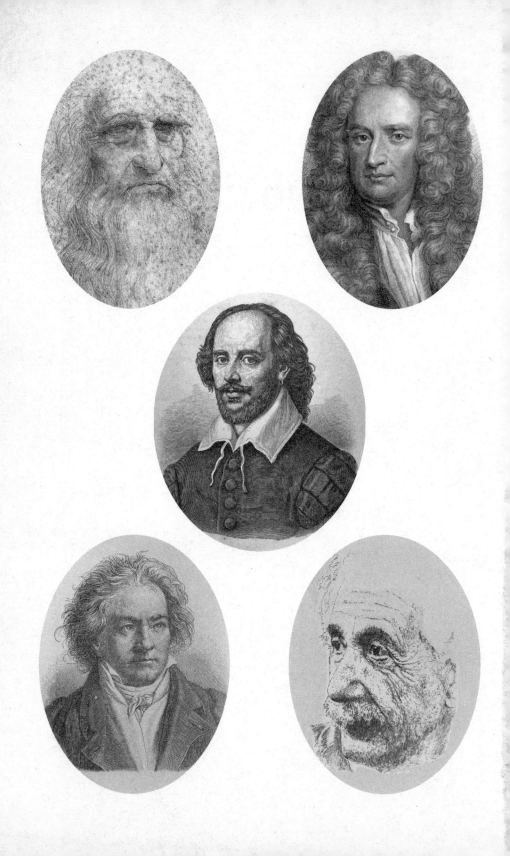

BEYOND GENIUS

A JOURNEY THROUGH THE CHARACTERISTICS AND LEGACIES OF TRANSFORMATIVE MINDS

BULENT ATALAY

PEGASUS BOOKS
NEW YORK LONDON

BEYOND GENIUS

Pegasus Books, Ltd.
148 West 37th Street, 13th Floor
New York, NY 10018

Copyright © 2023 by Bulent Atalay

First Pegasus Books cloth edition November 2023

Interior design by Maria Fernandez

Frontispiece: Top left, a self-portrait by Leonardo da Vinci (c. 1510). Upper right, Isaac Newton, engraving by Samuel Freeman after a portrait by Sir Godfrey Kneller. Center, William Shakespeare, 1841 engraving by E. Hader. Lower left, Ludwig van Beethoven, the engraver unknown. Bottom right, ink drawing of Albert Einstein by the author (1979). Created on the occasion of the centennial celebration of Einstein's birth, it was inspired by a 1947 photographic portrait by Yousuf Karsh.

All rights reserved. No part of this book may be reproduced in whole or in part without written permission from the publisher, except by reviewers who may quote brief excerpts in connection with a review in a newspaper, magazine, or electronic publication; nor may any part of this book be reproduced, stored in a retrieval system, or transmitted in any form or by any means electronic, mechanical, photocopying, recording, or other, without written permission from the publisher.

Library of Congress Cataloging-in-Publication Data is available.

ISBN: 978-1-63936-489-3

10 9 8 7 6 5 4 3 2 1

Printed in the United States of America
Distributed by Simon & Schuster
www.pegasusbooks.com

To all polymaths and autodidacts with a modicum of madness.

CONTENTS

Preface: Leonardo and the Devil — ix

Prologue — xi

PART I: Internal and External Factors for Genius — 1

1: Traits Positive and Negative — 3

2: Multiple Intelligences — 30

3: The Zeitgeist Factor — 44

PART II: Genius in the Arts — 63

4: A Singularity in the History of Art — 65

5: King Kong versus Other Monkeys — 94

6: Leonardo's Model — 127

7: The Intersection of Art and Science — 154

PART III: Genius in the Sciences — 171

8: The Universal Genius and Failed Scientific Revolution — 173

9: Interrogating Nature: Becoming Modern — 199

10: The Newtonian Revolution
 Case Study: Newton — 223

11: The Relativistic Revolution
 Case Study: Einstein — 255

12: The Quantum Revolution: Group Genius — 295

PART IV: The Mind and Brain — 317

13: Lumps, Bumps, and the Gifted Mind — 319

14: Eccentricity in Scientific Genius: A Tincture of Madness — 336

15: Swirls and Tortured Minds — 371

PART V: Conclusion — 399

16: Heroes, Rulers, and Rankings — 401

Epilogue: Genius in the Digital Age — 417

Acknowledgments — 435

Notes — 439

Index — 450

The plight of the wordy author. *Courtesy of ScienceCartoonsPlus.*

PREFACE
LEONARDO AND THE DEVIL

My first encounter with a transformative genius came early with Leonardo da Vinci. It consisted of seeing pictures of his two defining masterpieces, *The Last Supper* and the *Mona Lisa*, along with a quotation attributed to him: "The eyes are the windows to the soul." At the time, I was eight years old and living with my parents in England, where my father was serving as a military attaché from Ankara to London. Even low-level diplomats were expected to entertain frequently; accordingly, my family rented a commodious townhouse that was previously the London home of Lord George Nathaniel Curzon (1859–1925), a onetime viceroy of India. The walls and staircases of the first two stories of the townhouse were covered with landscape paintings and old Curzon family portraits, many dating back to the eighteenth century. I would study them endlessly and make watercolor copies of the landscape paintings. But those portraits bothered me. They did not communicate with me. Clearly, they had no soul!

Then, a week or two before my ninth birthday, I experienced an epiphany. I realized the individuals in those portraits could not communicate because their pupils were opaque! With a hole punch my family had recently acquired, I stood on couches and chairs, and went around making perfect circular holes for the pupils in many of the portraits. I convinced myself that

the subjects' communication skills improved with their pupils now open. Within a short time, however, I forgot about my handiwork.

On my ninth birthday, I received a box of lead soldiers as a present. That very evening, my parents had several guests over for dinner—including one diplomat, my mother later described as "strange." She remembered him as ". . . a dark-browed, squint-eyed man, glowing with a yellow pallor, who baffled everyone." Upon entering our house, he had walked right past my father who had extended his hand to shake his, approached instead one of the portraits. "His eyes have holes in them!" he announced. Then, walking over to another portrait, and then another, each time repeating his words, and finally declaring victoriously, "You must have a son!" From my adolescent perspective, this diplomat was the Devil! Who else could have spotted the crime and identified the culprit that quickly! The following morning, my father, in fear and rage, dumped my new collection of lead soldiers into the incinerator. By the time the paintings were restored, the incinerator had also been replaced. It was an inglorious beginning to my career as an artist–scientist. Again, according to my mother's recollection, the landlord was told of the near calamity but seemed unconcerned, saying, "Oh, those old paintings! Who cares about them!" I shudder to think how fortunate it was that the fabulously wealthy Curzon family did not own a Leonardo!

Leonardo is a member of an extremely rarefied breed of geniuses who far transcends *ordinary* genius. After that early encounter with him, I spent decades probing deeper and deeper into the lives, works, and psyche of that vapor-thin group.

PROLOGUE

Anyone who has seen *Hamlet*, listened to the magnificent *Fifth Symphony*, or gazed at the *Mona Lisa* might have wondered where the creators of these works got their ideas and how they executed them so well. Similarly, anyone who has watched a spacecraft rising from its launchpad on its way to a soft landing on an asteroid hurtling through space at 50,000 miles per hour, hundreds of millions of miles away, or questioned the origin and fate of our planet and universe might also have wondered how one applies established physical laws, let alone formulates the physical laws in the first place?

These achievements represent some of humanity's greatest masterpieces. What inspires the rare but most creative members of our species to create, express, or discover? Are their brains wired differently from the rest of us? Do they have a set of unique traits or experiences that set them on the path to their special brand of genius? I am a theoretical physicist and artist. I've taught undergraduate and graduate physics and mathematics for forty-three years, and I have been drawing and painting since I was a child. Steeped in these two intellectual cultures during my entire life, I have always wondered about the sources of inspired creativity, soaring intelligence, and those immortal legacies created by the greatest of all geniuses.

"Genius" is a very big subject, ambiguous, subjective, divisive, difficult to define—and entirely overused. Different cultures and disciplines field their own agents for massive change, their own heroes they herald as geniuses. Here we focus on genius in two basic intellectual cultures—the arts and the sciences—traditionally seen as nonoverlapping and in which true genius is not difficult to define, nor so ambiguous and subjective. A useful analogy may lie in the nonoverlapping magisteria of religion and science, where they can be complementary without contradicting each other. But, as we shall see, a surprising convergence occurs in the magisteria of the arts and the sciences.

Beyond Genius: A Journey Through the Characteristics, and Legacies of the Transformative Minds reveals some of the surprising discoveries I've made in my lifelong quest. I admit that embracing the conditions identified in the book cannot make any of us another Leonardo or Einstein, but it cannot fail to make each of us more creative and productive than we would otherwise be.

Although different types of intelligence and creativity come into play in the cultures of the arts and sciences, striking similarities exist in the traits, attributes, and habits of their most excellent practitioners. The two books I wrote earlier on the "universal genius" Leonardo da Vinci,[1] serve as a convenient starting point in understanding both the differences and similarities in the ways that genius works in the two separate cultures of art and science.

One of Einstein's favorite philosophers, Arthur Schopenhauer, once offered a catchy definition of genius: "Talent hits a target no one else can hit; Genius hits a target no one else can see." I begin with a simple model of genius—not as poetic as Schopenhauer's, but somewhat more quantitative. Genius is the *virtual* mathematical product of intellectual acuity, expansive creativity, and timeless legacy. Although there is no precision in the factors here as there would be in a *real* mathematical product, a zero in one factor would still make the product zero. In any discussion of genius, one question is asked more than any other: "Is genius due to nature or nurture?" This can be dispelled quickly as a false dichotomy. Nature and nurture must both be active for genius to thrive.

Like all other human qualities, genius comes in degrees, from "ordinary" to "magician" to "transformative." It knows no boundaries of religion, ethnicity, gender, age, handedness, or sexual orientation. Although, by the time I made that assertion, I realized I had to walk it back. Age does make a difference: genius in the mathematical sciences and lyric poetry usually occurs early in life, whereas genius in the writing of epic novels and in the social sciences much later. In our drafting ability, we all improve in the first nine or ten years of our lives, then nineteen of twenty of us begin to regress and rely on memory rather than on observation. That leaves only one of twenty, or five percent of the population, describable as possessing some artistic ability. That is also about the same age that we lose our ability to learn a foreign language at the level of a native tongue. As we shall see, handedness and sexual orientation do also appear to factor into genius.

LEVELS OF BRILLIANCE

As a professional scientist, I've listened to and addressed countless brilliant individuals in classes and seminars. Four of my students who graduated first in their class I regard as particularly memorable. One was a Moroccan student who worked as a short-order cook while maintaining a double major and a perfect grade point average. Another was a chain-smoking female single parent who had initially started her undergraduate studies at fifteen. She dropped out for three years, only to return and graduate with her original classmates on time and with a perfect GPA.

Among my students in theoretical physics at Oxford was a twenty-year-old who never took notes, concentrating instead with laser-like focus on the equations I was writing on the blackboard, and who, by the end of the lecture, appeared to know as much as I did about the subject. His attributes included a photographic memory and the ability to process and make instant connections.

A particularly precocious student I taught matriculated as an undergraduate at fourteen, triple-majored in physics, mathematics, and computer

science, and finished a four-year degree in three years. When he took my third-year level nuclear physics class as a first-year student, curiously sitting at the same desk that his expectant mother had sat at fourteen years earlier, his unusual quickness left me wondering, "Could his prenatal exposure to the material have given him an advantage?"

Three of the four earned doctorates, one of them started a successful software firm, and another, the female student, received a commission as a naval officer and taught in Admiral Rickover's Naval Nuclear Propulsion Program. They were all very, very smart! But none made a monumental contribution to any field, let alone went on to define a field or create an immortal legacy.

A Fields Medal in mathematics or a Nobel Prize in the sciences or literature can sometimes be regarded as a *sufficient but not necessary condition* to qualify as a genius. I regard the twenty-nine Nobel laureates I have met as genuinely brilliant, insightful, lucky (luck does count), and far more gifted than I am. Many of them are geniuses, but just "ordinary geniuses." With ordinary geniuses, we might study and master their works and then sit back and muse, "I could have done that myself . . . if I had worked really, really hard and were many times smarter than I am," as mathematician Mark Kac once reflected.

Ordinary geniuses follow the rugged topography of logic—down the slopes, across the valleys and streams, and back up the slopes—to reach the summit of their remarkable achievements. But two of the twenty-nine transcend the others and deserve the sobriquet "magician," which biographer James Gleick invoked in describing Richard Feynman in his book *Genius* (Open Road Media, 2011). Feynman's personal hero, the reclusive Paul Adrian Maurice Dirac, another magician, was the subject of Graham Farmelo's book, *The Strangest Man* (Basic Books, 2011).

But the most rare and remarkable category of genius is "the transformative genius," and the five exemplars in the book far transcend members of the other two categories.

Transformative geniuses rarely conform to any recognizable topography. They appear to leap from one summit to another, their creative efforts

altogether redefining existing disciplines and often "unveiling entirely new universes," a throwaway expression from the Caltech chemist Frances Arnold (Nobel Prize, 2018). Frequently, they are hard-pressed to explain how exactly they went about solving their problems. It is a combination of an insatiable curiosity, imagination, intuition, motivation, and intensity, often conjoined with surpassing intelligence, aversion to authority, and more than occasionally, a touch of lunacy. Ironically, either because we fully comprehend their works or realize we don't have a prayer of comprehending them, we put these geniuses on special pedestals and create myths about them. Charlie Chaplin and Albert Einstein were two of the most recognizable and beloved celebrities of the twentieth century. Kindred spirits, they valued each other's company. On one occasion (c. 1930), when they were recognized together in a crowd in downtown Los Angeles, applause broke out spontaneously. Einstein appeared puzzled but reflexively joined the comic genius in waving to the crowd. Chaplin leaned over and whispered to Einstein, "They're cheering us both . . . you because nobody understands you, and me because everybody understands me."

A glance at the book's index reveals the names of several hundred men and women—writers, painters, architects, sculptors, composers, mathematicians, scientists, leaders, heroes, villains—most of them prominent, many of them highly creative, and some of them geniuses. Unobtrusively buried in the list are the names of a handful of magicians and transformative geniuses. A liberal list might include Hildegard (von Bingen), Dante, Leonardo, Michelangelo, Shakespeare, Rembrandt, Newton, Bach, Goethe, Mozart, Beethoven, Darwin, Pasteur, and Maxwell, bracketed in antiquity by Thales, Phidias, and Archimedes and in modern times by Einstein and Picasso.

The thrust of the book involves the systematic dissection of the lives, traits, habits, strengths, failings, and where possible the thought patterns of five individuals: **Leonardo** (1452–1519), **Shakespeare** (1564–1616), **Newton** (1642–1727), **Beethoven** (1770–1827) and **Einstein** (1879–1955)—two pure artists, two pure scientists, and one artist–scientist with a functionally symmetric mind straddling the two cultures. Each scaled the very summit

of human achievement, producing works that include some of the defining masterpieces of our species, works so surpassing that when speaking of them, we rarely have to specify their creators. When we refer to *Hamlet*, everyone knows its author is Shakespeare; when we cite the *Ninth*, we are speaking of Beethoven; and with relativity, Einstein's name does not need mentioning.

Incidentally, it is conventional practice to refer to four of the five geniuses by their last names, and one by his first. I follow the practice and refer to Leonardo da Vinci as simply Leonardo. This is also true for Michelangelo, his compatriot, archrival, and bête noire.

Why Leonardo and not Michelangelo, why Beethoven and not Bach or Mozart? To the question, "Who is the greatest artist in history?" we can still respond that Leonardo, the older of the two by twenty-three years, might be the greatest on Mondays, Wednesdays, and Fridays, as long as we add that Michelangelo would be the greatest on Tuesdays, Thursdays, and Saturdays. Although fewer than twenty paintings by Leonardo are known, he happens to be the creator of the two most famous works in the history of art. He represents a more compelling choice than his rival for bridging the cultures of the artist and the scientist.

Nor would we claim that Beethoven is necessarily superior to Bach or Mozart. Both Bach and Mozart composed hundreds of surpassing musical works that have endured for centuries. Bach composed over 1,100 pieces and Mozart well over 600 in a short lifetime of thirty-five years. Beethoven was not as prolific, but each of his compositions was so transformative that it belongs in a special category. Mozart, for example, could easily turn out three or four pieces of music before lunch on any given day. Yet Beethoven labored for four years over the monumental *Fifth Symphony*, adding and subtracting instruments, notes, and effects until he found the perfection he sought. It is a perfection that will last as long as civilization itself.

As the ultimate creator/rebel, Beethoven is unrivaled in transforming music so completely and in such a lasting manner. He was the universal composer who, more than anyone else, took music out of the hands of the nobility and made it accessible to the common man. He personifies the idea

of triumph against adversity. His *Ninth Symphony* was performed at the toppling of the Berlin Wall, and it is performed at the opening ceremony of each of the Olympic Games. It is the official anthem of the European Union and was described by the recondite NPR radio host Martin Goldsmith as "the Anthem of the Human Race."

For a book with as many legs as *Beyond Genius*, it is imperative to consult specialists. In my years of teaching, my style has always been to supplement the rigor of complex ideas, frequently involving mathematics, with the human side of doing science and the historical backdrop to its discoveries. Three of the five exemplars in the book—Leonardo, Newton, and Einstein—became familiar friends as fellow professionals. Of course, I still bounced ideas off my scientist and artist friends. The other two—Shakespeare and Beethoven—were the unrivaled stars of my avocations, my lifelong passion for great music and literature. With them, I dug much deeper, viewing their works through an interdisciplinary prism, and taught myself what one normally cannot learn in formal classes.

My choice of Beethoven was reinforced while on a visit to the Aspen Institute in December 2008. I had been invited to the celebrated think tank to give lectures on Leonardo at the Renaissance Festival. In one session, while I was speaking about the mathematical symmetries that informed Leonardo's paintings, I noticed one of the participants in the workshop sitting in the back of the room, taking copious notes. Suddenly, he appeared excited. During a break in the lecture, he approached me and introduced himself as "Alan Fletcher: President and CEO of the Aspen Music Festival and School." The Princeton and Julliard-educated composer-conductor had carried out original research on Beethoven with Lewis Lockwood, one of the great Beethoven scholars of our time and former president of the American Musicological Society. Fletcher explained that he had just discovered that the symmetries with which Leonardo had imbued his paintings were also in the repeats in Beethoven's symphonies. It was an epiphany! Beethoven had only five years of formal schooling and could not even do ordinary arithmetic. He could not multiply twelve times twelve; he added twelve rows of twelves. But sophisticated symmetries found their

way into his works subconsciously, intuitively. It came from a deeper place. Since the symmetries are associated with nature's numbers, perhaps the composer was communing subconsciously with nature during his walks in the woods, receiving subliminal messages from the flowers and plants that surrounded him.

In 2015, *Oxford Today*, the university's alumni quarterly, reported that Professor Peter Sleight, a cardiologist at the university's Radcliff Hospital, had discovered that certain movements in Beethoven's music could actually lower an individual's blood pressure (as could a few movements in only two or three other composers' works). This was again a subconscious, intuitive, and unintended effect in Beethoven's music, nonetheless measurable and reproducible.

In the 1950s, Aaron Copland wrote a monograph, *What to Look for in Music*.[2] In a section on models of creativity, he compared Beethoven and Tchaikovsky: "Any musician will tell you that Beethoven is the greater composer. Because music which always says the same thing to you [Tchaikovsky] will necessarily soon become dull music, but music whose meaning is slightly different with each hearing has a greater chance of remaining alive." Fifteen years later, Leonard Bernstein, while delivering his famous lectures in the Norton Series at Harvard, expanded on this theme of open-endedness in a lecture entitled "The Delights and Dangers of Ambiguity."[3]

It is the open-endedness in Beethoven's music that helped to make it supreme. This may also be what makes Shakespeare's writings supreme. The usual explanations given for the poet-playwright's supremacy include his works' characterization as "technically brilliant and endlessly verbally inventive," "the largest vocabulary of any playwright," and "dozens of words and expressions that found permanence in our vocabulary."

Among dozens of excellent books about Shakespeare, it is Emma Smith's *This is Shakespeare* (Patheon Books, 2019) that most closely resonated with my understanding of genius in the arts. Smith, a young professor of Shakespeare Studies at Oxford, spelled out the theme of her book:

> Lots of what we trot out about Shakespeare and iambic pentameter and the divine right of kings and "Merrie England" and

his enormous vocabulary blah blah blah is not true, and just not important. They are the critical equivalent of "dead-catting" in a meeting or negotiation (placing a dead cat on the table to divert attention from a more tricky or substantive issue). They deflect us from investigating the artistic and ideological implications of Shakespeare's silences, inconsistencies, and, above all, the sheer and permissive gappiness of his drama.

Smith's analysis of the plays demonstrates how porous, ambiguous, open-ended, unendingly gappy, and unexpectedly relevant they are in our time. She was effectively substantiating a conjecture about Shakespeare by a contemporary. In a dedicatory tribute to the *First Folio* (1623), poet Ben Jonson wrote, "He was not of an age but for all time."

In May 2022, my family and I were about to visit London and made arrangements to attend a modern rendition of *Julius Caesar* in the Globe Theatre that had opened in 1997. The structure was very close to the actual site of the original Globe Theatre that had opened in 1599, with Shakespeare presiding over his play's premiere. How relevant can a 423-year-old play, recounting an attempted insurrection that took place 2,065 years earlier on the distant Italian peninsula, be now? Searingly, terrifyingly relevant!

We live in unprecedented times. Political, social, and religious differences cast a heavy pall over most of the inhabited areas of the planet. The separation of church and state and the establishment of gender and racial equality, cherished reforms that serve as the underpinnings of a modern democratic society, are suddenly in peril. Lies have become truths, and truths, lies. In the United States, we witnessed an attempted insurrection on January 6, 2021—though others might say, "No such thing happened!"

As common meta tags to describe sentiments in ancient Rome of the first century B.C.E., those in Shakespeare's world of the 1590s, and those in modern times, we can choose from scores of words: race, gender, class, violence, insurrection, democracy, autocracy, dictatorship, populist . . . As for why these emotionally packed words are so timeless, we do not have to look very far. The late Harvard evolutionary biologist E. O. Wilson

once commiserated about the incongruities of the human condition, "We have Paleolithic emotions, medieval institutions, and god-like technology." The last item, "god-like technology," could have been a reference to the nuclear age, to the digital age, or more prophetically to artificial intelligence (AI).

The human condition changes very little, even as we develop more and more powerful technology. Shakespeare recognized the human condition that would be articulated by E. O. Wilson four centuries later and suffused his writings with it while leaving conclusions up to his readers. Historic and technological developments during Shakespeare's writing years included the defeat of the Spanish Armada, the establishment of a permanent British settlement in Jamestown, Galileo's invention of the astronomical telescope in Florence that allowed humans to gaze at extraterrestrial worlds, and Leeuwenhoek's invention of the microscope in Holland that allowed humans to peer into the microscopic world of fleas, living tissue, and cells. Whether we could learn from history and not repeat our mistakes was left as an overarching question, one that is still very much alive and important for the survival of our species. The insurrectionists and the counterinsurrectionists in *Julius Caesar* are out to save their own vision of democracy, both discovering there are consequences to their actions. How much does resorting to violence solve our problems?

Sherwin Nuland, a Yale Medical School surgeon and fellow "Leonardista," once wrote a generous blurb for my earlier book, *Math and the Mona Lisa* (Smithsonian, 2004). In his own monograph, *Leonardo da Vinci* (Lipper/Viking, 2000), Nuland had written about his experience engaging in a dialogue with the subject, Mona Lisa:

> The smile is in itself Leonardo's ultimate message to the ages: There is even more to me than you can ever capture; though I have spoken so intimately to you in my notebooks even as I have spoken to myself. I have kept final counsel only with the depths of my spirit and the inscrutable source that has made me possible; seek as you may, I will commune with you only

so far; the rest is withheld, for it was my destiny to know things you will never know.⁴

This was also the message she whispered to me when I was nineteen and engaged her in an intimate dialogue. I stood four or five feet away from her for forty-five minutes in a room in the Louvre virtually devoid of other visitors. I imagined being able to hear the dulcimer sounds from the lyre player Leonardo had hired for the lady's amusement.

Leonardo was equally obsessed with solving questions about the workings of nature (science) as he was with creating the most effective and powerful representations of people and nature in his paintings (art). He allowed himself to transcend barriers between art, science, and mathematics, seeing them all as part of the whole. On that basis, he carried out numerous scientific investigations while maintaining careful notes; sometimes the experiments failed, but he knew that this was the only way to make progress. This does not mean we cannot bemoan the near loss of *The Last Supper* (the mural had begun to peel within decades of its creation) and the total loss of *The Battle of Anghiari* (the paint running down the wall within days of its application). In both murals, instead of using the time-honored tempera technique, Leonardo was experimenting with oil paint on wet plaster.

Leonardo was an artist doing science and a scientist doing art. He saw patterns and numbers in nature, and his paintings reflected these patterns and numbers, apparently in the same way that Beethoven's music reflected them. He once lobbied his patron, the strongman of Milan, Duke Sforza, to hire the mathematician–monk Luca Pacioli as a tutor for the Sforza children. (It is thought that his real motive in getting Pacioli hired was so he could learn formal mathematics from him.) Later, the two men collaborated in producing the book *Divina Proportione*, Pacioli providing the narrative, Leonardo, the illustrations. Like me, a distant disciple, he too had learned by collaborating with specialists and conflating different fields.

In 2002, to celebrate Leonardo's 550th birthday, I teamed up with Thomas Somma, director of the University of Mary Washington's

Ridderhof Martin Gallery, and organized a special exhibition: *Leonardo da Vinci: Artist, Scientist, Engineer*. David Alan Brown, curator of Renaissance Art at the National Gallery of Art (NGA), was the guest curator for Leonardo's artist side and I was the curator for his scientist-engineer side. With financial support from the state of Virginia, we procured twenty-four replicas of Leonardo's inventions. A set was originally built in the late 1930s by Mussolini-era engineer Roberto Guatelli, destroyed in the aerial bombing in Tokyo in WWII, and subsequently rebuilt and maintained by IBM in upstate New York. After perusing hundreds of pages of facsimiles of Leonardo's codices stored in NGA vaults, I also chose twenty-five drawings for the exhibition. One drawing (Folio 59b of *Codex Atlanticus*), though not as aesthetically pleasing as the others, resembled a ray diagram of light reflected from a convex spherical surface.

In a keynote lecture in 2005 at the International Conference on Management of Engineering and Technology in Portland, Oregon, I projected the ray diagram from Leonardo's *Codex Atlanticus* Folio 59b. I speculated that it may have been Leonardo's design for a reflecting telescope and suggested that someone should explore the possibility further. Among the participants in the meeting was André Buys from Pretoria, South Africa, a professor of nuclear engineering and an amateur telescope builder.[5] Fascinated by the prospect, Buys accepted the challenge, spending the next two years digging deeper into Leonardo's codices and replicating Leonardo's telescope.

Among the pages of the *Codex Atlanticus*, Buys also discovered an even lesser-known Leonardo drawing. It depicted the face of the moon with a blurred circular ring visible at four o'clock: a minor crater. Los Alamos National Laboratory scientist G. Reeves used the drawing to determine the date and time of the particular lunar libration as the early evening of December 12, 1512. Invisible to the naked eye, the ring has been known in telescope-based astronomy as the Tycho Crater.

So compelling was Buys's endeavor that the history of the astronomical telescope was pushed back a full century prior to Galileo's refractor and 157 years prior to Newton's reflector. I had been the inadvertent driver

in establishing Leonardo's provenance in the history of telescope-based astronomy.

CREATIONS IN ART—DISCOVERIES IN SCIENCE

Unlike the creative process in the arts, where the writer, composer, painter, or sculptor begins with a blank slate—score, canvas, or block of stone—the creative process in the sciences follows the prescription promulgated by Francis Bacon: observation, hypothesis, experimentation, conclusion, and publication. A resulting theory must be testable and provable. In their hypotheses, scientists are guided by established fundamental scientific principles and laws. And in their conclusions, their theories must be verifiable by experimentation and otherwise modified or discarded. Newton's three laws, the law of universal gravitation for the attractive force between masses, Coulomb's law for the attractive or repulsive force between charges, the laws of thermodynamics, the laws of electrodynamics, the theory of evolution, the theory of relativity, and quantum mechanics are among laws or theories that have been through the process.

Stratification defines the superstructure of the sciences. Physics, the most fundamental of the sciences, underlies chemistry; chemistry underlies the life sciences; the life sciences underly the social sciences. At the interfaces between these basic sciences exist a number of segue fields: physical chemistry, biochemistry, social biology. Ultimately, underlying the entire superstructure is pure mathematics, the nutrients of which rise upward through the strata by osmosis and capillary action and provide quantitative rigor and precision. However, although it is known as "The Queen of the Sciences," two questions regarding the nature of mathematics remain unanswered: (1) whether mathematics is a messy sort of science or a purely human construct in the manner of a collection of tools created by the human brain (Newton, Leibniz, von Neumann, Einstein, Dirac, and Feynman are among scholars who would have lined up on the two different sides of this issue), and (2) why it works so effectively in describing nature? Short of communicating

with extraterrestrial intelligent life or making progress with that "godlike technology" artificial intelligence, we may never be able to answer these questions.

Princeton's Hungarian American Eugene Wigner (Nobel Prize, 1963) first applied the formalism of group theory, previously regarded as pure mathematics, to atomic physics in the 1930s. He saw it grow in subsequent decades into an indispensable tool in the arsenal of high-energy physicists, only to confess his bewilderment regarding "the unreasonable effectiveness of mathematics": "The miracle of the appropriateness of the language of mathematics for the formulation of the laws of physics is a wonderful gift which we neither understand nor deserve."[6] Wigner became an admired older friend for me, a mentor with whom I discussed physics, creativity in the sciences, Newton, and *his* "admired older friend," Albert Einstein. Wigner also spoke frequently of his own inspiring teacher, which, in turn, spurred me to write the section "The Parable of László Rátz and the Martians." The book points out how important an inspiring teacher can be in instilling curiosity and passion to know.

As for the choice of the greatest scientist(s) in history, why Newton and Einstein and not Darwin, Pasteur, or Freud? As sentient creatures, we are more concerned with our own existence, our bodies and minds, our morality, and our spiritual growth than we are with inanimate nature—whether at the submicroscopic, human, or cosmic scale. The life and social sciences, located in the upper strata of the superstructure of science and responsible for explaining the body, brain, and mind, are on the whole more appealing to most people. But the nature of reality lies at its foundation, at the base level of physics, and revolutions there are more consequential than those in the upper strata. An unpoetic but concise definition of life is its nature as "self-replicating macromolecular systems." As such, physics in its wider role must explain all matter—the motion of heavenly bodies, the morphing of inanimate molecules into animate, evolution, the functions of a brain that can figure it all out and write poetry and paint, though we are nowhere near that point yet.

Newton's magnificent edifice, classical mechanics, was built on the assumption that the three dimensions of space are independent of the single

dimension of time. **Newton's theory is mathematically rigorous, deterministic, and intuitive.** Einstein, in his formulation of special relativity, integrated time into a four-dimensional space-time. At *relativistic* speeds; i.e., approaching the speed of light c, distances can be shown to contract but only in concert with time dilation, or the slowing down of time. Accordingly, identical twins in different inertial frames (traveling *not* together, but *relative* to each other) age at different rates. Special relativity further demonstrated the equivalence of energy and mass, expressed in the famous equation $E = mc^2$. Einstein's modifications made corrections to classical mechanics at relativistic speeds and effectively reinforced Newton's edifice. It did not overturn it. For the cause of motion and resulting trajectories, Newton had introduced the notion of force. With general relativity, Einstein posited mass as the cause of the warping in the four-dimensional space-time fabric, which in turn determined trajectories. **Einstein's relativity represented a change in the fundamental paradigm of reality and, like Newton's classical mechanics, it was mathematically rigorous and deterministic. But unlike Newtonian mechanics, it was counterintuitive.**

That the nature of art and the nature of science are different is well known. Art is practiced subjectively, science objectively. Great art is porous, ambiguous, anthropocentric (human-centered), open-ended, and indeterministic. In distinction, great science is mathematically rigorous, universal, and strives for completeness and elimination of ambiguities. But what emerges in this book is that art and science display a commonality in the most successful area of fundamental science. As revealed in the Copenhagen interpretation of the Heisenberg Principle in the 1920s, **quantum mechanics is mathematically rigorous, counterintuitive, and indeterministic.** This represents yet another change in the fundamental paradigm of reality.

In critical tests proposed by Irish physicist John Stewart Bell in the 1960s, quantum mechanics was also seen to possess an anthropocentric nature in the manner of the arts. Accordingly, works in both cultures are observer-dependent, a conclusion Einstein was unwilling to accept for the sciences. As quantum mechanics gradually proved itself during his

maturing years, Einstein came to see himself as a dinosaur, reconciling himself with the thought "Young revolutionaries are destined to become old reactionaries!" Yet his contributions have proved so seminal at scales of reality from the submicroscopic through the supra-macroscopic that his shadow has kept growing since his death in 1955. His relativity predicted the expansion of the universe, the implosion of massive stars into black holes, and the existence of massive black holes lurking in the centers of galaxies. His theories on the microscopic universe predicted the possibility of lasers, Bose–Einstein Condensate, the MRI, and much, much more. All of these came to fruition after his death.

Among the more surprising results presented in the book is the unlikely pairing of scientist Newton and musician Beethoven. The two men exhibited similarities so striking that one can describe them as "a pair of psychopathological twins born 128 years apart." This, however, is not an original observation. A century ago, British journalist J. W. N. Sullivan first noticed some of their shared peculiarities. Then fifty years ago, University of Chicago astrophysicist S. Chandrasekhar (Nobel Prize, 1983) cited Sullivan and those common conditions of Newton and Beethoven while delivering a lecture on "Patterns in Creativity."[7] Both men suffered from mysterious ailments, both had nervous breakdowns, both became suicidal, both resisted the irreversible and impulsive act of ending their lives, and both regained their irascible, reclusive personalities after changing their life patterns.

A PAIR OF LIMITATIONS

This book has a pair of limitations. The first limitation is its confinement to the Western tradition in the sciences and the arts since around 1400. Examining genius in art in the ancient civilizations of Asia, Africa, North and South America, Australia, the Middle East, and Oceania would have made it a compendium at least an order of magnitude more voluminous than the present book. As for science and technology, there is a cumulative

nature in these fields. The truly timeless inventions and history-changing technology of non-Western civilizations have long been integrated into modern science and technology. These include gunpowder, paper, and printing from China, the crucial mathematical concept of zero, the decimal system, and the place concept from India, all kept alive and gradually funneled from the Middle East to Europe.

A second limitation involves gifted women. The past was not fair to women, restricting their opportunities and limiting the attention given to their real achievements in the face of often insuperable obstacles. Though there has been increasing attention given to the history of great women, it pales in comparison to the attention given to men. I have done my best to incorporate the contributions of genius women that current historical records provide. Virginia Woolf, one of the great writers of the twentieth century, pointed out in a monograph in 1929 that the notion of genius was the creation of white men, for white men, and they did their best to make it exclusive. Although she was addressing only the plight of women novelists, her analysis and advice for rectifying a variety of injustices are still timely and applicable to women in other fields.

The two most significant technological developments in the ascent of humanity have been the invention of farming approximately 10,000–11,000 years ago and the harnessing of steam and electrical energy during the Industrial Revolution. While the geniuses in the history of the latter revolution are well-known, those in the former are not, that revolution coming long before recorded history. Recent discoveries in Upper Mesopotamia in southeastern Turkiye (formerly known as Turkey) point to roaming hunter-gatherers in the early Neolithic period first building a temple complex in Göbeklitepe 12,000 years ago, inventing farming within 1,000–2,000 years, and then creating settlements, cities, and eventually nations and empires.

Common sense suggests that it was the women, the *gatherers*—whose lives revolved around their knowledge and understanding of plant life—who invented farming. Whomever they may have been, individually or collectively, they remain nameless, hidden in the mists of the unrecorded past.

But there have been identifiable female geniuses, including in male-dominated fields, who have shattered glass ceilings to compete with the most creative males. Among them are polymaths Hildegard von Bingen, Sarah Bernhardt, and Hedy Lamarr. Immensely talented women painters include Artemisia Gentileschi, Judith Leyster, Élisabeth Louise Vigée Le Brun, and Frida Kahlo. Among the great writers in history are Jane Austen, George Eliot, and George Sand. In the closing years of the twentieth century, a soaring talent, Toni Morrison, won the National Book Award, Pulitzer Prize, and the Nobel Prize in Literature (1993).

As for female scientists, the best-known is Marie Curie, the recipient of two Nobel Prizes. But no less talented were Emmy Noether, Lise Meitner, and Maria Goeppert Mayer. As more access to education and opportunity is provided to women around the world, their achievements will be recorded and celebrated. In the sciences, for example, the years 2018, 2019, and 2020 each saw female scientists share Nobel Prizes. They are interwoven thematically into the text.

PART I
INTERNAL AND EXTERNAL FACTORS FOR GENIUS

1

TRAITS POSITIVE AND NEGATIVE

Talent hits a target no one else can hit;
Genius hits a target no one else can see.
—Arthur Schopenhauer

The notion of genius first appeared during the Golden Age of Greece when peripatetic philosophers identified a handful of their own as having been "touched by the gods," "touched by the genie," or geniuses for their groundbreaking teachings in logic, metaphysics, ethics, psychology, and epistemology. Aristotle, chief among a trio of the most influential, cited the pre-Socratic philosopher Thales of Miletus, a natural philosopher who lived almost three centuries earlier, as the first truly great philosopher genius. During the same time, however, artists would remain only artisans, and playwrights and poets above the artisans but below the philosophers. Gradually during the next two millennia, areas other than philosophy; e.g., literature, art, science, and music, experienced cultural revolutions and introduced their own geniuses. By the High Renaissance, the trio of Leonardo, Michelangelo, and Raphael were inducted into the circle; in the Elizabethan Age, Shakespeare; shortly thereafter in the Scientific Revolution, Galileo and

Newton; and during the Enlightenment, Bach, Mozart, and Beethoven all entered the pantheon of geniuses. Early in the twenty-first century, we are again swept up in a cultural revolution. The Information or Digital Age, like other revolutions, has already brought out a few candidates for genius designation, but assessing the scale and permanency of their contributions will require the test of time.

Although commonly accepted and even overused, the notion of genius is difficult to define. In the broadest sense of the word, it refers to individuals who display extraordinary intellectual ability or surpassing levels of creativity—different but complementary qualities. But what good are soaring intelligence or lofty levels of creativity if they do not result in lasting achievements? Intelligence or aptitude tests involve word associations, synonyms, and mathematical logic. Creativity is even more abstract, more amorphous, and much more difficult to nail down. Where surpassing creativity exists, there is an admixture of traits: an unquenchable childlike curiosity, open-mindedness, an unusual penchant for pattern recognition, and a passion to make connections—attributes assisted by good memory, originality, imagination, intuition, and insight. On the negative side, virtually unavoidable, are two essential traits: an aversion to authority and a touch of insanity.

The Greeks believed that a disordered mind, "a tincture of lunacy," as the Roman writer Seneca described it, was a gift of the gods and a critical trait of genius. Later, during the Renaissance and Enlightenment, society had little sympathy for the insane. They were imprisoned or otherwise kept out of sight. In modern times, psychotherapy and psychopharmacology are employed in eliminating or controlling symptoms of mental illness, although there still exist segments of modern society pursuing religious or spiritual treatment, such as exorcism. All the foregoing traits pertain to software issues of the brain. The actual biology or wiring of the brain is one of hardware. And although crucial to understanding genius, they are not as well understood. What is known, however, will be discussed in chapter 13, "Lumps, Bumps, and the Gifted Mind."

The expressions "thinking outside the box," "lowered inhibition," and "aversion to authority" are all closely related to creativity. It is well known

that the right hemisphere of the brain is mainly the emoting, romantic, and artistic side, in which inhibitions are hardly present. The left hemisphere is associated with objective, analytic, and rule-dependent thinking, where spatial acuity and precision are required, and where inhibitions remain powerful. Thus, engaging in scientific inquiry, playing board games, and the more vital activity of speaking are primarily functions of the left hemisphere. This division in the functions of the left and right hemispheres is not one hundred percent, but it is very high. The collective reversal of the functions of the two hemispheres of the brain may be as rare as the occurrence of *situs inversis* in the torso—where the visceral organs are reversed, with the heart located on the right, the appendix on the left—occurring in roughly one in every 10,000 individuals. The two hemispheres appear to function at cross-purposes with each other, but also in a complementary manner. Creativity requires collaboration between the two hemispheres.

Three years before his death in 1519, Leonardo da Vinci, while living in Amboise in the Loire Valley of France, suffered a stroke in the left hemisphere of his brain. The stroke left him partially paralyzed on the right side of his body. Since he was left-handed and still possessed full use of his left hand, he could still draw, write, and paint. But he complained of having diminished creativity. In the late twentieth century, the highly talented right-handed sculptor Frederick Hart suffered a stroke in the right hemisphere of his brain just eighteen months before he died in 1999. The stroke affected his left hand and not his preferred right, and he also complained of having lost his creativity. Hart's masterpiece *Ex Nihilo* will be discussed in chapter 6. A third example is Louis Pasteur, who suffered a stroke in his creative right hemisphere, leaving his left arm and leg permanently paralyzed. Pasteur spent the next two decades relying on his assistants to manipulate the experimental apparatus for him. As he perused his earlier publications, however, he would "marvel at the lands he had revealed by dispelling fogs of ignorance and overcoming stubbornness."[1] In a nostalgic line, he offered a tacit admission of reduced creativity compared to his younger days before the stroke: "How beautiful, how beautiful. And to think I did it all. I had forgotten it."

As humans, we are comprised of 19,000–20,000 genes.[2] Just as genetic markers have been identified for a predisposition to obesity or for certain types of breast cancer, gene research has uncovered connections to certain types of mental illnesses: e.g., autism, anxiety, depression, Alzheimer's disease, and schizophrenia. Add to these the long-known phenomenon that identical twins tend to have closer intelligence test scores than do fraternal twins, and it becomes likely that inherited or genetic factors are also involved in intelligence.

In 2017 a research group compiling genetic statistics at the Vrije Universiteit Amsterdam published its studies identifying a set of fifty-two genes as being compatible with higher intelligence scores.[3] Their database represented a consolidation of separate studies of nearly 80,000 individuals. A year later, in a merger with other studies, 939 additional genes were added to the list, along with speculation that numerous other genes may be correlated with high intelligence.[4] It is noteworthy that some of the genetic markers for mental illness appear to be the same markers associated with intelligence, adding to the notion of the inseparability of genius and insanity. This research is highly promising, albeit still in its infancy. Here we shall focus mostly on the software, although, on occasion, refer to the mind-brain connection or, loosely, the computer architecture.[5]

DEGREES OF GENIUS: A DISTILLATION

Seated marble statues of some of the preeminent sons of Trinity College, Cambridge—Francis Bacon, Isaac Barrow, Alfred Lord Tennyson, and George Babbage—line the periphery of the antechapel of Trinity. All appear to be in deep concentration. Holding a master class over the seated figures is a standing statue of Isaac Newton. Carved by the French sculptor Louis-François Roubiliac, at its base the statue bears the Latin inscription "Qui genus humanum ingenio superavit" ("With his intellect he surpassed the human race").

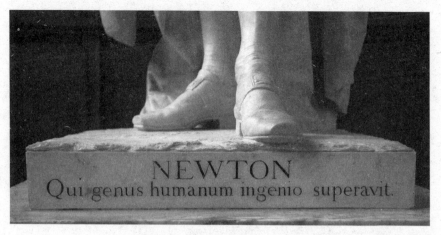

The base of Newton's statue by Roubiliac.

The message is succinct, and it is *grievously* understated! The canon of Newton's contributions to mathematics, physics, and science in general is unique! His defining masterpiece, *Mathematical Principles of Natural Philosophy*,[6] or simply the *Principia*, is regarded as the most influential work in the history of science and as the first event of the Enlightenment. His physics explained the nature of motion in the terrestrial as well as the celestial world, unifying the physics of heaven and earth. In marrying mathematics and physics, Newton provided the fuel for the Industrial Revolution. That, in turn, led to a marriage of science and technology that helped the nations of Western Europe gain ascendency over the rest of the world.

Just fifteen years after Newton's death, Benjamin Robins invoked differential and integral calculus and the laws of motion, carried out experiments with air resistance, and pointed out the critical importance of providing spin to projectiles by adding helical ridges in the interior surfaces of the muzzles of muskets and canons. Described by historian Niall Ferguson, "[Robins] was born with nothing but brains"[7] into an impoverished Quaker family. For successfully applying Newton's laws to ballistics, Robins deserves the sobriquet of genius, but an "ordinary genius." It had been a transformative genius who had formulated calculus (mathematics) and the universal laws of classical mechanics (physics) in the first place.

Robins, like many other geniuses before and after him, was self-taught, an autodidact. And like many other geniuses, he was also a bundle of contradictions, a conflicted Quaker pacifist who first revolutionized the science of artillery with his book, *New Principles of Artillery* (1743), and helped propel Great Britain into a worldwide superpower. When Robins's book was translated into German by the great mathematician Leonard Euler, it set off an arms race.

Recalling his student days at St. John's College, Cambridge, next door to Trinity College, the poet William Wordsworth wrote:

> *Near me hung Trinity's loquacious clock,*
> *Who never let the quarters, night or day,*
> *Slip by him unproclaimed, and told the hours*
> *Twice over with a male and female voice.*
> *Her pealing organ was my neighbour too;*
> *And from my pillow, looking forth by light*
> *Of moon or favoring stars, I could behold*
> *The antechapel where the statue stood*
> *Of Newton with his prism and silent face,*
> *The marble index of a mind forever*
> *Voyaging through strange seas of*
> *Thought, alone.* [8]

THE ARTIST EXPLORING NATURE—THE SCIENTIST CREATING ART

An examination of any two lives should yield commonalities ranging from the superficial to the genuinely astonishing. Just as it is with merely creative people and ordinary geniuses, so too it is with transformative geniuses even in the same field. They do not all display the same backgrounds, dispositions, traits, personalities, and motivations, nor do they demonstrate similar approaches to solving problems. Gaining a measure of insight is possible only by exploring tendencies and proclivities, similar shapes and forms

but not perfectly coterminous maps of creative genius. Einstein was an artist dealing with nature in the manner of Leonardo. Indeed, the roots of Einstein's creativity are understood best not by comparing him with Newton, but rather by comparing him with artist–scientist Leonardo, or even with his own contemporary, artist Picasso.[9] Newton had famously observed, "I keep the subject before me, and wait 'till the first dawning opens gradually, by little and little, into a full and clear light." Einstein could have made the same claim, but it was his legendary *gedankenexperiment* ("thought experiment") approach, augmented by his passion for the violin, that made him more of an artist.[10] Similarly, Leonardo, Robert Hooke, Michael Faraday, Ernest Rutherford, and Nikola Tesla, and even Einstein, each relatively innocent of mathematics, envisaged physical reality pictorially as invisible lines—fields—in distinction to visualizing them mathematically in the manner of Newton, Maxwell, and Dirac. In the distant past, Archimedes would have shared the mindset of the latter group. This distinction is ultimately one of top-down visualization versus bottom-up and will come up again.

Just as there exist close parallels in the personalities and talents of Einstein and Picasso, there exist even closer similarities, especially in their personal demons, of scientist Newton and composer Beethoven, to an extent that they can be described as "psychopathological twins."[11] Similarities in disposition and talent also exist between painter Raphael and composers Mozart and Schubert: each an unrivaled virtuoso in his field, but not a driver. And there are similarities between philosopher Aristotle and composer Bach, both supreme synthesizers but not creator-rebels.

In order to demonstrate the depth and originality of great ideas, chapter 7, "Intersection of Art and Science," and specifically the section "Aesthetics of Mathematics—Mathematics of Aesthetics," includes rudimentary math underlying great art. Subsequently, the description of nature in chapters 10–12 is rife with mathematics at the level of advanced undergraduate courses in the subject. The purpose is to make the book accessible and enjoyable to the layman and still edifying for the scientist. Abstract paintings hanging in modern art galleries frequently hear viewers'

assessment, *"Interesting!"* short for, "I don't have a clue what this artist is trying to say, but somebody must." Similarly, a layman encountering abstract mathematical expressions in this book should declare, *"Interesting!"*, and move on. They will still get the gist of the crucial importance of mathematics in understanding nature.

Each of our five subjects is a bundle of contradictions. Newton and Einstein were towering scientific figures. Ironically, Newton, supreme mathematician-scientist, who created an entirely new branch of mathematics in order to describe how nature functions, spent more time brooding over a pair of distinctly nonscientific interests—alchemy and biblical scripture. Einstein, the greatest scientist since Isaac Newton, was a skilled violinist who frequently found inspiration for his scientific endeavors while playing the music of Mozart, or while sailing his tiny sailboat *Tinef* on Long Island Sound . . . rejecting a life vest, even though he never learned how to swim. Most likely, however, these two distinctly nonscientific activities helped clear Einstein's head for those moments when he was engaged in intense concentration on physics problems. What is certain is that Einstein's *gedankenexperiments* always preceded his theories. His discovery of energy–mass equivalence ($E = mc^2$) explains the energy released in a nuclear explosion, and whose 1939 letter to Franklin Delano Roosevelt initiated the Manhattan Project to build the atomic bomb. And yet, he was an ardent pacifist much as Benjamin Robins had been. Einstein's discoveries and the contradictions in his system of values are explored in chapters 11, 12, and 14.

By weaving together their disparate passions, the transformative geniuses achieved tapestries of extraordinary beauty and complexity, and they did this again and again. Was there a physiological difference or something that could be mapped onto the brain? Only in the case of Einstein has the actual brain of one of our transformative geniuses survived, and there is tantalizing evidence that the organ featured an anomaly, possibly a hardwiring that made him *an Einstein*. Ultimately, understanding the patterns of their creativity may provide an entirely new appreciation of their work and genius, and indeed a better understanding than that provided by the pathology of formaldehyde-preserved brains. We will discuss similarities

and differences in their patterns of creativity, their noble traits, their miracles, and their human failings while making every effort to debunk the surrounding mythology.

All five individuals featured in this book share a common trait: they are polymaths harboring passions in disparate fields with the ability to fuse them together to reveal unexpected synergies. Newton harbored passions for mathematics and physics but separate from those was his obsession with alchemy and religion—constituting his "dark secrets." But the dark secrets did not detract from his formulation of rigorous and consistent scientific theories. His obsessive compulsion to preserve intellectual honesty in seeking the truth forced him to keep his religious sensibilities separate from his science. In his notebook he wrote, "Amicus Plato—amicus Aristoteles—magis amica veritas" ("Plato and Aristotle are my friends, but my greatest friend is truth").

Many creative people possess unusual physical attributes and mental faculties crucial for their particular field. Leonardo is believed to have had extraordinary eyesight, useful for his scientific observations of falling bodies, the trajectories of projectiles, and the flapping wings of birds. This is most likely similar to Ted Williams's estimated 20/3 eyesight (seeing an object twenty feet away as if it were three feet away) that allowed the legendary slugger to watch the spinning seams of a baseball as it hurtled toward home plate. The ability to focus on an object much earlier than individuals with normal eyesight offers the ability to freeze motion in the manner of modern high-speed photography. But, in Leonardo's case, it will be seen that in his eyes, he may have suffered from a condition called strabismus, a physical handicap serving as an artistic attribute.

A BEAUTIFUL MIND

In antiquity, Aristotle had noted, "No great mind has ever existed without a touch of madness," a sentiment echoed in the first century by Seneca, "There is no great genius without a tincture of madness."[12] The connection

between creativity and psychopathology[13] was also the focus of the writings of essayist Charles Lamb and George Bernard Shaw. Mental illness frequently eludes early recognition with idiosyncratic behavior being excused as the normal eccentricity of the highly creative: "After all, he is a genius!"

Psychiatrist Arnold Ludwig, in his book, *The Price of Greatness*,[14] uses the expressions "eminent," "great," and "genius" interchangeably. He reports on a ten-year study in which he examined the lives of 1,000 exceptionally creative men and women of the twentieth century. His subjects included celebrities of varying levels of achievement representing a wide range of creative fields. An important validation of the popularly held stereotype is that mental illness frequently accompanies exceptionally creative individuals, especially those in the arts. Another distinguished psychiatrist, Arnold Rothenberg, explores the subject of lunacy in his monograph, *Creativity and Madness*,[15] discussing highly creative individuals suffering from some measure of mental disturbance distilled from lengthy lists compiled separately by Ludwig and Rothenberg, Leo Tolstoy, Marie Curie, James Joyce, Pablo Picasso, Ernest Hemingway, Frank Lloyd Wright, Salvador Dalí, Albert Einstein, T. S. Eliot, Ansel Adams, and Virginia Woolf all exhibited mental disorders in different degrees.

James Joyce, author of *Dubliners*, *Portrait of the Artist as a Young Man*, and *Ulysses* (the last inspired by Homer's epic work), was a tormented Irish writer and, many would claim, the greatest writer in the English language in the twentieth century. He was an avant-garde modernist, writing in the groundbreaking narrative style of stream of consciousness. His works were known for their explicit content and candid portrayal of pimps, prostitutes, and Jesuit priests. His critics characterized his works as impenetrable. He claimed he was a sinner and a saint and superior to all other writers. Meanwhile, Joyce's daughter Lucia showed early talent as a modern dancer but became aggressive and self-destructive and was eventually committed to an asylum. Joyce doubted that she was schizophrenic, "After all, her thought patterns were similar to my own," he said. Carl Jung, who was treating Lucia, saw it differently: "The father and daughter were like two people who arrived at the bottom of the river. James had dived there, whereas Lucia had fallen

in." The difference between tormented genius and madness in this case may be one of control, distinguishing the genius, James, from the mad Lucia. This distinction immediately points to a "difference between full-blown forms of the illness and the milder forms of psychosis that are at the roots of the association between creativity and madness."[16]

There is one distinct act that immediately removes all doubt about an individual's mental disorder, and that is the impulsive and irreversible act of suicide. Comparing the statistics for suicide in three groups of writers, Ludwig reports that for nonfiction writers (e.g., journalists) the numbers are negligible; for fiction writers (novelists) 4%; and for poets 20%.

Ernest Hemingway, the recipient of the Pulitzer Prize (1953) and the Nobel Prize for Literature (1954), died by suicide with a shotgun in 1961. A complex and tortured man, he could well have been writing his autobiography when he penned, "Happiness in intelligent people is the rarest thing I know." His physician father, Clarence Edmonds Hemingway, a dominant figure in the writer's early life, had died by suicide (1928). His sister Ursula Hemingway Jepson would die by suicide in 1966, and his actress and model granddaughter Margaux Hemingway, in 1996. A dark thread ran through the fabric of this brilliant but supremely tortured family.

Although it has never been established conclusively, the preeminent Russian composer Pyotr Ilyich Tchaikovsky, on the verge of being exposed as gay, is believed to have died by suicide in 1893 by ingesting arsenic. Sixteen years earlier, giving heterosexuality a try, he had married Antonina Milyukova, but left her after a few weeks.

One of the most celebrated tortured geniuses was the postimpressionist painter Vincent van Gogh (1853–1890). While living in Arles in southern France and in the throes of schizophrenia, he cut off his left ear. A year later in hopeless despair, he died by suicide, a topic that will be discussed further in chapter 15.

Any discussion of insanity and artistic creativity would be incomplete without mentioning Michelangelo Merisi da Caravaggio (1571–1610). The ultimate holy terror of art, Caravaggio preceded van Gogh by three centuries. Unlike the great Dutch postimpressionist, Caravaggio did not

take his own life. But in a bar brawl, he took the life of another man and found himself on the run from the authorities and from the victim's friends. Eventually the friends tracked him down and assassinated him. Caravaggio's originality and his influence on artists throughout Europe for centuries to come will also be discussed in chapter 15.

Celebrity entertainers, surrounded by sycophants, greedy agents, and quack doctors, frequently fall victim to the brutal entertainment business. Steeped also in drug culture, there is a nonnegligible chance that they will not live out normal life expectancies. In a recent eponymous film, *Elvis*, you feel the iconic singer's pain when he confesses to his wife Priscilla, "I don't want to play Elvis anymore!" Elvis died in 1977 at forty-two. Before him, there were James Dean, Judy Garland, and Marilyn Monroe, and after him, Karen Carpenter, John Belushi, Michael Jackson, Prince, and John Lennon. In classical music and opera, there were Mario Lanza and Maria Callas. If they did not end their own lives, someone else (in Lennon's case) ended it for them. Each story is a Greek tragedy that should never be glamorized.

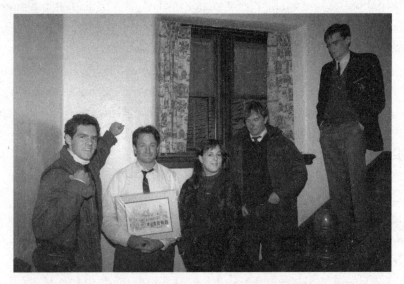

Robin Williams, second from the left, during the filming of the 1989 film Dead Poets Society. Peter Weir, director of the film, is standing on the stairs at the far right, while the author's son and daughter flank the actor. The campus of St. Andrew's School, Middletown, Delaware served as the fictitious Welton Academy. Credit author.

In 1989, the versatile actor Robin Williams starred in the film *Dead Poets Society*, in which a student at a private boy's school feels relentless pressure from his father. He is expected to excel academically, gain admission to Harvard, and become a physician, instead of what he wants to do: become a stage actor. Overcome by a feeling of total hopelessness, the boy takes his own life. The morality play is that of a father living through his son, much as Mozart's and Beethoven's fathers had done two centuries earlier. As an example of life imitating art, a second morality play, twenty-five years after the film was made Williams shocked the world by dying by suicide himself. The postmortem revealed the presence of high levels of antidepressants and medication for Parkinson's in his system. Williams was just sixty-three years old.

In January 2023, Elvis's daughter Lisa Marie, a singer and songwriter herself, died of cardiac arrest. She was fifty-four. Married four times, divorced four times, she too had struggled with opioid addiction. Her son, Ben Keough, had died by suicide just eighteen months earlier.

Creative scientists, although less prone to descending into the unfathomable depths of despondency and mental illness, are not altogether exempt. The great German mathematician Georg Cantor (1845–1918) suffered from bipolar disorder most of his life, the frequency of his bouts of depression seemingly increasing with age. During his bouts with depression, the barrage of unfair criticism from contemporaries could have led him to take his own life. Somehow, he resisted. However, his contemporary, the Austrian mathematical physicist, Ludwig Boltzmann (1844–1906), was unable to cope with the stress. Rival physicists who could not appreciate the originality and significance of his work had made life utterly unbearable for him. On a family vacation in Trieste in northeastern Italy, Boltzmann was having dinner with his wife and daughter when he quietly left the table, returned to their hotel room, and hanged himself.

During the Golden Age of physics in the early years of the twentieth century, Dutch physicist Paul Ehrenfest (1880–1933), once a student of Boltzmann, was bedeviled by the newfangled theory of quantum mechanics and the unrelenting pressure to produce (research papers). He turned a gun on himself . . . but not before he shot his son who had Down syndrome.

Finally, there is the case of the pioneer game theorist, John Nash, whose life was portrayed in the 2001 film *A Beautiful Mind*.[17] Born in West Virginia, Nash suffered during most of his life from schizophrenia, with violent emotional swings oscillating in resonance with his ability to maintain academic appointments. A deceptively simple PhD thesis he had written as a graduate student at Princeton in 1951 on game theory turned out to bear such bountiful fruit for economics that he was awarded the 1994 Nobel Prize in Economic Sciences and, posthumously, the Abel Prize in mathematics. When he was on medication, he was relatively sane but complained of feeling foggy. Nash did not die by suicide. Tragically, in 2015 he and his wife were both killed in a traffic accident while riding in a taxicab on the New Jersey Turnpike.

LEFT-HANDEDNESS, SEXUAL ORIENTATION, AND GENES

Among traits of genius that rise to prominence is the unusually high incidence of left-handedness compared with that in the rest of the population. According to Ed Wright, author of *A Left-Handed History of the World*, four of our five transformative geniuses—Leonardo, Newton, Beethoven, and Einstein[18]—were left-handed. If two other surpassing geniuses Michelangelo and Raphael were also to be included in the group, then six of the seven would be left-handed. Among other left-handers on Wright's list are Lewis Carroll, Mark Twain, Friedrich Nietzsche, Marie Curie, Alan Turing, and Bill Gates.

Artists demonstrate the same 10:1 preponderance of right-handers to left-handers as do the rest of our species. An artist employing shading to highlight a figure rests the heel of his hand on the surface of the work and makes rapid swiping motions with the point of his drawing utensil, creating parallel lines of controlled density. If the shading displays a positive slope (lower left to upper right in direction), the artist can be identified as a right-hander. Conversely, shading that displays a negative slope reveals the artist as a left-hander.

Regarding the question of sexual orientation, three of our five exemplars—Leonardo, Shakespeare, and Newton—exhibited sexual ambiguities. If Michelangelo were to be brought into the mix, then four of the six would be regarded as gay or bisexual. If we were to include Botticelli, then it would be five of seven, and with Caravaggio, six of eight. The foregoing list pertains to unusually talented Renaissance artists. Of course, if we were to include creative performing artists in just modern times, the list would swell rapidly, with Walt Whitman, Hart Crane, David Bowie, Elton John . . .

In the 2017 publication I mentioned earlier, the Vrije Universiteit Amsterdam group sought a correlation between genes and intelligence. Similarly, 2018 and 2019 saw announcements of the hot-button issue of genes and sexual orientation. An international collaboration of a group of psychologists, sociologists, and geneticists at Boston's MIT and Harvard,[19] with researchers at Vrije, found evidence of genes associated with sexual behavior. They gathered data from almost half a million individuals from questionnaires and DNA profiles.[20] In a 2018 publication, they identified four chromosomal markers or *variants*. Then in 2019, they identified a fifth marker. The results showed a number of tenuous connections between genes and psychological and physical traits. Among these were major depressive disorder or schizophrenia, a proclivity to risk-taking, the use of cannabis, and a general penchant for unusual experiences; e.g., nonheterosexual experimenting. Among physical traits, there were male-pattern baldness and left-handedness. The authors of the report readily conceded that human sexuality is complicated: that it is partly determined by genes and partly by environmental factors. Meanwhile, limitations exist in the study in that the subjects were almost exclusively whites of European descent—no Asians, no Africans, no Aboriginal Australians. Also, the researchers placed all participants who had reported even a single same-sex sexual event into the same group as those who admitted unreservedly to being gay.

Another far-reaching report was published by a group of geneticists and social scientists at the University of Oxford in 2019. They also had access to the voluminous UK Biobank. The authors cited additional evidence

of correlations between genes, the structure of the brain, superior verbal skills, and a number of traits favorable to creativity, albeit at the cost of predispositions to developing certain neurological and psychiatric diseases such as Parkinson's disease and Alzheimer's disease, and mental disorders including depression and schizophrenia.[21]

PHYSICAL HANDICAPS AS CREATIVE ATTRIBUTES

Christopher Tyler, a neuroscientist with a passion for art, has always been a highly original thinker. The head of Brain Imaging at the Smith-Kettlewell Eye Institute in San Francisco, Tyler is especially interested in how the artist sees and depicts his subject. In 1998 he published a paper positing the "centerline principle," applicable to single-subject portraits. Great Masters through the ages, including Leonardo, Van Eyck, Van Dyck, Hals, Rembrandt, and, in the twentieth century, Graham Sutherland and Picasso, all posed their subjects with one of the subject's eyes on the vertical bisector of the frame. With the subject's head turned slightly, the line could pass through the leading eye or through the trailing eye (see chapter 6).

In late 2018, Tyler published another important paper shaking up both the art and the ophthalmic communities. After studying six known or suspected likenesses of Leonardo, he found that five of them displayed strabismus in the eyes. In strabismus's exotropia form, the condition manifests in the focal axes of the eyes diverging slightly. Commonly known as "lazy eye," it afflicts approximately 1% of the world's population. Especially dramatic among the Leonardo likenesses that Tyler points to is Verrocchio's bronze statue of David, a work in which the sculptor's teenage apprentice is believed to have served as the model. The angle of divergence between the eyes is 13.2°, according to Tyler's measurement. He points out that a number of other iconic artists, including Rembrandt and Picasso, also suffered from the condition, as did Barbieri, aka "Il Guercino" (literally, "the squinter"). Tyler conjectures that the artist suffering from the anomaly

is able to suppress the view in one eye at will and see his subject with monocular, rather than binocular, vision. This allows the artist to readily project a three-dimensional scene onto a two-dimensional flat surface, which is ultimately what a painting happens to be.[22] While most painters are skilled in making two dimensions resemble three dimensions without being afflicted with the condition, those with strabismus may have an edge. The occurrence of the condition in a group of surpassing painters suggests they do have an advantage in their drafting abilities. The topic, however, remains a source of controversy among ophthalmologists and requires further study.

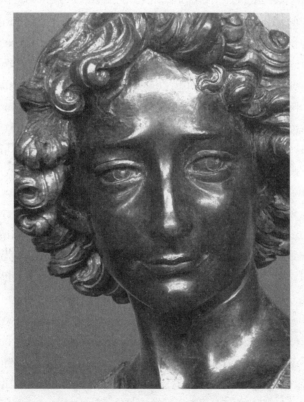

Andrea del Verrocchio, David, mid-1460s, with Leonardo as the likely teenage model. The sculptor has delineated the pupils and irises of the eyes with precision. According to Tyler, the axes of the eyes diverge by 13.2°.

Great composers are said to have possessed perfect musical pitch. But beyond this faculty, Italian composer/virtuoso Niccolò Paganini may have suffered from Marfan syndrome. Individuals with this condition are characterized as double-jointed, possessing unusually long slender fingers, and a peculiar yellowish pallor. With his superhuman feats on the violin, Paganini wowed his audiences, but his appearance caused considerable alarm: "Was he the Devil incarnate?" Similarly, composer/piano virtuosos Franz Liszt and Sergei Rachmaninoff possessed hypermobility (double-jointedness) in their disproportionately long fingers, with speculation that they also suffered from Marfan syndrome.

Beethoven, who had been a superb piano virtuoso, gradually lost his hearing. He gave up performing in music halls, channeling his creative outlet to composing. There it was his mind and his ability to hear sounds *virtually* that raised his work to a higher level. In his vocal pieces, musicologists have claimed, he sometimes assigned chords to singers that were beyond their reach. By the time he was totally deaf in 1824, he had forgotten the vocal ranges of the performers. Charles Limb, Johns Hopkins otolaryngologist, who also happens to be a virtuoso saxophonist, wrote about the last phase of Beethoven's creativity, "He starts composing like a madman. Just brilliant masterwork after masterwork. There was an evolutionary leap in his compositional style and his ability to break boundaries."[23] Marin Alsop, director of the Baltimore Symphony Orchestra and Beethoven scholar, echoes Limb, adding, "The pinnacle of Beethoven's forward-thinking... occurs in his late string quartets. I wonder if they would have been so avant-garde had he been able to hear them in real-time and space. This complete lack of self-censorship may have been the ultimate artistic liberator."

A composer who shared with Beethoven both the curse and the gift of having had to compose entirely in his head was the Czech pianist-conductor-composer Bedrich Smetana (1824–1884). Having enjoyed normal hearing until he was fifty years old, Smetana lost his hearing quite suddenly, the result of a syphilitic infection. Freed to forego performing, he concentrated on creating music. His greatest work, *Má vlast*

(*My Homeland*), consisting of six symphonic poems, came after the loss of his hearing.

Human figures in paintings by El Greco were always elongated in appearance. Among ophthalmologists, there have been speculations about the artist having suffered from astigmatism. Similarly, we can ask, "Have visual handicaps inspired the elongated figures in Swiss sculptor Alberto Giacometti's work or, conversely, the over-fleshy figures in Colombian sculptor Fernando Botero's sculpture?"

AUTISM AND MATHEMATICAL GENIUS

> *No one understands the mental faculty we call mathematical intuition; much less, genius . . . In no other intellectual realm does the genius find so much common ground with the idiot savant. A mind turning inward from the world can see numbers as lustrous creatures; can find order in them, and magic . . .*
> —Michael Gleich[24]

Newton is post-diagnosed as having been afflicted with high-achieving autism. Similarly, Dirac, the subject of Carmelo's *The Strangest Man*, was not crazy, as even Einstein once wondered. In our day, the word "autism" has become so expansive that some forms of the disorder are associated with the ability for analysis, creative thinking, and mastery of mathematics. Dirac's closest friends were numbers and equations. He once wrote:

> One should allow oneself to be led in the direction to which the mathematics suggests . . . one must follow up a mathematical idea and see what its consequences are, even though one gets led to a domain which is completely foreign to what one started with . . . Mathematics can lead us in a direction we would not take if we only followed up physical ideas by themselves.

Autism manifests in different ways. Gleich's words at the opening of this section apply mainly to mathematical ability, where certain individuals demonstrate the ability to perform lightning-fast arithmetic calculations but are otherwise oblivious to mathematics beyond basic operations. In a condition called synesthesia, numbers are seen as colors, allowing those who suffer from the condition to function as human computers. Shakuntala Devi, a woman from India who passed away in 2013, had been a child prodigy who gained international fame in 1977 after calculating the twenty-third root of a number with more than one hundred digits in just fifty seconds, compared with a full minute that the fastest computer at the time required to do the calculation. Three years later, she multiplied two randomly generated thirteen-digit numbers in twenty-eight seconds.

Carl Friedrich Gauss, among the top tier of mathematical geniuses, once derived a mathematical algorithm to determine the irrational number π to a prespecified number of digits. Then he hired a patient with autism, manifestly not a gifted mathematician, to grind the digits out as a human calculator. The man was given a routine algorithm, and according to contemporary witnesses, appeared to concentrate intensely, turning red, gritting his teeth, rolling his eyes, and even jumping up on a table. Then he climbed down from the table and proceeded to write out the value of π to 140 places.

Auticon is an award-winning multinational IT- and compliance-consulting business based in London and Munich. The company announced in 2017 that it was hiring high-performing people on the autism scale as 60% of its employees worldwide: "There is no disability as far as we are concerned, rather they employ different operating systems." Ironically, many autistic individuals with either eidetic faculty or synesthesia leave us in awe and are often described as prodigies, although they lack the ability for meaningful analysis and creative thinking. In distinction, another condition known as aphantasia represents the ability to construct complex pictures, even allow visual hallucinations, without robbing the afflicted of analytical insight. Aphantasia may explain the modus operandi of Einstein, Michael Faraday, and Nikola Tesla.

The term "prodigies" describes children up to and including age ten who gain professional levels of proficiency in the arts and sciences—especially in the rule-based fields of music, mathematics, and chess that are processed primarily in the left hemisphere of the brain.[25] Among the issues addressed in the study is the identification of the roots of precocity. One study focused on nine exceptional prodigies and their families. The prodigies were given multiple tests, including a full-scale Stanford-Binet IQ test, verbal and nonverbal IQ tests for working memory. Of the eight tested prodigies, one third had a diagnosis of Autism Spectrum Disorder (ASD). Four of the families reported ASD diagnoses in first- or second-degree relatives, with three of the four families reporting multiple members in their families with autism. This suggests that there is a relationship between genes and high-functioning autism and Asperger's syndrome, an issue we will revisit in chapter 13, "Lumps, Bumps, and the Gifted Mind."

PREPAREDNESS AND EUREKA MOMENTS

Chance discoveries are occasionally seen as "eureka moments." But if preparedness and mastery of the field are not there, it is unlikely that the crucial clues will be recognized. Many biologists and geologists acknowledged the likelihood of evolution. Charles Darwin had the necessary academic preparation when he undertook the five-year voyage to the New World. The cumulative experience provided the threads that he was able to weave into a complex tapestry—the theory of natural selection as the underlying process for the evolution of life. Even then, Darwin gained sole recognition for the authorship of natural selection only when his contemporary Alfred Russell Wallace showed magnanimity by bowing out. Wallace could very well have challenged Darwin for the first authorship of the theory, but he did not. The scientific spirit had evolved a great deal for the better since Newton, Hooke, Leibniz, and Huygens had locked horns two hundred years earlier over questions of provenance.

Louis Pasteur (1822–1894) called preparedness a necessary ingredient in making discoveries: "Dans les champs de l'observation, le hasard ne favorise que les esprits prepares" ("In the field of observation, chance favors only the prepared mind"). He had received training in virtually every area of the natural sciences, biology, microbiology, chemistry, and physics, as well as in art, and was unique for his wealth of contributions to medicine and for extending life expectancy. It was his early studies in art that gave him insight into chirality; i.e., on "handedness," that he brought to the structures of molecules and crystals. (A reflected image of a smooth white sphere in a mirror is indistinguishable from the sphere itself, but the reflected image of a human right hand is distinguishable, appearing as his left hand, and vice versa.) Some molecules possess symmetric shapes; others possess chirality—right-handed or left-handed chirality—resulting in distinguishable chemical properties.[26] This insight led polymath Pasteur to making the discoveries that manifestly improved quality of life, including improvements in the ultimate nectar for the French people—their wine. Among his myriad medical discoveries were the vaccines for rabies and anthrax and proof of the germ theory of disease. Pasteur also disproved the doctrine of the spontaneous generation of life by demonstrating that in sterilized and sealed swan neck flasks nothing ever developed. This doctrine had persisted since the age of the pre-Socratics, found its way into church doctrine, and even found spotty experimental demonstration during the Scientific Revolution of the seventeenth century. Flemish scientist Jan Baptist van Helmont (1580–1644) had offered a pair of recipes: "Soiled garments and wheat left under a bed would give rise to mice, not suckling but fully grown; and a twig of basil sandwiched between two bricks placed in sunlight would give rise to scorpions."

In the case of the discovery of the double-helical structure of deoxyribonucleic acid (DNA), researchers in a number of academic institutions around the world were on its trail, but it was the preparedness of James Watson and Francis Crick and their experiment that led the duo to the prize. It behooves us to recognize the combination of unique academic

skills that Watson, a biologist, and Crick, a physicist, brought to bear that allowed them to assemble the pieces of the puzzle and to recognize the correct shape of the macromolecule of life.

A frequently cited story about Pasteur, that he infected himself with bacteria only to apply a cure afterwards to counteract the infection, turned out to be a myth. But a modern Pasteur lives in Australian microbiologist Barry Marshall, who, on a hunch, did infect himself with a dangerous bacterium, *H. pylori*. In eradicating it, he offered a cure for a malady that had afflicted millions of adults around the world since time immemorial. Until a generation ago, 10% of the adult population suffered from the illness, causing the afflicted to double over in pain. The fear of perforated ulcers and ulcers morphing into stomach cancer were omnipresent for ulcer patients. Dr. Marshall and his collaborator, pathologist Robin Warren, investigated the incidence of one type of bacterium *Helicobacter pylori* that is present in the gut of every patient who suffered from ulcers. The medical establishment was skeptical, with many gastroenterologists ridiculing the claim that bacteria could survive in the hellish conditions of the gastric system.

In 1984 Marshall, three years after he embarked on the research, tried to infect pigs with the bacteria, but when that failed, decided to serve as his own guinea pig. After undergoing an endoscopy procedure to obtain his own baseline, he prepared a petri dish containing a culture of *H. pylori* and swallowed it. On the eighth day, an endoscopy revealed massive inflammation (gastritis), and a biopsy confirmed that *H. pylori* had colonized his stomach. On the fourteenth day after he had infected himself, he underwent a third endoscopy and began a regimen of antibiotics. Precisely twenty years after Marshall and Warren published their paper in the *Medical Journal of Australia*, in 2005, they were awarded the Nobel Prize for Physiology and Medicine.[27] One no longer hears of ulcers.

Werner Forssmann (1904–1979), as a young surgeon-in-training in 1929, proposed an experimental procedure to thread a thin tube through a vein to access a patient's heart. When he was forbidden by his superiors that under no circumstance would he be allowed to perform

the procedure on patients, he decided to perform it secretly on himself. With a surgical nurse unwittingly enlisted to help him, he undertook the experiment. First, out of sight of the nurse, he threaded a 26-inch (65 cm) urethral tube through a vein in his left antecubital fossa (elbow crease) all the way into his right ventricle (lower chamber). With the catheter in place, he asked the dumbfounded nurse to accompany him to a fluoroscopic X-ray machine to produce an image. (To probe the left ventricle, the procedure calls for threading the tube through an artery.) Forssmann recalled how physically painful it was: "I felt that I had planted an apple orchard and other men who had gathered the harvest stood at the wall, laughing at me."[28] Forssmann had performed the first heart catheterization in the history of medicine, and he would continue to perform additional experiments in the next few years to show the procedure's practicality. By 1935, however, he found himself sidelined by an indignant medical community. Giving up cardiology research, Forssmann spent the next two decades working as a urologist in a small hospital. In time, the field he pioneered became known as interventional cardiology. In 1954 he received the Leibniz Medal of the German Academy of Science and in 1956 a share of the Nobel Prize in Physiology or Medicine.

In the 1930s, Scottish physician Alexander Fleming (1881–1895) made the monumental discovery of the mold lysozyme growing in a petri dish inhibited the growth of certain bacteria. Growth of mold has always occurred and possibly its connection to inhibiting infection had been seen earlier, but its full potential as an antibiotic had not been recognized. The practical use and the mass production of penicillin as the first antibiotic in history awaited the collaboration of the Australian-born Oxford biochemist Howard Florey (1898–1945). Fleming, notified by Stockholm that he was selected as the recipient of the 1945 Nobel Prize for Medicine and Physiology, responded that he would accept the prize only if he could share it with Florey. The nobility of his request impressed the Nobel Committee. It readily agreed to present the prize to both men.

AGE AND THE SPARKS OF CREATIVITY

The annals of literature abound in authors who are one-hit wonders; e.g., Harper Lee, *To Kill a Mockingbird;* Ralph Ellison, *Invisible Man*; Emily Brontë, *Wuthering Heights*; Margaret Mitchell, *Gone with the Wind*; Harriet Beecher Stowe, *Uncle Tom's Cabin*. In distinction, transformative geniuses are never one-hit wonders. Each of the five transformative geniuses comprising the core of the book experienced artistic or scientific rebirths, anni mirabiles, sometimes more than once.

In the recent book *Sparks*, the author Claudia Kalb examines the lives and careers of a dozen eminent individuals in a variety of fields and organizes her subjects according to the ages at which they demonstrated bursts of creativity.[29] These bursts or "sparks," Kalb points out, can come in different stages of one life. There are the prodigies—Pablo Picasso, Shirley Temple, and Yo-Yo Ma; the twenties and thirties group—Bill Gates, Isaac Newton, and Sara Blakely; the mid-lifers—Julia Child, Maya Angelou, and Alexander Fleming; and a group of late bloomers—Eleanor Roosevelt, Peter Mark Roget (of *Roget's Thesaurus* fame), and Grandma Moses. Organized in four sets of three each, the book reaches a crescendo in the epilogue with Leonardo as the "eternal genius."

Whether in the visual arts of painting and sculpture or in literature, creativity *almost* always exhibits three periods—early, middle, and late. As the artist matures through the three periods, an increased sophistication is seen in their creations. This is true in the paintings of Leonardo, the compositions of Beethoven, and the plays of Shakespeare.

In the mathematical sciences, the period of greatest creativity occurs in one's younger years. Newton was twenty-three when he was at the peak of his creativity, Dirac twenty-three, Heisenberg twenty-four, Feynman in his early twenties, Galois twenty, Einstein twenty-six. Aryabhata, the Indian mathematician who formulated the algebra of zero in 499 C.E. was twenty-three. But Newton and Einstein had scientific rebirths, peaking again in their "Second Miracle Years." Newton was around forty-six when, in a second brief period, he wrote his three-volume magnum opus, the

Principia; Einstein experienced his second *annus mirabilis* at age thirty-five or thirty-six when he published his general theory of relativity. In distinction, experimental scientists and astronomers peak much later, in their forties and fifties. A conundrum that makes a contribution in the mathematical sciences particularly difficult is that, before making a dramatic breakthrough, one has to master all that is already known. How does one master the field without being able to spend a substantial period of his youth learning it? Each of the individuals just mentioned possessed an almost miraculous ability to guzzle the known material, as if drinking from a fire hydrant. Even laconic Dirac weighed in with a quatrain,

> *Age is, of course, a fever chill*
> *That every physicist must fear.*
> *He's better dead than living still,*
> *When once he's past his thirtieth year.*

As parsimonious with words as a Trappist monk, in his twenties, he formulated an axiomatic self-consistent quantum mechanics and later predicted the existence of antimatter. His papers and his book written in the 1920s comprise the bible of quantum mechanics and are masterpieces of precision and conciseness. Freeman Dyson, who spent the better part of seven decades at the Institute for Advanced Study, had also been Dirac's student at Cambridge. As a precocious nineteen-year-old, Dyson had sat in Dirac's lectures and later recalled listening to Dirac's theories, "Like exquisitely carved marble statues falling out of the sky, one after another. He seemed to be able to conjure laws of nature from pure thought. It was this purity that made him unique."[30]

A photograph exists showing Heisenberg, Schrödinger, and Dirac, the three most significant architects of quantum mechanics, standing on a platform at the Stockholm train station in 1933. The previous year's winner of the Nobel Prize in Physics, Heisenberg is there to honor the current year's recipients, Dirac and Schrödinger. Dirac and Heisenberg are both

accompanied by their mothers. The oldest and most colorful of the trio, Schrödinger, is there with his wife.

Lyric poets and novelists such as those of the English Romantic period tended to peak early, whereas epic writers much later in life. Poet/playwright Shakespeare, still in his teens and early twenties, devoured the history presented in *Holinshed's Chronicles* as well as the writings of contemporary authors with unimaginable speed. Epic writers such as Virgil, Tolstoy, and Joyce peaked later in life, armed with experience and wisdom gained through their years.

2

MULTIPLE INTELLIGENCES

*Mediocrity knows nothing higher than itself,
but talent instantly recognizes genius.*
—Arthur Conan Doyle

Beginning in the early 1980s, developmental psychologist Howard Gardner at Harvard published a series of papers and books on modalities of learning. *Frames of Mind*[1] and a decade later *Multiple Intelligences*[2] *(MI)* differentiated initially between seven types of intelligence, and in subsequent years swelled to nine. Among them were: (1) Musical-rhythmic and harmonic, (2) Visual-spatial, (3) Verbal-linguistic, (4) Logical-mathematical, (5) Bodily-kinesthetic (gross motor skills), (6) Interpersonal (social skills), (7) Intrapersonal (introspective), (8) Naturalistic (an awareness of nature), and (9) Existential—spiritual. As late as 2016, Gardner contemplated including the modality of teaching-pedagogical intelligence. In his theory, he suggested that each of us possesses all forms of intelligence to some degree, but that there is always a dominant form that characterizes each of us. Gardner granted the different forms of intelligence equal weight and argued that they can be individually

strengthened by suitable training or weakened by neglect. Gardner's theory has had an immense impact in academic institutions in helping to assess students' strengths and overcome their weaknesses.

In distinction to developmental and educational psychologists, mainstream psychologists, who generally accept the notion of general intelligence (GI), have been less enthusiastic in embracing Gardner's modalities, claiming that the developmental psychologist's definitions of separate intelligences were ad hoc—they were subjective and lacked empirical evidence. They argued that he was simply relabeling the traditional notions of ability and aptitude as types of intelligences. These psychologists suggest that different scholars may come up with altogether different modalities. Some of Gardner's detractors even suggest that his arguments are circular; e.g., "She is an especially gifted musician, therefore she must have enhanced musical-rhythmic and harmonic intelligence," and "Because she possesses high musical-rhythmic and harmonic intelligence, she was fated to be a gifted musician."

If in fact there is a credible basis to Gardner's claims for the types of intelligences in the arts and sciences examined in this book, then writers Shakespeare, Austen, and Tolstoy would be seen as possessing soaring verbal-linguistic and interpersonal intelligences; composers Bach, Beethoven, and Mozart possessing unlimited musical-rhythmic and harmonic intelligences; and scientists Newton and Einstein possessing boundless logical-mathematical intelligences. In the case of artist/scientist Leonardo, the modalities would include visual-spatial, naturalistic, and perhaps all the other modalities identified by Gardner and his followers.

As a useful algorithm, Gardner's theory could certainly explain the gifts of the titans in the performing arts. Ballet has been enriched immensely by the gifts of Anna Pavlova, Maria Tallchief, Rudolf Nureyev, and Margot Fonteyn; and modern musical dance by the attributes of Fred Astaire, Ginger Rogers, and Michael Jackson. The modalities that would apply to the foregoing dancers are presumably Gardner's musical-rhythmic and harmonic, augmented by physical or bodily-kinesthetic. How much poorer would the theater be without Sarah Bernhardt, Laurence Olivier, Marlon

Brando, Ingrid Bergman, and Meryl Streep; opera and stage without Enrico Caruso, Marian Anderson, Paul Robeson, Maria Callas, Joan Sutherland, and Luciano Pavarotti; jazz without Louis Armstrong, Miles Davis, and Duke Ellington; and music without vocalists Ella Fitzgerald, Billie Holiday, and Aretha Franklin. Here the modalities would again be musical-rhythmic and harmonic along with interpersonal and intrapersonal. Each of these individuals has been described as a genius in his or her field, and deservedly so.

In the history of sports, what would baseball have been without Babe Ruth, Hank Aaron, and Ted Williams; basketball without Michael Jordan, Lebron James, and, before them, Bill Russell; boxing without Muhammad Ali, Joe Louis, and Rocky Marciano; track and field without Jim Thorpe, Jesse Owens, Florence Griffith Joyner, and Usain Bolt; soccer without Pelé, Diego Maradona, and Lionel Messi. These athletes have served as exemplars of the physically or bodily-kinesthetically gifted—each an example of a congenital physical gift, honed by endless practice. One has only to watch videos of Michael Jordan on the basketball court or Lionel Messi on the soccer pitch weave their way through three or four defenders, leaving them bewildered and embarrassed, to wonder in disbelief, "How on earth does he do that!" They seem to possess a natural feel for their own skills bewildering to the rest of us, the ability to read their opponents' minds and moves and adjust their own moves instantly.

THE MIXED TYRANNY OF TESTING

The world's top universities have long trained leaders in government, industry, law, medicine, business, and the sciences. A degree from one of them is helpful in landing a job, at least the first job, upon graduation. But these are also the institutions toughest for gaining admission. In the United States, acceptance generally requires candidates to take standardized tests; e.g., SAT, ACT, GRE, LSAT, and MCAT. Similarly, there exist magnet high schools that are highly selective, particularly in the arts or sciences,

and they too administer admissions tests. In the sciences, one measure of an institution's success is the number of Nobel Prizes garnered by its graduates. The Public Schools System of New York City has produced forty-two Nobel laureates, with the Bronx School of Science alone accounting for an astonishing seven in physics and one in chemistry. James Madison High School in Brooklyn produced six Nobel laureates, three US senators (including Charles Schumer and Bernie Sanders), and the late Supreme Court justice Ruth Bader Ginsburg. Of course, the admissions test practice for the city's specialized schools has worked well as a preliminary filter. But are there downsides to testing? On a less-than-politically-correct day in the public schools in Brooklyn in the early 1960s, the students took IQ tests and were often assigned seats in the classroom according to their scores. It was not uncommon to hear a teacher chide a weaker student for his question, "That's an asinine question, a very asinine question. No wonder you are in the back row!"

Banesh Hoffmann, who collaborated with Einstein on a major paper at the Institute for Advance Study in 1937 and co-authored an excellent biography of him in 1972,[3] also wrote a monograph entitled *The Tyranny of Testing*.[4] In the book, he pointed out the unreliability of measuring intelligence and achievement. Hoffmann cited a question appearing in a reputable standardized test: "George Washington was born on February 22, 1732." The only choices offered to the student are to check true (T) or false (F). The A-student in the United States knows from their history classes that February 22 is indeed the day on which the first president's birthday is celebrated annually. And more than likely, they know 1732 to be the approximate correct year. Accordingly, the A-student confidently checks off "T." The B-student checks "T," but with less confidence. The mediocre student has no idea about the veracity of the statement, randomly checking off "T" or "F" with equal probability. The genuinely superior student looks at the question and realizes there is a problem. It is true that George Washington was born in 1732. But that was twenty years before Great Britain, along with her American colonies, changed its calendar from the Julian to the Gregorian in 1752, when an eleven-day correction

was made in the changeover. This student wonders: "Am I dealing with a 'malicious tester' or an 'incompetent tester?' Does the tester know the ambiguity in the question?" They might even return to earlier questions hoping to ascertain the competence of the tester. At the least, the gifted student is penalized by the distraction and may lose time on a rigidly timed test.

Overthinking is a problem with those who know too much. A consensus mathematical genius, Alan Turing, frequently lost to lesser brains who could play the game more instinctively. Andrew Hodges in *Turing: The Enigma* writes about Turing's Bletchley Park friend Jack Good: "Besides playing Chess, Alan taught Jack Good the game of Go, and before long found himself being beaten at that as well."[5]

Creativity and schizophrenia overlap in one type of psychological behavior known as over-inclusive thinking. Both see much broader boundaries of relevance than do normal people. Thinking too much could well be a curse of the gifted mind! Newton watching an apple fall and wondering whether the force that attracts the apple to the earth is the same force that keeps the moon in its orbit and Benjamin Franklin wondering whether a flash of lightning is the same physical phenomenon as an electric discharge are both engaged in over-inclusive thinking.

Aptitude and achievement tests can be fraught with intended and unintended ambiguities. For example, acquired test-taking skills can skew results in favor of the test taker. To be a true test of relative ability all those who take the test should be equally unfamiliar with the processes of the test-taking at the time of sitting the test. Nonetheless, such tests are still regarded as a first approximation of how students will perform in their higher education.

The Intelligence Quotient, or IQ, is a measure of one's cognitive abilities (intelligence) relative to one's age. An IQ of 90–110 is regarded as average and scores above 120 as superior. A standard deviation on the IQ bell curve (Gaussian) is 15 points; plus or minus 15 points around the norm (85–115) incorporates 68% of the population. Two standard deviations above or below the norm, or 70–130, incorporates 95% of the population, leaving the remaining 5% equally distributed outside. A range of three standard

deviations (55–145) excludes only 0.01% of the population. Arnold Ludwig[6] reports that in his study, IQ scores of 124–140 are sufficient for many kinds of greatness, and some individuals with high IQs could be regarded well below average in other forms of intelligence; e.g., social, political, and personal introspection.

Many high IQ societies were founded since the mid-twentieth century, among them the celebrated Mensa Society, the oldest of such groups, founded at Lincoln College, Oxford, in 1946. Its founders, Roland Berrill and Lancelot Ware, specified in the society's bylaws that the group would avoid politics and class distinctions. In accepting only 2% of applicants, Mensa is actually the least restrictive of the high-intelligence societies, with a present membership numbering 57,000 in the United States, 21,000 in the United Kingdom, and 13,000 in Germany. Its members number 134,000 in the entire world. Twice as exclusive as Mensa is the TOPS Society, which accepts 1 per 100 applicants, and twenty times more restrictive still than Mensa is the IQuadrivium Society, which accepts 1 per 1,000 individuals tested. Even more exclusive are the groups known as Mega, accepting 1 per 100,000, and Giga, 1 per 1,000,000. Writing for *Scientific American*,[7] Lena Groeger identifies several groups that have become defunct, including "the memberless Grail Society," a group that accepts 1 per 100 billion applicants, "but no one so far has applied," she reports. Incidentally, the world's population is eight billion, and anthropologists and statisticians estimate that the total number of *Homo sapiens* that have lived since the appearance of our species 200,000–300,000 years ago to be around 100 billion.

More interesting are the assessments, both positive and negative, offered by people who have joined high IQ groups: "I joined in search of a sense of belonging"; "I terminated my membership in the British Mensa chapter's online forum, because it is dominated by neo-Nazis who have white supremacist and eugenicist agendas." "In my experience most high IQ organizations seem to be fighting clubs for people with pathologically overdeveloped egos." Groucho Marx had an appropriate answer ready, had he been asked to join an exclusive club: "I refuse to join any club that would have me as a member."

CREATIVITY

Many composers carry a notebook to jot down musical ideas and themes, as do most visual artists a sketchpad, as do creative scientists. Scientist/artist Leonardo recorded his ideas copiously—faces in the crowd, scenery, vortices in whirlpools, striations in rocks, ideas for gadgetry, calculations, lists of vocabulary words to learn, food to buy. Perhaps mindful of a lasting legacy, a sense of history, Beethoven retained all his musical sketches. An effective putdown of someone devoid of creativity is the description, "Here is a man who has never lost a night of sleep over a (*blank*) problem!" Fill in the *blank* with your own choice of field: philosophy, physics, mathematics, music, painting. After obsessing over a problem, however, an incubation period is essential. Psychiatrists suggest that it happens when we are in touch with our primitive form of psychological reasoning, instinctive and subjective rather than rational and objective. Indeed, in the sciences or the arts, no control exists over when and where an inspiration, a moment of epiphany will occur—hiking in the woods, daydreaming, lying in bed half asleep.

For the musician, developing the theme into a finished product as a song, sonata, or symphony usually requires experimenting on a piano keyboard. Genuinely revolutionary ideas in the fundamental sciences, far rarer than in the arts, also come at unexpected times, with the scientist proceeding onto the next step at his desk with a good supply of blank paper, pens, and a trash can or at a blackboard with a box of chalk and a readily available eraser.

Two anecdotes involving Einstein offer hints regarding his own concerns while working. In the first, Einstein is walking along a hallway with Princeton physicist Eugene Wigner. He asks Wigner rhetorically, "Do you know, what is the greatest friend of a physicist?" Then he stops with a smile on his face and answers his own question by traipsing over to a wastepaper basket he just spotted to dispose of a crumbled sheet of paper. In the second anecdote, the hostess at a garden party pulls out a notebook from her purse and shows it to her famous guest: "Professor Einstein, I always carry a little notebook with me to jot down original ideas when they come to me. Do you also have a notebook," she continues, ". . . to write down your original

ideas?" Einstein replies wistfully, "Madame, I so rarely get original ideas that I don't need to carry a notebook around."

FAMILIAL BACKGROUNDS

Familial support, ranging from nurturing to inhibiting, is one of the greatest determinants of how children place in schools, how much creativity they exhibit, the skills they possess, and the careers they pursue. Nowhere is this phenomenon demonstrated more frequently than in academic families: the children of psychology professors frequently major in psychology, children of physics professors in physics, and children of art professors in art. They see working models in their parents' careers. Emmy Noether, one of the twentieth century's greatest mathematicians, was the daughter of a distinguished mathematician at the University of Erlangen; Nobel Prize–winning chemists Irène and Frédéric Joliot-Curie were the daughter and son-in-law of two Nobel laureates, Pierre and Marie Curie; and William Henry Bragg and William Lawrence Bragg comprise a pair of father-son Nobel laureates in physics. Danish physicist Aage Bohr won a Nobel Prize as had his father Niels Bohr fifty years earlier. The Indian physics Nobel laureate C. V. Raman was the uncle of physics Nobel laureate Subrahmanyan Chandrasekhar. An extreme example of a crowded family business is that of the Bernoulli family in Switzerland. Dating back to the seventeenth century, it produced eleven generations of mathematicians, several of them world-class.

Historically, familial ties have also been true among creative individuals outside academia, where a child is constantly striving to fulfill a parent's own unrealized yearning.[8] Antonio Vivaldi learned to play the violin from his father Giovanni Battista Vivaldi, a violinist in St. Mark's Cathedral in Venice. Johann Sebastian Bach had received his first keyboard lessons from an older brother who had taken care of him. He grew up to father twenty children. Although only ten survived into adulthood, he gave most of them personal instruction in music. Several of them became excellent composers,

but none rose to the prominence of their father.⁹ Wolfgang Amadeus Mozart's father, Leopold, was a competent musician but certainly not a great composer himself. By applying strict discipline in training his son and daughter, he succeeded in producing a prodigy in his son. Wolfgang's son, Franz Xaver Wolfgang Mozart, also became a fine composer. Ludwig van Beethoven's father, Johann, a singer and musician, was far more draconian in disciplining his son, applying Leopold's tactics and augmenting them with physical abuse. He succeeded in developing an immortal composer, but one who developed a lifelong loathing for him. It is a wonder that the boy never turned away from music. In recent times, jazz pianist and educator Ellis Marsalis Jr. was the legendary patriarch of a musical family. His four accomplished musician sons include Wynton Marsalis.¹⁰

In antiquity, lawyer, author, and magistrate Pliny the Younger was the nephew and adopted son of author and naturalist Pliny the Elder. In the German Renaissance, painter Hans Holbein the Elder was the father of Hans Holbein the Younger, and Lucas Cranach the Elder was the father of painter Lucas Cranach the Younger. In the Italian Renaissance, Gentile Bellini and his brother Giovanni were the sons of Venetian artist Jacopo Bellini. In his time Gentile was a far more sought-after artist than Giovanni, even receiving a generous commission to journey to Istanbul to paint the portrait of the Ottoman ruler Mehmed the Conqueror. In the rearview mirror of time, however, it is Giovanni who has come to be seen as the more talented sibling. In a realm where talent recognizes talent, it is no surprise that Albrecht Durer, aka "the Northern Leonardo" and the man who in 1500 may have created the finest self-portrait ever,¹¹ in visiting Venice in 1506, had already adjudged Giovanni the more talented of the two. Giovanni's recently restored masterpiece *San Zaccaria Altarpiece* has gained the distinction of being the first work of the Venetian Renaissance.

Artemisia Gentileschi became a successful Baroque painter, having been trained by her artist father Orazio Gentileschi in a time when women could receive training as artists only from close relatives. The great nineteenth-century Belgian painter François Musin was the father and teacher of the equally successful August Henri Musin. Finally, in the twentieth century,

N. C. Wyeth was a highly successful painter and illustrator. His son, Andrew Wyeth, became one of the nation's preeminent painters. Andrew in turn passed his paintbrushes to his son, Jamie Wyeth, who rounded off the three-generation deep tradition of gifted artists, each with his own unique style.

CENTER FOR TALENTED YOUTH

No parent, no educator, and no specialized program can take a normal, average child and make a genius of him, let alone a transformative genius. It is possible to identify and nurture talent and creativity. One of the most successful programs of its type exists in Baltimore, Maryland. Johns Hopkins University's Center for Talented Youth (CTY) identifies and inspires gifted students in summer and weekend programs. The vaunted program, founded in 1979 by Julian Stanley (1918–2005), describes itself as "a gifted education program for school-age children." Through the years since its founding, it has grown to offer programs on university campuses throughout the United States and around the rest of the world, serving over 10,000 students each year. Even a short list of the program's alumni reveals the success of Dr. Stanley's brainchild:

- Six of thirty-two American recipients of the 2006 Rhodes Scholarships.
- Numerous award winners in the Intel International Science and Engineering Fair, including grand prizewinners in 2007 and 2012.
- Sergey Brin, co-founder of Google.
- Lady Gaga, popular musician.
- Ronan Farrow, after receiving a BA from Bard College at fifteen, was awarded the 2006 Rhodes Scholarship to Oxford. Subsequently, Farrow attended Yale Law School and went on to become a Pulitzer Prize–winning journalist.

- George Hotz, the first person to hack the iPhone and recently in the news for designing self-driving cars.
- Mark Zuckerberg, founder of Facebook and *Time* magazine Person of the Year in 2010.
- Terence Tsao, the 2006 recipient of the Fields Medal, frequently called the "Nobel Prize of mathematics," and a recipient of the MacArthur Fellowship "Genius Grant" for work in mathematics.
- Adam Riess, the 2011 recipient of the Shaw Prize in Astronomy and Nobel Prize in Physics.
- Elissa Hallem, the 2012 recipient of a MacArthur Fellowship for work in neurobiology.
- Jacob Lurie, 2014 recipient of a MacArthur Fellowship for work in mathematics.

The students enrolled in CTY are primarily the products of highly supportive families. Most of them are children of upwardly mobile professional families. Many parents are immigrants from China, Korea, or India who harbor high aspirations for their children, convinced that given the opportunity, they would flourish. On a personal note, in a dozen annual keynote lectures I gave in the CTY Program at Johns Hopkins (1997–2012), I could sense the curiosity and enthusiasm for learning brimming in their eyes. When I called for questions, a forest of hands would shoot up reflexively. From the vantage point of lecturer, the receptivity of an audience is crucial to the success of a lecture.

Among modern cultural heroes on CTY's honor list, Google's Larry Page and Sergey Brin were both enrolled in Montessori schools as adolescent children, and Brin and Zuckerberg in CTY as teenagers. Sergey Brin's parents were Russian *refuseniks*, Jews who had immigrated to the United States from the former Soviet Union. Terence Tsao's father was a physician, and his mother the recipient of mathematics and physics diplomas from the University of Hong Kong. The prodigiously gifted Tsao personally rejects otherworldly gifts, stressing hard work and collaboration for his

phenomenal achievements: "One does not need some sort of magic gene." But on this point, we must defer to the specialists studying intelligence and creativity rather than the bearer of these traits as knowing better. Maybe there is no single "magic gene," but the concatenation of many specific genes can be identified.

Although Stanley would not live to see the global expansion of his cherished program, he deserves to be recognized as a visionary with an enduring legacy of educating highly talented students. With exceptional students and even ordinary geniuses, we might speculate about the psychological traits at the roots of their intellectual gifts. For instance, children who possess the predisposition to resist instant gratification—those willing to wait longer for two marshmallows rather than to accept the offer of one marshmallow immediately—grow up to become better test-takers and continue to become higher achievers as adults.

Smart parents often have smart children. But it is not sufficient just to be smart parents. They must be supportive parents cultivating thoughtful discussions around the dinner table, answering their children's questions, helping them with science projects but never doing their projects for them. Rather they must serve as sounding boards for their children. There often exists an abundance of books in the home . . . or at least, access to a good library. Being surrounded by books helps to create a curious disposition and a passion for learning. Neither a well-worn Bible in the home nor easy access to Google on a computer will suffice.

A Turkish American mother recounted her family's experience.[12] Her two children (daughters, six years apart in age) were selected for the Center for Highly Gifted Program in school in Maryland, both attended and graduated at the top of their high school in Bethesda, both earned bachelor's degrees in biomedical engineering at MIT with perfect GPAs (5.0/5.0).

The older of the two daughters earned a combined MD, PhD from Harvard Medical School and MIT consortium. She interrupted her program for a year to complete an MSc in immunology as a Rhodes Scholar at Oxford. Early on, an educational psychologist while working with her had told the family, "We can stop when she reaches the 140s in her IQ test, or we can

keep going until she tests in the 160s–170s." (That, obviously, was not in raising the girl's intelligence but improving her test-taking skills, an offer the family declined.) A few years later, the younger daughter earned a PhD in biomedical engineering at MIT with a PhD thesis selected as one of the most innovative biomedical research projects of the year, creating a diagnostic tool to distinguish quickly between bacterial and viral pneumonia, with extraordinary reductions in healthcare cost.

Humorous stories in the stratosphere of academia abound. Elyse Graham, writing in an issue of *Princeton Alumni Weekly*,[13] recounted a joke resonating with good-natured irony. In the 1940s a famous art history professor named Erwin Panofsky had twin sons. The boys graduated from Princeton first and second in the class of 1948. Their professors thereafter referred to the boys as Smart Panofsky and Dumb Panofsky.

Meanwhile, across town, Einstein asked a colleague at IAS, "How do you get people on the street from stopping you to ask for your autograph." He received the answer, "Cut your hair."

DOES IT TAKE GENIUS TO RECOGNIZE GENIUS?

The opening quote in this chapter, "Mediocrity knows nothing higher than itself, but talent instantly recognizes genius," comes from Arthur Conan Doyle, the creator of Sherlock Holmes, in his fourth and final novel, *Valley of Fear* (1915). Just as the German genius Durer in his time had recognized Giovanni Bellini's superiority over his far more sought-after painter brother, Gentile Bellini, Einstein could appreciate his great forebear Newton even more than others in the field, enough to compose a quatrain:

> *Watch the stars, and from them learn,*
> *To the Master's honor all must turn, Each in its track without a sound,*
> *Forever tracing Newton's ground.*

Early in their careers, four of the five paragons of transformative genius in this book (we don't know about Shakespeare) were recognized and championed by established masters. While their stories will unfold in later chapters, I offer an appetizer, an anecdote frequently cited by music historians involving a pair of towering composers. Sixteen-year-old Beethoven journeys from Bonn to Vienna to meet Mozart. He is carrying a letter of reference from his piano teacher Neefe. He knocks on the door of the now-mature wunderkind, who is entertaining friends. Mozart, intrigued by Neefe's letter, invites the teenager to his studio and asks him to play something of his own composition. Beethoven complies, but Mozart is skeptical that the piece is of Beethoven's own creation. He stops Beethoven and suggests, "I will play something, you perform an improvisation." As Beethoven plays his improvisation, Mozart quietly backs out of the room and signals his guests to join him in the doorway. There, he whispers to them, "Eines Tages wird er der Welt etwas zum Reden geben!" ("Someday, he is going to give the world something to talk about!").

3

THE ZEITGEIST FACTOR

There is a connection, hard to explain logically but easy to feel, between achievement in public life and progress in the arts. The age of Pericles was also the age of Phidias. The age of Lorenzo de' Medici was also the age of Leonardo da Vinci, the age of Elizabeth was also the age of Shakespeare, and the new frontier for which I campaign in public life, can also be a new frontier for American art.[1]
—John Fitzgerald Kennedy

The brain is no mushroom. Average or genius, the mind needs the light of earlier discoveries to develop. "If I have seen farther than others," Newton wrote, ". . . it is because I stood on the shoulders of giants." Disingenuous though the statement may have been coming from *him*, the reclusive genius among geniuses of the Scientific Revolution, the statement bears the weight of history. The ideas of Euclid, Copernicus, Galileo, Kepler, Descartes, Bacon, Boyle, Huygens, Wallace, and Hooke allowed Newton to start where they left off: he did not have to start from scratch. The zeitgeist of the Scientific Revolution prevailing in England in the seventeenth century was the crucial setting for Newton to thrive. Although Newton's

own modus operandi echoed the Royal Society's motto, *"Nullius in verba"* ("Take nobody's word for it"), for him, collaborating with other researchers was anathema. He launched the Newtonian Revolution that marked the crescendo of the Scientific Revolution, but he was himself *no Newtonian*.[2]

Similarly, although we are all dazzled by the sweeping ideas, originality, and sheer brilliance of Leonardo, the stage on which the quintessential Renaissance man acted was fifteenth-century Florence, where the Renaissance was already in full bloom. Also, is it any surprise that Shakespeare would emerge in the fecund era of the Elizabethan Golden Age or that Beethoven would appear in Vienna just after Haydn and Mozart made their impressive contributions and Europe was amidst the Enlightenment? Vienna would also later be home to Schubert, Brahms, the Strauss dynasty, Bruckner, and Mahler.

The intellectual atmosphere of early twentieth-century Europe created opportunities for gifted individuals to congregate and debate. The prevailing bohemian zeitgeist inspired Einstein to change the central paradigm of physics. Shortly afterward, the same zeitgeist inspired a brash group of "Young Turks" to introduce counterintuitive and indeterministic ideas into physics and vanquish some of Einstein's intuitive and deterministic arguments.

Within certain institutions—Harvard, Princeton, Caltech, Stanford, MIT, in the United States; Oxford and Cambridge in the United Kingdom; Berlin and Göttingen in Germany; and the Sorbonne in France—there has existed an institutional zeitgeist along with a temperament and tradition that cultivates scientific genius. Most illustrious of them all is the University of Cambridge, where Trinity College and the Cavendish Lab have together produced twenty-nine Nobel Prize winners. But ultimately the transformative geniuses seem to transcend the institutions with which they are associated. They are society's creations who themselves become agents for social and cultural change.

There is little doubt that the policies of local or national leaders are of crucial importance in defining society's zeitgeist, a spirit that can run the

gamut from extremely positive to extremely negative, from democratic to autocratic, from globalism to protectionism, from the production of good art to poor art. Leadership can have essential and long-term consequences. As Kennedy, in the opening quote, was contemplating wistfully, some of the great ages of humanity are connected with inspired leadership that produced conditions nurturing creativity. Whether the immediate incentives are finding employment, harvesting financial profit, gaining recognition, or simply satisfying one's curiosity, creative talent is attracted to inspiring causes.

The administration of the thirty-fifth president of the United States lasted only one thousand days but reverberated with an elegant, Camelot-like spirit. Governing was fun. New fashions emanated from the presidency. "Vigor" was the new watchword. In that sense, President Kennedy inspired a zeitgeist of creativity in science, technology, and globalism, and an awareness of the arts, but certainly not in the manner of the awe-inspiring accomplishments in the arts and sciences that bring him into the same orbit as those in the opening quote: Pericles, Queen Elizabeth I, and the Medici of Renaissance Florence. As it turned out, however, it was JFK's successor Lyndon B. Johnson in 1964 who signed legislation creating the John F. Kennedy Center for the Performing Arts on the banks of the Potomac River and, in 1965, the National Endowment for the Arts (NEA), with the belief that the arts have a role in the "spiritual and economic health of the nation and deserve government underpinning." Even more important, the sweeping civil rights and labor law that outlaw discrimination based on race, religion, national origin, and sexual orientation, originally envisaged by JFK in 1963, were passed by his legislatively crafty successor in 1964.

Each of the exemplars in this book may reign supreme in the criteria for genius but the fit must be just right for the talent and the times for genius to emerge and change the course of history. Otherwise, it will simply be wasted. Shakespeare, despite his unparalleled literary skills for composing poetry, for psychoanalyzing and exquisitely intertwining the complicated characters in his plays, if displaced in time and space to Renaissance Italy, would he have been able to produce the art of Michelangelo? Michelangelo, the most poetically gifted of the trio of titanic Renaissance artists, would

he have been able to write sonnets comparable to those of Shakespeare? It is important to point out that there exist different types of intelligence and creativity, and different intellectual spirits.

Ultimately, just as "nature or nurture" presents a false dichotomy, so does historical determinism versus history directed by individual human action present a false dichotomy. We are going to explore the gifts humans are born with and how these gifts interact with the zeitgeist of their times. Nineteenth-century philosopher William James made a case for the need for both—the top-down infusion of ideas from geniuses and the bottom-up infusion of forces by evolving societal circumstances.

ZEITGEIST AND GROUP GENIUS

Two group portraits, Raphael's 1510 masterpiece *The School of Athens* adorning the Vatican and the group photograph of physical scientists attending the 1927 Solvay Conference in Brussels, serve as a powerful pair of counterparts highlighting the importance of zeitgeist. The former depicts approximately forty of the best-known philosophers of antiquity, including Heraclitus, Parmenides, Socrates, Plato, Aristotle, Euclid, Archimedes, and the eleventh-century medieval Moorish philosopher Averroes, an anachronistic gathering spanning 1,500 years of intellectual history.

A modern counterpart of *The School of Athens* exists in the 1927 Solvay Conference photograph. The group represents the great modern natural philosophers, the pioneers of twentieth-century physics, assembled to discuss the newfangled theory of quantum mechanics. Nineteen of the thirty scientists in the photo had either already won the Nobel Prize or would soon. Generally speaking, those seated in the front row comprise the Old Guard, firmly established scientists, including Max Planck, Marie Curie, Hendrik A. Lorentz, and Einstein—all disciples of determinism in science. Several in the second and third rows are regarded as the New Guard, including Heisenberg, de Broglie, Schrödinger, and Dirac—revolutionaries espousing indeterminism. Two members of the Old Guard would play

significant roles in the unfolding drama of quantum mechanics. Einstein emerged as its most vocal critic and Bohr, embracing the theory, served as the enabler and father confessor for the young physicists launching the quantum revolution. Quantum mechanics, providing the physics of the small-scale universe, has come to explain the workings of every electronic device—from lasers and computers to digital cameras and cell phones, all of which we have come to take for granted in the twenty-first century.

The oldest individual in the photo was Lorentz at seventy-five, and the youngest Dirac and Heisenberg, both twenty-five. The Solvay Conference photo represents the zeitgeist of bohemian Europe between the two world wars. Organizing such conferences to be held in Brussels was the brainchild of the Belgian industrialist Ernest Solvay.[3] The gathering demonstrates the spirit of collegiality, sharing, and globalism as crucial elements of achieving scientific breakthrough, echoing the idealized model of science proposed by Francis Bacon three centuries earlier.

THE PARABLE OF LÁSZLÓ RÁTZ AND "THE MARTIANS"

Through the first half of the twentieth century, Hungary, with Budapest rivaling Vienna, produced an unusual number of gifted cultural leaders. The list includes Bela Bartók (1881–1945), Bela Lugosi (1882–1956), Zoltán Kodály (1882–1967), Albert Szent-Györgyi (1893–1986), George Szell (1897–1970), Leo Szilard (1898–1964), Eugene Ormandy (1899–1984), Dennis Gabor (1900–1979), Eugene Wigner (1902–1995), John von Neumann (1903–1957), Arthur Koestler (1905–1983), Antal Dorati (1906–1988), Edward Teller (1908–2003), Paul Erdos (1913–1996), John Kemeny (1926–1992), and Paul Halmos (1916–2006). Szent-Györgyi studied in England and returned to Hungary. George Gabor immigrated to Canada; Wigner, von Neumann, Teller, Szilard, Eugene Ormandy to the United States. Because of their extraordinary creativity in their respective fields, their lasting friendships, and close professional collaboration they became known as the Martians.

Many in the group won Nobel Prizes, and some of the others who did not win the coveted prize became just as famous as the ones who did. The seven nonscientists—Bartók, Szell, Ormandy, Dorati, Kodály, Rózsa, and Lugosi—became celebrities in the arts, six as composers or conductors, one as an actor. Szell and Ormandy built the orchestras of Cleveland and Philadelphia into two of the finest in the world, challenging the supremacy of the best European orchestras. One might only imagine the world without the mathematics of von Neumann, the physics of Wigner, and the music of Szell and Bartók. These exemplary leaders of the two intellectual cultures—the arts and the sciences—came from a land approximately the size of the state of Virginia.

Eugene Wigner, Hungarian American physicist at Princeton, was the recipient of the 1963 Nobel Prize in Physics. Early in the twentieth century he had been a student in the same class at the German-language Budapest-Fasori Evangélikus Gimnázium (or Gymnasium 19) as several of the others listed above. While sitting in Wigner's office at Princeton, I invoked the well-worn cliché to the Martian, "What was in the water?" Indeed, over the years I had asked him the question more than once, hoping to hear a fresh answer. But each time Wigner had smiled and pointed in the direction of the three framed portraits hanging on a wall. The first two were recognizable to any physicist: an engraving of Isaac Newton and photograph of Albert Einstein. The third portrait was that of his high school mathematics teacher, László Rátz (1863–1930). It was Rátz that was in the water—the mathematics teacher who had inspired von Neumann, Eugene Wigner, and Edward Teller in just one class alone. An inspiring teacher can make a significant difference in cultivating young minds. Richard Feynman frequently singled out his high school physics teacher, Abram Bader, who had inspired him, introducing him to "the principle of least action."

Regarding László Rátz and the Martians, it behooves us to ask whether two specific conditions that Arnold Ludwig introduced in *The Price of Greatness* are relevant for creativity in these remarkable individuals: (1) religion and (2) whether there were any impediments to gaining eminence. The preponderance of the Martians were Jewish. It is easier to count those

who were not Jewish than to list those who were: Von Neumann, who had been Jewish converted in his youth to Catholicism for convenience. Bartók was never Jewish! Each of the Martians received his undergraduate education in Budapest, and almost all moved to Germany in order to undertake graduate work.

In the early 1930s, when antisemitism was beginning to show its hideous head in Germany and in what had once been the Austro-Hungarian Empire from which the Martians had come, they relocated to England and the United States. Along with the Jewish Hungarian Americans, there were also Jewish German English and Jewish German Americans. Rather than list them all, I will just single out one—Max Born (1882–1970), who immigrated to England and won the 1954 Nobel Prize in Physics. For having given quantum mechanics its statistical-probabilistic interpretation, he is revered as one of the architects of modern physics, although few individuals outside the field have heard his name. If or when they are not confusing his name with two of the other titans of twentieth-century physics, *Max* Planck and Niels *Bohr*, they may know him as the grandfather of the singer-actress Olivia Newton-John.

As a postscript, similar to the small group who formulated quantum mechanics in those heady times in 1920, another example can be added to the notion of group genius where the whole far transcends the sum of the individual parts. Four of the first five presidents of the United States produced by Virginia were among the founding fathers of the United States: George Washington (1732–1797), Thomas Jefferson (1743–1826), James Madison (1751–1817), and James Monroe (1758–1831).

THE AUTODIDACTS

It is rare to see students who can read a serious textbook in the sciences on their own and gain the erudition that will shake the intellectual world. That is the world where magicians and transformative geniuses dwell. In the midst of extraordinary art being created during the High Renaissance,

a small culture of mathematicians also blossomed. Among its members, the entirely self-taught duo of Nicolo Tartaglia (1499–1557) and Gerolamo Cardano (1501–1576) competed in a quest to solve the cubic equation. Tartaglia, orphaned as a child and unable to afford school, paid a private teacher just enough tuition to teach him the first third of the alphabet, A–K. Subsequently he taught himself the rest of the letters, then the numbers. He devoured the known formalism of algebra and went on to discover the solution of the cubic equation. His results, however, were not complete, but another countryman, Cardano, generalized the formalism and prepared the stage for seventeenth-century discoveries in the field. The following centuries saw autodidacts in the English artillery engineer Benjamin Robins (1707–1751), English physicist-chemist Michael Faraday (1791–1867), French mathematician Évariste Galois (1811–1832), Croatian electrical engineer Nikola Tesla (1856–1943), and Indian mathematician Srinivasa Ramanujan (1887–1920).

Ada Lovelace (1815–1852) was the daughter of poet Lord Byron. Revealing her precocity for mathematics as a child, she devoured as much of the subject as she could lay her hands on. When Cambridge's Charles Babbage designed a mechanical general-purpose calculator, the Analytic Engine, she signed on as his assistant and wrote the first algorithm or computer program in history. It is the plight of autodidacts, however, that they become largely unsung geniuses, with the exception of Michael Faraday and Nikola Tesla, who made it into mainstream culture. Several of the foregoing will be discussed in the later chapters. Most importantly, the five transformative geniuses on whom the book concentrates were primarily autodidacts.

Ever since Euclid 2,500 years ago, mathematics in the West has called for rigorous proof of all mathematical assertions. As a young man growing up in Madras, India, Ramanujan elevated the branch of mathematics known as combinatorics virtually to an art form, intuiting complex results without burdening himself by generating proofs. While at Trinity College, Cambridge from 1914–1919, it was impressed on him that to be fully appreciated in academia, he had to provide rigorous proofs of his theorems. His innate insight and intuition helped him develop the skills to generate

the formal proofs that to him had always seemed simple and redundant. A devout Hindu, he always attributed his unusual ability to communing with his god(s). The intuitive manner of solving mathematical problems in the manner of Ramanujan finds a parallel in the modus operandi of Einstein and Leonardo. In that sense, Ramanujan also was an artist doing science whose preternatural mathematical insight and personal idiosyncrasies were celebrated in the 2015 film *The Man Who Knew Infinity*.

THE FLORENCE OF THE MEDICI

By the fifteenth century Europe and Italy had been in the grips of a cultural lethargy for almost a thousand years. However, gestation for a *Rinascimento* (Rebirth) had been underway for the last 250–300 years of that millennium. There had been the publication of *Liber Abaci* by mathematician Leonardo Fibonacci (1170–1250), the emergence of the greatest of late medieval painters Giotto (c. 1267–1337), and the publication of the *Divina Commedia* by Dante Alighieri (1265–1321).

As the birthplace of the Italian Renaissance, the Tuscan city of Florence will always be regarded as hallowed ground, where visionary leaders ruled, wealth and political influence became intertwined, and the greatest art in history was produced. It was in 1397 that Giovanni di Bicci de' Medici founded the bank that would flourish under his son Cosimo di Giovanni de' Medici (1389–1464). Cosimo, with the sobriquet *pater patriae* (father of the country), would steer the political and economic rise of Florence and prepare the stage for centuries of the family's dominance. In the early seventeenth century, Grand Duke Cosimo II de' Medici helped in promoting Artemisia Gentileschi of Bologna, arguably the greatest female painter ever, awarding her a commission. Although the House of Medici would never establish a monarchy, they were defacto rulers and kingmakers, producing three popes and countless cardinals.

During the first half of the fifteenth century, the Medici sponsored the first generation of great artists and architects in Ghiberti, Brunelleschi,

and Donatello. Then in the second half of the fifteenth century, Cosimo's grandson, Lorenzo de' Medici, *"Il Magnifico"* (1449–1492), in assuming the patriarchy of the family maintained the family's patronage of the arts and even increased the level of support. His close collaboration with Andrea del Verrocchio (1435–1488), a member of the second generation, led to the creation of a studio-academy unrivaled in history. As a painter, sculptor, and goldsmith, Verrocchio (literally "true eye") developed unique techniques for capturing light and movement and for portraying drama and emotional expression in whichever medium he worked. He passed his techniques onto his assistants, creating a third generation: Pietro Perugino, Domenico Ghirlandaio, Sandro Botticelli, Lorenzo di Credi, and Leonardo da Vinci. Verrocchio's pupil Ghirlandaio, in turn, passed some of these techniques onto Michelangelo, a member of the fourth generation. During the thirty years that Verrocchio operated his studio, some of the city's greatest artistic and architectural masterpieces were created, and a steady stream of surpassing artists was trained. Verrocchio effectively changed the course of the Italian Renaissance. As Ugolino Verino, a tutor to one of the Medici sons, wrote, "Whatever the painters have that is good they drank from Verrocchio's spring."[4] Among his own masterpieces, his greatest was his last: an equestrian statue of the Condottiero Bartolomeo Colleoni in Venice (1488). Balanced on three legs, with its front left leg raised, it is recognized as the greatest equestrian bronze ever created. The design and spirit have been copied for centuries since, including by the American sculptor Thomas Ball in his equestrian statue of George Washington in Boston (1864). The unfortunate irony is that in dying shortly before the casting of the statue, he was unable to stop a shameless foundry owner from inscribing his own name on the base of the statue. Verrocchio, however, gained immortality as Leonardo's teacher.

THE AGE OF ELIZABETH AND THE BARD OF AVON

By the time of his death in January 1547, the rapacious psychopath Henry VIII had ruled England for thirty-eight turbulent years. His tactics

involved unrestrained terror, beheadings, and a war against the Catholic Church. In his dissolution of the abbeys, he had destroyed countless religious buildings, inspiring Shakespeare later to write,

> *That time of year thou mayst in me behold*
> *When yellow leaves, or none, or few, do hang*
> *Upon those boughs which shake against the cold,*
> *Bare ruined choirs, where late the sweet birds sang.*[5]

Henry also mandated the destruction of thousands of books and at least as many priceless art objects. His modus operandi can be summarized as a variation on one of Kepler's laws of the planets: "The world revolves around Henry!" While his contemporary monarchs in Europe recycled mistresses, he chose to recycle queens. Of course, he also had his own share of mistresses and illegitimate children, but with the queens, he first gave them legitimacy. He honored six ladies, crowning them successively, before discarding four of them with convenient excuses (Jane Seymour was not discarded, but she died ten days after childbirth). The last of the six outlived him. The ultimate fates of his six queens—Katherine of Aragon, Anne Boleyn, Jane Seymour, Anne of Cleves, Katherine Howard, and Catherine Parr—can be remembered with the simple rhyming mnemonic, "Divorced, beheaded, died. Divorced, beheaded, survived!"

By the time Henry died, he owned fifty palaces and immense tracts of land, testimony to his greed. But the vile aspects of his legacy are partially offset by his association with two of the most successful colleges of the Oxbridge family—Christ Church at Oxford and Trinity College at Cambridge. Cardinal Wolsey had founded Cardinal College at Oxford, and he had built Hampton Court for his own use. Henry confiscated both, renaming the college Henry VIII College. After the king's death the college was renamed Christ Church.

It was Henry who launched the change from Catholicism to Protestantism for his country. Tudor descendants would finally establish the Anglican Church firmly as the religion of the land. Elizabeth I, his daughter

with the hapless Anne Boleyn, would become the most significant monarch in the history of the kingdom. Ascending to the throne in 1558, she remained resolutely committed to a spouseless lifestyle, married only to her job. During her reign, the invading Spanish Armada was defeated (1588). She supported and later knighted pirate Sir Francis Drake and author-adventurer Sir Walter Raleigh for their activities on behalf of the Crown in vastly expanding the influence of England in the New World. Under Elizabeth, England joined the other European nations Portugal, Spain, France, and Holland in global exploration and expansion.

Police tactics, replete with spies and informants put in place in her father's day, persisted through Queen Elizabeth's reign. Although there would still be frequent religious skirmishes between members of the "Old Church" and the "New Church," they would be held in check by her more tolerant, albeit firm, approach. After initial settlements in 1585 and 1603 failed, Jamestown, the first permanent English settlement, would not come until 1607, four years after the Virgin Queen's death. The vast area around Jamestown (in fact, for a while, the entire North American continent) would be named Virginia in her honor, as commodities, including lumber, indigo, tobacco, rice, and dried fish, brought back from the New World, enriched England's coffers.

Although after her death and through most of the seventeenth century religious and political wars would ebb and flow, the period of her reign would be regarded as the Golden Age of England. Long before the Enlightenment would flower in Europe in the eighteenth century, Queen Elizabeth displayed an enlightened disposition for the arts. The acting troupe Queen Elizabeth's Men was established on her orders in 1583. Then during the 1590s the acting troupes Admiral's Men and Lord Chamberlain's Men emerged to become dominant in the industry. The taste for the theater of the time can be seen in the surviving statistics: London, a city of 150,000–250,000, regularly saw 15,000 weekly theatergoers. It was the queen's political insight to "keep them happy" that assured her popularity with her subjects. The playwrights and poets of the time—Christopher Marlowe, Thomas Kyd, Ben Jonson, and especially Shakespeare—introduced literary

devices; e.g., Shakespearean sonnet, Spenserian Stanza, and dramatic blank verse, contributing to an explosion in expressive power. From the hindsight of history, we see that Queen Elizabeth, with a single-minded resolve to transform England and bring it into the Renaissance already sweeping Europe, succeeded beyond her wildest dreams. Her nation rose from a backwater military power fighting for its survival to a world-class military power and a cultural leader of European civilization. Elizabethan zeitgeist also laid the groundwork for the Scientific Revolution in England.

Queen Elizabeth's successor, King James I (formerly King James VI of Scotland), also turned out to be an enlightened monarch, displaying a passion for learning, a passion for writing, a passion for the theater, and a passion to further strengthen the Protestant Church in England. With his commitment to religion, he commissioned the first translation of the Bible from the Latin into English, resulting in the King James Version of the Bible in 1611. With his love for the theater, James continued to sponsor the acting troupe King's Men, which had morphed from the Lord Chamberlain's Men. Under James's patronage, Shakespeare continued to write for another ten years.

THE ZEITGEIST OF CAMELOT

John Fitzgerald Kennedy was a Roman Catholic and the son of an unremittingly ambitious and politically controversial Irish American father. The evangelical minister Billy Graham, "Pastor to Presidents," who over the decades ushered a dozen Presidents—from Truman to Obama—in and out of the White House, initially preached against Kennedy's presidency, declaring, "If you elect a Catholic, you'll have the Pope in the White House." Another nationally prominent evangelist, Norman Vincent Peale, also opposed the idea of a Catholic president with equal vigor. Their objections could have dealt a fatal blow against JFK in his run for the presidency. After his election, however, when Kennedy invited Graham to play golf with him in Palm Beach, the evangelical began to reassess his earlier

position, seeing this president as someone who could bring Protestants and Catholics closer together.

Kennedy possessed movie-star good looks, he was charming, he had attended Harvard, and had served heroically in WWII. He was elected to the House and then to the Senate. In Jacqueline Lee Bouvier, "Jackie"—elegant, beautiful, bilingual (in English and French), and considerably more conversant in the arts than he was—he found a wife who helped foster his image as an enlightened leader. This image was further enhanced when he appointed a cabinet comprised of brilliant academics, many from the Harvard faculty. Even before the election, Kennedy signaled his intent to quell political differences, proclaiming:

"Let us not seek the Republican answer or the Democratic answer, but the right answer. Let us not seek to fix the blame for the past. Let us accept our own responsibility for the future."

JFK defeated the heavily favored Republican candidate, Richard Nixon, but by barely a sliver. At his inauguration in January 1961, he again revealed a nobility in delivering one of the most inspiring and inclusive lines of inaugural speeches in American history: "And so, my fellow Americans: ask not what your country can do for you—ask what you can do for your country."[6] This was a clarion call to action for people to step up, to do what is right for the greater good.

Early in Kennedy's presidency, there was a glaring misstep. In 1959, with Eisenhower still president, Fidel Castro had launched a successful revolution overthrowing the corrupt Batista regime. Just two years later, in JFK's first year in office, a ragtag mob of 1,400 Cuban exiles trained by the CIA landed at the Bay of Pigs, ostensibly to take back the island. Castro's forces easily mopped up the invaders and its firing squads executed them in batches. The US government issued an unconvincing denial of its involvement, presenting Castro and his Soviet sponsors a momentous victory. At this juncture, the prospects for Kennedy's legacy looked bleak. But just a year later in October 1962, when US intelligence presented arial spy photographs showing the emboldened Soviets secretly transporting intermediate-range nuclear missiles (IRBMs) to Cuba, Kennedy countered

by launching a naval blockade, preventing all shipping from approaching the island, and he demanded the immediate removal of the missiles already on the island. For thirteen days he engaged Nikita Khrushchev in a dangerous game of Russian roulette. The Soviets removed their missiles and the Politburo put into motion the scheme to remove Khrushchev from his post (the process took almost two years) and make him into a nonperson. The Cuban Missile Crisis had come to an end, but it had taken the world to the edge of nuclear Armageddon. On this occasion, Kennedy was seen as victorious. He had neutralized the defeat of the Bay of Pigs invasion of the previous year.

Although Kennedy had personal failings as a serial womanizer, a compulsion that surfaced during the decades following his death, his legacy still has to be regarded as "Near Astounding." He took steps, albeit small, to desegregate schools to eliminate discrimination against minorities.[7] He created the Peace Corps, awakening generations of altruistic and international-minded youth. He created the Apollo Space Program that inspired generations of young techies preparing for careers in science and engineering. Boxcar-sized mainframe computers were miniaturized with scientists inventing transistors and subsequently printed circuits to replace vacuum tubes. In the twenty-first century Information Technology (IT) still attracts some of the most prodigious technical talent, pointing once again to fresh ideas gushing forth from young minds.

Any narcissism that rules one's nature may be partly inherited and partly forged by the unique dynamics of one's family life, especially the pressure from an overbearing father. Ultimately, however, it is each man's own responsibility to decide how to deal with the best angels of his nature or revert to the worst in carving out his legacy. In a severely truncated tenure of only one thousand days, he grew into the job, far transcending general expectations. He managed to create a zeitgeist favorable for creativity in both the arts and the sciences. No more than an average student in his secondary school days at Choate Rosemary Hall, nor as an undergraduate at Harvard, he was an avid reader of the biographies of history's great leaders. There is no evidence that he knew any more science than other well-rounded

liberal arts students, but he demonstrated latent respect for science and scientists while freely acknowledging that his deepest admiration would be reserved for great political leadership. During a dinner he hosted to honor a group of forty-nine Nobel laureates at the White House in April 1962, the thirty-fifth president could not hide his reverence for a personal hero. Kennedy began his address with a tribute to Thomas Jefferson (1743–1826):

> I think this is the most extraordinary collection of talent, of human knowledge, that has ever been gathered together at the White House, with the possible exception of when Thomas Jefferson dined alone. Someone once said that Thomas Jefferson was a gentleman of thirty-two who could calculate an eclipse, survey an estate, tie an artery, plan an edifice, try a cause, break a horse, and dance a minuet.

The third president of the United States, a brilliant visionary as a political philosopher and statesman, had been a child of the Enlightenment just like Goethe, Mozart, Napoleon, and Beethoven. He was the author of the Declaration of Independence and of the bill for the separation of religion and state. He had served as ambassador to France, as secretary of state and as vice president, and then for two terms as president. He had also founded the University of Virginia (UVA) in 1819, an achievement that became a greater source of pride for him than even the presidency of the nation. He spelled out these achievements in the epitaph he composed for himself.

Although Jefferson had trained as a lawyer, he always claimed that his favorite professor during his days as a student at the College of William and Mary had been the Scottish physician and natural philosopher William Small (1734–1775). It had been Dr. Small who infected Jefferson with a love for science and a reverence for Newton. On the shelves of his personal library in Monticello, Virginia, Jefferson displayed the marble busts of the three men whom he described as possessing the greatest minds in history. He wrote about them: "I consider Bacon, Locke, and Newton

as the three greatest men that have ever lived, without any exception, and as having laid the foundation of those superstructures which have been raised in the physical and moral sciences."

Jefferson's remains lie in a family plot on the grounds of his beloved estate, Monticello, in Charlottesville, Virginia. An obelisk bears the modest epitaph he wrote for himself: "Here was buried Thomas Jefferson, Author of the American Independence and the Statute of Virginia for religious freedom & Father of the University of Virginia."

Recently, presidential historian Jon Meacham explained how Jefferson's personal conviction that politics and science were connected:

> A politics of personal liberty created a sense of freedom to inquiry. A man liberated from monarchical or hereditary limitations stood a greater chance of possessing a mind free to roam and to grow and to create and to innovate in a climate in which citizens lived

together in essential harmony and affection. This was Jefferson's ideal republic—and he was committed to making it real.

In the Declaration of Independence, Jefferson had penned the noblest words in the founding of the United States: "We hold these truths to be self-evident, that all men are created equal, that they are endowed by their Creator with certain unalienable Rights, that among these are Life, Liberty and the pursuit of Happiness." Yet, as a crop and livestock farmer, Jefferson owned hundreds of enslaved people to work his estate. And, fully aware of his moral dilemma, he described it in letters to friends, "We have the wolf by the ears, and we can neither hold him nor safely let him go. Justice is in one scale, self-preservation in the other."[8] In his last will and testament, however, he made the mistake of failing to liberate them—as George Washington had done twenty-seven years earlier—and to put the country firmly on a course to abolish what has come to be seen rightfully as a deplorable crime of man on man. Historian William Crawley suggests that Jefferson must have foreseen the inevitability of emancipation when he wrote, "Time, which outlives all things, will outlive this evil also."[9] One of the principal architects of the nation, Jefferson was also a man of his time. Should his "crime" not be forgiven when it was not a crime in his own time, and maybe set the clock at the end of the Civil War? The Greeks of antiquity, long celebrated for inventing democracy, possessed five slaves for each free man. Certainly, homosexuality, a crime in many periods and places, has largely been forgiven in an enlightened age.

Reading everything about Jefferson that he could get his hands on, Kennedy developed a deep respect for science and technology. The Kennedy Cultural Center for the Performing Arts on the banks of the Potomac River in Washington, DC, and NASA's Kennedy Space Center in Cape Canaveral, Florida, serves as a pair of befitting monuments to the thirty-fifth president's personal interests. He never lived to see that he had inspired his nation's youth and created a spirit highly favorable for creativity, joining those enlightened leaders Pericles, Lorenzo de' Medici, and Queen

Elizabeth I cited in the opening quote in this chapter. Camelot became a nostalgic metaphor for Kennedy's presidency. During a 1963 interview by *Life* magazine, Jacqueline Kennedy remarked that her husband's favorite lines came from Lerner and Loewe's Broadway musical *Camelot*, "Don't let it be forgot, that once there was a spot, for one brief shining moment, that was known as Camelot."

PART II
GENIUS IN THE ARTS

4
A SINGULARITY IN THE HISTORY OF ART

Even had Newton or Leibniz never lived, the world would [eventually] have had the calculus, but if Beethoven had not lived, we would never have had the C-minor Symphony.
—Albert Einstein

E instein's pronouncement reflects the quintessential difference between creativity in the arts and creativity in the sciences. The life of the ultimate disruptor-revolutionary of music, Ludwig van Beethoven (1770–1827), is sandwiched between the lifetimes of two of the most brilliant scientists in history, Isaac Newton (1642–1727) and Albert Einstein (1879–1955), both theoretical physicists, both engaged in deciphering the deepest secrets of the clockwork universe, but with vastly different lifestyles and personalities.

The scientist's work begins with observations of natural phenomena plus the established laws of nature. The masterpiece of each man is embodied in the mathematical models he introduced to explain natural phenomena. The laws of the universe are precise and unequivocal, even though they can

sometimes be expressed in different but equivalent ways, according to how the questions are posed. A good physics student on earth should be able to travel to Kepler-186f, an earth-like planet five hundred light-years from the earth discovered in 2015, and pass an examination in physics administered there. And an exchange student from Kepler-186f should do equally well in an examination administered on earth.

However, an enduring artistic masterpiece starts with a clean slate—a block of marble, a blank canvas, a ream of blank paper, or a blank musical score—and usually within the prevailing tradition or genre, yet culminates in work so utterly transformative that the genre can never again be considered complete without its inclusion. From start to finish, such a creation can take a veritable infinity of different forms, and it is human subjectivity that ultimately judges the superiority of one work over another. "Beauty is in the eye of the beholder," a sentiment bearing the wisdom of millennia and repeated in different languages, including by John Locke and David Hume, owes its present wording to Margaret Wolfe Hungerford in the nineteenth century.

GAINING IMMORTALITY

Art is meant to communicate emotion. Most artists crave to have their artistic creations communicate universally, to endure, and for their own reputations to grow. The gifted director, writer, and comedian Woody Allen once quipped, "I don't want to achieve immortality through my work. I want to achieve it through not dying." That has never been an option, but there have been artists who in their own times may have shown promise to reach immortality through their work, but history has not always been kind to them.

There was the fifth-century B.C.E. sculptor/architect, Phidias, who collaborated with architects Iktinos and Callicrates in the design of the Parthenon before he carved the statuary in the pediments and friezes. The ruins of the Parthenon still stand as a reminder of the most beautiful "extrovert building"[1] ever built. The original statuary and friezes now grace the British Museum, and only their plaster copies can be seen in Athens. But

his massive chryselephantine (marble, covered in ivory plates and gold) sculpture of goddess Athena Parthenos that served as the centerpiece of the Parthenon and another colossal chryselephantine statue, that of Zeus in Olympia, have not survived. The latter had even been designated as one of the Seven Wonders of the Ancient World. There was also the fourth-century B.C.E. painter Apelles of Kos, described by the Roman historian Pliny the Elder as "the greatest painter of antiquity," but none of his original works have survived. The closest we come to glimpsing Apelles's works are a pair of copies discovered in the ruins of Pompeii, the Roman city destroyed by the cataclysmic eruption of Mt. Vesuvius in 79 C.E.[2] The first is a reconstruction of a mosaic depicting the Battle of Issus, fought between the armies of Alexander the Great and Darius III. The second work is the mural *Venus Anadyomene*, known to have inspired Sandro Botticelli (1445–1510) in one of his sublime masterpieces, the *Birth of Venus*. While working on his painting, the Renaissance master even developed a fantasy that he was the reincarnation of Apelles, depicting himself as the ancient divine in his masterpiece, *School of Athens*, while using Leonardo as the model for Plato and Michelangelo as Heraclitus."

Ultimately, tastes, techniques, and technologies are properties of their time. They evolve. This is reflected in the diversity of genres that have been invented in each of the arts—music, sculpture, painting, literature, and cinema. Bulgarian-born Christo (1935–2020) and his French wife Jeanne-Claude (1935–2009) were modern conceptual artists who created "environmental works of art." They admitted in advance that their creations would be epic, avant-garde, symbolic, but ephemeral in the manner of snowmen bathed in warming sunlight.[3] The works included the *Wrapped Reichstag* in Berlin; *The Pont Neuf Wrapped* in Paris; twenty-three miles of saffron banners creating *The Gates* in New York City's Central Park; and the twenty-four-mile (thirty-nine km) *Running Fence* in Sonoma, California, evocative of an endless clothesline. The duo also began an even more ambitious project, *Wrapped Coast* (Australia). With their works' accessibility, they generated endless curiosity but only mixed appeal from critics. Since it is not

their tangible works that will endure, perhaps it will just be their reputations as footnotes for fleeting works. Fellow artist Saul Steinberg described Christo's modus operandi: "He not only invented himself, he invented his art and, even more amazing, he invented his public." "[With its] decadence in the name of originality," as the late British writer Alastair Cooke liked to describe such modern art, it is unlikely to present serious competition to the legacies of Leonardo and Michelangelo. Nor will Malcolm Arnold's "Concerto for Vacuum Cleaner and Orchestra,"[4] with supporting "musical instruments" of three vacuum cleaners, one floor polisher, and four rifles, pose a serious challenge to Mozart's "Piano Concerto Number 21," or Beethoven's "Violin Concerto in D." In characterizing the traits and conditions of genius in the opening of chapter 1, we had specified intellectual ability, creativity, and *lasting* achievement. Accordingly, within our narrow characterization, the evanescent works of Christo and Jeanne-Claude do not qualify, but sadly, neither do those of Apelles.

Among all great composers, the only one who appears to have avoided fluctuations in popularity is Ludwig van Beethoven. By the nineteenth century, Bach's star had dimmed somewhat, and it was Mendelssohn who helped revive his luminescence. By the middle of the nineteenth century, Hector Berlioz was regarded (especially by his countrymen) as the "French Beethoven," completing "The Bs." By the end of the nineteenth century, the legendary conductor Hans von Bülow, in his ranking, replaced Berlioz with Brahms as the greater composer to complete the trio occupying the summit of Mt. Olympus, declaring: "I believe in Bach, the Father; Beethoven, the Son; and Brahms, the Holy Ghost of music."[5] On a lighter note, a *Peanuts* strip captured Schroeder at the piano.[6] Charlie Brown comments, "You've heard of Bach, Brahms, and Beethoven, right? Well, from now on, it's going to be Schubert, Schumann, and Schroeder!"

Modern music scholar Scott Burnham, in a fascinating treatise written for the Cambridge Companion, opens with the assertion,

> Of the reception of Beethoven's music these last two hundred years, one thing is clear: there has been little trace of the tidal

cycles of popular and critical approbation suffered by almost every other important composer.⁷

According to Burnham, since Beethoven's death, the composer has been reinvented again and again to suit the prevailing political and social spirit of the day, the zeitgeist, a significant clue to the composer's immortality, a point to which we will return later in this chapter and then in the epilogue. Moreover, it offers an explanation for the ascendency of the other transformative geniuses chronicled in this book.

COPLAND'S MODELS OF MUSICAL CREATIVITY

Regarding creativity in music, Aaron Copland (1900–1990), called the "Dean of American Music" by his peers, wrote an incisive monograph, *What to Listen for in Music*.⁸ In the book, he offered a formula to understand the creative process of different composers. Among the three basic types of creativity he identified is "traditional" creativity, characterized by Renaissance composer Giovanni Pierluigi da Palestrina (1525–1594) and the Baroque era composer Johann Sebastian Bach (1685–1750). Here, we'll call it the Palestrina–Bach Model. Composers working in this manner, Copland explained,

> Were born into a particular period of musical history, when a certain musical style is about to reach its fullest development. It is a question at such a time of creating music in a well-known and accepted style and doing it in a way that is better than anyone has done it before you.⁹

He identified a second type of creativity as "spontaneously inspired," and one that works best for shorter forms of music. Here hauntingly beautiful melodies are frequently seen. "Men of this kind," Copland explains, ". . . begin, not so much with a musical theme, as with a completed composition." The major composer possessing this type of creativity was Franz Schubert

(1797–1828), where "the music simply wells out." We label this the Schubert Model. Schubert, in a lifetime of only thirty-one years, composed nine symphonies (including his most famous work, the *Unfinished* or *Eighth Symphony*), his main body of work was comprised of shorter pieces that had erupted like geysers. There were overtures, masses, string quartets, quintets, piano sonatas, and over 600 *lieder* (songs). Perhaps with premonition of an early death, he wrote at the pace of a song a day.

The wunderkind of all time, Wolfgang Amadeus Mozart (1756–1791), a legend for his works of surpassing quality and prodigious quantity, must have possessed elements of both traditional and spontaneously inspired creativity. He was Copland's traditionalist, "creating music in a well-known and accepted [Classic] style and doing it in a way that was better than anyone had done before." Mozart was also Copland's "spontaneously inspired" creator. He composed symphonies, operas, and concertos of redoubtable power and of sublime beauty. He wrote them out in ink, and at a pace that few copyists could match. He was only eleven when he composed his first opera, *Apollo et Hyacinthus*. His operatic masterpiece *Don Giovanni*, described by many musicologists as the greatest opera ever composed, was completed in just six weeks. This suggests that Mozart would be a member of a hybrid Palestrina–Bach and Schubert Models.

In a letter to Mozart's father, Leopold, Haydn wrote with humility and awe:

> *Before God and as an honest man I tell you that your son is the greatest composer known to me either in person or by name; he has taste, and, furthermore, the most profound knowledge of composition.*

Einstein, whose quotation regarding Beethoven opened this chapter, actually claimed that his preference was *not* for the music of Beethoven, but for Mozart:

> *Mozart is the greatest composer of all. Beethoven created his music, but the music of Mozart is of such purity and beauty that one feels*

he merely found it—that it has always existed as part of the inner beauty of the universe waiting to be revealed.

Here Einstein was echoing the words of "Papa" Haydn, adding that in his own judgement Mozart had come of age in 1777 when he wrote his "Piano Concerto No. 9," a piece he described as "Mozart's *Eroica*!" Alfred Brendel, an Austrian piano virtuoso, known for his performances of Mozart, Schubert, Schoenberg, and especially Beethoven, was even more effusive about the concerto, "One of the greatest wonders of the world." Finally, among a stream of kudos expressed by his fellow composers—Beethoven, Wagner, Brahms, Tchaikovsky—there are the words of wonderment by H. C. Robbins Landon[10] at the 255th anniversary of Mozart's birth: "The Mozartian legacy, in brief, is as good an excuse for mankind's existence as we shall ever encounter and is perhaps, after all, a still small hope for our ultimate survival."

Copland's third type of musical creativity and the one exemplifying his personal ideal is seen in a class of composers he calls "constructivists." For us, this is the Beethoven Model. By the time Beethoven made his debut in Vienna in his early twenties, and even earlier during his formative years in Bonn, the ultimate creator/rebel of music possessed a disposition coiled to strike out at all manner of authority—social, civil, musical. Thus, he certainly could never have been a "traditionalist" in Copland's sense. Although he developed early the skills to innovate, to compose variations almost reflexively, Beethoven never possessed the spontaneous creativity of Schubert, nor of Mozart. His modus operandi called for an initial musical theme. From that would germinate ideas that he would fashion into the pillars and framework, and from which he would construct the musical work. He would experiment endlessly changing the combinations of musical instruments, trying out variations on the theme, and trying out inversions until he decided the work was *un-improvable*—perfect! According to Copland, it is the Beethoven Model that composers have largely employed ever since.

Modern musicologists assert that many of the famous composers on Broadway, including Irving Berlin, George Gershwin, Duke Ellington,

Leonard Bernstein, Cole Porter, and a slew of other twentieth-century masters of Broadway musicals—at least the musician half of the teams in distinction to the lyricist half—including Richard Rodgers and Oscar Hammerstein, Richard Rodgers and Lorenz Hart, Alan Jay Lerner, and Frederick Loewe, were all musical geniuses. We can also add to them more recent composers like Stephen Sondheim and Andrew Lloyd Webber who have possessed this type of spontaneously inspired creativity, composing tune after tune and musical after musical, many of which have become modern classics.

Regarding the attribute of universality so important for the creative artist, Gustav Mahler made a recommendation to his contemporary Finnish composer Jan Sibelius: "The symphony must be like the world." He said, "It must be all-encompassing of the universal spirit." This is true not only in classical music but in all art. It behooves us to mention one of the twentieth century's surpassing popular groups, significant for their social and musical influence, a quartet comprised of four young men from Liverpool, England. The Beatles were formed in 1960 and disbanded in 1970, evoking notions of a supernova suddenly appearing, shining brighter than all other heavenly bodies, and disappearing, without any apparent external forces. They were universal, they were controversial, and they were unforgettable. Five decades after they stopped creating their music, their albums are still sold and found in the collections of teenagers, their parents, and their grandparents. They have become modern classics. In the 1960s Leonard Bernstein had already tagged the group "the Schuberts of our times," recognizing their work as encompassing the universal spirit. Three decades later, Bernstein doubled down on his earlier words, describing the Beatles as "the best songwriters since George Gershwin."[11] Accompanying their soulful music were their ballads with John Lennon's haunting words:

> *You may say I'm a dreamer, but I'm not the only one. I hope someday you'll join us. And the world will live as one.*
>
> *A dream you dream alone is only a dream. A dream you dream together is reality.*
>
> *The more I see, the less I know for sure.*

A SINGULARITY IN THE HISTORY OF ART

This is group genius at its best, seen especially in the complementary skills of Paul McCartney and John Lennon.

FLETCHER'S RANKING OF COMPOSERS

In December 2008, the Aspen Institute held a workshop on the Italian Renaissance and the significance of Leonardo da Vinci.[12] As one of three featured lecturers, I introduced the distinction between "ordinary genius" and "transformative genius." Subsequently, musicologist and composer Alan Fletcher, director of the Aspen Music Festival and School, sitting in the audience and whom we will hear about presently in the context of "the unlikely mathematician," shared an essay with the other participants comparing the significance of classical composers. In his ranking, he intercalated two new categories—transitional and summative—between ordinary and transformative. In an associated table, he assigned columns to the four levels of genius—ordinary, transitional, summative, and transformative—and rows to their periods (approximately centuries).

TABLE 1. THE FLETCHER RANKING OF COMPOSERS

PERIOD	Ordinary	Transitional	Summative	Transformative
Medieval				Hildegard von Bingen
Renaissance				Josquin de Prez
Late Renaissance				Claudio Monteverdi
Baroque	Vivaldi	Schütz	Handel	Bach
Classical	Haydn		Mozart	Beethoven
Romantic	Schumann	Mahler	Verdi	Wagner
20th Century	Bartók	Stravinsky		

Alan Fletcher's ranking of composers spans six hundred years. Accordingly, in his ranking, the first row of interest includes musical geniuses from medieval times (Hildegard); the second and third rows, the Renaissance—from Josquin des Prez (a contemporary of Leonardo) and the late Renaissance (Monteverdi, a contemporary of Galileo); the fourth row, the Baroque period; the fifth row, the classical; the sixth row, the Romantic era; and the seventh row, twentieth-century composers.

Hildegard von Bingen (1098–1179) is an undeniable candidate for transformative genius designation, but only when medieval music is included. Fletcher wrote in a personal communique:

> If Hildegard were "only" known as a composer, instead of as a magisterial thinker about science, theology, and administration, she would still be one of the towering figures in intellectual and cultural history. Her monophony is sublime in its invention, subtle in its mathematical sophistication, and endlessly beautiful.[13]

Fletcher's explanation of the rationality underlying his rankings:

> The ordinary genius is still pretty good! The transitional genius does something quite new, standing on the shoulders of some prior great tradition. The summative genius masters every aspect of a style and all its genres so completely that the style, or a genre within it, like the Italian opera tradition of bel canto, has to change to retain vitality. Only the transformative geniuses enter the realm Bulent Atalay was describing to us. They may do something new, but with such mastery that it takes a century or more for others to "compose out" the implications of the innovation. This is certainly true of Monteverdi and Beethoven. Wagner is a rare type of composer who becomes a figure of worldwide cultural importance in his own time. Bach is unique in that he did not have such renown and even seemed to those few who knew his work across Europe to be a bit behind the times. But history has been kind to him; when one engages in the cocktail party game of wondering, "Who would be an ideal dinner guest?" I always think of Bach because it would be so much fun to show him how his music has come to be understood. Beethoven is the titan in all respects: innovation, mastery, influence, and cultural importance beyond music.

If I were compiling a similar four-column table of geniuses among scientists, I would place Newton and Einstein in the transformative genius column (possibly along with Galileo as a historical counterpart to Fletcher's Monteverdi among composers). In rows representing periods, for the late Renaissance, it would be Galileo; for the Baroque, Newton; and for the modern, Einstein. In the summative category (third column), for the nineteenth-century scientists, I might include Michael Faraday, Charles Darwin, and James Clerk Maxwell; and for the twentieth century, scientists Lord Rutherford, Sigmund Freud, Niels Bohr, and the triplet of Schrödinger, Heisenberg, and Dirac.

THE UNIVERSAL COMPOSER

Just as art communicates, great art communicates in a tantalizingly open-ended manner. In music, the composer seeks to draw the listener into a dialogue with his creation, and in the visual arts, the painter or sculptor seeks to draw the viewer into his creation. A great work of art is more engaging and confrontational, able to generate more complex dialogue with more tension than works of lesser quality. Copland compared the music of Beethoven and Tchaikovsky:

> Whatever the professional musician may hold, most musical novices still search for specific words, with which they pin down their musical reactions. That is why they always find Tchaikovsky easier to 'understand' than Beethoven . . . it is easier to pin a meaning-word on a Tchaikovsky piece than on a Beethoven one. Much easier! Moreover, with the Russian composer, every time you come back to a piece of his it almost always says the same thing to you, whereas with Beethoven it is often quite difficult to put your finger right on what he is saying. And any musician will tell you that is why Beethoven is the greater composer. Because music which always says the same thing to you will necessarily

soon become dull music, but music whose meaning is slightly different with each hearing has a greater chance of remaining alive.

"I know I am an artist," gasped the dying Beethoven in a heartrending understatement. He had changed the world of music as no one had before and perhaps no one would afterwards. For him, rules were meant to be bent, broken, or scrapped as long as the changes introduced elevated the art to Olympian heights. Austrian American polymath Robert Haven Schauffler (1879–1986) wrote about Beethoven, "He found the art of music narrowed to the pastime of a special class of society. He made it broadly human. He left it superhuman."[14] Certainly there were others who helped liberate music, but Beethoven did this more effectively than anyone else. He came around at an auspicious time in history, and he had the disposition and the genius to bring about the changes. Musicologist Donald Jay Grout captured his influence in a passage: "Beethoven was one of the great disruptive forces in the history of music. After him, nothing could ever be the same again; he had opened the gateway to a new world."[15]

In a recent article, "Deux Ex Musica" ("When the Gods have something to say . . ."), Alex Ross, music critic for the *New Yorker*, opened with a sweeping generalization:

> Beethoven is a singularity in the history of art—a phenomenon of dazzling and disconcerting force. He not only left his mark on all subsequent composers but also molded entire institutions . . . The art of conducting emerged in his wake. The modern piano bears the imprint of his demand for a more resonant and flexible instrument. Recording technology evolved with Beethoven in mind: the first commercial 331/3 rpm LP, in 1931, contained the Fifth Symphony, and the duration of first-generation compact disks was fixed at seventy-five minutes so that the Ninth Symphony could unfurl without interruption. After Beethoven, the concert hall came to be seen not as a venue for diverse, meandering entertainments but as an austere memorial to artistic

majesty . . . Listening underwent a fundamental change. To follow Beethoven's dense, driving narratives, one has to lean forward and pay close attention.[16]

Beyond listening to any other composer, with Beethoven, there is a sense that he demands one's full attention, and he receives it! Despite the hero worship that so many have been afflicted with, Ross admits this is not a good thing for music: "The idolatry has had a stifling effect on subsequent generations of composers, who must compete on a playing field that was designed to prolong Beethoven's glory."

He explains that as a teenager, he contemplated becoming a composer. Then while attending a concert in Boston, he remembers seeing in wonder and dismay, the single name BEETHOVEN emblazoned on the proscenium arch and saying to himself, "Don't bother!"

A TROUBLED LIFE

During his childhood days in Bonn, it was his father, Johann van Beethoven (1740–1792), who introduced Ludwig to the keyboards and pedals of the piano and organ, and to the strings of the violin and viola. But Johann was also the man who brought the boy dangerously close to detesting music altogether, as he came to detest his father. Although his formal schooling ended with the required fifth grade with only the bare elements of reading and arithmetic under his belt, young Ludwig's musical training was unusually thorough. Along with his father as his instructor, he had several other local keyboard teachers. By far, the most influential of them was Christian Gottlob Neefe (1748–1798). Growing up in Leipzig, Neefe differed from other *musici* in several respects. He had studied philosophy and literature, and the teaching techniques in music of Johann Sebastian Bach. Most importantly, he was a dedicated and selfless teacher who recognized the adolescent Beethoven's limitless potential from the beginning. Neefe exposed his pupil to the keyboard works of Bach and to his personal

favorite poet Schiller. He also introduced the boy to more contemporary works by Bach's sons. In mastering Bach's "Well-Tempered Clavier," Beethoven came to appreciate the one composer most frequently cited as the "musician's musician."

Neefe was aware of the toxic atmosphere in the Beethoven home—an abusive and depraved alcoholic for a father and a loving but somewhat helpless and sickly mother who could not fend for herself, let alone for her three sons. Neefe helped the boy secure a job as an assistant court organist with a small stipend to augment his father's salary. In 1783 at age twelve, Beethoven published a set of keyboard variations and subsequently his first three piano sonatas, dedicating them to the Elector Maximilian Frederick. By 1785, still only fourteen years old, he had become the main breadwinner for the family. In 1787, Neefe recommended his sixteen-year-old protégé for a grant from the Elector's Court to allow him to journey to Mozart's Vienna. In the recommendation letter he invoked the sacred "M-word," "that [Beethoven] could surely become another Mozart, if he were allowed to continue what he has begun." However, with the arrival of word from Bonn that his mother was dying from consumption (tuberculosis), Beethoven returned home after only two weeks in Vienna. By the time he relocated to Vienna permanently in November 1792, both his mother and Mozart had passed away.

During that last decade of the eighteenth century, Beethoven composed works that were modeled after those of Haydn and Mozart, but with flashes of the revolutionary Beethoven. By 1801 he was exploring self-expression that was wholly free-spirited, perhaps somewhat demonic. A combination of several factors fueled his future endeavors: the zeitgeist of the Enlightenment; the French Revolution; the explosive forces of the postrevolutionary Napoleonic era; the undiminished rage at his father, Johann; and the looming loss of his hearing. The significance of the last factor, the growing deafness, cannot be overstated.

The professional careers of most composers and other artists (painters, sculptors, writers . . .) are generally manifested in three periods—Early, Middle, and Late. In Beethoven's case, it is a little more complicated.

Musicologist/composer Robert Greenberg identifies 1789, 1802, and 1819 as the years of Beethoven's artistic rebirths, suggesting a partitioning of the composer's musical career into four periods. Although this may be an oversimplification, we shall follow the more common three periods: the first spans the years from his youngest days in Bonn through his first decade in Vienna when he is a thoroughly classical composer, in the modes of Haydn and Mozart. Not to be confused with the three (or four) periods of Beethoven's career in which he reinvented himself are the four "critical stations"[17] identified by musical scholar Scott Burnham for Beethoven's posthumous timeline, beginning with the composer's death in 1827. Then, as Alex Ross characterizes him, he was "the composer of the march of time," with mileposts forming an alternating series of forty-three- and fifty-seven-year periods, and time after time society rushing in to reinvent him. This appears to be the main evidence of Beethoven's rise to immortality, the total lack of a periodic tidal effect visiting other composers.

It was Beethoven's peculiar responses to his triumphs and crises that appear to have triggered his artistic rebirths. In 1789 the Electors agreed to grant half of his father's pension to the eighteen-year-old composer, recognizing him as the main breadwinner of the family. Elated by the increase in salary and possibly by the ipso facto public humiliation of his father, Beethoven promptly showed a burst of creativity, producing five sets of piano variations, ballet music, concert arias, chamber works for piano and winds, and two cantatas for vocal soloists and orchestra.

In his famous Heiligenstadt Testament of October 1802, Beethoven addressed his brothers, "Dear Carl and (blank) . . ." (the "blank," of course, was "Johann," his brother, namesake of his father), Beethoven is seen brooding over his loss of hearing and contemplating ending it all. The letter is as poignant as Hamlet's famous soliloquy, "To be or not to be . . ." But writing the letter served as a catharsis for Beethoven in overcoming this personal crisis by reinventing himself. With his "Third Symphony Opus 55," *Eroica*, composed between 1802 and 1805 and premiered in 1805, Beethoven's tacit proclamation of his artistic rebirth, or as Greenberg described:

[Emerging] in the guise of a hero, nothing less than a recreation of the expressive nature of instrumental music, a reevaluation of the role of artist as 'creator,' and a revolution in the nature of musical expression.

THE UNLIKELY MATHEMATICIAN

In the December 2008 Aspen Institute conference I mentioned earlier, my topic in one of the sessions was the "Mathematics Underlying Great Art." As I presented the Fibonacci sequence and explained how it found its way into art and architecture in the classical and the Renaissance periods, a man sitting in the back of the room caught my eye. He appeared to be taking copious notes, contemplating, counting. I had no idea at the time that this was Alan Fletcher, director of the Aspen Music Festival and Institute, and a distinguished composer and musicologist. Approaching me during a break, he explained that he had been examining Beethoven's First Symphony. He reported having found the repeats to follow the Fibonacci sequence, 1, 1, 2, 3, 5, 8, 13, 21, 34, 55, 89, 144 . . . (see chapter 7, "Intersection of Art and Science"). Subsequently, Fletcher wrote an essay that he distributed to the participants of the workshop. One passage of his essay reads:

> The first movement of Beethoven's First Symphony exhibits approximate golden section constructions: the introduction has 12 measures, but in a normal tempo they last about as long as sixty-six measures of the tempo of the rest of the movement. The rest is segmented Exposition[18] (96 measures), repeat of the Exposition (96 measures), Development[19] (78 measures), and Recapitulation[20] (120 measures). The numbers do not work out precisely to golden sections, but the Introduction through the Development is roughly golden with respect to the whole, and the Exposition, with repeat, and Development are roughly golden with respect to the Return.

Beethoven's Third Symphony (Eroica) has similar characteristics: Introduction (4 bars in the same tempo as the whole movement), Exposition (151 bars, repeated), Development (142 bars), Return (293 bars). The Introduction and Exposition are golden with respect to the Development and a negative golden section with respect to the rest; the Intro, Exposition and Development are golden with respect to the rest; the Development is a negative golden section with respect to the Return.

It is essential to point out that none of these ratios are exact. One can be virtually certain that Beethoven did not plan these proportions based on any knowledge of Fibonacci.

Beethoven was entirely innocent of mathematics. A poor student in his brief formal schooling, he could not multiply pairs of numbers, let alone perform long division. One of his surviving conversation books reveals that instead of multiplying twelve by twelve, he added a stack of twelves. There is also evidence, pointed out by Edmund Morris,[21] that he had a measure of dyslexia, on occasion writing 1181 instead of 1811, or 14 instead of 41. This psychological idiosyncrasy is associated with the ability to view things from different planes (not from a single horizon line), as in the technique of cubism in the paintings by Picasso and Braque, and as it is in the type of creativity demonstrated by Beethoven in his music.

Beethoven liked to take long hikes in the woods surrounding Vienna where he might have picked up subliminal messages from nature—from the patterns in the leaves on branches, branching in trees, swirls in the seeds of sunflowers, swirls in the scales of pinecones, and the petals of flowers. As the characteristic *phyllotaxis* of a variety of plants, the patterns would have registered in his subconscious mind and suffused his music. Leonardo had done this in his paintings, whether consciously or not. Most Leonardisti agree, however, with Leonardo there are no accidents. Accordingly, he may just have applied them consciously just as Béla Bartók did in his musical compositions.[22]

MUSIC OF THE HEART

In 2015, *Oxford Today*, the university's alumni quarterly, carried an article with the curious title, "Music of the Heart."[23] Professor Peter Sleight, a cardiologist at the university's Radcliff Hospital, in collaboration with other cardiologists, had published a research paper, "Dynamic Interactions Between Musical, Cardiovascular and Cerebral Rhythms in Humans."[24] They had discovered that slow music, specifically adagios, featuring a repeated rhythm or refrain lasting ten seconds had a uniquely calming effect on listeners. Apparently, such music matches the rhythm of the body's naturally occurring ten-second waves of blood-pressure control. The subjects in the study consisted of two dozen healthy subjects—men and women, approximately twenty-five years old, with half of them musically untrained medical students and the other half conservatory musicians. The subjects were all treated to musical excerpts, played in random order and in a variety of styles and genres. Meanwhile, their blood pressure and respiration rates were carefully monitored with EKG probes.

The repertoires found to be the most soothing were the adagio movement of Beethoven's *Symphony No. 9*, along with certain operatic pieces by Giuseppe Verdi and Giacomo Puccini. Verdi's "Va Pensiero" was shown to moderate blood pressure down to the normal level. Other pieces with similar results were Puccini's "Nessun Dorma" from *Turandot* and Bach's Cantata, "Gott soll allein mein herz haben" (BWV 169). The researchers found the prayer "Ave Maria," when spoken in Latin, also has a ten-second rhythm when it was read out fifty times, as it is sometime done in Catholic services in Italy.

As Sleight explains the phenomenon, "These pieces are especially rich in 10-second cycles that match perfectly the control rhythm of the cardiovascular system. Blood pressure measurements are sent to the brain after every heartbeat, but because the brain sends control messages back to the heart along two separate nerves operating at different speeds, they arrive out of phase with one another and only come back into phase once every 10 seconds." Sleight hypothesized that the effect might be due to the

synergy this slow, repeating music shares with the body's naturally cyclical processes, such as pulse and breathing rates. He added, "Our research provided improved understanding as to how music, particularly certain rhythms, can affect one's heart and blood vessels. But further robust studies are needed," he suggested, "which could reduce skepticism of the real therapeutic role of music." Sleight and his collaborators found that no significant differences exist in the responses of men and women, and between musicians and non-musicians.

One has to ask, what is the physiology of the auditory stimulus into the efferent nervous system bringing about the change? We all know it as we experience it. Certain cadences of rhythm accompanying melodies have the power to move us to tears, even when hearing them for the first time. How does that happen? Known phrases of music associated with certain events are easy to explain, but when one has never heard the piece before, there is something primeval about the physiology. One naturally senses the kernel of a wonderful meeting with the interaction between musicians, physiologists, and humanists.

Among the possible applications for this research are complementary therapies for psychological disorders such as anxiety and depression, and even cardiac conditions like high blood pressure, although considerably more research is required to formulate effective protocols for the incorporation of classical music. As Sleight points out, "Faster classical pieces, including Vivaldi's *The Four Seasons*, failed in lowering the listener's blood pressure." And he adds "more robust evidence is needed before we see cardiologists prescribing a dose of Taylor Swift or 30 minutes of Vivaldi a day."

Beethoven succeeded in bringing down the curtain on the genre that had come to be defined by Haydn and Mozart while raising the curtain on a new heroic, revolutionary, and adventurous spirit, that of Romanticism. He influenced Weber, Schubert, Brahms, Mahler, Tchaikovsky, Schoenberg, Stravinsky, Stockhausen, and continues right up to our day.

> The history of 20th-century music . . . is often written like a soap opera of scandals and spats between composers (eager to

explore) and performers (keen to show off)—a tradition that can be traced to Beethoven's door. A performer today struggling with Stockhausen or Boulez may be wise to recall Beethoven's words to the Schuppanzigh Quartet after it refused to play the last movement of his String Quartet No.13: "What care I about you and your bloody fiddles?"[25]

Released in 1812, his only opera, *Fidelio Opus 72*, was regarded as a mediocre opera but was supported by a great piece of music; his *Seventh Symphony Opus 92* again powerful, signature Beethoven. His *Eighth Symphony Opus 93*, released in 1813, is light, compact, and humorous. As Greenberg writes, "The upbeat nature of the *Eighth* belies Beethoven's dark mood; he wrote much of his most brilliant and upbeat music when he was depressed. Symphonies Nos. 2, 7, and 8 were all composed when he was despondent, even marginally suicidal."

By 1815 Beethoven found himself in a dysfunctional depression that lasted until 1819. During those four years and indeed the next five, there were no more symphonies. One work that is worthy of mention is *Wellington's Victory, Opus 91*, regarded as the composer's most controversial creation, a fifteen-minute orchestral work designed to be played by a multi-instrument automaton, a panharmonicon. Despite the Viennese listeners' sophistication in assessing music, they did not seem to mind its kitschy character, if for no other reason than that it celebrates a victory over the monster of the age, Napoleon.

German polymath and unquestionable genius Johann Wolfgang von Goethe initiated a series of meetings with Beethoven during the composer's darkest period. As the two men took walks in the park, a mutual admiration developed rapidly. However, after the third meeting the mutual admiration soured when they discovered irritable social behavior in each other. Beethoven found it objectionable that Goethe was playing up clumsily to members of the nobility, including the empress. As Goethe tipped his hat and stepped aside in order to let them pass, Beethoven took umbrage. According to Goethe's letter to a friend in Berlin, Beethoven leaned over and

whispered to him: "Keep walking as you did until now, holding my arm, they must make way for us, not the other way around."[26] Goethe, however, was sympathetic with the composer's boorish behavior, adding in the letter:

> *His talent astonished me; nevertheless, he unfortunately has a tumultuous personality, which is not completely wrong in thinking the world repulsive, but undoubtedly he makes no effort to render it more pleasant to himself or to others. He must be shown forgiveness and compassion, for he is losing his hearing, thing that affects less his musical side, but more his social one. As laconic as he usually is, he is even more so due to his disability.*

THE IMMORTAL BELOVED

During his years in Vienna, Beethoven frequently fell in love with women—engaged women, married women, women far above his own social station, and otherwise simply unattainable women. But he failed to successfully woo them. Some of the women may have initially been infatuated with him for his talent, but then came to reject him as uncouth and physically unattractive. In appearance, though muscular, he was short, about 5'5" (165 cm). His broad shoulders supported a disproportionately large head, a pockmarked complexion, and a mane described as an unkempt charcoal thicket.[27] In either 1812 or 1813, however, it seems there was finally a woman with whom he fell passionately in love and who reciprocated in equal measure. The evidence for this liaison is a sizzling letter, now known as *"Unsterbliche Geliebte"* ("Immortal Beloved"). The letter was discovered posthumously in a secret drawer of his writing desk:

> *My angel, my all, my own self—only a few words today, and that too with pencil (with yours)—only till tomorrow is my lodging definitely fixed. What abominable waste of time in such things—why this deep grief, where necessity speaks?*

> *Can our love persist otherwise than through sacrifices than by not demanding everything? Canst thou change it, that thou are not entirely mine, I not entirely thine? Oh, God, look into beautiful Nature and compose your mind to the inevitable. Love demands everything and completely with good reason, so it is for me with you, for you with me—only you forget so easily, that I must live for you and for me...*

Beethoven did not identify the recipient of the letter. Nor did he date the letter and mail it. For two hundred years, the identity of the mysterious woman has perplexed Beethoven scholars. The composer's "beloved" could have been one of a dozen different women. The 1994 film *Immortal Beloved*, while treating the audience to breathtaking music, proves to be historical fiction. It proposed, somewhat unbelievably, that Johanna Riess, widow of his late brother Kaspar Anton Karl van Beethoven, was the intended recipient of the letter. Greenberg enthusiastically praises musicologist Maynard Solomon, however, for having finally solved the puzzle. The mysterious woman appears to be Antonie Brentano, and the date, July 6–7, 1812. Brentano was ten years younger than Beethoven, married, and the mother of four children. A torrid love affair ensued, with talk of a life together. However, it was not Brentano, but the altar-fearing Beethoven who terminated the liaison. His memories of growing up in a dysfunctional home had jaded him against the idea of marriage.

The "Immortal Beloved" letter did not have the cathartic effect of the Heiligenstadt Testament of a decade earlier. There is no subsequent artistic rebirth, no burst of creativity. Instead, there is a dramatic shutting down of his creative juices. His life during the period 1815–1819 can be characterized as indolent and slovenly. Guides in Vienna will tell you that during his lifetime of fifty-six years, Beethoven lived in thirty houses, and that he was evicted from twenty-nine of them.

Although he had always been protective of his brothers, he was unusually cruel to the brothers' wives. After Kaspar's death in 1815, Beethoven became obsessed with taking over the sole guardianship of his son, Karl.

By hiring agents to smear the reputation of Kaspar's widow, Johanna, he engineered the legal adoption of the boy. In the process, he succeeded in destroying the lives of the nephew and his mother. Karl attempted suicide but failed. Loading insufficient gunpowder in the pistol and aiming the muzzle at only a grazing angle to his temple resulted in the bullet becoming embedded between his scalp and skull. As Greenberg observes, "The incident was no more than a classic call for help and to be left alone by a relentlessly meddlesome uncle." Meanwhile, Beethoven's widowed sister-in-law, Johanna, remarried and had a daughter, perhaps symbolically replacing the son she lost. She named the new baby Ludwiga, the feminine form of Ludwig. In this period, Beethoven invented his own reality, deluding himself that he was the son of Frederick the Great and claiming that he was his nephew's real father. During this period Beethoven was frequently on the wrong side of the fine line separating genius and insanity.

Earlier, he had idolized Napoleon, seeing him as a champion of the common man. But, holed up in the basement of a home in Vienna with shells of the French fusilier exploding all around, then getting news of Napoleon crowning himself emperor, he tore up the title sheet of the *Third Symphony*. He cursed at himself for his lack of judgment, "You bastard, you got it wrong . . . again!" Alex Ross's article for the *New Yorker* attributes a poignant line to Beethoven: "Everything I do apart from music is badly done and stupid."

THREE GS AND AN E-FLAT

In what are generally regarded as the two most important concerts in the history of music, Beethoven unveiled his *Fifth Symphony* (1808) and sixteen years later his *Ninth Symphony* (1824). For its power and originality, the deserving sequel to the revolutionary *Third Symphony* is not the *Fourth Symphony*, but rather the *Fifth*. Similarly, to complete his revolution as a deserving sequel to the *Fifth*, it is not the *Sixth*, *Seventh*, nor the *Eighth*, but rather the *Ninth*. To his dying day, however, it would be the *Third Symphony*, the *Eroica*, that would remain his personal favorite.

Although Beethoven did the main work on the *Fifth Symphony* during the years 1806–1808, he had developed the rough draft for the composition six years earlier. Along with the *Fifth Symphony*, he was developing the scores for the *Appassionata* [Sonata]; the *Fourth Piano Concerto*; the *Razumovsky String Quartets 7-9*; the *Fourth Symphony*;[28] the "Violin Concerto in D"; the concert aria "Ah! Perfido"; the *Sixth Symphony* "Pastoral"; the opera *Fidelio*; *Choral Fantasy in D*; and the *Mass in C*. The Napoleonic Wars raging in Europe, along with the actual occupation of Vienna by the French in 1805, provided the terrifying backdrop for the creation of these works. The burst of creativity in the two years 1806–1808 defines his anni mirabiles, just as 1665–1666 (and 1684–1686) had been for Newton, and 1905 (and 1915) would be for Einstein.

Eight of Beethoven's creations from the years 1804 to 1808 saw their premieres in a marathon four-hour concert on December 22, 1808, performed by a largely under-rehearsed, semiprofessional orchestra, in the unheated auditorium of the Theater an der Wien. The conductor of the *Fifth* and *Sixth* symphonies was Beethoven himself; the pianist performing the *Fourth* Piano Concerto was again Beethoven. While a wiser head would have known that the program was too long, Beethoven's solution, instead of cutting it down, was to introduce additional music, and even to repeat a lengthy passage. (With his hearing fading, he lost his place in the score of the *Choral Fantasy*, and after a pause, barked to the audience, "From the beginning!") The audience could not possibly comprehend such revolutionary works coming all at once. Even for the sophisticated audiences of Vienna, the concert was just too long and too revolutionary! The haggard audience came out of the theater drained, grumbling. Fellow composer Johann Friedrich Reichardt, who was in attendance as a guest of one of Beethoven's patrons, Prince von Lobkowitz, captured the audience's experience,

> There we sat, in the most bitter cold, from half past six until half past ten, and confirmed for ourselves the maxim that one may easily have too much of a good thing . . .

An animation of the evolution of the symphony by the legendary Leonard Bernstein[29] in a lecture he gave at his alma mater, Harvard, in 1956, dissected the first movement and showed how Beethoven introduced and removed instruments, continually experimenting with combinations of instruments, and with variations in the theme until the full symphony of approximately five hundred measures emerged fully confident, mature . . . perfect, and incapable of further improvement!

The opening passage of the first movement of the Fifth Symphony is comprised of three eighth notes on G and one half note on E-flat, followed by three eighth notes on F and one half note on D. Beethoven dedicated the symphony to Prince von Lobkowitz and Prince von Razumovsky, listed in their original spellings.

Prussian-born composer, music teacher, jurist, and draftsman E. T. A. Hoffmann (1776–1822) was a younger contemporary of Haydn, Mozart, and Beethoven. As a writer, he is credited with the fantastical stories adapted by Tchaikovsky for the ballet *The Nutcracker Suite* and he is the Hoffmann of Offenbach's ballet *The Tales of Hoffmann*. Just two years after Beethoven's famous December 1808 concert, Hoffmann had a job as a

music critic for a Leipzig publisher and is credited with the first incisive critique of Beethoven's *Fifth Symphony* and recognizing him as the first and truest of all Romantic Composers. In passionate rhetoric that colored the language of the Romantic era, in 1810 Hoffmann wrote:

> Haydn and Mozart, creators of modern instrumental music, were the first to show us the art [instrumental music] in its full glory. It is Beethoven who regarded that art as ardent love and penetrated into its innermost essence . . . Mozart leads us into the inner depths of the realm of the spirits. Fear envelops us but does not torment us: it is more a premonition of the infinite . . . Mozart claims the superhuman, the amazing which dwells in the inner spirit. Beethoven's music induces terror, fright, horror and pain and awakens that endless longing which is the essence of romanticism. Beethoven is a purely romantic composer (and precisely for this reason, a truly musical composer).

Although Hoffmann's claim of Beethoven as the first Romantic composer was accepted by the musical culture in his time, there is no longer universal agreement now that Beethoven was even a Romantic composer. Some of the most respected musicologists specializing in eighteenth- and nineteenth-century music, including Douglas Johnson at Rutgers, regard Beethoven as a classical composer.

In his *Fifth Symphony*, Beethoven created what has proven to be one of the most powerful, enduring, and universally appealing masterworks in the history of music. French Romantic composer Hector Berlioz (1803–1869) recognized the indomitable spirit Beethoven brought to the *Fifth Symphony*, remarking:

> [It] emanates directly and solely from the genius of Beethoven. It is his own intimate thought that is developed; and his secret sorrows, his pent-up rage, his dreams so full of melancholy oppression, his nocturnal visions and his bursts of enthusiasm furnish its entire subject, while the melodic, harmonic, rhythmic, and orchestral

forms are there delineated with essential novelty and individuality, endowing them also with considerable power and nobility.

In one of Beethoven's earliest biographies, *Beethoven as I Knew Him* (1840), the author Anton Felix Schindler, who had served as the composer's valet, amanuensis, and factotum, claimed that the composer, glancing at the score of the *Fifth Symphony*, had declared,

> So pocht das Schicksal an die Pforte!
> (That's how fate knocks on your door!)

The symphony came to be known as the *Destiny Symphony*. Other interpretations included "Trumpets Announcing: 'It's Judgment Day,'" and "A Bird That Sung in the Vienna Woods."

The first long-distance telecommunication technology in history came with the telegraph in 1844. American painter and inventor Samuel Morse (1791–1872) transmitted electrical pulses through an electric wire from one electromagnetic switch to another, triggering markings on a reel of paper tape.[30] Morse also developed the code for the conversion of combinations of electric pulses into symbols—letters and numbers. Among Morse's symbols, the combination of three dots and a dash, "• • •—" represents the letter "v" and, coincidentally, the Roman symbol for the number five. In its former capacity, it happens to be the first letter of the English word "victory." During WWII, the Allies adopted the work as their "Victory Symphony over the Axis Powers" (never mind that the principal enemy of the Allied side was Germany, the land from which the composer had hailed). As a number, it describes the work's chronological order among Beethoven's symphonies.

In 1989 the Berlin Wall was razed, the physical and symbolic end to the Cold War between the democratic Western Bloc of nations and the autocratic Eastern Bloc, with East Germany, Poland, Romania, Ukraine, and a host of other Soviet Bloc countries gaining their independence. As the metaphor for peace and the reunification of Germany, Leonard

Bernstein conducted Beethoven's *Ninth Symphony*. The beauty and power of Beethoven's music will endure. Peace, however, is fleeting. In January 2022, Russia invaded Ukraine to incorporate it back into the Eastern fold.

Beethoven's *Symphony No. 9* had been performed for the first time in Japan in 1918 and in 2018, a flash mob performance was organized to commemorate the centennial of that first performance. Just a few years earlier a dramatic recording was made of a concert with 10,000 singers in Japan singing the choral movement "Ode to Joy";[31] Friedrich Schiller (1759–1805)—physician, philosopher, historian, playwright, and poet—had written the ode in 1785. Subsequently he came to regard it as one of his lesser works, calling it "detached from reality and entirely forgettable." Nineteen years after his death, his ode would begin its rise to become the German polymath's most celebrated work as the lyrics of Beethoven's choral movement.

TENSION AND RELEASE

In basic music theory, tension and release comprise a pair of complementary technical terms, the former describing the anticipation created in a listener's mind; the latter, the mind seeking relaxation or release of the tension. Tension can be produced through reiteration, by increase in dynamic level, by gradual progression to a higher or lower pitch, or by (partial) syncopations between consonance and dissonance, which creates a feeling of release. These are general examples and not specifically related to Beethoven's *Fifth Symphony*. In introductory harmony, one can use any chord (as long as it is in the same key) to create tension, but the best way to release it is to move back to the tonic; i.e., the first scale degree of a diatonic scale and the tonal center or final resolution tone that is commonly used in the final cadence in tonal (musical key-based) classical, popular music, and traditional music.

The source of tension and release in Beethoven's music is in his ability to spin out the theme, as it is seen in the *Fifth Symphony*. As he explores a theme he expands and uses it in every possible way, exploring every possible voice and inversion before eventually coming to a cadence and release. The

theme is voiced in every possible way without resolution until the tension is at its height and then it is resolved in extensive cadences and codas.[32] Beethoven was an unrivaled creator of tension and release.

Thus, the question to ponder becomes, is the "tension and release" mechanism a matter of nature or nurture? In other cultures, among the Japanese and Chinese or among the Aboriginal Australians, can such a mechanism exist and be compatible with that in the West, specifically for the same combination of chords, or is it an acquired mechanism? Twenty-five hundred years ago, the Pythagoreans recognized that certain combinations of chords created consonance and others dissonance, that some combinations were harmonious and pleasing to the ear and others were not. The behavior may be programmed in our genes since our distant ancestors engaged in chanting in the savannas of Africa, or it may be culturally acquired in the West in distinction to the East.

5

KING KONG VERSUS OTHER MONKEYS

Be not afraid of greatness: Some are born great, some achieve greatness, and some have greatness thrust upon them.[1]
—William Shakespeare

How would the Bard have explained his own ascent to immortality? Four hundred years ago, his contemporary Ben Jonson, the brilliant poet and playwright and cantankerous literary critic, had already anticipated Shakespeare's immortality, writing in the preface of the *First Folio*, "He was not of an age, but for all time!" One hundred years ago George Bernard Shaw, eminent playwright, critic, orator, and legendary curmudgeon, wrote, "With the single exception of Homer, there is no eminent writer . . . whom I can despise so entirely as I despise Shakespeare when I measure my mind against his."[2] The modern Shakespearean scholar Stephen Booth offers a reasonable response to that lingering but rarely verbalized question, "Can he really be that great?"

Shakespeare is our most underrated poet. We generally acknowledge Shakespeare's poetic superiority to other candidates for

greatest poet in English but doing that is comparable to saying that King Kong is bigger than other monkeys [apes]. The difference between Shakespeare's abilities with language and those even of Milton, Chaucer, or Ben Jonson is immense. The densities of his harmonies—phonic and ideational both—are beyond comfortable calculation, are so great that the act of analyzing them is self-defeating, uncovers nests of coherence that make the physics of analyzed lines less rather than more comprehensible.[3]

No writer has influenced language and literature to the extent that William Shakespeare has. Unrivaled as a playwright and poet in English, or in any other language, he was also a most insightful psychologist and prophet. He was the ultimate explorer of the human heart. Among words used exclusively to characterize him: bardology, bardolater, and bardolatry, the last one describes "a facetious idolatry or excessive admiration of Shakespeare." It is a trap that is frequently difficult to avoid.

A COLOSSAL DETRACTOR

Count Lev Nikolayevich Tolstoy (1828–1910), usually referred to as Leo Tolstoy, however, displayed a clear Bard-iconoclasm, opening his short monograph, "A Critical Essay on Shakespeare,"

> I remember the astonishment I felt when I first read Shakespeare. I expected to receive a powerful aesthetic pleasure, but having read, one after the other, works regarded as his best . . . not only did I feel no delight, but I felt an irresistible repulsion and tedium . . .[4]

Author of *Anna Karenina* and *War and Peace*, Tolstoy was one of the greatest novelists in history, and certainly a genius of high order. Was his disappointment in reading Shakespeare merely professional jealousy at the

summit, akin to Michelangelo criticizing Leonardo, or Leibniz criticizing Newton? Or was something lost in the difficulty of translating languages or cultures across the centuries? Unlikely! Tolstoy could and did read all of Shakespeare in English, as well as in German and Russian translations, and did so at two or three different stages of his life.

Tolstoy was born into high aristocracy and wealth. He experienced the savagery of battle on the front in the Crimean War. In Paris he saw a public execution. Then, in reading Victor Hugo's *Les Misérables*, he was profoundly affected by a story in which the poor were forever doomed to injustice and misery. The protagonist Jean Valjean had to escape from prison after serving nineteen years for stealing a loaf of bread, then only to be hounded relentlessly by the police chief Javert. Ultimately, Tolstoy claimed he underwent a spiritual awakening in reading Christ's Sermon on the Mount, transforming him into a pacifist and ardent Christian anarchist. His writings on nonviolent resistance would inspire Mahatma Gandhi, Martin Luther King Jr., Mother Teresa, and Nelson Mandela.

The cathartic experience that changed Tolstoy's life also led him to oppose private ownership of land, the Russian Orthodox Church, and the institution of marriage. He wrote to a friend: "The state is a conspiracy designed not only to exploit, but above all to corrupt its citizens . . . Henceforth, I shall never serve any government anywhere."[5] It was not just lip service. Intellectual honesty drove him to write a last will and testament leaving his entire estate, not to his children and grandchildren, but to the serfs who were only recently emancipated. And he built thirteen schools for their children. Countess Sophia, his wife of fifty years, who adored him to the end, was convinced he had lost his mind. It was his value system and a distinctly different vantage point than that of everyone else that gave Tolstoy his aversion to authority. In literature, Shakespeare represented the ultimate authority. Why would one expect Tolstoy not to feel an aversion to that authority as well, especially in a critical essay he wrote in the last years of his life?

A complementary explanation for Tolstoy's diatribe may lie elsewhere. According to the British historian, author, and documentary filmmaker Michael Wood,[6] Robert Subtle, a distant cousin of Shakespeare, had also

been a poet. But unlike his famous cousin, a closet Catholic, he was a zealous spokesman for the old faith, and the author of the banned book *St. Peter's Complaynte and Saint Mary Magdalen's Funeral Tears*. Subtle's book bore the deadly dedication:

> To my worthy good cousin, "Master WS:" Poets, by abusing their talents, and making the follies and feigning of love the subject of the base endeavors, have so discredited this faculty that ". . . a poet, a liar and a lover," are three words of one signification . . . [whereas] the duty of poets is to glorify God.

Subtle was eventually captured, tried, and eviscerated in the Tyburn section of London near the site of Marble Arch. The calamitous path he followed caused his death and that of many devout followers. With his life and those of his immediate family members in peril, Shakespeare had successfully stayed out of the religious fray. That is, until just days after the execution of Subtle, when a collection of books was presented to the queen by the acting troupe. By accident or not, among the books was a copy of Subtle's *Saint Mary Magdalen's Funeral Tears* bearing the dedication to his "worthy cousin." According to Wood's account, "the Queen noticed it, tears welled up in her eyes, but she did not pursue the matter any further." Tolstoy may have unwittingly been echoing Robert Subtle's words, "The duty of poets is to glorify God."

CONSPIRACY THEORIES

Shakespeare's words have become so deeply engrained in our cultural DNA that the author's persona has faded into the mist and become wholly myth. The early success of his plays began to shake up London. Frequently cited was the reaction of Robert Greene, six years Shakespeare's senior, and already well-established as a dramatist. Greene was outraged that an uneducated outsider presumed to intrude in London's circle of dramatists—Kyd,

Lodge, Lyle, Marlowe, Nashe, Peele, and of course himself—all university trained. Greene wrote a scathing diatribe in *Groatsworth of Wit*. Picking up on Shakespeare's line, "O tiger's heart wrapt in a woman's hide,"[7] he continued, "There is an upstart crow, beautified with our feathers, that with his 'tiger's heart wrapped in a player's hide,' supposes that he is well able to bombast out a blank verse as the best of you. And being an absolute *'Johannesfactotum'* [a *"Mr. Do-it-all"*] is in his own conceit the only Shakes-scene in a country . . ." Greene died shortly after writing his review and before it appeared in print. In the rearview mirror of the Shakespeare story, the vitriolic review is seen as one man's jealous tirade.

Groups of skeptics have periodically emerged again during the last 160 years, still questioning how an undereducated playwright from the English hinterland who left school at thirteen could create such profound literature. One can hear them clamor, "You fool! The author could not possibly have been Shakespeare! Only Christopher Marlowe (1564–1593) could have written the works!" (Of course, Marlowe would have had to live another two decades beyond the accepted date of his death.) "No, no, no! It was the 17th Earl of Oxford, Edward de Vere (1550–1604) who penned them," claimed the group called the "Oxfordians" in the nineteenth century. "It was Queen Elizabeth (1533–1603) who wrote the plays, using a pen name." Other conspiracy theorists pointed to the 5th Earl of Rutland, Sir Roger Manners (1576–1612), and Sir Walter Raleigh (1552–1618) as possible authors.

After tracking down police records of the Shakespeare family's years in Stratford-upon-Avon, Michael Wood made a credible case for William Shakespeare having been the author.[8] The Shakespearean scholar Paul Cantor of the University of Virginia claims that Shakespeare had a miraculous genius that enabled him to project himself into the psyche of each of us and to suppress his own identity. John Keats (1795–1821) had described him as the "Chameleon Poet," a creature that can adapt himself to any identity. Shakespeare could write as if he were a man or woman, a hero or a villain, a leader or a follower, and do it so convincingly that each could claim him to be one of their own. "His great ability," said Cantor, ". . . was to represent the world and to represent it accurately."

In 2005, when Columbia University Shakespearean scholar James Shapiro wrote a book entitled *Contested Will: Who Wrote Shakespeare?* suggesting the secret genius was no other than Sir Francis Bacon (1561–1623), the *Guardian* columnist Robert McCrum published a rejoinder: "Professor Shapiro had gone over to the dark side, the blasted heath of the authorship question."[9]

In 2014 John Hudson revived the oldest of literary authorship sports with a theory of his own, which in 2019 journalist Elizabeth Winkler endorsed vigorously.[10] In a double punch, first, Hudson served up Emilia Bassano Lanier as the "Dark Lady" of the sonnets and speculated that Lanier was the true author of the plays, arguing that no one other than a woman could have gotten into the mind of a woman that completely and with that much empathy.

The sport of Shakespearean authorship is well beyond my weight class. But what I do know from the four other transformative geniuses examined in this book is the lack of education is not a handicap in the constitution of transformative genius. After all, Leonardo, with even less formal education than Shakespeare, painted the psychologically charged *The Last Supper* and *Mona Lisa* before going on to perform the greatest anatomical studies in history, and inventing entire fields of science. And there is Beethoven, who completed only the required minimum formal education of five years. He went on to change the very soul of music with his *Third*, *Fifth*, and *Ninth Symphonies*, and the late string quartets (Opus 127, Opus 130, Opus 131, Opus 132, Opus 133, and Opus 135),[11] each an ascent by a quantum step. Is it possible that for genius at this level, the insecurity derived from a paucity of education fuels a vengeful, insatiable drive that a subconscious script has to be fully played out in his head and a certain level of accomplishment has to be attained before he could feel satisfied with his effort?

GREAT ART VS. GREAT SCIENCE: GAPS, AMBIGUITIES, OPEN-ENDEDNESS

A fascinating new approach to answering the question "Why is Shakespeare relevant in the twenty-first century?" comes from Emma Smith,

a professor of Shakespeare Studies at Oxford's Hertford College. In her book *This is Shakespeare*,[12] Smith starts by questioning the usual list of answers one encounters in the theater and in academia: "Because his works encapsulate the human condition like no other"; "Because he wrote like an angel, putting it all so much better than anyone else"; "Because of the enormous vocabulary"; "Because he surpassed his contemporaries in vision, originality and literary mastery"; "Because he represents timeless values of tolerance and humanity." Then she answers her own questions: "No, that's not why, not at all! These are all equivalent to placing a dead cat on the table for diverting attention from more tricky and substantive issues. They deflect us from investigating the artistic and ideological implications of Shakespeare's silences, inconsistencies, ambiguities, and above all the 'sheer and permissive *gappiness* of his drama.'" She adds, "That '*gappy quality*' is essential . . . Shakespeare's plays are incomplete, woven of what's said, and what's unsaid, with holes in between." The reader has to supply answers relevant to his own world, his own time, his own experiences and values.

The Shakespeare in Emma Smith's book "is more questioning and ambiguous, more specific to the historical circumstances of his own time, more unexpectedly relevant to ours." Her description of Shakespeare's plays is in line with those of the school of New Critics headed by I. A. Richards (1893–1979) in describing great poetry being held in "dynamic tension."

What makes Shakespeare's works so powerful, the pervasive open-endedness, is also what makes Beethoven's *Fifth* and *Ninth Symphonies* and Leonardo's *The Last Supper* and his *Mona Lisa* so powerful. Remember Leonard Bernstein's characterization of the music of transformative genius Beethoven in distinction to that of ordinary genius Tchaikovsky. "You don't get tired of listening repeatedly to the same piece by Beethoven, although you become bored after listening repeatedly to the same piece by Tchaikovsky." So too it is with the open-endedness in Leonardo's paintings, each viewer is drawn into his paintings and each takes away a different interpretation. Recall Fletcher, in the category of (musical) transformative geniuses, his ranking included the endlessly controversial protean, polymath Richard Wagner (1813–1883). In a 2020 book Alex Ross, Pulitzer

Prize-winning author and music critic of the *New Yorker* and previously the *New York Times*, examines Wagnerism.[13] In the *Ring Cycle*, Wagner merged Germanic and Norse myths, manipulating them in creating drama of universal themes. "The incomparable thing about myth," Wagner himself had written, ". . . its content, through utmost compression, is inexhaustible for all time." Ross described the process as "The behemoth whispers a different secret in each listener's ear, always true and yet different for each of us." Accordingly, the works possess ". . . [a] near-infinite malleability." That term "malleability" used by Ross in describing Wagner's music is an additional quality to add to Emma Smith's description of Shakespeare's plays and to extend it to all forms of great art. It is what makes her book in resonance with the present book.

But with science, it is precisely the opposite effect one strives to achieve. Gaps, inconsistencies, open-endedness, ambiguities, and malleability have no place. Scientists want to be precise, to make their mathematical derivations consistent, to unify nature's laws. All of nature can be explained by the four fundamental forces of nature—gravitational, electromagnetic, weak nuclear, and strong nuclear forces.

Albert Einstein, in his two anni mirabiles, having rewritten Newton's physics, subsequently spent twenty-five years trying to achieve a grand unification theory (GUT) but failed. Three of the forces were unified during the two decades following Einstein's death by the so-called standard model of elementary particles. But one force—gravitation—has eluded inclusion into the unified whole, a single force that most physicists believe existed at the instant of the Big Bang. Mathematically speaking, the problem lies in unifying quantum mechanics, the physics of the submicroscopic world, and general relativity, the physics of the macroscopic. Superstring theory and its variations seek to bridge this problem with the Theory of Everything (TOE). Great science seeks unity and to eliminate ambiguities, inconsistencies, and gaps. Here a disclaimer is required: although the mathematics underlying the natural world may be rigorous and irrefutable, interpretation of its results and its predictions sometimes can draw sharp disagreements. The uncertainty principle serving as the underpinning of

quantum mechanics requires a probabilistic interpretation, which divided the Old School of physicists from the New School.

Just like the artist–scientists Leonardo and Einstein, the composer with mathematical intuition Beethoven, and the mathematician–physicist Newton, the humanist Shakespeare is also given to experimentation. In this sense, he is a scientist, a psychoanalyst–playwright.[14] For example, in the history–tragedy *Richard II*, which preceded *Julius Caesar*, Shakespeare placed the assassination at the end of the play, with the psychological build-up to the assassination taking place during the body of the play, leaving no time for the consequences of the assassination to unfold. In the tragedy *Hamlet*, which followed shortly after *Julius Caesar*, Shakespeare placed the assassination at the beginning, leaving almost the whole of the story for the consequences to play out. In *Hamlet*, we have the protagonist lying on psychoanalyst Shakespeare's couch for almost the entirety of the play.

But in *Julius Caesar*, the play reaches a crescendo—the political assassination—right in the middle, allowing for the second half of the story to unfold with Caesar's successor Octavius rallying his forces to defeat those of Brutus. Rather than allowing himself to be taken prisoner, Brutus falls on his own sword and commits suicide.

JULIUS CAESAR

The historical backdrop for Shakespeare's political thriller, *Julius Caesar*, is the defeat of Pompey the Great by Julius Caesar in a battle that took place in Pharsalus in central Greece in 48 B.C.E. The decisive battle effectively ended Rome's civil war. Pompey's strategy of starving out Caesar's unmanned army backfired. His reluctance and delay in engaging Caesar led to his ignominious defeat, followed by his flight to Ptolemaic Egypt, and eventual murder at the hands of Ptolemy XIII's men.

In the opening of *Julius Caesar*, Caesar has returned to Rome with his army and the people of the city greet him with adulation approaching worship. Caesar's allies in the Senate plan to shower him with honors and grant him unprecedented power. Others in the Senate fear that too much

power in any leader's hands, especially those of a narcissist, will lead to the abuse of power and ultimately to tyranny. In the latter group, Caius Cassius, harbors nothing but jealousy and disdain for the man, describing him sardonically, ". . . he doth bestride the narrow world / Like a Colossus, and we petty men / Walk under his huge legs and peep about." He masterminds a scheme to assassinate Caesar. But first, he must recruit the highly respected Marcus Brutus, a patriot in everybody's eyes and a close friend of Caesar, to participate in the coup. Along with Brutus, the eight conspirators include Cassius, Casca, and Cinna. All eight must share equally in the assassination of Caesar. Finally, Caesar's loyal friend Mark Antony must also be eliminated as a precautionary step lest he mount a countercoup against the conspirators. Cassius tells Brutus, "Antony and Caesar [must] fall together."

A genuinely noble patriot, Brutus, for the good of the republic, decides to go along with the conspiracy. In a monologue in his orchard, he reasons it is not for what Caesar might have done in the past, but rather, what he is capable of doing in the future. But in wrestling with the idea of committing the deed, he admits, "Since Cassius first did whet me against Caesar/ I have not slept." Emma Smith points out, at this juncture, Shakespeare already has *Hamlet* in his sights. Hamlet will contemplate killing his uncle Claudius—the man who had killed his father, usurped the throne, and married his mother. Hamlet also confesses that his preoccupation with the deed has made him an insomniac. "[It has] murdered sleep," he says.

As for the dual killing Caesar's loyal ally Antony, Brutus will have no talk of it:

> *Our course will seem too bloody, Caius Cassius,*
> *To cut the head off and hack the limbs,*
> *Like wrath and envy afterwards;*
> *For Antony is but a limb of Caesar . . .*
> *For he can do no more than Caesar's arm*
> *When Caesar's head is off.*

Of course, this will turn out to be a fatal mistake for the conspirators. The assassination takes place on the Senate stairs, each man plunging a

dagger into a horrified and puzzled Caesar. With his last gasp, he utters, "Et tu, Brute?"

Immediately, the conspirators continue with their plan, with Brutus, the member with the impeccable reputation, addressing the crowd:

> ... why Brutus rose against Caesar, this is my answer ...
> --Not that I loved Caesar less, but that I loved
> Rome more. Had you rather Caesar were living and
> die all slaves, than that Caesar were dead, to live
> all free men? As Caesar loved me, I weep for him;
> as he was fortunate, I rejoice at it; as he was
> valiant, I honour him: but, as he was ambitious, I
> slew him
> Julius Caesar, act 3, scene 2

As Brutus finishes his speech, a plebeian is heard, "Twere best he [Antony] speak no harm of Brutus here." Another plebeian chimes in, "This Caesar was a tyrant." Another voice still, "Nay, that's certain. We are blest that Rome is rid of him." Finally, another is heard, "Peace! Let us hear what Antony says." The conspirators can rest easy, Brutus has the crowd on their side. Antony, on the condition that he would refrain from blaming them for Caesar's death, is then allowed by the conspirators to also offer a funeral oration. The conspirators are confident that he cannot possibly do any harm to their cause.

Antony addresses the crowd:

> Friends, Romans, countrymen, lend me your ears;
> I come to bury Caesar, not to praise him.
> The evil that men do lives after them;
> The good is oft interred with their bones;
> So let it be with Caesar. The noble Brutus
> Hath told you Caesar was ambitious:
> If it were so, it was a grievous fault ... ,

> *And grievously hath Caesar answer'd it.*
> *Julius Caesar*, act 3, scene 2

Antony's speech begins by justifying the actions of Brutus and the other assassins, "I come to bury Caesar, not to praise him . . ." and initially puts the conspirators at ease. During the course of his speech, he repeats the line "Brutus is an honorable man" five times, while successively changing the tone of his message and invoking rhetoric and reminders of Caesar's loyalty and affection for the Romans. He flashes a prop, a scroll: ". . . here's a parchment with the seal of Caesar; I found it in his close,—'tis his will," Antony claims. Then he pauses, speaking of his reticence to read on. The pause in the speech is just long enough for the mood of the crowd to change from one of approval of Caesar's killing to one of disgust having been robbed of a loving benefactor and hero. Voices are heard demanding for Antony to continue: "We'll hear the will: read it, Mark Antony," "The will, the will! We will hear Caesar's will." Antony continues, portraying Caesar's generosity and his love for the people. The crowd becomes enraged by the deed of the conspirators. Caesar is back, elevated to godlike stature, and by then it is too late for the conspirators. Antony has a bloodthirsty mob in his spell, ready to turn on the assassins. In one of the greatest speeches in literature, Shakespeare reveals his understanding of both politics and psychology, what modern political psychiatrist Jerrold Post terms "dangerous charisma."[15]

The playwright introduces an entirely peripheral character, Cinna the poet, partly as light relief and partly to demonstrate the mindlessness of a crowd in frenzy. On his way to attend Caesar's funeral, Cinna—in fact a supporter of Caesar—encounters four plebeians who want to know his name. He responds innocently, "Cinna." The mob could not care less that the man is not the conspirator Cinna. It is enough that he is the namesake of the conspirator Cinna.

> CITIZEN: *"Tear him to pieces; he is a conspirator."*
> CINNA: *"I am Cinna the poet, I am Cinna the poet."*
> CITIZEN: *"Tear him for his bad verses, tear him for his bad verses."*
> CINNA: *"I am not Cinna the conspirator."*

CITIZEN: *"It is no matter, his name's Cinna; pluck but his name out of his heart and turn him going."*

ENRICHING THE ENGLISH LANGUAGE

Familiar Shakespeare lines include "To be, or not to be." "Methinks the lady doth protest too much." "All the world's a stage, and all the men and women merely players." "It was Greek to me." "All that glitters is not gold." "Don't kill the messenger." "I'll not budge an inch." "Wear my heart upon my sleeve." "Knock knock! Who's there?" "Frailty thy name is woman." "Woe is me!" "Conscience does make cowards of us all." "You can have too much of a good thing." "In my heart of hearts." "Devil incarnate." "Wild-goose chase." "Seen better days." "The milk of human kindness." "The finger of scorn." "The world is your oyster." "Top to toe." "What's past is prologue."

There are also the familiar images, metaphors, and well-known phrases we bandy about four hundred years after his death, rarely questioning their origins, but are never surprised when we find out that they are from Shakespeare. He also invented at least 1,700 common words.[16] However, recent scholarship using modern plagiarism software commonly applied by professors to students' papers has revealed that a number of other familiar "Shakespearean" words, including "hint," "critic," "swagger," "gossip," "grovel," "quarrelsome," and "sanctimonious," and familiar phrases, such as "now is the winter of our discontent," "a heart of gold," "bated breath," and "one fell swoop," were all borrowed by Shakespeare. Modern computer analysis has also dashed the claim that Shakespeare's vocabulary was massive, many times that of his contemporary writers. In reality, his word usage is at the median of a dozen or so of his peers. The common prefix "un" (e.g., unlikely) converting words to their antonyms is Shakespeare's invention. George Peele and Shakespeare's vitriolic detractor Robert Greene invoked broader vocabularies than the Bard. It is not that he used more words—he used just the right words. Rachel King explains the phenomenon: "The myth of [Shakespeare's] linguistic innovation has become part and parcel of his legendary status."

The characters he gave us in his plays—Hamlet, Mark Antony, Lady Macbeth, King Lear, Othello, Iago, Romeo, Juliet, and ... ah, Falstaff—have all become more real to us than many of the historic individuals on whom they are based. Who cares about the actual expressions in English, Latin, Italian, Greek, or Danish the protagonists might have uttered, or whether the characters even existed! The playwright spoke for them all in English. But his works are translated from the original into more than one hundred foreign languages, including the constructed language of *Star Trek*'s Klingon Empire. *Hamlet* and *Much Ado about Nothing* have both been translated as part of the Klingon Shakespeare Restoration Project by the Klingon Language Institute. It appears that Shakespeare is not just global. He is galactic; he is universal!

Harold Bloom, eminent literary critic, in a sharply focused monograph, *Falstaff: Give Me Life*,[17] captures the foundation of Shakespeare's immortality in his description of the playwright's ability to delineate the complexity of the entire range of human character:

> Literary character is always an invention and indebted to prior inventions. Shakespeare invented literary character as we know it. He reformed our expectations for the verbal imitation of personality and the reformation appears to be permanent and uncannily inevitable. The Bible and Homer powerfully render personages yet their characters are mostly unchanging. They age and die within their stories but their modes of being do not develop ... Shakespeare's personalities do ... [they] have little in common with [even] those of Ben Jonson or Christopher Marlowe.

A LIFETIME OF EXACTLY FIFTY-TWO YEARS

We have none of Shakespeare's original writings, not a single play or sonnet in his own hand. Speculation is rife about every aspect of Shakespeare's story. Parish churches in England have always kept dependable records on birth, marriage, baptism, and death, but little else about their parishioners.

For Shakespeare, we have the record of his baptism, his marriage certificate at eighteen, and the baptismal registries for his three children. We have just 147 lines of text in his own hand—part of a transcription of a play, though not one of his own. There are also four separate signatures on legal documents. And we have his epitaph inscribed on his funeral monument at Holy Trinity Church in Stratford-upon-Avon, on which the date of his death is cited as April 23, 1616, his fifty-second birthday.

> GOOD FRIEND, FOR JESUS' SAKE FORBEARE,
> TO DIGG THE DUST ENCLOSED HEARE;
> BLESTE BE THE MAN THAT SPARES THESE STONES,
> AND CURST BE HE THAT MOVES MY BONES.

William Shakespeare lived a life of only fifty-two years. He was born in Stratford-upon-Avon in the County of Warwickshire in the English Midlands, about eighty miles northwest of London. His parents were the well-to-do glovemaker and wool merchant John Shakespeare and his wife Mary Arden. In a day when one third of all children born died in the first year of life, he was the third of eight children born to the couple, but the first to survive childhood. His family was of the "old faith," Catholicism, revealed in the peculiar wording of his maternal grandfather's last will and testament. We have a firm date, not for Shakespeare's birth, but for his baptism in the parish registry of Holy Trinity Church in Stratford, as April 26, 1564. The exact date of his birth is unknown, but, at the time, baptism usually followed the birth by no more than a day or two. It is convention, inspired possibly by his countrymen's associating their greatest writer with the nation's patron saint, that gives us his birthdate as St. George's Day, April 23, rather than the 22nd, 24th, or 25th.

Given his 1564 birth, Shakespeare would have matriculated in grammar school in 1571 along with other seven-year-old boys of his day. And his school in Stratford-upon-Avon would have been King's New School, also known as King Henry VI School. His teacher might have been a recent graduate of Oxford, or a nonuniversity graduate who had impressed the local authorities

with his general erudition. In the beginning, Shakespeare would have learned proper manners, spelling, grammar, and Protestant godliness. Then he would have been introduced to arithmetic, to English literature, and eventually to Latin. The curriculum would have called for a ten- or eleven-hour day in the classroom, six days a week, the preponderance of the work calling for memorization. Since the Elizabethans were fond of both literature and plays, it would probably have been at this stage that he would have first participated in acting. Then at fourteen, boys of noble birth generally and those at or above Shakespeare's social station would have had the option to continue their studies at a university, preferably at Oxford, forty miles south of Stratford, or at Cambridge, eighty miles to the east. But no evidence exists of Shakespeare receiving any formal education beyond grammar school.

When Shakespeare was around fourteen years old and already infected by a love of literature, he was taken out of school. The senior Shakespeare, who had by then gained prominence in the town's social, political, and religious life as an elected member of the municipal council, an alderman, suddenly saw a reversal in his fortunes, gradually withdrawing from public life.

Very little is known about Shakespeare's life during two specific periods, his first and second "lost years." The first of these would be the four years between the completion of grammar school at age fourteen (in 1578) and his marriage to Anne Hathaway in 1582.

Among church records that have survived is the marriage license dated November 28, 1582, issued to William Shakespeare and Anne Hathaway by the bishop of Worcester. Shakespeare is just eighteen, and his bride, somewhat long in the tooth for a teenage husband, is twenty-six. The wedding is held at Temple Gafton, with vicar John Frith presiding. Also in the church record is the baptismal registry for Shakespeare's first child, Susanna, dated May 26, 1583, just six months after the couple married. Two years later in 1585, when Shakespeare is twenty-one, there are two baptismal registries for the births of fraternal twins, daughter Judith and son Hamnet. The boy is named after Hamnet Sadler, a childhood

friend of Shakespeare, and the Sadlers reciprocated by naming their son William.

INFLUENCE AND INSPIRATION

The seven-year span between 1585, when Shakespeare, newly married, was living on Henley Street in Stratford-upon-Avon, and 1592, when he was employed as an actor/writer in London, represents "the second lost years" of his life. There is much speculation about what he might have been doing during this period. According to one account, he was employed as a teacher in a grammar school in Lancaster, 200 miles north of Stratford, another that he was studying law. His plays and poetry are filled with legal imagery and metaphors demonstrating a deep familiarity with the law and lawyers. He is a polymath, like the other great geniuses. There is a speculation about his serving in the army, another about his traveling abroad, possibly even in Italy, site of so many of his plays. But like so much else about him, none of these guesses have ever been confirmed.

There was the timely release of the second edition of Raphael Holinshed's *Chronicles of England, Scotland and Ireland* (1587), a collaborative work crucial for providing Shakespeare with the ideas for his future history plays. Following a decade of gestation and a demonstration of a passion for English history and for retelling it, his creative powers were brimming. He was deeply influenced by two writers—one ancient, the other his contemporary. The first was one of his lifelong literary heroes, the Roman poet Ovid (43 B.C.E.–17 C.E.), who created works rich in wordplay, paradox, and a preoccupation with sexuality. The other was Christopher Marlowe (1564–1593), a contemporary playwright whose works prefigured many of the literary devices and themes that Shakespeare would bring to the stage.

An auspicious development in the summer of 1587 was the visit to Stratford of the touring stage company, Queen Elizabeth's Men. Shakespeare accompanied them on the road, accepting a job that he relished and with which he

could support his family. The troupe performed in Oxford in the courtyard of the Golden Cross Inn, in Gloucester at the New Inn, in a number of other nearby towns in the Midlands, as well as farther north in Lancaster. Although he relished performing, it is at this time that he began to write parts of plays. His name, however, would not appear on playbills for another few years.

Shakespeare revealed insecurities about his lack of a university education compared with his contemporary playwrights. In a pensive mood he wrote, "O, this learning, what a thing it is!"[18] This is reminiscent of Leonardo, who had regarded his lack of formal education, especially his inability to read classical texts in Latin, as a shortcoming. At this point, Shakespeare even conceded Marlowe's superiority:

> *O, how I faint when I of you do write,*
> *Knowing a better spirit doth use your name,*
> *And in the praise thereof spends all his might,*
> *To make me tongue-tied speaking of your fame!*[19]

Although neither the exact dates nor the order of events is certain, sometime between 1590 and 1592, Shakespeare relocated to London as an actor and playwright and completed the three parts of *Henry VI* and the early comedies: *The Comedy of Errors* (1593–1594), *Love's Labour's Lost* (mid-1590s), *All's Well That Ends Well* (1598), and *As You Like It* (1599). It is also at this time that he first came into the circle of the hottest playwright plying his trade in London and one who will influence Shakespeare in his art as a playwright.

THE MOZART MODEL OF CREATIVITY

If one were to characterize the Bard's creative process in the manner that Aaron Copland had identified for composers, Shakespeare would fit into the scheme of both the Bach–Palestrina Model and the Schubert Model. He is creating the very best work in an existing genre in the manner of the former model, but he is doing it at a gusher-like frenzied pace in the

manner of the Schubert Model. He is writing in final form in ink and rarely blotting (here we have the word of his contemporary, Ben Jonson). In the last chapter, we had labeled such a hybrid scheme the Mozart Model. But Shakespeare's modus operandi possesses commonality also with that of Beethoven, as he writes one play, he contemplates another along with a sonnet or two simultaneously.

Canterbury-born Marlowe, the same age as Shakespeare, had moved to London upon completing his studies at Cambridge in 1587. While a university student, however, he had been recruited as a spy by the Privy Council (the government), first as an agent in France for two years and subsequently to serve in England to keep a watch out for suspected Catholics seen as anti-Protestants and anti-government groups. Although rather murky, it is believed that Marlowe continued the practice of spying even after his university days. Or was he in reality a double agent, but perhaps engaged in a ruse to entrap outspoken anti-Protestants? As a spy, one would have expected him to keep a low profile, but he was as brazen as the larger-than-life characters he introduced in his plays.

Marlowe was the classic antiestablishmentarian, reveling in challenging order—religious, social, and literary. He was given to lobbing heretical grenades with reckless abandon in shaking up the authorities. Already suspected of being an atheist, he exhorted, "Christ was a (homosexual) lover of John the Baptist," "Protestants are hypocritical asses!" "Mary was a whore!" and "Jesus was a bastard!" In a time when blasphemy could have sent a man to prison, and treason to the gallows, this enfant terrible of Elizabethan literature was engaged in both. He demonstrated a self-destructive recklessness that must have left his handlers aghast. Before he could be arrested and brought to justice, however, he was killed in a bar brawl in May 1593, when he was just twenty-nine years old. The circumstances were mysterious, and the suspect was hastily cleared.

Marlowe's plays with their overreaching protagonists, daring plots, and style of blank verse influenced Shakespeare, who would adopt many of Marlowe's tools in his own plays. By the time of his death on

May 28, 1593, Marlowe had been a writer in London for only six years, but had produced half a dozen plays, including *Tamburlaine [Tamerlane], Parts I and II*; *Dido, Queen of Carthage*; *Dr. Faustus;* and *The Jew of Malta.* These works, especially the last four, are of such innovative originality that in the twenty-first century, Marlowe is still recognized among the ten greatest English playwrights, an honor he would have deserved if for no other reason than for influencing Shakespeare. In the 2016 *New Oxford Shakespeare* edition, Christopher Marlowe is credited as a co-author of Shakespeare's *Henry VI* plays, *Parts I, II, and III.* Computer analysis suggests Marlowe wrote *Part I*, the authorship of *Part II* is not clear, but Shakespeare wrote *Part III*.[20]

A burgeoning friendship with Henry Wriothesley, 3rd Earl of Southampton (1573–1624), also provided inspiration especially for Shakespeare's sonnets. Southampton at age nineteen was nine years Shakespeare's junior. He was a man of vast wealth, a descendant of a long Catholic tradition, and a man who aspired to serve as a patron for promising writers. He was also fashionable in demeanor, flirtatious, and openly bisexual. In Shakespeare, Southampton found a writer of incalculable talent, a married man, a father of three, and a writer in need of patronage. It seems Shakespeare was also perhaps ready to resolve his own sexual ambiguity. Neither the difference in age, nor the disparity in their social stations, appears to have hindered their mutual attraction.

During the following four years, Shakespeare wrote *The Taming of the Shrew* (1590–1592), *Richard III* (1591), and *Love's Labour's Lost* (mid-1590s). He composed the narrative poems *Venus and Adonis* (1593) and *The Rape of Lucrece* (1594), all dedicated to the Earl of Southampton. In 1593, when a bubonic plague outbreak in London caused playhouses to close, Shakespeare concentrated on writing plays and poetry at a frenzied pace. This burst of creativity will be echoed by one that Newton experienced during an outbreak of the plague in 1665–1666. With an advance of £100 from Southampton, in 1594 Shakespeare purchased a share in the acting troupe the Lord Chamberlain's Men. When the plague had abated sufficiently, London theaters reopened to the public, and gradually the company gained

popularity in London, even receiving the ultimate honor of invitations to perform at the court of Queen Elizabeth I.

By 1596, Shakespeare was thirty-one years old. In the last five or six years, he had composed eleven plays approximately half of them in the popular genre of chronicle plays. For the first time, in the productions of *Richard II* and in *Romeo and Juliet*, his name appeared on the title page as an author.

Shakespeare's supremacy among all writers stems from his plays. Through the years television game shows hosts have asked, "How many plays did Shakespeare write?" The acceptable number would be thirty-seven. However, where clarification is allowed, Shakespeare's name is associated with forty plays. Two of the forty bear recognizable imprints of John Heminges and Henry Condell, Shakespeare's friends and members of his company. By convention, they are left out of the total count. Another play written by Shakespeare personally was lost, with the prospects of its recovery rated as "hopeless," making the final tally thirty-seven.

In the last two chapters, an important theme has emerged: great music and great literature are both open-ended. Shakespeare's drama evinces the same abstract quality that made Beethoven's *Fifth Symphony* universal, timeless, and entirely fresh in each age.

THE SONNETS

Shakespeare composed 154 sonnets, each in conventional English sonnet form of fourteen lines—consisting of three quatrains, ending with a couplet. The preponderance of the sonnets was composed between 1592–1595 (but some as late as 1598), all resonating in power and beauty, and all deserving to be read, and reread. They confront timeless human issues—themes of mortality, the impermanence of all human creations, the nature of love and friendship, the magnificence of the universe, and the enigmatic mystery of art in lyric language of exquisite beauty. The poetic device of iambic pentameter, "daDUM-daDUM," in resonance with the human heartbeat, switches to the reverse—trochaic pentameter, "DUMda-DUMda," when needed. As

a device that enhances the drama; e.g., in *Macbeth*, the ghoulish quality of the witches' voices is accentuated. This is a device also seen in the sonnets.

If the sonnets are to be regarded as a vehicle for autobiographical conjecture, as instruments for the telling of Shakespeare's own story, as many critics have suggested since the nineteenth century, then it is in the sonnets that his ambiguous sexuality—not an uncommon trait of creative genius—reveals itself.

> *If I could write the beauty of your eyes,*
> *And in fresh numbers number all your graces,*
> *The age to come would say, "This poet lies;*
> *Such heavenly touches ne'er touched earthly faces"*[21]

When he was addressing his "beloved," as he did in his "Sonnet 17," no other poet could have expressed himself more romantically. During the decade of the 1590s, Shakespeare engaged in a stealthy relationship with his benefactor Wriothesley (Southampton). Was the "fair youth" who bewitched him the Earl of Southampton? How about the dark lady in the latter sonnets?

Artistic Rebirth 1
The Middle Period (1595–1601) and the Annus Mirabilis

Contemporary critic Francis Meres writes a gushing review of Shakespeare's work. By 1601 Shakespeare is thirty-seven years old, and he has composed eleven plays in the last six years, twenty-two plays since 1591, many of them genuine masterpieces: *Julius Caesar*, set in Italy (1599–1600); *As You Like It*, set in Arden Forest, Flanders (1599–1600); *Twelfth Night*, set in Italy (1599–1600); and *Hamlet*, set in Denmark (1600–1601).

For Shakespeare, a number of unsettling events ushered in the seventeenth century. In 1601, his father, John Shakespeare, died in Stratford. One of many theories among scholars is that his father's death motivated Shakespeare to write *Hamlet*, perhaps most renowned of all his plays and the longest of all his tragedies. This and other of Shakespeare's plays over

the next few years take on a dark, brooding tone. The same year his friend and patron, Southampton, is sentenced to death for his role in the Essex Rebellion. This is only a minor rebellion—ill-conceived and badly planned by Robert Devereux, 2nd Earl of Essex. Just two years earlier Devereux had been ordered by the queen to sail to Ireland with troops and to put down a rebellion against English rule. But Devereux, after a series of inconclusive battles against the Irish, returns without having crushed the rebels. In fact, by agreeing to a treaty merely to appease them, he infuriates the queen. She accuses Devereux of gross incompetence and strips him of his aristocratic rights and future income. Embittered, Essex conspires against the queen. Southampton, although a Catholic and never an ardent fan of the Protestant queen Elizabeth, is drawn into the plot. He allows the plotters to meet in his home. Initially condemned to death along with the others and incarcerated in the Tower of London, Southampton is given a reprieve, while the others are executed. Contemplating death and suicide, the protagonist in *Hamlet* delivers the most famous soliloquy in all of literature, "To be, or not to be . . ." The shattering personal experiences in Shakespeare's life echoed in Hamlet's lines are the spark in the playwright's burst of creativity. Two centuries later it would be Beethoven's looming deafness echoed in his Heiligenstadt Testament that would serve as the spark in Beethoven's burst of creativity.

Artistic Rebirth 2
The Late Period (1601–1613)

We saw in chapter 3, "Zeitgeist Factor," that after Queen Elizabeth's death in 1603, James VI of Scotland was brought to London and crowned King James I of England (albeit still retaining the crown of the king of Scotland). In ushering in the Jacobean Age, James, just a year after his coronation, ordered a new translation of the Bible. Forty-seven translators, all members of the Church of England and all clergymen, were employed, mostly to translate the Old Testament from the oldest (Byzantine) Greek version of the Bible. Although it was not completed until 1611, the book became the

celebrated King James Version of the Bible, KJV. This product of a massive group effort is regarded as first-class literature: authoritative, dignified, and brimming with a majesty of style. Of course, the KJV reflected both England's and James's passion for Christianity and for good literature, and became King James I's greatest legacy.

James, however, also knew the darkness of the soul. He believed with head, heart, and soul in the existence of dark forces pervading the world. It was the devil and his agents causing all the miseries of the world—from famines to pestilence, from wars to plagues, from fires to floods. Witchcraft was altogether real for him, and it is believed that he personally witnessed the public burnings of thousands of witches. A sobering passage from mathematician Morris Kline's book, *Mathematics in Western Culture*, puts James's worldview into perspective.

> A seventeenth-century poll to select "the most influential man" of that age would surely have been won by the devil. According to the science of demonology developed and preached by the theologians the devil and his assistant evil spirits caused wars, famines, plagues, and storms. They amused themselves by frightening children and keeping churned cream from turning into butter. Also aiding the devil in his work were witches, "anointed" human beings who derived their powers from him. Witches could infect people, transform themselves into wolves and devour their neighbor's cattle, and even have carnal relations with the devil himself. In idle moments they rode broomsticks up and down chimneys or through the air.[22]

It was fortunate for the theater industry that the king was still an ardent supporter of the stage. During the twelve-month period spanning November 1604 to November 1605, James attended eleven performances of Shakespeare's troupe. The troupe, born as the Queen's Men and subsequently renamed the Lord Chamberlain's Men, was renamed again the King's Men.

Interpreters of Shakespeare: The Actors and Directors

The skills of a first-rate thespian include sharply honed acting skills, clear enunciation, robust projection, versatility, pride, presence, confidence, commitment, memory, and mastery of expressive hand and facial gestures. They also call for insight into human behavior, echoing American actor Harrison Ford's remark in a 2023 CBS interview, "The natural instinct of an actor is to be interested in human behavior [. . . to be a people watcher]." For an actor to have worked in the Royal Shakespeare Company, or to be described as a "Shakespearean actor," immediately conjures thoughts of an ordination into the highest professional guild of all. Seasoned Shakespearean actors have all acted in assigned parts, from the heroic to the villainous, and demonstrated how believable they were in expressing emotions, from boundless joy to excruciating pain. In their personal lives they have shown their own stages of maturation, the weathering with time, and human strengths and frailties paralleling Shakespeare's own characters, in a manner of *life imitating the stage.*

AGING SHAKESPEAREAN ACTORS

An important attribute for actors is a good memory. But what happens when that memory begins to fail? A poignant and funny story I heard in Oxford was of a famous aging Shakespearean actor who, around 1950, is shopping in a store in Knightsbridge, the fashionable shopping district in central London. As he gazes down at the end of an aisle, he half recognizes an elegantly dressed woman, but cannot quite place her: "Is she a celebrity, an actress, an aristocrat?" He sees that she has a few other individuals accompanying her. He decides he must avoid her, lest he can't remember her name in time. Alas, as he meanders through the aisles trying to get to a door, he suddenly finds himself face-to-face with her . . . To make matters worse, she recognizes him! He engages her in light banter, hoping to ascertain her identity. "Hello, how are you? By the way, has your husband retired yet, or is he still working?" he asks. Startled, the woman responds, "No, no, he's still the king!"

Shakespeare and Austen: A Shared Relevance in the Twenty-first century

While Shakespeare is unique in the power, timelessness, and universality of the human psychology portrayed in his plays and sonnets, two other English writers, Geoffrey Chaucer (1343–1400), writing two centuries earlier, and Jane Austen (1775–1817), writing two centuries later, were also titans of undeniable genius, leaving behind immortal literary legacies rife with psychology. Chaucer lived before the last half millennium covered in this book. Accordingly, he lies outside this book's purview, but Austen is fair game for discussion.

Literary critics since the mid-nineteenth century have been building bridges between novelist Austen and dramatist Shakespeare. In a number of articles and books, contemporary Australian scholar John Wiltshire[23] offers an inventory of critics who have written about Shakespeare's influence and inspiration on Austen. Distilled from his lists are the following: (1) In 1843, Lord Macaulay described Jane Austen as "a prose Shakespeare . . . among the writers who have approached nearest the manner of the great master"; (2) Walter Scott described her as "possessing 'Shakespearean' qualities of 'tenderness and passion,' and marvelous 'dramatic power'"; (3) Alfred Lord Tennyson made the assessment, "Next to Shakespeare in her realism and the life-likeness of her characters," a message echoed by Rudyard Kipling; (4) Shakespearean scholar Richard Simpson in 1870 added "[Austen's] relation to Shakespeare was not one of resemblance merely but of influence"; (5) in 1911, A. C. Bradley wrote about Austen, "surpassing excellence with that comparatively narrow sphere whose limits she never tried to overpass . . . which gives her in that sphere the position held by Shakespeare in his"; and (6) in the mid-twentieth century, British author and journalist Claire Tomalin compared *Mansfield Park* with *The Merchant of Venice*, suggesting "Shakespeare's plays and Austen's novels are both so alive and flexible as works of art that they can be interpreted now one way, now another." Here precisely is that open-endedness, a dialogue rich in ambiguities, and mastery of the language that Emma Smith attributed to Shakespeare, that also elevates Austen to a similar timelessness in literature.

Few other writers in English lure the reader to read between the lines, capable of interpretation in diametrically opposite ways. In the bicentennial year of Austen's death (2017), Nicholas Dames of Columbia University wrote an article titled "Jane Austen is Everything" in the *Atlantic Monthly*:[24]

> The hazel-eyed woman in the mobcap is not just an iconic figure but a symbol of Literature itself. As Austen's own Emma Woodhouse put it to her querulous father, "One half of the world cannot understand the pleasures of the other."

Dames asks,

> Is Austen the purveyor of comforting fantasies of gentility and propriety, the nostalgist's favorite? Or is she the female rebel, the mocking modern spirit, the writer whose wit skewers any misguided or—usually male—pompous way of reading her . . . Do we read Austen to flee modernity, or to see it clearly?

Recently, Emma Smith gave a lecture to a group of Oxford students comprised of two disparate groups: British literature students and business students. Her lecture entitled "Building the Shakespeare Brand—Marketing the Theater in the Elizabethan Period" demonstrates Shakespeare's unexpected relevance to modern business models.[25] Similarly, Mihir Desai, professor in the MBA program of Harvard, in a recent book, *The Wisdom of Finance: Discovering Humanity in the World of Risk and Return*,[26] offered a novel approach to risk-taking in investment and entrepreneurship: "What Jane Austen can teach us about risk management."

Austen had a decent finishing-school training by the standards of young women of her time, and like Shakespeare, she was basically an autodidact, lacking higher formal study. Austen was a wholesome young woman, a product of her times, with the common interests of other young upper-middle-class women—love, marriage, pride, financial security, family

reputation, and happiness. Her novels are morality tales infused with humor, in the genre of comedy of manners.

Austen detractors might say that she painted fancy fairy tales, variations on her own sheltered provincial world, insulated from reality, that there is nothing about the Industrial Revolution beginning to sprout in England at the time, nothing about England being locked in the Napoleonic Wars between 1800 and 1815, and nothing about those wars shaking up the European continent. There is also nothing about the American Revolution in which the British colonies broke off from England and nothing about the French Revolution. Austen was well aware that she was not worldly:

> *I think I may boast myself to be, with all possible vanity, the most unlearned and uninformed female who ever dared to be an authoress.*
> —Jane Austen, in a letter to Rev. James Clarke, 1815

But what she knew, she knew well, and expressed it with uncommon mastery of the English language. She was not a novelist superior to the Brontë sisters, Victor Hugo, or Tolstoy. But she preceded the other great nineteenth-century writers by at least thirty years and wrote half a dozen consistently great novels. Her centrality is well established.

Austen's Oxford-educated father cherished his rich library and successfully infected his children with a love of learning. In Jane, his seventh child, he recognized early a passion not only for reading, but also for writing. He gave her a mahogany lap desk on her nineteenth birthday that effectively became her portable office. As she relocated with her family to the Georgian city of Bath for five years, and following her father's death, took up residence with her mother and sister in London, Clifton, Southampton, and, finally, Chawton, the portable office always accompanied her. In fact, she composed all six of her novels on that lap desk—four of them published in her lifetime and two posthumously. The six novels, in chronological order of their publication, were *Sense and Sensibility* (1811), *Pride and Prejudice* (1813), *Mansfield Park* (1814), *Emma* (1815), and, appearing a year after her death, *Northanger Abbey,* and *Persuasion* (1818).

In a brief lifetime of forty-one years, she saw her first book published when she was thirty-six and her fourth when she was thirty-nine. The four novels released while she was alive listed the author cryptically as "a Lady," not to generate mystery, but because she guarded her privacy religiously. Sir Walter Scott, critiquing *Emma* in the *Quarterly Review* for March 1816, hailed her as "this nameless author, a masterful exponent of the modern novel."[27]

After her death,[28] her remains were interred in Winchester Cathedral. Three of her brothers and her nephew were the only mourners present at the funeral. The epitaph, delivered by her eldest brother James Austen (1765–1819) read, "The benevolence of her heart, the sweetness of her temper and the extraordinary endowments of her mind obtained the regard of all who knew her, and the love of her intimate connections."

In the posthumous edition of *Northanger Abbey*, Austen's brother Henry, serving as her agent, revealed to the literary world that it had been his sister Jane who had written the collection of novels.[29] He described Jane's books as having "sprung into life fully formed—painlessly, effortlessly." This is exactly as Mozart's music has always been described. In fact, like Mozart, Austen was exceptionally precocious, having mastered the structure of the novel by age eleven. Henry characterized Jane's compositions as "rapid and correct," a flow of words that "cost her nothing," appearing as easily as everything she wrote appeared—"finished from her pen." We are to imagine no labor, no dedication, no ambition, no intellect or skill, but simply "a gift," "a genius," "an intuitive power of invention." The British word "swot," describing a student who has to work assiduously in order to excel, has negative connotations. It is much better to excel without any effort. This may have been the reason for Henry Austen's choice of words: she was no swot! Fifty-two years after her death, her nephew James, who had been present at her funeral service, published the first biography of this extraordinary woman who had lived in the realm of her imagination, and otherwise lived a distinctly unremarkable life.

Following the release of her two posthumous novels, interest in her works temporarily declined. But the hiatus was short-lived. By 1833 interest had

picked up again, especially in the form of complete collections of a tidy half-dozen novels. Her books have never been out of print since. How ironic it is that as one of the supreme purveyors of romantic love in the Romantic era, Austen never walked down the aisle herself, nor saw her name on any of her novels.

Since Jane Austen's death, a cult-like cadre of readers, while claiming to love all six novels, have been engaged in ranking them, and sometimes changing the order as their own lives and experiences progressed. The exercise is not unlike ranking Shakespeare's plays or Beethoven's symphonies. A frequently repeated refrain in this book is that rankings are driven by our moods and sensibilities, our own petite bourgeois prejudices, and even our stage of life. In the age of cinemas, theater, and social media, new and different adaptations, prequels, sequels, and blogs have offered new adaptations of Austen's plots ranging from the incisive to the absurd.

SATIRE IN SHAKESPEARE AND AUSTEN

Satire, as a literary device, is not meant to make others laugh at people or ideas, as much as to warn readers subtly about prevailing corruption, about tolerance of intellectual dishonesty, etc. It may even focus on vices threatening civilization or offer noble solutions for the betterment of humanity. In *King Lear*, Shakespeare introduced the satirical character Fool, a buffoon who could speak out without fear of punishment. He had the gall to invoke the proverb "the empty vessel makes the loudest sound," presumably with His Majesty in mind. Shakespeare invoked the same proverb again in *Henry V*.

"Call me Ishmael" in *Moby Dick* (1851) and "It was the best of times, it was the worst of times" in *Tale of Two Cities* (1859)[30] are the two most familiar opening lines in all of literature. Almost as familiar are those from *Pride and Prejudice*: "It is a truth universally acknowledged, that a single man in possession of a good fortune, must be in want of a wife." The expression "in want of" variously means "lacking" or "needing." For satirist Austen, as far as young gentlewomen were concerned, it was open season

for any single man of wealth. But it is a sardonic and mocking message. In her novel, Austen introduced Mrs. Bennet and Mr. Collins as satirical characters. In poking fun at them, she was out to discredit the social customs and the archaic property inheritance laws of her day, patently unfair to women. She used Mrs. Bennet to mock the preposterous need to keep up appearances, social climbing, and matchmaking for money rather than love. But Mrs. Bennet possesses the redeeming qualities of devotion and caring for her children. The ridiculous clergyman Mr. Collins is the least deserving to inherit the Bennet family's property.

As a woman of her time, Austen had lost her love, Tom Lefroy, when his family perceived the Austen's as being financially deficient. A few years later, she rejected the proposal from Harris Bigg-Wither, even knowing that time was running out for her to find a husband. Or possibly she believed spinsterhood would give her greater opportunity to write. Her satires are gentle, subtle, but powerful protests against the prevailing laws and norms of a male-dominated society.

THE TWO GEORGES

Jane Austen was singled out as the writer who gave the English novel its modern character. She was extraordinarily gifted but kept her gender close to the vest, lest her works be ignored. Other exceptionally talented women writers contended with discrimination against women in other ways. The genre Austen introduced was embraced and expanded by novelist-poet sisters Charlotte Brontë (1816–1855), Emily Brontë (1818–1848), and Anne Brontë (1820–1849).[31] In the Brontë sisters' novels, humor was kept in check, but the originality, realism, and psychological insight were not. Initially the sisters published their works using the pen names Currer, Ellis, and Acton Bell, respectively. After their novels *Jane Eyre*, *Wuthering Heights*, and *Agnes Grey* saw early success, the sisters began to publish using their own names, as other female writers in the Victorian era were beginning to do.

Another great author, Mary Anne Evans (1819–1880), born just two years after Austen died, sought to avoid the stereotype of women writing lighthearted romances. Her writings comprised a pair of contrary components: fiction and nonfiction, drawing mainly on contrary hemispheres of the brain. For the nonfiction component, she used her own name, while working as an editor, literary critic, translator, and journalist, and earning a solid reputation. Describing her diverse interests, she penned the words, "I take walks, play on the piano, read Voltaire, talk to my friends, and just take a dose of mathematics every day." Rather than being seen as spreading herself thin, however, this remarkable polymath decided to have the fiction and nonfiction components judged separately.

For fiction, she wrote novels and poetry under the male pen name George Eliot, gaining recognition as one of the finest practitioners of the age. Although she lived twenty years longer than Austen, she wrote just one more novel. Set in rural England, the novels in chronological order of their release are *Adam Bede* (1859), *The Mill on Floss* (1860), *Silas Marner* (1861), *Romola* (1862–1863), *Felix Holt, the Radical* (1866), *Middlemarch* (1871–1872), and *Daniel Deronda* (1876). By critical acclaim, *Middlemarch* is Eliot's masterpiece and one of the greatest of all Victorian fiction novels. It describes the intersections of intricately conjured stories in a fictitious town in the English Midlands during the years 1829–1832.

Amantine Lucile Aurore Dupin (1804–1876) was an immensely talented and highly colorful French novelist. She exhibited the same brilliance and creativity as her contemporary male novelists Victor Hugo (1802–1885) and Honoré de Balzac (1799–1850). In her time, her social-minded, feminist writings were sought even more than those of Hugo and Balzac. With full confidence in her talent, the blue-eyed beauty felt the drive to behave outside prevailing social norms. She dressed like a man, puffed on a cigar like a man, and adopted the pen name of a man: George Sand. Among Romantic era women writers, whether she was any more liberated sexually than any of her counterparts is not as important as the fact that she was the only one liberated enough to act on it! This is especially true in comparison with the tight-laced Brontë sisters. Victor Hugo wrote of her,

"George Sand cannot determine whether she is male or female. I entertain high regard for all my colleagues, but it is not my place to decide whether she is my sister or my brother." Russian novelist Ivan Sergeyevich Turgenev (1818–1883), in eulogizing Sand, declared: "What a brave man she was, and what a good woman."

6
LEONARDO'S MODEL

Principles for the Development of a Complete Mind: Study the science of art. Study the art of science. Develop your senses. Especially learn how to see. Realize that everything connects to everything else.
—Leonardo da Vinci

The expression "Jack of all trades, master of none" is a derisive proverb describing the notion of spreading oneself too thin. It has equivalent expressions in most world cultures. A Chinese version reads, "Armed with ten knives, yet none of them sharp." And an Estonian version admonishes, "Nine trades, the tenth hunger." A rare version that has only positive connotations is the Turkish expression "On parmağında on marifet" (Ten skills on ten fingers), suggesting praise for individuals with a diversity of interests. As for the original English version, a pearl of different wisdom prevails in the expression's sequel: "Jack of all trades, master of none . . . but often better than a master of one!" Indeed, cross-fertilization of diverse fields can bear the most bountiful of fruits.

In the currently prevailing model of technological development, engineers and innovators specialize in one field or another. Rather than being

dismissive about spreading ourselves thin, we should embrace the opportunity to be as expansive as possible. In direct contradiction of the prevailing model, the most successful innovators through the ages have been polymaths who benefited from cross-semination of fields. Phidias, Archimedes, von Bingen, (Roger) Bacon, Brunelleschi, Leonardo, Michelangelo, Galileo, (Francis) Bacon, Kepler, Johannes Vermeer, Descartes, Huygens, Hooke, Newton, Leibniz, Voltaire, Franklin, von Goethe, Schiller, von Humboldt, Darwin, Pasteur, Marie Curie, (Sarah) Bernhardt, Einstein, (Emmy) Noether, Heisenberg, von Neumann, and (Hedy) Lamarr were among history's polymaths. Shakespeare understood human behavior better than any psychoanalyst and devoured history books chronicling the stories of England, Scotland, Denmark, ancient Rome, and medieval Italy.

"Leonardo's model" is a double or even triple entendre. The expression could just as easily refer to Lisa Gherardini, the young woman immortalized in the most famous portrait in history. For me, a physicist, it could describe a nuclear model; e.g., the shell model, liquid drop model, optical model, and unified model. Or it could describe Leonardo's modus operandi—his ability to see things from different vantage points and to cobble together seamlessly the elements of his vast universe—painting, music, mathematics, anatomy, geology, hydrology, physiology, meteorology, and psychology. The mind-boggling number of fields he mastered may never be matched. The quintessential Renaissance man was history's ultimate polymath.

Leonardo did not invent the theory of *linear perspective,* nor did he introduce the technique of *spolvero* to transfer a drawing onto a wall or board, but he applied them with precision. But he did invent *atmospheric perspective*: peering into the distance, he saw objects accompanied by diffusion of light, producing degradations in color and resolution. This would have to be carefully represented in the background of a realistic painting. He introduced *sfumato* (smooth blending) to make the edges of rounded bodies more diffuse; he invented *velatura,* the application of microscopic layers of varnish in which opaque pigments are suspended in translucent oil with his fingers, reducing the sense of flatness of the surface paint; and he used *chiaroscuro*, exaggerated contrasts of light and shadow to create illusions of

volume, a technique just beginning to come into use in his time. A century after Leonardo, Caravaggio introduced heightened chiaroscuro, *tenebrism*, to augment the drama of the scene.

In approaching the mechanical aspects of registering an image on a surface, whether in a drawing or a painting, Leonardo was a scientist systematically experimenting with the elements of painting. He knew that some experiments were doomed to fail, but also that without experimenting, progress was not possible. Einstein echoed that sentiment four hundred years later: "A person who never made a mistake never tried anything new." One of Leonardo's grand experiments, *The Last Supper*, failed partially—the paint flaked off; another, *The Battle of Anghiari*, failed completely—the paint ran.

Detail of Raphael's cartoon for The School of Athens, *showing the perforations.*

Five hundred years ago art supply stores did not exist. Drawing and painting materials were simple or called for simple ingredients: color pigments in powder form, bone ash, red lead pigments, ivory black, goose feather pen, silverpoint, handmade paper, and wooden boards. Stretched canvas on which to paint, first introduced in northern Europe, was not adopted by Italian artists for a decade or two after Leonardo's death. Techniques were shared among artists and apprentices in the Renaissance workshop, *bottega*, and experimentation was common. Sometimes, however, there were industrial secrets to be ferreted out from rivals, as when Raphael hired away one of Titian's assistants to learn the formulas for the especially brilliant colors used by the Venetian painter, just as Titian had done to concoct the colors developed by the glassblowers of Murano.

The full cartoon for Raphael's mural School of Athens required numerous small sheets. The cartoon is preserved in the Ambrosiana Library in Milan. Compare the cartoon here with the mural (seen in figure 2, color photo insert page II) to see how Raphael rethought the design and included Michelangelo and himself.

Once a full-size rendering, "a cartoon," was created from sheets spliced together, the drawing could be transferred to the surface of a board or to a wall. In the technique known as *spolvero*, invented by Leonardo's master Verrocchio, an awl was used to make perforations outlining the drawing. A muslin bag containing powdered charcoal was used in patting the perforations, creating a stencil outline on the prepared surface of the board. Modern infrared images of Renaissance era paintings, including Verrocchio's and Leonardo's paintings, show the circular dots of charcoal below the paint. Multispectral digital photos reveal the *underdrawing*, the

overall design, the placement of arms, or the turn of a face. The assembled patchwork of such sheets creates the cartoon for Raphael's *School of Athens*.

The two versions of *Virgin of the Rocks*, dating from Leonardo's Milan period in the 1480s and 1490s, respectively, help in understanding how he fused art and various areas of science. In both versions the quartet of Virgin Mary, an angel, the infant John the Baptist, and the infant Jesus are seated in the mouth of a cave. The setting reflects the artist's preoccupation with nature. Outside the cave are a variety of flora, each with its accepted Renaissance symbolism. And inside the cave appear a variety of rocks, stalactites, and stalagmites. The Virgin and the angel are both depicted as exquisite young women. The cherubic pair of toddlers appear cuddly, watching each other with fascination, as one would expect toddlers to do. The arrangement of the quartet forms an equilateral pyramid. The pyramidal composition structure had not been seen in any earlier paintings, but after Leonardo, the pyramid appears in the works of other painters. Raphael's *Alba Madonna*, a *tondo* (circular painting) hanging in the National Gallery of Art, Washington, displays the pyramid. Michelangelo's only frameable painting, *The Holy Family*, also a *tondo*, hangs in the Uffizi Gallery in Florence. There, a pair of equilateral triangles organizes the composition, one right-side-up, the other upside-down. They form the Star of David.

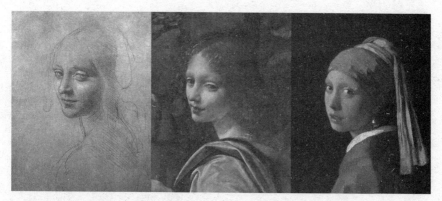

(Left) Leonardo's study for the angel for the Virgin of the Rocks *is a silverpoint drawing on specially prepared paper.* (Center) Leonardo employed the drawing in the first version of Virgin of the Rocks (Louvre). (Right) *The ethereal gaze of the subject may have inspired Johannes Vermeer's* Girl with a Pearl Earring *(1665), now hanging in the Mauritshuis Museum, The Hague.*

In the triptych, Leonardo's study for the face of the angel, rendered in silverpoint, is seen in the left. Sir Kenneth Clark described the drawing as "One of the most beautiful drawings, I dare say, in the world." Seen in the middle image in the triptych is the painted version of the angel appearing in the finished painting *Virgin of the Rocks*.

Two hundred years later, Leonardo's rendition of the face of the angel would inspire Vermeer's *Girl with Pearl Earring*. In the case of Vermeer's painting, the sitter's pose may have come from Leonardo, but the moment captured by the artist was "that fleeting moment the subject turned her face." According to Antonie van Leeuwenhoek, a close friend of the artist, though better known as the inventor of the microscope:

> [He] decided to paint his niece, seated ... She sat and gazed out the window. "Look here," he suddenly called out, unseen from behind the curtain. Quickly, she turned, surprised to hear his voice. Immediately, he spied the image he wanted to portray. "It is as if we have caught her unawares," he said.

THE POLYMATH AS PORTRAITIST

A good portrait invariably triggers a three-way conversation, creating a triangle between the artist and the subject portrayed, between the finished portrait and the external viewer of the portrait, and between the artist and the viewer. The first leg of that triangle involves the eye of the beholder (the artist) and the eye of the beheld (the subject). Among the topics discussed in this chapter will be that psychological interplay. Several of the color images in the book have been chosen to include visitors viewing works of art, including Leonardo's *Mona Lisa*, Leonardo's *Belle Ferronière*, van Gogh's *The Starry Night*, and Frida Kahlo's *Self-Portrait Dedicated to Leon Trotsky*.

Approximately fifteen years apart, Leonardo painted the portraits of three young women, the works collectively labeled "the three sisters:" *Ginevra d'Benci*, *Lady with an Ermine*, and *Mona Lisa*. Between the second

and third of "the sisters," he also created a fourth portrait of a lady, La Belle Ferronière, although not a bridal portrait per se like the other three. The painter is known to be Leonardo, but the identity of the sitter remains open to speculation.

The *Ginevra d'Benci*, the first of the four portraits, now hangs in the National Gallery of Art in Washington, DC. Leonardo was twenty-one when he created the bridal portrait of the sixteen-year-old Ginevra. The painting also reveals the artist's preoccupation with colors, shapes, patterns, proportions, along with his love of nature. In the proportions, if the distance from the top of Ginevra's head to her chin is assigned one-unit of length, the distance from the top of her head to the horizontal line defining the bodice forms the ratio 1:1.618, the golden ratio, theme of the next chapter, and Leonardo's burgeoning interest in mathematics. This is the same proportions that would guide the compositions of *Lady with Ermine* and the *Mona Lisa*.[1]

Leonardo injected a touch of humor by including the juniper, *ginepro* in Italian, a subtle play on the subject's name. The unusual two-sided painting displays on the reverse side the palm and laurel, a pair of plants symbolic of intellectual and moral virtues. They form an arched frame around a scroll reading BEAUTY ADORNS VIRTUE, emblematic of the subject of the portrait.

The second portrait is that of Cecilia Gallerani, the twenty-one-year-old mistress of Ludovico Sforza, Leonardo's patron during his Milan years. Known as the *Lady with an Ermine*, the portrait is the unrivaled gem of the Czartoryski Museum in Krakow, Poland. It has been described as "the first truly modern portrait," "a portrait both sensible and sensual,"[2] and "a breakthrough in psychological portraiture." It is a natural precursor or a missing link in the evolution of the portrait of the *Mona Lisa*.

Leonardo softened the focus on her face ever so slightly with a hint of an almost transparent veil over her face held in place by the thin straps on her forehead and under her chin. They are parts of a *ferronière*, a fashion accessory popular in Milan at the time. Cecilia's long sensual fingers stroking the animal (probably a ferret, mislabeled an ermine[3]) are seductive. The portrait is bewitching, simultaneously exuding piety and sexuality, even more

than the *Mona Lisa*. Her eyes are turned away from the viewer, avoiding any embarrassing eye contact but rendering the viewer into an unintended voyeur, unlike in *La Belle Ferronière* and the *Mona Lisa*.

When Cecilia first arrived in Milan as a mere sixteen-year-old courtesan from her hometown of Sienna, Ludovico Sforza had snatched her up as his mistress and most likely commissioned Leonardo to do the portrait then. However, when Ludovico saw it politically advantageous to undertake marriage with Beatrice d'Este (1475–1497), the new first lady promptly banished the mistress from Milan. Cecilia, meanwhile, had already been immortalized in one of the most beautiful portraits in the history of art. Just as Leonardo had posed his earlier subject, Ginevra d'Benci and as he would do so again in his portraits *Mona Lisa* and *La Belle Ferronière*, he has Cecilia in a three-quarter pose that affords a more expansive view of her visage. Cecilia's pose possesses a gentle dynamism, as do the portraits *La Ferronière* and *Mona Lisa*. Cecilia's face is turned slightly toward her left and her torso slightly towards her right, creating the shape of a helical corkscrew. In the case of the *Ginevra* and the *Mona Lisa*, the subjects are set outdoors, where the vegetation and topography provide the backdrop. With the *Ginevra*, the evergreen juniper bush creates a dark backdrop to accentuate her light pale skin (a tanned complexion would have been as demeaning as callused hands, signs of inelegance and coarseness, and definitely not aristocratic).

Along with her sister portraits, *Cecilia* holds important secrets about the artist's painting techniques. Leonardo practiced *velatura*, the application of infinitesimally thin layers of translucent paint and glaze, sometimes smoothed out with his fingers. On the slender neck of *Cecilia's* likeness are Leonardo's fingerprints. The same fingerprints appear in the juniper bushes in the background of the Ginevra portrait. On the occasion of the five hundredth anniversary of Christopher Columbus's discovery of the New World, the painting of *Cecilia* visited the National Gallery in Washington and hung next to Ginevra.

The agreement between the owners of the *Cecilia* in Krakow and the National Gallery for the eight-week visit allowed for the painting to be

displayed for six weeks, followed by its study in the gallery's conservation laboratory for two additional weeks. In 1992 the lab did not own the high-quality photographic equipment required to photograph Leonardo's fingerprints. (High-resolution digital cameras had not even been invented.) An institution far better equipped for such forensic work, the Federal Bureau of Investigation (FBI), was called in. Leonardo's fingerprints were photographed and are now on file at the FBI building, just a few blocks west of the National Gallery. Leonardo, with his interest in gadgetry, would have found the technology fascinating.

In the third portrait, *La Belle Ferronière*, speculations are rife about the identity of the subject, explaining the alternate title for the painting, *Portrait of an Unknown Woman*. Was it Isabella of Aragon; a mistress of Henry II of France who actually had the nickname "Ferronière"; was it Ludovico's onetime consort Beatrice d'Este; or was it Lucrezia Crivelli? According to Vincent Finnan, an ardent Leonardista, it is more than likely Crivelli, Ludovico's mistress following the banishment of Cecilia. Painted just prior to Leonardo undertaking the creation of *The Last Supper*, Crivelli bore Ludovico a son, Gian Paolo, just two months after d'Este's death in 1497. As in the portrait of the Cecilia, the background the subject's face and hands are illuminated agains a starkly contrasting dark background.[4]

THE ENIGMA OF THE *MONA LISA*

The portrait *Mona Lisa*, frequently referred to as *La Gioconda* in Europe, is the jewel in the crown of the world's greatest art gallery, the Louvre. Each visitor to the gallery who gazes upon Leonardo's psychologically charged painting comes away with a different impression: "She follows you around," "She has a secret," "She is confident," "She exudes an air of superiority," "She is pregnant." Ultimately, she is bewitching, although not quite as pious as *Ginevra de' Benci* and not as sensual as *Cecilia Gallerani*. For many years now, the most valuable work of art on the planet has been cordoned off from the crowds that resemble a massive rugby scrum. It is protected by inch-thick

(2.5 cm) bulletproof glass and hangs behind a rope, then a semicircular wooden balustrade, followed by a cantilevered shelf below the painting. She can no longer hypnotize her admirers nor become intimate with them except through high-resolution digital photographs. These days one sees hundreds of visitors at a time herded into the cavernous room where she hangs. Holding smartphones above the crowd, they shoot photos of her; then they turn their backs on her to shoot selfies. Rather than creating high-resolution images, they are each proclaiming, "I was there!"

The model for the painting, née Lisa Gherardini, married the merchant Francesco del Giocondo (hence, the work's alternative title, *La Gioconda*). Leonardo painted her portrait, elevating her to immortality, to the apotheosis of all female representation. Visual tease and ambiguity define her. Leonardo poured into the *Mona Lisa* all that he knew, all that he had learned from years of experimenting as a scientist–artist. Vasari reported that Leonardo even hired musicians to play in his studio to get his model to relax and look pensive.

Most modern professional digital cameras shoot photos of file size from a few megapixels up to sixteen megapixels. Recently, French engineer Pascal Cotte constructed a specialized Lumiere Technology camera that shoots images of 240-megapixel file size. It can peer into fourteen different regions of the electromagnetic spectrum from the infrared, through the visible, to the ultraviolet, as well as into the very short X-ray region. It is with this camera that the *Mona Lisa* was studied. (Electromagnetic radiation of differing wavelengths is able to penetrate each of the layers of the painting.) Previously unknown features were revealed, such as the underdrawing from the *spolvero* marks and Leonardo's habit of changing the design as he worked, and the question of the missing eyelashes and eyebrows: "Did they exist at one time?" Indeed, they had originally been there but were removed, unintentionally, by the cleaning of the painting's surface during the past 500 years. The X-radiation also revealed that the covering over her left shoulder is a veil, that the subject was actually slenderer than she appears in the painting. Peeling away the yellowed varnish and restoring the original pigments to their five-hundred-years-ago color—a virtual process

done with Photoshop—recreates the bluish tinge of the sky and the slight blush of the subject's cheeks. The painting is reengineered to Leonardo's original vision.

Mona Lisa wears that enigmatic smile. But the smile disappears when you look directly at the mouth and reappears when you look slightly off to the sides, perhaps 5°–10°. Leonardo employs a subtle optical illusion.[5] A good artist would make sure that the horizon is level behind her; a poor artist may not. What does Leonardo do? Just like the poor artist, he makes the horizon line uneven, thereby creating an unsettling effect, a tension, causing the viewer's eyes to inadvertently go back and forth. It is a mesmerizing experience to scan the face, the eyes, the mouth, with that smile appearing and disappearing. Leonardo's trick is reminiscent of the tension and release in music. The psychology with which he was imbuing his portraits was an example of "motions of the mind," according to his own description of the effect. Just as he had posed his earlier subjects, *Ginevra d'Benci* (c. 1473) and *Cecilia Gallerani* (c. 1492), he had Lisa Gherardini (*Mona Lisa*) sit in a three-quarter pose that afforded a more expansive view of her visage. The virtues of intelligence and piety are on display. In the case of the Ginevra and the Mona Lisa, the subjects are set outdoors, where the vegetation or the rocky background are on display. The backdrop of a rocky landscape, a meandering river, and a multi-arch bridge was regarded for centuries by art scholars as most likely a figment of the artist's imagination. The craggy cliffs on the left of the Mona Lisa are now thought to be entirely real, the Balza Rocks in the village of Valdarno on the road between Florence and Arezzo. The bridge also has been identified with reasonable certainty to be the Ponte Buriano in Arezzo, spanning the River Arno and built two and a half centuries before Leonardo incorporated it into his painting.

THE EYE OF THE BEHOLDER—THE EYE OF THE BEHELD

Discovered by Christopher Tyler, English-born psychologist and art lover living in San Francisco, California, the "centerline principle" posits that

in a preponderance of single-subject portraits created by the masters, the vertical bisector of the portrait passes through or very close to one eye of the subject.[6] The principle holds true for Leonardo's *Mona Lisa* and the *Lady with an Ermine*, self-portraits by Rembrandt van Rijn, and Picasso's *Portrait of Dora Maar*. It can be the right eye or the left eye, and it can be the leading eye (e.g., the Mona Lisa) or the trailing eye (e.g., Rembrandt's self-portraits and Picasso's *Portrait of Dora Maar*). This is a principle never taught in art schools, but the most talented painters seem to have focused on one eye of their subjects. Tyler's discovery was important enough to garner a major story in the *New York Times* in 1998. A dollar bill folded down the middle will have George Washington's right eye passing through the centerline. This was also the case for two-dollar, five-dollar, and ten-dollar bills, until some of them were redesigned in an effort to make forgery more difficult (seen in figure 9A, color photo insert page IX).

Examining the nine portraits arranged in a 3 × 3 matrix by Tyler, one painting that begs a question is Picasso's *Portrait of Dora Maar*. Why would the pathologically obdurate Picasso ever do something that other artists had done before him by putting Dora Maar's left eye on the centerline? Like the other artists, he did this entirely unwittingly. If he had known the principle in advance, undoubtedly he would have placed the culprit eye not on the centerline, but somewhere in the right or left bottom of the frame. One of the works appearing in Tyler's matrix (at the figure 9A, lower center) is by the English portrait painter Graham Sutherland.

Sutherland was later commissioned by the British Parliament to paint a portrait of Sir Winston Churchill for his eightieth birthday (1954). The work that resulted captured the soul of the iconic statesman, warts and all—a man of action, a gifted orator, who exuded passion, courage, and confidence. It also accurately conveyed some of Churchill's other characteristics: he was known to be vain, irascible, and obstinate. The steadfastly honest portrait of the statesman by one of his genuine admirers, however, completely failed to please the Churchill family. They wanted the portrait to convey the subject's heroic personality. In the portrait he is *Lionesque* but decidedly not *Rembrandtesque*. Presented to the Churchill family,

the portrait soon vanished. The fate of the painting came to light in 2015. Shortly after it was unveiled, it was destroyed, driven to the countryside in the middle of the night by Lady Clementine Churchill and her older brother and burned! But note, the centerline passes close to the subject's left eye, likely an intuitive, but not deliberate, choice by the artist.

Another portrait on that color plate is the posthumous rendering of John F. Kennedy by Jamie Wyeth, the youngest member of the three-generation family of gifted American artists.[7] Wyeth placed neither of his subject's eyes on the centerline of the frame, but a close scrutiny of the painting shows that JFK's left eye passes close to a vertical line that divides the canvas horizontally, 1:1.618 parts measured from the left edge of the frame. The painter was brilliant in placing JFK off to one side, suggesting the manner in which the subject is sequestered in his own thoughts, possibly weighing his decisions in a crisis.

It has been known during most of the twentieth century that a preponderance of portraits has subjects showing off their left cheeks in distinction to their right. Like the foregoing centerline question, the left-cheek question has begged for an answer: Is it the artist deciding which way the subject should face, or is it the subject of the portrait making the decision? Is it the subject showing off his/her "better" side? In 1999 Mike Nicholl, a young faculty member of the Psychology Department at the University of Melbourne, finally answered the question regarding the left-cheek dominance in portraits. His discovery made a splash in the Arts Section of the *New York Times*. Professor Nicholl, addressing a large group of students in an auditorium, announced to them that photographic portraits were going to be made of each of them. Then he separated the group into two equal groups, where each could not hear the directions given to the other group. To the first group he explained, "Your portrait is going to be produced, framed, and hung on the walls of a loved one—a parent, a boy or girl friend." In the first group, those who prominently displayed their left cheeks outnumbered those displaying their right cheeks. Then he told the second group that their portraits were going to hang next to a portrait of

Albert Einstein, a certifiable genius. This time, it was the right cheeks that were overwhelmingly favored by the subjects. Professor Nicholl and his colleagues gave a simple but compelling explanation. The right brain is the hemisphere in which we emote. And if we want to be endearing, we put forward our left cheeks, which is of course controlled by the right brain. We do mathematics in the inferior parietal lobe in the left hemisphere of the brain, just above the ear. That hemisphere controls the right cheek. Accordingly, if we want to appear especially intelligent and deserving of hanging next to Einstein, we reflexively display our right cheek. Moreover, males and females appeared to behave the same way in this test.

The supreme Dutch Master Rembrandt van Rijn (1606–1669) presents a curious case. Born approximately 150 years after Leonardo, Rembrandt, in a lifetime of sixty-six years, produced ninety-seven self-portraits, fifty-seven in oil, and forty as etchings and drawings. In those fifty-seven oils, there is a preponderance of 5:1 with right cheek dominant over the left cheek. Why would Rembrandt prefer to impress with his intelligence (his left brain causing the right cheek to become prominent) rather than with his kindness and graciousness, with his emotional right brain making his left cheek prominent?

On page IX of the color photo insert, figure 9D features a representative sample of six self-portraits by Rembrandt. We see him leading with his intelligence (left brain) rather than with his emotional side (right brain), showing graciousness and kidness. He is looking in a mirror, where what appears to be his right cheek is actually his left and vice versa. His natural inclination is also to present his congenial side.

THE DUTCH MASTERS OF GENRE PAINTING

The Golden Age of Holland and Flanders, a period spanning almost the entirety of the seventeenth century, saw some of the greatest painters in history, including Rembrandt van Rijn, Johann Vermeer, and Frans

Hals—listed in rank order of significance. In the foregoing section, I briefly discussed the gold medalist, Rembrandt.

Before discussing the significance of the silver medalist, Vermeer, consider the influence of the bronze medalist, Frans Hals (c. 1582–1666). With lively, open brush strokes, Hals portrayed his sitters with a dash of realism and an unmistakable air of calm, and sometimes with humor. The subjects came from all levels of society—from mayors and clerks to military officers. There were fishermen and itinerant troubadours; and there were gentlemen, gentlewomen, and just ordinary people. His works reflected the mercantile economy that had fueled a culture favorable to artists, scientists, and explorers. Although Hals had little to do with science himself, he did paint an outstanding portrait of the French polymath, René Descartes (1596–1650), mathematician, philosopher, and physicist, who spent two decades in the Dutch Republic. His painting of a group of guards, *The Officers of the St. George Militia Company* (1639) was an inspiration for Rembrandt's masterpiece, *The Night Watch* (1642), by far the greatest draw in Amsterdam's Rijksmuseum and a rival of Caravaggio's *Beheading of St. John the Baptist* (1608) as the greatest single painting of the seventeenth century.

The prevailing zeitgeist of seventeenth-century Holland allowed at least one exceptionally gifted female painter, Judith Leyster (1609–1660), to emerge and compete with the best of the male painters. A seventeenth-century art critic offered an assessment of her talent: "Leyster is a true 'leading star' among artists," a pun on her name that literally translates in Dutch to "leading star."[8] While other women participated in the mercantile economy of the Netherlands in the background, supporting their father's, husband's, or brother's businesses, Leyster struck out on her own. For six years (1629–1635), she operated her own studio in her native Haarlem, trained apprentices, became the first woman accepted as a member of Haarlem's prestigious Guild of St. Luke, and produced two dozen paintings. Granted, the two works by Hals and Leyster featured here portray similar subjects—minstrels—but it is Leyster's overall style, with her subjects, composition, brushwork, and colors that is reminiscent of her older

contemporary, Frans Hals, who also lived in Haarlem. Leyster's painting *The Concert* depicts two male musicians playing string instruments and a woman vocalist seated between them. A well-known self-portrait of Judith Leyster hanging in the National Gallery of Art in Washington almost certainly confirms that the woman in the trio is Judith Leyster herself. The man on the left in the trio has been identified as Leyster's husband. For three centuries Leyster's work was attributed to Hals. In recent years, after the painting was irrefutably attributed to Leyster, a woman, the painting's valuation plummeted. This is the unfortunate curse that some genuinely talented women in the arts have had to deal with. (see figure 10D, color photo insert page X.)

A century before Leyster, three women painters, Sofonisba Anguissola (c. 1532–1625), Lavinia Fontana (1552–1614), and Artemisia Gentileschi (1593–1656), had broken into the male enclave of portrait painting in Renaissance Italy. A century after Leyster in Holland, Vigée Le Brun would follow suit in France. Anibal Sofonisba of Cremona had encouraged all six of his daughters to develop painting skills, but only the oldest showed the necessary gifts to overcome gender bias and tradition. With a gift for creating psychological portraits, she impressed Michelangelo and Vasari, the latter sufficiently to earn inclusion in his compendium *Lives of the Most Excellent Painters*.

Like Sofonisba, Fontana also became a highly sought-after portrait painter, living first in Bologna and then in Rome. For the aristocratic patrons who commissioned her, it was important for them to show off their wealth. Fontana had a gift for portraying her sitters with opulence and still appearing unassuming. Her work shows impeccable attention to detail, especially in the subject's clothing, just as had portraits by Sofonisba. But Fontana's portraits; e.g., *The Noblewoman*, lack the psychological aspects of Sofonisba's women. In her private life, Fontana had eleven children. How she managed to take on commissions is a mystery, considering her male peers rarely had to contend with household chores, let alone rear children!

In the generation following Sofonisba and Fontana, Caravaggio ushered in the Italian Baroque period with his signature style of enhanced

chiaroscuro, tenebrism (*tenebroso*), with a star disciple emerging in Artemisia Gentileschi. History will remember Gentileschi as the first woman offered membership in Florence's Accademia di Arte del Disegno. And it will remember her supreme self-confidence, offering her reassurance to Grand Duke Cosimo de' Medici who had awarded her a commission: "My illustrious lordship, I will show you what a woman can do."

Gentileschi's paintings were biblical, they were allegorical, they were also stealthily autobiographical—in the manner of Shakespeare's sonnets and the paintings of Frida Kahlo. Gentileschi showed that she could depict a Venus as voluptuous as any painted by Peter Paul Rubens or Diego Velazquez, or a villain with as much shattering impact as any painted by her idol Caravaggio. Her skill as a painter, her self-assurance, and the autobiographical element are evident in her depiction of herself as the model for the Roman goddess of love in *Venus and Cupid* (1625–1630).[9] In chapter 15 we will return to discuss a shattering experience in Gentileschi's youth that served to fuel her grit.

Sofonisba, Fontana, and Gentileschi were born too late to have made names for themselves to be included in Vasari's epic compendium, *The Lives of the Most Excellent Painters, Sculptors, and Architects*. But they were certainly good enough to be included had the book been published half a century later.

In 2012, the National Museum for Women in the Arts (NMWA) located in Washington celebrated the works of female artists who had been active during the hundred years spanning the mid-eighteenth through the mid-nineteenth centuries. A special exhibition entitled *Royalists to Romantics*[10] was organized. It included works on loan from national collections in France, augmented by works from NMWA's own collection along with at least one painting from the Uffizi. The most celebrated artist in the exhibition was the Parisian painter Élisabeth Vigée Le Brun.

From her artist father, Vigée Le Brun received early training. In her art-dealer husband's business, she had access to the works of the great Dutch and Flemish painters of the seventeenth century, especially those of Anthony Van Dyck and Peter Paul Rubens. Copying past masters has been a timeless technique in the training of artists through the ages. Most

importantly, she had a natural gift. Just a century earlier, Fontana might have been successful in recording her sitters' wealth, but for the powdered and pampered aristocrats of France, wealth was a given. They were interested in being seen for their looks. And Vigée Le Brun possessed the genius to capture her clients' in the manner they saw themselves or aspired to look.

Before the French Revolution, Vigée Le Brun became a sought-after portraitist and court painter for Queen Marie Antoinette. When the Revolution erupted, the ardent royalist anticipated the dangers for royalty and their supporters. She took her daughter and abandoned France, and her husband. Albeit, as a consolation, Monsieur LeBrun succeeded in saving his own life and claiming the family's fortune for himself. Meanwhile, the artist's royal patron Marie Antoinette became one of the more celebrated victims of the guillotine.

OVERLOOKED POLYMATHS

In the prologue and in chapter 4, we saw Hildegard von Bingen (c. 1090–1179), aka "Saint Hildegard" and "Sibyl of the Rhine." She was a poet, composer, philosopher, Christian mystic, visionary, and one of the finest naturalists of her time. She was also an outspoken feminist. Pragmatic and questioning, she opposed the self-flagellation practiced by zealots in the church, including her cousin, another Benedictine nun; she was the first writer to admit women could have orgasms. She shattered glass ceiling after glass ceiling in so many different fields. According to many musicologists, Hildegard, as a liturgical composer, was in a class with Monteverdi and Bach. A legend in the church for nine hundred years, she was declared by Pope Benedict XVI in 2012 to qualify as a canonized saint, completing a beatification process begun centuries ago but left unfinished.

Some individuals are surpassingly talented that they are described as being "famous for being famous." Among performing artists Sarah Bernhardt, Vaslav Nijinsky, Enrico Caruso, Laurence Olivier, Jascha Heifetz, and Maria Callas qualify as members of such an elite group. Although

their reputations of greatness may be well established, they have not left behind tangible creations, except perhaps audio and video recordings. When they are also polymaths, talented in distinctly different fields, there may be physical legacies left in areas outside their main artistic specialties. Two individuals worthy of discussion in this context are the actresses Sarah Bernhardt and Hedy Lamarr.

Sarah Bernhardt (1844–1923) was a towering figure in the theater in the nineteenth century, an actress of multifaceted versatility, able to play leading female roles in French plays or male roles in Shakespearean plays. She was the first woman to play Hamlet (1899). French poet and dramatist Edmond Rostand (1868–1918) described her as "the queen of pose and the princess of the gesture." On his personal grading scale, American writer, publisher, and humorist Mark Twain (1835–1910) proclaimed: "There are five kinds of actresses: bad actresses, fair actresses, good actresses, great actresses—and then there is Sarah Bernhardt." In a lifetime that extended well into the twentieth century, she traveled around the world, performed on international stages, and lived long enough to see her own performances in silent era films and to hear her own voice on gramophone recordings.

It is a rare historian of the theater who also knows that the legendary actress was an impressive polymath. In her youth, Bernhardt developed the skills to carve marble. Once on a trip to Breton, in the northwest corner of France, she witnessed the drowning of a boy entangled in a fishing net and the boy's grandmother overcome by grief. The tragedy spurred the thirty-two-year-old actress to carve a seated statue of the elderly woman, cradling the body of her grandson, in a composition inspired by Michelangelo's masterpiece the *Pietà*. The statue is known as Bernhardt's most ambitious work among the more than fifty she created in her lifetime.

As for Michelangelo di Lodovico Buonarroti Simoni, transformative genius who received no more than a few droplets of ink while his great rival is mentioned in every chapter of this book, he was also a polymath of highest order. Michelangelo was not only the sculptor who at twenty-four carved the divine *Pietà*, he was the painter who decorated the Sistine Chapel, the architect and engineer who built St. Peter's dome, and the

prolific poet who wrote the inspiring words, "I saw the angel in the marble and carved until I set him free."

LEFT: *Michelangelo Buonarotti,* Pietà, *(1499), St. Peter's Basilica, Vatican City.*
RIGHT: *Sarah Bernhardt,* Après la tempete, *(1876), NMWA, Washington. The woman cradles her dead grandson, part of his fishing net visible on her lap. Bernhardt's rendition of the old woman's wrinkles, the boy's hair, the frothy sea, the coarse fishing net, each with a different texture, testifies to her mastery in technique. Photo credits: Tiziana Belli for the "Pietà" and the author for "Après la tempete."*

Hedwig Eva Maria Kiesler was born to Jewish parents in Vienna in 1914 and moved to Hollywood where she gained stardom with her professional moniker Hedy Lamarr. With green eyes and jet-black hair, she is still remembered playing the beautiful biblical vixen Delilah opposite Victor Mature's Samson in *Samson and Delilah* (1949). Displaying some of the less savory habits of a movie star of either gender, she notched up multiple marriages. She married six times, the same as Henry VIII, and divorced six times, four more than Henry.

When she was five years old, she had disassembled a music box, demonstrating a heightened curiosity, a trait that she would preserve throughout her double life as an inventor while holding her day job as an actress. Her

first marriage at the age of eighteen had been to a wealthy arms manufacturer, Fritz Mandl, twice her age. Her curiosity fueled a passion for gadgetry and the design of armament. In 1938 she relocated to the United States, and by the early 1940s became interested in helping her new country in its war effort. She knew that the guidance systems of radio-controlled torpedoes were susceptible to electronic jamming, causing the torpedoes to veer off course. With a colleague, composer George Antheil, she submitted a preliminary design to the navy for a new frequency-hopping, spread-spectrum technology. The inspiration had its roots in the design of the mechanical workings of rolls for player pianos. In 1942, using her married name from her second husband, Hedy Kiesler Markey, she applied for and was awarded a patent for the design, *United States Patent #2,292,387, dated June 10, 1941*. She found a skeptical military more inclined to accept internally inspired projects. The design was shelved. Two decades later, at the height of the Cuban Missile Crisis in 1962, an updated design of the Markey–Antheim frequency-hopping technology found its way onto U.S. naval ships. In the twenty-first century, the idea inspired modern spread-spectrum communication technology, Wi-Fi, and Bluetooth technology. She was inducted into the National Inventors Hall of Fame posthumously.

TENSION AND RELEASE: LAOCOÖN'S MISSING ARM

> *[Laocoön] . . . a work to be preferred to all that the arts of painting and sculpture have produced.*
> —Pliny the Elder

Homer, the mythical blind poet who purportedly lived in Ephesus in the late eighth and early seventh centuries B.C.E. wrote a pair of epic poems about the Trojan War that had taken place almost five hundred years earlier. The war had been triggered by Paris, the son of King Priam of Troy, running off with Helen, the beautiful wife of the Achaean king Menelaus

of Sparta. "A thousand ships were launched by the Greeks," Homer wrote, "who laid siege to Troy." Numberless warriors died. Among the heroes was the warrior Achilles, who defeated Hector, the brother of Paris. Achilles himself was killed by an arrow from the bow of Paris that struck him on his only vulnerable spot—his ankle. But ten years of fighting ended in an impasse. Then, the Greeks, following a brilliant idea of the seer Calchas, constructed a colossal hollow horse. A team of Greek warriors commanded by Odysseus climbed inside the horse, which was then pulled in front of the gates of Troy and left there. The subtle message to the Trojans: "We recognize the futility of the siege. It was a mistake! In forfeiting we leave this horse as a token of respect."

Waking to the sight of the solitary horse outside their city gates, the Trojans were perplexed. "What deadly fraud is this?" declared the Trojan priest-seer Laocoön, "It's a ruse devised by the Greeks!" His words might just have moved the Trojans to reject the horse, to set fire to it outside the city gates. But the gods supporting the Greeks sent a sign. They released a pair of serpents to kill Laocoön and his two sons, Antiphantes and Thymbraeus. The appearance of the serpents was interpreted by the Trojan chiefs as a sign from their own benevolent gods of punishing the delusional priest. The Trojans dragged the horse inside the city walls, and, in the process, made one of the most famous blunders in history. Its lesson: "Beware of Greeks bearing gifts."

The marble statue of Laocoön is a second-century C.E. Roman copy of a Greek bronze created by the trio of Rhodesian masters Athanadoros, Hagesandros, and Polydoros in the Hellenistic period of the third or second century B.C.E. In the opening quote of this section, Pliny the Elder was describing the marble version believed to have adorned the palace of the Roman emperor Titus in the first century C.E. However, it was actually a marble copy of the original bronze statue. In 1506, during the papacy of Julius II, the marble copy (sans the right arm) was unearthed in excavations being carried out at the vineyard of Felice De Fredis. It was painstakingly restored, and even Michelangelo, sent by the pope to examine it, is said to have stood in awe of the statue. It was moved to

Rome where it became the centerpiece of the new Vatican Museum. For its restoration the pope commissioned a team of thirty artists to speculate on how the missing arm should be crafted. Each had to put himself into the mind of the original artist trying to convey the anguish of Laocoön. Twenty-nine of the thirty sculptors conjectured that the missing right arm was extended upwards, clutching the serpent by the neck and fighting to keep its gaping jaws away. Michelangelo alone argued that, for maximum impact, the arm should be in a cocked position over his shoulder. His idea was to maximize the drama with a message of tension and release. The restoration of the arm was completed in accordance with the wishes of the majority.

LEFT: *After the discovery in 1506 of the statue* Laocoön *with the missing right arm, Vatican officials appointed a commission of thirty sculptors. Their mission: to decide on how to best restore the missing arm. Twenty-nine of the sculptors voted to restore the arm fully extended, as in the copy of the statue appearing on the left. Only one sculptor, Michelangelo, insisted that the arm be in a cocked position in order to maximize tension. (Napoleon in the 1790s received the copy of the statue seen on the left.)* RIGHT: *In 1906 the original missing arm was discovered, and the original statue in the Vatican was restored to its original form. Michelangelo had been right! The photo on the left shows a scaled-down copy of the statue on display at the Ambrosiana Library in Milan. On the right is the correctly restored* Pietà *in St. Peter's Basilica. Photo credit: Tiziana Belli.*

Four hundred years after the statue was discovered, the missing right arm showed up, darker after having leached minerals from the ground for an additional four hundred years. The design of the arm turned out to vindicate Michelangelo's choice! The story points out the insight characterizing a transformative genius in distinction to the gifted artists of the High Renaissance. And most certainly, it suggests that the trio who created the statue in antiquity were also no ordinary geniuses.

In 1797 Napoleon Bonaparte demanded the statue as a war reparation from the Vatican for a war that he had started. He was given a copy and told that the original was being readied for shipment. It never made the trip to Paris. Copies of the incorrectly restored statue, created before 1906, have survived (see the attached images showing the pre-1906 and the post-1906 versions). The statue of Laocoön is still regarded as the most famous statue in the Vatican Museum. An even more famous statue, *Piéta*, created by the twenty-four-year-old Michelangelo, sits just inside the main entrance of St. Peter's Basilica, but the basilica is technically not part of the museum.

FRANCES ARNOLD—MARCHING TO A DIFFERENT DRUMMER

In the field of biochemistry, Kary Mullis (1944–2019) had a reputation as an untamed genius, a rebellious freethinker who did not accept climate change (rare among scientists) but believed in astrology (virtually nonexistent among scientists), judged "a good day" by the height of waves he could surf on the coast of his native California, and showed a strong penchant to partake in LSD. He attended graduate school at UC Berkeley, an institution famous for aversion to authority, especially in his days in the late 1960s. For inventing the technique to mass replicate an infinitesimal sample of DNA, whether in dried blood splatter or in the marrow in Neanderthal bones, he was awarded the 1993 Nobel Prize in Chemistry. Mullis's technique rose to special prominence during the year(s) of the COVID-19 pandemic, when a negative PCR test result becoming a requirement for international travel.

As quirky a life as Mullis enjoyed, it simply presaged the life and experiences of Frances Arnold, who was awarded half the 2018 Nobel Prize in Chemistry for her research on enzymes. Born in 1956 in Pittsburgh to a homemaker mother and a nuclear physicist father, Arnold was the second of five children. School for her was yawningly easy. She excelled, but frequently chose to skip. At fifteen, she hitchhiked to Washington, DC, to protest the Vietnam War in 1971. When her parents exhorted her to conform, "Our way or the highway," she took the highway. Despite less than stellar grades, her near-perfect SATs and a compelling essay impressed the admissions office at Princeton, who admitted her to study mechanical and aerospace engineering. Princeton challenged her but not enough for her to follow the traditional path. She took a year off to live in Italy and work for a company making nuclear reactor parts and to take a land excursion on an old Motoguzzi 500 motorcycle from Milan to Istanbul. (When she took her "junior year abroad," the now-common practice did not exist. She was decades ahead of her peers.) After returning to the United States, she completed her undergraduate degree at Princeton in 1979, and like Mullis, earned a doctorate at UC Berkeley. She also stayed on at Berkeley to undertake postdoctoral work in biophysical chemistry. The following year, at thirty, Arnold joined the faculty of the chemical engineering department at Caltech[11] and embarked on a program to develop techniques to reengineer the architecture of enzymes—complex macromolecules consisting of several thousand amino acids linked together in long chains and folded up into three-dimensional structures. Following personal conviction that nature was "the best bioengineer in history," she figured out how to let evolution assist her in the lab. She pioneered the use of "directed evolution to design new enzymes."[12]

She demonstrated it by engineering a new version of the enzyme subtilisin, one that could still function in the solvent dimethylformamide (DMF) rather than in the watery environment of a cell. Starting with the DNA in a particular subtilisin, she introduced mutations into the gene and reinserted the new variants into bacteria, which then produced new proteins. She sorted through the resulting proteins to find those that exhibited

the desired properties. She then extracted their DNA and repeated the process, breeding generation after generation until she was left with a variant that was exactly what she wanted. "It's Darwin's survival of the fittest, except that Arnold decided what 'fittest' means." Her research group at Caltech calls for steadfast collaboration between the disciplines of chemistry, bioengineering, biochemistry, molecular biology, microbiology, chemical engineering, chemistry, and applied physics.[13] Arnold's portrait appears in the color plate section of the book along with those of a number of other Nobel laureates.

Striking parallels exist between the traits and approaches to research of Arnold and Mullis—both brilliant, both original, both offbeat, both marching to their own drums. Leonardo would have approved wholeheartedly of their approach to investigating nature. Over five hundred years ago he wrote:

> Human subtlety will never devise an invention more beautiful, more simple or more direct than does nature because in her inventions nothing is lacking, and nothing is superfluous.

Arnold was the fifth woman to receive a Nobel Prize in Chemistry since Marie Curie was awarded the first in 1911. Just two years after Arnold, in 2020, two other women, Jennifer Doudna and Emmanuelle Charpentier, became the sixth and seventh women awarded the coveted prize.[14] Their discovery, CRISPR-Cas9, is an acronym for Clustered Regularly Interspaced Short Palindromic Repeats, a microbial "immune system" that prokaryotes—bacteria and archaea—used in preventing infection by viruses called phages. At its core, the CRISPR system gives prokaryotes the ability to recognize precise genetic sequences that match a phage or other invaders and target these sequences for destruction using specialized enzymes. Just as "DNA," another acronym in the biological sciences, has become a common household word, "CRISPR" is also on course to do so.

In 2021 computer scientist Cynthia Rudin became the first woman, and only the second recipient of any gender, to be awarded the Squirrel AI

Award.[15] Known as the "Nobel Prize of Computer Science for Artificial Intelligence," it is comparable to the Nobel Prize in the traditional fields, in that it carries a monetary component of a million dollars.

The technique introduced by Doudna and Charpentier in 2012 proved seminal so quickly that the two of them and a number of subsequent researchers all became contenders for a fast-tracked award. The Nobel Committee in Stockholm, however, chose to honor them as the pioneers. Sickle cell anemia, muscular dystrophy, eye disease, Huntington's disease, cystic fibrosis, and a variety of cancers are among the 7,000 diseases caused by faulty gene mutation. Many of these diseases would be candidates for treatment by the gene editing and therapy offered by CRISPR technology. As with Frances Arnold, Doudna's job title at Berkeley reveals her as a polymath in the life sciences: "Professor of Biochemistry, Biophysics, and Biology."

7

THE INTERSECTION OF ART AND SCIENCE

*Painting is a science and all sciences are based on mathematics.
No human inquiry can be a science unless it pursues its path
through mathematical exposition and demonstration.*
—Leonardo da Vinci

In painting figures on a two-dimensional surface, the artist seeks to create illusions of depth and realism, projecting three-dimensional reality onto a two-dimensional surface. From the cave paintings of Lascaux in the South of France we know that almost 20,000 years ago, exceptionally talented artists applied charcoal and red ochre to walls to convey their impressions of wild animals. They seemed to understand intuitively notions of positive and negative space, that diagonal lines created illusions of motion and speed.

While the artist can be subjective in his endeavors, the scientist is constrained by objectivity. For the artist and the scientist, the qualities of truth and beauty are equivalent. The aphorism "beauty is in the eye of the beholder," however, suggests that truth also is in the eye of the beholder, not objective, while for science, there can be only one truth, an objective

truth. When John Keats paired the two qualities in his immortal work, "Ode on a Grecian Urn"—

> *Beauty is truth, truth beauty,—that is all*
> *Ye know on earth, and all ye need to know.*

—he was describing an artistic creation and emphatically not commenting on a scientific truth. A "beautiful theory" to the scientist is one that is universal and verifiable. The mathematics of change (calculus), the laws of motion, the double-helix structure of the DNA macromolecule, the theory of general relativity, and the theory of evolution are each an example of profound scientific "truth."

AESTHETICS OF MATHEMATICS—MATHEMATICS OF AESTHETICS

> *Mathematics, rightly viewed, possesses not only truth, but supreme beauty, a beauty cold and austere, like that of sculpture, without appeal to any part of our weaker nature, without the gorgeous trappings of painting or music, yet sublimely pure, and capable of a stern perfection such as only the greatest art can show. The true spirit of delight, the exaltation, the sense of being more than Man, which is the touchstone of the highest excellence, is to be found in mathematics as surely as in poetry.*
> —Bertrand Russell

The great mathematical logician Bertrand Russell described the inherent rigor and beauty as "the aesthetics of mathematics." The other side of the coin would be the aesthetic philosopher's interest, "the mathematics of aesthetics," the mathematics underlying shapes, proportions, and symmetries inherent in great art. It is the latter topic we will discuss here.

Classical Western art produced during the Golden Age of Greece and the Glory Days of Rome achieved immense emotional impact. These

were times corresponding to cultural revolutions, not only in art, but also in music, literature, philosophy, and science. In art, surviving examples are mostly in sculpture, primarily because marble and bronze endure, in distinction to painted surfaces that fade and crumble. Salient proportions, symmetries, and harmonious parts were essential elements in the Greek ideal of beauty.

Pythagoras of Samos (570–495 B.C.E.) received his early training in mathematics and philosophy in Thales's academy in Miletus, across the bay from Samos on the Anatolian Coast of Turkiye. As a young man, he may have met Thales, the legendary pre-Socratic founder of the school. After Miletus, Pythagoras is believed to have received additional training in Babylon and later still in Alexandria. His reputation as a mathematician, though, came after he moved to Crotone in the sole of the Italian boot, where he established the Pythagorean academy as the first scientific laboratory in history. The fields the Pythagoreans hoped to understand were mathematics, music, and their interconnections. They discovered that there were five possible types of regular polyhedrons—the tetrahedron, cube, octahedron, icosahedron, and dodecahedron. One of Pythagoras's quotations that has endured proclaims: "There is geometry in the humming of the strings, there is music in the spacing of the spheres."

But, blending scientific hunches and superstition, they developed a number of controversial beliefs—that whole numbers, positive integers, held all of nature's secrets; that only four elements (fire, earth, air, and water, respectively) existed in nature; that in different admixtures these four elements made all known materials; and that the first four of the polyhedrons were the *atomos* (atoms) of the elements—which would make them pseudoscientists. The fifth polyhedron, they believed, described the shape not of an element, but of the universe. Familiar to all middle school geometry students, the Pythagorean theorem states that in all right triangles—triangles that possess one 90° angle, and the three sides, of lengths a, b, and c units—satisfy the relationship $a^2+b^2=c^2$. For example, $3^2+4^2=5^2$ describes a right triangle of side lengths of (3, 4, 5), and the combination of these integers comprises the Pythagorean triple (3,4,5). Countless

other Pythagorean triples exist, among them (5, 12, 13), (16, 30, 34), and (39, 80, 89), all satisfying the famous theorem.

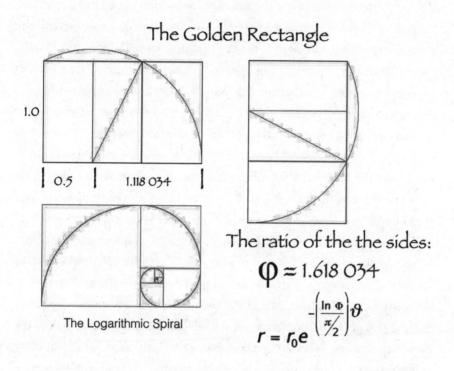

With a compass and ruler, Pythagoreans could construct the golden rectangle (in which the ratio of the height/width is given by φ =1.618). For architects of succeeding generations, the ratio served as an ideal proportion in architectural design. Numerous classic temples, including the Parthenon in Athens and the much larger Temple of Artemis built a century earlier in Ephesus, employed the shape for their east and west façades.

The architects of the Parthenon were aware that a horizontal taut string rope will appear to sag in the middle because it is viewed against the backdrop of the convex curvature of the horizon itself, which they regarded in turn as arrow straight. They knew also that a row of columns rising precisely perpendicular or "normal" to the convex surface would appear splayed at the top. Finally, columns that are perfectly straight on their

sides appear thinner at their waistline, another distracting optical illusion. Accordingly, the builders introduced design features to counteract these distracting optical illusions. The bedrock foundation of the Parthenon was shaped into a convex curve with a radius of curvature of 3.5 miles, and the columns were aimed to meet in the sky 1.5 miles above the edifice.[1] Finally, the columns were "fluted" to produce an illusion of lightness. It all works perfectly to create a structure that is now known as the most beautiful "extrovert building" in the history of architecture—a product of salutary optical design canceling out the detracting optical illusions.

Two and a half millennia later, in the last quarter of the twentieth century, officials of the National Cathedral in Washington advertised a competition for a commission for an integrated set of carvings for the tympanum over the doors of its main (western) façade. The winner of the competition would be Frederick Hart (1943–1999), with many positive and negative qualities of a classic genius—a suffering artist, an autodidact who had dropped out of school in the ninth grade, a social-minded protester with an aversion to authority but with a miraculous eye for proportion.[2] With his figurative realistic style, Hart became the most skilled sculptor in the second half of the twentieth century, as Rodin had been in the first half. Without any training in mathematics, Hart demonstrated the inscrutable ability to commune with nature far better than other sculptors have done, subconsciously recognizing the logarithmic spiral and imbuing his creation with a "growth curve."

No artist or architect needs to know the equation for it, but nature behaves as if it knows it well, employs it frequently in its animate as well as its inanimate creations. The chambered nautilus, the embryo in a mother's womb, the shape of the human ear, the horns of a ram, hurricanes, water vortices, and spiral galaxies are all described by logarithmic spirals.

MATHEMATICS UNDERLYING GREAT ART: *IL PISANO* AND *IL FIORENTINO*

Although ϕ, the monogram of Phidias ($\phi\epsilon\iota\delta\iota\alpha\sigma$) is used as the symbol for the golden ratio, it could just as easily be the vernacular version of the

letter F, after Leonardo Fibonacci di Pisa (1170–1250). "Il Pisano" (the Pisan) lived on the Italian subcontinent almost 1,700 years after the Pythagoreans, his lifetime spanning many of the years that Pisa's signature tower was being erected. Neither his proper name meaning "the son of the simpleton," nor his nickname "*bigalone*" (blockhead) would have elevated him above the sorcerer on the social ladder; in time, however, he would earn a reputation as the finest mathematician of his age, and one of many catalysts reawakening Europe from the lethargic Dark Ages.

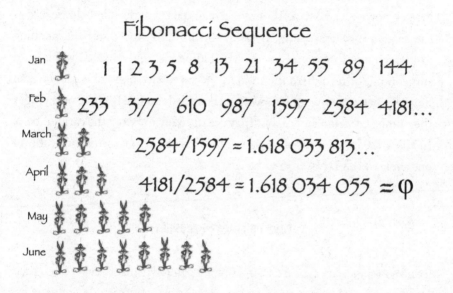

Fibonacci received an early education under Islamic mathematicians in the Algerian city of Bugia, where his father had been a customs official. After returning to his family hometown of Pisa, he maintained his mathematics research in practical algebra, culminating in a massive compendium in 1202, *Liber Abaci* ("the book of calculation"). In the introduction of his book, Fibonacci introduced Europe to the Indo-Arabic decimal system, the place concept, and the all-important zero. He also explained the superiority of the decimal system over Roman numerals with their cumbersome

arithmetic operations. The book offered examples, problems, and hints to help commerce with a variety of calculations, including conversions of monetary units, and conversions of weights, lengths, and volumes of commercial goods.

In the final chapter of *Liber Abaci*, Fibonacci introduced the sequence 1, 1, 2, 3, 5, 8, 13 . . . , and that the ratios of sequential terms converge to ϕ. But here the approach to arriving at the golden ratio is entirely different than that of the Pythagoreans. The former was geometry, the latter number theory. As for the terms of the series, they are the celebrated "nature's numbers," seen in trees, flowers, and petals. The arborist may know that the numbers are seen in the sequence of branching in trees, shrubs, and vines, and the botanist in the veins of leaves and petals. The radiologist and especially the hand surgeon might recognize the ratio in the successive pairs of digits in each finger. A beekeeper would know that the male bees in a beehive outnumber the number of female bees, but they are unlikely to know the ratio to be ϕ. In the 1980s Israeli biophysicists measured the length-to-width ratio of one cycle of the DNA also to be ϕ.

THEORY OF LINEAR PERSPECTIVE

Two thousand years ago, artists in Pompeii painted realistic scenery, but their artwork lacked depth and correct proportions. In a painting depicting gods, nobles, concubines, and sex slaves in a two-story house, the artist would employ parallel horizon lines—one for the top story, another for the lower, and another still when a basement was included. As humans, we possess horizontally positioned pairs of eyes. We see only one horizon line. Roman artists never understood the inconvenient reality of linear perspective.

It was in the early fifteenth century that the architectural genius Filippo Brunelleschi (1377–1446) formulated the theory of linear perspective. Having lost the competition for the commission for the Baptistery Doors in Florence to Lorenzo Ghiberti (1378–1455), in 1401 the dejected silversmith-sculpture-architect trained artist relocated to Rome, taking along

with him a young sculpture-apprentice named Donatello (1386–1486). He spent thirteen years exploring the streets of the Eternal City. He examined the second-century architectural marvel the Pantheon, with its immense hemispherical dome. He also wandered around the ruins of the Roman Forum, monumental architecture abounding in a state of decay, and increasingly populated by grazing cows. In frequently gazing out at the expansive layout of the Roman Forum, he identified lines and patterns, and formulated the theory of linear perspective. This epochal theory is of fundamental importance in the history of art. It revolutionized the work of artists.

Two discoveries of Brunelleschi were of crucial value for the young Leonardo: (1) Brunelleschi's engineering plans for the dome of Florence's Cathedral, Santa Maria del Fiore, in inspiring Leonardo's lifelong passion for engineering, and (2) the invention of linear perspective, especially important for visual artists.

One-Point Perspective. In a nutshell, there exists one horizon line, drawn at the height of the artist's eye level. In the theory of one-point perspective, the viewer is gazing into a room or a courtyard, with facing walls on the right and left side (there can be a wall across from the viewer, but it is not necessary for the geometric construction). The parallel lines on the facing walls, known as orthogonals, when they are extrapolated, will all appear to meet on the horizon point at one vanishing point.

A recent play on Broadway, *The Curious Incident of the Dog in the Night-Time*, was about a "high-functioning boy with Asperger's syndrome who learns to use his uncanny genius for math to navigate the world." The stage consists of a dark room with LED lights illuminating separate Cartesian grids on each flat surface—the floor, the facing walls, and the back wall. It is a minimalistic stage set. If the lines from the two facing walls and from the floor are extended along the grid lines, they all meet at the vanishing point on the horizon line. The photo of the stage set was taken from the balcony of the theater, considerably higher than the stage and to the right of the center. But if the viewer descends, the horizon line is also lowered with the *orthogonals* still converging at a single vanishing point.

The stage for the Broadway play, The Curious Incident of the Dog in the Night-Time. *The horizon line and the vanishing point, VP, are identified in a display of one-point perspective. The vantage point for the photo is the front row of the balcony. Credit author.*

In 1495 Leonardo received a commission to paint an expansive mural 4.6 m x 8.8 m (15 ft x 29 ft) on the rear wall of the refectory (dining room) of the Santa Maria della Grazie, the church attended by the Sforza family. The final product, resonating with psychological overtones, just like the portraits of *Cecilia Gallerani* and the *Mona Lisa*, was completed three years later and ushered in the High Renaissance. Michelangelo's mighty frescoes adorning the Sistine Chapel and Raphael's sublime murals in the pope's apartments, including his masterpiece *The School of Athens* adorning the walls of the Stanza in the Vatican, were produced only a dozen years after Leonardo's groundbreaking mural *The Last Supper*, described by Kenneth Clark as the "keystone of Western Art."

As long as artists had been painting their own visions of *The Last Supper*, from the medieval period onward—the exact composition, the

symbolism, and even the colors were frequently spelled out in detail by the clergy sponsoring the work—there had been little variation in the formula that had evolved. Jesus would be seated at the center of the table, the Apostles distributed around him, all facing the viewer, all with glowing halos over their heads, except of course for Judas, sans halo with only his back visible to the viewer, lest the viewer gaze into the eye of evil. There would be a great deal of gilding on the panel, gold symbolizing virtue and divine love.

Leonardo decided to portray the Last Supper in a realistic setting, embodying simplicity rather than elegance and wealth. The seating would reflect a democratic distribution with Judas facing the viewer also. The Twelve Apostles would be symmetrically placed six on one side of Jesus, six on the other, and grouped into four separate trios. Judas is seated in the center of the second trio from the left with his profile in a shadow cast by his seating partner St. Peter, the shadow obscuring the "eye of evil."

The electric moment captures the moment as Christ announces one of them is going to betray him. Eleven of the Apostles recoil in horror, but one sits emotionless, holding a small pouch in one hand, presumably containing his loot, the "thirty pieces of silver." A saltcellar is visible in front of the figure of Judas, its contents spilled symbolically on the table. Seen as a whole, the large fresco displays impeccable one-point perspective—the "parallel lines" defining the ceilings and walls on the sides, the lines delineating the coffered ceiling, the horizontal edges of the tapestries hanging from the walls, and the side edges of the table can all be extrapolated. They converge on the forehead of Christ. Italians speak with their hands. It is true now, and it was true five hundred years ago. The thirteen individuals in the mural speak with their hands, and the twenty-six hands are all captured with different gestures. Jesus's right hand and Judas's left appear to be simultaneously reaching for a plate holding bread, but Judas's hand is drawing back reflexively. In his notes, Leonardo reminds himself, "Make no two pairs of hands exactly the same." That in large measures captures the fleeting moment.

Missing are the symbolic kitschy golden oval halos above the heads of the loyal disciples usually depicted in other artists' renditions of *The Last Supper*. In Leonardo's rendition, light from the center window serves as the halo for Christ. In the manner of a modern Hollywood casting director, Leonardo chose the faces for the dinner guests to fit his own vision. For the purpose, he would be on the prowl in the streets and in the marketplaces in Milan, notebook and chalk in hand, to capture the faces he envisioned that would complement his scene. Many of his facial studies for the grand mural have survived.

In 1954 Salvador Dalí was commissioned by a private art collector to paint a version of the Last Supper in his signature Surrealistic style. The completed painting was purchased in 1956 by the National Gallery of Art in Washington. Dalí's *Sacrament of the Last Supper* commingled mathematical symmetry and numerology in the manner of the Pythagoreans. The painting celebrates the number twelve: twelve Apostles placed symmetrically, the twelve hours of the night, the twelve hours of daylight, the twelve months of the year. The polyhedral shape, located just below the arms of the Lord (his face outside the frame), is used as an organizing geometric construct—dodecahedron with twelve pentagonal façades. For the Pythagoreans the dodecahedron was alone among the five regular polyhedral figures for not being associated with one of the four elements, the *atomos*. The dodecahedron was a cult figure representing the shape of the universe, a fact Dalí may or may not have known. The painting has a length-to-width ratio of 1.618 to 1.000, the golden ratio.

Bramante (1444–1514), the architect of St. Peter's Basilica in Rome, also designed a small church, Chiesa San Satiro, an architectural wonder in Milan (1476–1482). The floor plan had been ordered by its patrons to be in the shape of a Greek cross, with four equal arms. The space available to build the church, however, permitted only three equal length arms, not four. When one enters the church and gazes in the direction of the altar, an artificial foreshortening created by the converging lines of perspective makes the arm behind the altar appear to be of normal length. The diptych presented here consists of a pair of photos: the left, looking directly at the

altar, makes the short arm appear to be of normal length. The second photo, shot from the right side of the altar, reveals that the arm behind the altar to be only one to two meters deep. Perspective, optical illusions, trompe l'oeil, and mathematical patterns are just as important for the photographer as they are for painter and architect.

Bramante's design of the interior of the Chiesa San Satiro in Milan creates an optical illusion of a depth of 15–20 feet (5–6 m) behind the altar. The photo on the right shows the recess to be no more than a few feet deep.

In a nutshell, in two-point perspective, we consider an exterior edge of a building that has a square base, and the two visible walls fading away at 90° from the corner. We also define a horizon line at eye level. All the "horizontal lines" of the two perpendicular walls defining the corner—the tops and bottoms of windows, the roofline—are

extrapolated to converge at a pair of points on the horizon line. These are the two vanishing points for two-point perspective.[3] Three-point perspective in unusually tall buildings, like a skyscraper, call for an additional third point high above the building where all vertical parallel lines would appear to converge.

With his *Last Supper*, completed in 1498 in Milan, Leonardo ushered in the High Renaissance, the most significant period in the history of the visual arts. He inspired his younger contemporary, Michelangelo, primarily a sculptor who would paint his own masterpiece on the ceiling of the Sistine Chapel, and he inspired Raphael, who in a short life of thirty-seven years created a prodigious number of great works. The titanic trio of Leonardo, Michelangelo, and Raphael influenced art to an extent never seen before and never seen afterward.

A discussion on the intersection of art and science would be incomplete without an examination of Holland in its Golden Age. In the seventeenth century a class of resourceful entrepreneurs emerged, reminiscent of the bankers and merchants in Florence that had fueled the Italian Renaissance. Amassing considerable fortunes by investing in exploration and import/export activity, wealthy merchants helped create a special zeitgeist. Windmills were built to pump out water from lowlands which made it possible to reclaim land from the sea, and new technologies were created with brass and glass instruments. German-Dutch lens maker Hans Lippershey (1571–1619) invented the "spyglass" in 1608 and Dutch businessman and scientist Antoni van Leeuwenhoek (1632–1723) the microscope. Lippershey's invention inspired Galileo in creating his first refracting telescope in 1609 that would completely revolutionize astronomy. Leeuwenhoek's invention inspired Robert Hooke to train his own apparatus on microscopic life. His observations presented in the *Micrographia* would go a long way in revolutionizing biology.

Benedictus Spinoza (1632–1677), born to Jewish parents, in his most important work, *Ethics*, claimed that immutable natural laws governed nature. Assisted by mathematics, humans could understand nature. He rejected the traditional concept of God the creator. His ideas about freedom

of speech, tolerance, and democracy still form the basis for the modern rationalist's worldview. In answering a question regarding his own religious views, Albert Einstein, inspired by his singularly favorite philosopher, quipped, "I believe in Spinoza's God!"

The wealthy merchants also began commissioning works of art to hang in their own homes. Especially during the thirty years spanning 1655–1685, Dutch School painters created works that were distinctly nonreligious in nature, showing instead the interiors of homes, replete with furniture, tapestry, musical instruments, maps, and paintings. Always featured were well-dressed residents, well-to-do husbands, wives, and servants. Ter Borsch was the wellspring of the movement that rapidly spread to other artists—including Gerrit Dou, Frans Hals, Judith Leyster, Gabriel Metsu, Jan Steen, Pieter de Hooch, and Johannes Vermeer (eighteen painters in all). The cities these artists live in were all connected by the network of canals in the kingdom: Haarlem, Amsterdam, Leiden, The Hague, Delft, Rotterdam and Dordrecht, and, lying farther to the east, Zwolle and Deventer. The canals made it possible for the artists to observe, collaborate, and emulate each other's works.

In the twenty-first century Vermeer is regarded as second only to Rembrandt van Rijn in the usual ranking of Dutch painters of the Golden Age. In his own time, Vermeer was not appreciated as he is now. In his works, there is always the pensive serenity, the inner calm of his subjects, the remarkable intelligence of the artist, never insinuating himself into the scene; he is less intrusive than a fly on the wall. His technique of light and shadow, the unmatched application of chiaroscuro, linear perspective (apparent especially in floor tiles), and there is also the subtle understated expressions of the subjects.

VERMEER AND THE CAMERA OBSCURA

The Latin expression *camera obscura* literally means a "dark room." As early as the fifth century B.C.E. the Chinese philosopher Mozi wrote

about light entering a dark cavity through a small opening and creating an inverted image of the exterior scenery on the interior wall opposite the opening. A century later Aristotle described watching a solar eclipse in Athens: light from the sun passes through a hole in the ceiling and is seen as an image on the floor below. In the Islamic Golden Age, Ibn al-Haytham, the scientist-mathematician at the House of Wisdom in Bagdad, wrote a multivolume book on optics demonstrating an understanding of the physiology of seeing. In his model the eye functioned as a camera obscura. Light entering the eyeball, not through a pinhole but through a convex lens, is focused on the rear of the eye. In the early sixteenth century Leonardo also produced detailed drawings of the anatomy of the eyeball—complete with optic nerves leading to the brain drawings—and separately, the camera obscura.

In the early seventeenth century Kepler made a portable camera obscura from a box, replacing the pinhole with a convex lens, allowing the image to be viewed on ground glass in the rear of the box. During the Golden Age of Holland in the seventeenth century, opticians ground lenses of high optical quality to use in spectacles, microscopes, and telescopes. They also made boxes that resembled portable box cameras similar to Kepler's. A mirror was positioned in the box to reflect the light rays at 45°, restoring the original configuration of exterior scenery. (It would not be for another two centuries that photographic emulsion was developed in France and the modern camera was born.) In the present context, however, it is not the modern camera, but the camera obscura seen in Holland that is of primary interest. Did Vermeer take advantage of optical technology in creating his exquisite paintings as recent claims suggest?

In chapter 6 we saw Antonie van Leuwenhoek's recollections of Vermeer working on the *Girl with the Pearl Earring*. In a lengthy letter to the Royal Society of London dated December 14, 1685, and preserved in the archives of the society,[4] van Leuwenhoek also mentioned the artist's experiments with the camera obscura and cited two additional paintings:

Ten years ago, today, my friend and neighbor, Johannes Vermeer, died in his home here in Delft . . . I knew him for his entire life. We were born within two days of each other and baptized here in the Delft Old Church on the same day . . .

He [Vermeer] had obtained a lens and an Italian book on optics and perspective and was reading about how to set up a camera obscura. The next day, he borrowed from me a large black cloth and draped it over a window in his house. In the wool fabric, he cut a small hole, over which he placed his lens, held by a wooden frame. On the opposite wall of the darkened room, the glass cast a shimmering image of the outside scene, upside down and backward.

He then re-hung the cloth midway across his studio as a curtain and placed the lens in front of the tiny hole. On the back wall of the room floated an image of the whole window and the chair beside it. [He recalled conversation with his contemporary artist, de Hooch] "But is it still art if you use a lens?" de Hooch asked. "Of course, it is art" Johannes answered. "Lenses are merely a tool—and a limited one, at that . . . Only you, Antonie, truly understand me." He gazed out before him, then looked me sharply in the eye. "I want to paint you!"

. . . he dressed me in a long Persian gown, and positioned me huddled over maps, holding a caliper. Behind me, on top of a cabinet, he said he would place the globe I bought in Amsterdam. "I want to show you as a geographer probing the limits of the earth." He mixed paints, and dipped his brush in one color, then another.

The canvas took him 4 months. I paid him 100 Guilders—all I could afford. Yet he was very pleased with the work. He asked to paint me again—as an astronomer, gazing through the window up to the sky, scanning the heavens. I bought it, too.

Johannes Vermeer's The Geographer, Städelsches Kunstinstitut Museum in Frankfurt and The Astronomer, Louvre, Paris. Antonie van Leeuwenhoek, served as the model for both paintings. The matching pair of paintings represent the only instances in which Vermeer featured a single male figure here surrounded by scientific instruments. It was Vermeer's signature style to integrate his figures into a stable geometrical framework created by the windows, chairs, and tables, and by infusing his interiors with natural light. Leeuwenhoek, the model for both The Astronomer and The Geographer, and Vermeer were in their mid-thirties.

The portraits, tender, expressive, and modern, exude mesmerizing serenity. Nina Siegal, describing a 2023 exhibition of Vermeer's collected works, captures our affection and fascination: "The mysterious 'Sphinx of Delft,' who was born in 1632, painted mostly in two rooms of his house, rarely traveled, left behind scant surviving documents and died penniless, in 1675. We still don't even have a clear picture, for example, of what Vermeer looked like."[5]

PART III
GENIUS IN THE SCIENCES

8

THE UNIVERSAL GENIUS AND THE FAILED SCIENTIFIC REVOLUTION

The following passage appears in a letter dated October 10, 1517, by Cardinal Luis of Aragon as he journeyed through Germany, the Netherlands, France, and northern Italy.

> In one of the outlying parts [of Amboise] Monsignor and the rest of us went to see Messer Lunardo Vinci the Florentine . . . This gentleman has written of anatomy with such detail, showing by illustrations the limbs, muscles, nerves, veins, ligaments, intestines and whatever else there is to discuss in the bodies of men and women in a way that has never yet been done by anyone else. All this we have seen with our own eyes; and he said that he had dissected more than thirty bodies, both of men and women, of all ages. He has also written of the nature of water, of diverse machines and of other matters, which he has set down in an infinite number of volumes all in the vulgar tongue . . .[1]

Between the sixth and third centuries B.C.E., the great natural philosophers were well on their way to establishing science as a permanent intellectual culture. Over the next 1,700 years, a period spanning the glory days of Rome, followed by a millennium of darkness during the medieval period, fundamental science remained dormant or even regressed, although technology saw monotonic progress. The Romans regarded natural philosophy as an effete waste of time, preferring engineering. During a brief period of two to three decades, between the end of the fifteenth and early sixteenth century, Leonardo came tantalizingly close to launching both the Scientific and Industrial Revolutions single-handedly. His efforts failed. But just twenty-four years after his death in 1519, Copernicus and Vesalius fired the first successful shots in the Scientific Revolution. Two centuries later, James Watt and Eli Whitney ushered in the Industrial Revolution. Where would we be if the scientific revolutions of the ancient Greek philosophers or the combined Scientific and Industrial Revolutions of Leonardo had succeeded?

While expressing general familiarity with some of Leonardo's mechanical designs, few in the public would claim to know of his love of nature and of his scientific investigations. Even as a child, he sought to decipher nature's secrets and to augment his own designs with patterns he saw in nature, frequently declaring,

> Human subtlety . . . will never devise an invention more beautiful, more simple, or more direct than does nature, because in her inventions nothing is lacking, and nothing is superfluous . . . Simplicity is the ultimate sophistication.

For Leonardo, science and art were inseparably intertwined. He produced anatomical drawings that have never been surpassed in quality. He experimented obsessively. He knew experiments could fail, but then experimentation was the only path to significant advances in art or in any other field. It allowed him to perfect his techniques in painting—in composition, in the use of linseed oil with his colors, linear perspective, *chiaroscuro, sfumato, velatura, spolvero,* and in imbuing his subjects with emotion and

movement. We may feel frustrated that his ingenuity sometimes got the best of him. Rejecting orthodoxy of the time-tested techniques of tempera and employing instead oil-based paint on wet plaster led to the near irrecoverable loss of *The Last Supper*. As moisture gathered in the wall, the paint began to flake off. But the decomposition had not happened yet when he started a potentially greater masterpiece in Florence just five years later. Along with the oil on wet plaster, Leonardo added wax to the mix. That experiment failed completely! In 1504–1505, political philosopher and statesman Niccolò Machiavelli persuaded the city officials in Florence to commission the rival duo of Leonardo and Michelangelo to paint a pair of immense frescoes on two facing walls of the Salone dei Cinquecento (Hall of the Five Hundred) in the Palazzo della Signoria, aka Palazzo Vecchio. Leonardo was to paint *The Battle of Anghiari* on the eastern wall and Michelangelo *The Battle of Cascina* on the western wall.[2] After stenciling the cartoon onto the wall, Leonardo began to apply the amalgam of paint, linseed oil, and wax. But when he felt that the paint was not drying fast enough, he had metal braziers containing blazing charcoal brought into the mural's proximity. The paint and wax caught on fire, the wax and paint running down the wall and puddling on the floor. Meanwhile, Michelangelo, who had not proceeded beyond preliminary studies, had to abandon his work on the western wall when he was summoned by the Pope Julius II to move to Rome and complete his tomb. The series of events led to the abandonment of the greatest artistic duel in the history of art.

THE PARABLE OF THE THREE BLIND MEN

"Leonardo is difficult to study and grasp," wrote architectural historian Kim Williams:

> ... scholars tend to approach [him] from their own point of view: from an architectural point of view..., or as the surgeon Sherwin Nuland writing about Leonardo's anatomical studies, or the art

historian Martin Kemp taking on the theme of his writings about painting. Leonardo reminds me of the story of the blind men and the elephant: asked to provide a description of the elephant through touch, one man feels its side and declares that the elephant is like a wall; another feels the tail and says that an elephant is like a snake; a third feels a leg and says that an elephant is like a column. Leonardo is one big elephant.[3]

While working as an apprentice in Verrocchio's studio in Florence (c. 1470), Leonardo assisted the master in a daring engineering project: to crown the lantern atop Brunelleschi's dome with a gilded hollow copper ball, 7.5 ft (2.3 m) in diameter. Following Brunelleschi's technique in originally building the dome, Verrocchio's team constructed special hoists to raise the ball and place it on the lantern. The project awakened in Leonardo a lifelong passion for gadgetry and mechanical engineering. It was the same year that he painted the angel in Verrocchio's *Baptism of Christ* and shaped the golden curls in the angel's hair with the correct logarithmic spirals.

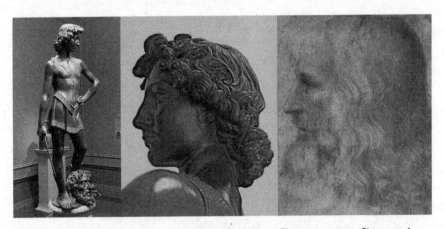

LEFT: Verrocchio's David (late 1460s), Bargello Museum, Florence. CENTER: Close-up of the statue's left profile. RIGHT: Leonardo's profile is seen in his mature years in the chalk drawing executed by Francesco Melzi in 1517. A careful scrutiny of the two profiles reveals a compelling resemblance in the contours of the noses, the upper and lower eyelids, the cheeks, and the shapes of the lips... Christopher Tyler had cited this statue as among suspected likenesses of Leonardo in the case he made about the artist afflicted by strabismus.

THE UNIVERSAL GENIUS AND THE FAILED SCIENTIFIC REVOLUTION

Giorgio Vasari was only nine when Leonardo died in far-off Amboise and could never have known him personally. As a painter, Vasari was no more than average, but as a chronicler of the artists of his time, he became known as the first and greatest art historian. His compendium, *The Lives of the Most Excellent Painters, Sculptors, and Architects*, appeared in print in 1550, and in a second edition in 1568. By then he was fully aware that Leonardo was no ordinary genius:

> [Leonardo] had such a power of intellect that whatever he turned his mind to, he made himself master of with ease . . . The most heavenly gifts seem to be showered on certain human beings. Sometimes supernaturally, marvelously, they all congregate in one individual This was seen and acknowledged by all men in the case of Leonardo da Vinci, who had . . . an indescribable grace in every effortless act and deed. His talent was so rare that he mastered any subject to which he turned his attention He might have been a scientist if he had not been so versatile.

In that final remark, "He might have been a scientist," Vasari showed he had no idea of the depth and breadth of Leonardo's technical endeavors. The *known* areas of science and technology that Leonardo explored can be grouped into civil, commercial, military engineering, and architectural projects, involving aerodynamics, hydrology, meteorology, cartography, urban planning, and nature conservancy. Then there is mathematics and the fundamental sciences of physics, optics, astronomy, biology, botany, geology, and zoology. Anatomical and geological studies comprised his favorites. He was the father of paleontology and also the father of robotics. It is easier to list the areas of science and technology he did not investigate than those he did. He did not harness steam, electrical, solar, nor nuclear power. Nor did he formulate calculus, relativity, and quantum mechanics, leaving something for future generations. In the following, I will discuss a sampling of a few topics that are especially significant to understand Leonardo's universal genius.

Freud, in awe of Leonardo's legendary curiosity and achievements wrote in 1910:

> ... the great Leonardo remained like a child for the whole of his life in more than one way. It is said that all great men are bound to retain some infantile part. Even as an adult he continued to play, and this was another reason why he often appeared uncanny and incomprehensible to his contemporaries ... [he] was like a man who awoke too early in the darkness, while the others were all still asleep.

During the century that followed Freud's, so much more has come to light of Leonardo's vast universe.

LEONARDO, ENGINEER

LEFT: *Leonardo's CV, prepared for Ludovico Sforza, strongman of Milan. It is not known whether the letter was ever sent and the possibility exists that Leonardo was offered the job because of his prowess on the lyre.* RIGHT: *Leonardo's letter addressed to Sultan Bayezid II was discovered in 1952 in the archives of Topkapi Palace in Istanbul.*

A Pair of Curriculum Vitae

On two occasions, in c. 1481 and c. 1503, Leonardo submitted his curriculum vitae. Although he normally wrote his personal notes from right to left, in composing a formal letter to Ludovico Sforza in 1481, he showed that he could readily write from left to right in the normal manner that Italian vernacular is written. In the letter, he was applying for the position of a military engineer in the Sforza court. After a simple salutation, "Most Illustrious Lord," the letter continues:

> ... *having now sufficiently considered the specimens of all those who proclaim themselves skilled contrivers of instruments of war, and that the invention and operation of the said instruments are nothing different from those in common use: I shall endeavor, without prejudice to anyone else, to explain myself to your Excellency, showing your Lordship my secrets, and then offering them to your best pleasure and approbation to work with effect at opportune moments on all those things which, in part, shall be briefly noted below.*

The eleven items cited in the letter include a mix of his contraptions and skills, some already implemented, others still on the drawing board, "... design for extremely light and strong portable bridges, Scythed Chariots (to mow down enemy foot soldiers on the battlefield), armored carts (precursors of tanks), mortars, light ordnance ..." and "in times of peace, skills for city planning." Item 11 on the list appears as a throwaway line: "I also paint." He was offered the position in Milan, where he spent the better part of the next two decades designing machinery, and only occasion doing his art: *The Lady with an Ermine*, *The Musician*, two versions of *Virgin of the Rocks*, and the fresco *The Last Supper* belong to this period.

A Bridge for the Sultan

A tradition exists among historians in Turkiye that Leonardo was invited to Istanbul to paint a portrait of Fatih Sultan Mehmet (Mehmed the

Conqueror) but having recently received employment in Milan, he was unable to accept the commission in Constantinople. No documentation exists to corroborate this story. But we do know that Leonardo's contemporary, the Venetian painter Gentile Bellini, journeyed to Constantinople and painted the defining portrait of the sultan familiar to all Turks. Although some discrepancy exists in dates, Gentile Bellini's portrait of Mehmed hangs in the National Gallery of Art in London.

In 1500, after the French invaded Milan and imprisoned Leonardo's patron, Ludovico Sforza, Leonardo found himself out of a job. Accompanied by his mathematician friend Fra Luca Pacioli and his own feckless assistant Gian Giacomo Caprotti, otherwise known as Salai (1480–1524), he left Milan and set out on the road in search of new employment. He traveled east to Mantua and Venice and worked for a time in Venice as a military engineer. It was in Venice, it is believed, that they came into the circle of merchants trading with the Ottomans. Two decades after his letter to Sforza in Milan, he wrote a letter to Sultan Bayezid II of the Ottoman Empire—most likely hiring a scribe to write on his behalf. Ironically, the letter is written from right to left, in the manner of Old Turkish, but in a direction normal for him personally.

In the letter, Leonardo is seen applying for a position in the court of Sultan Bayezid II,[4] the son of Fatih Sultan Mehmet. The letter is dated July 3, although the year is not specified, it is now believed to be 1502. Leonardo proposes four separate projects, including a bridge over the Golden Horn, and concludes with a far more ambitious project, the possibility of a suspension bridge over the Bosporus:

- "I have a design for a gristmill powered by wind, without the need for running water."
- "I have developed a bilge pump to remove water without the use of ropes and pulleys."

Here, Leonardo has a hydraulic apparatus in mind, judging by the drawings found in his notebooks.

- "I, your faithful servant, understand that it has been your intention to erect a bridge from Galata (Pera) to Stambul . . . across the Golden Horn ('Haliç'), but this has not been done because there were no experts available. I, your subject, have determined how to build the bridge. It will be a masonry bridge as high as a building, and even tall ships will be able to sail under it." This bridge is the subject of the present story.
- "I plan to build a suspension bridge across the Bosporus to allow people to travel between Europe and Asia. By the power of God, I hope you will believe my words. I will be at your beck and call at all times."

In Sultan Bayezid's court, the letter was mistakenly attributed by a scribe to Ricardo of Genoa, instead of Leonardo of Florence. He did not get the job.

After viewing a special exhibition of drawings and replicas of Leonardo's inventions in 1996, Sand became transfixed by the beauty and modernity of a bridge Leonardo had sketched in a notebook believed to be a preliminary design for the Golden Horn.[5]

Vebjørn Sand is a contemporary Norwegian artist who divides his time between Oslo and New York. He approached the Norwegian Public Roads Administration proposing a partnership in building a variation of Leonardo's bridge in Norway. Finding a receptive audience willing to resurrect the half-millennium-old design originally planned for Turkiye and to implement it in Scandinavia had to be a pleasant surprise for him. Leonardo's design could be adapted for a pedestrian/bicycle bridge over Highway E-18, connecting Oslo and Bergen, in the town of Ås about 12 miles (20 km) southwest of Oslo. Leonardo's original specs for the Golden Horn would be scaled down to roughly one third for the new bridge. The roadway would measure 360 feet in length.

The Leonardo-Sand Bridge in Ås, Norway, 20 km (12 miles) west of Oslo on Highway E-18. The ultimate fusion of form and function, the bridge is a ⅓ scaled-down version of the original bridge proposed by Leonardo to Sultan Bayezid's Court. The graceful curve of the road surface and the parabolic support displays the "pressed-bow design." Photo shot from a drone befitting the spirit of Leonardo's obsession with flying machines. Credit Michael Atalay.

Between 1996 and 2001, the Leonardo Bridge Project team performed systematic design and structural load tests in close collaboration with architects and engineers. In preliminary studies, a Leonardesque stone bridge and a laminated wood version were developed and tested. In the end, the bridge was created as a steel-reinforced structure, comprised of laminated wood. In the creation of the Leonardo Bridge, precisely shaped components were prefabricated then assembled on the site employing modern cranes. A set of three parabolic supports was created for the bridge—a central component supporting the roadway, and a pair of parabolic components leaning into each other and bracketing the central parabolic component to stabilize it. The roadway rested on metal pillars of varying lengths (not visible in the photo). The bridge would have gained a great deal more attention if its unveiling had not coincided with the horrors of 9/11. But it had become familiar enough by 2005 that *Wired* magazine declared it "one of the five coolest bridges in the world."[6]

Recently, engineering students at MIT revisited Leonardo's bridge design to assess its weight-bearing capability.[7] They reviewed the possible materials and technology available five centuries ago, and even the geological conditions in the estuary. Then they built a model scaled down to 1:500 using 3-D printing technology to create the components. In their model, they employed only 126 blocks, but a full-size version would have required thousands. Leonardo hadn't specified the material for the bridge, but the MIT group concluded that stone blocks, precisely cut, could have withstood the forces exerted on the bridge.

The Pacifist Military Engineer

Among the weapon designs found in the codices are some that are derivations of Roman or medieval origins, and others original. The chariot with scythe blades protruding from the axles was an ancient Roman invention. The trebuchet and the colossal crossbow were medieval weapons. A drawing of a trebuchet specializing in catapulting carcasses of animals over city walls is clearly a weapon designed for biological warfare. A century earlier, Mongol invaders had propelled plague-ridden carcasses over city walls knowing that whatever deadly spirit they carried would

spread to the enemy. Leonardo's original designs for weaponry included a variety of cannons—a steam-powered musket, a mortar cannon, a multibarrel device evocative of the Gatling gun; the Wheelock (as a competing mechanism with the flintlock) to provide the spark to ignite gunpowder and discharge a lead ball; the submarine; pontoons to walk on water; and a diving bell. When Leonardo worked briefly in the employ of Cesare Borgia and his notorious warlord's diplomat Niccolò Machiavelli, he created the first ever topographic maps seen in history. These maps were part of a plan to divert the River Arno away from Pisa, denying its rival access to the sea.

Leonardo designed a shielded circular cart with multiple guns mounted radially, a tank, in his earlier years in Milan. This machine calls for a disclaimer. Although the drawing is unquestionably in Leonardo's own hand, it featured a faulty gear design. The crew of four men provided the muscle power, but the crank action by one pair of men would have worked against the crank action of the other pair. Rather than propelling it forward, the combined action would have just rotated the tank in its place. Over the years, speculations regarding the faulty design have ranged from simple oversight to an unintentional Freudian slip by the pacifist Leonardo. It could also have been a military engineer masking his industrial secret, ostensibly to confuse other manufacturers of the weapon.

Commercial and Civil Engineering Projects

Leonardo's *Codex Atlanticus* is housed in the Ambrosiana Library in Milan. Drawn between 1478 and 1519, the collection of 1,119 pages was first assembled into a single volume by sculptor Pompeo Leoni in the late sixteenth century. In 1796, after Napoleon successfully vanquished Milan, he added salt to the wound by demanding the priceless codex, along with *The Last Supper* and the *Laocoön* from the Vatican Museum—all as "war reparations."

Codex Atlanticus comprises four decades of Leonardo's intellectual musings, jam-packed with designs of machines including sketches for paintings, mathematics, the design for a double-hulled boat; locomotion in water by

rear and side-wheelers; portable bridge; swinging bridge; canal dredger; odometer; an anemometer for measuring wind speed; and a hygrometer for measuring humidity. There are city plans featuring streets at multiple levels and city maps allowing city growth in concentric circles, in some cases to quarantine the plague. Among his designs is a gear system to convert rotary motion into reciprocating motion and vice versa, machines for lens shaping and grinding, and machines for erecting tall posts. Also, there survives a variety of designs for odometers to measure land distances. Modern engineers would be impressed by an engineering drawing for a practical automatic transmission four centuries before the appearance of the automobile.

Human Flight

> *I have always felt it is my destiny to build a machine that would allow man to fly . . . There shall be wings! If the accomplishment be not for me, 'tis for some other.*
> —Leonardo da Vinci

The expression "preternatural vision" is still somewhat ambiguous as a faculty used in describing the ability to freeze motion in the manner of ultra-slow-motion cinematography. In the twentieth century the famed baseball slugger Ted Williams, rumored to have possessed an astonishing 20/3 vision (the ability to see twenty feet away as if it were just three feet), claimed he could see the seams on a baseball approaching him at over 90–100 mph. Leonardo's notebooks from 1485 onward abound in studies pertaining to human flight. He studied the aerodynamics of the wings of birds, declaring, "Why should humans not be able to do what the birds do!" In order to replicate the motion of bird wings, Leonardo designed human flying machines—a variety of strap-on *ornithopters* wings, frames most likely covered in canvas and controlled by pulleys, and an aerial screw with gears and rotary handles prefiguring the helicopter.[8] It would have been

impossible to actually raise a heavier-than-air-flying machine off the ground with human muscle power alone. But as gliders, they would have worked. Although I have personally never seen Leonardo's own words among the codices, an enticing quotation is attributed to Leonardo by aficionados of hang gliding: "Once you have tasted flight, you will forever walk the earth with your eyes turned skyward, for there you have been, and there you will always long to return." Did he make a glider and actually experience flight, or was this merely another pipe dream? Among his drawings is a rough sketch of a square pyramid-shaped parachute accompanied by numerical specs, in case one of the machines made it aloft but failed in flight.

> If a man has a tent made of linen of which the apertures have all been stopped up and be twelve braccia across and twelve in depth [a braccia is approximately 27 inches], he will be able to throw himself down from any great height without sustaining injury.⁹

Aeronautical engineers in the twentieth century have cited Leonardo's design of the parachute, awed by his prescience, though skeptical about its workability. A few years ago, Olivier Vietti-Teppa, a Swiss BASE jumper, traveled to South Africa, constructed Leonardo's parachute, carried it up in a helicopter, and made a jump. It works!

Prefiguring Robotics

The terms "robots" and "robotics" in the modern age bring to mind the multidisciplinary collaboration of mechanical and electrical engineering, constructed with plastic and alloy parts, digital and analog computers, perhaps controlled by artificial intelligence, and generally powered by electrical energy. Robots are used in dangerous jobs such as detecting and defusing bombs, squeezing through tight crevices under collapsed buildings and coal mines, or seeking hidden chambers in Egyptian pyramids. Robotic rovers sent to Mars and to a number of asteroids have performed chemical analyses in search of organic molecules—life. Following the nuclear reactor

meltdown at the Fukushima Daiichi, Japan, in 2011, robots were used in probing the radioactivity levels in areas where humans could not possibly have survived. While massive robots are used in welding and assembling substantial portions of cars, the da Vinci Surgical System is routinely used for delicate obstetric surgery. And robots of another class are used in replicating themselves.

Known for most of the twentieth century, Leonardo's drawing of a cart powered by coiled springs dates from around the time of Leonardo's first relocation to Milan. Impressive enough in its own right, it has been giving up its secrets especially since the dawning of the twenty-first century. Capable of performing linked activity guided by sensory feedback, Leonardo's cart is an early robot!

Around the time Leonardo was about to undertake the painting of *The Last Supper* (1495), Duke Sforza assigned him a task. He was asked to organize a pageant in Milan. Among decorations and contraptions for the event, Leonardo designed an automaton. Although the final product has not survived, detailed drawings and notes are found in the *Codex Atlanticus*. Operated by a series of pulleys, gears, cables, and weights, the machine is a fully functioning knight in armor—capable of sitting down, standing up, walking, moving its arms independently, raising its visor, and opening a door in its breastplate to pull out a surprise: a bouquet of flowers. Using Leonardo's drawings as blueprints, in 2002 engineer-roboticist Mark Rosheim built a prototype of the robotic knight and wrote a book about the project.[10]

LEONARDO, SCIENTIST

Prefiguring Copernicus: Heliocentric Picture

André Buys points to two quotations that offer clues to Leonardo's rejection of the Ptolemaic model in favor of the heliocentric, thirty years before Copernicus published his groundbreaking theory in 1543. (Of course,

Aristarchus of Samos had put forward the heliocentric universe in the third century B.C.E., but his theory was largely forgotten after the infant church embraced the geocentric picture.) Leonardo's words are revealing for their skepticism of the church's position:

> The earth is not in the center of the Sun's orbit, nor at the center of the universe, but in the center of its companion elements, and united with them. The sun does move . . . If you were standing on the moon . . . our earth would seem to reflect the sun as the moon does.

And in the following, Leonardo indicates tacit understanding of the gravitational force extending infinitely as was later demonstrated by Newton,

> Gravity is limited to the elements of water and earth; but this force is unlimited, and by it infinite worlds might be moved if instruments could be made by which the force could be generated.

Of course, Newton expressed the force mathematically, as decreasing with the inverse-square of the distance, something that Leonardo would not have known.

Prefiguring Galileo: Law of Free Fall and Trajectories of Projectiles

If there exists a faculty we can call "preternatural vision," Leonardo would have possessed it in spades, complementing his other attributes, those prodigious skills of observation and intuitive understanding of physical laws. From dropping objects from towers, he knew that their pace of acceleration downward was constant, independent of their weights, a principle not to be demonstrated by Galileo until a century later.

The trajectories of projectiles from the days when hunters and warriors first hurled spears and arrows at their targets have been of interest but perennially misunderstood. Artillery books published as late as 1615, almost

a full century after Leonardo's death, were still depicting trajectories of projectiles rising in straight lines at a variety of angles, losing energy and slowing down, reaching their highest point, their apogees, then flipping over and plummeting straight down. They had missed Galileo's demonstration of 1609 that trajectories of projectiles were parabolic curves. Almost 120 years before Galileo, Leonardo, in his drawings, had already shown clearly that the trajectories described parabolas, and that for different initial angles, the trajectories comprised families of parabolas of different apogees and ranges.[11] Again, their full mathematical description had to await Newton's publication of classical mechanics in his *Principia*.

The latest interdisciplinary foray into understanding Leonardo's pioneering work on gravitation was announced in February 2023. Morteza Gharib, a Caltech professor of aeronautical studies, succeeded in deciphering a series of triangular constructions in Leonardo's *Codex Arundel*. When the horizontal and vertical components representing the displacement in the droplets are plotted, they create a parabolic trajectory, revealing the constancy of gravitational acceleration.[12] Even with cruder tools and mathematics available to Galileo and Newton, Leonardo showed that acceleration due to gravity with less than 10% discrepancy compared with the modern value. Gharib published his results in a fascinating article in the journal *Leonardo*.

Prefiguring Newton: The Reflecting Telescope

Beginning in early 2000, I began collaborating with the late art historian and chemical engineer Thomas Somma in organizing a celebration of Leonardo's 550th birthday. We arranged for a six-week exhibition entitled *Leonardo: Artist, Scientist, Engineer* to open on April 15, 2002, at the Ridderhof Martin Art Gallery of the University of Mary Washington in Virginia. The celebrated art historian David Alan Brown, curator of Renaissance art at the National Gallery of Art in Washington, served as the guest curator for Leonardo's artistic endeavors. I served as the guest curator for Leonardo's science and engineering endeavors. The exhibition featured

replicas of Leonardo's inventions borrowed from the IBM Center,[13] along with several rare Renaissance-era books belonging to the National Gallery of Art. Also on display were two dozen copies of Leonardo's drawings I personally selected from NGA's collection of facsimiles from *Codex Atlanticus, Codex Arundel,* and *The Windsor Collection.*

At the event's formal opening on Leonardo's birthday, April 15, two of the guests were my good friends—Norman Ramsey of Harvard and William D. Phillips of the National Institute for Standards and Technology (NIST)—both distinguished Nobel laureates. As I gave them a private tour, I took them to view a special drawing in one of the cases. Ramsey and Phillips stared with rapt attention at one of the drawings, and in disbelief declared simultaneously, "That's the reflecting telescope!" Leonardo's drawing illustrated parallel rays of light falling on a semicircular concave mirror and their reflections all converging at "a focal point" that happened to be about half the radius of curvature of the mirror. That would be a century before Galileo's creation of the refracting telescope in 1609 that revolutionized astronomy and Newton's compact and yet far more powerful reflecting telescope created in 1671. "Construct glasses to see the moon magnified," Leonardo had written in the early 1500s.

André Buys, a professor at the University of Pretoria in South Africa, who had trained as a nuclear and mechanical engineer, is a telescope hobbyist. In Leonardo's study of parallel rays of light falling on a spherical mirror, the reflected rays converge at roughly one half the radius of curvature of the mirror, a rule used by modern telescope makers constructing long focal-length telescopes. After studying facsimiles of Leonardo's codices that offer clues for the design of the reflector, Buys replicated Leonardo's telescope. In his instrument, the cylindrical tube is mounted on a heavy wooden base, pivoted to swing approximately ±30° relative to a vertical axis. At the base of the tube is a concave mirror, produced by grinding a flat circular glass on one of Leonardo's grinding machines, also replicated for the project. To create the reflective surface for the mirror, he used a special bronze speculum, already in use in the fifteenth century. Leonardo had designed his mirror grinding machinery to be powered with

a foot pedal. Buys substituted a modern electrical motor for human power. Buys wrote:

> Leonardo had the knowledge and skills to make a telescope. He used a telescope to enlarge the image of the moon . . . and his telescope anticipated most of the later inventions, including Newton's and Herschel's . . .

Of course, there will always be some uncertainty: "Are we sure this is a telescope and not a mortar gun?" Buys's research, however, helps to establish the primacy of the astronomical telescope. He offers Leonardo's own words:

> To see the real nature of the planets, open the covering [roof] and note at the base one single planet, and the reflected movement of this base will show the nature of the said planet; but arrange that the base may face only one at the time.

Leonardo left a drawing of the full moon that virtually seals Buys's argument. At roughly 4:30 on the face of the moon in the drawing there appears a small, barely visible circle. Viewing the moon with the naked eye or even with commercial binoculars, the small circle cannot be seen. But larger modern telescopes pointed at the moon reveal the circle, now known as the Crater Tycho. NASA astronomer G. Reeves used Leonardo's drawing to determine the lunar libation to ±2° and calculated the time the drawing was created: it was in the early evening on December 12, 1513. The notebook happens to date from 1513–1514 when Leonardo lived in Rome.

DIVINA PROPORTIONE AND OTHER MATHEMATICAL MUSINGS

In the 1490s, Leonardo persuaded Duke Sforza into hiring the Franciscan friar Luca Pacioli as a mathematics tutor for the Duke's children. Leonardo, meanwhile, put aside his paintings in order to personally learn additional

mathematics from the friar and collaborated with the friar to create a book, *Divina Proportione* (Divine Proportion). Pacioli wrote the text and Leonardo produced the sixty illustrations of polyhedral solids—variations on platonic solids, truncated and stellated versions, seen as transparent solids in the manner of modern Lucite structures. In the book, Leonardo also illustrated the proportions for the idealized human face, and, using a straight edge and compass, introduced a new font.

The mathematics he learned from Pacioli reinforced his earlier conviction that there was a purity and precision, a certain universality of mathematics, beyond that in any other subject. Like the great mathematicians and scientists who would appear in the following centuries, he expressed that wonderment:

> No human investigation can claim to be scientific if it does not pass the test of mathematical proof.
> He who does not understand the supreme certainty of mathematics is wallowing in confusion.
> Painting is a science and all sciences are based on mathematics. No human inquiry can be a science unless it pursues its path through mathematical exposition and demonstration.

Leonardo's pronouncement prefigured Galileo's words by a full century:

> Philosophy is written in this grand book, the universe, which stands continually open to our gaze. But the book cannot be understood unless one first learns to comprehend the language and read the letter in which it is composed. It is written in the language of mathematics, and its characters are triangles, circles, and other geometric figures without which it is humanly impossible to understand a single word of it.

Two Living Bodies [14]

Among all the sciences, geology and anatomy appealed deeply to Leonardo. He saw the massive body we inhabit as a living dynamic organism and he saw

the human body as a dynamic organism. Leonardo exhibited a dual passion for geological–paleontological subjects and for anatomical–physiological.

During the eighteenth and nineteenth centuries, naturalists began to realize that the fossils they had been collecting were actually the remains of ancient animals and plants and that the state of terra firma as they saw it was just a passing phase of the planet. The agents for change were the natural forces of rain, wind, and sunlight, along with rivers transporting silt and debris and depositing them downstream. Sedimentary rocks, seen in layers known as strata, represented the geological history of the earth—the older rocks underlying the younger. The concept of studying layers, stratigraphy, is useful for establishing relative dates of cultures in an archaeological excavation, and is also useful in establishing relative dates of the earth.

During the sixteenth and seventeenth centuries, the church was at war with itself and with a new breed of rationalists; and the rationalists were also at war with one another. With the Scientific Revolution already under way, the 1650s saw the Irish cleric James Ussher publish his chronology, pinning down biblical Creation to a precise time: 6:00 P.M. on October 23 in 4004 B.C.E. But while Newton was well on the way to establishing himself as history's supreme scientist, as he systematically unraveled the secrets of the universe, he was also engaged in the not-so-scientific practice of searching for clues in the scriptures to confirm a biblical timeline.

In 1859, Darwin, with an equal mixture of conviction and trepidation, publish his magnum opus, *On the Origin of Species*. This was a highly controversial theory of evolution by natural selection, promulgating the notion that organisms change over time as a result of changes in heritable physical or behavioral traits. Darwin postulated that organisms that better adapt to their environment have a better chance to survive; and in the process have more offspring, enhancing the opportunity to propagate their offspring.

In 1861 Darwin acknowledged Jean-Baptiste Lamarck as a "forerunner of evolution." But he had no idea that Leonardo offered a conjecture regarding the necessity of evolution three hundred years before Lamarck. Leonardo had speculated, "Nature, being inconstant and taking pleasure in creating and continually producing new forms, because she knows that

her terrestrial materials are thereby augmented, is more ready and more swift in her creating than is time in his destruction."

Over five hundred years ago, Leonardo was engaged in his own systematic interrogation of nature. He made numerous observations on plains, cliffs, mountains, and rivers. In his Milan days, he explored caves high on Monte Rosa in the Apennine Mountains of northern Italy and found fossilized seashells (most likely Cenozoic era mollusks), fish bones, and unusual and massive animals. He claims in his notes that a group of peasants, aware of his curious interest in fossils, brought him a sack of fossilized seashells. By pondering the body of evidence, he came to a series of astonishing conclusions foreshadowing modern geology and paleontology:

> The stratified stones of the mountains are all layers of clay, deposited one above the other by the various floods of the rivers ... In every concavity at the summit of the mountains we shall always find the divisions of strata in the rocks ... it must be presumed that in those places there were seacoasts, where all the shells were thrown up, broken, and divided [pulverized].

The seashells and fish had to be the remains of animals that sometime in the distant past swam at sea level. He found completely inadequate the claim that these were all the residue deposited by the biblical flood. Accordingly, where once there was sea, now there is land. The surface of the earth must have changed dramatically over time and will continue to change. Leonardo wrote, "The shells in Lombardy are at four levels, and thus it is everywhere, having been made at various times."

King Charles III, formerly Prince Charles of Wales, who does not get enough credit for his work for historical preservation in the United Kingdom, fully appreciates the treasure housed in the Royal Collection at Windsor Castle. As Prince Charles, speaking on behalf of the royal family, he explained in a foreword for a recent book by Francis Wells, *The Heart of Leonardo*:

The Royal Collection is immensely fortunate to hold the finest surviving group of drawings by Leonardo—over five hundred sheets, which have been together since Leonardo's death and were probably acquired by King Charles II in the seventeenth century.

Wells is an eminent British cardiac surgeon at Cambridge's Papworth Hospital who has performed numerous open-heart operations, including hundreds of successful mitral valve repairs and replacements. He claims his own surgical procedures were inspired by Leonardo's general modus operandi and his five-hundred-year-old studies of the heart. In the book, Wells presents a detailed analysis of Leonardo's studies, most of the illustrations having been chosen from Leonardo's two hundred exquisite anatomical drawings among the five hundred comprising the *Codex Windsor*.

Leonardo's anatomical drawings far surpass[15] in quality and insight those found in Flemish anatomist Andreas Vesalius's *De humani corporis fabrica libri septem* (1543). Vesalius, after receiving training in medicine at Europe's finest medical school, the University of Padua, had published the set of illustrated medical books that revolutionized the medical component of the Scientific Revolution.

Englishman William Harvey (1578–1661) received the degree of a Doctor of Medicine from the University of Cambridge before starting additional training at Padua. An ardent royalist, he became the private physician to the hapless King Charles I, and in that role, he could not avoid becoming embroiled in the English Civil War. When the king took up asylum in the royalist stronghold of Oxford, Harvey also relocated to the university town, continuing as the king's physician on the side, accepting the post of warden of the university's Merton College. Harvey focused much of his research on the mechanics of blood flow in the human body. Most physicians of the time felt that the lungs were responsible for moving the blood throughout the body.

Harvey's masterpiece, *Exercitatio Anatomica de Motu Cordis et Sanguinis in Animalibus* (commonly referred to as *de Motu Cordis*), was published in

Latin in Frankfurt in 1628, when Harvey was fifty years old. The first English translation did not appear until two decades later. Harvey, observing still-beating hearts in living animals in surgery, was able to see that systole was the active phase of the heart's movement, pumping out the blood by its muscular contraction.

Harvey's contemporaries believed the blood to be continually formed anew from digested food, to be dissipated and used up in the tissues, and regarded the primary function of the heart to be the production of heat. Harvey also used mathematical data to prove that the blood was not being consumed—in short, that there was a conservation principle of blood operating in the living body. It is unfortunate that Harvey did not come out strongly against the practice of bloodletting, commonly practiced at the time and through the next 150 years.

A hundred and fifty years earlier, Leonardo was performing anatomical studies on cows, horses, and small animals. He claimed to have performed postmortems on thirty human cadavers. Wells, in a brief chapter on the history of anatomy, mentions that the practical time for dissection of bodies was the winter, reducing the fetid conditions accompanying warm temperatures. He also mentions that finding bodies to do sanctioned study involved criminals convicted of unusually serious charge, preferably from faraway lands, and non-Catholics (preferably of Jewish descent).

The story, both engaging and endearing, involved Leonardo's postmortem on an old man. In first encountering the man in a hospital, Leonardo asks, "How old are you?" The man responds, "I don't know, but my grandson is fifty-eight." Leonardo realizes the man is a centenarian. But when the man suddenly dies with a smile on his face, Leonardo wonders: "How can anyone die happy?" "I felt compelled to do an anatomy of him." Regarding the vessels leading to the heart, he describes them as "brittle and clogged." As a counterpart to the old man, when he has a chance to do a postmortem on a child, he characterizes the same vessels as "clear and supple." Leonardo had discovered atherosclerosis, or hardening of the arteries, four centuries before Viennese surgeons described the life-threatening condition.

Recognition of the circulation of blood with the heart serving as a pump, the valves serving as unidirectional gates, are in line with his understanding hydrological pumps. His drawings of the vital organ suggest that he understood the purpose of the heart as a muscle pumping blood through the circulation system of the body.

It has been five hundred years since Leonardo died. Modern scholarship estimates that only 20–25% of his notes and sketches have survived. What other projects in science and technology he had conceived were jam-packed into those missing notes, we shall never know. We, his successors, may or may not have reconceived them all independently. His interests and discoveries in the sciences alone were every bit as expansive as his general interest in everything. He claimed plans "to write 120 books." He did not write any books, although he illustrated *Divina Proportione* for his mathematician friend Luca Pacioli, but he is not even acknowledged in the book. A hundred years after his death a book was published, *The Art of Painting*, based on notes Leonardo left behind. But since he did not publish in his own time, he did not influence any of these fields appreciably. This is part and parcel of the tragedy of Leonardo.

Ironically, in his scientific and technological innovations, the man who made a career of inventing the future failed to influence the future. How tempting it is to speculate that if his discoveries had found their way into the hands of competent scientists and engineers, the Scientific Revolution could have been launched thirty years before Copernicus and Vesalius and the Industrial Revolution could have been advanced by two or three centuries. It is also tempting to speculate that if Newton had not lived, science and technology may have been delayed by two or three centuries. Such is the power of the transformative genius.

Precisely because he was equal parts artist and scientist, one might characterize Leonardo as the ultimate master of form and function. His product had to look good and it had to function well. The academic year 2008–2009 saw the birth of a new program at Virginia Commonwealth University (VCU) in Richmond, Virginia, known as the Da Vinci Center for Innovation in Product Design and Development. A succinct description

of the center's mission appears on its website: "A collaboration of VCU's Schools of the Arts, Business, Engineering and College of Humanities and Sciences, the VCU da Vinci Center is a unique collegiate model that advances innovation and entrepreneurship through cross-disciplinary collaboration."[16]

Then, on the occasion of Leonardo's 557th birthday (April 15, 2009), the center celebrated the first year of its founding with me as keynote speaker, followed by a demonstration by graduate students who had participated in a joint project: the design and construction of an affordable hospital gurney/operating table, foldable and compact, to be used in Bangladesh and other developing nations. Ultimately, the center's modus operandi embraces Leonardo's type of lateral thinking to unite separate disciplines for the greater good of humanity.

It is an obvious truism that we judge ourselves by what we think we can do while others judge us by what we have done. In Leonardo's case, there was no false modesty when he wrote, "I have offended God and mankind because my work didn't reach the quality it should have."

Leonardo prefigured Copernicus's understanding of the heliocentric universe by 30 years, Galileo's discovery of constant gravitational acceleration by 110 years, Harvey's theory of the circulation of blood by 120 years, Newton's creation of the reflecting telescope by 160 years, Darwin's theory of evolution by 350 years, Viennese surgeons' recognition of atherosclerosis by 400 years, and robotics by 450 years. And yet, on his deathbed, he would turn to his assistant Melzi and muse, "Did anything get done?" Meanwhile, we stand in awe and wonder, "Were there a dozen different supreme geniuses all using the same name, 'Leonardo da Vinci?'" Was the greatest mind of the Renaissance also the greatest genius of all? After all, he did have a significant advantage.

Leonardo da Vinci was like a man who awoke too early in the darkness, while the others were all still asleep.
—Sigmund Freud

9

INTERROGATING NATURE: BECOMING MODERN

If a man will begin with certainties, he shall end in doubts; but if he will be content to begin with doubts he shall end in certainties.
—Francis Bacon

In Copernicus's landmark 1543 book, *De revolutionibus orbium coelestium*, the word "revolution" shifts man's understanding of the universe from a picture in which the sun and the planets revolve around the earth to one in which the earth and the *other* planets revolve around the sun; i.e., from a geocentric to a heliocentric picture. In the broader sense, however, the word has assumed a much broader meaning, not just a physical revolution of one body around another but a fundamental change in understanding, a dramatic shuffling in organizational and social structures, an upheaval in political power, and all this in a relatively short time. History has seen numerous revolutions, among them the Scientific and Industrial Revolutions, the American, French, and Communist Revolutions, and it has seen counterrevolutions. There are revolutions, and there are revolutions. All revolutions are not equally consequential.

Israeli historian Yuval Noah Harari opens his book *Sapiens*[1] by identifying three monumental revolutions in the ascent of humanity. The first of these is the **Cognitive Revolution** of 70,000 years ago when our direct ancestors, *Homo sapiens*, developed the cognitive faculty that enabled them to engage in shared tasks. They could hunt large game; assemble in larger groups than before; they could observe, introspect, speculate, and articulate their observations. They could create cultures, invent religions, and formulate ideas. Much, much later, they would formulate the ideas that are described by the modern suffix "-ism": feudalism, capitalism, Marxism, socialism, feminism, and globalism.

Harari identifies a second revolution of comparable significance in the **Agricultural Revolution** that took place 10,000–11,000 years ago when the wild grain einkorn was first harvested near the Dead Sea around Jericho. An important discovery made in 1994 is the Neolithic temple complex at Göbeklitepe (potbelly hill) in southeastern Turkiye dating from 12,000 years ago, suggesting that the establishment of religious centers preceded the invention of farming, and human settlements. By 7500 B.C.E., proto-cities began to spring up. The largest among them was the Neolithic Çatalhüyük with a population of 5,000–10,000 inhabitants and located in south-central Turkiye. In ascending order of complexity, kingdoms, empires, and civilizations would follow.

Other significant developments to mark on a timeline would be a number of civilizational achievements: the emergence of Sumer in Mesopotamia (now Iraq) as the first nation in history, c. 4000 B.C.E.; the invention of writing by the Sumerians, c. 3500 B.C.E.; the construction of the first Egyptian pyramids, starting with the Step Pyramid of Djoser in Saqqara, 2640 B.C.E.; the Golden Age of Greece or the Age of Pericles, mid-fifth century B.C.E.; the unification of the states of China by Qin Shi Huang, third century B.C.E.; the birth of Christ between 6 B.C.E. and 4 B.C.E.;[2] the invention of paper by Ts'ai Lun in the beginning of the second century C.E.; the Italian Renaissance of the fourteenth to sixteenth centuries; the Enlightenment of the eighteenth century; World Wars I and II in the twentieth century; the harnessing of nuclear energy; and the Digital Revolution.

The Third Revolution

According to Harari, the third grand-scale revolution in writing the human story, and the subject of this chapter, is the **Scientific Revolution** of five hundred years ago.

Artistic expression, whether in the plastic arts, music, or literature, is much older than science. About the therapeutic effects of literature, Rudyard Kipling wrote, "Words are, of course, the most powerful drug used by mankind." We can readily expand Kipling's metaphor of the therapeutic effects of literature, bibliotherapy, to encompass other forms of arts. We sometimes say that a love of the arts brings intrinsic beauty and pleasure to our lives as humans and that it plays a civilizing role. We recognize that it enhances self-esteem, instills good aesthetic values, and gives us pride in the accomplishments of our species. And we know that throughout history, music has been used successfully in treating illness.

Although we believe in our hearts that there is a curative and ennobling power of the arts, it is difficult to quantify music's effects. Nonetheless, as we saw in chapter 4, physiologists found certain pieces of music composed by Bach, Beethoven, and Rossini actually lowered one's blood pressure. The same methodology employed in gathering scientific evidence of the salutary effects of music could be extended into investigating the effects of art therapy and bibliotherapy also.

The sciences, in distinction to the arts, seek actively to improve the physical quality of life and to assure greater safety and security. Aside from the fact that intrinsic beauty does exist in science and the mathematics that underlies science, the outcome of scientific research is readily quantifiable. The curve describing the increase in life expectancy closely parallels curves for energy production and consumption. We have learned to understand the universe through science and not through art, nor through religion. In the case of science and religion, the late Harvard paleontologist Stephen Jay Gould summarized the nonoverlapping magisteria of the two cultures: "Science gets the age of rocks, religion gets the rock of ages . . . Science explains how the heavens go, religion tells you how to get to heaven."[3] On

the negative side, science misused is far more dangerous than art misused. We see the negative aspects of science and technology manifested in arms races, especially for weapons of mass destruction.

A frequently cited incident in the history of science classes is an exchange that took place in 1959 at the University of Cambridge. The celebrated British scientist and writer C. P. Snow was delivering the annual Rede Lecture when he mentioned the existence of two intellectual cultures—the culture of the humanist and the culture of the scientist. Then he paused and began to lament the sad state of affairs that communication between the two groups is strained at best and nonexistent at worst. The humanists in the audience protested loudly, "Science is not a culture!" Exactly forty years later, in its December 1999 issue, *Time* magazine recognized the twentieth century as the "Century of Science." It makes little sense to deny that science is indeed a culture: it has a different language and methodology. Moreover, we can now posit the existence of a third intellectual culture, computer science, which despite its name is neither a natural science nor one of the humanities. It has pervaded every aspect of our societal fabric and it is here to stay. Science, judiciously practiced, enhances the quality of human life! America catapulted ahead of the rest of the world in the twentieth century after droves of scientists migrated from Europe in the 1930s, just as China is racing to do in the twenty-first century. Like nuclear science, the rapidly expanding applications of artificial intelligence promises both good and evil to human quality of life.

THE BIRTH OF NATURAL PHILOSOPHY

Two centuries before the iconic trio of Greek philosophers, Socrates, Plato, and Aristotle, appeared, there were the pre-Socratic philosophers, most prominently Thales of Miletus, whom Aristotle acknowledged as the "father of Greek philosophy" and as "the first natural philosopher," a true scientist. Thales established an academy in Miletus that trained other natural philosophers, including Anaximander, Anaximenes, and Pythagoras. He was a

formidable genius who deserves much more space in this book than I can possibly give him. He is known for the pronouncement "natural phenomena can be explained by natural laws. The gods cannot be credited [or blamed] for what happens in nature." With that statement, Thales showed he understood the existence of laws governing natural phenomena, what we would now call the "laws of physics," "the laws of chemistry," "the principles of biology."

The only date we have for Thales with any degree of certainty is a solar eclipse he predicted on May 28, 585 B.C.E.[4] Imagine the power any mortal could wield by forewarning people that the sun would be blotted out by the moon in the middle of the day! That eclipse, by the way, is one of the few definite anchor dates we know of in the ancient Mediterranean world. According to historian Herodotus, the eclipse was interpreted as an omen for stopping the battle between the Medes and the Lydians.

Three hundred years after Thales, another natural philosopher, Aristarchus of Samos, made two complementary discoveries: first, that the earth possessed a spherical shape, and second, that it was a planet like the other known planets, Mercury, Venus, Mars, Jupiter, and Saturn, all revolving around the Sun, the *heliocentric picture*. In the process, he prefigured Copernicus by 1,800 years. His professional life in Alexandria overlapped with that of a younger colleague, Eratosthenes of Cyrene, who measured the circumference and the radius of the earth with tolerable accuracy, close to the values accepted now of 40,000 km (25,000 miles) and 6,400 km (4,000 miles), respectively.

Unhappily, the theories of the more famous natural philosophers, Aristotle, Hipparchus, and, later, Ptolemy, held sway. When the infant church embraced the *geocentric* model over Aristarchus's *heliocentric*, the correct picture fell into a two millennia period of dormancy. With apologies to medievalists who are loath to call the Middle Ages a dark time in human history, we can safely say that the sciences, during the period spanning the fall of Rome to the flourishing of the Italian Renaissance, were at least in a partial eclipse of a much more enlightened period in human history. Greeks had been excellent scientists and mathematicians. The Romans, who were surpassing builders during their glory days, regarded the Greek devotion to pure science and mathematics as effete musings of a burned-out

civilization, unlike their own. Accordingly, while science was on the rise and peaked during the Golden Age of Greece, it plummeted during the early Christian era and remained on a dismal flat line. After the collapse of Rome, the Byzantine or Eastern Roman Empire flourished for another thousand years. And yet no meaningful scientific discoveries date to this millennium. Technology, on the other hand, maintained a gentle monotonic rise both in the Roman era and through the medieval age.

The foregoing suggests that science and technology can develop independently. It is only when science and technology were coupled following the Scientific Revolution, however, that a healthy synergy blossomed, leading right into the Industrial Revolution. Science and technology began to drag each other upward at an ever-accelerating pace. In the past two to three centuries, it has become virtually impossible to do science without technology and to do technology without science.

With the Scientific Revolution our ancestors began to understand the world, to use science to improve their lives, and begin their ascent to modernity. Thus, this epoch is more significant than all other great ages of man—more significant than the Egyptian, Chinese, Greco-Roman, Byzantine, Mesoamerican, Ottoman, and the Italian Renaissance.

A pair of books published in 1543 serves as dual cornerstones for this revolution. The first book, *de Revolutionibus*, was of course the masterwork of Nicolaus Copernicus (1473–1543). He was born in Torun, in the Prussian kingdom of Poland, and educated in mathematics and astronomy at the University of Padua. He returned to Poland where he received his doctorate in canon law and ordination as a Catholic priest. He wrote his defining book while serving as a faculty member at the Jagiellonian University in Krakow. Fearing retribution from the church, however, he delayed the book's release until he knew he was on his deathbed. Of course, the thesis of his book was actually a rediscovery of Aristarchus. *De Revolutionibus* represented a first step in revolutionizing astronomy. How humbling for humans to find themselves demoted from their hallowed position as God's special creatures at the center of the universe to one in which they might be inhabitants of just another world!

The second monumental book published in 1543 was the *Fabrica*, short for *De humani corporis fabrica libri septem* (*On the Fabric of the Human Body in Seven Books*). The magnum opus of Andreas Vesalius (1514–1564), it would revolutionize human anatomy and medicine. Born in Flanders, Vesalius received his training as an anatomist and physician in the medical school of the University of Padua, one of just two institutions in Italy granted Papal sanction to carry out anatomical studies on human cadavers. The recently built operating theater was ideal for medical students to witness procedures being performed in the operating pit. Of course, the actual surgery would still be the responsibility of a barber-surgeon moving around inside the pit, following instructions given by a professor of surgery sitting on a high chair in the pit. The professor himself would not physically participate in the surgery.

Unlike the other physicians, however, Vesalius personally performed the surgical procedures, while Jan Stefan van Calcar, a Neapolitan artist trained by Titian, created the illustrations with the precision demanded by Vesalius.

The operating theater of the University of Padua's Medical School where Vesalius received his training and where he later taught. In an adjacent building is the lecture room where Galileo developed some of his theories in classical mechanics and gave lectures during eighteen years of his tenure on the faculty.

The publication of the *Fabrica* brought Vesalius instant fame. He was promoted to the post of imperial physician, serving as personal physician to Charles V and later to Charles's successor, Philip II. With celebrity came new license, the permission to perform demonstrations on cadavers in front of church and city dignitaries.

In 1564, one of his demonstrations had catastrophic consequences. The subject of the autopsy, a young prince who had just passed away, was laid out on the operating table. The initial atmosphere of morbid curiosity filling the operating theater suddenly gave way to bone-chilling horror when Vesalius cut into the subject's chest and found the man's heart still beating. Shrill voices rose from the audience: "The devil!" howled one. "Burn him . . . burn him at the stake," shrieked another. Vesalius was led away and jailed, but before he could be brought to trial, Philip II (1527–1598), of the Grand Armada fame and an admirer of the surgeon, stepped in with an order diffusing the crisis. "Send him to the Holy Land for spiritual redemption!" Vesalius was released and departed for Jerusalem immediately. After completing his purification, he boarded a galleon for a return to Italy. Alas, the ship on which he was sailing was wrecked off the coast of the Ionian island of Zakynthos.

There he contracted a fatal illness and died, just short of his fiftieth birthday. The entire episode would serve as a setback for future anatomical research on the Italian peninsula. Then in 1600 another serious setback to science occurred when Giordano Bruno, a Dominican friar, was burned at the stake in Rome for publishing an endorsement of Copernicus's views (and even going beyond them with his own wild speculations, including the notion that stars were distant suns and the existence of extrasolar planets that might harbor life). But his ideas included the outlandish: the attribution of souls to inanimate objects. An even more serious charge was his flagrant denial of the divinity of Christ, the doctrine of eternal damnation, the virginity of Mary, and the validity of the Trinity. The Inquisitors had had enough. They burned the annoying friar alive in the marketplace Piazza Campo de' Fiori in Rome on February 17, 1600. Three centuries later, the Freemasons erected a larger-than-life bronze statue of the hapless friar at the very spot of his execution.

Giordano Bruno, his face forever shaded by his hood, stands on a high pedestal in the Campo de' Fiori, Rome. Erected in 1889, the bronze statue is located at the spot where Bruno was burned at the stake three centuries earlier. Sculptor Ettore Ferrari's unrepentant monk faces the Vatican. Photo credit: Tiziana Belli.

The story of the banishment of Vesalius and the memory of Bruno's immolation would serve as a damper on the creativity of one of history's greatest scientists, Galileo. The Tuscan, described as the first modern scientist, published his observations in terrestrial physics—including the motions of balls rolling, sliding, falling, thrown, or oscillating harmonically on a spring or a pendulum. He launched blocks of wood off horizontal tabletops, plotted their trajectories, and demonstrated that projectile motion was parabolic in shape. He dropped darts from the Leaning Tower and introduced the notion of acceleration (in distinction to velocity), which

he found was a constant independent of the weight. These discoveries, described mathematically, brought Galileo fame and scientific authority.

When he heard through the scientific grapevine that the Dutch lens maker Hans Lippershey had constructed a "spy glass" (1608) comprised of tube and a combination of lenses, a refracting telescope, Galileo set out to make his own version. Without the detailed specs of Lippershey's device, Galileo had to improvise, and indeed to develop a more powerful model. Carrying his device to the top of the Campanile of Venice, he reported approaching merchant ships and made a tidy fortune from patrons.

He was the first to recognize the astronomical potential of the telescope. When he improved the device's magnifying power twenty-fold and turned it at the night sky, however, the tide began to turn against him. It was the celestial observations—the craters and *mare* (seas) on the moon, sunspots, multiple moons orbiting Jupiter, "ears" on Saturn (shown later by Cassini to be rings), and phases of Venus—that began to put him at odds with the church. The clerics insisted that heavenly bodies had to possess smooth surfaces and only the earth could have a moon. When Galileo asked them to take a glance through his telescope, they politely declined, insisting he had faulty vision. It was not necessary to look!

At the Museo Galileo Museum of the History of Science in Florence, where many of his instruments are preserved, emblazoned on a wall, his words read: "All truths are easy to understand once they are discovered; the point is to discover them." In 1623 Galileo became convinced, as Archimedes had insisted eighteen centuries earlier, that mathematics provided the pillars on which natural law rested. He wrote:

> Philosophy is written in this grand book, the universe, which stands continually open to our gaze. But the book cannot be understood unless one first learns to comprehend the language and read the letter in which it is composed. It is written in the language of mathematics, and its characters are triangles, circles, and other geometric figures without which it is humanly impossible to understand a single word of it.

Meanwhile, in northern Europe, far from the reach of the church inquisitors, the German polymath Johannes Kepler, mathematician-astronomer-astrologer, had been seeking to answer questions on planetary motion. Having heard that the Danish astronomer Tycho Brahe was in possession of the best data in Europe and had recently relocated from his observatory on the island of Hven to Prague, Kepler set out in pursuit of the data. He applied for work as the astronomer's assistant and, in fact, spent 1600–1601 with Tycho. But soon he discovered that the astronomer was averse to sharing his data, especially with someone with greater mathematical skills than his own. Kepler, unable to lay his hands on the Brahe's data, became disheartened and prepared to leave. But during a banquet Brahe hosted for another nobleman, he experienced an urge to go and relieve himself. The common dilemma suggested either he should force himself to hold it in, or to excuse himself and possibly insult his guest. Brahe chose badly. In forcing himself to stay, he suffered a burst bladder that ultimately led to his death. Alas, Kepler saw his opportunity and stole the data. One account has Tycho whispering to Kepler with his dying breath, "Don't let my life seem to have been in vain." Kepler's larceny proved that, occasionally, crime is justified for the greater good.

In possession of Tycho's data, Kepler immediately set out on a mission to answer the questions, "Do we live in a geocentric or a heliocentric universe, are the orbits circles or retrograde trajectories?" During the course of a dozen years, he succeeded in determining the proper trajectories of the planets. He published his three laws of planetary motion, the first two coming quickly, the third after a full decade of analysis:

(1) The planets, *including the earth*, revolve around the sun in elliptical orbits, with the sun at one of the two focal points of the ellipse. (There is nothing at the other focal point.)

(2) The areas swept out by a planet's radius vector (a line connecting the center of the planet to the center of the sun) are equal in equal periods of time; i.e., the constancy of areal velocity (in the language of calculus still to come), as $dA/dt = Constant$.

(3) The square of the period of a planet's orbit varies directly as the cube of the mean radius of the orbit. ($T2 = CR3$, where C is a constant). As an example, Saturn's distance to the sun is ten times that of the earth's distance to the sun. Cubing the 10 yields 1,000; taking the square root of 1,000, yields the period, T, as 32 years (i.e., it takes Saturn 32 Earth years to sweep out an orbit). Similarly, Kepler's third law predicts periods for Mercury of 88 Earth days, Venus of 243 Earth days, Mars 2.02 Earth years, and Jupiter 12 Earth years, all correct!

The planets were other worlds, just as Copernicus, Galileo, and Kepler, as well as the obnoxious Bruno had all claimed. Galileo and Kepler, in their correspondence, expressed mutual admiration for each other as "fellow Copernicans," members of a small fraternity of astronomers who recognized a new world order. However, when Kepler asked Galileo if he could borrow one of his telescopes, Galileo decided not to honor the request. The German was much too astute a mathematician, even better than he.

With Martin Luther himself no fan of science, Kepler was denounced by the Protestant leaders of Europe, but was never seriously threatened with bodily harm by the clergy. Galileo, on the other hand, felt the full wrath of the Roman Catholic Inquisition. After being so badly shaken by the Reformation, the Catholics were not about to tolerate any more heresy. The church had already dealt with Bruno and was chomping at the bit to take on new challengers to its authority. After journeying six times to Rome on invitations from the Inquisitors and each time meeting increased hostility, Galileo could only save himself by undergoing a last-minute conversion, lest he too met the fate of Bruno. He was now a believer in the church-sanctioned geocentric picture! Addressing the Inquisitors, he swore that he "abjured, cursed, and detested [his] earlier teachings, and would never repeat them again." The components of his punishment varied, from the lightest, "reciting the seven penitential psalms once a week for three years," to the heaviest, "living his last years under house arrest [it turned out to be eight to nine years]." He died in Florence in 1642, a frustrated, blind, broken man. His reckless practice of viewing sunspots through a telescope had done permanent damage to his retinas.

> As a religious heretic, Galileo was buried outside the city walls of Florence. Ninety-five years later, he was partially forgiven and brought back into the city for burial in the Chiesa Santa Croce, where other great sons of Florence were buried, among them Dante, Michelangelo, and Machiavelli. However, in the disinterment process, two of the fingers from his right hand were separated, but fortunately preserved. They are now displayed under glass in the Galileo Museum of the History of Science in Florence. Mounted vertically, the middle finger points toward the heavens. Galileo's adoring daughter, the nun Sister Virginia, was also buried in Santa Croce near her father.

At the threshold of the seventeenth century, in England, the spirit of exploration of the New World that had begun late in the lifetime of Queen Elizabeth I was beginning to spread into an entirely different realm. Perfumed dandies, gentleman scientists, were beginning to emerge and undertake the exploration of nature in a country that had been the scientific backwater. The zeitgeist of the Elizabethan–Jacobean era that produced great literature was also a salutary time for science. In 1600, the same year that Bruno was executed in Rome, Cambridge-educated William Gilbert (1544–1603), physician to the queen, published the results of systematic experiments he had been carrying out on lodestone and other ferromagnetic materials. His book *De Magnete* was not only the first to explore the physical phenomenon of magnetism, it was the first book devoted exclusively to experimental science.

Interrogating Nature

Even more than any monarch, clergyman, or scientist, it was an Elizabethan lawyer, Sir Francis Bacon (1561–1626), who planted the seeds for the new zeitgeist fueling the Scientific Revolution. A contemporary of Shakespeare, Bacon could have listed on his CV "jurist, statesman, courtier, scientist, philosopher, orator, and essayist." Having been

homeschooled as a child, in 1573 he matriculated at Trinity College, Cambridge. He was twelve. It was as a student at Cambridge that he was first introduced to Queen Elizabeth I. She was impressed by the adolescent prodigy but did not reward him in any way. At the accession to the throne of James I in 1603, Bacon, at forty-two, began his meteoric rise. He was showered with accolades, appointed to the office of Attorney General in the King's Privy Council, and later to the Lord Chancellorship of England.

It is neither as a statesman, nor as a scientist, but as a philosopher of science that Bacon will be remembered. In fact, as a statesman, he had mixed success. To his credit, upon the settlement of Jamestown in 1607, Bacon became a vocal advocate of Britain colonizing the Virginia colonies, thereby joining Portugal, Spain, and Holland in the business of exploration and colonization. A decade later, however, he was accused and brought to trial for accepting a bribe. He had a short stay in the Tower of London and barely avoided a much longer stay in debtor's prison when the Crown stepped in and paid his fine of £40,000. After the scandal that dishonored him, he sought redemption by turning to epistemology and his true calling as a writer, declaring, "Knowledge is power." He identified a "pair of books" of crucial importance to humans: *Nature* and *The Scriptures*. To disarm the religious fundamentalist, he added, "In order to glorify God, you have to learn *His* way . . . [by] understanding nature." In the refined language of his profession, legalese, he described the process as "interrogating nature . . . and questioning it in the court of the mind."

Bacon's call for systematic experimentation, in distinction to Aristotle's less than enthusiastic embrace of the practice, established his own moniker, "The Father of Empiricism." For the process of carrying out the interrogation, in his book, *Novum Organum* (1620), he proposed the use of inductive reasoning, where the sequence of steps called for a "bottom-up" approach, from specifics to generalization. In this, he was challenging the Greek divine, *"the Philosopher"* (Aristotle). He stressed that explanations of natural phenomena had to be devoid of religious arguments, reminiscent

of the pronouncement of the pre-Socratic Thales of Miletus. Ironically, as an actual scientist, Bacon himself was a failure. While trying to demonstrate that freezing meat (by covering it with snow) would help to preserve it, he contracted pneumonia and died.

DEDUCTIVE REASONING

The logical reasoning formalized by Aristotle, practiced by other ancient philosophers, and continued by scholastics through the Middle Ages was deductive reasoning. This form of logic is characterized by a sequence of "top-down" steps, from generalization to specifics. The process entails carrying out the sequence of steps: *theory > hypothesis > observation > confirmation*.

In the seventeenth century René Descartes's three-word tautological trick, *"Cogito ergo sum,"* ("I think, therefore I am!"), is an example of a deductive argument. If the premise, "I think," is true then the conclusion, "I am," has to be true. Of course, the proposition suggests that the act of thinking is the minimum sufficient requirement for the state of existence. In deductive reasoning, good conclusions follow from good premises and bad arguments from poor premises. Some information could be a figment of imagination, deception, or mistake.

An example of faulty deductive logic has a behavioral biologist performing an experiment. He obtains a normal healthy frog and orders it to jump. The frog jumps. The researcher amputates one of the frog's front limbs and orders the frog to jump. The frog again jumps. Then, the researcher amputates the frog's other front limb and again orders the frog to jump. The frog jumps. Next, the researcher amputates one of the frog's hind legs and again orders the frog to jump. The frog wobbles in place and eventually makes a feeble jump. Next, the researcher amputates the frog's other hind leg and barks the order, "Jump!" The frog sits helplessly. Despite repeated orders to jump, the frog is unable to jump! The researcher records in his lab book, "The frog jumps as long as he has two hind limbs.

Amputating one of the frog's hind legs causes some impairment in the frog's hearing while the amputation of both hind legs results in the frog's complete loss of hearing!" There is a false unpronounced premise that all healthy frogs will respond to orders and jump, rather than that they will jump reflexively when they are startled by a loud sound. Thus, the outrageous conclusion!

Twice before, specifically in chapters 1 and 3, I mentioned the complementary nature of top-down versus bottom-up reasoning to achieve scientific insight. In a 2009 keynote lecture prepared for delivery to the American Mathematical Society,[5] renowned mathematical physicist Freeman Dyson (1924–2020) introduced the notion of "mathematicians as birds" and "mathematicians as frogs." "Birds," he said, ". . . fly high in the air and survey broad vistas of mathematics to the far horizon. They delight in concepts that unify our thinking and bring together diverse problems from different parts of the landscape." In distinction to the birds, Dyson said, "The frogs live in the mud below and see only the flowers that grow nearby. They delight in the details of particular objects, and they solve problems one at a time." While identifying René Descartes as a bird and Francis Bacon as a frog, Dyson continued,

> Neither Baconian empiricism nor Cartesian dogmatism has the power to elucidate nature's secrets by itself, but both together have been amazingly successful. For four hundred years English scientists have tended to be Baconians and French scientists Cartesians. Faraday and Darwin and Rutherford were Baconians; Pascal and Laplace and Poincare were Cartesians. Science was greatly enriched by the cross-fertilization of the two contrasting cultures.

We should add here, Newton was the ultimate frog-like mathematician, but with a unique ability to also survey from above, to see the larger picture, and Einstein was "supreme among physicists as a bird who saw further than others,"[6] and possessed adequate mathematical skills to provide the mathematical basis for his vision.

INDUCTIVE REASONING

As proposed by Bacon, logical reasoning, in this case, represents the reverse process to deductive reasoning. Here the flow is "bottom-up," from specific observations/measurements proceeding to the stage where patterns or regularities, inferences, are seen. From these, tentative hypotheses can be explored, and broader generalization/theory formulated with some degree of probability: *observation > pattern > tentative hypothesis > theory*.

To reiterate, the two forms of reasoning are exactly the inversions of each other—"bottom-up" for inductive and "top-down" for deductive—with inductive reasoning as the process generally associated with the scientific method. It is described as being more open-ended than deductive and leads to more cautious assertions. It can never lead to certainty, but only to increasing levels of probability. Although rarely stipulated, statements in modern science are all about probability, anticipating what is most likely to occur. The fact that the sun has risen from the east 1.64 trillion days in a row suggests that, in all likelihood, it will rise from the east again tomorrow. The alternative is so negligibly small that we ignore it.

Although the modern scientific method generally calls for inductive reasoning, in reality the two forms are frequently conflated when there is a lack of adequate information. Indeed, sometimes it becomes necessary to carry the argument in a circle. Seasoned modern scientists would rarely question the epistemology of their methodology. The culture of science becomes engrained in them. It is intellectual honesty that trumps methodology and the possibility of cognitive dissonance.

During this time, religious battles and wars of the seventeenth century that raged all through Western Europe had now spread to the Americas. It involved the Catholics, the Protestants, and the rapidly multiplying sects of the Protestants, including the Puritans. Witchcraft was accepted widely in all of them, with an estimated 90,000 witches being condemned to death—burned,

drowned, hanged, quartered. Morris Kline, in his *Mathematics in Western Culture*, has this description of the terrifying age:

> On the basis of the most flimsy evidence, old men, young men, women, and children were accused of being witches. In order to be certain that no suspects were overlooked, anonymous accusations were solicited . . . The accused were imprisoned, tortured, and urged to confess. Whether or not the accused confessed, torture went on until death, for failure to confess was interpreted as obstinacy, while confessions obviously called for punishment. To ease the infinitesimal consciences of the judges some of those who did not confess were awarded "certificates of innocence"—posthumously.[7]

Believers in witchcraft included farmers and millers, artists and artisans, and just ordinary people. They also included national, clerical, and cultural leaders: James I, who ordered the translation of the Bible into English; Martin Luther, the architect of the Protestant Reformation and founder of Lutheranism; John Calvin, founder of Calvinism; John Wesley, founder of Methodism; and several popes. Meanwhile, in New England, Cotton Mather had become so disenchanted by the descent into liberal decadence of his own alma mater Harvard that he began a campaign for the establishment of a new institution. The Collegiate School in Connecticut was founded in 1703, and subsequently renamed after a philanthropic English businessman, Elihu Yale, who in 1718 donated 457 books, nine bales of goods worth £560, and the coat of arms and portrait of King George I.

England's two greatest universities, Oxford and Cambridge, collectively known as the Oxbridge Colleges, have always been federations of autonomous colleges. Oxford, the slightly larger of the two, incorporates thirty-eight colleges compared with Cambridge's thirty-one. The heads of the colleges at both are variously called principals, presidents, masters, and wardens. Oxford, founded in 1096, is the oldest university in

the English-speaking world and the third oldest in the world. Only the University of al-Qarawiyyin in Fes, Morocco (859) and the University of Bologna in Italy (1088) are older.

The academic fortunes of Oxford and Cambridge reached higher echelons of society, ebbing and flowing with national politics. Of the two, Oxford is generally cited more frequently for choosing the losing side of such skirmishes. In the sixteenth century, Cambridge prospered when it sided with the monarchy against the church leaders who had tried to oppose King Henry VIII, in his decision to divorce his wife and remarry again and again. The university was rewarded when the king founded Trinity College, which would become Cambridge's most famous college.

Meanwhile, Oxford, which had opposed the ruthless despot, saw a number of its religious leaders burned at the stake. One of its colleges, recently founded by Cardinal Wolsey and named Cardinal's College, was appropriated by the king and renamed Henry VIII College. After the king's death, the name of the college was changed again, this time to Christ Church, which would become Oxford's most famous college. Among the extraordinary legacies of the Oxbridge Colleges, Oxford is unique for its record of producing prime ministers (thirty, including thirteen by Christ Church) compared with Cambridge's fourteen. In the thirteenth century, Oxford had been the institution of a trio of brilliant natural philosophers Duns Scotus, Roger Bacon, and William of Ockham (of Occam's razor fame). Starting in the seventeenth century, however, Cambridge would be unrivaled for producing many more great scientists in a tradition harking to Newton's unique legacy.

WARDEN WILKINS OF WADHAM

On November 25, 2014, Oxford's Wadham College hosted a meeting at the university's indoor amphitheater, the Sheldonian Theater. The occasion for the meeting was the celebration of a trifecta of interconnected events

that had taken place during the seventeenth century. The first was the construction of the Sheldonian, begun in 1664 on a design by Wadham alumnus Christopher Wren (1632–1723). Of course, following the Great Fire of London two years later, Wren would relocate to London and begin the task of designing fifty-three churches, including St. Paul's Cathedral, which would become the city's defining architectural masterpiece. The second was the 350th anniversary of the birth of the Royal Society of London, and the third, the 400th anniversary of the birth of John Wilkins. Founded in the early seventeenth century as one of the university's third generation of colleges, by the 1660s Wadham boasted John Wilkins as its sixth warden. Wilkins exhibited the curiosity and enthusiasm of a scientist and the political deftness that allowed him to flitter between two mortal enemy groups, the Royalists and the Cromwellians, during a critical period in English history. Having written a paper, "How One Might Fly to the Moon," Wilkins displayed the prescience of an early John Kennedy, another science-believing nonscientist closely linked to the Apollo program that took humans to the moon.

Wilkins collected around him other like-minded scholars from Oxford, including Boyle, Wren, and Hooke, as members of a sort of science club setting out on a field trip to London. The group would serve as the nucleus of a new institution and follow closely the research strategy put forward half a century earlier by Francis Bacon: (1) They would not just theorize in exploring nature but carry out systematic experiments; (2) They would develop new technology—e.g., telescopes, microscopes, thermometers, barometers, chronometers, and hydraulic pumps; and (3) They would share their discoveries by publishing them. They would follow the code *Nullius in Verbe* (Take no one's word). Arguments had to stand or fall by their own weight and not by the word of authority quoted. Ultimately, science was meant for the betterment of humankind.

The actual timing of the group's travel to London in 1661 coincided with the ascent to the throne of Charles II. They moved into the facilities of Gresham College, founded by Elizabethan philanthropist Sir Robert Moray (1608–1673) who petitioned the king to give the group a royal

charter and to serve as a hands-off titular chancellor. Although Charles II was a frustrated scientist himself, eager to participate in interrogating nature, he agreed to Moray's request. With the king's sponsorship the institution would become the Royal Society of London, free and unfettered by government pressure, an attribute that would prove to be a permanent tradition. Meanwhile, Wilkins also promoted the hiring of Hooke as the Royal Society's first paid Curator of Experiments.

In his own experiments, the king frequently heated and distilled large quantities of mercury. Eventually, he began to exhibit loss of appetite and insomnia. Suffering from an ulcerated and abscessed leg, he had little opportunity to take exercise and developed uremia, attendant in kidney failure. These symptoms are all recognized effects of chronic mercury poisoning. At the time, the accepted medical treatment for many idiopathic illnesses called for bleeding, which in his case exacerbated his condition. His father, Charles I, born in 1600, had reigned between 1625 and 1649 and died in the name of his religious and political principles. Known to history as the "royal martyr," he was a victim of the executioner's axe. Charles II, when he succumbed to his illness at fifty-five, was also a royal martyr, but his principles were of science. (see figure 1C, color photo insert page I.)

A MODERN LIBRARY OF ALEXANDRIA

After earning an undergraduate degree in classics from Johns Hopkins University, Abraham Flexner (1866–1959) returned to his native Kentucky as a high school teacher and briefly taught Latin and Greek. For failing every student in a class that he was teaching, he could hardly be considered an inspiring educator. But for a pair of monumental achievements on a much larger stage, he will forever be seen as a visionary educator.

Inspired by the research model of Germany's famed Heidelberg Medical School, he wrote "Medical Education in the United States and

Canada" (1910) for the Carnegie Foundation, leading to a major reorganization of medical education. The Flexner Report, first implemented at his alma mater Johns Hopkins, put the institution on a firm course to becoming one of the premier medical centers in the world. Then as an encore, in 1929, while visiting Oxford, he encountered an unusual phenomenon. One of the colleges of the university, All Souls College, was modeled after the School of Athens and the Library of Alexandria, serving as a home for scholars without saddling them with teaching duties. On his return to the United States, he approached the Bamberger Family of department store fame with a proposal to establish the Institute for Advanced Study. It was to function as a postdoctoral think tank stocked with great minds but devoid of students. There would be stellar young postdocs along with established academics on sabbatical leaves from their own universities, all visiting with term appointments, and there would be a judiciously selected body of permanent faculty members who would serve as mentors for the others. During its first decade (1930–1939), before the buildings housing IAS could be built, the scholars worked in borrowed space at Princeton University's Fine Hall, with Flexner serving as its director.

Einstein made three visits to Oxford during the years 1931–1933 (it was in the 1931 visit that he gave three lectures on relativity and received an honorary doctorate).[8] There is dispute about when exactly Flexner tracked down Einstein, but on October 31, 1932, the *New York Times* printed a story accompanied with the lead synopsis:

> Professor Albert Einstein's decision to carry on his future work in America is of less importance than the inauguration of the educational venture with which he will be associated. The name of this great scientist lends dignity to the Institute for Advanced Study, to be launched next year by Dr. Abraham Flexner, but if this super-university succeeds, its effect upon American life may be far more important than the theory of relativity and all of its corollaries.

At the time, Einstein was mulling over offers of academic appointments from a number of universities, including Caltech, Oxford, and Princeton. But when he heard Flexner's invitation to join IAS in its infancy, he found it appealing. He would go on to spend the next twenty-two years (1933–1955) there, though most of his great discoveries were already behind him. He was still eminently successful as a magnet attracting and inspiring other great minds, an authority!

Over the years, the institute's permanent faculty, term members, and visitors have included Hermann Weyl, Hetty Goldman, Emmy Noether, Erwin Schrödinger, John von Neumann, André Weil, Kurt Gödel, I. I. Rabbi, Paul Dirac, Alan Turing, C. N. Yang, T. D. Lee, Niels Bohr, Freeman Dyson, Wolfgang Pauli, Edward Witten, Frank Wilczek, J. Robert Oppenheimer, and Albert Szent-Györgyi. Thirty-three have been recipients of the Nobel Prize in Physics; forty-two (out of a total of sixty-one) Fields Medalists in mathematics; and sixteen (of a total of eighteen) Abel Prize Laureates in mathematics, including Karen Uhlenbeck, the 2019 recipient. Many winners of the Wolf Prize and MacArthur "Genius Grant" Fellowships have also been affiliated with the institute. T. S. Eliot and John Nash, Nobel Prize winners in Literature and in Economics, respectively, have been members. Danish physicist Niels Bohr (1885–1962), one of the most influential scientists in history and a close friend of Albert Einstein, made the institute his home away from home during multiple visits to the United States spanning the years 1938–1958.

According to Ellen Carol DuBois,[9] one of those who "moved the world" would turn out to be Flexner's own authority- and tradition-averse second daughter, Eleanor Flexner (1908–1995). Dividing her attention between two causes, she worked as a left-wing activist, a member of the Communist Party from 1936 to 1956, and as a women's and minority rights activist, marching and writing about injustices women faced. Although these activities were social-minded, either could have earned her an invitation to interrogation sessions with Senator Joseph McCarthy's House Un-American Activities Committee (HUAC). As it turned out, she fell between the

cracks and was never called up by the HUAC. As a feminist, she wrote the first authoritative history of women's struggles, *Century of Struggle: The Women's Rights Movement in the United States* (1959).

Two visionary members of the Flexner family. LEFT: Abraham Flexner. RIGHT: Abraham's daughter Eleanor Flexner. Her wide-ranging account of women's rights in America is still considered the preeminent text on the topic more than a half century after it was published. Credit: Associated Press.

10

THE NEWTONIAN REVOLUTION
CASE STUDY: NEWTON

> *Nature and Nature's Laws lay hid in night:*
> God said, "Let Newton Be and all was light."
> —Alexander Pope[1]

On his deathbed, Galileo reiterated that strong conviction expressed two decades earlier, "The laws of nature are mathematical." But this time, he added, "a mind keener than mine will have to come along to prove it." He would never know how prophetic he was in that prediction. In the year that he died, Isaac Newton was born in Woolsthorpe Manor in southern Lincolnshire in the English hinterland. It was Christmas Day 1642.

NATURE CAN'T BE FOOLED

On January 28, 1986, the space shuttle *Challenger* was launched from Cape Canaveral, Florida, on its fourth mission. Just seventy-three seconds

into the flight, when the shuttle reached 46,000 feet (14,000 meters), a catastrophic explosion took place. The shuttle plunged into the Atlantic Ocean, killing all seven astronauts on board. The blue-ribbon commission tasked with tracking down the cause of the disaster included Richard Feynman. Among possible explanations discussed by a panel of engineers was the failure of rubber O-ring seals in the prevailing freezing temperatures that January day. But when the engineers appeared unwavering in their skepticism, the effects of freezing temperature were put on the back burner.

Although not an experimentalist per se, Feynman performed a simple experiment. The Caltech physicist had brought with him a pair of identical O-ring samples, a pair of identical micrometers, along with a Styrofoam cup filled with ice water. As the television cameras panned back and forth between the panel of engineers sitting at a table and members of the commission seated in the small auditorium, Feynman was seen compressing the O-ring samples with the micrometers, then immersing one in ice water and keeping the other at room temperature. Toward the end of the session, as the cameras zoomed in on Feynman, he was seen dramatically removing the micrometers from the two rings. *Voila*! The O-ring retrieved from the ice water remained collapsed while the one maintained at room temperature instantly regained its original shape. Hot gasses had escaped from a compressed O-ring at a joint between two sections of a solid fuel tank, causing the tank to recoil and swing violently into the main tank filled with liquid fuel. Feynman's simple demonstration pointed out that rationalization alone could not be trusted to resolve questions in science, that experimentation was crucial. The final arbiter is nature, and, as Feynman declared, "Nature can't be fooled!". It is unfortunate that Feynman's wisdom was not available to Aristotle, who, rather than count the teeth in his wife's mouth, claimed that women were blessed with fewer teeth than men. It is also reminiscent of the belief of biblical literalists that a male has one less rib than a woman because one of his ribs was taken to create the woman.

HYPOTHESES, PRINCIPLES, THEORIES, AND LAWS

"I have a theory . . ." Is there anyone who has not heard the familiar refrain before being subjected to a half-baked conspiracy theory about the "JFK assassination," the "moon landing" ("It took place at a Hollywood studio"), the "suicide of Marilyn Monroe," the "absurdity of relativity!" ("Jewish physics!"),[2] and "man-made climate change is a conspiracy of the left." For climate change, it is imperative to trust science[3] and neither one's gut feelings or science deniers."

In distinction, the theory of relativity, the theory of quantum mechanics, and the theory of evolution are among the greatest scientific discoveries of our species. As for laws, Newton's three laws of motion and the universal law of gravitation, Kepler's three planetary laws, Boyle's law, the laws described by Maxwell's equations, the second law of thermodynamics, and the law of supply and demand in economics are among the great intellectual achievements uncovered by science. These are not alternative facts. After the accumulation of a century of supporting data, and *without a single (and repeatable) violation,* Einstein's theory of relativity and Darwin's theory of evolution should be called "laws."

To complicate matters, there also exist endlessly tested and verified "principles." The principle of least action, the equivalence principle, the Heisenberg uncertainty principle, the Pauli exclusion principle, Bernoulli's aerodynamics principle, all in physics; the principle of linear perspective in painting; and the principles of melody, of "tension and release" in music, are all rigorously tested and have served as dependable guides to understand nature or to understand human nature.

The terms "hypothesis," "principle," "theory," and "law" have become ambiguous and, in some circles, even interchangeable. Partly to blame are scientists whose cavalier attitudes have come to encourage those who have no clue about the nature of science to characterize Darwin's theory of evolution as, "after all, it's only a theory," as a prelude to offering alternative explanations; e.g., the "theory of theistic creation" or the "theory of

intelligent design." Since the last two are not testable and not verifiable, they are not scientific theories. Thus, just as there are "revolutions and there are revolutions, and they are not equally consequential," there are also "theories" and there are "theories," and they are not equally consequential nor equally valid.

Before *Homo sapiens* became "modern"; that is, before the Scientific Revolution, natural phenomena were attributed to the gods and goddesses, then the auspicious to God and the calamitous to the devil and his helpers. "God knows best!" "It happened for a reason." "He is in a better place." These may be well-meaning platitudes to mollify friends in despair, but are any of the assertions actually based on personal experience and understanding? Five hundred years ago, Leonardo used to affirm his credo as he signed off from each of his completed notebooks, "Discepolo della sperientia" ("Disciple of experience or experiment"). Indeed, the key to understanding reality follows hypothesis, experimentation, observation, theory, and confirmation. Certainly, speculations based on experience and educated guesses can be helpful in forming hypotheses, but experimentation is crucial in order to establish the truth. That is the gist of the Challenger Commission's final results.

Newton's laws of motion and his universal law of gravitation are *laws*, but *within relativistic limits*. The process of fine-tuning physical theories is usually an incremental process, but on very rare occasions requires a complete change in a fundamental paradigm. Einstein's special theory of relativity offered a change in the original paradigm of Newtonian mechanics by replacing the independence of three-dimensional space from time and making time one of the components of four-dimensional space-time. As we shall see, at extremely high velocities time experiences dilation, and three-dimensional space experiences contraction. But these effects happen in an interdependent manner; i.e., time dilation is always accompanied by length contraction and vice versa. Einstein's general theory, applicable to acceleration and gravitation, replaced Newton's gravitational force with a warping of space-time by massive objects. For a space vehicle to journey to the moon and make a soft landing, the velocities are slow enough that

Newtonian physics suffices. In order to use a GPS, however, one has to access general relativity. As one approaches the speed of light or in dealing with extremely massive objects such as massive stars, neutron stars, and black holes, the predictions of Newton's laws begin to deviate from reality and eventually break down, requiring relativistic corrections. But it is incorrect to characterize the changes offered by relativity as a complete upheaval of Newtonian laws but rather as strengthening them. Einstein was aware of the significance of his own contributions, but in comparing them with that of Newton, he was humble and generous, "Fortunate Newton, happy childhood of science. Nature to him was an open book, whose letters he could read without effort. He stands before us strong, certain, and alone."

Newton lived his entire lifetime of eighty-four years in a slender isosceles triangle defined by vertices at Woolsthorpe Manor, Cambridge, and London. He may never have even seen the seashore, his only travel beyond that sliver coming with a seven-mile downriver journey he once made from London to the Royal Observatory in Greenwich and back. Yet he uncovered more of the essence of the clockwork universe than anyone had before him, and anyone would do afterward. He demonstrated that the universe was comprehensible, that the laws of nature were universal, and that these laws obeyed mathematical principles. In spite of his boundless canon of contributions in classical mechanics, fluid mechanics, optics, and pure mathematics, his own assessment came wistfully: "I do not know what I may appear to the world, but to myself, I seem to have been only like a boy playing on the seashore and diverting myself in now and then finding a smoother pebble or prettier shell than ordinary, whilst the great ocean of truth lay all undiscovered before me."

His words reveal both the childlike curiosity that fueled his wonderment of nature and the realization that his own discoveries amounted to an infinitesimal fraction of the truth that still awaited to be unveiled. He saw his system of the world as an open-ended process, but "open-ended" only in the sense that it offers the methodology to interrogate nature at every level imaginable. (But it is not "open-ended" in the sense of a psychological

device intentionally suffused in an artistic creation, a painting, a musical composition, a literary work of fiction.) He never got into the fray of the nature of mathematics, "Is it a discovery or a creation?" Let it suffice here to say that mathematics underlies the collective strata of the sciences—physics, chemistry, biology, and the social sciences. As for why the laws of nature are mathematical has still not been answered with any degree of satisfaction. Recall how Eugene Wigner lamented the situation in a compelling essay, "The Unreasonable Effectiveness of Mathematics in the Natural Sciences." He had added, "The enormous usefulness of mathematics in the natural sciences is something bordering on the mysterious and . . . there is no rational explanation for it."[4]

The inherent precision of mathematics—and yet with an uncertainty of its nature—frequently comes up in this book, and yet, the answer is well beyond the book's scope. I personally confess to have gone back and forth a number of times. I have a feeling that the "bird mathematicians" would regard it as a human creation, and the "frog mathematicians" as a science . . . or is it the other way around?

THE POSTHUMOUS CHILD

Isaac Newton was born on Christmas Day 1642 to Hannah Ayscough-Newton (1623–1679) in the village of Woolsthorpe-by-Coltersworth in the county of Lincolnshire. England was still using the Julian calendar, in which a year was reckoned as 365.25 days. It was not until 1752, or twenty-five years after Newton's death, that the British accepted the more accurate Gregorian calendar, which reckoned the year as 365.24255 days. The latter had been introduced in Rome in 1584, but sixteenth-century England was repugnant to accept anything the Catholics had embraced. Newton's Christmas birth in 1642 is now corrected to January 4, 1643. He was a "posthumous child," as the English described a child born after his father's death. The father, an illiterate yeoman farmer also named Isaac Newton, had died three months earlier. He was also a premature baby

who, according to contemporary accounts, was small enough to fit into a quart pot and was not expected to survive infancy. He did survive, forged a legacy deserving of the heavy mantle of "the architect of the modern age," and lived well into his ninth decade. His own immediate forebears, his stepsiblings, and his acquaintances were all common, average individuals. There is no evidence that the favorable concatenation of genes that made Newton into a transformative genius could also be found in any of them. There were only the shared interests of obtaining a year or two of education, getting married, and having children to help in ordinary farm tasks, all subordinated to concerns of pleasing God and avoiding the temptations offered by the devil. In Newton's case, he lived in virtual physical isolation and the isolation of his own brilliance. Just as with Leonardo and Shakespeare before him, he was an autodidact who had to digest so much information on his own. His grammar school education spanned just seven years, shortened by one year spent on the farm.

Newton spent the first three years of his life with his mother and maternal grandparents in Woolsthorpe Manor. But when he was just three years old, his mother married Barnabas Smith (1582–1653), the wealthy rector of nearby North Witham. At the time, she was just thirty-three years old and the vicar sixty-three. A cruel prenuptial contract called for the widow to leave her son with his grandparents. As the vicar took his wife to North Witham, he showed enough magnanimity to cede a small tract of land to the boy in exchange for taking his mother away.

In 1653, when Newton was ten, his stepfather passed away, and his mother, now Hannah Ayscough-Newton-Smith, returned to Woolsthorpe, accompanied by three new children. However, just eighteen months after he was reunited with his mother, in 1654, he was sent away to grammar school, King's School in Grantham. The distance of eight miles was not far, but neither was it practical for walking to and from daily. While attending school in Grantham, he made occasional trips home, but otherwise boarded in the loft above William Clarke's apothecary shop.

He became used to being alone in the loft, passing his time daydreaming, scrawling charcoal pictographs, or carving geometric shapes on the exposed

timber of the garret. He created sundials, calibrating them with precision, whittled model watermills and windmills, and made miniature furniture for a dollhouse. The dollhouse furniture was a present for Katherine Storer, one of Clarke's stepdaughters. The relationship with Miss Storer would be remembered as Newton's only romantic connection with a female during his entire life. He occasionally helped Clarke in the apothecary shop in the preparation of potions, a practice that spurred his interest in chemistry. He would also have access to Clarke's books, his own favorite becoming *The Mysteryes of Nature and Art* by John Bates. During this period, he learned to recognize chemicals, to measure them out with precision, and to gain some insight into pharmacology. Ironically, the experience would later lead him to one of his darker interests, alchemy, regressing from an interest in chemistry to one for the pseudoscience of alchemy.

At King's School, with its puritanical values, teacher John Stokes taught the children a simple curriculum of Latin and more Latin, and some practical mathematics useful in reckoning the areas of land, conversion of volumes, and keeping budgets. But a recently discovered copy of *Euclid's Elementa*, copied by hand and dated 1654 by Stokes, suggests that the teacher may have also introduced some of the students to more challenging mathematical exercises, rudimentary algebra, and the extraction of square and cube roots of numbers. He would have realized having ignited Newton's passion for numbers and an obsession for reading everything that he could get his hands on. As the universal language of serious scholarship, Latin would be immensely useful to him through his career, just as "broken English" has come to serve as the universal language in the present day. After five years in school, in 1659, Hannah recalled her almost-sixteen-year-old son to Woolsthorpe to assume the running of the family farm. The innocent puppy love with Katherine Storer was nipped in the bud and it also appeared that there would be no further formal schooling.

Back on the farm in Woolsthorpe, however, Newton would frequently lose himself in his readings and become inattentive to routine farming tasks. It became quickly evident to those around him that he was proving

to be a failure as a farmer. Schoolmaster Stokes may have communicated with Hannah and possibly with Hannah's brother, the Reverend William Ayscough, that school was a better place for the boy than the farm. It is known that Rev. Ayscough stepped in and convinced Hannah to allow her son to continue his education at King's School and to prepare for university.

Fragmentary evidence of Newton's graffiti, drawings, and carvings of geometric figures have survived in Woolsthorpe. In the interior of a stone window frame a carving shows a square inscribed in a circle, resembling part of a geometric construction that Archimedes had employed in determining the value of the irrational number π, the ratio of the circumference to the diameter of a circle. In the third century B.C.E. in Syracuse, Sicily, Archimedes had constructed a circle, inscribed and circumscribed triangles, then hexagons and dodecagons in a repeated sequence of doubling the sides to compute π to six places. The scheme most likely inspired Newton to seek higher precision on the irrational constant. Later, on half a blank page in a book he owned, he left behind the computation of π to sixty places, having used his mathematical discovery of the binomial theorem in concert with his technique of integral calculus to generate the improved value of π:

π = 3.141 592 653 589 793 238 462 643 383 279 502 884 197 169 399 375 105 820 974 944 . . .

As he ran out of space on the page, he abruptly signed off, "a good mind need not be wasted on such trifling."[5]

Newton's epitaph in Westminster Abbey opens with the words:

> HERE IS BURIED ISAAC NEWTON, KNIGHT, WHO
> BY A STRENGTH OF MIND ALMOST DIVINE, AND
> MATHEMATICAL PRINCIPLES PECULIARLY HIS OWN . . .

The mathematic principles "peculiarly his own" referred to *fluxions* and *fluents* (differential and integral calculus) that Newton formulated to describe motion and change. He had kept this mathematical treasure

a secret until Leibniz published his own version of the calculus in 1684, provoking Newton to charge the German polymath with plagiarism. We will return to this bitter episode later in this chapter.

Newton spent a total of six years at school in Grantham, five initially, interrupted by a year on the farm, then followed by an additional year. Reverend Ayscough's contacts at his own alma mater, Trinity College, must have helped in his nephew's acceptance to Cambridge. Schoolmaster Stokes, who had also recognized his star pupil's superior mind, is said to have rejoiced in hearing of the boy's decision to continue with his education. In distinction, Newton's mother Hannah, allowed her son to matriculate at Cambridge only grudgingly. In spite of her own annual income of £700, she paid only £10 each year to support her son, choosing to have him attend only at the lowest step on the institution's social ladder, a *subsizar*, a student-servant-valet waiting on tables, eating their leftovers, and emptying their pot pans. He would have to pay for the lectures he attended, albeit at a reduced fee. Nevertheless, living extremely frugally, Newton was able to supplement his funds from interest on money he lent to wealthier students.

Largely neglected by his mother during his formative years, he harbored a complicated admixture of love and bitterness toward her. But a visceral loathing was reserved for his stepfather who had taken his mother away when he was just a toddler. Perhaps the only thing he did not abominate about Rev. Smith was a massive notebook of a thousand pages that he inherited from the vicar. Each page had been numbered by Smith, some pages bearing theological headings and others just left blank. The notebook that Newton called his Waste Book became a repository for his musings, lists of vocabulary words, youthful confessions, obsessive computations, scientific speculations, and occasionally invectives directed at Hannah and Barnabas. He used his Waste Book from 1658 through the 1680s.

In June 1661, he matriculated at Trinity, displaying little evidence that he knew any more mathematics than any of the other entering students. He would have been enrolled in a curriculum established a century earlier—initially, grammar, logic and rhetoric, and later Aristotelian *logic*, Aristotelian *Ethics*, Aristotle, and more Aristotle. He was familiar with

Sanderson's *Logic*, often regarded as segue for the study of more advanced mathematics. Early in his first year, while strolling through the annual Stourbridge Market on the banks of the River Cam, he picked up a number of items: a quart of ink, a small notebook, an equilateral prism (60° at each edge), a pot pan, and a copy of a book on astrology.

It is with this prism, now preserved in the Whipple Museum of Science of the University of Cambridge, that Newton performed his first optical experiments.

Aristotle, in his theories of motion and gravitation, commenced from the principle that no effect or motion takes place without a cause. By introspection rather than by experimentation, he invented the ambiguous notions of "essence" ("nature") possessed by different elements and "esse" (the affinity "to become"). "The reason for the downward motion of a heavy body, such as the element earth," Aristotle had explained, ". . . could be attributed to its nature, causing the body to move downward toward the center of the universe, its "natural place." The proclamations of Aristotle, "*The* Philosopher," were sacrosanct on myriad topics in agriculture, botany, ethics, logic, mathematics, medicine, metaphysics, natural philosophy (physics), philology, philosophical psychology, and politics.

In 1662 Newton underwent a religious crisis. In drawing up a list of his sins before and after Whitsun that year, he appears to have charted out a course of personal improvement. His conscience was still troubled by remembered boyhood sins, including "Stealing cherry cobs from Eduard

Storer," "Calling Dorothy [sic] Rose a jade," "Squirting water on Thy day [i.e., Sunday]," "Refusing to go to the close at my mother's command," "Striking many," "Punching my sister," "Peevishness with my mother," and very much more ominously, "Threatening my father and mother Smith to burne them and the house over them" and "Wishing death and hoping it to some." In his dark days, he even briefly considered suicide. His response to his religious crisis, embracing mathematics and science, turned out to be cathartic.

Perhaps a more puzzling aspect of Newton's religious quest was the astrology book that he purchased at the fair requiring knowledge of rudimentary geometry and trigonometry that Newton did not possess. Accordingly, he bought a copy of Euclid's *Elements*, and was surprised by the simplicity of the propositions set out by Euclid. Instead of investing the time to master plane geometry, though, he concentrated on the analytic geometry introduced in the appendix of another book he also acquired, Descartes's *Géométrie*. This was a new tool in mathematics, marrying algebra and geometry, and allowing algebraic equations to describe geometric lines, curves, and surfaces. Unlike Euclidean geometry, it accommodated two and three dimensions.

In 1664 Newton attended a lecture by the brilliant mathematician Isaac Barrow, recently appointed as the first Lucasian Professor of Mathematics.[6] When Newton approached Barrow to take over his mentorship, the well-seasoned academic accepted him, having little idea of Newton's vast potential. In short order, Newton was concentrating on his private study of mathematics and optics, in a program that left little time to devote to the official university curriculum involving classics, Euclidean geometry and Aristotelian philosophy. He devoured the works of Thomas Hobbes, Galileo Galilei, René Descartes, Robert Boyle, Pierre Gassendi, and other mathematical works far more advanced than Euclid's *Elements*. By mastering all the mathematics known up to the time and beginning to formulate original work, he had pushed past all the mathematicians who had lived before him: He also began to fill his college notebook with a series of entries headed prominently "Quaestiones quaedam Philosphicae" ("Certain Philosophical Questions"): "general topics on the nature of matter,"

"place," "time," "motion," "cosmic order," the subheading for tactile qualities, "rarity, fluidity, softness," "violent motion," "occult qualities," "light," "color," "vision"—forty-five topics of wide-ranging scientific questions, each a heading for an individual page. Although most of them were synthesized from other sources, they figured in his long-term quest, abstract qualities that would become the physical observables of physics. He defined them and sought their connections. He was creating physics for the ages.

He took copious notes in his notebooks and he liberally annotated the books that he owned, confirming other mathematicians' proofs and sometimes making corrections in their derivations. He computed obsessively, sometimes out to fifty terms. It is estimated at his death that he left a personal library of over 2,000 volumes, 800 of which are housed in the Wren Library of Trinity College, many of them with a minute spindly handwriting.

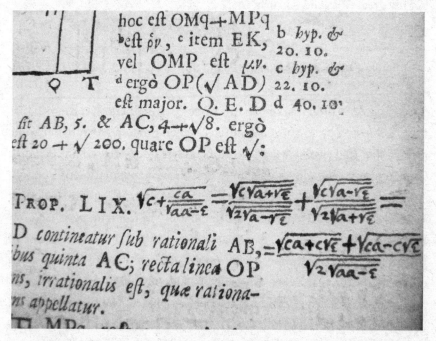

Newton's personal copy of Euclid's Elements. The "NQ-section," unique to the Wren Library, houses 800 personal books that had belonged to Newton, many of them personally annotated. The structure of the nestled square roots suggests that he was using Nicolo Tartaglia's solution of the cubic equation formulated in the sixteenth century.

In Aristotle's picture of the universe, embraced by Hipparchus two centuries later and again by Ptolemy five centuries later still, the planets, literally "wanderers," were embedded in crystal spheres which rotated with different periods around the earth. Outside these crystal spheres lay an immense opaque shell with circular holes, resembling an immense colander, and a fire raging outside, creating the appearance of stars where the holes are located. This opaque sphere with a center at the earth rotated with a period of twenty-four hours. In this geocentric picture, Aristotle saw comets as atmospheric phenomena. Newton realized that Aristotle's notion of comets with rays and comets with tails were not tenable, like so much else in Aristotle's system. He expanded on the earlier creed, writing above the title "Quaestiones" in his Waste Book, "Amicus Plato amicus Aristoteles, magis amica veritas" ("Plato is my friend, Aristotle is my friend, but my greatest friend is truth").

ENGLAND'S *ANNUS HORRIBILIS* AND NEWTON'S *ANNUS MIRABILIS*

The years 1665–1666 marked an utterly devastating period in English history, dominated by a pair of calamitous events. First, in 1665, the bubonic plague that had been ravaging continental Europe crossed the English Channel from Holland and began to decimate the population of London. An estimated quarter of a million people in the United Kingdom, including 100,000 (or about 20 percent of the population) in London, perished after having been infected by the bacterium *Yersinia pestis*. The infectious vector turned out to be flea-infected rats, ferried on board ships arriving from continental European ports, especially in bales of wool from warehouses in Amsterdam. The death toll could have been worse if the enlightened king, the gentleman-scientist Charles II, had not listened to his physicians and the scientists of the new Royal Society to ban groups from congregating. Diarist Samuel Pepys, a Cambridge-educated government official, recorded his observations as notices posted daily of the body counts, mounting frustrations of sequestered people, the rebellious youth and hotheads resisting

the government's decrees. Annalee Newitz, opinion writer for the *New York Times*, offered connections to the COVID-19 pandemic of our time: "It's reminiscent of all those modern Americans who went to the beaches in Florida over spring break, despite what public health experts told them."[7]

By September 1666 the plague had largely subsided when the Great Fire of London ignited in a bakery on the eastern edge of the City. It was fanned by westerly winds and spread quickly through the tinderbox tenement houses. For centuries these shoddily built structures had been proliferating to accommodate a rapidly growing population. Wooden skyscrapers, often five and six-stories high, the upper stories built as *jetties*, progressively protruded farther and farther until the thatched roofs of houses facing each other on narrow streets virtually touched and created canopies over the streets and alleys. Poor luck with the weather, limited fire-fighting technology, and chronic mismanagement of the fire brigade by the local authorities conspired to keep the conflagration unchecked for days. By the time the fire had run its course, it had destroyed almost two thirds of the city. The fire stopped short of the masonry buildings of the financial district and the houses of the wealthy set in more spacious gardens, and it led to the complete rebuilding of London, including Christopher Wren's masterpiece, St. Paul's Cathedral.

The plague and the Great Fire had a synergistic effect that was so severe and the devastation so complete, that Londoners might well regard this brief period of history as their annus horribilis (the horrible year). The plague turned out to be far more important in the long run than the Great Fire. A decision by authorities to disperse crowds, including those in scholarly communities such as the universities of Oxford and Cambridge, each approximately fifty miles from London, forced the scholars to retire to their homes.

Newton was awarded a BA degree, albeit without distinction, in the spring of 1665, and he returned to Woolsthorpe for the summer. But with news of the outbreak of the plague in Cambridge, his stay in Woolsthorpe was going to be extended indefinitely. Almost twenty months later, when he visited Isaac Barrow in his study at Cambridge again, he had with him

a list of his "mental inventions." As he would recount almost six decades later in an interview with his niece's husband, John Conduit, the summary of his work at Woolsthorpe read:

> In the beginning of the year 1665 I found the . . . Binomial series. The same year in May I found the method of Tangents . . . and had the direct method of fluxions & the next year in January had the Theory of Colours & in May following I had entrance into ye inverse method of fluxions. And the same year I began to think of force with gravity extending to ye orb of the Moon & (having found out how to estimate the wch [a] globe revolving within a sphere presses the surface of the sphere) from Keplers rule of the periodic times of the Planets being in sesquialterate proportion of their distances [3/2 power dependence of period to distance] from the center of their Orbs, I deduced that the forces wch keep the Planets in their Orbs must [be] reciprocally as the squares of their distances from the centers about wch they revolve . . . All this was in the two plague years of 1665–1666. For in those days I was in the prime of my age for invention & minded Mathematicks & Philosophy more than at any time since.

Any one of the items on the list would be any great scientist's defining masterpiece. For Newton, they were incremental steps. His endeavors can be grouped broadly into three areas: pure mathematics, where his interest lay in unifying the impossibly large, infinity, and the vanishingly small, the infinitesimal; optics, in a quest to understand the nature of light; and dynamics, the desire to understand the nature of motion, first celestial and then terrestrial. In time he would establish interconnections, but they would not come to him in a flash. The pieces of the complex puzzle would have to percolate and undergo distillation in the next two decades before they would come together in a consistent and rigorous intellectual system in the *Principia*.

Barrow must have quivered when first seeing Newton's "mental inventions." Himself highly precocious, matriculating at Trinity College,

Cambridge at thirteen and elected as a fellow of the college at nineteen, Barrow was only thirty-six years old when he saw Newton's work. He soon announced his retirement from a burgeoning career as mathematician to become a theologian. In his letter of resignation, he recommended his young assistant as his successor to chair, "Mr Newton, a fellow of our College, and very young... but of an extraordinary genius and proficiency in these things." Holders of this, the most distinguished chair in academia, have included Dirac, and more recently Stephen Hawking.

The year 1666 is the annus mirabilis (miracle year) also for Britain. The Dutch navy was defeated, the Great Fire of London had been extinguished with the city beginning a regime of complete rebuilding, the plague had been stopped, and Newton had enjoyed the most creative period seen in the annals of science. His early interest in comets did not persist, but a pair of questions about a comet's trajectory and the nature of gravitation exactly twenty-years later would become the cruces catalyzing a second burst of creativity, his second annus mirabilis.

In the sciences the expression *annus mirabilis* is so rare that only twice in history has it been invoked, and in each instance to describe a single individual's effort. Newton's was of course the first. The second annus mirabilis refers to a period 230 years later, when twenty-six-year-old Albert Einstein, still in the hunt for a serious physics position, published a series of four monumental papers in 1905. Moreover, it is generally acknowledged that each man experienced a scientific rebirth, a *second* miracle year: Newton, when he sequestered himself between 1684 and 1686 to compose the three books of the *Principia*, and Einstein in 1915 when he developed his general relativity.

THE *PRINCIPIA*

Unrivaled as the greatest scientific work in history, Newton's *Principia* was originally written in Latin, the scholarly language of the time. It is divided into three books or volumes. Inspired by the axiomatic treatment of

Euclid's *Elements*, the formalism of the *Principia* is comprised of definitions, axioms, propositions, principles, and proofs, the proofs all demonstrated with plane geometry. Although he had already formulated *fluxions* and *fluents* (differential and integral calculus), he did not invoke calculus, lest the reader be distracted.

Book I of the *Principia* begins with eight definitions and three axioms. The axioms are now known as Newton's laws of motion:

> 1. A body continues in its state of rest, or uniform motion, in a straight line, unless it is compelled to change that state by forces impressed on it. This is actually a discovery of Galileo and can be described by the simple mathematical expression ($\Sigma F = 0$ or simply $F = 0$). If the sum of the forces on a body (left side) equals zero then there is no change in motion; i.e., there is no acceleration (right side).
> 2. The change in motion is proportional to the motive force impressed and is made in the direction of the straight line in which that force is impressed *($\Sigma F = ma$)*. The proportionality constant is the mass of the body (m). In distinction to the first law, if a net (nonvanishing) force exists, then a proportional acceleration will result in the same direction as the force. Note: the first law is subsumed into the second law as a special case.
> 3. For every "action" (force) there is always an opposed and equal "reaction" (force). The law's mathematical expression is $F = -F'$. The negative sign reveals the opposite direction of the two forces. The law in its simplest form explains that when we are standing on the ground, we apply a force (our weight) on the ground, and the ground applies an equal and opposite force on us. It also explains how rockets accelerate in airless space, by expelling gasses from its nozzle and the gasses pushing back against the nozzle. It's important to point out that the action-reaction pair of forces act, not on the same body, but on contrary bodies.

Newton's own copy of the Principia on display at the Wren Library, Trinity College. The priceless copy contains annotations—in the author's own hand—for planned changes for the second edition. Credit author.

Book II of the *Principia* deals with the motion of bodies through viscous media and pales in intrinsic importance when compared with the subjects of books I and III. Historians of science have debated why Newton even produced it, except that it successfully invalidates the notion that in interstellar space, heavenly bodies are carried by vortices, and that such vortices are unsustainable as the source for orbital motion. The vortices had been assumed as the fundamental bases of the gravitational theories of three towering giants—Kepler, Descartes, and Huygens. Vortices, after all, possessed the nature of tangible contact forces. They could push and they could pull. Newton had to function outside the prevailing understanding. When he published the universal law of gravitation, Kepler and Descartes were long gone, but Huygens was still around to object, and he objected vociferously—for a time, at least. But the theory was much too successful in all its predictions, even if it struck at the mystical!

Newton was intent on showing how gravity works, not why. Regarding the nature of the actual gravitational force, he would have said, "Hypothesis

non fingo" (I do not feign a hypothesis) as he is reported to have responded when asked, "What constitutes space?"

A century later, the great Scottish philosopher David Hume encouraged thinking outside the box, to being receptive to what may seem outlandish assumptions in the beginning. Two centuries later, Hume's admonishment impressed Einstein in his quest in the formulation of relativity.

"THE GREATEST ABSTRACTION OF THE HUMAN MIND"[8]

So characterized Richard Feynman the reasoning underlying Newton's law of universal gravitation, the main focus of book III of the *Principia*. The notion of an inverse-square law of the gravitational force, even within the context of the swirls of vortices, had been in the air for some time. But no one could demonstrate this property mathematically.

In the schematic diagram (not drawn to scale, and assuming a simple circular orbit for the moon), an apple falls to the ground, E. According to the simple expression for Galileo's law of free fall, *s(t)* = ½ $g\ t^2$, where *s(t)* represents the distance of fall from an initial height, *g* is the acceleration due to gravity on the earth *-32 ft/sec²* (or *-9.8 m/sec²*) and *t* represents time, in one second the apple drops *16 ft* (or *4.9 m*) from its original height. Newton regarded the moon as continually "falling" radially toward the earth (E). If it did not fall, it would continue in a straight line, *MT*, tangent to its orbit. In one second, instead of moving along *MT*, it falls by *TM'*. He recognized that the angles ∠EMT and ∠MM'T were both 90°, that the angle ∠MTM' was shared by both triangles ΔMM'T and ΔEMT. When two of the angles of a pair of triangles are equal, then their third angle must be equal, deeming the triangles "similar" to each other. He knew that the distance between Earth and the moon, EM, is around 240,000 miles, and the distance between the earth and the apple (not the distance from the apple to the ground, but the distance from the apple to the center of the earth) is 4,000 miles. The ratio of these two distances is sixty. Since the two triangles are similar, the ratios of the corresponding legs will be the

same. Knowing the period of the moon to be 28 days (= 28 days • 24 hours/day • 3,600 sec/hour) and the radius of the orbit (240,000 miles), he could compute the moon's speed, and therefore, how far it would travel in 1 second. He determined the distance *TM'* that the moon would fall toward the earth to be *1/19th* of an inch. Finally, knowing the ratio of the distance the moon falls in *1* second to the distance the apple falls in the same second, Newton found to be *1/3,600*. This happens to be *1/60²*. It was not until 1686 that he finalized his theory of universal gravitation: every object in the universe attracts and is attracted to every other object, and inversely as the square of their distance of their separation, *1/r²*.

$$F = G\frac{mm'}{r^2}$$

The symbol *G* represents a proportionality constant universal gravitational constant, left to be determined experimentally in the future.

A simplified circular orbit of the moon. In the geometric construction, there exist a pair of similar triangles Δ(MM'T) and Δ(EMT). Imagine an apple tree on the surface of the earth (E) and an apple ready to drop.

In Cornell's annual Messenger Lectures in 1964, Feynman, described Newton's notion of gravitation, "Nature uses only the longest threads to weave her patterns, so each small piece of her fabric reveals the organization of the entire tapestry." One hundred and fifty years earlier, Lord Byron had written:

> *When Newton saw an apple fall, he found*
> *A mode of proving that the earth turn'd round*
> *In a most natural whirl, called gravitation;*
> *And thus is the sole mortal who could grapple*
> *Since Adam, with a fall or with an apple.*

There is no evidence that Newton was actually struck by an apple. It is an appropriate coincidence, however, that in the Wren Library of Trinity College, a larger-than-life marble statue of Byron is seen guarding the special alcove holding eight hundred books once owned by Newton, many bearing his annotations in the margins. An inspiration may exist in the apple, however, in Robert Hooke's communication with Newton. Hooke had suggested to Newton that perhaps planetary motion was due to motion tangent to the orbit and an attractive force between the bodies (centripetal or "center-seeking") but confessed to not being sufficiently skilled to carry out the required mathematics. Later in 1684, he pleaded with Newton to give him credit for the idea. Newton would have none of it. He left out any mention of Hooke from the *Principia*, although Hooke had been entirely correct. Newton's anger at Hooke for criticizing him (incorrectly) for his discoveries in optics would never abate. Later, when he was elected president of the Royal Society of London, Newton made every attempt to erase the name and legacy of Hooke at the institution. The natives of Zimbabwe describe a pair of land animals in their world: "Elephants never forget, buffalos never forgive." Newton proved to be a mix of the two lumbering land animals of Africa. Newton's apple, with a bite missing, inspired Steve Jobs.

Conflating his second law of motion, the universal law of gravitation, and the notion of centripetal force (center-directed acceleration), Newton

went onto derive orbital velocity, Kepler's third law (the square of the period of a satellite varies as the cube of its orbital radius, determined empirically by Kepler). After Irish physicist William Hamilton's introduction in the early nineteenth century of the notions of kinetic energy K.E. and potential energy P.E., the escape velocity of a space vehicle could be determined. It turns out that G is the universal gravitational constant, M the mass of the body (planet) from which the satellite was launched, and r, is the orbital radius or the distance between the satellite and the center of the heavenly body (planet) around which it revolves. Newton intuited, but did not demonstrate mathematically, that inside the earth (i.e., $r<R$, where R is the radius of the earth), with the surrounding mass pulling in every direction, that the gravitational force would be linear ($F = -kr$) rather than inverse-square. That happens to be Hooke's law governing the harmonic motion of an oscillating spring. (Mathematics can easily demonstrate for the parameters of the earth, that if a hole is drilled, passing through the center of the earth, and an object is dropped into the hole, then the object would oscillate between the two diametrically opposite points on the earth; e.g., New York and Perth. The time for one full back-and-forth oscillation would be ninety minutes, the same as that of a low-earth orbit.)

WEIGHING THE EARTH

One hundred and ten years after the publication of the *Principia*, in 1797, wealthy gentleman-scientist Henry Cavendish, working in his private lab in London, measured the universal gravitational constant, G. At the ends of a slender rod, he fixed a pair of masses; he suspended the rod horizontally from its midpoint by a slender filament. He also placed a pair of massive balls on a pair of columns—on the same plane as the slender barbell. The small masses were attracted by the heavy balls, creating torque and causing the barbell to rotate. By correlating the masses and the distances of separation between each small mass and the large balls, he determined the value of the universal gravitational constant, $G = 6.67 \times 10^{-11} \: N \cdot m^2/kg^2$.

The orbital and escape velocities for the earth can now be computed, as 5 mi/sec (8 km/sec) and 7 mi/sec (11 km/sec), respectively. Cavendish wrote a paper with a grand and curious title, "Weighing the Earth." He set the expression for universal gravitational force equal to Newton's second law, here the weight of the body. On the left side of the equation the force was comprised of the product of the factors G (now known), an arbitrary mass m, the mass of the earth M (unknown), all divided by the square of the radius of the earth (known) was set equal to the arbitrary mass m times gravitational acceleration g (known, *32 ft/sec² or 9.8 m/sec²*). Of course, the two arbitrary masses m, on the two sides of the equation divide out. A simple calculation revealed the mass of the earth as *M = 6x1024 kg*. That is six million, million, million, million kilograms. Since the volume of a sphere can be computed from the expression *V = (4/3)πr³*, we can also determine the volume of the earth, and its average density (mass/volume). The average density of the earth emerged as 5.5 grams/cm³, or 5.5 times the density of water. Geologists give the average density of material on the surface of the earth to be about half as much.

With the mass of the earth, the distance between the earth and the sun, and the period of the earth's orbit (one year) all known, the sun's mass can also be determined in a secondary application of the foregoing, yielding M_s = *2x10³⁰ kg* (or *330,000* times the mass of the earth).

THE CALCULUS WARS

In a manuscript dated November 1665, it is clear that Newton had insight into the method of fluxions, differential calculus, to determine the instantaneous slope at a specified point on a smooth curve, and from the equation of a tangent at that point, the radius of curvature. He was already using the binomial theorem and the elements of infinitesimal calculus—both his own creations—to solve problems regarding change and motion by 1666, but he was keeping it all close to the vest. By the late 1670s Newton and Leibniz communicated on mathematical issues and Newton, uncharacteristically,

shared his ideas with his rival, including the mathematical expression known as the fundamental theorem of calculus, demonstrating that the integral is the anti-derivative of a function. The fundamental theorem of calculus forms the backbone of calculus and links its two main ideas, the concept of the integral, the infinite summation of vanishingly small elements, and the concept of the derivative, the infinitesimal dissembling of a continuous distribution.

Newton had numerous feuds with other great men, and when he did not see critics as nonthreatening puppies nipping at his ankles, he saw them as mortal enemies. A rare rival in his own intellectual weight class was the German polymath Gottfried Wilhelm Leibniz. Four years his junior, Leibniz was trained in mathematics, philosophy, law, ethics, theology, politics, history, philology, and mechanical engineering. He could write scholarly works on each of these subjects in Latin, French, English, and German. Without ever coming face-to-face, Newton and Leibniz engaged each other in mortal combat in the Calculus Wars that lasted longer than the Hundred Years' War and the War of the Roses combined. The issue concerned the provenance of infinitesimal calculus.

In 1684, the same year that Newton began formulating the *Principia*, Leibniz published his version of infinitesimal calculus. Meanwhile, fearing that the use of calculus in the formulations in his book would not be comprehended by other scholars, Newton decided instead to use only plane geometry familiar to all. However, when Leibniz's publication of the calculus appeared first, Newton was left fuming. He publicly accused Leibniz of plagiarizing. When Leibniz countersued Newton over the primacy of calculus he had no idea that the system was rigged against him. By then Newton was president of the Royal Society, the one passing judgment on Leibniz's claim, and so he was the one writing the final judgment posing as a "fair arbitrator!"

The Calculus Wars never quite came to an end, although 330 years after they began, most scholars regard the two surpassing geniuses, one English, the other German, as the coinventors of calculus. As modern mathematicians readily admit, Leibniz's notation was the superior of the two, and is

the one now used universally. The war never had to be fought! There was more than enough credit to go around. Leibniz, very much the more gracious of the two, when asked his opinion of Newton by the queen of Prussia, replied, "Taking mathematicians from the beginning of the world to the time when Sir Isaac lived, what he had done was much the better half."

The time of descent is compared for five separate curves: (a) straight line, (b) parabola, (c) circle, (d) cycloid (the brachistochrone curve), and (e) sixth degree polynomial. An animated race of five balls released simultaneously finds the ball tracing the brachistochrone emerging as the clear winner.

During the lengthy series of skirmishes of the Calculus Wars, scholars on the continent accepted Leibniz as the inventor of calculus, while those in England claimed it was England's own favorite son who had formulated the theory. But then two Swiss brothers, Jacob Bernoulli (1654–1705) and Johann Bernoulli (1667–1748), insinuated themselves into the battle, introducing a new weapon. They had recently developed their own brand of calculus—now known as the calculus of variations. They applied their calculus to a specific problem suggested by Johann in 1696: "Is there a preferred trajectory to minimize the time for a body in a gravitational field

in descending from a high point to a laterally displaced lower point?" With their calculus of variations, they discovered that, indeed, a particular, favored trajectory, the "cycloid" or "*brachistochrone* curve," exists that minimizes the time for the descent. It is said that it took the Bernoullis ten years to formulate the calculus of variations, and two weeks to actually solve the problem using their specialized approach. As disciples of Leibniz primacy, the Bernoullis hoped their brachistochrone problem could offer them an opportunity to show up Newton. They knew that Newton had relocated to London to work as warden of the Royal Mint and not engaged in mathematics for years. They sent him a letter challenging him to solve the problem.

Newton's niece, Catherine Barton, narrated the subsequent scene. "Uncle Isaac arrived home from the Mint at 4:00 pm and found the letter from the Bernoullis. He went straight upstairs to his bedchamber, would not come down for supper, and his candle was lit through the night. The next morning, he mailed the solution to the Bernoullis," *unsigned*! When Johann Bernoulli saw Newton's solution, it is said he gasped, murmuring, "You can recognize the lion from the claw marks."

The story reveals essential aspects of Newton's personality. He had accepted a job as warden of the Royal Mint and moved to London. But what was supposed to have been a sinecure for him he had embraced with passion and become even more merciless. He would see counterfeiters go to the gallows, rejecting individual pleas to "have mercy." And even though he had not done pure mathematics for over a decade, proceeded to solve a difficult problem. But he simply had had enough of these characters challenging him, nipping at his ankles. He would go upstairs, virtually reinvent calculus, and come down in the morning with the solution.

MAXWELL'S MAGNIFICENT SYNTHESIS

The harnessing of electricity is the most significant technological innovation of our species. The century that Einstein was born into saw a synthesis of seemingly disconnected electrical discoveries finally connected into a

consistent closed circuit. Two thousand years ago Pliny the Elder, historian, naturalist, as well as high-ranking Roman official, had written about seeing the spear tips of soldiers standing guard on the ramparts glowing in certain atmospheric conditions. In the Middle Ages and in the Renaissance natural philosophers wrote about how rubbing certain materials, such as amber and glass, with silk, wool, and cat fur caused them to cling together (akin to clothes being pulled out of a clothes dryer or walking down a long hotel corridor and touching a doorknob). This is all understood now as static electricity

In the late eighteenth century, the French natural philosopher Coulomb, knowing that Charles François de Cisternay du Fay and Benjamin Franklin had already established the existence of two types of static charges (±), proceeded to determine the nature of the force between them. The force turned out to be the direct product of the charges and inversely as the square of their distance of separation:

$$F = C \frac{qq'}{r^2}$$

where q and q' represent the charges. The symbol C is a constant of proportionality that depends on the system of units used and the medium that separates the charges. In its structure, the equation is evocative of Newton's law of universal gravitation.

In the eighteenth century Benjamin Franklin, American printer, inventor, and visionary statesmen, flew a kite during a lightning storm and showed that lightning is nothing but an electric current, a discharge between clouds or between clouds and the ground when a very high electric potential difference exists between them. The following decades saw other important discoveries in electricity and magnetism by physicists, chemists, and mathematicians—Gauss, Volta, Oersted, Ampere, Biot-Savart, Henry, and especially Faraday. Michael Faraday (1791–1867) came from poverty and attended only primary school. He was a simple and deeply religious man, "innocent of mathematics," as nineteenth-century scientists would have characterized an individual who possessed little mathematical training. But like other autodidacts with unusual physical intuition, he rose

to the pinnacle of his field. Faraday's ability to visualize, think in pictures, puts him in a class with Leonardo and Einstein. He performed experiments with electrolysis, he introduced the notion of electromagnetic fields, Faraday lines, and in 1831 he discovered the physical law that changing magnetic fields lines (magnetic flux) induces electric currents. This law underlies all generators and alternators from microscopic devices to hydroelectric and nuclear power generators powering entire cities.

James Clerk Maxwell was born in Scotland in 1831, the year that Faraday made his greatest discovery, and died in Cambridge in 1879, the year that Albert Einstein was born in Ulm, Germany. A child prodigy, Maxwell went on to synthesize electromagnetic theory and to make major contributions in every existing field of mathematical physics, most notably in thermodynamics, statistical mechanics, and the theory of light and colors. In a contemporary tribute, a colleague at Cambridge University described him as "a man who was incapable of making a mistake in physics." Maxwell published his most important paper in 1863–1864, and his comprehensive and self-consistent *Treatise on Electrodynamics* ten years later. The latter opens with the acknowledgment of his debt to Faraday, as "... *the father of that enlarged science of electromagnetism.*" His synthesis boiled down to just six integral equations, or equivalently, differential equations. A generation later, Oliver Heaviside (1850-1926), a self-taught mathematician-physicist in London, developed vector calculus and, with the formalism's improved efficiency, condensed Maxwell's equations to just the four, so familiar and beautiful to modern scientists and engineers:

$$\nabla \cdot E = \rho/\varepsilon_0, \quad \nabla \cdot B = 0, \quad \nabla x E = -\partial B/\partial t, \quad \nabla x B = \mu_0 g E + \varepsilon_0 \mu_0 \partial E/\partial t$$

Maxwell's equations. The first two equations are read "divergences of the electric and magnetic fields," respectively, scalar equations, each representing a single equation; the last two are "curls of the electric and magnetic fields," vector equations, each representing three separate scalar equations. The symbols ε_0, μ_0, and g represent the "permittivity," "permeability," and "conductivity," characteristic properties of the intervening medium for the fields and the current.

In the language of vector calculus, the first equation is a compact way of representing the Coulomb force (attraction and repulsion of charges). The second equation is the statement that magnetic charges (magnetic monopoles) do not exist. The third equation is the mathematical statement of Faraday's law of electromagnetic induction (the principle of the generator). The fourth equation, known as Ampere's circuital law, explains how a current-carrying loop immersed in a magnetic field feels a torque and spins (the principle of an electric motor).

If we were to perform certain mathematical operations, specifically, taking the "curl of the curl" in the third or the fourth equation, we could show that each equation reduces to the classic wave equations for electromagnetic waves traveling at a velocity

$$v = \sqrt{1/\epsilon\mu}$$

This result alone is one of the greatest achievements of Maxwell's equations in showing that in a vacuum (empty space), all electromagnetic radiation travels at the speed of light, c = 300,00 km/sec (186,300 mi/sec), and this radiation spans a spectrum from the shortest wavelength—gamma rays, to the longest, the radiation emitted by power lines. Visible light is just an infinitesimal sliver of the total electromagnetic spectrum.

Electromagnetic theory and electric gadgetry—static charges, currents, electrical forces, the source of magnetism, magnets, light as electromagnetic radiation, the telegraph, electrical motors, and generators being developed by inventors and engineers could suddenly be understood at a fundamental level and optimized. The coupling of theory and experiment fueled an almost vertical ascent of both. The contraptions of Thomas Edison, Nikola Tesla, and others could no longer be seen as mysterious black boxes. They are examples of electrical gadgetry explained by fundamental physical laws. Maxwell's synthesis of electrodynamics was an achievement comparable to Isaac Newton's synthesis of classical mechanics published in 1687. The two theories, classical mechanics and electromagnetic theory, formulated

180 years apart, could now be seen as two complementary edifices of physics, each working beautifully in its own right.

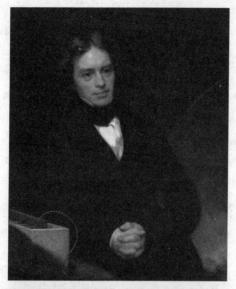

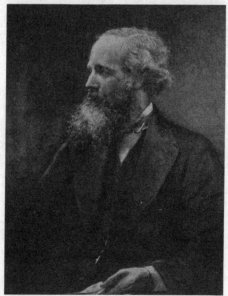

Portraits of Michael Faraday (1791–1867) and *James Clerk Maxwell (1831–1879)*. *These two portraits, along with an engraving of Newton, comprised the collection hanging in Albert Einstein's study. In an interview in England in 1933, Einstein singled out Maxwell as the "giant on whose shoulders he had stood."*

Both theories assumed absolute space and time—the three dimensions of space (x, y, z) and independent of them, the dimension of time, t. The mass m of a body m would also be absolute in the sense that it was independent of space, time, and motion. Both theories assumed the existence of *luminiferous aether*, or *ether*, an imagined invisible medium permeating the entirety of the universe and serving to propagate light. Paradoxically, *ether* had to be soft and hard at the same time to allow heavenly bodies to fly through it unimpeded, and yet had enough to explain the astonishingly high speed of light. Ether, postulated by Newton and repostulated by Maxwell, became a convenient medium to define the state of absolute rest, or a stationary frame for the universe.

11

THE RELATIVISTIC REVOLUTION
CASE STUDY: EINSTEIN

> It would not last, the Devil howling, "Ho."
> Let Einstein be, restore the status quo!
> —J. C. Squire[1]

In 1895, the preeminent Scottish Irish physicist Lord Kelvin (1824–1907) expressed a professional opinion: "Heavier-than-air flying machines are impossible." Then in the closing days of the nineteenth century, Kelvin, his major discoveries behind him, took stock of the state of affairs in physics and issued another opinion: "There is nothing new to be discovered in physics now. All that remains is more precise measurement."

Just a few years earlier, in 1887, Albert A. Michelson (1852–1931), already famous for measuring the speed of light more accurately than anyone else ever, had collaborated with Edward W. Morley in an experiment to detect the ether. Their failure to detect the mysterious substance challenged many of the fundamental assumptions of physics. When

Einstein's theory of relativity resolved the difficulties, Michelson lamented, "To think that I created this monster!" He died never having fully comprehended Einstein's theory. Revisiting this "failed experiment" many years later, Einstein described it as "the most important scientific experiment ever performed."

Both Lord Kelvin's and Michelson's pronouncements represent inauspicious expressions of hubris disproved shortly thereafter by subsequent events as "famous last words." At the time of Lord Kelvin's pronouncement, physics had been in ferment for at least a dozen years and was poised at the threshold of a golden age, a thirty-year period that would shake it to its core, and, indeed, not once, but twice! The period describes the "rebirth," or the Renaissance of the Scientific Renaissance of three hundred years earlier, along with a three-year period near the end (1925–1928), its High Renaissance. Albert Einstein would do for physics what Leonardo da Vinci had done for art, serving as its principal driver. Both theories formulated in this period can be correctly described as mathematically rigorous, counterintuitive, with both introducing new paradigms that would change the way we see reality.

The Relativistic Revolution, like Newton's classical mechanics and Maxwell's electrodynamics, is grounded in scientific determinism. It is attributed to one man who had set out, as he mused on several occasions, "to read the mind of God." In contrast, the Quantum Mechanical Revolution is grounded in scientific indeterminism. The underlying theory is the product of group genius, where the entirety far exceeds the sum of its parts. Although quantum mechanics began its rise slightly earlier than the Relativistic Revolution and also had Einstein's crucial imprimatur, it took longer to come together. We will relegate its discussion to the next chapter.

Regarding the change of paradigms involving the new theories, Feynman once observed:

> Trying to understand the way nature works involves a most terrible test of human reasoning ability. It involves subtle trickery,

beautiful tightropes of logic on which one has to walk in order not to make a mistake in predicting what will happen. The quantum mechanical and the relativity ideas are examples of this.

Einstein was more succinct, "Raffiniert ist der Herrgott aber boshaft ist er nicht" (God is subtle, but He is not mischievous). Those immortal words are carved into a mantlepiece in Fine Hall at Princeton University, where he first pronounced them in 1921.

Relativity came in two stages: special relativity (1905) and general relativity (1915). Special relativity explained the null result in the Michelson–Morley experiment and changed forever the paradigm of space-time that had been in place since natural philosophers first began to interrogate nature. It succeeded in resolving a haunting mathematical incompatibility identified between the two central pillars of physics—Newton's classical mechanics and Maxwell's electrodynamics. General relativity offered a fresh view of the large-scale universe of celestial bodies, and to explain the cosmic background radiation (not to be confused with ether), stars that collapsed by their own weight, black holes, gravitational lenses, and the creation and expansion of the universe.

LINGERING PROBLEMS FROM THE NINETEENTH CENTURY

Beginning in 1885, Heinrich Hertz, just five years after completing his PhD and already a full professor at the University of Berlin, had begun to experiment with equipment featuring two pairs of electrified metal terminals. Physicists already knew that when a pair of terminals was raised to a high enough voltage difference, a spark would take place between the terminals. But when Hertz brought a second apparatus in the general proximity of the first, the discharge in the first pair triggered a discharge in the second pair. The electromagnetic radiation predicted by Maxwell's equations served as the agent for the terminals' communication. Within

two years, Hertz also found that if the terminals of the secondary pair were bathed in ultraviolet light, the discharge would occur more readily, even at a somewhat lower voltage than before. With the identification of ultraviolet (UV) radiation liberating electrons from the second pair, he became the first scientist to observe the photoelectric effect (photon in, electron out), although not investigated in detail until Lenard revisited the problem. Hertz died in 1894 at thirty-six after contracting a brain infection, but he bequeathed a legacy of immense wealth in the quest to achieve wireless communication, including radio, radar, television, and cell phones, and gained immortality by having the unit of frequency, *hertz* (one cycle per second), named after him.

MICHELSON–MORLEY EXPERIMENT

The same year that Hertz observed the photoelectric effect, Michelson and Morley performed their experiment to detect the motion of the earth through the ether in a basement lab of Case School of Applied Science in Cleveland, Ohio. The notion of cutting-edge science being performed in Cleveland, a backwater city in academia at the time, was as likely as a traffic accident that also took place in Cleveland in 1895. At the time, only two cars existed in the entire city. They collided and were totaled at a downtown intersection. Unlikely events do take place!

A useful schematic analogy to help understand the "ether current" experienced on the earth is offered as the "River Problem."[2] In the upper two drawings in the accompanying diagram, we imagine a river of width L flowing to the right (indicated by the arrow). Identical twins Larry and Gary, who possess equal physical capabilities, are pitted against each other in a swim meet. Larry is to swim from A to B, a distance L in the direction of the current, then to swim from B back to A against the current. Gary is to swim from A to C, perpendicular to the current, and subsequently return to A. The speed of each swimmer, relative to stationary water, is designated by c, and the speed of the current relative to the shore by v.

In the upper left diagram, when there is no current $v = 0$, the twins return simultaneously to the finish at A. When there exists a current of velocity v, however, Larry swims with a net velocity $(v+c)$ swimming downriver, and $(v-c)$ swimming upriver. As for Gary, he must aim at a point C', slightly upstream (since he is going to be swept downriver), to reach the opposite shore at C. His net speed crossing the river diagonally is determined from the Pythagorean theorem,

$$\sqrt{(c^2 - v^2)}$$

Subsequently, Gary must reverse course, aim at a point A' upstream, in order to return to A. The general solution of the problem comparing Larry's time to Gary's reduces to the simple ratio:

$$\frac{t_{Larry}}{t_{Gary}} = \frac{1}{\sqrt{1-\frac{v^2}{c^2}}}$$

In the case where there is no current ($v = 0$), the ratio reduces to $t_{Larry} = t_{Gary}$, assuring a tie for Larry and Gary. In the case when the speed of the current is equal to or greater than the speed of swimmers ($v \geq c$), then the solution to the problem would be imaginary (or the square root of a negative quantity). The swimmers would be swept away by the water, unable to return. But in the case of general interest, when $0 < v < c$, the numerator would be larger than the denominator, yielding $t_{Larry} \geq t_{Gary}$. Accordingly, Gary, swimming the perpendicular course, would win the race. This analysis applies to twins swimming transverse and parallel courses in a river, and it also applies for light traveling transverse and parallel courses in the hypothetical ether.

Michelson and Morley created their apparatus, an interferometer, as a tabletop apparatus consisting of an array of three mirrors and a source of light all mounted on a slab of marble, with the marble set to float on a bed of liquid mercury. (The mercury, heavier than marble, was meant to dampen vibrations, and also to allow the interferometer to be rotated by 90°, effectively interchanging the parallel and perpendicular arms of the apparatus.) The mirror at A was semi-silvered, or polarized, and placed at 45° to the direction of the original incident light beam, thus splitting the beam into two components, sending 50% to a fully silvered mirror placed perpendicular to the original beam at B, and the other 50% straight ahead to a fully silvered mirror at C. The "parallel and perpendicular arms" of the interferometer measured one meter. The two beams, collected at their return to A, were added together and compared to see if they were in phase, whether they had arrived in synch, or whether one beam had taken longer than the other. With the interferometer anchored in place in the laboratory in Cleveland, and Cleveland being a part of the earth traveling through interstellar space, the two beams should have arrived at A at different times—the perpendicular beam before the parallel beam.

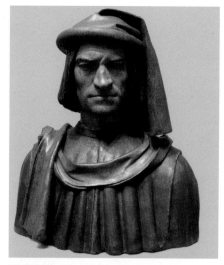
FIGURE 1A

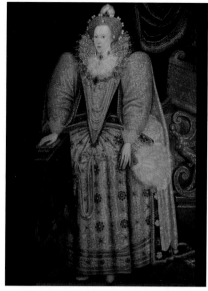
FIGURE 1B

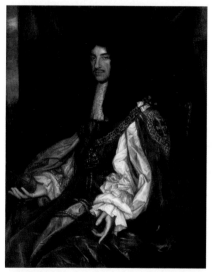
FIGURE 1C

FIGURE 1D

Zeitgeist favorable for the Arts and Sciences
None of the individuals on this page would be described seriously as a creative genius, but all five were in leadership positions and all were enlightened leaders who succeeded in creating the cultural spirit salutary for the advancement of the arts and/or sciences. **FIGURE 1A:** The bust of Lorenzo de' Medici "Il Magnifico" by Andrea del Verrocchio, National Gallery of Art, Washington, DC. **FIGURE 1B:** Full-length portrait of Queen Elizabeth I, Master's Lodge at Trinity College, Cambridge. The last member of the Tudor Dynasty, she reigned during the Golden Age of England, the Shakespearean Age. **FIGURE 1C:** *Portrait of Charles II* (1660–1665) by John Michael Wright, National Portrait Gallery, London. The sponsoring monarch of the Royal Society of London, the king was a gentleman scientist. In his dealings with the Society, he practiced a strictly hands-off policy that has endured into the 21st century. **FIGURE 1D:** The 35th President John F. Kennedy, and his wife Jackie, photographed in 1959 in Hyannis Port, Massachusetts.

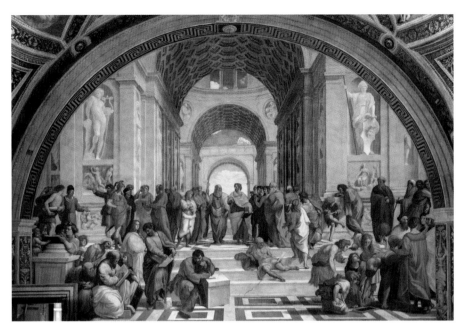

FIGURE 2

Raphael, *The School of Athens* (1510)
Raphael, *The School of Athens*, (1510) Stanza della Segnatura, Vatican. The opulent architecture features both Greek and Roman elements. Plato and Aristotle are seen where the orthogonals of one-point perspective would converge. To the left of Plato and Aristotle, the bald man in a green robe, seen in profile, is Socrates. Plato is holding a copy of his book *Timaeus* and Aristotle, his *Nicomachean Ethics*. The model Raphael used for Pythagoras was Bramante, the Vatican's architect, and his personal champion. To the left of Pythagoras is Anaximander, to the right Archimedes. The turbaned figure looking over Pythagoras's shoulder is Averroes. The man with a laurel on his head to the left of Averroes is either Epicurus or Democritus. The model for Plato is Leonardo. The model for Aristotle is thought to be one of the masters of perspective, Bastiano da Sangallo. In the original full-size cartoon that Raphael intended to use as a stencil for the mural, Heraclitus was conspicuously missing. It is said that Michelangelo, in first viewing the cartoon, was clearly impressed, but expressed disappointment that he had not been included as a model. Raphael painted Michelangelo in the guise of Heraclitus, the dark brooding figure with his elbow on the chest near the center foreground. He knew that Heraclitus was also an exceedingly difficult man. The group in the lower right features Euclid, bent over with a compass in hand, teaching his students geometry. As an afterthought, Raphael also included his own likeness in the guise of the legendary painter of antiquity Apelles, who is peering out from the group second from the extreme right in the foreground, a subtle cameo appearance in the manner of Alfred Hitchcock in his films. Humanists of the 16th century were not as familiar with the natural philosophers Thales, Aristarchus, and Eratosthenes. Otherwise, Raphael may well have included them in the group portrait. Hypatia, the gifted female mathematician and last head of the Library of Alexandria, appears in the mural. She is wearing a white robe and standing to the left of Parmenides, who is wearing a gold shirt and holding a scroll. Raphael had learned perspective from Leonardo and applied it masterfully.

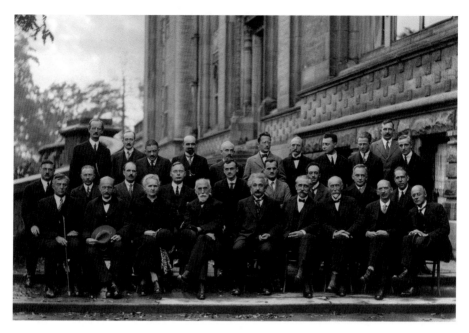

FIGURE 3

The Solvay Conference of 1927
Rear Row, left-to-right: Piccard, Henriot, Ehrenfest, Herzen, de Donder, Schrödinger, Verschaffelt, Pauli, Heisenberg, Fowler, Brillouin. Middle Row: Debye, Knudsen, W. L. Bragg, Kramers, Dirac, Compton, de Broglie, Born, Bohr. Front Row: Langmuir, Planck (hat in hand), Curie, Lorentz, Einstein, Langevin, Guye, Wilson, Richardson. Missing: Rutherford and W. H. Bragg. Marie Curie is effectively the Hypatia of *The School of Athens*. Although Rutherford is missing, he is implicitly represented by his son-in-law Fowler, PhD advisor to Dirac. Since black and white photos have their own timeless quality, many readers would prefer this group photo in its original B&W version. However, in color, it offers a better balance to Raphael's five-hundred-year-old masterpiece, seen on the facing page. The colorization was done by Belgian digital artist Sanna Dullaway.

FIGURE 4B

FIGURE 4C

FIGURE 4A

Shakespeare's World
FIGURE 4A: The audience at the open-air Globe Theatre moments before the appearance of the actors on stage to perform Shakespeare's *Julius Caesar*. Photo by the author (May 2022). **FIGURE 4B:** William Shakespeare (1564–1616), *The Cobbe Portrait* c. 1610, believed to be the only authentic image made during the playwright's life. Owned by Henry Wriothesley and passed down to Archbishop Cobbe (1686–1765). **FIGURE 4C:** From his perch on a nearby wall, a contemporary Roman schoolteacher practices his oratory on a captive audience, his students. It is said, "Only in prison do you have a captive audience!" But that is the curmudgeon's point of view. A good teacher is frequently a good orator. This man delivering Mark Antony's address to the crowd held their rapt attention. Photo by the author at the ruins of the ancient Roman Port of Ostia Antica (2015).

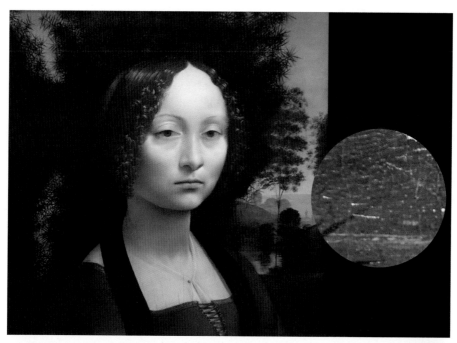

FIGURE 5A

FIGURE 5B

Polymath as Portraitist
FIGURE 5A: Leonardo's *Ginevra de' Benci* and the artist's fingerprints, c. 1483. The circle extracted from an area in the juniper bush near the subject's left shoulder reveals Leonardo's fingerprints, also seen in a few of his other paintings, including the neck of the *Lady with an Ermine*. **FIGURE 5B:** Leonardo's *La Belle Ferronnière* (1493–1494) Louvre, Abu Dhabi, on loan from the Louvre, Paris. The portrait may depict Lucrezia Crivelli. The subject stands modestly behind a low wall but gazes out at her visitors, engaging them in a dialogue, and sees them reflexively reach for their smartphones to announce, "I was with her . . . I was with a Leonardo." The vertical centerline passes through the subject's left eye. Photo by the author in Abu Dhabi in 2018 coinciding with the painting's visit.

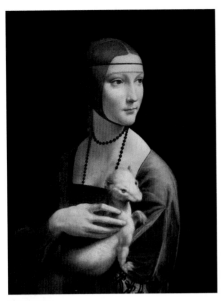

FIGURE 6A

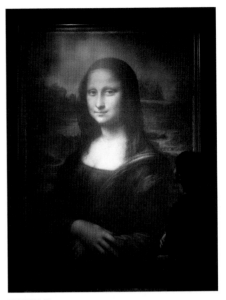

FIGURE 6B

FIGURE 6C

FIGURE 6D

Lady with an Ermine, Mona Lisa, and **Ponte Buriano**

FIGURE 6A: Leonardo da Vinci, *Lady with an Ermine,* Czartoryski Museum, Krakow, Poland. Painted in oil and tempera on wood panel between 1489–1490, the portrait of Cecilia Gallerani during a period in her life when she was the mistress of Duke Sforza. **FIGURE 6B**: Leonardo da Vinci, *Mona Lisa* (1503–1506), the Louvre Museum. The enlarged reproduction and its young admirer examining the bridge were photographed in the Museum of Science, Boston, at a special exhibition highlighting Leonardo's experimentation. It was engineer Cote's multi-spectral camera that revealed some of the painting's secrets. **FIGURE 6C**: Entrance to the Ponte Buriano with a sign and traffic light. **FIGURE 6D**: The bridge seen in the *Mona Lisa* next to the lady's left shoulder is almost certainly Ponte Buriano in Arezzo, a one-lane medieval bridge over the Arno River. Modern cars and trucks now drive across daily, the flow controlled by traffic lights located at the two ends of the bridge.

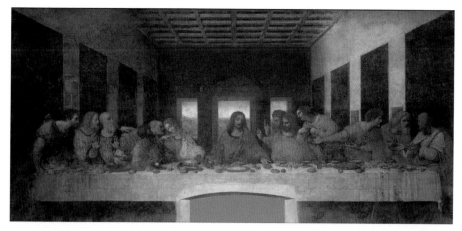

FIGURE 7A

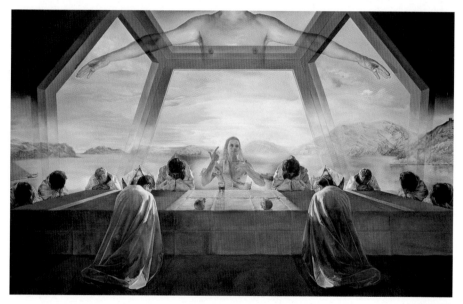

FIGURE 7B

Last Suppers envisioned by Leonardo da Vinci and Salvador Dalí
FIGURE 7A: Leonardo da Vinci, *The Last Supper*, (1498). Oil with tempera grassa, Refectory of Santa Maria delle Grazie, Milan. The group portrait is comprised of the four trios and Christ in the center. First trio (from the left): Bartholomew, James the Younger, and Andrew; second trio: Judas Iscariot, Peter, and John; Christ; third trio: Thomas, James the Greater, and Philip; fourth trio: Matthew, Jude Thaddeus, and Simon the Zealot. Judas, his face hidden in shadow, is clutching the purse with thirty pieces of silver, and he has upset the saltcellar. The orthogonals of linear perspective would converge at a vanishing point that is located at Christ's head. **FIGURE 7B:** Salvador Dalí, *Sacrament of the Last Supper*, (1954-1955) National Gallery of Art, Washington, DC. The sun setting behind Christ creates shadows on the table of each of the apostles, the halves of a small loaf of bread, and even the glass of wine. Christ, a transparent-translucent figure, lacks a shadow.

FIGURE 8A

FIGURE 8B

The intersection of Art and Science
FIGURE 8A: The eastern façade of the Parthenon. When the missing roofline is recreated by extrapolating the slopes of the roof pediment, along with its center ornament, the façade is almost exactly framed by the golden rectangle, of a height/width ratio of 1:1.618. Here the logarithmic spiral has been integrated into the golden rectangle. **FIGURE 8B:** The equation for the logarithmic spiral is plotted in red, scaled to fit, and superimposed on Hart's masterpiece, *Ex Nihilo* ("From Nothing"), above the central door on the western façade of the Washington National Cathedral. It is quite extraordinary that Hart, with no knowledge of mathematics, organized the carving in a logarithmic spiral passing precisely through the elbows of five of the eight models depicted, and fairly close to seven of the eight. Photo of full-scale maquette in the artist's studio.

FIGURE 9A

FIGURE 9B

FIGURE 9C

FIGURE 9D

Center-Line Principle and Left Cheek Principle

FIGURE 9A: Array of nine iconic portraits demonstrating the centerline principle. Top row (left-to-right): Rogier van der Weyden (1460), Sandro Botticelli (1480), Leonardo (1503); second row: Titian (1512), Peter Paul Rubens (1622), Rembrandt (1659); bottom row: Gilbert Stuart (1796), Graham Sutherland (1937), and Pablo Picasso (1937). Courtesy of Christopher Tyler (1998). **FIGURE 9B:** Graham Sutherland's *Portrait of Churchill* commissioned for his 80th birthday. The painting was unceremoniously burned in a funeral pyre shortly after it was created in 1954. The centerline of the frame passes close to the subject's left eye. **FIGURE 9C:** Jamie Wyeth's *Portrait of John F. Kennedy* (1967), created four years after JFK's death. The centerline passing near Kennedy's left eye divides the canvas into 1:1.618 parts. Compliments of Jamie Wyeth. **FIGURE 9D:** Rembrandt produced 57 self-portraits in oil. The six self-portraits reproduced above depict the artist in his 30s and 40s in the first row, and in his 50s and 60s in the second row. These are selected to represent the 5:1 ratio of the right cheek dominance in Rembrandt's self-portraits. Like the majority of individuals sitting for a portrait, he is displaying predominantly his left-cheek, controlled by his emoting right hemisphere. The self-portrait in the lower right, seen at the National Gallery, Washington, DC, displays his right cheek controlled by his "intelligent" left hemisphere.

"I can show you what a woman can do." —Artemisia Gentileschi

FIGURE 10A

FIGURE 10B

FIGURE 10C

FIGURE 10D

FIGURE 10E

A Gallery of Great Women Painters
FIGURE 10A: Artemisia Gentileschi, *Venus and Cupid*, (c. 1625–1630), Virginia Museum of Fine Arts, Richmond, Virginia. FIGURE 10B: Artemisia Gentileschi, *Self-Portrait as the Allegory of Painting* (c. 1638), National Gallery, London. FIGURE 10C: Judith Leyster, *Self-Portrait* (c. 1630), National Gallery of Art, Washington, DC. FIGURE 10D: Judith Leyster, *The Concert* (c. 1633), National Museum of Women in the Arts, Washington, DC. This painting was mistakenly attributed to Frans Hals, until just a generation ago when the mistake was rectified. FIGURE 10E: The only interloper in the Gallery of Great Women Painters, is an actual Frans Hals, *Jester Playing a Lute* (1623), Musée du Louvre.

"More savage than Caravaggio: the woman who took revenge in oil" —Jonathan Jones

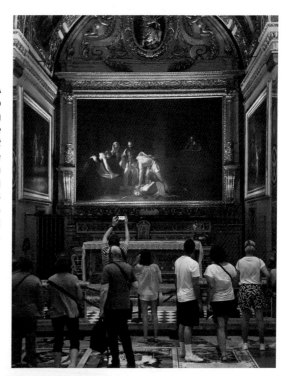

FIGURE 11A
A group of visitors to St. John's Co-Cathedral, admiring Caravaggio's altarpiece, *The Beheading of St. John the Baptist* (1608). The artist scrawled the message, "Made by Michelangelo da Caravaggio," with the blood flowing from the martyr's neck. Here, as in many of his other paintings, his own likeness is employed for that of the victim. Photo by the author.

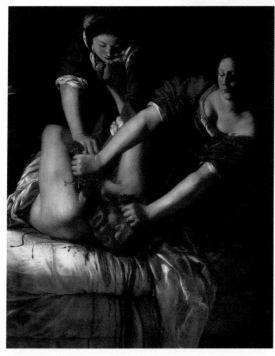

FIGURE 11B
Artemisia Gentileschi, *Judith Slaying Holofernes*, Museo di Capodimonte, Naples. The artist painted herself as Judith beheading her rapist Agostino Tassi in the guise of Holofernes.

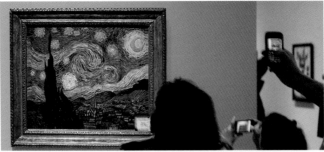

FIGURE 12A

FIGURE 12B

FIGURE 12C

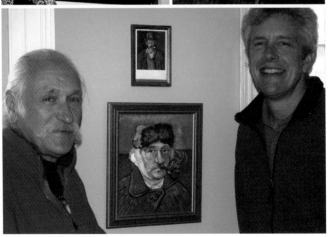

FIGURE 12D

Works by a Pair of Troubled Artists
FIGURE 12A: Vincent van Gogh, *The Starry Night* (1889), Museum of Modern Art (MoMA), New York. On December 23, 1888, while in the grips of a psychotic episode, van Gogh admitted himself into a mental asylum in Saint-Rémy. Through the bars of the window in his room, he painted arguably the best-known of his works. Visitors to the MoMA are seen recording their own images of *The Starry Night* and transmitting them instantly to friends with the tacit announcement: "I am here with van Gogh!" The man who suffered intense loneliness in his brief lifetime of 37 years can now never avoid crowds. FIGURE 12B: Frida Kahlo's *Self-Portrait Dedicated to Leon Trotsky* (1937), National Museum of Women in the Arts (NMWA), Washington, DC. A visitor to the museum is trying to make out the note addressed to Trotsky that Frida is holding in her hands. FIGURE 12C: Before checking into Saint-Rémy, van Gogh mutilated his left ear with a straight razor, then created a self-portrait (seen in the paintings as his right ear). FIGURE 12D: In 2000, the contemporary painter Daniel Ludwig (far right) created a portrait of his father, psychiatrist Arnold Ludwig, à la van Gogh, as a gentle reminder to stop smoking.

FIGURE 13A

FIGURE 13B

FIGURE 13C

FIGURE 13D

FIGURE 13E

FIGURE 13F

Newton's World

FIGURE 13A: Woolsthorpe Manor, Newton's house. The bedroom in which he was born is seen in the upper left. The bedroom that served as his study and laboratory during 1665–1666 is in the upper right; the kitchen is just below. The vantage point in shooting the photo is the location of the legendary apple tree, which still stands. **FIGURE 13B:** Newton's Original Apple Tree. A brass plaque at its base recounts Queen Elizabeth II's visit to honor it. A piece of the wood traveled to the moon on an Apollo Mission. **FIGURE 13C:** Trinity College Quadrangle. Across the Trinity College Courtyard with its manicured lawn stands the yellow two-story building housing Newton's rooms and to its right, the tower of the main gate to the college. The photo was shot from the fountain at the center of the quadrangle. On the left is the Trinity College Chapel. **FIGURE 13D:** Roubiliac's *Statue of Newton*. Roubiliac's statue is holding an equilateral prism in his hands. Antechapel, Trinity College, Cambridge. **FIGURE 13E:** The dining room of Trinity College, Cambridge. Portraits of past masters and other great sons of Trinity hang on the facing walls. Presiding over the scholars is Henry VIII, founder of Trinity. **FIGURE 13F:** The interior of the Wren Library. Lord Byron's seated statue is located at the far end of the hall. Originally carved for Westminster Abbey, the statue was rejected by the Abbey officials who felt Byron was a reprobate and need not be honored with the other great British dignitaries. An edited version of *Principia*'s first edition is kept in a glass case. An alcove immediately to the right of Byron's statue is unique in the world: it contains 800 of Newton's original collection of 2,000 books.

FIGURE 14

Limited Gallery of Nobel Laureates
The portraits on this and the facing plate are among the Nobel Prize (NP) winning scientists discussed in the book. All except two of the fourteen, Eric Kandel and Frances Arnold, were recipients of the prize in physics. And all the photos except two, Maria Goeppert Mayer and Frances Arnold, were photographed by the author. Upper row. Left: Born in 1902, **Paul Adrien Maurice Dirac** NP'33. With his relativistic wave equation, he predicted the existence of anti-matter. He was the youngest recipient of the prize before Pakistani teenager Malala Yousafzai was awarded the Nobel Peace Prize in 2014. Dirac's photo was shot at the Einstein Centennial held at the Institute for Advanced Study (1979). Center: An exceptionally unassuming man, **John Bardeen** was the only two-time recipient of the Nobel Prize in the same field (physics): '56 and '72. (Other double-recipients are Marie Curie, who received a NP in Physics and Chemistry, and Linus Pauling, in Chemistry and Peace). Bardeen was a PhD student of Eugene Wigner at Princeton. Right: a trio of physics Nobel Laureates, **Richard Feynman** NP'65, **T. D. Lee** NP'57, and **Murray Gell-Mann** NP'69 at the American Physical Society Meeting in April 1970. Lee's co-recipient C. N. Yang NP'57 was also at the meeting but was not in the field of view for the photo. Lower row. Left: **Eugene Wigner** NP'63, one of the "Hungarian Martians," professor at Princeton for three decades, introduced Dirac to his sister Margit, the future Mrs. Dirac. With child-like enthusiasm, Wigner is demonstrating the proof of a geometric theorem that he had just conceived during a sleepless night to a younger friend, the author. Center: **Maria Goeppert Mayer** NP'63, at her desk with a copy of the Chart of Nuclides behind her. Right: **Hans Bethe** NP'67, illuminated by an overhead projector during a lecture he gave to the American Physical Society in Washington, DC, in 1968.

FIGURE 15

Limited Gallery of Nobel Laureates (Continued)
Upper row. Left: **Steven Weinberg** NP'79, shared with Sheldon Glashow and Abdus Salam for their contributions to the theory of the unified weak and electromagnetic interaction between elementary particles. Photo shot following a physics seminar at Johns Hopkins University, Baltimore (1987). Center: **Norman Ramsey** NP'89, wrote the first PhD thesis on nuclear magnetic resonance (NMR) and later designed the first atomic clock. Hanging on the wall behind him is a pair of framed documents, including a photo of Ramsey with King Carl XVI of Sweden and a copy of the Nobel Prize certificate. Right: **William Phillips** blowing gently into a cup of coffee in order to demonstrate "evaporative cooling." The picture resonates with irony. Phillips shared the NP'97 for developing the technique of trapping and cooling atoms with multiple lasers and achieving nano-Kelvin temperatures. The portrait of Einstein imprinted on the cup was reproduced from an ink drawing by the author. Lower row. Left: **Eric Kandel** NP'00 for physiology and medicine, following a lecture at the Cosmos Club, Washington, DC (2014). Center: **John Mather** NP'06, NASA physicist, shared the prize in physics with George Smoot for the design of the Cosmic Background Observer satellite. Right: **Frances Arnold** NP'18, shared the prize in chemistry for her work in "directed evolution of enzymes." Credit: All photos are by the author, except the one of Frances Arnold who graciously provided the photo of herself in her lab at Caltech (2020).

FIGURE 16A

The greatest artists and scientists have become inseparable from their masterpieces and essential ornaments of our species. And although they have gained immortality through their works, these geniuses may never have been able to recognize themselves in ways their descendants have come to see them. After giving a guest lecture at Johns Hopkins Medical Center in Baltimore in the late 1990s, I came across a billboard advertising a DNA testing clinic, "Who's the Daddy?" featuring a decidedly pregnant Mona Lisa. The year 2020 saw a conflation of social media, the COVID-19 pandemic, and gallows humor. The *Mona Lisa* sprung back into action presenting an anonymous cartoonist's poster, "Stages of Quarantine." The great lady dons a face mask; she begins hoarding toilet paper; her hair reveals a need for coloring; then, she appears in a straight-jacket; another image still shows her as corpulent in a portrait by Fernando Botero. In a final image, Mona Lisa is seen receiving a dose of the recently produced vaccine. Meanwhile, van Gogh in his self-portrait with mutilated ear appears to have trouble donning his mask.

FIGURE 16B

Love is the Answer. Einstein carrying a placard is an illuminated painting by the Los Angeles-based French pop artist Thierry Guetta, aka Mr. Brainwash. The popular modern perception is that Einstein was a brilliant, social-minded, pacifist lover. The photo was shot in 2019 at the Galeries Bartoux on Central Park South in New York City.

When the experiment was carried out, the beams were found to return to A at exactly the same time. No ether current was detected! Fitzgerald in Ireland and Lorentz in the Netherlands speculated that an actual contraction of the longitudinal arm of the apparatus, *A-B*, took place, inspiring the limerick

> *There once was a young man named Fisk,*
> *Whose fencing was incredibly brisk,*
> *So fast was his action,*
> *That Lorentz contraction,*
> *Reduced his foil to a disk.*

X-RAYS

In 1895 German physicist Wilhelm Roentgen (1845–1923), while at the University of Würzburg studying cathode rays, identified a new type of radiation, much shorter in wavelength than ultraviolet, specified as X-rays. With an ability to penetrate human bodies and distinguish between soft and hard tissue, the technology became the first of a number of radiological imaging tools for medicine. Roentgen was awarded the first Nobel Prize in Physics (1901).

MARIA OF THE RADIUM, POLONIUM, AND CURIUM

"The greatest scientific deed of her life, proving the existence of radioactive elements and isolating them," said Einstein, ". . . owes its accomplishment not merely to bold intuition but to a devotion and tenacity in execution under the most extreme hardship imaginable, such as the history of science has not often witnessed." Einstein, no stranger to adversity himself, was expressing personal empathy and admiration for Marie Curie (1867–1934), one of the pioneers of the Scientific Renaissance of the early twentieth century.

An inescapable message underlying Einstein's words is that women are no less creative than men, but the obstacles they face can be virtually insurmountable. In the patriarchal society that has prevailed for millennia, it has been extraordinarily difficult for women to create artistic or scientific masterpieces of the same order as men. But Curie succeeded against unimaginable odds and prevailed. Her achievements earned her two Nobel Prizes—in 1903 in Physics, and in 1911 in Chemistry. She was also a single mother bringing up two daughters. One earned a Nobel Prize in Chemistry, and the other wrote a seminal biography of her mother.

After completing her degree, Marie Curie could have signed on to undertake research in the exciting new area of X-ray physics launched by Wilhelm Roentgen. But Curie took a job instead as a research assistant to Henri Becquerel (1852–1908) investigating phosphorescence. The phenomenon is characteristic of certain crystalline rocks that glow after being subjected to ultraviolet radiation from sunlight. But gradually, the glow diminishes and disappears. Her research partner was Pierre Curie, eight years her senior, whom she would soon marry. Among various materials Becquerel earmarked for the study was a dark ore, pitchblende. The sample emitted radiation of a peculiar kind—much, much shorter than visible light, much shorter even than X-radiation, and capable of penetrating solid material. The discovery on December 21, 1898, was entirely serendipitous, entirely valid, but a result of accidents and miscommunication.

The Curies set out on the laborious task of shoveling mounds of pitchblende and applying chemical separation techniques to identify the culprit substance in the pitchblende—a sliver less than a teaspoon of a pure radioactive material that glowed without dimming, unlike in phosphorescence. Marie Curie became the first to speculate that the radiation from radioactive material may be the emission of atoms and not of molecules, that the process was not the result of chemical activity. At a time, the existence of atoms was still a source of dispute. J. J. Thomson, the discoverer of the electron, had speculated, "If atoms really exist, they are probably comprised of negatively charged electrons embedded in a wad of positively charged

material." His picture, known as the "plum pudding model," assured a neutral net charge for the atom.

Marie and Pierre Curie during the chemical extraction of radium from pitchblende.

Fifteen years after the Becquerel team's discovery, the New Zealander Ernest Rutherford performed his gold foil experiment at Manchester University. He bombarded a microscopically thin piece of gold foil, resembling Saran Wrap, with alpha particles employing a radioactive source. The large-angle deflection of many of the alpha particles was startling. In a famous remark, Rutherford likened the phenomenon "to shooting fifteen-inch naval shells at a tissue and having them bounce back in your face!" He felt it necessary to propose a new structure for the atom—that of "the nuclear atom." Negatively charged electrons, he suggested, were orbiting a positively charged, exceedingly small, but extremely heavy nucleus—again assuring

the neutral overall charge for the atom. When the neutron (n) was discovered by James Chadwick in 1932, a more sophisticated model emerged: a nucleus is comprised of positively charged protons (p) and neutrally charged neutrons. Visible light is emitted by the decay of electrons in the outer orbits, Roentgen's X-rays from the decay of electrons in the innermost orbits, and the Becquerel team's radioactive emission from the nucleus. The radiation was emitted from the nucleus in the form of alpha (a), beta (b), and gamma (g) radiation—with two protons plus two neutrons comprising the a, an electron comprising the b, and a photon comprising the g.

Among radioactive sources found in nature is the long-lived isotope of uranium, uranium-238 (comprised of 92 electrons, orbiting a nucleus with 92 protons and 146 neutrons). Through a cascade of decays with the emission of a, b, and g radiation, the original nucleus ends as lead-206. This is a stable nucleus, one possessing an infinite half-life. In comparison, uranium-238 has a half-life of 4.5 billion years, the intermediate nuclei in the series possessing much shorter half-lives. After 4.5 billion years, the original quantity of uranium-238 will be down to one half of the original quantity, and after two half-lives, the amount left will be one fourth.

A more frequently cited isotope, uranium-235 (with 92 protons, 143 neutrons, and a half-life of 735 million years), exhibits a decay series evocative of the isotope uranium-238 series. But more important than the decay series of uranium-238 is the isotope's penchant for transmutation by fission (division), offering the mechanism to harness massive amounts of nuclear energy.

At the light end of the periodic table, another type of nuclear reaction occurs. Under intense heat and pressure, hydrogen and helium nuclei fuse together. More powerful than even fission, fusion accounts for the energy radiated continuously by a star during a lifetime of billions of years. It is also the mechanism for man-made hydrogen (or thermonuclear) bombs, where the required compressive heat and pressure is generated by the ignition of an atom bomb as the trigger. Many physicists, including the author, also feel that *controlled* fusion reactions will offer the be-all and end-all source of energy for civilization in the future, with virtually unlimited amounts

of energy stored in the heavy hydrogen atoms in the seas. On December 5, 2022, the Lawrence Livermore National Laboratory announced having achieved inertial confinement fusion ignition.

The isotope of another atom, carbon-14, with a half-life of around 5,700 years, is used in dating organic relics, things that are or were alive at one point—bones, tusks of elephants, seashells, wood, leather, and mummified flesh. But it is not useful for dating fossils, in which the cells in a onetime living creature have been replaced atom by atom with the atoms of the inorganic minerals of the surrounding ground. The stopwatch having been set at the time of the organic material's death, after ten half-lives (57,000 years), the original radioactivity will be down to approximately one-thousandth of the original, making carbon-14 testing much less reliable. Neolithic period organic relics can be dated, but not the fossils of dinosaurs dating back to 66 million years and beyond when there is no longer any carbon-14 left in the sample. In the decades following Marie Curie's death, most of the foregoing phenomena were understood.

Marie Curie was brilliant, insightful, tenacious, *and* fully human. In April 1906, when her beloved husband Pierre was crossing a Paris street, he was run over by a horse-drawn carriage and killed at the age of forty-six. Four years later, Marie Curie became involved in a love affair with a man five years her junior. Her lover, Paul Langevin (1872–1946), was married, the father of four, and a physicist who had once been a PhD student under her husband. The couple wrote passionate letters to each other and even settled into a double life, renting an apartment together near the Sorbonne. When the affair came to light, they were both vilified, but *she much more than he*.

Referring to the famous 1927 Solvay Conference photo (see figure 3, color photo insert page III), Curie is seated in the front row with Planck (hat in hand) immediately to her left and Lorentz, Einstein, and Langevin to her right.

The Nobel Committee in Stockholm had already announced the 1911 chemistry prize with Curie the sole recipient when the French newspaper appeared denouncing the Langevin–Curie affair as salacious, Curie as "emancipated," "foreign," and "intellectual," all pejoratives. "She pushed the father of a family to destroy his home."[3] The self-pontificating publisher

Gustave Téry even released excerpts from one of Curie's love letters, incurring Langevin's wrath. He struck back by challenging the publisher to a duel. Fortunately, both men survived the faceoff.

Nor were the Swedes amused by the revelation of the Curie–Langevin affair. The head of the Nobel Committee, Svante Arrhenius, contacted Curie and suggested she consider refraining from accepting the prize until her name was cleared. Curie, with impressive composure, wrote back, "The prize was awarded to me for the discovery of radium and polonium. I believe that there is no connection between my scientific work and the facts of my private life."

Beyond even the Nobel Prize, an unrivaled honor for scientists is to have fundamental physical units named after them. There is the newton for force, pascal for pressure, the coulomb for charge, the ampere for current, the ohm for electrical resistance, etc. In 1910 the unit of curie was introduced and defined as the radioactivity of 1 gram of the isotope radium-226. Also, an immense honor is to have an element of nature named in one's honor. The element Einsteinium represents element number 99 (it has 99 protons). Ten years after Marie Curie's death, the element with atomic number 96 was discovered in bombarding plutonium atoms with protons at Berkeley's cyclotron. The element was christened Curium, in honor of the Curies.

Marie Curie was rare among female scientists honored in their day in a timely fashion.[4] However, she was also the object of intense gender bias. Despite two Nobel Prizes under her belt and numerous other awards, she was never admitted as a member of the French Academy of Sciences. Even her faculty position at the Sorbonne had come after her husband's premature death. Marie Curie, a martyr to science, died of leukemia at sixty-seven, having contracted the disease from a lifetime of handling radioactive material.

The Electron, e^-

In 1897 J. J. Thomson (1856–1940) at Cambridge, shooting a beam of cathode rays through an electric field E and simultaneously a magnetic field B,

discovered that cathode rays were comprised not of continuous radiation but of discrete particles. The experiment revealed that these particles, electrons, possessed the charge-to-mass ratio of $e^-/m = -1.76 \times 10^{11}$ Coul/kg. Although the experiment yielded the charge-to-mass ratio of the electron, one could not ascertain the separate values of the charge and the mass. It would be Robert A. Millikan at Caltech whose oil-drop experiment in 1911 finally yielded the value of the charge, $e^- = -1.61 \times 10^{-19}$ Coulombs, as well as the mass of the electron, $m = 9.1 \times 10^{-31}$ kg.

With the charge and the mass of the electron now known, it was possible to compute the relative strengths of the electrostatic repulsion of a pair of electrons (according to their charges) and the gravitational attraction of the pair (according to their masses). The result is an astonishing 10^{42}, the largest known naturally occurring constant in the universe.

BLACKBODY RADIATION

At the end of the nineteenth century, there was another unresolved problem, that of blackbody radiation. A metal block, tooled to contain an amorphous cavity, along with a hole drilled into the cavity from outside, constitutes a blackbody. When the block is cold, the hole is the darkest area of the body. When the block is heated and becomes intensely hot, the hole becomes the brightest area of the block. (Thus, what makes the most efficient absorber when the body is cold makes the most efficient emitter when it is hot.) The radiation streaming out of the hole, blackbody radiation, exhibits a unique distribution. When the intensity of the radiation is plotted against the wavelength, a characteristic distribution emerges—a skewed bell curve, steeper on the short wavelength side than on the long wavelength side.

Among explanations offered for the peculiar distribution were two possible theories: first, a theory by the German physicist Wilhelm Wien (1864–1928) involving physics by analogy. The shape of Wien's curve not only resembled the blackbody curve, but almost perfectly fits the

experimental curve at short wavelengths. This was a source of encouragement to physicists. But Wien's theory was undermined by the fact that it was not derived from fundamental principles. A competing theory published by John William Strutt, aka Lord Rayleigh (1842–1919), and James Jeans (1877–1946) yielded a curve that fit the experimental blackbody curve at long wavelengths but failed miserably at short wavelengths, veering off and climbing almost vertically at shorter wavelengths. This failure, however, was to be taken seriously since it involved well-established physics principles of electromagnetic theory and statistical mechanics.

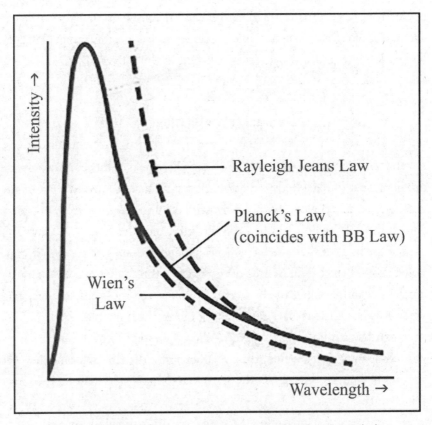

The blackbody radiation curve with the intensity plotted on the vertical axis and wavelength on the horizontal. Also shown are the distributions predicted by the classical theories of Wien ("encouraging"), Rayleigh-Jean ("disastrous"), and the quantum theory of Planck ("perfect").

Finally, in December 1900, Max Planck (1858–1947) showed that electromagnetic radiation emitted from a blackbody (BB) was quantized, that it was emitted as discrete packets, each with energy,

$$E = h\upsilon = \frac{hc}{\lambda}$$

In this equation, c stands for the speed of light; the frequency and l, the wavelength of the radiation, respectively, and the constant $h = 6.63 \times 10^{-34}$ *joules • sec*, Planck's constant. Light is emitted in discrete packets, called quanta by Planck, and photons by later generations of scientists.

The quantized nature of radiation was bedeviling, and immediately gave rise to the question: "If radiation is emitted as discrete bundles, photons, as it leaves its source, does it retain its discrete nature as it traverses through space and time?" Planck was not addressing this problem. His primary motivation was to achieve a mathematical description of the BB-curve, using a mathematical artifice to achieve this end. Thus, the result was an ad hoc hypothesis. Even he did not understand the consequence of his theory immediately. Two weeks later it was the first day of the twentieth century and the beginning of a thirty-year period in physics that would shake the world.

Einstein's First Annus Mirabilis

In the definitive biography of Einstein, Walter Isaacson[5] opens with the young physicist's letter to Conrad Habicht in 1905:

> I promise you four papers . . . the first deals with radiation and the energy properties of light and is very revolutionary. The second paper is a determination of the true sizes of atoms. The third paper explains the jittery motion of microscopic particles [pollen] suspended in water. The fourth paper is only a rough draft and is "Zur Elektrodynamik bewegter Körper" (On the Electrodynamics of Moving Bodies).

As a postscript, he could have added a fifth paper, although he had not yet fully developed it. A spin-off of the fourth paper, it would establish the equivalence of energy and mass, to be expressed in the most famous equation in all of science, $E = mc^2$.

The year 1905, when Einstein was twenty-six years old, is frequently compared with 1665–1666, when twenty-three-year-old Newton had experienced a period of explosive creativity. In his private life Einstein was engaged in a balancing act—maintaining a full-time job at the Patent Office and doing part-time research on the toughest problems then tormenting physicists while at the same time bouncing his one-year-old son Hans Albert on his knees. During the period 1903–1905 the family was living in an apartment in the Swiss Capital of Bern at 49 Kramgasse, thereafter, to be known as the Einsteinhaus, site of his annus mirabilis.

THE PHOTOELECTRIC EFFECT

At the beginning of the twentieth century, Philipp Lenard was regarded as one of the finest experimental physicists in Europe. In 1902 he designed an apparatus in which a pair of parallel metal plates (electrodes) were encased in a glass vacuum tube. Ultraviolet light could be aimed through the transparent glass tube at the surface of one of the plates to liberate "photoelectrons" (ordinary electrons, just renamed for the mechanism that released them). A variable voltage applied to the plates and completing the circuit would sweep the electrons across the gap (conversely, stop the flow of electrons between the plates when the voltage is reversed). The flow of electrons could then be recorded as the photoelectric current with a device called an ammeter. The Nobel Prize Committee awarded Lenard its 1905 prize in Physics for his groundbreaking discoveries of cathode rays. Einstein posited the notion that light possessed a dual particle-wave nature; i.e., light does indeed behave as particles in some physical phenomena and as waves in others.

In the photoelectric effect, light exhibits a particle nature, acting as "lumps," kicking out photoelectrons from the surface of the metal plate. The radiation of wavelength λ possesses linear h/λ.

Written here in two equivalent forms:

$$h\nu = h\nu_0 + T_{max}$$

$$hc/\lambda = hc/\lambda_0 + \tfrac{1}{2}mv_{max}^2$$

The expressions on the left of these equations represent the energy of the incident radiation, expressed in terms of the frequency ν or the wavelength λ, respectively; the first terms on the right side represent the photoelectric work function (expressed as minimum frequency n0 and maximum wavelength λ_{max}, respectively), and the second terms on the right represent the maximum kinetic energy T_{max} that a photoelectron can possess. Since kinetic energy must be a positive quantity, the incident energy must be greater than the threshold energy for photoelectrons to be liberated. With his explanation, Einstein rejuvenated Planck's theory of 1900 regarding blackbody radiation, that light was emitted in quanta. But the question that begged an answer would be: "Is this quantized property retained through the radiation's lifetime, even after traveling for millions of years and distances of millions of light-years?"

Einstein received the 1921 Nobel Prize in Physics for the photoelectric effect, rather than for the far grander edifice of the Special and General Theories of Relativity, not to be fully accepted for another few years. With his dual-nature assignment for light in 1905, Einstein made a major contribution to quantum theory. Twenty years later, Louis de Broglie took up the dual nature of light and extended it to particles, proposing that particles possessed a dual particle-wave nature also, in some physical phenomena behaving like particles and in others, as waves.

Possessing momentum (defined as the product of their mass and velocity), they could be treated as waves of wavelength,

$$\lambda = h/momentum$$

The same year (1905), Einstein formulated his theory of Brownian motion and also answered the question about the size of atoms. At this juncture he had a practical decision to make—which of the papers to submit to satisfy the requirements for his doctoral degree. As the least controversial, he chose the paper on the size of atoms. In his paper on Brownian motion, Einstein calculated the net force of millions of atoms, colliding randomly with the microscopic grains of pollen, in order to demonstrate the existence of atoms and to determine their size.

THE SPECIAL THEORY OF RELATIVITY

The special theory of relativity applies only to inertial frames (to frames at rest or moving uniformly). For the special theory, Einstein started with two postulates: the first, one first posited by Galileo, and second, a counterintuitive postulate of his own.

> (1) The principle of relativity (in distinction to the theory of relativity), originally posited in the seventeenth century by Galileo, states that no experiment can be performed entirely within a uniformly moving frame of reference to detect the motion of the frame itself.
> (2) All observers, regardless of their relative motion to each and to the source, will measure the speed of light as the same constant value c.

These postulates reject the absoluteness of space and time, positing instead only the absoluteness of the speed of light. There can be a veritable infinity of inertial frames, defined by their relative motions. Measurements in different frames can all be different from each other and all be

correct. If a pair of laser beams are aimed into the sky from two diametrically opposite points on the globe (e.g., New York City and Perth, Australia), common sense, intuitive, Newtonian physics would have the beams separating from each other at a combined speed of $c + c = 2c$. According to Einsteinian counterintuitive relativistic physics, adding c and c would yield the sum $c + c = c$.

Physicists have deep faith in the simple statement that physical laws are universal. They are the same everywhere in the universe and the same in all inertial frames. Testing the mathematical description of a physical law calls for an application of the Galilean-Newtonian (G-N) transformation, a set of four simple equations in existence since the seventeenth century. To assure that a law would remain the same, *invariant*, we assign the four physical coordinates of (x, y, z, t) the stationary system and (x', y', z', t') in the moving system. For motion in the x-direction and preserve, the Galilean-Newton (G-N) transformations are:

$$x' = x - vt, \quad y' = y, \quad z' = z, \quad t' = t$$

When the G-N transformations are applied to Newton's laws, these laws remain the same; i.e., they are invariant to a G-N transformation. For example, Newton's second law, $F = ma$, simply becomes $F' = m'a'$. A ball bounced on the floor inside an airplane would behave exactly the same as it would have bouncing on the floor of a lab. Seen in their respective frames, the ball oscillates up and down. But, observed from a frame outside the airplane (the prime frame), the trajectory of the ball would be seen as a succession of parabolas—bouncing over Farmer Jones's field, Farmer Brown's field, Farmer Smith's field, etc. However, when the G-N transformations are applied to Maxwell's equations, these equations do not remain unchanged. This immediately puts the universality of Maxwell's edifice at risk.

Near the end of the nineteenth century, Lorentz formulated a new set of four transformation equations (Lorentz transformations) specifically to leave Maxwell's equations unchanged:

$$x' = \frac{x - vt}{\sqrt{1 - \frac{v^2}{c^2}}}, \quad y' = y, \quad z' = z, \quad t' = \frac{t - \frac{xv}{c^2}}{\sqrt{1 - \frac{v^2}{c^2}}}$$

Applied to Newton's laws, however, they caused Newton's laws to change. This development put Newton's edifice at risk. Correct transformation tests, just like the physical laws, must be universal or standard for all physical laws. One cannot apply one set of transformations to one set of physical laws and another set to a different set of physical laws. The mathematical incompatibility between the two edifices of physics brought out deep cracks in the firmament of classical physics. The question became which of the two transformations was correct . . . *if either*? Again, accepting G-N transformations would have doomed the physical laws of Maxwell, while accepting the Lorentz transformations would have doomed the classical mechanics of Newton. At the least, the decision would call for radical modification of the physical laws of either those of Newton and/or those of Maxwell. That counterintuitive second postulate about the speed of light drove Einstein to accept the Lorentz transformations and Maxwell's equations and to be the correct combination for all velocities, to reject the G-N transformations as only approximations for pedestrian velocities, and to require "relativistic corrections" to Newton's laws.

THE EFFECTS OF SPECIAL RELATIVISTIC

• **Length Contraction, Time Dilation, and the Twin Paradox**

An individual taking a measurement for a length or distance in his own frame of reference records the $l' = x_2' - x_1'$ (proper length), and an individual in another inertial frame records for the *same length* the $l = x_2 - x_1$ (improper length). Employing the Lorentz transformations, the relationship between the proper and improper lengths, the relationship between the proper time

t and the improper time t, and the relationship between the proper mass ("rest mass") m_0 and the improper mass m reduce to

$$l' = \frac{l}{\sqrt{1-\frac{v^2}{c^2}}}, \quad \tau = \frac{\tau'}{\sqrt{1-\frac{v^2}{c^2}}}, \quad m = \frac{m_0}{\sqrt{1-\frac{v^2}{c^2}}}$$

Inside a spaceship, a precisely calibrated measuring stick has a proper length of 1.00 unit (feet, yard, meter, etc.) by definition. If the spaceship is traveling at 50% the speed of light (v = 0.5c), to an observer outside the spaceship the same measuring stick will possess an improper length 87% of its original length. An astronaut lying down next to the measuring stick, in the direction of motion and oblivious to the motion of the spaceship, will also shrink to 0.87 of his proper height. (For example, instead of measuring 6'0 for his height, he would measure 5'2" but would not know it.) At 99% the speed of light, the improper length of the measuring stick will shrink to only 14% of its original length. (The 6-ft tall astronaut would still be 6 feet tall as he measures his own height but only 10" tall r by an outside observer.) Finally, in the limit as v approaches c, $v \to c$, the improper lengths of the measuring stick and the astronaut would shrink to zero!

Imagine identical twins Gary and Larry were born minutes apart on March 14, 2000. When they are 30 years old, on March 14, 2030, the relativistic twin Larry boards a spaceship, "instantly" accelerates to 99 percent the speed of light, and settles into a constant velocity (an inertial frame).[6] When he returns precisely ten years later, as he reckons it with an atomic clock in his spaceship, he would assume the date on earth to be March 14, 2040, just as in his spaceship. But in Gary's inertial frame on the earth, the time that would have elapsed would be 71 years, making Gary a centenarian of 101 years. Would they still be identical twins? (Though, of course, they would look their ages, 40 and 101, respectively.)

- **Non-Relativistic (Linear) and Relativistic (Non-linear) Addition of Velocities**

Imagine an inertial frame centered at A, and a second inertial frame centered at B separating from A at a velocity v. Finally, imagine an object at C traveling relative to A at velocity u and relative to B at u'.

In the inertial frame A, the coordinates of point C are denoted by (x, y, z, t); and in frame B, the coordinates of the same point C' are denoted by (x', y', z', t'). Velocities u and u', are distances divided by times, relative to the two frames. In Newtonian or non-relativistic physics, the relative velocities can be seen as the addition (or difference) of velocities: $u = u' + v$ and $u' = u - v$. Mathematically speaking, the expressions represent *"linear addition,"* in adding or subtracting two velocities, *"1 + 1 = 2"* or *"1 = 2 - 1."* To obtain the relativistic counterpart of these expressions, we apply the Lorentz transformations for the primed quantities. The results are expressions for the nonlinear addition and differences of velocities:

$$u = \frac{u' + v}{1 + \frac{u'v}{c^2}} \quad \text{and} \quad u' = \frac{u - v}{1 - \frac{uv}{c^2}}$$

If Spaceship A is at rest, Spaceship B is traveling east at $v = 0.6c$, and Spaceship C is also traveling east relative to B at $0.8c$, nonrelativistic physics (or linear addition of velocities), would suggest Spaceship C to be traveling relative to A at

$$u = u' + v = 0.8c + 0.6c = 1.4c \quad nonrelativistic$$

$$u' = \frac{u' + v}{1 + \frac{u'v}{c^2}} = \frac{0.8c + 0.6c}{1 + \frac{(0.8c)(0.6c)}{c^2}} = \frac{1.4c}{1.48} = 0.95c \quad relativistic$$

or 40% faster than the speed of light. In distinction, relativistic physics reveals the total velocity to be 95% the speed of light. The sum $c + c$ added relativistically is c, tantamount to writing *"1 + 1 = 1."*

• Relativistic Kinetic Energy and Equivalence of Energy and Mass

Energy exists in many forms—electromagnetic radiation (including solar energy), thermal energy (heat), chemical energy (locked in the configuration of electrons and released by chemical reactions), nuclear energy, gravitational energy, elastic energy, rest energy, and in two fundamental classes, as kinetic energy and potential energy. The concept of energy due to motion, as mass multiplied by velocity squared, was first imagined by Leibniz who called it *vis viva* (living force).

In the nineteenth century, Lord Kelvin coined the expression kinetic energy for the energy due to motion. William Rankin introduced potential energy for energy due to position. Kinetic energy was formalized in the mathematical expression as K.E. = ½ mv^2, based on the quantity of work done in displacing a particle (body) by an increment of distance dx, and, in the process, of accelerating the particle from rest to a velocity of v, accordingly the kinetic energy that the particle has gained.

In order to satisfy the conservation of linear momentum (a fundamental law of nature, a discovery of Newton), mass must also obey the Lorentz transformation,

$$m = \frac{m_0}{\sqrt{1 - \frac{v^2}{c^2}}}.$$

Einstein realized that this expression is a good candidate for Newton's binomial theorem:

$$mc^2 = m_0 c^2 + \frac{1}{2} m_0 v^2 + \frac{3}{8} m_0 \frac{v^4}{c^4} + \frac{5}{16} m_0 \frac{v^6}{c^6} + \frac{35}{128} m_0 \frac{v^8}{c^8} \ldots$$

The first term on the right is independent of the body's velocity v. It is the rest energy, which exists by virtue of the body's existence. The second, third, fourth, etc., however, and indeed, the infinite series of terms on the right side all contain the body's velocity, v. The nonrelativistic kinetic energy

seen earlier (K.E. = ½ mv²) must be just an approximation for that infinite series of such terms.

$$mc^2 = m_0 c^2 + K.E.$$

Yielding for the total energy (rest energy plus kinetic energy):

$$E = mc^2$$

The most famous equation in physics is a statement of the equivalence of energy and mass. Here m is the variable mass, and not the rest mass $m0$, and c^2 is the speed of light squared.

• **Correction to Newton's Second Law**

In nonrelativistic form Newton's second law is simple,

$$\boldsymbol{F} = m\boldsymbol{a} = m\frac{d\boldsymbol{v}}{dt}$$

In relativistic form, the law becomes

$$\boldsymbol{F} = m\boldsymbol{a} = \frac{m_0 \, d\boldsymbol{v}/dt}{\left(1 - \frac{v^2}{c^2}\right)^{3/2}}$$

In the foregoing pair of formulas, vector quantities (one's with magnitude and direction, viz. force, velocity, and acceleration) are indicated by emboldened symbols, whereas scalar quantities (ones with only magnitude, viz. mass, speed, time) are not emboldened.

While in the nonrelativistic case, there is no limit to the velocity to which a body can be accelerated, in the relativistic case, the body can approach, but *never* reach the speed of light c.

Finally, the connection between linear momentum p and kinetic energy K.E. is modified from its nonrelativistic form to its relativistic form as follows:

$$K.E. = 1/2\, mv^2 = \frac{p^2}{2m} \quad (nonrelativistic) \text{ becomes}$$

$$K.E. = \sqrt{p^2 c^2 + m_0^2 c^4} \quad (relativistic).$$

(That last expression, incidentally, would prove to be of crucial importance for Dirac in his formulation of the relativistic version of Schrödinger's equation.)

Einstein's blinding pace of achievements in his first annus mirabilis in 1905 required some time for the physics world to digest, but once his ascent began, there was no stopping until he reached the top rung of the academic ladder. In 1908, he landed a position as privatdozent in theoretical physics; in 1909, as associate professor of theoretical physics at Zurich University; in 1911, as professor of theoretical physics at the German University of Prague; in 1913, as professor at his alma mater, the Polytechnic (ETH); and in 1917, as director of the Kaiser Wilhelm Institute in Berlin and professor in theoretical physics at the University of Berlin, the last position engineered for him by Planck. In less than ten years, Einstein had zigzagged his way to the top.

Einstein's Second Annus Mirabilis—General Theory of Relativity

With the publication of the special theory of relativity in 1905, Einstein had thrown down the gauntlet, effectively challenging other physicists to formulate a general theory of relativity accommodating acceleration. It would again be Einstein who would break the tape at the finish line. His general theory of relativity would be his magnum opus. It came in November 1915, when he was thirty-six, and after he had driven himself to the point of exhaustion in that ten-year marathon race, run in the last few months at a sprinter's pace.

For Newton, the force of gravitation was action at a distance, propagating through space at infinite speed. Jostling one heavenly body would cause the jostling of every other heavenly body instantly. Newton had been uneasy about the precise mechanism, but in his famous disclaimer, "Hypotheses non fingo" ("I feign no hypotheses"), he had made it clear that he was not about to speculate about what is not experimentally verified, and that the occult especially had no place in natural philosophy. Certainly, Newton did not have the luxury of seeing the two hundred years of progress of physics, and especially the developments of the decade or

two at the end of the nineteenth century. For Einstein, the gravitational field would propagate exceedingly fast, but ultimately obey the speed limit set by light. The breakthrough came when he postulated the equivalence principle as an underpinning for the general theory. Not to be confused with the special relativity effect of the "equivalence of energy and mass," the postulate underlying the general theory of relativity is the equivalence principle, positing the effects of gravitation and the effects of acceleration to be *virtually* indistinguishable."

Recall the identical twins Larry and Gary whom we met earlier. Now imagine that Larry is standing on the floor of an elevator at rest in an elevator shaft. He feels the downward pull of gravity, *1-G* of gravitational force. On the floor of the elevator is a bathroom scale on which he is standing. He sees the scale to register 80 kg (of mass, equivalent to 176 pounds).[7] He holds a pair of apples in his hands. With his arms stretched out to his sides, he releases the apples simultaneously and watches them accelerate downward at $g = 9.8\ m/sec^2$ *(32 ft/sec²)* and to simultaneously strike the elevator floor.

Now imagine his twin, Gary, who is in an enclosure designed to look like the interior of an elevator. If the enclosure were simply drifting at uniform velocity through interstellar space, Gary would be floating in the enclosure, feeling no gravitational pull, the bathroom scale recording *zero*.

But suppose Gary's enclosure is equipped with a powerful booster rocket below the floor, quietly accelerating the enclosure in the direction of the ceiling at *1-G*; that is, $a = 9.8\ m/sec^2$. Like his twin, Gary would stand on his bathroom scale and record his weight as 80 kg. Next, he would hold a pair of apples out to his sides and release them simultaneously. He would see the apples "descend" with an acceleration of $a = 9.8\ m/sec^2$ and strike the floor simultaneously. (Actually, it is the floor rising up to meet the apples, but Gary would not be able to tell.) The acceleration of the enclosure has created pseudo-gravitation. Gary and Larry would not be able to distinguish which of the two enclosures they occupy.

There is, however, a minor disclaimer—it should be "virtually indistinguishable" rather than exactly indistinguishable in the equivalence

principle. In Gary's frame of the accelerated enclosure in space, the trajectories of the two apples descending would be *precisely* parallel to each other. In Larry's frame in the elevator on earth, the trajectories of the two apples falling downward would be *almost* parallel, but extrapolated into the earth, the two "parallel lines" would converge at the center of the earth 6,400 km (4,000 miles) down. The physical laws gleaned from gravitation could be applied to pseudo-gravitation (acceleration) and vice versa.

Einstein had eliminated ether as the all-pervasive medium between heavenly bodies in his special theory of relativity, which meant all that was present were mass-energy and space-time. He conjectured that mass-energy of a body caused a distortion, or warping, in the fabric of space-time and that all other bodies, including light, were simply following the warped space-time. As a solution of the field equations, Einstein obtained an expression for excess radius created by a body of mass M:

$$R_{excess} = \frac{G}{3c^2} \cdot M$$

G is still the universal gravitational constant introduced by Newton in 1687 and measured experimentally by Henry Cavendish. If we substitute the mass of the source for M (the earth, sun, galaxy . . .) and c the speed of light, the radius excess for the earth is about 1 cm, and for the sun, 0.5 km. On May 29, 1919, just six months after the conclusion of WWI, British astronomer Arthur Eddington led a group seeking to test the general theory of relativity. A perfect solar eclipse had been predicted for Principe Island, located just south of the equator and west of the African nation of Gabon.

It is a happy natural coincidence that the distance between the sun and the earth is 400 times the distance between the moon and the earth, or exactly the same as the ratio of the diameters of the sun and the moon. This means that in a total solar eclipse, the disc of the moon completely blocks out the sun, creating a night sky at midday. A star located behind the sun and not seen became visible on photographic plates.

In 1986 Princeton University astrophysicists captured an image of a single galaxy observed at two different spots. An invisible source of

curvature, a "gravitational lens," was created by an exceedingly massive object that happened to be located between the earth and the distant galaxy at just the right distance to focus the two light rays from the actual image onto earth. Another ten years later, the Hubble orbiting telescope captured an "Einstein ring," a circular glow created by an invisible source of space-time curvature. The culprit was most likely a massive black hole, invisible even to telescopes, and located between the galaxy and the earth at precisely the correct distance to focus all the light onto the earth. With the new James Webb Telescope, the numbers observed will multiply rapidly. In February 2023, a twelve-billion-year-old galaxy was seen as an Einstein ring, lying only 16,000 light-years behind a companion galaxy that is much too dim to be seen, but its gravity acting as a gravitation lens. The ring itself is nursery for stars being born.

An Einstein ring. JWST's view of a galaxy dating to just 1.4 billion years after the Big Bang. Reported in February 2023.

A quantum of radiation, a photon, does not possess rest mass. But, because it has energy, it can be regarded as possessing *effective* mass. If

we equate the total energy of a photon regarded as a wave and the photon regarded as a particle, $E = hf = mc^2$, we can obtain an expression for the effective mass as $m = hf / c^2$. In the foregoing expressions h represents Planck's constant, f the frequency of the photon, m the effective mass, and c the speed of light in vacuum. Light, as it "falls" from the top of a tower to the bottom, would see an increase in its energy, manifested by an increase in its frequency. And it is the increase in the frequency, Δf, that corresponds to the increased passage of time. With $g = -9.8\ m/sec^2$, a tower of 100 meters (330 ft) in height, a clock located at the top of the tower will be ahead of a clock at the bottom by about 10^{-14} *parts*. The residents of a penthouse will be aging faster by that amount than the residents in the basement.

According to the equivalence principle, with gravitation and acceleration associated with similar effects, in an airplane that is accelerating, a clock will have ticked farther along in the cockpit (and in the first-class section) than on a clock in the rear, the economy section. First-class passengers age slightly faster than economy-class passengers!

EMMY NOETHER

Amalie Emmy Noether was born to Jewish parents Max and Ida Noether in Erlangen in 1882. Her groundbreaking work in abstract algebra, introducing Noether's ring and the Noetherian module, would provide powerful tools for pure mathematicians. Her papers on group theory, noncommutative algebra, and Noether's ring would put her on the map for physicists. The latter unites two of the central pillars of physics—symmetry in physical laws and conservation principles. Her contributions to group theory have been indispensable for the physics of the infinitesimal—the universe of molecules, atoms, nuclei, and elementary particle.

In her youth, Noether was exposed to traditional female household skills. From the start, she showed little interest in a traditional job open to women any more than Newton showed for farming. Emmy's passion was

mathematics. Two of her three brothers became scientists, although none showed the genius of Emmy Noether. In her teen years, Noether could only dream of making a career in academia, as had her father, a professor of mathematics at the University of Erlangen. But at the time, Germany simply did not accommodate female academics. In 1900 she received a diploma from a teacher's college in Erlangen to enable her to teach English and French in girls' schools. Between 1900 and 1902 she was allowed to audit mathematics classes at Erlangen but not to participate as a degree candidate. When Erlangen announced that it would be accepting women as degree students, she matriculated in the mathematics program there. In 1907 she completed her doctorate in mathematics, graduating with highest honors, summa cum laude. During the years spanning 1908–1915, she worked as a member of the mathematics faculty at Erlangen, teaching without pay and supported by her father.

In 1915, when one of the leading mathematicians of her era, David Hilbert, offered her a position as his assistant at the Mathematical Institute of Göttingen, she jumped. She took the position, albeit without pay—again supported by her father—but with the opportunity to work with Hilbert. Their initial quest would be to derive the general relativity field equation in competition with Einstein.

In general relativity, there was a conundrum. It seemed possible for an object that lost energy by emitting gravity waves to speed up. An object with less mass, however, should slow down, not speed up! This seemed to be a violation of the conservation law of energy. The insight into the solution to the conundrum came from Noether, whom Einstein happily acknowledged:

> Yesterday I received a very interesting paper on invariants from Miss Noether. I'm impressed that these things can be seen in such a general way. It would do the old guard at Göttingen no harm to be sent back to school under Miss Noether. She knows her stuff.

$$\frac{d}{dt}\left(\sum_a \frac{\delta L}{\delta \frac{dq_a}{dt}} \delta q_a\right) = 0$$

Mathematical Truth and Beauty *Noether's theorem. This mathematical expression is one of the two terms of Lagrange's equation, a recasting of Newton's second law in terms of energy instead of force. L, defined as the difference of kinetic and potential energy, is known as the "Lagrangian." In proving that the time derivative of the expression in the parenthesis equals zero, Noether effectively showed that the expression itself remained constant in time. Energy conservation was reduced to time invariance. Accordingly, a displacement or "translation" of a system in space was tantamount to the conservation of linear momentum, and rotation in space to the conservation of angular momentum. Noether's theorem encompassed all scales, from the subatomic to the large-scale universe. Although Keats had employed the expression "truth and beauty" in the realm of art. The conciseness and power of Noether's theorem deserves Keats's description in the realms of the mathematics and physics.*

Noether's theorem would not be published formally until 1918, but it had satisfied the concerns of Einstein and Hilbert regarding general relativity. In 1933, when the Nazi government began dismissing Jewish faculty members from German universities and Einstein abandoned the country permanently, Noether also packed her bags and left. At Einstein's urging, Bryn Mawr College offered Noether a fully paid guest professorship—initially for one year but subsequently extended. Just as she finally seemed to catch a break, she became ill with cancer. When she died in 1935 at just fifty-three years old, Einstein wrote a tribute for her in the *New York Times*: "Noether was the most significant creative mathematical genius thus far produced since the higher education of women began." But in singling out Noether, it was unfortunate that Einstein effectively ghettoized her as a "woman genius." She was, in reality, one of the greatest mathematicians, male or female, of the century.

THE LONG SHADOW OF THE TOOLMAKER

Einstein's gravitational field equation suggested an expanding universe. The artist–physicist Einstein found this suggestion aesthetically displeasing. In order to obtain the intuitively reasonable static universe solution; i.e., one that was not changing in size, he added a cosmological constant, Λ, as a fudge factor that would maintain the universe as a static system. Toward the end of the 1920s, the astronomer Edwin Hubble discovered that galaxies, island universes, do indeed recede from each other. Einstein was shocked! He confessed that he should have trusted his equation in the first place and immediately dropped the fudge factor, restoring the equation to its original form, compatible with the observed expansion.

Einstein's scientific shadow continues to grow unabated as technology catches up with the science. Einstein's ideas have been tested, retested, and extended in thousands of papers and brought a score of Nobel Prizes.

"Human-computer" Henrietta Swan Leavitt's 1912 discovery of a direct connection between the luminosity and the periods of Cepheid variables as

a tool for determining intergalactic distances and Hubble's 1929 discovery of the expansion of the universe are both crucial for astronomy. A century on, they are honored with Leavitt's law and the Hubble's law.

Then there is English-born Cecilia Payne (1900–1979), who defied the advice of her music teacher Gustav Holst, composer of *The Planets*, to pursue a career in his field and traipsed off to Cambridge instead to do an undergraduate degree in the sciences. After earning a BA there, she traveled to Cambridge, Massachusetts, and completed a PhD at Harvard, with her thesis "Stellar Atmospheres." She was still just twenty-four. Her remarkable conjecture claimed that the most abundant elements in the universe were hydrogen and helium, by a factor of a million, over other elements, in distinction to the commonly held theory at the time that the relative abundance of heavenly bodies paralleled that on the earth. By 1954, her discoveries fully confirmed, she became chair of the Department of Astronomy, the first woman at Harvard to do so, and promoted to the rank of full professor, again a first at Harvard.

The achievements of Leavitt, Hubble, and Payne were all deserving of the Nobel Prize. But astronomy had not yet entered the realm of physics as astrophysics and cosmology. For them, it was not gender bias, but timing.

Along with the expansion of the universe, general relativity predicted the collapse of stars but left open questions to be resolved by future generations of astrophysicists whether (1) the entire universe will slow down, then bounce back, collapsing on itself; (2) keep expanding forever reaching zero speed at infinity; or (3) or expand forever while accelerating. In 1930, Subrahmanyan Chandrasekhar was traveling from India to England by steamship to undertake graduate study in astrophysics at Trinity College, Cambridge. During the long journey, he made relativistic calculations with tentative predictions: a star, if its initial mass is over 1.4 solar masses (m_s) but less than 2.5 m_s, it would explode as a supernova, leaving behind a dense core as a white dwarf (or neutron star). If its mass is greater than 5 m_s, it would undergo catastrophic collapse into a black hole, the attractive gravitational force overwhelming the repulsive forces within the atoms of the star.[8]

When Chandrasekhar died at eighty-four, the *New York Times* on August 22, 1995, published his obituary, reporting that he had taught for almost fifty years at the University of Chicago, that he and his physicist wife had both been polymaths, and that he had been unusually faithful to his academic obligations. During one academic term, he drove seventy-five miles from the university's Yerkes Observatory to teach a course in Chicago with only two students enrolled, then drove seventy-five miles back. "That might have raised questions about the investment of time and energy . . . but the Nobel Prize in Physics was awarded in 1957 to the entire class [of two], T. D. Lee and C. N. Yang." Chandrasekhar's own Nobel Prize would come in 1983 for "pioneering work in astrophysics," with Caltech physicist William Fowler as the co-recipient.

General relativity also predicted the existence of cosmic microwave background radiation (CMBR) that should still be present in interstellar space, left behind as relic radiation from the Big Bang that created the universe. Described poetically as the "whisper of creation," CMBR was serendipitously discovered in 1964 by two Bell Lab scientists, Arno Penzias and Robert Wilson, looking for the source of static in radio reception. Using the Lab's Horn Antenna in Crawford Hills, New Jersey, they unwittingly scooped the trio of Princeton University astrophysicists, Robert H. Dicke, Jim Peebles, and David Wilkinson, who had been working on the design of an apparatus to search for this radiation. What the Bell Lab scientists detected was, indeed, microwave radiation, in the form of blackbody radiation peaking in the microwave region of electromagnetic radiation corresponding to a temperature of approximately 3 K (Kelvin) and an age of roughly fourteen to fifteen billion years for the universe. Penzias and Wilson garnered the 1978 Nobel Prize in Physics. The uniformity of the wavelength and the temperature of the CMBR, however, was in conflict with the observed lumpy universe of galaxies, stars, and planets that we know.

In 1992, the orbiting NASA satellite Cosmic Background Explorer (COBE), designed by John Mather at NASA's Goddard Space Center and George Smoot at the University of California, Berkeley, discovered ripples in the background radiation—temperature variations at the fifth place, the

warmer spots giving rise to the lumps. Smoot and Mather shared the 2006 Nobel Prize in Physics for their discovery.

Data from the COBE satellite revealed a perfect fit between the blackbody curve predicted by the Big Bang theory and observed in the microwave background. The peak corresponds to 2.735 K.

Among other predictions of general relativity is the emission of gravitational waves as "ripples in the fabric of space-time," resulting from catastrophic cosmic events, such as the collisions of massive black holes. Recall how crucial Michelson–Morley's tabletop interferometer of 1887 and the special theory of relativity of 1905 had been in their mutual explanations. On two occasions, in late 2015 and again in early 2016, a century after the publication of the general theory, gravitational waves were detected with the Laser Interferometer Gravitational-Wave Observatory (LIGO).

The project, funded by the National Science Foundation and operated by Caltech and MIT, called for a collaboration between two installations—one in Livingston, Louisiana, and the other in Hanford, Washington, 3,000 km (1,860 miles) apart—and connected in coincidence ("to trip" only if the gravity waves arrived simultaneously). At each site, a pair of laser beams were simultaneously aimed at a pair of target mirrors located 4 km (2.5 miles) from each other and in directions perpendicular to each other. The laser beams in the LIGO experiment bounced back from mirrors at their original source. They were acting as a single colossal interferometer.

The events registered manifested as variations in space-time were only *fractions of the diameter of an atom.*[9] They turned out to be the result of the collision of a pair of black holes that took place in the distant past, with the signal traveling at the speed of light just now reaching the earth. In October, the 2017 Nobel Prize in Physics was awarded to three physicists, Rainer Weiss, Barry Barish, and Kip Thorne, who had designed the LIGO experiment and directed the project of over a thousand collaborators.[10] Subsequently, in November 2017, LIGO announced its fourth and latest detection of gravitational wave. Its two detectors, along with a new detector in Europe called Virgo, registered the signal from two massive black holes 1.8 billion light-years away. James Peebles, now the Albert Einstein Professor of Science, Emeritus, at Princeton and one of the three researchers originally scooped by Penzias and Wilson, was accorded one half of the 2019 Nobel Prize in Physics with one quarter each going to Michel Mayor and Didier Queloz, who had discovered an exoplanet orbiting a solar-type star. The Nobel Committee described its award to Peebles in terms of the range of his contributions: "theoretical framework, developed since the mid-1960s, the basis of our contemporary ideas about the universe . . . James Peebles was able to interpret these traces from the infancy of the universe . . . The results showed us a universe in which just five percent of its content is known matter. The rest, 95 percent, is unknown dark matter and dark energy."[11]

Again in October 2020 when the Nobel Prize in Physics was announced, few in the field were surprised when the recipients had made major discoveries in the physics of gravitational collapse: British mathematical

physicist Roger Penrose of Oxford had written a seminal paper in 1965, while American astrophysicist Andrea Ghez of UCLA and German astrophysicist Reinhard Genzel at the Max Planck Institute both investigated massive black holes at the heart of galaxies. Ghez became the fourth female to win the coveted prize, the first having been Marie Curie.

WEIGHING THE UNIVERSE

After measuring the universal gravitational constant G embodied in Newton's gravitational law in 1797, Cavendish had written a paper with a ponderous title, "Weighing the Earth." In the paper, he had determined the mass of the planet to be 6×10^{24} kg and its average density 5.5 grams/cm^3, five and a half times the density of water and twice the average density of all materials found on the surface of the planet's surface. Modern astrophysicists have determined the average temperature of CBR to be 2.735 K, the size of the observable universe to be 13.72 billion light-years[12] and including the luminous and dark matter and dark energy, the total mass/energy content to be of the order of 10^{52}–10^{53} kg. Most significantly, we also now know exactly what we don't know: Why is the universe accelerating in its expansion, instead of slowing down in its growth? What is the long-term fate of the universe? Are there other and even possibly an infinite number of universes comprising a multiverse. Does extraterrestrial intelligent life exist—even though we might sometimes doubt the existence of intelligent terrestrial life? How can general relativity be reconciled with quantum mechanics?

Some of Einstein's far-reaching ideas at the submicroscopic scale had been conceived within the tenets of "old quantum theory," the formulation of which Einstein had played a crucial part. However, all these ideas can be explained more completely in light of modern quantum mechanics. Just three years after he formulated general relativity, he wrote a paper on "the stimulated emission of radiation," in which a photon absorbed by certain atoms and molecules would trigger the emission of a pair of photons in phase, "coherent," and that pair, in turn, could each give rise to two new

pairs, and so on. The words "maser" and "laser," acronyms for "microwave amplification by stimulated emission of radiation," and "light amplification by stimulated emission of radiation," respectively, were just about to emerge at the time of Einstein's death. The laser especially has become virtually ubiquitous in everyday technology since then. In 1964 Charles Townes, Nicolay Basov, and Aleksandr Prokhorov shared the Nobel Prize for the invention of the maser and the laser. In 2018, Arthur Ashkin, Donna Strickland, and Gérard Mourou shared the prize for developing groundbreaking improvements in laser technology.

On November 4, 2011, Norman F. Ramsey, one of the titans of twentieth-century science, passed away in Wayland, Massachusetts. His life and career had spanned almost a century. He was born in August 1915 in Washington, DC, to a military officer and his mathematics teacher wife. Ramsey graduated from high school at fifteen in Kansas, where his father had been posted. Matriculating at Columbia University, Ramsey graduated at the top of his class with a BA in mathematics. His academic success earned him a scholarship to attend Cambridge University in England, where he completed a second bachelor's, this time in physics. In those heady days at Cambridge, he came into contact with many of the pioneers of modern physics, including J. J. Thomson. Ramsey liked to quip while giving lectures in his later years that he had attended one lecture by Thomson, "already so old that his dentures would fall out during the most inopportune moments." Then he would add, "I am now even older, but my teeth are *not* going to fall out!" After Cambridge, Ramsey returned to Columbia, and under the Polish American physicist Isidor Isaac Rabi, wrote the first PhD thesis on nuclear magnetic resonance (NMR).

Subsequently, Ramsey took an academic position teaching at the University of Illinois. But with WWII in Europe escalating, he took leave from Illinois in order to head a group developing the 3-cm radar at MIT. This was followed by an even more critical wartime stint working on the Manhattan Project in Los Alamos. After the war he briefly returned to Columbia and, with Rabi, now the recipient of the 1944 Nobel Prize, he began to revive experiments on molecular beam methods that had been

left dormant during the war years. On the side, he helped to start the Brookhaven National Accelerator Lab, heading its first physics division. Then in 1947, he accepted a position on the faculty of Harvard, where he designed the equipment to measure atomic and molecular energies (and frequencies) with hitherto unseen precision. One of the characteristic frequencies in the vibrations of the cesium (Cs) atom became the basis for the atomic clock, and in time led to a new definition of the unit of time. *One second corresponds to 9,192,631,770 vibrations of Cs*, a phenomenon possessing far greater stability than the slightly vagrant revolutions of the earth around the sun, the traditional time measure since time immemorial. The atomic clock, in turn, makes the global positioning system (GPS) possible.

In the 1960s, in collaboration with his PhD student Daniel Kleppner, Ramsey developed the hydrogen maser. In time, this technology would be applied in the experimental confirmation of general relativity's prediction that gravity has an effect on the passage of time.[13] Twenty-five years after working on NMR, he saw the work extended to medicine. Paul Lauterbur, a chemist at the University of Illinois, developed the MRI, the single most important medical diagnostic tool since Wilhelm Roentgen introduced X-ray technology. MRIs allowed radiologists to peer inside the organs comprised of soft tissue and to distinguish tumors from healthy tissue. Lauterbur was awarded the 2003 Nobel Prize in Physiology and Medicine.

Norman Ramsey served on the faculty of Harvard University for forty years, retiring officially in 1986, but repeatedly failing retirement afterward. With obsessive fervor, he kept abreast of new developments in his field, viewing the practice as a hobby. It was the compendium of his discoveries that led to his award of the 1989 Nobel Prize in Physics.

A 1924 letter to Einstein from a young Indian physicist Satyendra Nath Bose (1895–1974) led to a fruitful collaboration with seminal consequences: the birth of Bose–Einstein statistics and the Bose–Einstein condensate (1925), the latter also deserving of the Nobel Prize. However, this phenomenon representing a fourth state of matter—along with gaseous, liquid, and solid—would require the cooling down of rarefied gas to within a virtual cat's whisker of absolute zero.

During the 1970s, Ramsey's former student, Daniel Kleppner, served as William Phillips's PhD mentor. With skills developed in Kleppner's lab at MIT, Phillips moved to the National Bureau of Standards (NBS), renamed the National Institute of Standards and Technology (NIST) in 1988. During the 1980s, in collaboration with Steve Chu and Claude Cohen-Tannoudji, he developed the technique of laser cooling and trapping and succeeded in lowering the temperature of a cluster of atoms to 0.18 µK (micro-Kelvin), a temperature millions of times colder than the 3.7 K of intergalactic space. The trio shared the 1997 Nobel Prize in Physics. Ramsey used to revel in describing Phillips as his "research grandson." By the mid-1990s, Eric Cornell, Wolfgang Ketterle, and Carl Wieman developed "the evaporative cooling technique" and used it in tandem with laser cooling and trapping. They became the first to witness the formation of the Bose–Einstein condensate (BEC) in a rarefied gaseous cloud of 2,000 rubidium atoms—all with precisely the same quantum numbers and behaving as only a single atom or "singing in unison." Cornell, Ketterle, and Wieman shared the 2001 Nobel Prize. It had been another of Kleppner's PhD students, David Pritchard, who served as advisor to Cornell and Wieman. This makes Ramsey the research great-grandfather of Ketterle and Wieman, and I. I. Rabi their research great-great-grandfather.

In 1935, Einstein had co-authored the Einstein–Podolsky–Rosen (EPR) paper. The paper, although not fully appreciated by physicists at the time, has been frequently cited since the 1990s. It introduced the concept of quantum entanglement (though the actual expression "entanglement" itself was introduced by Erwin Schrödinger that same year in a follow-up to the EPR paper).

Frances Arnold, 2018 Chemistry Nobelist at Caltech, commenting on the choice of the five transformative geniuses who dominate this book, wrote, "Those minds brought forward whole new universes for us to explore."[14] Although her "new universes" is a metaphor describing the revolutionary ideas developed by the most creative thinkers of all, in Einstein's case it happens to be literally true. The foregoing section in this chapter is meant to show how seminal his ideas in the sciences have been, sprouting out like the branches of a tree, so many of the branches resulting in Nobel Prizes.

12

THE QUANTUM REVOLUTION: GROUP GENIUS

Bohr was inconsistent, unclear, willfully obscure and right. Einstein was consistent, clear, down-to-earth and wrong.[1]
—John Stewart Bell

Quantum mechanics—the creation of several surpassing geniuses in a period of just three years—is the finest example of "collective" or "group genius" in the history of science. The expression "group genius," inseparable from the then-prevailing zeitgeist, refers to genius traits and legacies far transcending the sum of its parts. Its underlying principles, promulgated in the Copenhagen interpretation under the group's "father confessor" Niels Bohr, are counterintuitive and indeterministic in distinction to classical mechanics (including relativity), where they are intuitive and deterministic. Just like great art, quantum mechanics is open-ended and porous. The most successful scientific theory in history may forever remain as tantalizing and enigmatic as Mona Lisa's smile, resonating with a message from nature: "It was my destiny to know more than you!"[2]

The celebrated fifth Solvay Conference (1927) had been organized to debate the credibility of quantum mechanics based on the matrix mechanics and uncertainty principle of Heisenberg, the wave mechanics of Schrödinger, along with the probabilistic interpretation of wave functions set down originally by Max Born. Like two tennis champions facing each other across the net, Einstein served *gedankenexperiment* after *gedankenexperiment* with blinding speed and perfect placement. Bohr returned the serves with topspin, slices, and scattershot effects. And he won all the points. The Bohr–Einstein debates were continued at the sixth Solvay Conference in 1930 and they would have continued at the seventh conference in 1933 had Einstein chosen to attend. The controversy has had monumental significance for the philosophy underlying quantum mechanics and the fundamental nature of reality.[3] To his dying day Einstein was never able to reconcile himself with the uncertainty principle. In a memorable exchange, one that was repeated again and again with minor variation, Einstein decried the uncertainty principle: "God does not play dice with the universe!" Bohr offered the riposte: "Einstein, stop telling God what he can and cannot do!"

In 1935, Einstein, in collaboration with Boris Podolsky and Nathan Rosen, wrote a paper claiming quantum mechanics was incomplete, that there existed "hidden variables" (the actual expression was introduced much later), and for that reason quantum mechanics was forced to be probabilistic and not exact. The puzzling assessment in the opening quotation of this chapter was offered by John Stewart Bell (1928–1990).[4] Bell, lacking the academic pedigree of many of the creators of quantum mechanics, was an unlikely candidate to delve deeper into the firmament of the theory than anyone else. In a sense he was a Benjamin Robins of his time. Yet this veritable quantum mechanics hobbyist, hailing from Northern Ireland, formulated a remarkable theorem testing the theory's veracity. Bell's theorem (1964) states:

> If [a hidden-variable theory] is local it will not agree with quantum mechanics, and if it agrees with quantum mechanics it will not be local.[5]

With experiments suggested by Bell, his theorem and its subsequent variations have been put to repeated experimental tests since 1972, most prominently by the French physicist Alain Aspect in the 1980s. Bell himself confessed to having been initially in Einstein's corner in examining the Bohr–Einstein debates, but came to change his mind. At the submicroscopic scale we cannot examine nature without disturbing it, without insinuating ourselves into the process. Orthodoxy in physics fully accepts this concept. Late in the twentieth century, the legendary Rudolf Peierls of Oxford described the Copenhagen interpretation as "battle tested." But it is also the nature of human warfare that the defeated side is bound to resurrect the challenge.

Ironically, Einstein had been a crucial player in launching the quantum revolution in the first place. In his Nobel Prize–winning theory of the photoelectric effect (1905), he had built on Planck's blackbody theory and proposed the wave-particle dual nature of light. Then in 1912, Bohr, recognizing the unit of Planck's constant h to be that of angular momentum, had quantized the radii of the circular orbits of electrons by quantizing their angular momenta. And he had proposed that the decay of electrons from higher permissible orbits to lower ones would result in the emission of photons and, that the reverse, absorption of photons by atoms would account for the elevation of electrons from lower to higher orbits. Soon there were minor additional improvements to Bohr's theory, with the Bohr–Sommerfeld theory, accommodating quantized elliptical orbits to explain the splitting in atomic spectra for hydrogen. The formalism, however, could go no further in explaining the microscopic world of elements beyond hydrogen. The impasse lasted for a decade. Physicists now refer to all the foregoing as the "old quantum theory."

ULTIMATE EXAMPLE OF GROUP GENIUS

In 1924, Louis de Broglie submitted a PhD thesis to the faculty of the University of Paris (Sorbonne). In the unusually short thesis, he proposed

that an electron possessing a momentum $p = mv$ (where m and v are the mass and velocity of the electron, respectively) could be treated as a "pilot wave" of wavelength $\lambda = h/p$. The expression is simply the inverted form of $p = h/\lambda$, employed by Einstein in explaining the photoelectric effect. The de Broglie hypothesis is tantamount to saying, "Matter—e.g., electrons, protons, nuclei, atoms, molecules—possesses a dual particle-wave nature, just as light (photons) possesses a particle-wave dual nature." Langevin, serving as an outside examiner of de Broglie's thesis defense, was initially skeptical. In the summer he sent Einstein a copy of the thesis seeking some guidance. The hypothesis posited a wild notion, but it was complementary to Einstein's characterization of light. Einstein responded in September or October, offering the comment, "interesting." Just the suggestion to put it on the back burner was enough to change Langevin's skepticism to one of optimism. Einstein later wrote to Langevin, "de Broglie has 'lifted a corner of the great veil.'"[6] The late Max Dresden, a professor at SUNY Stony Brook and an entertaining raconteur of physics history, offered a more inventive version of Einstein's message to Langevin: "Give the boy his PhD. He can't do any damage with a PhD in physics."

Independent of the de Broglie hypothesis, in mid-1925 Werner Heisenberg at the University of Göttingen formulated matrix mechanics with crucial contributions from Max Born and Pascual Jordan. Then in the first half of 1926, Austrian Erwin Schrödinger, inspired by the de Broglie hypothesis, published wave mechanics. Although having seemingly little in common with matrix mechanics, his theory was capable of giving similar answers to many atomic problems that Heisenberg's matrix mechanics gave. Schrödinger's remarkable achievement came following a bizarre fortnight. While a member of the physics faculty at the University of Zurich, in December 1925 he had taken a working vacation, retreating to the ski chalet, Villa Herwig, in Arosa in the Swiss Alps.[7] Demonstrating that a Peyton Place–like atmosphere can pervade even the summit of an intellectual Mount Olympus, Schrödinger had taken with him his girlfriend Itha Junger and left behind his wife Annemarie in the arms of a friend, the mathematician and physicist Hermann Weyl.

Six years later, in 1931, Weyl, whose wife was Jewish, left Europe for the relative safety of the United States. He accepted an appointment at the new Institute for Advanced Study in Princeton just before the arrival of Einstein. After the demonstrated success of Schrödinger's wave theory (1926) and the success of the Davisson-Germer experiment in demonstrating the wave nature of the electron[8] (1927), Einstein nominated de Broglie for a Nobel Prize in 1928. De Broglie was awarded the 1929 Nobel Prize in Physics.

In the early nineteenth century, the brilliant Irish mathematician William Hamilton had unified geometrical optics and classical mechanics. More specifically, he had shown that "classical mechanics corresponds to geometrical optics's limit of a wave motion."[9] Schrödinger's intent was to extend this unification to wave mechanics. According to Freeman Dyson, Schrödinger's approach entailed:

> ... using wave optics as a model, to write down a differential equation for a mechanical particle, but the equation made no sense. The equation looked like the equation of conduction of heat in a continuous medium. Heat conduction has no visible relevance to particle mechanics. But then came the surprise. Schrödinger put the imaginary i (i.e., $\sqrt{-1}$) into the equation, and suddenly it made sense ... Schrödinger found to his delight that the equation had solutions corresponding to the quantized orbits in Bohr's model of the atom.[10]

In 1927 Heisenberg formulated the uncertainty principle. The same year, Dirac began his quest to unify quantum mechanics with special relativity. By 1928 he derived the equation that bears his name, and in the process achieved the relativistic description of the wavefunction of an electron. His celebrated equation yielded energy levels for electrons and for positively charged electrons (positrons) as well as the effects of spin. He also introduced operator theory with the powerful and compact bra-ket notation ("<|>"). When his book, *Principles of Quantum*

Mechanics, was published, it did not have to wait long in gaining the distinction "Bible of Quantum Mechanics" and to be regarded as the greatest scientific book since Newton's *Principia*.

In the early 1940s, John Wheeler, Princeton University physicist and thesis mentor to Richard Feynman, visited Einstein at his home at 112 Mercer Street. He told the great man about developments in quantum theory. He also asked Einstein whether he was ready to accept the probabilistic nature of quantum mechanics. Einstein mused, "I still can't believe that the good Lord plays dice." After a pause, he continued, "Maybe I have earned the right to make my mistakes."[11]

The two equations that Schrödinger formulated, initially called "Schrödinger's equation of the first type" and "Schrödinger's equation of the second type," subsequently gained recognition as Schrödinger's time-dependent and time-independent equations, as important for quantum mechanics as Newton's second law is for classical mechanics. Expressed in notation more familiar to modern physicists:

$$i\hbar \frac{\partial \Psi(x,t)}{\partial t} = \frac{-\hbar^2}{2m} \frac{\partial^2 \Psi(x,t)}{\partial x^2} + V(x,t)\Psi(x,t) \quad \text{Time-dependent}$$

$$\frac{-\hbar^2}{2m} \frac{\partial^2 \psi(x)}{\partial x^2} + V(x)\psi(x) = E\psi(x) \quad \text{Time-independent}$$

They are both "second degree" partial differential equations. E, V represent the total and potential energy, respectively,

$$\hbar = h/2\pi; \; \Psi(x,t) \text{ state function}; \psi(x) \text{ wave function}.$$

m mass of particle. The foregoing equations are one-dimensional problems but can readily be generalized for three-dimensional problems.

Both Schrödinger and Dirac began to identify connections between his wave mechanics and Heisenberg's matrix mechanics, seeking to demonstrate the mathematical equivalence of the two formalisms.

The axiomatic approach to formulating modern quantum mechanics commences from a finite series of postulates: (1) For every physical observable a, we may associate a mathematical operator A from whose properties we may deduce the possible results of measurements of the physical observable a; (2) The only possible result of measurement of the physical observable a is one of the *eigenvalues* (or proper values) of the operator A; (3) For every dynamical system there exists a state function which contains all the information that is known about the system; and (4) If we know the state function for any system at some particular time, then the evolution of the state function at all subsequent times is determined by the time-dependent Schrödinger equation.

To say that two operators A and B *commute* means that $AB = BA$, and that they *do not commute*, that $AB \neq BA$. If A and B commute, then the physical observable to which they correspond, a and b, can be known simultaneously with perfect accuracy, unfettered by the Heisenberg principle. If A and B *do not* commute, then the observables a and b *cannot* be known simultaneously. Therein lies the mathematical essence of the uncertainty principle.

Let Δx, Δy, and Δz represent the uncertainties in a particle's coordinates in the x, y, and z directions, respectively. And let Δp_x, Δp_y, and Δp_z represent the uncertainties in the components of the particle's linear momentum, p_x, p_y, and p_z. The uncertainty principle can be expressed mathematically in a series of inequalities. These include:

$$\Delta x\, \Delta p_y = 0 \text{ and } \Delta x \Delta p_z = 0, \text{ whereas } \Delta x \Delta p_x \geq \hbar/2$$

The position of the particle in the x-direction can be known simultaneously and with perfect accuracy with the particle's momentum in the y- and z-directions since the product of their associated uncertainties is zero, but it cannot be known simultaneously with its momentum in the x-direction since the product of their uncertainties cannot be zero. Similar statements can be made about the particle's other position and momentum coordinates. Position and linear momentum comprise a pair of conjugate pairs. So do any pair of components of the particle's angular momentum. Finally, energy and time comprise a third

pair of conjugate pairs. Thus if ΔE and Δt are the uncertainties in energy and time, $\Delta E\, \Delta t \geq \hbar/2$.

An intuitive explanation for the uncertainty principle, as Heisenberg personally (but mistakenly) proffered, is the so-called observer effect: the measuring instrument disturbs what it is measuring, producing a value that was not the value before the measurement was made. Later, however, it was shown that the uncertainty principle in quantum mechanics was a necessary consequence of treating particles as waves, and not because of the observer effect.

HEISENBERG

A Mozart-like wunderkind in physics, Werner Heisenberg (1901–1976) compiled the most impeccable academic credentials. The son of a professor of Middle and Late Greek, he attended the Universities of Munich and Göttingen, studied physics under Sommerfeld, Wien, Max Born, and Frank, and mathematics under Hilbert, acquiring a far more impressive formal education than Einstein. He worked as a privatdozent in Göttingen for two to three years before undertaking a postdoctoral fellowship funded by a Rockefeller Grant to study under Niels Bohr at the University of Copenhagen. But it was at this juncture that Heisenberg's career shifted into high gear. During his Christmas vacation in 1925, he formulated matrix mechanics, approximately six months before Schrödinger independently formulated wave mechanics. Initially, he knew nothing about matrix algebra but benefited from partnership with the more mathematically gifted Pascual Jordan (1902–1980) and Max Born, their immediate supervisor. Then in 1927 Heisenberg formulated the uncertainty principle that immortalized his name.

Heisenberg's life slipped into a checkered period in the following decade. He had won the Nobel Prize in Physics (1932); ten years later he found himself the head of the Nazi's A-Bomb program, Hitler's Uranium Club, just as a younger compatriot, Werner von Braun (1912–1977), was put in

charge of the V-2 rocket program. As the war wound down, in April 1945, the ten most prominent German nuclear physicists, including Heisenberg, Hahn, and C. V. Weizsacker were arrested by the "Bastard Brigade"[12] and taken to England, "lest the Russians get to them first." They were interviewed and their private conversations secretly recorded in the safe house of Farm Hall in Godmanchester, near Cambridge. There they were detained until January 1946, when they were allowed to return to Germany to commence university assignments. During interrogations by British and American scientists, the German scientists claimed they had taken a moral stand in the project and failed to build a nuclear bomb for Hitler on purpose. The interrogators were left confused. It was a hung jury. Heisenberg took it upon himself to start sketching the design of a bomb; within a week he had completed a design closely resembling one of the bombs the United States actually dropped on Japan. The Farm Hall interrogations by Allied scientists is now regarded as a failed mission for not having resolved the questions regarding the Nazi effort to build the bomb.

Hahn, who had been a pacifist and thought to be suicidal, was awarded the Nobel Prize while in detention—a first ever. Meanwhile, Jordan, the gifted mathematical physicist who had helped Heisenberg in formulating matrix mechanics, remained in hot water on both sides. Having been a member of the Hitler Youth in his younger days and later a member of the Nazi Party, he was seen as a Nazi sympathizer by the Allied side. For having defended Einstein's relativity and the Copenhagen Interpretation of quantum mechanics, he was seen as politically unreliable by the Nazis. Otherwise, Jordan would most likely have been awarded a share in the 1954 Nobel Prize in Physics.

As an aside, a Heisenberg-like uncertainty principle is frequently invoked in an altogether different realm. Pollsters and politicians have long known that publishing poll results influences voters' minds. Accordingly, politicians will cherry-pick poll results. In this version, the uncertainty principle is indeed an observer effect and has nothing to do with physics.

THE MYSTIC OF THE ATOM

Paul Adrian Maurice Dirac (1902–1984) was of course the third of the trio of the main architects of quantum mechanics, more laconic than anyone else and yet spreading the word more effectively. Born a year after Heisenberg, Dirac was the second of three children of a Swiss immigrant and his English wife in Bristol, England. In time, he would prove to be a prodigious mathematical physicist, and no less reclusive than his great predecessor Newton.

As a child, Dirac attended Bishop Road Primary School, just two years older than a schoolmate who would become far better known worldwide, Archibald Alec Leach, aka Cary Grant. The polar opposite of the film star, Dirac shunned all publicity. For his secondary education, he attended the Merchant Venturer's Technical College where his father taught French. Known through his life as pathologically taciturn and reclusive, as well as an unwavering literalist, he explained later on that the reason he got used to speaking so sparsely was due to his father's insistence that the children speak with him only in perfect French, and that he had not mastered the language. Later Dirac would confess to having concluded as a child that males and females had different languages. He also never knew about shared love in the family until he visited the Bohr family in Copenhagen.

He matriculated at Bristol University where he studied electrical engineering. Jobs being scarce in post–WWI England, Dirac decided to stay on at Bristol University for a second undergraduate degree, this time in mathematics. His grades in both fields brought him first-class honors, the equivalent of a summa cum laude diploma in the United States. This success, in turn, led to his acceptance at St. John's College, Cambridge, to pursue graduate work in theoretical physics.

In first matriculating at Cambridge, Dirac expressed an interest in studying relativity, something he had undertaken on his own in Bristol. But when his PhD advisor, Ralph Fowler, sent him a preprint of Heisenberg's 1925 paper and asked him to study it, the simple request would lead to a watershed moment for physics. In Dirac's formulation, Heisenberg's uncertainty principle would be incorporated into the non-commutative nature of some quantum

mechanical operators (i.e., for the operators A and B, the products $AB \neq BA$). (Incidentally, operators themselves are not measurable: they are mathematical entities; e.g., constants, variables, or instructions for differentiation which, when applied, "operate on" *eigenfunctions*, produce measurable quantities, *eigenvalues*.) Whereas the earlier formalisms were somewhat ragged, Dirac's system would become known as a consistent, axiomatic, rigorous, concise, and open-ended tool, reminiscent of Newton's *Principia*.

In 1926 Fowler asked Dirac to give lectures on the subject, the first to be delivered as a formal course in England. Dirac, in characteristic manner, wrote out the notes with the precision, clarity, and economy of thought that defined him, and delivered them verbatim to a group comprised of the best contemporary and future physicists. Among the legion of legendary physicists who took his quantum mechanics course were countless future Nobel Prize winners. He repeated the lectures a second year, and a third year, and indeed through his forty-three years on the faculty of Cambridge. English cosmologists Dennis Sciama, Sciama's students Stephen Hawking, Fields Medalist Michael Atiyah, and Pakistani Nobel laureate Abdus Salam all took his course. American physicist J. Robert Oppenheimer, who would later become director of the Los Alamos Lab tasked with developing the atom bomb, took Dirac's course. Later back at Berkeley, Oppenheimer taught a course in quantum mechanics and one of his students Willis Lamb would garner the 1955 Nobel Prize for his discoveries concerning the fine structure of the hydrogen spectrum. As we saw in the last chapter, Norman Ramsey (Nobel Prize, 1989) took Dirac's course.

Chandrasekhar recalled his student days, and how he took Dirac's class four times in its entirety. Even though Dirac taught the course by repeating the material from his recently published textbook word for word, "it was like a piece of music you want to hear over and over again."[13] The quote echoes Aaron Copland's observation of Beethoven's music in comparison to Tchaikovsky's that repeated listening to the same piece still keeps it fresh. Chandrasekhar received a Nobel Prize in 1983. Exactly fifty years earlier, Dirac had arrived in Stockholm to receive his Nobel Prize, accompanied by his mother.

Quantum mechanics underlies all the foregoing physical phenomena. As a self-consistent axiomatic theory with an unimaginably rich array of applications and subtle differences in interpretation it can predict phenomena in advance or explain them after they have been observed. British-born Duncan Haldane, Higgins Professor at Princeton and the 2016 Nobel laureate, spoke about how he followed a different interpretation of the theory that he had picked up from his own advisor, Philip Anderson. American-born, Harvard-educated Philip Anderson, then a professor at Cambridge, was the 1979 Nobel Prize winner in Physics. Haldane's interview had come ninety years after Dirac had begun to teach the subject at Cambridge.[14] Thus an unending chain of Nobel Prizes is traceable to the work of Dirac and his contemporaries, those pioneers of modern physics, in a manner paralleling that of Einstein.

Freeman Dyson, eminent contemporary theoretical physicist and one of the longest-serving professors at the Institute for Advanced Study, remembered taking Dirac's course at Cambridge in 1942:

> Dirac's discoveries were like exquisitely carved marble statues falling out of the sky, one after another. He seemed to be able to conjure laws of nature from pure thought . . . It was this purity that made him unique.[15]

Tall, gawky, frail, Dirac, addressing a classroom at Cambridge, never quite presented an imposing figure, and I imagine that neither did Newton in his day at the university, nor during the year (1689–1690) when he represented Cambridge in the British Parliament. In teaching his classes, Newton, required to give a certain number of lectures, was known to have addressed an empty classroom. His only recorded speech in Parliament consisted of four words: "The window needs closing."

In March 1979, Dirac stayed at the home of his brother-in-law, Eugene Wigner (Nobel Prize, 1963) while attending a celebration of the Einstein Centennial held at the Institute for Advanced Study. Along with Wigner and Dirac, numerous other past and future Nobel Prize winners were in attendance, including Steven Weinberg, Roger Penrose, Penzias,

and Wilson, and others just as famous as the Nobelists; e.g., Stephen Hawking, John Wheeler, Dennis Sciama, Freeman Dyson, and Rudolf Peierls. Although Dirac was not a dynamic speaker, on the two occasions when he was called on to comment on a technical question, the room became unusually quiet, everyone straining to hear the insight of a laconic genius, indeed, as if the words were being parsed by another Lucasian Professor 250 years before him. Neither were J. J. Thomson, Planck, nor Einstein dynamic lecturers. In the case of Einstein, Sir John Eccles (1903–1997), Nobel Prize recipient for Physiology or Medicine (1963), liked to recount an event from his days as a Rhodes Scholar at Magdalen College, Oxford:

> In May 1931 Einstein visited Oxford to give a set of three talks. As two of the younger members of Magdalen College, Schrödinger and I were assigned the responsibility of serving as ushers. The first evening the room was packed, the university dignitaries there to see a great celebrity, the scientists to hear great physics. Einstein faced the blackboard and proceeded to address it from no more than two feet away... in German! By the third evening, only the German-speaking physicists were in attendance.[16]

That blackboard still hangs, now protected by glass, in the university's Museum of Science on Broad Street. A second board he had filled was unfortunately erased by a conscientious custodian. In distinction to Einstein and Dirac, Richard Feynman was a captivating speaker, whether addressing professional scientists or laymen. Sometimes one hears college students offer an excuse for a particularly poor professor, "He is too smart, he can't possibly communicate." It should be pointed out that "abstract thinking and the ability to communicate are orthogonal functions, they are linearly independent" (invoking a pair of common expressions straight out of quantum mechanics). There can be hypnotizing speakers who are not intellectually gifted (most dictators fall into this category); there can be soaring intellects who lack the gift of gab (Newton, Einstein, and Dirac);

and there can also be geniuses who can communicate as well as the best of Shakespearean actors (Feynman and Dyson).

By 1928 Dirac conjoined Einstein's relativistic equation for momentum and energy with his own non-commuting operator formalism to derive the "Dirac equation," useful in describing the behavior of subatomic particles moving close to the speed of light, as it happens in b-decay. The four-component Dirac equation yielded four times as many solutions as expected from the nonrelativistic quantum mechanics, the wave theory of Schrödinger, and the matrix theory of Heisenberg. But were Dirac's real or spurious solutions? $\pm \hbar/2$ Trusting the intrinsic power and beauty of mathematics, Dirac saw in these solutions a pair of surprises. The first surprise was that electrons, and indeed other subatomic particles in the class of elementary particles called fermions, engaged not only in quantized orbital motion predicted by nonrelativistic quantum mechanics, they also possessed quantized spin. That spin could have only two values, spin-up and spin-down. Three decades earlier in 1896 the Dutch physicist Pieter Zeeman, applying a strong magnetic field to a beam of electrons, had observed a spectral splitting into two or more lines. (For his discovery, Zeeman had shared the 1902 Nobel Prize in Physics with Hendrik Lorentz.) Nonrelativistic quantum mechanics could explain splitting due to the quantized orbital motion but could not explain the additional splitting into pairs, doublets. Dirac's formulation could explain those pairs.

The second surprise was just as fundamental as the existence of intrinsic spin in the electrons, but it was even more dramatic, more shocking, in its prediction for nature. Corresponding to spin-up and spin-down electrons, all possessing negative charge, were spin-up and spin-down particles that possessed positive charge. Initially, Dirac thought the positively charged particles might have been protons. But protons happen to be 1,836 times more massive than electrons and there was no indication that the masses of these positively charged particles were any different than that of electrons. Again trusting the mathematics, Dirac realized he was looking at a sort of mirror image set of particles to the electrons. His equation had uncovered the existence

of antimatter electrons, or "positrons," exactly equal in mass, but opposite in charge to the electron.

The rest mass of the electron and positron are each 0.511 MeV (million electron volts). Electromagnetic radiation with a minimum of 1.02 MeV energy (i.e., equal to the combined rest masses of the electron-positron pair) could materialize in a phenomenon called "pair creation." Conversely, an electron-positron pair, when they collide, would result in "pair annihilation," giving off a minimum of 1.02 MeV of gamma radiation.

In 1932 Carl David Anderson (1905–1991), Robert Millikan's PhD student at Caltech, performed a crucial experiment using a Wilson cloud chamber. The cloud chamber, invented by Scottish physicist C. T. R. Wilson in 1912, was the first of a line of cosmic ray detectors and had earned for Wilson the 1927 Nobel Prize in Physics. (Wilson is seated in the front row, second from the far right in the famous 1927 Solvay photo, the year that he was honored). Basically, the apparatus consists of a cylinder with a tight-fitting piston and a glass window on the side of the cylinder allowing a camera to capture any drama that can take place inside the cylinder. The cylinder holds water-saturated air at the verge of condensing. The camera is tripped at the moment the piston is withdrawn, and the resulting drop in pressure causes condensation to take the place of the tracks of cosmic radiation. This much is basic application of the cloud chamber. In Anderson's experiment a steel plate was placed horizontally inside the cloud chamber and the entire apparatus was immersed in a strong magnetic field. The film plates revealed pairs of tracks starting from the plate and curving in opposite directions with virtually the same radius of curvature. A gamma photon in the cosmic radiation had struck the steel plate, and the photon had created an electron-positron pair. In 1933 Dirac shared the Nobel Prize with Schrödinger for their respective formulations of quantum mechanics. Dirac was against the idea of accepting the prize until Lord Rutherford convinced him of the danger of becoming even more famous for rejecting it. He was also offered knighthood, but rejected it; later in life, when he was offered knighthood again, he decided to accept it, lest he be addressed by his first name. Three years after Dirac and Schrödinger, Anderson won the

1936 Nobel Prize for the detection of the positron that had been predicted by Dirac's mathematics. In fact, it was Anderson who actually coined the term "positron" to describe the positively charged electron.

Physicists, having developed quantum mechanics and applied it to understand atoms and molecules during the first three decades of the twentieth century, turned their powerful new tool to investigate the atomic nucleus. Two crucial facts—the equivalence of energy and mass ($E = mc^2$) discovered by Einstein and that 99.9% of an atom's mass resided in the nucleus discovered by Rutherford—suggested that there was far more energy in the nucleus than in the rest of the atom. If nuclear energy could be harnessed, its yield for the same amount of fuel would be many thousands of times greater than the yield of chemical fuel. The experiments performed in the early 1930s involved the light elements and did not produce much optimism that nuclear energy could be harnessed anytime in the foreseeable future, if at all. Rutherford even declared,

> ... anyone who looked for a source of power in the transformation of the atoms was talking moonshine."[17] For Leo Szilard, one of the celebrated (Hungarian) "Martians," who was present at Rutherford's presentation, it became a challenge and an obsession.[18]

A German discovery in 1938, and a pair of letters—Einstein's letter to President Roosevelt in 1939 and a memorandum by Frisch and Peierls to the leaders of the United Kingdom in 1940—served as crucial catalysts in ushering in the nuclear age and changing forever the course of history.

THE FRISCH–PEIERLS MEMORANDUM

The Frisch–Peierls Memorandum (1940), although overshadowed in its impact by the Einstein letter, offered an effective blueprint for the new technology, and in retrospect exhibited remarkable prescience. Their memorandum, while reiterating the feasibility of constructing "a superbomb,"

pointed out that the device could be made light enough to be delivered by an airplane. The authors of the memorandum were two young German expatriate physicists seeking to defend their adopted homeland of England from the menace of Hitler's Germany.

In a detailed and yet compact memo, Frisch and Peierls explained how such a weapon could be built. Just to recap some of the information from the last chapter, the authors distinguished between the two common isotopes of uranium, U-235 and U-238: the lighter isotope capable of releasing energy, comprises only 0.7% of uranium found in nature and the less useful heavier isotope comprises 99.3%. Frisch and Peierls explained that the U-235 required enrichment to above 90% in the admixture, in order to create the "critical mass" necessary, about 5 kg (11 pounds), to trigger an explosive chain reaction. The memo suggested the enrichment process could be achieved by gaseous diffusion, already developed by a German physical chemist in Munich. It addressed the damage to life and property from a nuclear explosion: as primary effects to life and buildings and as secondary effects to life from radioactive fallout and contamination damage. They pointed out, however, that *not* developing the superbomb, especially if the enemy might just be developing it, would be suicidal. They even speculated that if both sides possessed such an instrument of war, then at least a stalemate might emerge. In this, they anticipated what has become known as "mutually assured destruction." The authors pointed out the crucial need to keep the study secret, lest the other side had not already foreseen the full possibility of the technology. The authors avoided the social and political ramifications of developing the superbomb, confessing they were out of their depth on these issues. The memo escalated through the chain of command quickly, resulting in the creation of the MAUD Committee, an acronym for military application of uranium detonation.[19]

Austrian physicist Otto Frisch (1904–1979) was the nephew of the brilliant Austrian Swedish physicist Lise Meitner. Like his aunt, Frisch was born in Vienna and studied at the University of Vienna before attending graduate school at the University of Berlin. After completing his PhD, he

took a job at the University of Hamburg in Germany to work under Nobel laureate Otto Stern. With Hitler's ascent to power in 1933, both Stern and Frisch lost their jobs in Hamburg and abandoned Germany. Frisch worked at Birkbeck College in London with Maynard Blackett (Nobel Prize, 1948), then embarked on a five-year stint at the Bohr Institute in Copenhagen. With Hitler's annexation of Austria 1938, Lise Meitner had already moved to neutral Sweden. There, she received the news from her former colleague in Germany, Hahn, that in bombarding uranium with neutrons, he and Strassmann had discovered the element barium, approximately half as heavy as uranium, in the product. Meanwhile, Frisch, who happened to be visiting Meitner during his Christmas vacation in 1938, learned about the German discovery. Together Meitner and Frisch wrote a paper speculating on the physics of the process: the likelihood that uranium nucleus, in capturing a neutron, had split into two fragments of similar mass, with barium representing one of these fragments. The nucleus U^{235} had undergone "fission" (an expression Frisch borrowed from biologists). They also computed the approximate energy released (200 MeV) in a single fission event. When Frisch returned briefly to Copenhagen, he divulged the news of the German discovery of the uranium fission process to Niels Bohr, who was just preparing to leave for the United States. Bohr, while answering questions to skeptical scientists, had an epiphany in explaining the different behavior of the two isotopes of uranium. It was the lighter isotope that had the appetite to capture thermalized (slow-moving) neutrons and undergo fission.

Sir Rudolf Peierls (1907–1995) was a brilliant scientist with an unmatched academic pedigree: undergraduate studies first at the University of Berlin then at the University of Munich under Arnold Sommerfeld. When Sommerfeld went on sabbatical, Peierls transferred to the University of Leipzig to study under the young Werner Heisenberg. Before Peierls had completed his PhD research, however, Heisenberg set out for a world tour, allowing his student to continue his research at Einstein's old school ETH Zurich under Wolfgang Pauli. The thesis he wrote at ETH was accepted at Leipzig, with Heisenberg as the thesis advisor.

Subsequently, Peierls undertook postdoctoral research in Rome under Enrico Fermi with a Rockefeller Fellowship, then under Dirac's former mentor, Ralph Fowler, at the Cavendish Lab at Cambridge. In 1933, he attended the seventh Solvay Conference in Brussels, which had grown to forty participants, including three extraordinary female scientists—Marie Curie, Marie's daughter Iriné Joliot-Curie, and Lise Meitner. Einstein, off to America, did not attend, and Pascual Jordan because of his membership in the Nazi Party was not invited. The same year, with the rising tide of antisemitism in Germany, Peierls took the momentous decision to remain in England. Although a nonpracticing Jew, he understood the dangers of returning to Germany. The Anglo Australian physicist Mark Oliphant, onetime assistant to Rutherford in Manchester and now at the University of Birmingham, recruited Peierls in 1937 to his department, as he would recruit Frisch in 1939. After the duo's collaboration in 1939–1940 and the Frisch–Peierls Memorandum, both men were employed in 1941–1943 in MAUD, then lent to the Manhattan Project in 1943. There they worked alongside Hans Bethe, Leo Szilard, Niels Bohr, Enrico Fermi, and Richard Feynman, first in New York and then in Los Alamos.

Rudolf Peierls giving a physics seminar in Virginia (1981).

After the war, Frisch accepted a professorship at Cambridge. Although offered a similar post at Cambridge, Peierls returned to the University of Birmingham where he stayed until 1963 to see the development of the one of the best theoretical physics programs in England and, in fact, in the world. Among his students in 1951 was John Stewart Bell, author of Bell's theorem, on leave from CERN for a year. In 1963 Peierls relocated to Oxford, accepting an invitation as the Wykeham Professor and head of the Department of Theoretical Physics at the ancient institution. As in Birmingham, he again succeeded in assembling an exceptional research and teaching family of students and faculty. In England's age-required system, Peierls retired in 1974. In the twenty-first century, the department he built was renamed the Rudolf Peierls Centre for Theoretical Physics. Although his greatest contributions were in solid state and nuclear physics, as a virtuoso physicist, he demonstrated a repertoire spanning virtually the entirety of topics in theoretical physics.

In 1946 Peierls and Frisch were awarded the Medal of Freedom,[20] and subsequently Peierls was awarded the Lorentz Medal (1962), Max Planck Medal (1963), Enrico Fermi Award (1980), and knighthood by the Crown (1968). During the last half century of his life, Peierls was active in nuclear arms control. Brilliant, wise, modest, and kind, he had always been in the thick of things during the Golden Age of Physics, a colleague of the greatest minds in science during the "Century of Science." His obituary, appearing in the September 30, 1995, issue of *Economist* magazine, opened with the line:

> The flowering of quantum mechanics and nuclear physics in the first half of the 20th century was an extraordinary time in science during which the secrets of the atom and its nucleus surrendered to a band of brilliant theorists and experimenters.

One evening in 1973 Professor Peierls invited two guests, his friend Frisch and an exceedingly junior member of the department (the author), to dinner at New College, Oxford.[21] The two friends recounted their days

at the University of Birmingham. Along with their study which produced the land-shattering memo regarding the feasibility of the superbomb, they had systematically scoured technical publications to see whether Heisenberg was doing any fundamental research in physics. The absence or even dearth of research papers suggested Heisenberg was involved instead in the development of the German A-bomb. It turned out Heisenberg was indeed the principal scientist in his nation's nuclear weapons program. But the German program ran into serious technical difficulties, along with Hitler's lack of enthusiasm based on his personal instincts rather than on the advice of scientists toward the feasibility of a superbomb, a trait of the führer for which the Allies can forever be grateful.

On a personal note, in October 1972 when I first met Peierls, I was with my six-year-old son Michael. I addressed him as Sir Rudolf, not knowing yet that he liked to be addressed as Professor Peierls or Prof. (and Rudy by his peers). A little later, Michael asked, "Why did you call him Sir Rudolf?" I explained to him that he had been knighted by the queen. After a short pause, Michael mused, "He doesn't look like a knight to me!"

WHAT EINSTEIN DIDN'T KNOW

While recognizing that science strives to be precise, unambiguous, and close-ended, we can still take inventory of what we do know and what we would still like to know. Einstein's dream of unifying the forces of nature in a Grand Unified Theory (GUT) or a Theory of Everything (TOE) never came to fruition in his lifetime. By the time he died in 1955, he did know the universe was determined by four forces: gravitation, electromagnetism, weak nuclear force, and the strong nuclear force. Physicists now are confident that one equation—a beautiful, open-ended work of art to a few and terrifying monster to others–finally presents itself. Its ultimate distillation into a thimble-size expression might have to await the next Newton or Einstein.[22]

$$Z = \int D(Fields)\exp\left(i\int d^4x\sqrt{-g}\left(\overset{(Gravitational)}{R} - \overset{(Electromagnetic)}{F_{\mu\upsilon}F^{\mu\upsilon}} - \overset{(Strong\ Nuclear)}{G_{\mu\upsilon}G^{\mu\upsilon}} - \overset{(Weak\ Nuclear)}{W_{\mu\upsilon}W^{\mu\upsilon}}\right.\right.$$

$$\left.\left. + \sum_i \underset{(Matter)}{\overline{\psi}_i D\psi_i} + \underset{(Higgs\ boson)}{D_\mu H^\dagger D^\mu H} - \underset{(Dark\ energy)}{V(H)} - \underset{(Dark\ Matter)}{\lambda_i \overline{\psi}_i H \psi_i}\right)\right)$$

The theory of everything (TOE). The equation takes into account the four basic forces of nature: gravitational, electromagnetic, strong nuclear, and the weak nuclear plus (in the summation term) all known matter, the Higgs boson, dark energy, and dark matter. The so-called Standard Model has succeeded in unifying the three forces electromagnetic, strong, and weak. The gravitational force, however, has so far eluded coming into the mix. Many physicists believe that gravitation too will someday be shown as part of a single force that includes the four forces that existed at the instant of the Big Bang.

Quantum fluctuations that began from a mathematical singularity in space-time, a dimensionless pinpoint at the instant of the Big Bang, have stretched and stretched into the known universe after 13.7 billion years. Written in the language of tensors, the equation incorporates all four forces, plus the hitherto undetected "dark matter" (27%) and "dark energy" (68%) predicted by mathematics to explain the accelerated expansion of the universe.[23] The detected matter accounts for less than 5% of the universe. In other words, 95% of the universe is missing.

PART IV
THE MIND AND BRAIN

13

LUMPS, BUMPS, AND THE GIFTED MIND

A cast was taken from the face of Newton after his death and is still preserved in the University Library at Cambridge. A copy of it is in the Museum of the Phrenological Society. As the philosopher, however, died at the advanced age of eighty-four, and as his mental powers were greatly diminished during his later years of life, it cannot be regarded as a faithful representation of what his forehead had been in the vigour of his days. It shews, nevertheless, a great development of the organs of 'Locality' and 'Weight.' In his bust and statue by Roubiliac to be seen at Cambridge, the organs of the perceptive faculties are exceedingly prominent. These were the chief faculties for his discoveries.[1]

—Q. M. Q., *The Phrenological Journal and Miscellany* (1831)

Investigation of functions of the brain took center stage during the late eighteenth and early nineteenth centuries with the work of Franz Joseph Gall (1738–1828), the physician and pioneer neuroscientist living in Vienna, who tried to correlate various mental functions and faculties with specific areas of the brain. He would look at his friends and identify their defining traits and attempt to correlate these traits with the physical appearances on

their heads. Gall constructed a diagram of the head for the phrenologist, identifying a list of thirty-eight mental functions reflecting the concerns and values of the time, including *Agreeableness, Alimentativeness, Approbativeness, Amativeness, Benevolence, Conscientiousness, Spirituality,* and *Veneration.*

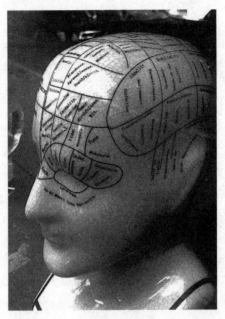

A copy of a bust originally created by American phrenologist Lorenzo Niles Fowler (1811–196).

PRICE ON COMPOSERS' HEADS

The popularity of phrenology in Vienna had less than salutary consequences for one group of Viennese artists. The city was home to Haydn, Mozart, Beethoven, von Weber, Schubert, and Brahms. Although it is impossible to know who among the great composers had his bumps stroked by the tactile fingers of phrenologists while he was still alive, we know that a number of them became postmortem subjects. Joseph Haydn, who died in 1809, was awaiting burial when one phrenologist seized the opportunity to

apply his "science" to the composer's skull. He had the head "borrowed... fully resolved to return it promptly." However, the skull quickly became an object of fascination for wealthy European families. The skull was secretly circulated among a number of homes for 145 years before finally being reunited with the rest of the body in 1954. Shortly after Beethoven died in 1827, rumors began to circulate that an unscrupulous phrenologist was offering a generous reward to any gravedigger who could deliver the composer's skull to him. Beethoven's friends reacted by immediately taking turns sitting vigil at his gravesite, lest the phrenologist's agents organize a nocturnal visit with shovels and spades before a marble tomb could be erected over the grave.

Mozart's skull suffered an ignominious fate similar to Haydn's. After the composer's death in December 1791, his body was buried at St. Marx's Cemetery in the suburbs of Vienna in a communal grave alongside several other recently deceased residents of the city.[2] But common practice called for periodically reorganizing cemeteries: corpses from older graves were dug up and discarded to make room for the more recently deceased. Joseph Rothmayer, one of the two gravediggers who had originally buried Mozart's body, claimed he had maintained notes on the excavation. When St. Marx Cemetery was being reorganized in 1801 and a phrenologist offered a reward for Mozart's remains, Rothmayer retrieved the skull and swore to its authenticity. The skull, with the lower jaw and central incisors missing, would soon become an item of curiosity like the skull of Haydn, to be bandied about for a hundred years. Mozart's skull came to a final rest in 1901 in the Mozarteum in Salzburg, the central repository for Mozart memorabilia and Mozart scholarship. Unsure of its authenticity, however, the officials of the institution stopped exhibiting the skull publicly after 1951. But in 1991, 200 years after the composer's death, a team headed by French anthropologist Pierre-François Puech methodically examined the skull and published their results. There was substantial evidence that the skull indeed belonged to Mozart.

Modern forensic pathologists are frequently called upon to examine human remains in order to establish or confirm identity, especially when

foul play is suspected. When only skeletal remains exist, the pathologist might proceed by pasting cork disks of statistically established flesh thickness on various key points on the skull. In the manner of a sculptor, the pathologist proceeds to build up the overlying flesh using clay. Puech's group examined the skull thought to be that of Mozart and reported that it exhibited a vertically rising broad and bulbous forehead, large ovoid eye sockets, prominent cheekbones, a small brow ridge, and evidence of a once-cracked left temple subsequently healed.

Modern anatomists and neuroscientists attribute the bulging shape to early closure of the metopic suture, the separation between the bones of the forehead that usually begins to diminish and disappear beginning when a child is about eighteen months old. But they attach no connection between exceeding brilliance and a bulbous forehead. The evidence of a healed crack in the temple of the skull, according to Puech, could have been the result of the violent spill that Mozart is known to have taken while riding his horse during the spring of 1790, eighteen months before his death. Puech suggests the pressure from a hematoma could explain the debilitating headaches the composer suffered.

A 1994 article in *Neurology* speculated that the subdural hematoma could have been the prime factor leading to the early death of Mozart.[3] A 2011 paper argued that Mozart suffered from medical conditions related to severe vitamin D deficiency. We may never know the cause of Mozart's death with any degree of certainty. But the medical treatments commonly practiced at the time, including the use of patent medicines containing high levels of antimony and the aggressive bloodletting, would have exacerbated his rapid decline just before his death.

In the late twentieth century, forensic pathologists also studied the skull suspected to have belonged to Johann Sebastian Bach. A convincingly close likeness emerged in the clay overlay with the oil portraits of Bach. In the early twenty-first century the skeletal remains of Copernicus were also identified. Archaeologists retrieved the remains from a grave long suspected to be that of the astronomer. A tooth and a femur bone offered a DNA match to strands of his hair left in a book. Subsequently, forensic

facial reconstruction was applied to the skull to reveal Copernicus's likeness for the first time in four and a half centuries.

The pseudoscience of phrenology may have been popular among the aristocracy in Vienna, but it was never a source of amusement to the church, which saw itself as a protector of the human soul. When Gall was exiled from Vienna, he moved to Paris. The oversimplification and abundance of mistakes notwithstanding, his work proved seminal as one of the earliest attempts to point out the localization of brain functions. In Paris, neurologist Marie Jean Pierre Flourens (1794–1867), more a clinician than a theorist, became a vocal critic of Gall's work, giving a healthier direction to the emergence of neuroscience. Flourens took an assortment of animals (mostly dogs and chickens) and started to systematically excise certain parts of their brains. Interested in proving or disproving whether Gall was correct regarding the affinity for romantic love residing in the anterior regions, he removed the region near the cerebellum. The missing region caused impairment in particular motor functions, but the animal showed no difficulties expressing romantic love. With his system of elimination, he tested many of Gall's claims, replacing them with questions to be answered by improved techniques.

In the 1860s Pierre Paul Broca (1824–1880) appeared on the neurophysiology scene, when it was already established that the cerebral cortex, the outer layer of the brain, could be divided into four major lobes, with each of these lobes connected to a specific function. The frontal lobe was involved in planning and short-term memory phenomena; the temporal lobe was involved in hearing and also memory; the occipital lobe was involved in visual perception; and the parietal lobe in spatial phenomena. Broca became a giant in the field initiated by Gall. But unlike Gall, he was an experimentalist. Instead of phrenology, dealing with bumps on the skull—merely a hard external shell housing the brain—Broca was interested in the bumps on the organ, the brain itself. He felt that patients exhibiting impaired behaviors could provide the clues for understanding the functions of various other areas of the brain: patients with localized lesions in the brain, patients with tumors, patients who had suffered from strokes. In 1861 a patient who

presented himself to Broca had an unusual aphasia (a disorder impairing language fluency). His patient could understand language perfectly well, but he could not articulate words. Moreover, the aphasia extended to various other aspects of language usage; e.g., an inability to write words. When the man died Broca performed an autopsy and found that the man had a lesion in the frontal cortex, a region he named after himself, Broca's area.

Subsequently, Broca encountered seven or eight other patients with similar aphasias, having trouble writing out words or articulating ideas. Broca found that in every case, the lesion was not only in the entire frontal cortex but that it was in the *left* frontal cortex, the major region of mental functioning. It became clear to him that speaking is a function of our left hemisphere. This discovery stimulated researchers to examine other regions of the brain to see what other functions could be localized.

In 1873 a second important clinical contribution came from Carl Wernicke. A patient had presented himself with a variation of the deficiency encountered by Broca's patients. In this instance, it was an inability to grasp the meaning of words. Upon the patient's death, Wernicke performed an autopsy and found a lesion in the left central hemisphere. Whereas Broca's area is related to the production of speech, Wernicke's area is related to the comprehension of speech. Following the recent tradition initiated by Broca, Wernicke modestly named the region he had identified Wernicke's area.

Until the end of the nineteenth century, when Rontgen introduced X-ray technology, anatomical images were produced only during surgery or postmortem studies. During the last two decades of the twentieth century, medical imaging technology made immense progress. The modern radiologist's armory includes computerized tomography (CAT scan), magnetic resonance imaging (MRI), and positron emission tomography (PET scan)—complementary technologies allowing anatomical imaging with unprecedented detail while the subject is alive. An MRI can display images of exquisite resolution. A powerful magnetic field generated by a massive superconducting coil is applied to the subject placed in the machine, causing a partial alignment (polarization) of the spins of some of the nuclei (protons) of the hydrogen atoms, and accordingly of the water molecules in the subject.[4] Since

different organs and tissues—blood, walls of a blood vessels, plaque, etc.—all contain different amounts of water, an MRI image is capable of revealing distinctions far beyond that of the conventional X-ray. Functional magnetic resonance imaging (*f*MRI) is basically an MRI applied to the brain, and it is able to pinpoint the areas of the brain where various mental functions are being carried out. Blood rushes to the parts of the brain requiring oxygen to process a particular function or operation, such as performing a mathematical calculation or creating a work of art. Sometimes positron emission tomography (PET scan) is correlated with *f*MRI images to pinpoint areas in the brain as sites of certain specific activities. Modern *f*MRI and PET scan studies have shown that similar areas of the frontal lobe are activated in mania, schizophrenia, and creativity, just as the area of the brain activated by hallucinogenic drugs is also the area activated by religious activity.

Viennese-born Eric Kandel, professor of psychiatry and neurophysiology at Columbia, is a rare specialist in both the psychoanalytic aspects of the mind and the genetic-molecular or biological aspects of the brain. Recipient of the 2000 Nobel Prize in Medicine or Physiology for his explanation of memory and learning at the molecular level, Kandel is a strong advocate of the heritable genetic aspects of mental disorders. As he points out in *The Disordered Mind*,[5] the artistic right hemisphere and the logical left behave differently when a stimulus—usually a word, picture, or sound—is received. The left hemisphere takes the stimulus, no matter how minor, seriously by showing detectable activity, whereas the easily bored right hemisphere does not. If the stimulus is unusually strong, however, the right hemisphere immediately springs into action.

Entirely in keeping with Kendal's explanation of the different but complementary nature of the two hemispheres of the brain is the report of a 2019 study conducted by a team of neuroscientists at the University of Freiburg, Germany.[6] In the online prepublication of a more comprehensive paper to follow, Elisabeth Hertenstein and her collaborators reported the results of an experiment using the technology of transcranial direct current stimulation (tDCS). They applied a small voltage laterally to the scalp creating a minuscule electrical current between the two hemispheres of the

brain, specifically between the inferior frontal gyrus (IFG) on the left and IFG on the right. With the positive probe (anode) attached to the right, the creative right hemisphere appeared to be stimulated to work harder, while the cathode on the left had a calming influence on the not-so-creative left hemisphere. The subjects' creativity was enhanced by 10–20%, a significant difference. The researchers found that reversing the polarity of the voltage, in order to stimulate the left side instead, resulted in no enhancement in creativity. The experimental cohort, the subjects of the study, comprised ninety healthy university students. The testing of creativity followed a sustained twenty-two-minute application of the electrical stimulus. To measure the creativity, the researchers administered three complementary tests assessing different aspects of creativity.[7]

EINSTEIN'S BRAIN

Although certain mental functions may indeed be correlated with intense activity taking place in localized regions, it has also become clear that the processing of ideas calls for cooperation between different and widely separated localities. Only one preserved brain of a surpassing geniuses exists—that of Albert Einstein. The rupturing of an abdominal aneurysm brought on Einstein's death on April 18, 1955, at the age of seventy-six. Following Einstein's death, Thomas Harvey, a young Yale-educated pathologist at Princeton Hospital, performed the postmortem. In accordance with Einstein's wishes, his body was cremated and the ashes scattered. But this was not done until Dr. Harvey had surreptitiously removed the brain and stored it in a jar of formaldehyde. When the news came to light of the unauthorized removal and appropriation of the brain, it drew the ire of several of Einstein's friends. But with the permission of Einstein's son Hans Albert, the pathologist retained the brain with intentions of performing studies on it. In time even the memory of the existence of the brain would disappear, but not before Harvey lost his job in Princeton and returned to his hometown of Lawrence, Kansas. With little expertise in neuroscience,

Harvey exercised wisdom in simply maintaining the brain untouched until neuroscience could make sufficient strides to revisit the brain. Three decades after Einstein's death, word of the existence of the brain surfaced anew, creating a mix of morbid fascination and euphoria. Walter Isaacson's description of Einstein's brain as "a wandering relic" evokes memories of the skulls of Haydn and Mozart being bandied about among European aristocratic houses during the nineteenth century.

In the early 1980s Harvey allowed small pieces of the brain to be examined by Marian Diamond, a professor of physiology at the University of California, Berkeley. The initial findings revealed the brain to display a higher density of glial cells than the brains of others, most significantly in the left inferior parietal cortex. Later in the decade larger samples of the brain were made available to neurologists at McMaster University in Hamilton, Ontario, where more definitive studies were carried out.

According to modern neuroscience, the area of the brain specialized for mathematical abstraction, the imagery of movement, and visuospatial cognition is the inferior parietal lobe. Canadian neuroscientist Witelson and her collaborators at McMaster University reported in a 1999 article, "The Exceptional Brain of Albert Einstein,"[8] that they had discovered a peculiar abnormality in Einstein's brain. Although normal in size, the brain was missing the parietal operculum, with the inferior parietal lobe having grown approximately 15% wider than normal to fill the area of the missing area. In the Canadians' studies, another noteworthy feature of Einstein's brain was the existence of an unusually shallow Sylvian fissure, a groove slicing through the brain. This feature, the researchers suggest, allows the brain cells in the area to be packed closer together and permit more interconnections and functionally to allow better cross-referencing of information and ideas—of critical importance for analytical processing.

Although Einstein was a late talker, in time he became an excellent German speaker, but not so in English. Wigner used to explain that his own facility in English was poor, and he would resort to the excuse that Einstein had offered him: "Facility in a foreign language is inversely proportional to facility with mathematics."[9] Could this anomaly have been

the source of Einstein's special gifts? Or was Einstein engaging Wigner in one of his typical jokes? Another explanation could be that it was the particularly strenuous cerebral exercises that Einstein carried out that had caused the abnormality in the first place, in the manner of Gall's conjecture, but without the associated external lumps on the skull. In any event, the nature of the special and general theories of relativity requires facility with complex geometric visualization and abstruse mathematics, both specialties of the inferior parietal lobe. Ultimately, the foregoing represents a fascinating conjecture but not conclusive proof that Einstein's brain was physiologically hardwired differently than those of others. Before a cause and effect can be firmly established, however, extensive pathology on the brains of other mathematically gifted individuals who died at roughly the same age (mid-seventies) would need to be carried out. Even with increased numbers of mathematically gifted individuals willing their organs to science, it will be very difficult to find others of comparable creativity. A disclaimer here, however, must be repeated: although we cannot deny that compared with most other scientists Einstein was mathematically gifted, he was not a mathematician of the highest order as was Newton, Gauss, Maxwell, or a von Neumann. He was a mathematical "bird" and not a "mathematical frog."

Just as it is with the rest of the human body, the head and face possess virtually perfect symmetry on the outside. Slight differences that may exist between the two sides of the face are usually subtle and only the individual himself may be aware of them. Over the years compelling arguments have been made that bilateral symmetry is a significant aspect of human aesthetics. In the interior of the skull—in the shape and density of folds, the cerebrum, and cerebellum, the corpus callosum and hippocampi, or collectively, the *morphology* of the brain—the two hemispheres possess bilateral symmetry. One side of the brain closely mirrors the other. In their functions, however, the left and right hemispheres exhibit distinct asymmetry, a fact known to neuroscientists for two centuries. In the brain's neurological connections to the rest of the body, there exists massive crossover, leading to the right hemisphere controlling the left side of the body and the left hemisphere the right side. This, in concert with the fact that

right-handed individuals outnumber left-handers by roughly 10:1, leads to a simple conclusion: handedness is determined mainly in the left hemisphere.

FUNERALS FOR A PAIR OF SECULAR SAINTS

Newton in his final months suffered from gout, a condition usually manifesting in inflammation in the feet and joints accompanied by swelling, redness, and a low-grade fever, making walking or even standing quite painful. Modern medicine explains that an individual suffering from the condition produces an abundance of uric acid that crystallizes into needle-like spikes, visible under a microscope. In soft tissue, gout can give rise to the formation of hard nodules, tophi, appearing as disfigurement at joints, and even as kidney stones in the urinary tract. Untreated gout can cause cardiovascular disease with metabolic syndrome. The tophi can attack organs, and afflicted individuals can die from kidney, liver, and pancreas failure. Accordingly, tophi were most likely the cause of Newton's death. Doctors called in to treat him applied the cure-all technique of the day—they bled him again and again. The bleeding undoubtedly exacerbated his discomfort and expedited his death.

A century later, during the last three or four years of his life, Beethoven was suffering from declining health. He was over the worst of his psychological disorders, although his physical state had slipped considerably. In late 1826 and early 1827, he was suffering from severe stomach aches, abdominal bloating, vomiting, and dehydration. Doctors treated the malady in four separate minor procedures, *paracenteses*, or abdominal taps to drain fluid, with the first of these causing an infection. Any surgical intervention in the days before sterilization and antibiotics could be just as dangerous as the disease itself. Beethoven slipped into a coma on March 26, and a Catholic priest was called in to give him last rites. According to his close friend, Anselm Hüttenbrenner, death came on March 27 with only he and the composer's maligned and much-abused sister-in-law, Johanna, present.

A postmortem performed on the composer revealed that he had deterioration of his liver from cirrhosis. "The doctors described his pancreas

as 'shrunken and fibrous,' with the exit duct being very thin and narrow. Large amounts of reddish fluid had accumulated in Beethoven's abdomen, likely from bacterial infections mixed with some blood, possibly a result of draining fluid from his abdomen in his last days."[10] Cirrhosis is commonly associated with heavy alcohol consumption, but more likely in Beethoven's case from poor genes. He was never a heavy drinker. The autopsy of his skull reported that the aural nerves and surrounding arteries were considerably atrophied, explaining his deafness. "The number one theory," according to musician and Johns Hopkins otolaryngologist Charles Limb, was "... inflammation of the inner ear, probably following a typhus meningitis."[11] Of course, the deterioration in his hearing happened over a period of almost three decades. In 1804 he was able to conduct the debut of his *Third Symphony*, and he continued playing the piano in public as late as 1814, though he had begun using ear trumpets by 1812. By 1818, he was employing conversation books to communicate with friends, and by 1825, he could not hear conversation at all. His autopsy also showed that his brain had diminished in size, evident from the large volume of fluid. The shrinkage in the brain had been a development of his later years, and yet there had been no noticeable cognitive impairment reported by his friends.

Another kinship Newton and Beethoven shared was that each man transcended his own field in his own time and gained recognition as a supreme genius and national cultural treasure. Each became the first in his field to receive a state funeral, hitherto reserved for royalty, exceptional statesmen, and outstanding military leaders. According to biographer James Gleick, at Newton's funeral on March 31, 1727, "Lord Chancellor, two dukes, three earls bore the pall, with most of the Royal Society following behind. The corpse lay in state in Westminster Abbey for eight days and was buried in its nave."[12]

The young historian and writer François-Marie Arouet from Paris, who would later make a name as the foremost Enlightenment philosopher, Voltaire, happened to be visiting London at the time of Newton's death. Witnessing Newton's funeral, he wrote of his astonishment at seeing a kingly funeral accorded to a commoner. Newton was a natural philosopher, a scientist, and a man whose achievement lay entirely in the realm of the

mind. Receiving a state funeral and being buried in Westminster Abbey completed his beatification as a secular saint.

One hundred years later on March 26, 1827, Beethoven was similarly honored at his death. He was accorded a day of mourning by the city of Vienna, with shops and theaters closed for the day and a crowd numbering an estimated 30,000 turning out to witness the funeral procession. Among the forty pallbearers, torchbearers, and other mourners were musicians, and at least three distinguished composers—Hummel, Czerny, and Schubert. The music played or sung during the procession included Mozart's "Requiem," Ignaz von Seyfried's "Libera me," Beethoven's own "Miserere," and a funeral march arrangement from his "Sonata Op. 26" for four trombones. A friend of the deceased composer wrote a letter to mutual friends describing the funeral: "No Emperor of Austria ever had a funeral like that."

MODERN FORENSIC ANALYSIS OF HAIR

Questions have persisted through the centuries regarding whether Newton and Beethoven ingested large amounts of heavy metals that could possibly explain their health maladies, their psychological issues, and their respective deaths.

In the late 1970s, the news began to circulate in scientific circles that Newton's hair, trimmed in the early 1690s, was preserved in the collections of the Royal Society of London. Meanwhile, technology to detect concentrations of certain substances, as little as one part per trillion—comparable to a needle in a haystack the size of the Great Pyramid—had come into use in the form of neutron activation analysis (NAA). This is a forensic technique applied to solids, liquids, or suspensions. A sample to be tested, such as bone fragment, hair, or fingernails, is placed in a small cylindrical plastic vial known as a rabbit and shot pneumatically into the core of a teaching and research nuclear reactor (TRIGA). After bombardment by neutrons lasting up to twenty to thirty minutes, the sample is retrieved. A scintillation or Germanium-Lithium (GeLi) detector examines the gamma spectrum of the sample to reveal the elements that were in the sample before the irradiation process.

Newton's hair provided an opportunity for nuclear physics to attempt to answer the Newton puzzle, "What had caused his 1693 nervous breakdown?" Duke University scientists L. W. Johnson and M. L. Wolbarsht reported in a paper, "Mercury Poisoning: A Probable Cause of Isaac Newton's Physical and Mental Ills,"[13] on the results of neutron activation analysis performed on Newton's hair, which revealed the existence of unusually high concentrations of mercury, lead, bismuth, and antimony—heavy metals deleterious to living organisms—as the likely sources of his nervous breakdown, but not the cause of his death. The risky lab habits he practiced in his alchemy experiments had taken their toll. A few years after giving up alchemy, Newton recuperated, regaining his health and the taciturn, reclusive, and irascible personality that had always defined him.

The greatest scientific mind in history had severely damaged itself, but the science he had spawned developed in time the tools to explain how he had done it. For Newton, the diagnosis came three hundred years too late.

But he never undertook serious scientific cogitation again, except once. Jacob and Johann Bernoulli, mathematician brothers in Basel, after a ten-year endeavor, had just formulated a new branch of mathematics—the calculus of variations. They challenged Newton and Leibniz to solve their *brachistochrone* problem, in an effort to discredit the former and lionize the latter. When Newton solved the problem in one evening, and sent it to them unsigned, the Bernoullis were shaken to the core, one of the blurting, "You can recognize the lion by his claw!" Newton's formidable analytic powers were still clearly intact.

Newton's death mask and a lock of his hair on display at the Royal Society of London. The opening quote from the phrenology journal (chapter 12) referred to this death mask while the statue by Louis–François Roubiliac appears in figure 13D, color photo insert page XIII.

During most of his adult life, Beethoven also suffered from stomach pains, frequent throes of colic, severe diarrhea, and dehydration. And his personality mirrored his physical maladies, as he became testy and irritable. Beginning in 1994, his hair also came under scrutiny. Within two to three days after his death in March 1827, friends, doctors, and souvenir hunters stripped every strand of his hair from his scalp. Among the visitors was the fifteen-year-old musician Ferdinand Hiller, who was described as picking up a pair of scissors and snipping off a lock of the composer's hair. Almost six decades later, Hiller passed the lock of hair to his son as a birthday present. And just as the skulls of other great composers had been bandied about among wealthy Europeans, the Hiller sample was also transferred from one wealthy European household to another. Of the eight samples with reasonable provenance that have survived, the Hiller sample gained prominence as the most authentic.

In 1994, five strands from the sample underwent rigorous testing at Argon National Lab in Illinois, revealing the presence of lead two full orders of magnitude higher than seen normally in healthy individuals. According to the Mayo Clinic, the signs and symptoms of unusually high levels of lead poisoning include high blood pressure, joint and muscle pain, difficulties with memory or concentration, headaches, abdominal pain, mood disorders, reduced sperm count, and liver disease.[14] The lead in Beethoven's case could have been the source of many of his physical and psychological maladies. The tests, however, revealed the absence of another heavy metal, mercury, normally used in treating syphilis in the early nineteenth century. At least Beethoven's medical treatment did not include one for relief from syphilis. As for the lead, how had Beethoven ingested it?

The next round of investigation on the composer's hair came between 2014 and 2023 and grew into a collaboration of thirty-two researchers from multiple countries and in various fields—medicine, musicology, museum administrators, and, most importantly, the burgeoning new specialty of genomic sequencing, medical genetics, genetic genealogy, geogenetic triangulation.... The primary investigator and the instigator of the analysis turned out to be Tristan Begg, a doctoral candidate at Cambridge. Like

Darwin and Pasteur in the nineteenth century, Begg had been developing the right combination of passion and skills to oversee the genomic analysis. Although younger and less established than the other researchers, he served as the lead author of a compelling collaborative paper in March 2023.[15]

Among the issues resolved were the authentication of Beethoven's hair. Five of the eight locks investigated were declared authentic. The Hiller lock was out! It included strands from a female and an Ashkenazi Jew at that (Hiller was married to a Jewish woman). A pair of fragments of cranial bones purportedly belonging to the composer and in possession of the Beethoven-Haus in Bonne turned out to be authentic. Members of five Flemish families with the surname van Beethoven who were convinced to be genetically related to the composer, were out! They shared the name, but not the genes. Among the discoveries was Beethoven's genome possessed the markers for lactose intolerance and hepatitis B, the latter associated with a predisposition for cirrhosis, and consequently for liver disease. He did not have to be a heavy consumer of wine to succumb to the illness. The lead poisoning conclusions of 1995 paper proved to be a red herring. A surprise result, however, was the appearance of an illegitimate birth somewhere in the Beethoven family line with Beethoven's father Johann having likely been born out of wedlock.

HONORING CULTURAL HEROES AND DESECRATING THEIR REMAINS

The thirteenth-century Franciscan Church of Santa Croce in Florence is a mausoleum for many of the cultural leaders of Italy, accommodating the remains of Dante, Ghiberti, Donatello, Machiavelli, Michelangelo, Galileo, Volta, Marconi, Rossini, and Fermi. In this function, Santa Croce parallels the Westminster Abbey in London.

Dante is honored with a tomb in the Santa Croce, albeit an empty one. Having been exiled from Florence for his political activities, the iconic Italian writer is buried in Ravenna. Raphael is buried in the Pantheon in Rome. Leonardo is not even buried on the Italian peninsula. Three years

before he died in May 1519, he had relocated to Amboise in the Loire Valley of France as a guest of the twenty-one-year-old King Francis I. The young monarch, who had recognized the Florentine's miraculous mind, offered him a large house, Château du Clos Lucé, located a stone's throw from the royal palace, and a sinecure as the "First Artist, Engineer, and Architect of the King." In Santa Croce, a commemorative plaque still has claims on the city's favorite son, *Il Fiorentino*.

Accounts of Leonardo's death vary. In one account the king and his entourage, as well as Leonardo's loyal assistant Melzi, were present when Leonardo died on May 2, 1519. Another narrative has the king a day's distance by horseback from Amboise. Leonardo received a royal burial in the Chapel of St. Hubert at the Chateau d'Amboise where a carving on the marble floor identifies the site. However, during France's Wars of Religion (1562–1598) between the Roman Catholics and the Protestants (Huguenots), the Palace of Amboise was desecrated and even the skeletal remains housed in royal graves scattered and thrown into mass pits. On that occasion, even Leonardo's crypt was violated. But during the nineteenth century, before phrenology had faded, the writer Arsène Houssaye had the pit excavated. He reportedly climbed into the pit and raised a particularly large skull in the air, announcing triumphantly, "Voila, Leonardo da Vinci! Large enough to house the greatest brain." The science writer for the UK *Telegraph* described the Houssaye's protocol "short on science and strong on myth and wish-fulfillment."[16]

14

ECCENTRICITY IN SCIENTIFIC GENIUS: *A TINCTURE OF MADNESS*

> Genius and madness have something in common: both live in a world that is different from that which exists for everyone else.
> —Arthur Schopenhauer

In the last chapter, the focus was mostly on the hardware side of the mind/brain dichotomy and how the growing fascination with geniuses' scalps paved the way for neurology. The present chapter focuses on the software side of the dichotomy—the mind—but mostly on the mind of the scientific genius.

All levels of genius call for nonlinear thinking, the métier of individuals who are profoundly different from the rest of humanity. It is the source of unease created in the rest of us dealing with them and their creations is a price they must pay. The late anthropologist-writer Loren Eiseley wrote: "It is frequently the tragedy of the great artist, as it is of the great scientist, that he frightens the ordinary man."[1]

The expression "tincture of madness" comes from the Roman philosopher, dramatist, and poet Seneca, who offered the phrase as a description of a crucial ingredient of genius. Whether showing a penchant to "break bad"[2] or to make occasional excursions across that meandering blurred line between sanity and insanity, as long as it is not full-blown insanity, highly creative individuals are cursed. Genius is frequently accompanied by qualities and behavior outside the norm, whether it is homosexuality (which in an enlightened age is not regarded as a disorder), benignly idiosyncratic behavior, or indeed some form of mental disturbance, such as severe panic or anxiety attacks, depression, bipolar disorder, narcissistic personality disorder, schizophrenia, or hallucinations. Geniuses, with their unconventional modus operandi, are rarely understood by their contemporaries and frequently subjected to suspicion, derision, and even persecution. Shakespeare pointed out the inseparability of creativity and lunacy when he had Theseus in *A Midsummer Night's Dream* speak the line "the lunatic, the lover, and the poet are of imagination all compact." Two hundred years later, Lord Byron echoed Shakespeare's message: "We of the craft are all crazy. Some are affected by gaiety, others by melancholy, but all are more or less touched."

Legendary curmudgeon Oscar Wilde (1854–1900) once wrote, "The public is tolerant. It forgives everything except genius." We can add a caveat to the foregoing: ". . . but when the public finally does recognize genius, it venerates it, it beatifies it!" This is what happened to each of the five—Leonardo, Shakespeare, Newton, Beethoven, and Einstein—and a few others, but not necessarily in their lifetimes. Some might add, "It also happened to Moses, Jesus, Muhammad, Buddha, and Confucius," the architects of major religions.

Since a measure of insanity appears to heighten artistic creativity, it is not surprising that mental disorders afflict creative artists (writers, composers, painters, sculptors, architects) a bit more frequently than creative scientists. A significant correlation exists between artistic creativity and suicide. Only a negligible number of nonfiction writers and journalists die by suicide, a fraction comparable to the rest of the population. But the number rises to

4% for fiction writers and an astonishing 20% for poets. This data comes from psychiatrist Arnold Ludwig's book *The Price of Greatness*,[3] which also points to a correlation between the lifetime rate of alcoholism in a variety of professions: natural sciences (negligible), social sciences (10%), architecture (22%), music performance (40%), and theater (60%). In the context of alcoholism, Ludwig also reports on the three broader classes of writers: nonfiction (27%), fiction (41%), and poetry (34%). The only anomaly evident is a minor inversion: fiction writers present higher rates of alcoholism than do poets, whereas they present a lower rate of suicide.

Game theory, originally developed by the incomparable twentieth-century mathematician John von Neumann, helps in tactical and strategic decision-making, whether in chess games, finance, or international relations. Von Neumann (1903–1957) was a mathematician, physicist, and pioneer computer scientist who made major contributions to the foundations of mathematics, functional analysis, ergodic theory, representation theory, operator algebras, geometry, topology, numerical analysis, quantum mechanics, hydrodynamics, quantum statistical mechanics, computer architecture, linear programming, and the mathematics of self-replicating molecular systems (life), even before the structure of DNA was deciphered by Watson and Crick. Physics Nobel laureate Hans Bethe wrote about having "wondered whether a brain like von Neumann's does not indicate a species superior to that of man." The eminent nuclear physicist, Edward Teller, once observed, "Von Neumann would carry on a conversation with my three-year-old son, and the two of them would talk as equals, and I sometimes wondered if he used the same principle when he talked to the rest of us." Von Neumann was listed in chapter 3 among the Martians taught by László Rátz in Budapest's Gymnasium 19, as were Wigner, Teller, and Szilard. He was also a close friend and colleague of Einstein at the Institute for Advanced Study. Wigner once compared him to other brilliant men he knew:

> Paul Dirac was my brother-in-law; Leo Szilard and Edward Teller have been among my closest friends, and Albert Einstein

was a good friend too. But none of them had a mind as quick and acute as John von Neumann.

Von Neumann was a child prodigy of unfathomable breadth and depth who grew up to become one of the greatest mathematical geniuses and only somewhat eccentric. Unlike most scientists, he was openly superstitious, always pulling and pushing a drawer handle seven times before actually opening the drawer,[4] and he was an unusually poor driver throughout his life.

Paul Dirac was more eccentric and an even worst driver than von Neumann. Wigner characterized his "famous brother-in-law" as a driver with only two "eigenvalues," invoking the language of quantum mechanics, "stop and full speed," like modern taxi drivers on New York's Park Avenue. As for Einstein, he never learned to drive. Kurt Gödel (1906–1978), a genius mathematical logician and admired colleague of von Neumann and Einstein at the institute, had an obsessive and perplexing fear of being poisoned. He could not allow himself to eat food prepared by anyone other than his wife, Adele. When she became ill and was hospitalized for a few weeks, Gödel literally allowed himself to starve to death.

John Nash, whose life inspired the book and film *A Beautiful Mind*, while wrestling with bouts of schizophrenia, added significantly to game theory, originally conceived by von Neumann. He broadened the range of the theory specifically in its aspects applicable to noncooperative sides, where the actions of the participants are mathematically and logically determined in securing the best outcomes for their respective sides, this, despite the fact that a particular decision might also assist a rival. Nash received the 1994 Nobel Prize in Economics for his contribution to game theory. Two of the most influential mathematical scientists in history—Ludwig Boltzmann and his student Paul Ehrenfest, both pioneers of statistical mechanics, and Alan Turing, pioneer of computer science—suffered from deep depression. Boltzmann died by suicide in 1906, as did Ehrenfest in 1933, and Turing in 1954.

What can be said about Newton, the greatest mathematician and scientist of them all? Richard Westfall, author of the definitive biography *Never*

at Rest: The Biography of Isaac Newton,[5] confessed to having become increasingly dumbfounded even after spending twenty years studying his subject:

> The more I have studied him the more Newton has receded from me . . . It has been my privilege at various times to know a number of brilliant men, men who I acknowledge without hesitation to be my intellectual superiors. I have never, however, met one against who I was unwilling to measure myself so that it seemed reasonable to say that I was half as able as the person in question, or as a third or a fourth . . . The end result of my study of Newton has served to convince me that with him there is no measure. He has become for me wholly other, one of the tiny handful of supreme geniuses who have shaped the categories of the human intellect, a man not finally reducible to the criteria by which we comprehend our fellow beings . . .

The year 1987 marked the 300th anniversary of Newton's publication of the *Principia*. At the Smithsonian's National Museum of Natural History in Washington a room had been set aside for an exhibition of Newton memorabilia: from his youth, a notebook with entries less than an eighth of an inch tall and calculations trailing off in endless spidery lines of digits; from his senior years, his spectacles and a lock of wispy white hair; and postmortem, his death mask.

A group of my university students and I gathered around a framed sheet mounted on a wall: the proof of a geometric theorem, in Newton's own hand, displayed on a wall. Suddenly a docent and a group of visitors entered the room and stopped in front of a glass case. The docent, with a glance at the items on display, offered a casual explanation: "This exhibition is to commemorate the famous English scientist Sir Isaac Newton. He may have been gay . . ." Then, as if to respond to an unasked question, she added ". . . and they say he was insane. But we're not sure!" They promptly left the room to examine something else in comparable depth. My students and I stood stunned. Newton did not fare well with this docent. One of my students repeated incredulously, "He may have been gay . . . and he was insane!"

Just a few hundred yards away, across the grassy tract of the National Mall, stands the Smithsonian's Air and Space Museum. On display inside the building are sections of NASA's Apollo rocket boosters, capsules that transported astronauts into orbit and onto the moon, and mockups of unmanned spaceships that traveled to the outer reaches of the solar system and into deep space. The physics that guided the spacecraft was the classical mechanics Newton formulated 335 years ago. In its simplest form, the same physics explains the underlying engineering principles of all architectural structures: the vector sum of the forces and separately the vector sum of the torques must vanish. Ultimately, the Air and Space Museum, from its content to its marble, steel, and glass structure, is a monument to Isaac Newton. So is most of modern science. "He was a genius of extraordinary caliber," said his biographer Westfall, ". . . and in my understanding of things genius, that order [of genius] imposes certain penalties."[6]

The docent, however, may have been correct in her glib description of Newton as a latent homosexual. He had become exceedingly fond of the young Swiss mathematician Nicolas Fatio de Duillier, his roommate between 1690 and 1693. After de Duillier moved back to the continent, Newton wrote to him, pleading with him unsuccessfully to return to Cambridge. Also in 1693, he wrote to his two friends, philosopher John Locke and diarist Samuel Pepys, claiming he had been suffering from "discomposure in head or mind or both." In his communication to Locke, he complained of his extreme displeasure regarding Locke's attempt to "embroil me with women." Later he wrote again, this time apologizing and offering an excuse for his boorish behavior: "I had not slept an hour a night for a fortnight together & for 5 nights together not a wink." On his deathbed thirty-four years later, he claimed that his greatest achievement was never having strayed from a life of celibacy! The letters of 1693 smack of a reaction to a romantic breakup.

As for the docent's second point, Newton had indeed wandered to the edge of insanity on at least three occasions. In 1661, shortly after matriculating at Cambridge, he apparently underwent some form of religious crisis.

His conscience remained troubled by recurring memories of his boyhood sins. His response to his religious crisis turned out to be cathartic, coinciding with a period of total immersion into mathematics. He devoured on his own the entire canon of mathematics developed up to that time, and quietly pushed past to entirely new vistas in the field. As the secrets of the universe fell into place one after the other, there was an entirely confusing entry. Was Newton offering God an apology?: "Forgive me for knowing more than Thee."

During the years 1675–1679, Newton was fighting depression. He had been doing groundbreaking research in mathematics and physics. But at the same time, he was becoming increasingly involved in experiments in alchemy, a now-discredited mystical pseudoscience. The only other great scientist of the time engaging in alchemy, also secretly, was Robert Boyle (1627–1695) of Boyle's law fame.

Newton harbored a pathological aversion to criticism and became incensed when he received undeserved scorn for his theory of optics. He had performed his experiments with meticulous care and his conclusions were correct. Most critical were the Dutch polymath Christiaan Huygens (1629–1695) and the Englishman Robert Hooke (1635–1703), curator for experiments for the Royal Society. Newton's theory of physical optics had gone over their heads. Then Hooke, the perennial thorn in his side, made disparaging remarks about the primacy of the reflecting telescope. Newton was again right on the primacy of the telescope and again he was infuriated. Then Hooke, as if he had had no role in offending Newton, contacted him directly. He offered him an unsolicited piece of technical advice regarding the possibility of gravitation causing centripetal (center-seeking) acceleration and asking Newton to accept him as a collaborator. Newton then stopped all communication with Hooke, and later in writing the *Principia*, refused to give Hooke any credit. In truth, Hooke's suggestion may have been a catalyst for Newton, but it was the rigorous mathematical formulation that Newton alone could supply that would make the theory of universal gravitation one of the greatest monuments of science, described by Feynman as "the greatest abstraction of the

human mind." Meanwhile, history has not been kind to Hooke, who in reality was an exceptionally original scientist, "a bird" in Dyson's model of mathematical creativity, just innocent of mathematics.

In June 1679 Newton received the news of the death of his mother. She had never been a loving or generous woman. Nonetheless, Newton took the news of his mother's death hard, staying in Woolsthorpe for the rest of the year. It is possible that he was suffering from an Oedipus complex, as some scholars have claimed, but it is unlikely that sorrow triggered a nervous breakdown.

A twenty-month period in 1692–1693 proved to be another poor period for Newton. He had lost Duillier as a roommate and returned to his secret alchemical experiments. There had been a fire in Newton's apartment destroying reams of his papers which gave rise to speculations about this being the source of his distress and another possible catalyst for his nervous breakdown.

We know that the recently deceased Robert Boyle left a considerable quantity of "red earth" that he had at his disposal to John Locke, and Locke, in turn, shared it with Newton. The rare and very expensive "red earth" was the source of "quicksilver," or mercury. On the margins of Newton's notes, one reference is to "the taste of lead" and another to "the taste of mercury." His September 13, 1693, letter to Pepys, cites "sleeping in his bedchamber [bedchamber, study, and laboratory all in one] with mercury boiling in a crucible nearby." He had performed the most intricate physics experiments revealing the nature of light and created the first reflecting telescope, but when it came to chemistry, he had risky lab habits. Those notes offer clues but are not incontrovertible proof that the culprit behind his second nervous breakdown had been the heavy metals he was ingesting.

Finally, there were physical and behavioral signs recorded personally by Newton (or reported by his friends): extreme irritability, severe insomnia, the tendency to blush easily, a change of temperament, and most conspicuously the tendency to avoid friends. In that September 13 letter to Pepys, he had concluded with the puzzling line, "I am now sensible that I must withdraw from your acquaintance and neither see you nor the rest of my friends

anymore." These behaviors are common symptoms of erethism—mercury poisoning. Much later he wrote to his friend Wickens, who had once been his roommate, joking about his hair turning prematurely white from the fumes of the boiling quicksilver.

Years of isolation and the intellectual honesty required of science in conflict with pronouncement in the Scriptures had made him a Unitarian. He rejected the Trinity, and yet he was the most famous resident of the college named after the Trinity. He was obsessed with the spiritual world, writing some 30,000 pages on the scriptures and speculating on the approach of the Apocalypse based on cryptic numerical clues. In a letter dated from 1704 and maintained in Jerusalem's Hebrew University, he claimed to have used the book of Daniel to predict the end of the world:

> This I mention not to assert when the time of the end shall be, but to put a stop to the rash conjectures of fanciful men who are frequently predicting the time of the end, and by doing so bring the sacred prophecies into discredit as often as their predictions fail.[7]

Then in an attempt to assuage contemporary worrywarts, he explained that the earliest the world could possibly come to an end was in 2060.

One of the preeminent scientists of our time, Lord Martin Rees, retired master of Trinity College, Cambridge, former Astronomer Royal of England, president of the Royal Society, and a trustee of IAS Princeton wrote about Newton and Darwin:

> Charles Darwin is my personal favorite Fellow of the Royal Society. I suppose as a physical scientist I ought to have chosen Newton. He would have won hands down in an IQ test, but if you ask, 'Who was the most attractive personality?' then Darwin is the one you'd have to meet. Newton was solitary and reclusive, even vain and vindictive in his later years when he was President of the Society.

Martin Rees, president emeritus of the Royal Society, in his office at Trinity College, with a newly painted portrait for display at the college.

NEWTON AND BEETHOVEN: PSYCHOPATHOLOGICAL TWINS

Unusual parallels exist in the personalities and traits of Newton and Beethoven. Some of the parallels in their patterns of creativity were first pointed out in an essay written in the 1920s by J. W. N. Sullivan, an English author, literary journalist, and science writer. Fifty years later, S. Chandrasekhar, an Indian American astrophysicist and recipient of the 1983 Nobel Prize in Physics, delivered a series of lectures[8] at the University of Chicago, referring to the similarities. Finally, in revisiting the subject after another fifty years, the present book presents a more expansive compilation.

Born in the month of December 128 years apart, one in 1642, the other in 1770, there were the coincidental parallels. Both lived in periods of violent change, both matured into fiercely independent, supremely confident, and driven men. Both remained angry and vindictive through their lives

and neither suffered fools well. Both saw critics "as midgets on stilts," a metaphor used by Einstein to describe academic administrators in Princeton. Newton and Beethoven both showed obsessive attention to detail, but both kept the much bigger picture in focus. Newton, of course, possessed miraculous mathematical insight; Beethoven mathematical intuition, unwittingly imbuing his musical compositions. Accidental physical traits of the two men included their identical heights 5'5" (165 cm), both being left-handed, and both dying on virtually the same date (in late March) exactly one hundred years apart.

Much of the foregoing is merely coincidental, but certain personality traits, including their vindictive anger, are stereotypical of their similar upbringings. Newton and Beethoven were both products of unloving dysfunctional homes. This is rarely a good recipe for maturation into happy adulthood. And yet, how common has this pattern been through the ages. What generally follows is a cascade of insecure feelings of inadequacy that the victims fight to overcome for the rest of their lives, often unsuccessfully.

Beethoven's father, arriving home night after night routinely intoxicated, would yank the boy out of bed and force him to practice on the keyboard. A happy day in the boy's life was when he was seventeen and the authorities in Bonn recognized him as the main breadwinner in the household and responsible for his brothers' sustenance. His income would thereafter be supplemented with part of his father's pension. One should not infer that dysfunctional families routinely produce geniuses. They generally produce individuals with volcanic temperaments who can be burdens on society. If some of the other internal and external conditions are satisfied—the proper concatenation of genes, an auspicious nature, surpassing intelligence—then the intense drive powered by a vindictive nature could well augment creativity.

The mathematical genius who shared a lifelong loathing for an abusive father with Beethoven was Paul Dirac. His father Charles, a French teacher, was no drunkard, but he was a misanthrope. He demanded that everyone in the home speak only French. While the middle sibling Dirac could join the father in the dining room, the mother and the other two siblings ate

their meals in the kitchen. The eldest sibling Felix died by suicide to escape the loveless home. Although Paul picked up the frenzied work pace that drove him throughout his life from his father, he attributed his own reclusive nature to him. In his later years, he confessed to loathing his father, stating, "I owe him nothing!"[9]

Both Newton and Beethoven routinely engaged in quarrels with others who got in their way. Newton had adopted dirty fighting tactics in his battles with Hooke, Huygens, and Leibniz. But less known are Newton's recurring battles with John Flamsteed (1646–1726), the first and longest-serving Astronomer Royal of England. Ironically, Flamsteed, since his undergraduate days at Cambridge, had been an admirer of Newton. In fact, in 1674, he had attended the new Lucasian professor's lectures. In pre-telescope astronomy, close to a century earlier, Tycho Brahe had spent four decades making observations of the night sky. In the telescope-aided era a century later, Flamsteed spent four decades meticulously recording his observations. His efforts had succeeded in tripling the size of Brahe's star atlas.

In 1681 Flamsteed proposed that the comet observations in 1680 and 1681 represented not two different comets, but rather a single comet approaching and then receding from the sun. Newton had originally disagreed with Flamsteed but had changed his mind, speculating that comets orbited the sun-like planets. But unlike the planets, their orbits were highly eccentric with their two foci far apart (whereas in a circular orbit the two foci coincide). When he published the *Principia* (1687) he used Flamsteed's data, made available to him secretly by the astronomer's onetime assistant, Edmond Halley, data that Halley shared secretly with Newton. The episode doomed the relationship with Flamsteed who resolved to keep his data under lock and key at Greenwich until it could all be independently confirmed.

Three decades later, in 1712, Newton, now president of the Royal Society, and Halley again colluded to get a hold of Flamsteed's latest data and publish it. This was done in a pirated edition of four hundred copies. Again, there was no mention of the observations having been compiled by

the Astronomer Royal. But this time Flamsteed was able to get his hands on three-quarters of the total printing and destroy them. Despite the disrespect he had suffered from Newton, Flamsteed responded with both restraint and grace, writing in a letter he wrote to an assistant, "If Sir I. N. would be sensible of it, I have done both him and Dr. Halley a great kindness."

Similarly, Beethoven quarreled with each of his contacts—his patrons, publishers, and landlords, frequently short-changing them. He tried to sell the dedication of several of his works to multiple patrons. He swore at conductors, musicians, and vocalists. He expressed disapproval of Goethe for prostrating himself in front of aristocrats and royalty. He was scornful to the grand statesman Prince Metternich, even though Metternich helped him to gain guardianship of his nephew Karl. Finally, recall how he took pleasure in insulting his own brother Johann, how abhorrent he was in his treatment of his sister-in-law Johanna, and how his treatment of his nephew drove the young man to attempt suicide.

He did not marry his "immortal beloved" Antonie Brentano. Musicologist Robert Greenberg speculates that Beethoven knew he had come from a highly dysfunctional family and was convinced that he could not make a good husband or father but would be a failure just as his father had been.

AVERSION TO AUTHORITY

To punish me for my contempt for authority,
fate made me an authority myself.
—Albert Einstein

Among all great scientists—including Galileo, Pasteur, Darwin, and Dirac—Einstein alone qualifies to compete with Newton for the title of the most influential scientist in history. His physical appearance, especially in his mature years with the famous unkempt white mane creating a halo, complements the general reputation of Einstein as a kindly, personable,

humor-loving, caring humanist, a pacifist, and an eternal champion of the downtrodden. But Einstein was human with human failings accompanying his gifts. In the following, we address some of the lesser-known facets of his life and works.

Einstein used his fame to fight bigotry, racism, and religious intolerance. In 1937 the legendary contralto Marian Anderson (1897–1965) gave a concert in Princeton, but following the performance, when she tried to check in at the Nassau Inn, she was denied a room. An outraged Einstein made the great vocalist his houseguest at 112 Mercer Street and gained a lifelong friend in the process. Meanwhile, with the talent and dignity she displayed, Anderson gained promotion from First Lady Eleanor Roosevelt and invitations to the Kennedy and Johnson White Houses.

Einstein also became a good friend of the stage and concert star Paul Robeson (1898–1976). Through Robeson, he became aware of the civil rights activities of W. E. B. Du Bois (1868–1963), who would become a little-known pen pal. When J. Edgar Hoover's FBI began to target Du Bois for his socialist leanings, even arresting and trying him for failing to register as an agent of a foreign state (he had been a signatory to the Stockholm Peace Appeal opposing nuclear weapons). The trial was terminated only when the defense attorney announced to the judge: "Dr. Albert Einstein has offered to appear as a character witness for Dr. Du Bois." Subsequently, Einstein wrote a powerful essay suggesting the parallels between ghettoization of Jews in Germany and segregation in America.[10] Einstein, as that rare individual who could honor any university by accepting its honorary doctorate, routinely turned down such invitations, but in 1946 he traveled to Pennsylvania's Lincoln University, the alma mater of Robeson, Thurgood Marshall, and Langston Hughes, and accepted an honorary degree.

Although he may have been the most famous Jew in the world, endorsing Jewish causes liberally and doing everything in his power to help save Jews in distress, he did not accept the orthodoxy of the religion. One of his most celebrated pronouncements was "I do not believe in the God of theology who rewards good and punishes evil."

In his riveting book *Einstein on the Run*,[11] Andrew Robinson chronicles Einstein's connection with the United Kingdom, "England has always produced the best physicists . . . I'm not thinking only of Newton. There would be no modern physics without Maxwell's electromagnetic equations," "It was English astronomers [Eddington's team] who first confirmed general relativity," and ". . . in England everything is judged by achievement." In 1921, returning from a visit to America, Einstein stopped over in England for the first of his four visits. He received an honorary doctorate in Oxford's Sheldonian Theater. He traveled to Manchester and visited Lord Rutherford's lab, and in London he gave a talk at Royal Albert Hall to a packed house. A decade later, in 1931, 1932, and 1933, he returned to England again.

According to Robinson, Einstein initially told an associate, "I shall become a naturalized Englishman as soon as it possible for my papers to go through." This never came to be, as Elsa joined him and together they sailed to the United States to take up permanent residence at the end of 1933. Albert would never return to Europe, not even to accompany Elsa on her visit in 1934 to see her dying daughter Ilsa.

Einstein was a prolific letter writer, corresponding with the great and the ordinary, with some of the most brilliant scientists of the golden age of physics, with royalty (the Belgian Queen Elisabeth), with children who asked for help in solving algebra problems, and with the father of psychiatry, Sigmund Freud. In a 1932 letter he asked Freud, wistfully, whether there was "a prescription against man's lust for hatred and destruction."

THREE LETTERS

In the following pages are three letters that help shed additional light on Einstein's system of values. In chronological order, these are letters to the Turkish president Kemal Atatürk (1933), US President Franklin Delano Roosevelt (1939), and Israeli Prime Minister David Ben-Gurion (1952).

Einstein's 1933 letter to Atatürk created an intersection in the lives of two of the most extraordinary figures of the twentieth century: Albert Einstein and Kemal Atatürk, Einstein's personal choice for the greatest leader of the twentieth century. As we shall see later, Einstein's choice reinforces that of psychiatrist Arnold Ludwig's 2002 ranking in *King of the Mountain*.[12]

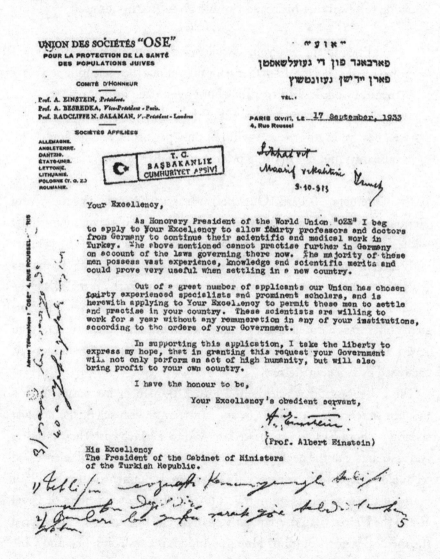

Einstein's letter to Atatürk's Turkiye, Dated September 17, 1933.

Sami M. Günzberg, a Jewish Turkish dentist from Istanbul, attending an international conference in Paris of the Union for the Protection of the Health of the Jewish Population (OSE) met Einstein, who was serving as its honorary president.

Together they hatched a plan. Einstein would write a letter to President Atatürk employing Prime Minister Ismet Inönü as the intermediary, knowing full well that his request would go to Atatürk himself:

> ... I beg to apply to your Excellency to allow forty professors and medical doctors from Germany to continue their scientific and medical work in Turkiye. The above mentioned cannot practice further in Germany on account of the laws ... in granting this request your government will not only perform an act of high humanity, but it will bring profit to your own country.

By September 30, 1933, Günzberg translated Einstein's letter from German into Turkish and, along with a cover letter of his own, submitted it to the Turkish government.[13] As Atatürk's personal dentist, he had apparently spoken earlier with the Turkish leader about the plight of Germany's Jews under Hitler. Atatürk convened a meeting with the principals—the Prime Minister, the Minister of Education, and Dr. Günzberg—and Einstein's offer was accepted. The invitation was then extended to the German Jewish scientists, and the reform of Turkish higher education was underway, catalyzed by Einstein's letter.

The collaboration would help Atatürk transform his nation into a modern state. Scores of German and Austrian Jewish scientists, not just the forty whom Einstein requested, moved to Turkiye with their families and assistants. For the next fifteen years the medical schools and science and technology departments, especially in Istanbul, flourished. By the 1950s many of these scientists immigrated to the newly created State of Israel and to the United States. Frequently championed by Einstein, they staffed the medical schools of Johns Hopkins and Harvard, Columbia, and Chicago. They came to the physics departments of Princeton and Einstein's

Institute for Advanced Study. Mustafa Öz, a physician and the father of the cardiologist and television celebrity Mehmet Oz, was trained by some of the Jewish German medical school professors who moved to Turkiye during the 1930s.

Enrico Fermi (1901–1957), the finest Italian scientist since Galileo, was rare as both an experimentalist and a theorist. By the early 1930s, Fermi was already doing experiments bombarding uranium nuclei with neutrons and in the process creating hitherto unknown heavier-than-uranium elements, the transuranic. Both Rudolf Peierls in 1932 and Leo Szilard in 1934 studied with him at the University of Rome with Rockefeller Foundation Fellowships. In 1938, when Fermi traveled to Stockholm to accept the 1938 Nobel Prize in Physics for his work with transuranic elements, his failure to wear the Italian Fascist uniform and to strike the Italian Fascist salute drew the ire of authorities in Rome.[14] Cognizant of the danger from rising antisemitism (his wife Laura was Jewish), the Fermis chose not to return to Italy. They traveled first to England and then immigrated to the United States, where Fermi took a position first at Columbia University, then at the University of Chicago.

It behooves us at this juncture to revisit the trio of scientists in Germany—Otto Hahn, Fritz Strassmann, and Lise Meitner—who had been experimenting with uranium. By mid-1938 Lise Meitner, aware of the danger posed by her Jewish heritage, left Germany before the results of their experiments were fully understood and relocated to neutral Sweden. Meanwhile, Hahn and Strassmann, continuing with the research, realized by late 1938 that along with the heavier elements in the target there were some new ones formed, half as heavy, among them iodine-131, cesium-137, and strontium-90. Hahn communicated these findings to Meitner in Sweden. Initially skeptical about the possibility of nuclei physically splitting, Meitner realized that there was also the presence of the element barium among the products, half as heavy as the original uranium and not present at the beginning, thus formed in the splitting of the uranium nucleus. Meanwhile, Meitner's nephew Otto Frisch, working at the Bohr Institute in Copenhagen, received the news from his aunt when he came to

visit her during his Christmas vacation. Upon returning to Copenhagen, Frisch promptly informed Niels Bohr, who was just preparing to leave for a conference in the United States. It was in the States that Szilard first heard of the discovery.

In July and August 1939, just three weeks apart, Szilard made two visits to Einstein to tell him about the recent discovery in Germany. The ramifications were clear: in a chain reaction, the extra neutrons could multiply, triggering the release of unimaginably large quantities of energy. The result would be a superbomb. During the first visit, Szilard convinced Einstein that he should write a letter to his personal friend, the Belgian Queen Elisabeth of Bavaria, warning her of Nazi Germany's interest in the high-quality uranium supply in the Belgian Congo.[15]

Far more important, however, was Szilard's second visit to Einstein on August 2, when they discussed a moral obligation to report the news of the German discovery to government leaders. If the Nazis were on an ineluctable course to build such a bomb, the Allies had to beat them to it. The Germans, realizing the potential of such a weapon, suddenly ended sales of uranium from the mines in Jáchymov, Czechoslovakia. Szilard convinced Einstein that he alone had the stature to be taken seriously regarding such an extravagant-sounding project and that Einstein would have to be the one who wrote the letter to President Roosevelt. For Einstein, an ardent pacifist, to have to initiate the process of building a weapon of mass destruction had to be singularly agonizing. But he saw no way out.

Within six years the super-secret mobilization resulted in the creation and testing of the first atomic bomb in Alamogordo, New Mexico, on July 16, 1945. When Einstein later heard on the radio the news of an atomic bomb having been dropped on Hiroshima, he is said to have uttered in exasperation the Yiddish phrase "Oy vey!" ("Woe is me!"). Later, he also confided in friends that he believed that if FDR had still been alive (he had died in April, four months earlier) the bomb would not have been dropped. Vice President Truman had never been in the loop and had never been apprised of the project. But he was briefed and gave the final order for the use of the bombs. Like most of the European scientists of Jewish descent, Einstein

believed that the bomb had been created to be used against Hitler. He lived to see the Russians develop their own atomic bomb in August 1949, the Americans develop the far more powerful hydrogen (thermonuclear) bomb in November 1952, and the Soviets their hydrogen bomb in August 1953. Einstein is said to have grieved to friends, "I know not with what weapons World War III will be fought, but World War IV will be fought with sticks and stones." He regarded his own role in instigating the program as "the greatest mistake of his life." The nuclear genie had been released and could never be returned to the bottle. (Note: this is his second reference to "the greatest mistake of his life," the first having been the "fateful fudge factor" he introduced into the general relativistic field equation, discussed in chapter 11.)

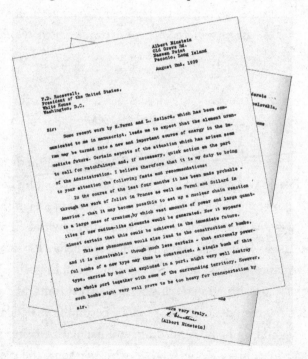

On November 17, 1952, a letter was hand-delivered to Einstein, then seventy-three years old, by Abba Eban, the Israeli ambassador to Washington. Eban's letter explained that Prime Minister David Ben-Gurion was inquiring whether "you would accept the Presidency of Israel if it were offered you by a vote of the Knesset. Acceptance would entail moving to

Israel and taking its citizenship." Ben-Gurion's invitation drew a self-deprecating response from Einstein:

> *I am deeply moved by the offer from our State of Israel (to serve as President), and at once saddened and ashamed that I cannot accept it. All my life I have dealt with objective matters, hence I lack both the natural aptitude and the experience to deal properly with people and to exercise official functions. For these reasons alone I should be unsuited to fulfill the duties of that high office, even if advancing age was not making increasing inroads on my strength. I am the more distressed over these circumstances because my relationship to the Jewish people has become my strongest human bond, ever since I became fully aware of our precarious situation among the nations of the world.*

FAILURE OF A FAMILY MAN

In a personal reflection about how he had "sold himself body and soul to science," Einstein was not sounding a boastful note about his contribution to science but owning up with sadness to his failures as a family man.

His first wife, Mileva Marić, was born to parents with Serbian roots in the eastern Austro-Hungarian Empire three years before Einstein was born in Ulm, Germany. She was the most crucial player in Einstein's life during two critical decades, bringing out his best and worst traits. She started out as a fellow foreign student in Switzerland, becoming his collaborator in physics, his sounding board, and diligent amanuensis, rising to become his passionate love, his wife, the mother of his two sons, and eventually, as Einstein saw it, descending to become his tormentor and bête noire.

The daughter of a well-to-do civil servant and landowner from Novi Sad in the Austro-Hungarian Empire, she was bright but unusually reserved. She was also a plain young woman with a noticeable limp from a congenital hip deformity. She had journeyed to Switzerland to study physics after

impressing her early teachers, who had advised her father, "She could leave a mark in physics and mathematics."

As the only woman in the entering class at the Swiss Federal Institute of Technology in Zurich (ETH), aka the Zurich Polytechnic, she captured young Einstein's eye right from the beginning. But when Einstein began to show her special attention, she found herself conflicted, falling for the handsome young man with the mischievous sense of humor, penetrating soulful eyes, and trim mustache (a signature feature that would become fuller and fuller through his life). Afraid of her own feelings, she decided to move to Heidelberg to audit classes at the city's famous university.

During their separation Einstein and Marić maintained a close correspondence and their attraction for each other increased. She wrote to Einstein regarding the lectures of Philipp Lenard on the kinetic theory of gasses that she was auditing. At a time when the existence of atoms and molecules was not yet fully confirmed, Lenard's approach to reconciling microscopic and macroscopic phenomena made him a source of inspiration for Einstein. Lenard was performing experiments with cathode ray tubes and investigating the photoelectric effect, in which certain materials irradiated by ultraviolet light become positively charged as electrons are liberated by the action of the UV-light. He clearly spoke Einstein's language in several different areas of physics. Later, when Lenard emerged as an outspoken antisemite, however, he became Einstein's implacable foe. By the time he retired from the faculty of the University of Heidelberg (1931), Lenard had won a Nobel Prize in Physics (1905), but he had allowed professional jealousy, nationalism, and antisemitism to cloud his intellectual honesty. He distrusted the "hyper-theoretical physics" practiced by Einstein, regarding it as pernicious intellectualism. Joined by another Nobel laureate, Johannes Stark, Lenard made outrageous remarks about Einstein's masterwork, calling relativity *Jüdische Physik* (Jewish physics). Most likely neither man had ever encountered a theory as counterintuitive as relativity. Meanwhile, Einstein reciprocated in kind about Lenard's intellectual deficit, writing to a friend:

> *His theories on the ether seem to me almost infantile, and some of his investigations border on the ludicrous. I am very sorry that you must waste your time with such stupidities.* [16]

At Einstein's urging, Marić left Heidelberg and moved back to the Polytechnic, and by 1898 the two became virtually inseparable. According to Isaacson, two of Einstein's professors, Heinrich Weber and Jean Pernet, recognized the young man's originality, but also his penchant for insubordination. Einstein and Weber started out on the right foot, but by his last year at the Polytechnic, Einstein had worn out Weber's impatience and would receive a tongue-lashing: "You're a very clever boy, Einstein . . . an extremely clever boy. But you will never allow yourself to be told anything."[17] Pernet was even more frustrated with Einstein's contempt for authority, and especially for his frequent absence from class. In a class in introductory experimental physics, Pernet assigned Einstein a flat 1.0, on a grading scale of 1–6. Isaacson points out that this earned the professor the dubious honor of "flunking Einstein in a physics course." Four years after matriculating at the Polytechnic, the top four of the five students in the class of 1900 were awarded their undergraduate degrees and began to hunt for jobs. Einstein's GPA was 4.9, next to the bottom of the group, and Marić's 4.0, the lowest in the group. She did not graduate but resolved to finish somewhere, sometime. She did get another chance, but alas again scored 4.0, ending her aspiration for an academic career.

Einstein and Marić were good for each other and they were bad for each other. At the least, they distracted each other. Of course, Einstein's dismal record of class attendance had not endeared him to his instructors, who behaved frugally in their praise in writing his references. While his friends were offered posts at the Polytechnic Institute, Einstein tried unsuccessfully to gain a position as an assistant lecturer at a number of universities, first in Switzerland, then in Germany, the Netherlands, and Italy. He worked initially as a tutor for high school students in Schaffhausen, Switzerland. In 1901, after he became a naturalized Swiss citizen, he landed a job as a

patent clerk third class at the patent office in Bern with the help of his fellow student and good friend Marcel Grossman.

Mileva Marić and Albert Einstein.

Despite the modest success in their academic lives, Einstein and Marić continued their courtship, and on one of Einstein's visits to see Marić in northern Italy, their assignation resulted in Marić's pregnancy. Several letters date from this period—poignant, romantic, loving, humorous, and many with references to issues in physics. Marić first moved into a room a few kilometers away from Einstein residence, but as her pregnancy became more noticeable, she moved back in with her parents where, in January 1902, she gave birth to a baby girl. Einstein again wrote to Marić, inquiring about their daughter and expressing an uncontrollable longing to see her. "Lieserl . . . is she healthy, does she cry a lot? I love her so much and don't even know her yet!" Shortly afterwards, however, all talk of the child ended abruptly, spawning speculation among Einstein historians that the child

was born with Down syndrome and was either institutionalized or given up for adoption. Other historians believe she contracted scarlet fever and died in 1903. In another letter, Einstein is eager to share "his ideas on the electrodynamics of moving bodies." Although this sounds a bit kinky, he was planting the seeds for the special theory of relativity. According to Einstein biographer Andrew Robinson, the notion that Marić was a significant contributor to the groundbreaking special theory of 1905 is not supported by the fifty-four surviving letters between the two lovers.[18] This is also the conclusion of Alice Calaprice, former senior editor at Princeton University Press, who worked with the voluminous Einstein papers and separately published the definitive collections of Einstein quotations.[19] Marić proved to be an effective listener and a careful copy editor for Einstein, going over his mathematics and his manuscripts. However, it was Besso whom Einstein would later single out for highest praise "as a sounding board for scientific ideas, the best in Europe." Accordingly, in the name of intellectual honesty, we admit Marić was not an Einstein, and an unlikely author of the theory of relativity, as some later claimed.[20] When Einstein announced that he planned to marry Marić, his friends expressed strong reservations and his parents (especially his mother) virulent opposition: "She is from a different ethnic background," "She is older than you," "She is homely . . . if you do marry her, at least don't have any children." But Einstein had made up his mind. The couple married in 1903. The following year in Bern she gave birth to the couple's first son, Hans Albert, and in 1910 to their second son, Eduard, in Munich.

By 1912 Einstein's personal life showed signs of fraying. He was becoming increasingly alienated from Marić. On trips to Berlin, he became entangled in a relationship with his cousin Elsa (Löwenthal) Einstein (1876–1936). At the time of Albert and Elsa's meeting, she had been divorced for four years. Like Marić, Elsa was also Einstein's senior by three years, and like Marić, she was the mother of two children, Ilsa and Margot, daughters from her marriage to Berlin textile trader Max Löwenthal. In a letter to Elsa, Albert characterized Marić as "an unhappy, humorless creature." In another letter, he described their relationship:

"I treat my wife as an employee whom I cannot fire. I have my own bedroom and avoid being alone with her."

In 1914, when Einstein accepted a prestigious offer of a professorship from Planck, calling for his permanent relocation to Berlin, Marić and the boys, now four and ten years old, accompanied him. But shortly thereafter Einstein asked for a divorce. She would not give it to him, choosing to stay for the good of the children and presumably hoping he would come to his senses.[21] At this point he wrote a note to Marić, spelling out his conditions under which he would stay in the marriage. He might as well have been writing the outline of a term paper:

A. You will see to it . . .
 (1) That my clothes and linen are kept in order,
 (2) That I am served three regular meals a day in my room.

B. You will renounce all personal relations with me, except when these are required to keep up social appearances, and
 (1) You will expect no affection from me . . .
 (2) You must leave my bedroom or study at once without protesting when I ask you to.

Marić found her husband's behavior intolerable, and just three months after their arrival in Berlin, she returned to Zurich with the boys. After the initial separation in 1914, she suffered a mild nervous breakdown. Although despondent, she was still not ready to grant Einstein a divorce, especially with unfettered access to the boys. Meanwhile, Einstein, living in Berlin and working at a frenetic pace to complete the general theory of relativity, would forego eating and sleep, driving himself into physical and mental exhaustion. Elsa came back into his life and slowly nursed him back to health.

His marriage to Marić finally came to an anguished end in February 1919. Through Michele Besso as an intermediary, Einstein first promised Marić that he would not move in with Elsa, nor marry her for several years after the divorce, if at all, and second, that "when" he received the

Nobel Prize, he would "cede all accompanying proceeds to her and the boys." Knowing better than anyone else the significance of the revolution he brought to physics, he was confident that he would be awarded the Nobel Prize. Of course, he was right. The Nobel Prize was awarded in physics each year after 1901, including during the war years, but not in the two years 1916 and 1921. Although Einstein received nominations—and sometimes from multiple sources each year between 1910 and 1922, it was all for naught. Finally, after the 1922 Nobel Prize had already been announced for Niels Bohr, Einstein received a telegram from Stockholm: he was being awarded the 1921 Nobel Prize in arrears for his explanation of the photoelectric effect.

Albert and Elsa Einstein sailed from Antwerp to New York in 1930, round trip. Then they took a final one-way cruise in 1933. Each of these crossings were on the SS Belgenland *belonging to the Red Star Line. Shortly before the final crossing, they visited the German consulate in Brussels, where, for the second time, Einstein renounced his citizenship. On his arrival in New York, he would begin a new life at the Institute for Advanced Study and never return to Europe. In 1895, at the age of sixteen, he had renounced his German citizenship for the first time when he moved to Switzerland to finish high school in Aarau. However, two decades later he had accepted German citizenship again in taking a job as director of the Kaiser Wilhelm Institute in Berlin in 1914.*

According to Pais, the monetary component of the prize did not come through until 1923, and Einstein transmitted the entire sum to Marić. According to another account, Einstein signed over to Marić only the interest from the proceeds after they had been invested but not the full award. He loved his sons, but always from a distance. As for his first promise—that he would not marry Elsa—unhappily he had already reneged on it and married Elsa in the summer of 1919.

Née Elsa Einstein, Albert Einstein's first cousin once removed, had changed her name when she married Max Löwenthal in 1896. But in 1908, when she obtained a divorce from Löwenthal, she, along with her two daughters, Margot and Ilsa, reverted to Einstein, and moved into an apartment in Berlin. Accordingly, when she married Albert Einstein, she did not have to change her name again. There is one last twist in this dark comedy. Shortly before he married Elsa, he wrote to Besso that he was unable to decide whether to marry Elsa or her daughter Ilsa. Wiser than Einstein, Besso advised, "Marry the mother!"

Elsa died in 1936, Marić in 1948. Taking inventory of his life, Einstein exulted, in a letter to a friend in 1952, "I am the triumphant survivor of two wars, two wives, and Hitler." He also admitted with genuine sorrow to have been less than charitable with his two sons, who were shattered by the breakup of their parents' marriage.[22] The younger son, Eduard, initially an excellent student with ambitions of studying for a career in psychiatry, showed signs of mental illness. In 1932 he was diagnosed with schizophrenia and committed to a sanatorium in Zurich. Following his initial bout with the illness, he was in and out of hospitals many times. He never married. In 1957 he was committed to an asylum permanently, eventually becoming a forgotten fixture, and finally dying in 1965. His father, who had died ten years earlier, had not seen him since 1925.

The older son, Hans Albert, initially trained as a civil engineer at his father's alma mater, the Zurich Polytechnic. Subsequently, he received a doctorate and became a specialist in sediment transport and hydraulic engineering. He lived in Switzerland (1904–1926), Germany (1926–1938), and in the United States (1943–1973). It was at the urging of his father, who

had foreseen the destruction that the rising Nazi tide would bring, that he left Europe and immigrated to the United States. First he took a job in South Carolina, where he worked for the US Department of Agriculture as a specialist in sediment work. Then he moved to California to work at Caltech as a researcher for the US Army Corps of Engineers. Finally, he settled into a teaching position at UC Berkeley in 1947. When Hans Albert first married his wife Frieda Knecht in 1927, he heard from his famous father, "You can do better," relaying the twenty-five-year-old echoes from his own parents:

> Einstein opposed Hans's bride in such a brutal way that it surpassed the scene that Einstein's own mother had made about Mileva. It was 1927, and Hans, at age 23, fell in love with an older and (to Einstein) an unattractive woman. He damned the union, swearing that Hans's bride was a scheming woman preying on his son. When all else failed, Einstein begged Hans to not have children, as it would only make the inevitable divorce harder.[23]

Hans Albert's oldest child, Bernhard Caesar Einstein (1930–2008), trained as a physicist. When Einstein died, Bernard, an amateur musician, was the recipient of his grandfather's beloved violin. But what a stigma Hans Albert Einstein, and subsequently Bernhard Caesar Einstein, must have lived with, everyone they met wondering secretly, "Do they have Einstein's genius?" They did not.

THE EINSTEIN–MONROE AFFAIR

This second marriage appears to have devolved into one of convenience, with Einstein feeling free to pursue romantic interests with a several young women, and he was surprisingly candid with Elsa about his extramarital machinations. If celebrity status and political power possess aphrodisiac properties, so does perceived genius. There were at least a dozen women

in his life.[24] While he was married to Elsa there was Betty Newman, his secretary; Margarete Epstein, wife of his sculptor (she turned out to be a Russian spy);[25] Estella; Toni; Ethel. He shared holidays, read books, and attended concerts with them.

By far his most scandalous liaison *would* have been with the goddess of the silver screen, Marilyn Monroe (1926–1962). It was Hollywood actress Shelley Winters who first suggested an affair had taken place.[26] In 1947 Ms. Winters and Marilyn Monroe were roommates and close friends. (At the time the two actresses-in-training were studying with Lee Strasberg at the New School in New York City.) According to Ms. Winters, "just for fun . . ." they each made ". . . a list of ten men they would like to sleep with." Ms. Monroe's list had a pronounced intellectual flavor and reflected an attraction for men over fifty. Winters wrote, "I never got to ask her [Marilyn] before she died how much of her list she had achieved. But on her list was Albert Einstein." (Monroe would have been around twenty-one or twenty-two and Einstein in his late sixties.) "After Monroe's death," Winters wrote, ". . . I noticed that there was an inscribed photograph in a silver-frame of Einstein on her white piano." Urban legend perhaps, but the more bizarre such legends are, the more traction they seem to gain. Indeed, it turns out to be a myth, cleared up by Monroe's friend, actor Eli Wallach. It seems Wallach had given her the photo of Einstein, and as a private joke, inscribed it personally, "To Marilyn, with respect and love and thanks, Albert Einstein."[27] Although it appears that Einstein did not have a tryst with Monroe, his reputation as a veritable Casanova remains only slightly reduced. (See figure 16B, color photo insert page XVI.)

THE PARALLEL LIVES OF EINSTEIN AND PICASSO

Earlier we examined the remarkable similarities and differences in the defining traits of Newton and Beethoven. Clearly, they were not products of the same culture nor the same zeitgeist, but they represented soaring spikes in creativity in their own times. In shared temperaments and vindictive

anger, neither suffered fools well. They were both recalcitrant, reclusive, and never forgot slights. On multiple occasions each man strayed across the boundary between sanity and insanity. The two men could have been identical twins in their psychopathology.

Pablo Picasso, the most influential artist of the twentieth century, and Einstein, its most influential scientist, were contemporaries and products of the rebellious spirit and bohemian zeitgeist sweeping Europe at the turn of the twentieth century. Neither Einstein nor Picasso suffered from mental illness, but they both displayed a penchant for breaking bad and an unremitting resistance to authority. If Newton and Beethoven were twins in psychopathology born 128 years apart, then Einstein and Picasso were at least cousins in psychopathology born just two years apart. However, they never met. Einstein's interest in the arts revolved around classical music and not painting or sculpture. There is no reference to the sciences in the biographies of Picasso.

During the same years that Einstein enjoyed his peak in creativity; i.e., the first two decades of the twentieth century, he and Picasso were preoccupied with space and time in the manner in which these dimensions pertained to their respective fields, Einstein with relativity in physics, and Picasso with cubism in painting. In cubism a subject is moved around, captured from several different angles, and melded into one composition. In comparing Newton and Beethoven, we had pointed out the mathematical intuition the two men displayed. With Picasso and Einstein, it is an artistic intuition that is a common denominator. Certainly, this is necessary for the artist. But Einstein's unusual modus operandi embraced *gedankenexperiments* ("thought experiments"). Einstein was very much an artist doing science, in the manner of Leonardo, and in Dyson's model of mathematical creativity, he was a bird looking down and making connections over wide terrain.

Creative artists, whether in painting, writing, or composing, frequently display early, middle, and late periods, and produce works throughout their lives. Picasso had many more than three periods. His well-defined periods include his work before 1900, his Blue Period (1901–1904), Rose Period (1904–1906), African art and primitivism (1907–1909), analytic

cubism (1909–1912), synthetic cubism (1912–1919), neoclassicism and surrealism (1919–1929), Great Depression to the Museum of Modern Art (MoMA) Exhibition (1930–1939), World War II and later works (1939–1949), and final years (1949–1973). His talent for self-promotion could well have matched his talent for artistic expression. This is a trait that Einstein could never have matched. He was not interested in self-promotion. Picasso, for his abysmal treatment of the women in his life—including two who were driven to suicide—easily qualifies as a poster boy for "breaking bad," and on a decidedly larger poster than Einstein.

The series of portraits of Dora Maar spanning the couple's nine-year relationship saw her evolve from his muse to a creature with talon-like nails. During his time with Dora Maar, Picasso had continued to see his dependable, longtime mistress Marie-Therese Walter who, just four years after the artist's death in 1973, died by suicide, having frequently confided in friends "[how] she could not live in a world without Picasso." However, Dora Maar, a talented painter and surrealist photographer herself, influenced Picasso more than the score of other women who had orbited him throughout his life. For example, she was the driving force in having him join the Communist Party.

Arthur I. Miller, a professor of history and philosophy of science at University College London, wrote a first-class analysis of the similarities and dissimilarities between Einstein and Picasso.[28] In his book Miller reproduced an explanation by Dora Maar, the most perceptive of Picasso's women:

> There were five factors that determined his way of life and likewise his style: the woman with whom he was in love; the poet, or poets, who served as catalysts; the place where he lived; the circle of friends who provided the admiration and the understanding of which he never had enough; and the dog who was his inseparable companion.

An end-of-the-year issue of *Life* magazine in 1968 featured the artist in his studio in southern France. He was captured in photos, bare-chested,

frequently wearing only underwear. Even more than Einstein, he was constitutionally incapable of conforming. David Douglas Duncan, Picasso's close friend, longtime guest, and personal photographer during six years in the 1950s, had a Dachshund named "Lump" who became a happy companion for Picasso. Certainly Lump was better treated than many of Picasso's human companions and was even included in some of his paintings. Although the Einstein family living in Princeton in the 1940s did have a dog named Chico, as well as a cat and at various times a parrot, there is no evidence that there was a dog during his days with Marić when he was at the peak of his mental invention in Bern. Regarding the other four factors spelled out by Dora Maar, they could have described Einstein's world.

THE ECCENTRICITY OF GENIUS

Helen Dukas (1896–1982), Einstein's secretary of twenty-seven years, was an endless source of Einstein lore. She lived with the Einstein family as the house manager in the simple wooden frame house at 112 Mercer Street, Princeton, and spent another twenty-seven years in the house until her own death in 1982.[29] Upstairs in Fuld Hall, where her office was relocated after Einstein's death, Ms. Dukas became the keeper of his voluminous collection of papers.[30] She frequently recounted stories of her famous boss to friends, and she confirmed or denied other stories she heard about him. On a personal note, I got to know her well beginning in 1974. She spoke about his wisdom, his independence of spirit, his legendary aversion to authority, his love of a good joke, and his amusing eccentricities. For example, he had used an un-cashed check for a thousand dollars as a bookmark until it deteriorated into illegible scrap.

Ms. Dukas told me about how he never used shaving cream when he shaved. He would come down the stairs each morning for breakfast with pieces of tissue stuck to his face to stop the bleeding from razor nicks. Whenever one of his assistants asked him why he didn't use shaving cream, he would dismiss the idea, "Oh, you don't need that stuff!" One day the

assistant gave him a tube of brushless shaving cream. He started coming down the stairs in the morning with his face aglow, devoid of tissue. "Why haven't I discovered this before?" he asked in wonderment. After the tube was used up, he went back to sticking pieces of tissue on his face. She recounted the story about one or two of his assistants accompanying him daily on his one mile walk home for lunch. They would always get sidetracked in front of the house. Then they would turn around and begin to walk back toward the Institute. Miss Dukas would run after them each time, calling out, "You haven't had lunch yet!" They would turn around and come into the house to rectify the omission before returning to the office.

LEFT: *Helen Dukas, Albert Einstein, and Margot Einstein, taking the oath of allegiance to the United States (1940).* RIGHT: *Dukas in a 1975 photo at the author's home at the time, 74 Einstein Drive, Princeton.*

Despite his poor behavior with women, Einstein was hardly insane, but he stood in close proximity to insanity. His son Eduard was in and out of asylums throughout his life, until he entered one last time. Recall from chapter 1 that close proximity to insanity is also a feature of genius.[31]

Physics lore includes a little-known teatime meeting at the Institute for Advanced Study during the academic year 1947–1948. Einstein is seated in the common room of Fuld Hall discussing a vexing problem in physics

with his younger colleague Paul Dirac, on sabbatical leave from Cambridge. Einstein stops mid-sentence, distracted by an odd phenomenon he has observed in the cup he is stirring, and remarks, "I wonder why the tea leaves have congregated in the funnel. Should they not be nearer the edge?" (Tea leaves sink to the bottom since they are heavier than water. And in stirring in circular motion, one would expect the leaves to be "centrifuged" and move outward.) Einstein continues, "I wonder if anyone has worked it out . . . Someone should work it out." Dirac glances at Einstein's cup and nods, agreeing with Einstein. It is not worth acknowledging Einstein's remark verbally with even a single *dirac* (one word a year)!

The next day the scene is repeated with Einstein and Dirac having a cup of tea and discussing a troublesome issue in serious physics, when Einstein interrupts the tête-à-tête, remarking, "By the way, Dirac, I worked out the problem of the tea leaves." This time, Dirac answered using three full units of *dirac*, "So did I!" But without any further discussion of the tea leaves, they returned to the serious physics on hand. The intuition of Einstein and the mathematics of Dirac would have conjured up the correct explanation in a flash. I imagine both men felt it was too trivial to discuss.

On a personal note, it was during the summer of 1982 when I was back in Oxford for a summer stint in the Department of Theoretical Physics that I first read the story of the tea leaves on the same day I had coffee with Professor Peierls, then the retired head of the department. He had known Einstein and Dirac well. I told him the story and asked, "Have you ever heard about the incident with the tea leaves?" Professor Peierls listened intently before responding, "No, but that doesn't make them right!" In that moment, Peierls had captured precisely the proper spirit of science. Physical theories and laws stand or fall, not by the weight of the authority cited, but by the reasoning underlying the explanation or by the results of experiments.

This is the same Dirac who had fascinated and mystified Einstein, inspiring him to describe his younger friend, "This balancing on the dizzying path between genius and madness is awful."

15

SWIRLS AND TORTURED MINDS

God whispers to us in our pleasures, speaks in our consciences, but shouts in our pains. It is his megaphone to rouse a deaf world.
—C. S. Lewis

C. S. Lewis (1898–1963), prolific author, influential lay theologian, and honored with burial in Poets' Corner at Westminster Abbey, routinely invoked the divine in explaining the heightened measure of the senses in describing the processes of a tortured mind. His words encapsulate Artemisia Gentileschi's unchained rage in painting her masterpiece *Judith Slaying Holofernes*, Vincent van Gogh's chained aloneness sitting in an asylum and painting *The Starry Night*, and Edvard Munch's unchanging plea for help in painting four different versions of *The Scream*.

AUTISM AND THE ILLUSTRATOR

The modern artist/illustrator Stephen Wiltshire visited a studio in Brooklyn's Pratt Institute where he set up shop and spent a week drawing an

18 ft (5.5 m) three-dimensional panoramic depiction of all five boroughs of New York City. All the buildings, streets, docks, windows, and doors, thousands of details in all, were drawn with near-perfect scale, the entire panorama based on his memory of a twenty-minute helicopter ride over the city. It was as if he had taken thousands of mental snapshots that he later assembled into a collage. The London-born artist had drawn panoramas of other metropolitan areas, including Tokyo, Rome, Frankfurt, Madrid, Dubai, Jerusalem, Hong Kong, and, of course, his hometown of London, after similar helicopter rides. Wiltshire cannot fail to dazzle anyone with his photographic memory. Just prior to his teen years the artist had been diagnosed with autism. He compensated for his inability to speak by sketching architectural structures. Wiltshire possesses an eidetic faculty—perfect visual memory. Like Wiltshire, the character Dustin Hoffman played in the 1988 film *Rain Man* possessed eidetic vision. In one scene in a diner, his half-brother, played by Tom Cruise, spills the contents of a box of matches. The instant the last match hits the floor, Hoffman announces the total count, 246, as if he had taken mental snapshots of the matches in midair.

SEXUAL ORIENTATION AND CREATIVITY

The connection between biology and sexual orientation comprises an active field of research in neuroscience. A unique genetic determinant for sexual orientation has not been demonstrated conclusively. There have been studies suggesting different, even contradictory, positions, with social scientists hypothesizing that there may be a combination of factors—genetic, hormonal, and social—which determine sexual orientation. Since 1989, when psychiatrist Richard C. Friedman published his landmark book, *Male Homosexuality: A Contemporary Psychoanalytic Perspective*,[1] sexual orientation has been seen largely as rooted in biology. Friedman effectively debunked the Freudian notion that homosexuality was a choice that could be "cured."

Psychiatrist Rothenberg, author of *Creativity and Madness*,[2] connects creativity and homosexuality, citing the story of Tiresias, the Greek

mythological soothsayer. The wandering blind seer is either a hermaphrodite, possessing simultaneously both male and female genitalia, or a transgender person who has undergone surgery, experiencing life first as a man, then as a woman, then again as a man. He is called on by Zeus and his wife Hera to help resolve an argument. "Is it a man or a woman who derives greater pleasure from the sex act?"[3] Zeus maintains that it is the woman, while Hera's assertion is that it is the man. Tiresias's answer is straightforward. Siding with Zeus, he explains:

> If the parts of love's pleasure be counted as ten,
> Thrice three go to women, one only to men.

Hera, in rage, has the soothsayer blinded, and Zeus, rather than restore his vision, bestows on him the power of inner sight, anointing him as the most insightful and wise mortal of all. When Oedipus, after the Trojan Wars, encounters Tiresias and demands to know what fate has in store for him, it is the soothsayer's responsibility to divulge the shocking fate awaiting Oedipus, "to kill the King [who happens to be his father] and marry the King's widow [who happens to be his mother]." For the ancient Greeks, oracular prescience was regarded as a trait bestowed by the gods, just as it was with insanity and with genius.

A third and most compelling source connecting sexual orientation and creativity is psychiatrist Arnold Ludwig, author of *The Price of Greatness: Resolving Creativity and Madness Controversy.*[4] A close personal friend, Ludwig spent several decades as an academic and, on the side, a physician tending to prison and psychiatric institutions.

This was a time when homosexuality was widely accepted. Among ancient writers, Aeschylus and Sappho are known to have been gay. There was the Sacred Band of Thebes, the elite unit of the Theban army, which made Thebes for a short time the dominant power in Greece, defeating the Spartan army, but completely annihilated by the Macedonians led by Philip II and his eighteen-year-old son Alexander in the battle of Chaeronea. The Band of Thebes consisted of 150 pairs of lovers.

Alexander the Great, his name synonymous with "military genius," was known to be bisexual. According to his tutor, the philosopher Aristotle, Alexander and his boyhood friend Hephaestion formed "one soul abiding in two bodies." In antiquity, statesman-philosopher Cato described the bisexual Julius Caesar "as every woman's husband and every man's wife!"

Many of the titans of the Italian Renaissance—including Botticelli, Leonardo, and Michelangelo—were gay. A more expansive list of highly creative and talented homosexuals or bisexuals would include Christopher Marlowe, William Shakespeare, Peter Ilyich Tchaikovsky, Marcel Proust, Oscar Wilde, Walt Whitman, Vaslav Nijinsky, Tennessee Williams, Truman Capote, Edward Albee, Gertrude Stein, W. H. Auden, Andy Warhol, and Allen Ginsberg.

In societies where homosexuality is viewed as immoral or illegal, there have been suicides by some of the most gifted ornaments in the arts. One of the most beloved composers of the classical repertoire, Peter Ilyich Tchaikovsky died shortly thereafter under speculation of suicide. Leonardo in his twenties, after being denounced anonymously for his involvement in a homosexual scandal in Florence, was despondent. Happily, he did not resort to anything catastrophic but looked for employment elsewhere. He left Florence in 1482 and took a job in the Sforza court in the city of Milan.

Although homosexuality, as a trait of highly creative individuals, is more likely to be found among artists than among the scientists they outnumber, there are most certainly homosexuals among scientists. Echoing the tragedy of Tchaikovsky is the suicide of mathematician Alan Turing. Born in London in 1912, Turing was one of the most original mathematicians of the twentieth century. In a seminal 1936 paper, he proved that there cannot exist any universal algorithmic method of determining truth in mathematics and that mathematics will always contain "undecidable propositions." In a 1950 paper, he introduced the Turing test as the underlying definitional principle for artificial intelligence (AI): a computer that can simulate human responses under specific conditions. During the Second World War Turing worked at the Government Code and Cypher School, a super-secret UK government installation at Bletchley Park, and

was responsible for building the machine that succeeded in deciphering the German Enigma Code.

The mathematician was charged with gross indecency after having sexual relations with a nineteen-year-old man, a burglar who had broken into his house. Given a choice between chemical castration and imprisonment, he chose the former and received a series of injections for hormonal treatment for libido reduction. The procedure rendered him impotent, and the conviction led to the loss of his security clearance. The man who made such dramatic contributions to the defeat of Hitler's military was denied further work in cryptography. Despondent, he laced an apple with cyanide and took a bite, ending his life at the age of forty-two.

CARAVAGGIO: THE HOLY TERROR OF ART

Born just seven years after the death of his immortal namesake, Michelangelo Merisi da Caravaggio (1571–1610) lived only thirty-eight years, and with his working name of Caravaggio, he gained a reputation as one of the most original and influential painters in the history of Western art. If Pablo Picasso could be characterized as the "enfant terrible of Western art," Caravaggio would have to be characterized as its "holy terror." On the continuous spectrum of mental stability, spanning "breaking bad" at the mild end to "full-blown lunacy" on the other, Caravaggio would be found somewhere nearer the lunatic fringe, but with breathtaking talent. Born in Milan in the autumn of 1571, Caravaggio was a contemporary of Galileo, Kepler, and Shakespeare. He was orphaned as a boy but was able to teach himself the basics of the three Rs just as an older compatriot Tartaglia had done. At thirteen he was apprenticed to the Milanese painter Simone Peterzano, remembered now only as the master of Caravaggio. In Milan, he would have studied Leonardo's fresco *The Last Supper* and met other Milanese artists. By the age of twenty he relocated to Rome. The Papal State offered more lucrative opportunities for artists than did Milan. A born revolutionary, he was not particularly interested in practicing the

age-old technique of initially creating drawings and then stenciling them onto canvases before applying paint. Probing through the layers of Caravaggio's paintings with modern imaging technology—multispectral probes including infrared reflectography and x-rays—one sees no underdrawings, no *spolvero*. Caravaggio may have envisioned the completed work in advance just as Michelangelo claimed he visualized his final statue in a block of marble. He embraced and honored Michelangelo, adopting the best of his tricks. In his painting *The Entombment*, in which the dead Christ is being lowered into his grave, Caravaggio depicts Christ's limp right hand in a pose almost identical to the way Michelangelo depicted Christ's right hand in his Piéta. Caravaggio's rendering of Christ's right hand as he points in *The Calling of St. Matthew* is modeled after God's hand in Michelangelo's fresco *The Creation of Adam*. Caravaggio, however, was not interested in producing works in the rising new genre of Mannerism introduced by Michelangelo.

Caravaggio's paintings typically depict biblical scenes of shocking drama in radical naturalism—violence, torture, eroticism, or death—in a manner one might see in a modern *Criminal Minds* episode on television. It is a style in reaction to the softened and sanitized depictions seen in mannerism and in the High Renaissance. His subjects, instead of being idealized, are depicted with warts, tears, and other defects. Frequently a single shaft of light illuminates faces and highlights other fleshy focal points to accentuate the drama. He captured observed realism, not imagined allegory. Like Leonardo, he chose common people in the marketplace as his models, but unlike Leonardo, he did not leave preliminary studies. He employed innovative optical devices such as exaggerated light and dark areas, or heightened chiaroscuro, *tenebrism*. A few of his works, such as *Omnia Vincit Amor* (*Love conquers all*) and *St. John the Baptist*, both employing his young assistant Cecco as the model, can only be described as homoerotic. He left his contemporaries in awe of his skills. But when he was not generating admiration or envy, he was fomenting condemnation for the gore in the paintings and for his lawless behavior. The titles of his paintings alone might have modern psychiatrists reaching for their *Diagnostic and Statistical Manuals* (DSM) to evaluate Caravaggio: *Narcissus* (c. 1595);

Abraham and the Sacrifice of his son Isaac (1598); *David and Goliath*, where David has decapitated Goliath (c. 1607); *David with the Head of Goliath* (c. 1607), where David is holding up Goliath's massive head in his left hand, bearing an uncanny resemblance to the artist himself; *Judith Beheading Holofernes* (c. 1607); and revisiting an earlier theme, *Sacrifice of Isaac* (1603).

There might be one other source of influence in Caravaggio's work. He regularly made incursions into the circle of a number of scientists, among them Galileo, who was only seven years older. An exceptionally talented draftsman, Galileo personally created the frontispiece of his book *Dialogue Concerning the Two Chief World Systems* and found himself in hot water for portraying *Simplicio* (Simpleton) with an unmistakable resemblance to the pope, and depicting himself as the *Interlocutor*. Caravaggio first met Galileo at the home of the Del Monte family. In his painting *Ecce Homo* (c. 1601), Galileo is thought to be the model for Pontius Pilate.[5]

Caravaggio's tenebrism was embraced by Flemish painter Peter Paul Rubens, Italian Lorenzo Bernini, and the Dutch masters Rembrandt van Rijn and Johannes Vermeer. His style also influenced the Romantic painters Spaniard Francisco Goya and Frenchman Theodore Gericault, French impressionist Édouard Manet, and American impressionist Thomas Eakins. In the twentieth century, Graham Sutherland's *Portrait of Churchill* and Jamie Wyeth's *Portrait of John F. Kennedy* also show the influence of Caravaggio. His lighting technique is even present on the silver screen, including in all three episodes of *The Godfather*, directed by Francis Ford Coppola. These artists are all unwitting disciples of Caravaggio, all *tenebrosi*.

In nineteenth-century England, John Ruskin (1819–1900), Oxford-educated essayist, watercolorist, art critic, art patron, and philanthropist, steeped in Victorian sensibilities, expressed disdain for Caravaggio's work and was a vocal detractor, even castigating Caravaggio for his dark, gritty realism "filled with horror and ugliness and filthiness of sin."

Caravaggio's troubled life imitated his troubled art. According to contemporary accounts, he worked on a painting at a feverish pace for a fortnight, afterward going off for a month or two in search of drunken debauchery and mayhem. He rarely went out without a sword at his side,

in the manner of the trouble-seeking gunslingers of American West in the nineteenth century. His behavior is reminiscent of cowboys at the end of a cattle drive, feeling compelled to engage in booze, poker, and brawls. Caravaggio drank heavily, quarreled, and, with his ambiguous sexuality, consorted with prostitutes male and female. He murdered a man in 1606, a prostitute's pimp named Ranuccio Tomassino, and to avoid arrest and hanging, he escaped south to Naples. From there he sailed to Malta, home of the Knights of St. John. He took up residence in the capital city of Valetta, as a guest of the Knights.

A tour of the Maltese capital will invariably bring out a guide boasting that Caravaggio had lived there during 1607–1608 and created his masterpiece, *The Beheading of Saint John the Baptist*, a candidate for the title "*The painting of the seventeenth century.*" In Valetta, he also created portraits of a number of Knights of Malta. But he was again arrested following a brawl. He had battered down the door of an aristocratic knight and seriously injured the man. While under arrest, he again escaped, this time to Sicily. (See figure 11A, color photo insert page XI.)

Exhibiting increased instability, he confessed to Sicilian associates that he believed he was in danger and needed to return to the Italian mainland. He was on his way to Rome via Naples, hoping to gain a papal absolution, when he mysteriously disappeared. Although suspected of being a vendetta assassination, Caravaggio's disappearance remains a cold case.

> "More savage than Caravaggio: the woman who took revenge in oil"
> Artemisia Gentileschi turned the horrors of her own
> life—repression, injustice, rape—into brutal Biblical paintings
> that were also a war cry for oppressed women. Why
> has her extraordinary genius been overlooked?[6]
> —Jonathan Jones

This question was asked rhetorically in announcing a special exhibition, *Beyond Caravaggio*, before it was scheduled for opening at the National

Gallery of Art, London, in 2016. Caravaggio's signature style had a profound influence on the new Italian Baroque style that emerged from Mannerism, most immediately in the works of an ardent disciple, Artemisia Gentileschi (1593–1656), who produced surpassing works for commissions in Rome, Florence, Venice, and Naples. After receiving a commission from the Grand Duke Cosimo II de' Medici in Florence, she gently chided him with rare self-confidence for a female painter making inroads into a traditional male occupation, "My illustrious lordship, I will show you what a woman can do!"[7]

The most dramatic painting among her works is *Judith Slaying Holofernes*, which resonates with more power and violence than even Caravaggio's painting, *Judith Beheading Holofernes*, completed fifteen years earlier.

Gentileschi's father Orazio, a talented painter himself, had trained his four children—the eldest a daughter along with three sons—in the skills of a painter. Demonstrating far more talent than her siblings, Artemisia was singled out for the bulk of the family's attention for further training. Orazio's close friend Michelangelo Caravaggio would drop by the Gentileschi home frequently and the exposure to a painter of his stature must have been an inspiration for the precocious child.

When she was just twelve, her mother died; a year later, her idol Caravaggio engaged in his murderous rampage leading to his flight from Rome, never to make it back. Four years later the family engaged a local painter, Agostino Tassi, as an instructor for Gentileschi. Tassi's employment, however, brought tragic consequences. Tassi forcibly raped her and refused to marry her to save her honor.[8] She had him arrested and tried, describing the crime in court with graphic and horrifying detail. Court records of the trial lasting seven months have survived. Pope Innocent X, citing Tassi's artistic record, sided with the accused painter, announcing, "[He] is the only one of the artists who has never disappointed me."

The court found the perpetrator innocent and Gentileschi guilty of making a false accusation. The pope's agents condemned her to physical torture: the application of thumbscrews, albeit with a wink, for lighter severity, "after all, she is only 18." This had to be tacit acceptance of Tassi's guilt and her victimization. Indeed, she had been victimized twice: first by

her rapist, then by the court. The arts columnist for the *Guardian* described the drama in the painting:

> With words and images, she fought back against the male violence that dominated her world . . . The dying man is Holofernes, an enemy of the Israelites in the Old Testament, and the young woman beheading him is Judith, his divinely appointed assassin. Yet at the same time he is also . . . Agostino Tassi, while the woman with the sword is Artemisia Gentileschi, who painted . . . effectively, a self-portrait.[9]

Gentileschi was a spectacularly talented painter and resilient feminist. Letizia Treves, curator of a new exhibition at the Uffizi, sees in Gentileschi works the message "a spirit of sisterhood, of women in it together." It was with the quality of her paintings that Gentileschi left her mark as an artist of the highest order, while her rapist would be condemned to the permanent realm of footnotes of history. (See figures 10B and 11B, color photo insert pages X and XI.)

SEEING THE WORLD THROUGH A YELLOW FILTER

> *And my aim in my life is to make pictures and drawings,*
> *as many and as well as I can; then, at the end of my life, I*
> *hope to pass away, looking back with love and tender regret,*
> *and thinking, 'Oh, the pictures I might have made!'*[10]
> —Vincent van Gogh

Vincent van Gogh (1853–1890) was born in southern Holland in 1853, attended school until he was thirteen, and then squandered his time at one unsuccessful venture after another until 1880. He had been a theological student, a French tutor, and a salesman for works of art in his brother's gallery. While serving as an evangelist to coal miners in Wasmes, Belgium,

he took up painting. His first efforts were images of peasants on the farm digging potatoes and peasants eating potatoes. *The Potato Eaters*, created in 1885 in Nuenen, is his best-known work from this early period. The works from this time are all characterized by dark colors and intensely somber moods, reflecting the miserable impoverished lives of the miners and farmers.

Modern psychiatrists have identified as many as four separate mental illnesses in van Gogh. He displayed manifestations of epilepsy, manic depression, psychoses, and rejection. They report that he had also suffered from hypergraphia. The latter is a behavioral condition characterized by an obsession to write or draw. They connect this illness to a symptom associated with temporal lobe changes in epilepsy, Geschwind syndrome. Compounding his mental illness were the medical issues of gastric syphilis. Mental illness abounded in his immediate family. Three of Vincent's five siblings—his brothers Cornelis and Theodorus (Theo) and his sister Wilhelmina—also exhibited mental illness. It would have been unusual for someone sharing this gene pool to be entirely stable.

In 1886 van Gogh moved to Paris to live with his most loyal and supportive sibling, Theo. There he could not avoid becoming steeped in Impressionism, the extraordinary art movement sweeping the city. He felt the influence of Japanese printmakers and began to formulate a personal technique, post-impressionism, exuding the idea of emotional spontaneity in the depiction of the subject. More than with most other artists, van Gogh is personally inseparable from his art. A treasure trove of correspondence has survived between Vincent and Theo that offers clues to van Gogh's evolving art and a connection to his medical diagnoses. Having started to paint seriously fairly late for an artist, he worked with obsessive fervor, and produced over 900 canvases and 1,300 graphic works on paper.

Craving the bright sunlight and colors of the French region of Provence, in 1888 he relocated to Arles, one stop short of Marseille on the Paris-to-Marseille rail line. There he opened his "Studio of the South" and spent the next 444 days painting at a prodigious pace, producing around 200 paintings. He depicted fields, orchards, peach trees, seascapes, houses, details of his room, furniture, and everyday objects. But the bright happy

colors he employed belie his intense loneliness. He tried to get a few of his Parisian artist friends to join him in Arles, succeeding in convincing only his fellow postimpressionist Paul Gauguin (1848–1903).

After Gauguin concluded a brief visit, van Gogh received an announcement from Theo, who had long provided him with unfailing financial and emotional support, that he was about to marry a young Dutch woman. The two events left van Gogh deeply despondent and in a hopeless slide. In despair, he picked up a straight razor and cut off his left ear. Wrapping it up in paper, he walked over to a brothel where he gave it to a horrified young woman, only recently identified as Gabbi Ratchel. The artist then created a pair of self-portraits: one showing his bandaged mutilated side, seen earlier in chapter 1, and the other his healthy side. Subsequently, sensing the desperate state he was in, he committed himself into an asylum in Saint-Rémy. But a short time later, he checked himself out. Within a year, his moods oscillating with increasing frequency between optimism and hopelessness, he died by suicide by shooting himself in one of the beloved fields he had painted earlier. (See figure 12C, color photo insert page XII.)

As a sidenote, it behooves me to mention Jeanne Calment (1875–1997), a resident of Arles, confirmed as the longest-living individual known in history. Calment's father owned a drapery store in town. In an interview she gave in the early 1990s, she described the store "where the [van Gogh] would buy canvas for his paintings. He was more interested in drinking than painting . . . Most of the girls were afraid of him, but the prostitutes liked him because he paid them well." The author of the blog, Martin Bailey, commented about how he cherished listening to her stories comprising a direct link between the artist and our day.[11]

Van Gogh's earliest works, painted just ten years earlier, had been mediocre at best. But in evolving, the quality improved, paralleling the progress of his illness. His best works coincided with his descent into madness during the last three years of his life. And his tragic suicide was a final expression of full-blown madness.

At Saint-Rémy van Gogh came under the care of Paul-Ferdinand Gachet, whom he would come to admire and to depict in a pair of portraits.

The physician is believed to have treated him with massive doses of digitalis—often prescribed as a treatment for epilepsy, the symptoms of which van Gogh was beginning to present. In one of the two portraits of Gachet, the physician is holding purple foxglove, *digitalis purporea*, the plant from which the drug digitalis is derived. Digitalis poisoning manifests itself in "yellow vision," as California physician and art lover, Paul Wolf, explains.[12] Wolf cites a line by van Gogh, "How beautiful yellow is." This is the period of van Gogh's famous series of sunflowers.

In 1889 van Gogh painted one of his most famous paintings, *The Starry Night*, featuring yellow coronas surrounding the stars, symptomatic of overmedicating with digitalis. Then shortly before his suicide in 1890, he painted one of his more celebrated works, *Wheat Fields*. This painting with the concentric circles and tightly wound Archimedean and hyperbolic spirals with swirling brush strokes, according to Dr. Wolf, may well be a manifestation of van Gogh's manic depression.[13] Ignored, misunderstood, undiscovered while he was alive, van Gogh created close to a thousand paintings during the 1880s, with some of the best during his fifteen months in Arles, but sold only one.[14] Van Gogh's contemporary Claude Monet bemoaned the wasted talent, "How could a man who loved flowers and light so much and rendered them so well, how could he be so unhappy?"

Pattern recognition in the case of shapes, especially when it is heightened by some measure of madness, can be otherworldly, in the manner of a psychedelic drug. So it was when van Gogh painted what is perhaps his most recognized work, *The Starry Night* (1889). In a letter to his brother, Theo, he wrote about this painting: "This morning I saw the countryside from my window a long time before sunrise, with nothing but the morning star, which looked very big."

The window to which he is referring was in his room at the Saint-Paul Asylum in Saint Rémy in southern France. The scenery, however, is semi-fictitious: a steep church spire on a hilltop, silhouetted against the night sky, is reminiscent of his native Holland rather than southern France. Van Gogh tried to capture the background sky, replete with swirling patterns of stars and a shooting star, with rapid circular and swirling brushwork

and brilliant colors: white, yellow and shades of blue. The swirls in *The Starry Night* resemble the spiral a garden hose makes when it is wound uniformly, an Archimedean spiral. A more sophisticated view of van Gogh's swirls connects them to the eddies witnessed in turbulent flow. (Recall, Leonardo's preoccupation with eddies and the swirls captured in modern Schlieren photography.) Large eddies give rise to smaller eddies as a result of chaotic fluctuations (evocative also of images in fractal geometry). These eddies are present in rapidly moving water, in a model submarine basin, in colored streams of air rushing through a wind tunnel, and in satellite views of storms on earth.

It has long been claimed that a connection exists between the artist depicting scenes of lunacy and his own concern about straying across the divide. Pioneer French psychiatrists in the mid-nineteenth century invented a term, *monomania*, to describe this situation. A century earlier, Goya had painted a series of haunting images, deranged patients, or *Dark Paintings* (1819–1823) as they are now known, to satisfy an assignment by his physician.

> *Goya's work certainty evoked the suffering and torment of these individuals. Interestingly, Goya had been taken seriously ill in 1792 at the age of forty-seven with loss of balance, difficulty in walking, partial blindness and deafness. It has been suggested that this could have been a viral-induced Vogt–Koyanagi–Harada syndrome. Over the following months, [Goya] gradually recovered but remained permanently deaf. This harrowing illness may well have had an influence on his later work. It is also quite possible he had a fear of insanity himself because two of his relatives (an aunt and uncle) were affected in this way.*
> —Alan. E. H. Emery, *Practical Neurology*, June 2008

Four versions exist of *The Scream* by Norwegian Expressionist Edvard Munch: two in tempera on cardboard, one in pastel on cardboard, and another in charcoal on cardboard. All are attributed to the artist's

emotional instability. They are autobiographical by Munch's own admission, "painted by a madman." His sister, Laura Munch, had been inflicted with insanity and Munch was petrified that he too would one day descend into the unfathomable depths of lunacy. A psychological analysis of the work suggests that he has set up a defense in the form of the plunging perspective of the roadway and its fence, which preserves a traditional world of three dimensions, holding at bay the swell of art nouveau curves. Safe in this rational world, the two men in the distance (his companions who have turned away) remain unequivocally masculine. In the foreground unified nature has come close to crossing the fence, close enough to distort the form and personality of the protagonist.

Van Gogh, Caravaggio, and Michelangelo all had violent tempers, and frequently lashed out, in the manner that Newton and Beethoven expressed their anger and frustration. Vindictive anger generally starts in one's childhood. As a boy, Michelangelo had expressed aspirations to become an artist and his father Ludovico Buonarotti, to bring the boy to his senses, had delivered a cruel thrashing. As the boy grew up, harboring lasting anger for his father, he was unable to avoid picking up his father's bizarre habits. Among these habits, he preserved as an obsessive-compulsive disorder through his long life the practice of never removing his boots, night or day. (On one occasion when he did take them off, the skin came off with his boots.)

As a fifteen-year-old apprentice in the studio of Ghirlandaio, Michelangelo derided fellow apprentice Pietro Torrigiano (1472–1528) for his lack of talent and received a punch on his nose in response. The resulting broken proboscis became an identifiable physical feature of Michelangelo the rest of his very long life. Torrigiano himself was not an untalented sculptor. He was simply not up to Michelangelo's standards. After his assault on Michelangelo, he abandoned Florence in fear of the Medici, wandering through northern Italy before relocating to England and imported the Italian Renaissance with him. His violent temper frequently landed him in trouble, and he died in prison in Spain.

NEITHER GODDESSES, NOR DOORMATS

Three female artists who lived in the shadows of their famous male artist partners were Camille Claudel, Frida Kahlo, and Françoise Gilot, their own careers as artists subordinated to those of their men. All three women butted horns regularly with difficult narcissistic men—with the life of two of the women ending tragically, that of the third flourishing. The stories were also echoed in the lives of Picasso's common-law wife, Dora Maar, and Einstein's first wife, Mileva Marić.

French sculptor Camille Claudel (1864–1943) was the mistress and muse of Auguste Rodin. Although remarkably original and talented herself, she was overlooked in her lifetime. Fraught with feelings of injustice and persecution from a campaign launched against her by Rodin and "his gang," she began destroying her own works. In 1913, she was involuntarily committed to the asylum of Ville-Évrard. The following year she was transferred to the asylum of Montdevergues where she lived in relative obscurity until her death forty years later.

German Mexican painter Frida Kahlo and her husband, the famous Mexican painter Diego Rivera, always had a contentious relationship, oscillating between passion and strife. They loved each other but their private spaces were so important for them that they could not live apart, nor could they live together. A wise architect talked them into building identical neighboring houses—one white, one blue—joined by a rooftop bridge, so they could visit each other.[15] They were both independent-minded in their artistic expression and fervent Marxists in their politics. They hosted Leon Trotsky during a two-year period when he was on the run from Stalin's agents. (The agents caught up with him and assassinated him in Mexico in 1940.) They had a publicly open marriage, and each had affairs, including Kahlo's brief affair with Trotsky. At one point, Kahlo and Rivera divorced each other, only to remarry a year later. When Rivera became embroiled with Kahlo's younger sister in 1935, the couple's marriage of ten years entered a period of irreversible decline, culminating in a final divorce in 1939.

Kahlo's works comprised primarily self-portraits in which she employed brilliant colors, inspired by Mexican folk art. She portrayed herself devoid of pretension but dour, and sometimes even posed in the nude. Her works are suffused with introspection and deep social consciousness, calling for justice and equality. She explained, "I paint self-portraits because I am so often alone . . . because I am the subject I know best." A near-fatal traffic accident when she was an aspiring medical student at eighteen had resulted in her trading plans from giving medical care to one of receiving medical care the rest of her life. Having to undergo repeated surgical procedures, wearing braces and corsets, and becoming dependent on painkillers, she descended deeper and deeper into depression. Her art reflects a tortured mind and broken body. Death came from an overdose of painkillers. Whether it was accidental or premeditated has never been established with certainty, but testimonies from friends point to the high likelihood of suicide. Largely overlooked in her time, Kahlo was rediscovered in recent years and embraced especially by feminists and the LGBTQ community.

The complicated relationship of Rivera and Kahlo served as a mirror for that of Picasso and his common-law wife, Gilot. "Women are either goddesses or doormats," the enfant terrible of twentieth-century art, Pablo Picasso, declared. But Françoise Gilot would be neither! She was independent-minded and well-educated, having studied English literature at the University of Cambridge and completed a BA in philosophy at the Sorbonne. She lived with Picasso during the decade spanning 1943–1953. Just two years after Picasso replaced her with his next mistress, she met and married the artist Luc Simon and remained with him for two years. Meanwhile, the unusually narcissistic Picasso began threatening art dealers instructing them not to handle her work. In 1970 Gilot married another titan, this time in the biological sciences, Jonas Salk, developer of the first successful polio vaccine. They were married for twenty-five years until the physician died in 1995. Just four years before she passed away at 101 in June 2023, Gilot wrote a book, *Colorful Life: Françoise Gilot on Her Art, Former Loves, and a Long Life* (2018). Although not a creative genius in a class with Picasso and Salk, she never allowed herself to be in the shadow of the two

geniuses. This remarkable woman became a role model for generations of talented and independent-minded women.

The public has a perverse fascination with madness. Art galleries and collectors seek the creations of gifted and often crazy artists, either they are especially good and/or the public demand for them is high. In 2006, Picasso's *Portrait of Dora Maar* (1941), one of the latter day editions of his mistress, the version depicting her as a Shrek with talons sold for $95 million; then in 2010 Picasso's *Nude, Green Leaves, and Bust* sold for $107 million. The 1895 pastel-on-board version of Munch's *The Scream* brought $120 million at a Sotheby's auction in 2012. Van Gogh's *Portrait of Dr. Gachet* sold for $82.5 million in 1990 and for $151 million in 2012. On the table in front of Gachet are foxglove leaves, the source of the drug digitalis. The kind doctor was treating van Gogh for schizophrenia. Digitalis is known to cause "yellow vision," inspiring the artist's Yellow Period when he painted sunflowers galore, interiors and exteriors of houses aglow in shades of yellow ochre. A version of Cezanne's *The Card Players* sold for $250 million in 2011 to the royal family of oil-rich Qatar.

FORGIVING BAD BEHAVIOR

> We are forced to deal with a very uncomfortable fact: Great art is sometimes—perhaps often—made by very bad people, or people who harbor very ugly attitudes, or attitudes we now find abhorrent.

The words belonging to screenwriter-novelist Tarloff capture a recurring and timeless conundrum in the arts. Separating the work from its creator is a relevant topic in our era, when many prominent figures have been denounced and their reputations shattered by revelations of previously undisclosed sexual misconduct. A recent article in the *New York Times* carried the eye-catching title HE'S A CREEP, BUT WOW, WHAT AN ARTIST![16] In posing the question "Can we appreciate art even if it was created by

someone who behaved deplorably?" the article featured a color plate showing a breathtakingly beautiful painting, Caravaggio's *Marta e Maddalena*.

Sexual scandals and sexual ambiguities have long plagued artists but often faded into the fog of time. Filippo Lippi (1406–1469) was a painter and a priest, a member of the Order of the Carmelite friars. His religious paintings, including *Adoration in the Forest*, *Coronation of the Virgin*, and the *Adoration of the Magi* (a *tondo* or circular painting), adorn some of the greatest galleries in the world. Gazing at the mastery of his works can rise to a spiritual experience. In his private life Lippi was far from saintly, accused of "deflowering" a virgin and fathering the child of a nun (1461). An accusation had been dropped into one of the *tamburi*, wooden boxes strategically placed around Florence for precisely such anonymous denunciations. On April 8, 1476, a similar denunciation was made involving Leonardo. He and three other members of the Verrocchio's workshop were accused of consorting with a seventeen-year-old known male prostitute named Jacopo Saltarelli. No record of the group being incarcerated for the incident exists, possibly suppressed because one of them was a member of the Medici family. However, for Leonardo the incident was devastating.

Arriving at the port of New York in 1882, the Anglo-Irish poet and playwright Oscar Fingal O'Fflahertie Wilde (1854–1900) presented his passport. A customs official asked Wilde a routine question, "Sir, do you have anything to declare?" Wilde's response must have puzzled him: "I have nothing to declare but my genius!" Earlier in the chapter, I offered another quotation from Wilde: "The public is tolerant. It forgives everything except genius." This could have been one of Wilde's throwaway witticisms, or the playwright could have been lamenting the fact that even as a genius, he was not being forgiven for his questionable behavior. In prudish Victorian England, Wilde took as his wife (1884) Constance Lloyd, the daughter of a prominent Irish barrister, and the couple had two children. But the marriage may have been just for show. There had been rumors since his student days at Oxford that he was a homosexual, but Constance refused to believe the rumors. That is, until he was arrested and tried for "gross indecency" with his lover, Lord Alfred Douglas, son of the Marquess of Queensberry.

Wilde was sentenced to two years' hard labor in prison before being released and relocating to Paris where he was determined to open a new chapter of his life. He changed his name to Sebastian Melmoth and began berating anyone who inadvertently called him Oscar. An enormously gifted writer, he nurtured controversy and shock value, but he also felt entirely defeated. Today Wilde is best remembered for his works, *The Importance of Being Earnest* and *The Picture of Dorian Gray*.

Shakespeare in *Julius Caesar* had Mark Antony addressing the crowd, prepping them to listen to the dead Caesar's selfless deeds and his generous gifts to the people:

> The evil that men do lives after them;
> The good is oft interred with their bones;

Is the good really buried and forgotten, while the evil lives on? If Shakespeare had really believed this, he would not have been the prophet that we all know and revere. It is with their legacies that great geniuses, especially transformative geniuses, achieve immortality. And it is their human failings and shortcomings that die and are forgotten.

Who remembers or cares two centuries after Beethoven's death the invectives and insults he lavished on players in an orchestra; the stiffed lenders, landlords, and patrons, when he also gave us music that has achieved immortality? Ten generations of humans since his death have been enthralled by his music. As with Beethoven, who remembers after three and a half centuries Newton's quarrels with other great scientists, his treatment of Hooke, Leibniz, and Flamsteed or the servants at Woolsthorpe chattering among themselves, "If only the plague would clear out . . . so that the master can return to '*versity*.'" Both Newton and Beethoven were seen with their vindictive tempers as being users of friends and foes to get their way. But who remembers or cares about these unfortunate habits? After all, Newton, beyond any other soul, demonstrated that nature could be understood, that it possesses mathematical order. Einstein took over and expanded Newton's mathematical formalism to help us understand the

large-scale universe. Perhaps excursions into eccentricity, misbehavior, or even insanity are the price that have to be paid for immortal legacies. We can leave Aristotle the final word: "No great mind has ever existed without a touch of madness."

THE PLIGHT OF WOMEN OF GENIUS—*A ROOM OF HER OWN*

British modernist author, novelist, essayist, and publisher Virginia Woolf (1882–1941) was born into an affluent blended family of eight children. While she and her two sisters were homeschooled, her brothers were sent away for higher education to Cambridge. Reading her works leaves one in awe of her erudition, her productivity, her heightened grit, her artistry with words, resonating with rich prose as mellifluous as poetry. In distinction to her brothers, who received top university training, she was largely an autodidact. She also had dalliances with homosexuality and incursion into mental disorder, common but not prerequisite traits for genius. Her novels and essays place her among the leaders of the stream of consciousness narrative style, a school to which Joyce and Hemingway also belonged. In fact, she provided strong moral support for Hemingway, although only partially reciprocated by the great American novelist, who happened to share many of her character traits.

The year 1929 marked the midpoint between two world wars—the "war to end all wars" and the more devastating war that would follow. It was also the year that the Great Depression erupted, first in the United States, then rapidly spread in the manner of a pandemic around the world. Despite the economic upheaval, the year saw a number of philanthropists emerge and fund the establishment of lasting cultural institutions, including the Institute for Advanced Study in Princeton and the National Gallery of Art in Washington. Although earlier suffragette movements had succeeded in getting the vote for women in most western nations, they had failed in changing women's economic dependence nor made room for genuinely gifted women like Virginia Woolf to gain deserving recognition. That

year, however, saw the release of a new book by Woolf, *A Room of One's Own*, transcribed from a pair of talks she had given in October 1928 at Newnham and Girton Colleges in London. For her lectures, Woolf had been asked to speak about "women in fiction." In addressing that narrow assignment, she was not out to advance the condition of women in general, but rather to suggest the conditions necessary for women of literary genius to blossom and add to the world of literature. She made it clear in the essay that genius was the creation of white males, for white males, and that the creators of the notion had always guarded the exclusivity of their group. Although some of her other writings, such as her novel *Mrs. Dalloway*, are more elegant and considered more significant works of literature, *A Room of Her Own* was a work by a genuine genius commenting about the plight and fate of female geniuses. A century on she is revered as a significant feminist, but also castigated for not supporting downtrodden women on the whole.

Woolf spoke of sitting on a riverbank ruminating about the disparities in men's and women's privileges and opportunities. She described the fictitious Oxbridge College[17] with its splendid centuries-old buildings and manicured courtyards and recalled the experience of being chased away by a beadle (a lowly college official among whose duties was to keep non-scholars and fellows out of the library and off the grass). During the darkest days of WWII, on March 28, 1941, she filled her overcoat pockets with rocks and drowned herself in the River Ouse in Lewes, South Sussex. A stirring love letter-suicide note combination to her husband became a final literary masterpiece, confessing her struggles with depression. Her suicide presaged Hemingway's later suicide as an all-too-dark fate of genius fiction writers.

Baffling perhaps, in *A Room of Her Own*, Woolf described the ideal fiction writer to be virtually saintly in disposition, devoid of prejudice and rage, and to be androgynous—not in the sense of possessing a biological combination of the two sexes as in a hermaphrodite but possessing a mental combination. In modern parlance, a female writer was to be in touch with her masculine nature and a male writer with his female. She wrote, "[For a fiction writer] It is fatal to be a man or woman pure and simple; one must be woman-manly or man-womanly. It is fatal for a woman to

lay the least stress on any grievance; to plead even with justice any cause." Woolf referred to the different sides or areas of the brain. She called for both sexes to function symmetrically in their left and right hemispheres. What she meant was that an author had to display a sexually indeterminate nature. She invoked the writings of Shakespeare and Coleridge. What placed Shakespeare's fiction literature at the very pinnacle was in part that he was at peace with himself, devoid of emotion, of rage, of sexuality. Shakespeare's understanding of the feminine psyche inspired a few scholars to claim Shakespeare was a woman (one conjecture named Queen Elizabeth I and another the "dark lady" of the sonnets).

Demonstrating another and more important trait of genius, intellectual honesty, Woolf made it clear that she was not inclined to rewrite history, to attribute William Shakespeare plays to a Wilhelmina, Christopher Columbus's expeditions to a Christina, or the theory of gravitation to another "she." She pointed out the crucial importance of building on tradition. Shakespeare needed a Marlowe, who needed other great writers before him. There had been no tradition of female writers until the late eighteenth century. An important reason that women in the past had not produced masterpieces comparable to the male geniuses, she explained, was because they had not had the same dramatic life experiences comparable to Shakespeare relocating to London and Tolstoy fighting in the Crimean War.

The plight of women, Woolf explained, was that they had first to complete wifely chores, including the bearing of children, or they had to work in secret. Even Jane Austen developed the habit of hiding her writings under blotter pads. Woolf's explanation applies to other creative artists also, to painters, to composers. She could have added that the late Renaissance Bolognese painter Lavinia Fontana (1552–1614) had eleven children; Victorian musical genius Clara Schumann eight.

It was essential for Woolf's creative female writer to have privacy, a room of her own equipped with a securable door, and financial independence. Patronage generated dependence, obligation, and other attachments. She envisioned an annual income of £500 (approximately £30,000 or $40,000 in today's currency). She called for women to write liberally, to seek adventure,

to have full financial independence, to have the time to write ... and a room of their own. She wrote, "One cannot think well, love well, sleep well, if one has not dined well."

Woolf created a fictitious sister for Shakespeare, Judith, presumably with the genetically endowed capabilities, what I have frequently called the concatenation of genes, with which she could equal her brother's supremacy. But the freewheeling world of the London theater would have been closed to her, the experiences of which were so essential to the nurturing of William's genius.

How many women geniuses did it take to create a man genius? History has seen countless instances of "great men" being promoted by "great women behind them." It behooves us to ask the question, however, "To what degree was the woman supportive—on a spectrum ranging from "the credit was stolen from her" (as in the case of scientists Lise Meitner, Rosalind Franklin, and Jocelyn Bell Burnell) to "offered as whole-hearted support, even at the price of ignoring fame for herself?" In most cases, we will never have a satisfactory answer. The following three examples, however, dramatize the extremes. Our first story is American writer Meg Wolitzer's 2003 novel, *The Wife*, adapted as a screenplay for the 2017 film of the same title. The story takes place in President Clinton's era of the 1990s. It involves a family of three—husband, wife, and grown son—all writers. In the film, flashbacks to the 1950s and '60s reveal the wife was a college student in her already-married husband's creative writing class. She babysat for the professor's child, became embroiled in an affair with the professor, and went on to displace the wife and become "wife number two." Judging by the age of their aspiring writer-son, the marriage has already lasted around thirty years. But she has come to see her husband as lazy, a user, and a man with a perpetually roving eye for young women who might recycle her for a younger, third wife. When the Nobel Prize for Literature is announced, it is the husband who is credited for the work that happens to be a book ghostwritten by the wife. He proves himself to be a pathetic cad, shamelessly preparing to accept the award rather than giving her the credit as the author. At a reception in Stockholm, she sees him courting

the media, and also courting a pretty young woman. Played convincingly by Glenn Close, the ever-deserving writer-wife gives the never-deserving husband-writer the boot, along with the lesson, "There's nothing more dangerous than a writer whose feelings have been hurt." As the British film critic Peter Bradshaw assessed the film in a review for the *Guardian*:

> The final plot turn can be read as a parable for patriarchal politics and the artist's prestige: when people read novels, they are not merely responding to a text, they are consuming the artist's prestige and reputation, which is itself a created performance. It is a smart, supremely watchable and entertaining film, and Close gives a wonderful star turn.[18]

And what about the second facet of the original question, "Are there now or have there been women in the past who dedicated their lives eagerly to promote their men, even at a cost to their own careers?" Our next story is about a heroic effort by a woman in promoting a man—a man who happens to be deserving but incapable of promoting himself. Well-known to music historians is Clara Schumann, née Clara Wieck, superior to her husband Robert as a piano virtuoso but not as a composer. Born eleven years apart, they were married in 1840 and maintained a musical partnership, even chronicling their lives in joint diaries. They were deeply in love and reared eight children, the youngest, Eugenie, following as a concert pianist in her mother's shoes but always in her shadow. Robert and Clara toured and performed together, frequently with the great violinist Joseph Joachim and their own young protégé Johannes Brahms. Robert, however, turns out to have been suffering from bouts of bipolar disorder as early as 1833. In 1854 he had a complete mental breakdown. He attempted suicide by throwing himself into the Rhine River—following his sister Emilie who had died by suicide in 1825. Shades of Virginia Woolf and the Hemingway family. Rescued by fishermen, Robert, still with a measure of wherewithal, checked himself into an insane asylum near Bonn. He never recovered and died two years later at forty-six. Shades of Vincent van Gogh.

Even after Robert's death, Clara lived another forty years, traveling and performing in European concert halls and teaching young students, again frequently with Joachim and Brahms, and performing the established greats, especially Beethoven and Mozart, but always including in her programs her late husband's compositions. She even turned down a proposal of marriage by Brahms, fourteen years her junior, who had fallen in love with her. History will remember Clara Schumann as the genius virtuoso who introduced the practice of performers playing without looking at musical scores propped up in front of them. Even more importantly, history will remember her for elevating Robert Schumann to the ranks of the titans of the Romantic period. In a touching final tribute to their love and devotion, she chose to be buried in Bonn next to Robert.

Our third story is about "The Woman Who Made van Gogh," the title of a featured story in a 2021 *New York Times Magazine*.[19] Hans Luijten, a scholar on the staff of the Van Gogh Museum in Amsterdam, spent fifteen years studying the voluminous collection of letters between Vincent van Gogh and his younger brother Theo, Johanna van Gogh-Bonger's correspondence with art critics and gallery owners after both brothers had died, and the diaries of Johanna van Gogh-Bonger that had remained under embargo since her death in 1925 and finally released in 2009. Luijten spent another ten years writing a book chronicling his discoveries. It is to "Jo" (the diminutive Johanna preferred for herself) that Luijten grants the lion's share of the credit for creating the "van Gogh genius" designation. Jo was, of course, the artist's sister-in-law and was very nearly overlooked by history herself.

Vincent van Gogh died in 1890 at the age of thirty-seven, and Theo died just eighteen months later in 1892 at thirty-three. At Theo's death, Jo found herself with a toddler to raise (named Vincent after his uncle) and an inheritance of over 400 van Gogh paintings and countless drawings. She also had on hand the collection of 902 letters to study. The letters from Vincent to Theo vastly outnumbered the letters from Theo to Vincent. The more stable of the two brothers, Theo had preserved his older brother's letters. The disparity in numbers was fortunate, allowing

Jo to peer deeply into Vincent's mind, then for Luijten into the dynamics of all three.

When she had first married Theo at twenty-two, Jo had already received an education as a language teacher—in French, German, and English. But she had no background in art, art history, or in business. She proved, however, to be an unusually gifted autodidact in all these categories. From her husband's interest in handling the works of impressionists and post-impressionists, in distinction to the practitioners of cold realism—the style preferred by officials of the Académie des Beaux-Arts in Paris—she saw a sea change coming in artistic expression.

Having grown up in a conservative Dutch family where it was discouraged to be different ("The tallest nail gets hammered down"[20]) she went with her instincts—to become cultured, to meet interesting artists and art critics, and to read incessantly. Her favorite writer was the social critic and early feminist writer George Eliot (née Mary Ann Evans). While her diaries reveal that she was riddled with insecurity, "We women are for the most part what men want us to be," Jo wrote about her gratitude to Eliot: "That great, courageous, intelligent woman whom I've loved and revered almost since childhood . . . an incentive to be better."

Jo found answers on her own to questions such as "Which critics to approach?" "How to exhibit and sell paintings?" For example, in one-man exhibitions of Vincent's works, she learned to hang lesser paintings chosen "for sale" purposes adjacent to masterpieces she specifically marked, "On loan—not for sale!" As gallery art dealers now know, such arrangements catalyze the sales of lesser works. She carefully managed the exposure of Vincent's paintings. Critics who knew little or nothing about Vincent described their reactions to her: "Mrs. van Gogh is a charming woman, but it irritates me when someone fanatically raves about something they don't understand." But when she treated or tricked them into reading the artist's own words in those letters, where he is pouring out his soul, explaining his personal analyses of what he saw and how he represented it, the critics began to write articles and books based on Vincent's own worldview of art.

He was a common man who painted common themes for the common man. This is as revolutionary as Beethoven's taking music out of aristocratic palaces and making it accessible to humanity at large. In a solo exhibition she single-handedly arranged in Amsterdam's Stedelijk Museum in 1915, there were 484 of Vincent's works on display, the largest exhibition of the artist's works ever, their value in today's market tens of billions of dollars.

Jo's rescue and elevation of van Gogh as an endearing tortured genius finds parallels in Clara's rescue and elevation of Robert Schumann. In van Gogh, Jo permanently fused the message and the messenger. With the possible exception of Leonardo, no other artist in history is now seen as totally inseparable from his art.

PART V
CONCLUSION

16

HEROES, RULERS, AND RANKINGS

The following question was debated in a very polite and learned company: "Who was the greatest man, Caesar, Alexander, Tamerlane, Cromwell, etc.?" Somebody answered that Sir Isaac Newton excelled them all. The gentleman's assertion was very just; for if true greatness consists in having received from heaven a mighty genius, and in having employed it to enlighten our own mind, and that of others, a man like Sir Isaac Newton, whose equal is hardly found in a thousand years, is the truly great man . . . That man claims our respect who commands over the minds of the rest of the world by the force of truth, not those who enslave their fellow creatures: he who is acquainted with the universe, not they who deface it.
—Voltaire

In their universality and lasting powers, how do the legacies of creative geniuses stack up against those of conquerors, monarchs, political leaders, and religious figures? For Voltaire there was no question that the power of universal truths should triumph over the power of the sword. Another question that begs to be answered is "Does effective leadership require superior intelligence and creativity, those defining traits of genius?"

RANKINGS

Rankings can be useful. If we plan to take them seriously, however, we must know in advance how they are compiled and how authoritative are the sources. But even if they are not scientific in their compilation, they can still be useful, if for no other reason than as a parlor room game to spur further dialogue or perhaps even to inspire scientific inquiry. Myriad rankings are published regularly to help us in making decisions. *U.S. News and World Report* publishes annually its issue of the "Best Colleges and Universities" and the "Best Hospitals." Although they frequently adopt seemingly confusing criteria for judging, their rankings are limited to entities within the same category.

Early in the book we discussed musicologist Alan Fletcher's ranking of great composers through the centuries. Rankings of the impact of national, religious, and cultural leaders, all in different fields, can be far more difficult. Even comparing national leaders calls for comparisons of the nature of their leadership (inherited, elected, or usurped), political values, visions, and legacies. Comparing the overall significance of our five paragons of genius, for example, calls for a comparison of their lasting legacies in different fields in the ascent of humanity. In this chapter we will undertake this task, approaching it in a piecemeal manner with three radically different rankings that already exist: (1) Arnold Ludwig's ranking of the greatest political leaders of the twentieth century, (2) *Time* magazine's choice for the "Time 100: The Most Important People of the Century," and (3) Michael Hart's ranking in his book *The 100: A Ranking of the Most Influential Persons in History*. As we have already seen, qualities that constitute greatness or genius in the arts are somewhat different from those that constitute greatness in the sciences.

Einstein, who championed reason over blind faith, rarely engaged in hyperbole. In penning the words "only two things are infinite, the universe and human stupidity, and I'm not sure about the former," he was dead earnest. He could have been lamenting his fellow humans' lack of curiosity, their hopeless naiveté, or their unrestrained cruelty of mankind. He had

witnessed totalitarianism in Europe and racism in America. He had seen an ethnic genocide, and he could foresee the nightmare of nuclear holocaust.

Ludwig's Mountain

Arnold Ludwig's book *The Price of Greatness* figured prominently in pointing me to the role of madness in creativity and genius. For the attributes of leadership, we refer to another of the Ludwig's books, *The King of the Mountain: Nature of Political Leadership*.[1] Regarding the three rankings of greatness discussed in this chapter, only Ludwig employs objective rating criteria. He takes into account a measure of reliability; i.e., the degree of correlation that exists among the different raters examining the same group.

After an exhaustive examination of the achievements of national leaders from 199 countries during the years 1900–2000, a "baker's century" spanning 101 years, Ludwig published the result of his study in *The King of the Mountain*. A distinguished professor of psychiatry, first at the Medical School of the University of Kentucky and subsequently at Brown University, Ludwig introduced an unusual and effective approach to evaluating the nature of political leadership, not from the usual vantage point of a political scientist or historian, but from the point of view as a medical scientist. A passage in his book reads:

> As it happens, of all the fields of human endeavor, politics seems to be [the] one most rooted in primitive primate behavior. The natural and social sciences rely heavily on information gathering, problem solving, and reasoning. The arts rely heavily on creative expression, intuition, and the exercise of special skills. In contrast to the arts and sciences, which require the use of mankind's highest mental faculties, located largely in the neo-cortex, the most evolutionarily advanced part of the brain, the striving for political power seems fueled more by secretions from man's nether parts—his gonads and adrenal glands—as well as activity from within the limbic system and hypothalamus, the most ancient part of the brain, all of which deal with such responses

as fight-or-flight, territoriality, aggression, sex, and survival... becoming a ruler requires no special academic training, artistic skills, or even superior intellect. That is why charisma, oratory, manipulation, and intimidation are often more important than are wisdom, special expertise, and administrative experience.

Ludwig's words comport with E. O. Wilson's regarding the survival of the human race as one of conflicting conditions, "Paleolithic emotions, medieval institutions, and god-like technology." It is the "paleolithic emotions" that factors in most strongly in leadership and politics. Bluster and bravado are often more important to electability than grace, intelligence, or wisdom. In *King of the Mountain*, Ludwig examines factors crucial to leadership and creates a scale based on the traits of leaders from the past (i.e., pre-twentieth century) whose names have become synonymous with leadership. To reiterate, although leadership does not require extraordinary intelligence, wisdom, or knowledge, it does require an abundance of the alpha male gene, bluster, and frequently a gift for oratory. Governing by division and badgering of religious or ethnic minority groups is often part of the modus operandi of leaders.

Ludwig discusses an experiment carried out at Wake Forest University on a group of twenty male macaque monkeys. In the first phase of the experiment, after the animals' behaviors and the levels of dopamine activity in their brains were measured, the monkeys were placed in groups of four in five separate cages. The researchers found that within three weeks a pecking order had emerged among members of each group—with a leader, a pair of followers, and a "loser" doomed to intimidation by the others. The order in the hierarchy closely paralleled the levels of dopamine D_2 receptor activity, the dominant male displaying the greatest dopamine activity and the submissive loser the least.

In a second phase of the experiment, each monkey was supplied with a catheter in a forearm vein and trained to select either an injection of cocaine or an injection of saline solution. The dominant alpha male, "already intoxicated with power," does not need additional dopamine, and resists

the gracious offer of an enhanced high by rejecting the shot of cocaine. It is the submissive male monkey who seeks "a fix."

When the experiment performed with male macaques was repeated with females, entirely different behavior was observed. Whereas the male macaques were able to organize into a hierarchy within three weeks, their female counterparts were unable to do so even after three months. Ludwig explains, "Stature had little to do with which monkey was temporarily 'on top.' A bottom-up mentality mainly prevailed." There was a virtual dialogue taking place:

> "Your turn to be in charge . . . "
> "But I'm not interested . . . I've got more important matters to tend to."

Fundamental differences between genders may just explain the civilizing influence females bring to the male-female dichotomy. A top-down approach in solving problems by men versus a bottom-up approach by women—*if the interpretation of the experiment holds true for humans*—would be akin to the complementary manner in which problem solving is carried out most effectively.

Since the middle of the twentieth century there have been a number of female heads of government in democratic countries: Indira Gandhi (India), Golda Meir (Israel), Sirimavo Bandaranaike (Ceylon, which became Sri Lanka), Margaret Thatcher (UK), Corazon Aquino (the Philippines), Tansu Çiller (Turkiye), Benazir Bhutto (Pakistan), Isabel Peron (Argentina), and Angela Merkel (Germany). In efficacy as leaders, the women have ranged from 1–10 (1 being lowest). Some have been unifying, others divisive. Meir, Thatcher, and Merkel were at least as effective as any of their male counterparts, especially when they were teachers or educated in the sciences and not just the humanities. Thatcher was trained in biochemistry at Oxford University under the tutelage of a great female scientist, the recipient of a Nobel Prize. Merkel holds a doctorate in quantum chemistry.

Ludwig explains that he spent eighteen years on the project, initially examining the traits and modus operandi of individuals whose names are inseparable from leadership—Darius, Julius Caesar, Augustus Caesar, Hadrian, Charlemagne, Genghis Khan, Kublai Khan, Frederick the Great, George Washington, Napoleon Bonaparte, and Otto von Bismarck. He created a Political Greatness Scale (PGS) based on eleven criteria that he identified—including military prowess, the nature and lasting power of their reforms, moral exemplar, statesmanship, length of tenure, political legacy, size of the population governed—and assigning finite number of points to each. The maximum score attainable is thirty-seven points, and none of the touchstone leaders of the past come anywhere near that maximum score. Moreover, since one nation's hero is frequently a rival nation's villain, Ludwig endeavored to filter out the "evil factor." The ultimate question then becomes "what did these leaders do for their respective countries?"

All the leaders in Ludwig's list who ranked among the top thirty are national leaders. Half of them would be regarded as enemies in democratic societies—e.g., Hitler, Stalin, Mao Zedong, Benito Mussolini, Ho Chi Minh, and Fidel Castro—just as the leaders of democratic nations would be regarded as enemies in autocratic nations.

Ludwig distilled the total number of leaders who ruled during the century from 1,941 down to 377 about whom sufficient data exist and applied the test only to that group. Four-term president of the United States, Franklin D. Roosevelt, generally regarded as the most influential American president in the twentieth century, and Mao Zedong, founder of the People's Republic of China, both earned thirty points and tied for second place. Stalin and Lenin trailed just behind them with twenty-nine and twenty-eight points, respectively. Charles de Gaulle's PGS score was twenty-seven points. Also ranking exceptionally high on Ludwig's PGS were Woodrow Wilson and Harry Truman, with scores of twenty-four and twenty-three points, respectively. Ronald Reagan and Winston Churchill tied with twenty-two points. David Ben-Gurion trailed with twenty-one points and Nelson Mandela with twenty points.

Finally, alone at the summit of Ludwig's Mountain was the founder of Modern Turkiye, Kemal Atatürk, with thirty-one points. This choice would have pleased Albert Einstein, who held the Turkish leader in high esteem.

Kemal Atatürk (1881–1938), the founder of the secular and democratic nation of Turkiye.

Before examining Atatürk's genius, we briefly review a study by another eminent psychiatrist, Jerrold Post, who in collaboration with Stephanie Doucette published *Dangerous Charisma*.[2] Post's and Doucette's approach explores narcissism as a crucial factor fueling political ambition. The recently deceased Post, a pioneer in political personality profiling, was the founding director of the CIA's Center for the Analysis of Personality and Political Behavior. Multidisciplinary in nature, political personality profiling calls

for assessment of the underlying psychology, cultural anthropology, group behavior, and politics—and it is not psychoanalysis. As such, the book does not violate the Goldwater Rule of the American Psychiatric Association (APA), which mandates a face-to-face examination before publishing a psychological profile.

Although *Dangerous Charisma* was written to primarily address the present political divide in the United States, the book identifies the peculiar pairing of a leader whose defining trait may be quintessential narcissism with supporters who possess certain psychological vulnerabilities and needs. Each side needs the nourishment the other side provides. The authors differentiate between two versions—"destructive charismatic leadership" and "reparative charismatic leadership." In the destructive version, they cite David Koresh's Branch Davidians, Rev. James Jones's Jonestown, Castro's Cuba, Hitler's Germany, Ayatollah Khomeini's Iran, and Saddam Hussein's Iraq with the leader-follower relationship becoming a force for destruction.

It is in the context of the "reparative version" that the authors cite Atatürk, along with Mahatma Gandhi, Martin Luther King Jr., and Nelson Mandela as examples of the leader-follower relationship that qualify as a force for healing. Atatürk, following his military victories in Gallipoli in WWI in 1915 and the War of Independence from occupying Allied troops in 1922, took off his uniform, vowing never to wear it again. He then founded the modern Republic of Turkiye, turning his nation's sight westward and launching an extraordinarily wide range of reforms—social, legal, economic, political, and educational. Embracing a credo, "Peace at home, Peace in the World," he made friends with former enemies. A wartime foe, Prime Minister Eleftherios Venizelos of Greece, even nominated him for the Nobel Peace Prize. By the time he died late in 1938, he had succeeded in compressing into fifteen years what had taken the west and the United States two hundred years to accomplish. He had transformed the Ottoman Empire from a caliphate, described in 1851 by Tsar Nicholas I as "the sick man of Europe," into a secular democracy with full gender equality.

Ninety years after Atatürk launched his revolution creating the modern secular Republic of Turkiye, his nation finds itself in the midst of a

counterrevolution with current President Recep Tayyip Erdoğan systematically dismantling Atatürk's reforms and redirecting his country's vision away from the west and southward toward Mecca.

To repeat an earlier assertion in the book, the United States is the single greatest product of the Enlightenment, the legacy of group genius, like quantum mechanics but in another realm. As a secular democracy at the mature age of quarter of a millennium, it still remains an exceptional idea. Although as a complex tapestry, it too is showing signs of fraying with a tear emerging somewhere down its middle, with division and polarization becoming the new order.

TIME MAGAZINE'S PERSON OF THE TWENTIETH CENTURY

Time magazine established the tradition of naming a "Man of the Year" in 1927, choosing Charles Lindbergh for its first honoree. Each year's selection is announced in an end-of-the-year issue. Every US president since 1927 has received the honor; Dwight D. Eisenhower received it twice—in 1944 as the commander of the Allied Forces during WWII and again in 1959 in his last year as president. Franklin D. Roosevelt is the only individual who was honored with the title three times—first as president-elect in 1932, then again as the incumbent president in 1934, and again in 1941.

Numerous women were honored with the title over the years, including Wallis Simpson (1936), Queen Elizabeth II (1952), Corazon Aquino (1986), Melinda Gates (2005), and Angela Merkel (2015). Over the years, annual honorees included several individuals who were less than benevolent, among them Adolf Hitler (1938), Joseph Stalin (1939 and 1942), Nikita Khrushchev (1957), and Ayatollah Khomeini (1979). The year 1989 saw the end of the Cold War with the fall of the Berlin Wall and the Eastern Bloc nations beginning to discard their Soviet yokes one after another. *Time* magazine's editors selected Mikhail Gorbachev as their "Man of the Decade." For in the solo recognition of Gorbachev, they may have been unfair. The Cold War would not have come to an end if it had not been for the

shared efforts of President Reagan and, to a lesser degree, Prime Minister Margaret Thatcher.

In 1999, the award was renamed "Person of the Year." The same year, the editors of *Time* were faced with a particularly difficult task. It was the last year of the decade, the last year of the twentieth century, and the last year of the second millennium. Being chosen *Time* magazine's "Person of the Century" was a grand honor. The century had seen two world wars, scores of countries born and scores destroyed, military victories, scientific discoveries, calamities, geniuses, heroes, and villains. The population of the world had grown almost fourfold, from 1.6 billion in 1900 to 6.1 billion in 2000. For the person who most influenced the century, the editors could easily have chosen one of its villains, such as Hitler, whose insane adventures had led to at least sixty million deaths in the war that he started. Or they could have selected Stalin, a dictator who practiced failed policies for quick modernization that led to the death of about fifteen million in the gulag, and is quoted as saying, "A single death is a tragedy and a million deaths statistics."[3] Or it could have chosen Mao, whose misbegotten plans accounted for far more "unnatural deaths" than even Hitler."[4] The editors, having been chastened by a backlash after selecting Ayatollah Khomeini, reviled in the democratic and secular nations of the West, as the Man of the Year in 1979, decided to choose as the Person of the Century a benevolent individual. *Time* experimented with enlisting its readers, hoping to elicit a popular choice they could endorse. From Turkiye, where there was still intense admiration and affection for Atatürk, a huge surge of votes poured in for their legendary founder, threatening to overwhelm all other entries. The editors tabled these votes, declaring Atatürk "a great man, but his influence was regional."[5]

After deliberating on their own, they made an announcement: "The 20th century was the century of science, and Albert Einstein was the face of science." The *Time* editors' decision surprised even physicists. The runners-up, the editors announced, were President Franklin D. Roosevelt and Mahatma Gandhi. In Einstein, they had chosen a cultural leader, a man whose realm was that of the mind.

THE MOST INFLUENTIAL PERSONS IN HISTORY

In 1978 Michael H. Hart published his book, *The 100: A Ranking of the Most Significant Persons in History*.[6] Hart was daring in beating *Time* magazine to the draw, and indeed in writing a book that was far more ambitious in its scope. Hart's timescale spanned the entirety of human history, and it spanned all cultures. In first seeing the book critiqued in the *Washington Post*, the reader's reaction might have been: "Great! We are going to get yet another journalist's account of history. We will not get the proper representation of scientists, inventors, or artists." That concern could have been dispelled by reading the author's background. Hart was the recipient of a first-class liberal arts education, attending the Bronx High School of Science in New York, earning an AB in mathematics at Cornell, an LLB at New York Law School, and an MS in physics at Adelphi University. Then he had topped it off with a PhD in astronomy from Princeton and worked as an astrophysicist for NASA. He had clearly been around the intellectual block, delving deeply into both the humanities and the sciences. In perusing Hart's ranking, most readers would likely have agreed about many of the individuals he had chosen, while disagreeing about others.

Homo sapiens exhibit curiosity and a penchant for religious worship. They ask questions, they seek answers. What is the purpose of life? How and when did everything begin? Is there extraterrestrial life? Is there a God? And if they are not created by God, they are bound to create their god(s). Accordingly, it is no surprise that the stratospheric rankings of #1–#6 (except #2) on Hart's list were assigned to the architects of the world's major religions. Hart assigned the top rank #1 to Muhammad, #3 to Christ, #4 to Buddha, #5 to Confucius, and #6 to St. Paul. The interloper at #2 was the reclusive Isaac Newton as the architect of the modern age. The first six were followed by #7 Tsai Lun who, eighteen centuries ago in China, invented the technique for making paper, and #8 Johannes Gutenberg, who in 1452–1453 introduced movable type and published the Bible that bears his name. The technology that he invented gave rise to a revolution, fueling the rise of literacy. #9 went to Christopher

Columbus, who opened the New World to European countries, which were rapidly becoming overcrowded and undernourished. Albert Einstein, *Time* magazine's choice for Person of the Century, would garner the #10 position on Hart's list.

Hart's most controversial rankings were the top six places. Although born to Jewish parents in Brooklyn, Hart ordered the central figures of the monotheistic religions with Muhammad (#1), higher than Jesus Christ (#3), and Christ higher, in turn, than Moses (#15). The 2.2 billion Christians in the world outnumber the 1.6 billion Muslims by more than half a billion. Hart explained that he would have ranked Christ #1, except Christianity would not have gotten off the ground if it had not been for the Apostles, and especially the foremost proselytizer of all, St. Paul. And, he adds, Christ's message of universal love is not even generally accepted around the world. Accordingly, Christ should be happy with his #3 ranking. In distinction, Islam is a one-man religion, Hart writes, with its architect as successful as a warrior-chief, an administrator, and a religious leader who did not claim to be divine, but a prophet, just like the other prophets (including Jesus Christ). We can debate who should be the gold medalist ranking #1, Muhammad or Christ? Or should Moses, the earliest of the three architects of the three monotheistic religions, have been ranked #1? And Jesus may be rated #3 by one pollster but not included at all by the Israelis, Chinese, or Hindus. Hart must have wrestled with such choices.

The next ten places on the list are Karl Marx #11; Louis Pasteur #12; Galileo #13; Aristotle #14; Lenin #15; Moses #16; Darwin #17; Qin Shi Huang, unifier of the separate kingdoms of China in the third century B.C.E. and first emperor of the Qin Dynasty #18; Caesar Augustus, the founder and first emperor of the Roman Empire in the first century B.C.E. #19; and Mao Zedong #20.

When Hart published the second edition of his book in 1992, a considerable reshuffling of names was evident, in keeping with the dynamic process of creating rankings in changing times. Echoing the collapse of the Soviet Union and the discrediting of Communism, Karl Marx

was demoted from #11 to #27, Lenin from #15 to #84, Stalin from #63 to #66, Mao Zedong from #20 to #89. Hart also reconsidered many other figures in the new edition, promoting the "father of chemistry," Lavoisier, from #31 in the first edition to #20 in the second edition. In the second edition positions #11 to #20 were assigned to Louis Pasteur #11, Galileo #12, Aristotle #13, Euclid #14, Moses promoted by one to #15, Darwin promoted by one to #16, Qin Shi Huang promoted by one to #17, Augustus Caesar promoted by one to #18, and Nicolaus Copernicus promoted by four to #19. Among ranks #20 through #30 were the names of Antoine Lavoisier #20, Constantine the Great #21, James Watt #22, Michael Faraday #23, James Clerk Maxwell #24, Martin Luther #25, George Washington #26, Karl Marx #27, the brothers Orville and Wilbur Wright as a doublet at #28, Genghis Kahn #29, and Adam Smith #30.

Hart grouped together three conqueror/expansionists, Alexander the Great #33, Napoleon #34, and Hitler #35. Unhappily, he is right to have them on the list, although the order of their ranking could be inverted. The damage wrought by Hitler was very much greater in scale than that of the other two expansionists combined. The basic list(s) created by Hart is his alone and he deserves credit for the ambitious task he undertook. Its rankings do not distinguish between objective and subjective criteria, temporal factors, and cultural and cross-cultural criteria in the manner of Ludwig's list.

In the appendices of *The 100*, Hart tabulates his selection of significant individuals according to countries of the world: the United Kingdom leads with eighteen, Germany is second with fifteen, France follows with ten, while the United States and China each account for seven. Hart also tabulates them by fields. Scientists and inventors lead with thirty-seven, followed by political and military leaders with thirty, secular philosophers with fourteen, religious leaders with eleven, artists and literary figures with only six.

In the 1978 edition of *The 100*, none of the individuals listed nor those in the Honorable Mention list were still alive. In the 1992 edition, however,

one living person, Mikhail Gorbachev, made it onto the list at #95. Perhaps on Hart's list, this slot should be another doublet with the addition of Reagan.

Werner Heisenberg was assigned #43 in the first edition and #46 in the second edition of Hart's list. Although the uncertainty principle introduced by Heisenberg serves as the underpinning of quantum mechanics, this slot would be better served with the addition of Schrödinger and Dirac, making this slot a triplet that should be promoted from Heisenberg's ranking at #43 to somewhere in the top twenty. Quantum mechanics is at least as important as relativity.

Of the three American presidents on the list of *The 100*, George Washington at #21 and Thomas Jefferson at #70 (#64 in the 1992 list) are both of central importance in the founding of the United States. Many readers of Hart might wonder about the wisdom of placing John F. Kennedy at #80 when a number of other US presidents, including Abraham Lincoln and Franklin D. Roosevelt, are just Honorable Mentions, and Harry Truman and Ronald Reagan are missing from the list altogether. Hart credits Kennedy as the main instigator of the program that put humans on another heavenly body. It is not surprising that Hart speculates that in five thousand years the only person remembered from the twentieth century might be Neil Armstrong, the first man on the moon.

On two earlier occasions we asserted that the two most important technologies in the ascent of humans were the discovery of farming and the harnessing of electricity. We will never know who planted the first seed and found that cereal would grow in its place. (To reiterate, this may well have been a woman.) But we do know a great deal about the pioneers of electrical technology. The French scientist Coulomb first quantified the attraction/repulsion of unlike/like charges in 1785, establishing it as an inverse-square force (similar to that of Newton's universal gravitation published a century earlier). The most important breakthroughs in electromagnetism came from experimentalist Michael Faraday and theorist James Clerk Maxwell, their masterpieces coming thirty years apart. Both are ranked in the twenties in Hart's list and deserve to be there (recall

that it was their portraits that were displayed in Einstein's office along with that of Newton).

At #38 on Hart's list is Thomas Edison, inventor of the lightbulb, ticker-tape machine, gramophone, motion picture camera, and many other devices. Serbo-Croatian American engineer Nikola Tesla is at least as significant as Edison, having developed alternating current technology, induction motors, remote control, wireless signal transmission, and myriad other gadgets. He may even have beaten Marconi to the draw in the invention of transatlantic wireless transmission. Although as an entrepreneur he was not as successful as Edison, he possessed a much deeper understanding of electromagnetic theory. It is his AC generators that are used throughout the world to generate and transmit power over the electric grid. Tesla is not on Hart's list but should be there as part of another doublet with Edison, though they disliked each other.

Darwin launched the Darwinian revolution with his theory of evolution in 1859. He is ranked high in the teens along with another life scientist, Louis Pasteur. Just as important for the life sciences was the 1953 discovery of the double-helical structure of DNA, "the molecule of life," by Francis Crick and James Watson. Sharing the 1962 Nobel Prize in Physiology and Medicine, Crick and Watson should be included in an updated list of *The 100*.

Hart recognizes among writers Shakespeare at #36 in the 1978 list (and #31 in 1992) and Homer as #95 in the '78 list (and #98 in 1992) but recognizes no other great writer, not Dante, Goethe, Tolstoy, Hugo, or Dickens, nor Dostoyevsky, Keats, Austen, or Melville. He recognizes composer Beethoven as #42 in the 1978 list (and #45 in 1992) and Bach as #74 in the '72 list (and #72 in the 1992 list), while relegating Mozart to Honorable Mention. He recognizes visual artists Michelangelo, awarding him #49 on the '78 list (and #50 in the 1992 list) and Picasso #98 (in both lists). Conspicuously absent from Hart's list is polymath Leonardo, having been relegated to Honorable Mention. At least he is in the good company of Mozart. If Leonardo had published his discoveries in a timely manner, he would have single-handedly launched the Scientific and the Industrial

Revolutions, accelerating technological progress by approximately two centuries. He would have been near the top of the list. Again, it is Hart's list and we can only debate as a parlor room game.

This chapter opened with Voltaire's words expressing his conviction that Newton's legacy was more significant than those of the greatest conquerors and rulers of history. A century before Voltaire, in 1605, Francis Bacon (#78 and #90 on Hart's lists) had written:

> We see how much more durable the monuments of genius and learning are than those of the hand. The verses of Homer have continued without a syllable or letter loss above five and twenty hundred year, in which time numberless palaces, temples, castles, and cities have been demolished and are fallen to ruin.[7]

The same sentiment resonates also in Percy Shelley's sonnet "Ozymandias" (Ramses II), lamenting the decay and disappearance of the monuments to his legacy:

> *My name is Ozymandias, King of Kings;*
> *Look on my Works, ye Mighty, and despair!*
> *Nothing beside remains. Round the decay*
> *Of that colossal Wreck, boundless and bare*
> *The lone and level sands stretch far away.*

The power of great ideas trumps the power of the sword. By "great ideas" we must include those of the architects of the great monotheistic religions. Finally, genius is not necessary to govern, although in rare instances leaders possessing extraordinary vision have come along and forged extraordinary legacies; e.g. Atatürk, Mandela, Lee Kuan Yu, Deng Xiaoping, and the group genius manisfested in the founding fathers of the United States. But even such legacies appear to be perishable unless they are carefully nourished by subsequent generations.

EPILOGUE

GENIUS IN THE DIGITAL AGE

Whether their sources were fact or fiction, moral tales were important for the ancient Greeks. Herodotus of Halicarnassus wrote about a meeting between Solon, one of the founding fathers of Athens, and Croesus, the king of Lydia. In the story, Solon, known for his wisdom as a lawgiver, embarks on a ten-year journey around the known world. Toward the end of his journey, he visits Sardis, the capital of the Lydian Kingdom, where he meets its immensely wealthy ruler Croesus.[1] The two men engage in a discussion reflecting moral values. After giving Solon a tour of his palace, culminating with a visit to his treasury, Croesus asks his guest, "Who is the most '*obios*' [the Greek notion of "contented"] man you know of?" Expecting a simple affirmation from Solon that the most contented man is himself, he is puzzled by the Athenian's reluctance to affirm what he regards as the obvious answer. Solon's choice for the most contented man is reserved for "Tellus of Athens, who lived a full life, had children and grandchildren, and died defending his country. And the Athenians gave him a public funeral and highest honors."

Croesus is surprised and disappointed that this "wise man" chose a common man as the most contented human being. He asks Solon, "In

that case, who is the second happiest man?" expecting this time that the choice has to be Croesus. Solon refuses to play Croesus's game. He offers the names of two brothers Cleobis and Biton, from Argos, who were "beautiful and good and endowed with immense physical strength." At a ritual service for the Goddess Juno, their priestess mother was to be driven to the temple by an oxen cart. With the oxen not available on time, the two brothers donned the oxen's yokes and pulled the cart a distance of forty-five furlongs themselves. The physical strain, however, was overwhelming for them, bringing about their death as they reached the temple. In witnessing the brothers' devotion to their mother and their superhuman feat, the worshippers were left awestruck by their noble deed, making their mother proud. With this second rejection Croesus is crushed. He is convinced that Solon is a fool, and his reputation as a wise man is entirely undeserved.

SOLON'S TEST

But the tale does not end there. Croesus, aware of the neighboring Persian Empire's penchant for expansion, ponders whether he should make a preemptive strike. Acting with caution, he decides to consult an oracle first. But which one of the many oracles of Greece should he trust? To determine the best choice, he sends to three most reputable oracles[2] a test question, one whose answer he already knows secretly. His research helps him to settle on the Oracle of Delphi as the most reliable. After bestowing gifts on the Delphic Oracle to curry favor, he asks a crucial question, "Should I invade the Persian Empire?" only to receive a cryptic response, "A great empire will fall!" Croesus seizes upon the oracle's response, interpreting it as support for his plan to invade Persia. He launches a surprise attack. Alas, King Cyrus's forces defeat those of Croesus and take the Lydian ruler prisoner. The oracle had never been specific about which "great empire" would fall. The beleaguered Croesus, tied down on a pyre for a fiery execution, cries out in despair, "Oh, Solon! I should have listened to you."[3] The lesson of Solon: "It ain't over till it's over!"

ARTIFICIAL INTELLIGENCE

Among the most promising as well as potentially the most dangerous of the new technologies is artificial intelligence. In 1997 IBM built a supercomputer, Deep Blue, programmed to play chess. Along with the capability of computing 200 million moves per second, the basic rules of the game and a massive compendium of master matches were fed into the machine's memory. Playing a six-game match against the reigning world chess champion, Garry Kasparov, Deep Blue prevailed. It out-computed him, and, without displaying any insight and thought, a machine beat a human chess champion for the first time. In the following two decades more powerful chess-dedicated algorithms were created. The best of the chess-playing computers, Stockfish, easily defeated Deep Blue. In 2017 the artificial intelligence company DeepMind, a division of Alphabet, Inc., unveiled a new computer, the AlphaZero. The machine's algorithm consisted only of the basic moves allowed in chess, but without a library of past master matches.[4] It would learn the game by playing itself, again and again, millions of times within a few hours, and in the process introduce hitherto unimagined strategies to the game. AlphaZero, playing in a hundred-game match against Stockfish, proved totally invincible. No human chess player would think of isolating his queen in a corner with nowhere to go, and yet in game #10, that is precisely what it did. In a fascinating article, mathematician Steven Strogatz observed,

> ... this peculiar retreat was venomous: No matter how Stockfish replied, it was doomed ... Most unnerving was that AlphaZero seemed to express insight. It played like no computer ever has, intuitively and beautifully, with a romantic, attacking style. It played gambits and took risks. In some games, it paralyzed Stockfish and toyed with it.[5]

The most daunting problem hitherto undertaken by artificial intelligence was announced publicly in September 2021. Two years earlier the Von

Karajan Institute had approached Ahmed Elgammal, director of the Art and AI Lab at Rutgers University, asking him to collaborate on a project to celebrate the 250th birthday of Beethoven in 2020. Could a team of computer scientists, musicologists, composers, and performers be assembled to create Beethoven's *Tenth Symphony* from a smattering of sketches the composer had left behind? The computer would have to learn Beethoven's works, his work habits, and essentially assume his volatile personality. During the process of the construction, the presence of Beethoven's spirit was omnipresent, but his voice was not, whether to applaud or condemn the AI-assisted work. Would the symphony he had planned as his magnum opus be 50%, 25%, if at all to his liking? Could the finished work simultaneously capture Beethoven's limitless power, his deep love of humanity, his mastery of tension and release, and his impatience with the imperfect? Meanwhile, many in the artist community warned, "AI, keep your clammy hands off the arts!" Ahead of its planned public premiere in Bonn, on October 9, 2021, *Smithsonian* magazine carried Elgammal's account of the process, including the repeated tests.[6] Elgammal recounted: "We challenged the audience to determine where Beethoven's phrases ended and where the A.I. extrapolation began. They couldn't . . . Only those who intimately knew Beethoven's sketches for the Tenth Symphony could determine when the AI-generated parts came in."

As a lifelong Beethoven aficionado, I listened to the *Tenth*, and thought it really did sound like Beethoven, but Beethoven's magic was missing. There were no Beethoven surprises. AI may eventually learn to assume the composer's moods and a modicum of madness and incorporate magical surprises—perhaps around the time when a similar app composes Shakespeare's thirty-eighth or thirty-ninth plays? Those inscrutable insights are reminiscent of the Vatican assembling a group of sculptors in 1506 to decide on the recreation of the missing arm of the *Laocoön*. It took the transformative genius Michelangelo to provide the magic as the lone dissenter in that group.

We are learning of the incalculable opportunities for malice through hacking—by criminals and foreign operatives—leading to loss of privacy,

loss of property, theft of savings, and even impediments to democratic governance. The words "virus" and "virality" are no longer scourges associated with biological systems alone. They now affect cyberspace: a vulnerable few contract an initial "infection" that subsequently spreads exponentially through the broader population, ultimately enabling the infection to "jump" into entirely different populations. A few years ago, we would have regarded as highly unusual the pairing of the expression "social media" with "weaponize" or "radicalize." Now we hear about terrorists being radicalized by social media. There is even anxiety associated with humanity's future relationship to intelligent robots. Tim Cook, Steve Jobs's handpicked successor as the CEO of Apple, gave a commencement speech to MIT's graduating class of 2017, spelling out some of the dangers:

> Technology today is integral to almost all aspects of our lives and most of the time it's a force for good. And yet the potential adverse consequences are spreading faster and cutting deeper... Sometimes the very technology that is meant to connect us divides us... It takes our values and our commitment to our families and our neighbors and our communities, our love of beauty and belief that all of our faiths are interconnected, our decency, our kindness. I'm not worried about artificial intelligence giving computers the ability to think like humans. I'm more concerned about people thinking like computers without values or compassion, without concern for consequences.[7]

On November 17, 2022, the National Cathedral in Washington hosted the Ignatius Forum: "Man, Machine, and God." The program, sponsored by the Paul Ignatius Foundation, brought out Mr. Ignatius, celebrating his 102nd birthday. Former Secretary of State Henry Kissinger, still sharp at 99, joined in from his office in New York City. Eric Schmidt, computer scientist at MIT, and Anne Neuberger, deputy NSA advisor for Cyber and Emerging Technology comprised the panel, and Paul Ignatius, a *Washington Post* reporter and the son of the founder served as the moderator. If

a 99-year-old and a 102-year-old can be concerned about the future of our species, then the rest of us should be concerned. Their combined message was sober and somewhat more somber than the Apple CEO's. Kissinger's admonishment was to immediately seek an agreement with the Chinese never to use AI in warfare.[8]

Einstein lived before the second Information Revolution, but he anticipated its dangers: "I fear the day that technology will surpass our human interaction. The world will have a generation of idiots." Although none of the new innovators or entrepreneurs of the present Information Revolution—among them Bill Gates, Steve Jobs, Elon Musk, and Jeff Bezos—could ever claim levels of creativity in the arts and sciences comparable to a Leonardo or an Einstein, they are undeniably visionaries engaged in inventing the future, and in the process introducing a new class of genius as entrepreneur-innovators. In chapters 1 and 2, we had alluded to creativity in the Digital Age. In concluding the book, we revisit the topic and speculate on whether the genius designation applies to any of them, and in what degree. Technology is progressing at a blinding speed. Only future generations can look back and fully assess the influences of these individuals using Solon's test; i.e., well after their deaths.

THE AGE OF BILLIONAIRES

Great talent in art requires patronage. In their time, artist–scientist Leonardo and artist–architect Michelangelo, and pure artists Shakespeare, Bach, and Beethoven sought out wealthy patrons to allow them to create their works without having to worry about having to sustain themselves. For several hundred years, talent in the sciences has almost always been associated with members of academic institutions that accorded them salaries. Scientists and innovators in modern times also seek outside funding.

The word "startup" has become a familiar term in the Digital Age. The innovators are not only in need of funds to sustain themselves while implementing their original ideas and taking them to the market, but

EPILOGUE: GENIUS IN THE DIGITAL AGE

subsequently funds to build hardware and to hire teams of talented assistants, from engineers to business managers and lawyers. The attached table contains thirteen names, including Alan Turing who is not a modern innovator but an unwitting initiator. A mathematical genius who completed a first-class education in mathematics and helped England and the Allies win WWII, he never amassed personal wealth. The others all represent the modern innovators of the Digital Age. The list is by no means complete. The inventors of the internet, Vinton "Vint" Cerf and Bob Kahn, and other inventors of newer technologies—e.g., YouTube, Twitter, Zoom, ChatGPT, etc.—are not included in the table. Timothy Berners-Lee is included. He developed the World Wide Web (www) and for altruistic reasons disavowed any financial gain from his creation. Many of these breakthrough innovators were admitted to prestigious universities after showing their intellectual acuity in high school. Nine of the dozen dropped out of school before completing their terminal degrees. The astonishing 75% dropout rate was most likely powered by the conviction that they needed to get a head start on bringing their ideas to the world, that their ideas were just too important to wait until commencement day or until an advance degree could be completed. A characteristic that so many of these innovators share is the overwhelming self-assurance that the power of ideas trumps a formal degree.

Modern Tech Innovators	EDUCATION	Completed Terminal degree	PERSONAL FORTUNE 2018	PERSONAL FORTUNE March 2023
Alan Turing (1912–1954)	Cambridge (BA), Princeton (PhD)	√	N/A	N/A
Larry Ellison (1944–)	Univ. Illinois, Univ. Chicago	DO	$61 billion	$150 billion
Steve Wozniak (1950–)	UC Berkeley	DO	$100 million	$100 million
Dean Kamen (1950–)	Worcester Plytech	DO	$500 million	$500 million
Bill Gates (1955–)	Harvard	DO	$93 billion	$119.5 billion
Timothy Berners-Lee (1955–)	Oxford (BA, MA) First in physics	√	N/A	N/A
Steve Jobs (1955–2011)	Reed College	DO	$8 billion	N/A

Modern Tech Innovators	EDUCATION	Completed Terminal degree	PERSONAL FORTUNE 2018	PERSONAL FORTUNE March 2023
Jeff Bezos (1964–)	Princeton (BA)	√	$164 billion	$157 billion
Elon Musk (1971–)	Penn (BA), Stanford (PhD)	DO	$20 billion	$248.1 billion
Larry Page (1973–)	Michigan (BS), Stanford (MS, PhD)	√	$54 billion	$105.6 billion
Sergey Brin (1973–)	Maryland (BS), Stanford (MS, PhD)	DO	$52 billion	$100.3 billion
Michael Dell (1984–)	Univ. Texas	DO	$23 billion	$64 billion
Mark Zuckerberg (1988–)	Harvard	DO	$78 billion	$111 billion

The first column lists the names of thirteen brilliant individuals, all born in the twentieth century, and arranged in the chronological order of their births. The second column lists the academic institutions they attended. In the third column, the tag "√" means they completed the last degree in which they were enrolled, while "DO" stands for "dropped out" before earning that degree. Of course, "N/A" stands for not applicable. The last two columns list their personal fortunes: first, for the dozen entrepreneurs in early 2018, and subsequently, for each of them five years later. The increase in their personal fortunes reflects how well the high-tech companies they founded were positioned for growth during the pandemic. The most dramatic rise, and the single largest drop within those five years involved Elon Musk. The $100 billion he lost initially, associated with his purchase and reorganization of Twitter, was more than recouped. The AI frenzy in 2023 significantly boosted the personal fortunes, especially of Page, Brin, and Musk. Source: Forbes' Real-Time Billionaire, https://www.forbes.com/real-time-billionaires/#34e0eadc3d78.

Two of the innovators—Steve Wozniak, who first designed the circuitry and wrote the software for Apple personal computers, and Dean Kamen, who created the portable dialysis machine, the self-balancing transporter Segway, and the stair-climbing iBot—are relative paupers with personal fortunes of $100 million and $500 million, respectively.

The United States is a nation of immigrants, its fortunes advanced by the physical toil of the nineteenth-century railroad builders from East Asia and the brainpower and work ethic of European immigrants and their offspring in the twentieth century. Einstein is the most famous of a group

that includes mathematicians John von Neumann, Emmy Noether, and Terence Tsao; physicists Eugene Wigner and the other Martians, Wolfgang Pauli, C. N. Yang, T. D. Lee, Chien-Shiung Wu, Maria Goeppert Mayer, and Subrahmanyan Chandrasekhar; musicians Enrico Caruso, Irving Berlin, Eugene Ormandy, Mstislav Rostropovich, and Yo-Yo Ma; and more recently, computer scientist-entrepreneur Sergey Brin and pediatrician-entrepreneur Priscilla Chan-Zuckerberg. They have all given back far more than they have taken. According to the February 2019 issue of *National Geographic*, entrepreneurial immigrants have always contributed to United States economic growth. First- and second-generation Americans founded an astonishing forty-four of the top 100 Fortune 500 companies listed in 2018.

STEVE JOBS

Of the dozen modern innovators listed in the table, two stand out for the quality, quantity, and diversity of their ideas: Steve Jobs (1955–2011) and Elon Musk, born in 1971 and very much alive.[9] Both began as game designers and programmers, and both became innovators and entrepreneurs (Musk also dabbled in hacking), both experimented with hallucinogenic drugs (Jobs with LSD, Musk with MDMA[10]). Both learned early what they wanted to do with their lives—making their hobbies into their work. It is impossible not to be impressed by both men for their imagination, perseverance, grit, showmanship, and their refusal to acknowledge the impossible.

But we will follow Solon's lesson and resist discussing Musk's genius traits. Let it suffice that the projects he has been associated with are the secure online payment website PayPal; the battery-powered car, the Tesla; a solar-powered city (with the first one in Australia); and the SpaceX Program with recoverable rockets; and most recently Twitter, and AI. While hosting an episode of *Saturday Night Live* (*SNL*) in 2018, Musk announced that he had grown up with Asperger's syndrome, presumably attributing his creativity to the condition.

Here we will end with a brief nostalgic look at the life and legacy of Steve Jobs. After all, his Solon clock began to tick in October 2011 when he died.

> *Of all the inventions of humans, the computer is going to rank near or at the top as history unfolds and we look back. It is the most awesome tool that we have ever invented. I feel incredibly lucky to be at exactly the right place in Silicon Valley, at exactly the right time, historically, where this invention has taken form.*
> —Steve Jobs

Steve Jobs founded Apple with his friend Steve Wozniak in 1976 in what since has become a standard setting for digital startups, a garage in the Bay Area of California. In August 2018 the company was declared to have become the first trillion dollar company in history. Just a month later Amazon announced it had just reached a trillion-dollar valuation, the second company to do so. Despite the pandemic wreaking havoc in the overall US economy, Apple reached the two-trillion-dollar milestone on August 18, 2020, answering the question, "How will the company fare in the post-Jobs period?" Meanwhile, the stocks of Microsoft, Amazon, Alphabet, and Facebook have also soared.

Steve Jobs's biological father, Abdul Fattah "John" Jandali, grew up in a Muslim home in Homs, Syria, and, in his earlier days, spent time in jail as a student activist protesting the government. His biological mother, Joanne Schieble, a Catholic of Swiss-German descent, came from a provincial midwestern background in Wisconsin. Jandali and Schieble met while graduate students at the University of Wisconsin. After they spent a summer at his home in Homs, Schieble became pregnant. Heavy pressure from her parents to cease seeing the young Muslim led her to decide to move to San Francisco to give birth and to give the baby up for adoption. Years later Jandali would claim that they had been deeply in love, "star-crossed lovers" as the Bard may have described them. Schieble required that the adoptive parents be wealthy and college graduates. She

dropped these requirements when Paul Jobs (1922–1993), a Calvinist from Wisconsin, and his wife Clara Hagopian, housewife of Armenian descent—neither of them wealthy nor college graduates—appeared as candidates to adopt the boy, resolutely promising to give him a college education when the time came.

Paul and Clara were devoted parents to Steve and a second adopted child, Patricia, indulging both at every turn. The children were still toddlers when Clara taught them to read. Being able to read before starting school can be a double-edged sword: it can boost a child's confidence in those early grades, or it can cause the child to become bored and cynical in school. In Steve's case, it was the latter. He displayed an aversion to traditional schools, children of his age, and authority in general. He was a young rebel whose behavior was rewarded several times by being suspended from school. He credited his fourth-grade teacher, Imogene "Teddy" Hill, for turning his rebellious energy into a passion for quenching his insatiable curiosity. Jobs had Teddy as a caring and attentive champion, as Leonardo had his uncle Francesco, as Beethoven had Christian Neefe, and as Einstein had the medical student Max Talmud. A genuinely dedicated mentor can ultimately become an inspiring figure for any ten-year-old. Jobs described her strategy: "She bribed me into learning."

Paul Jobs had received training as an engine-room machinist in the Coast Guard and acquired technical skills and a love of gadgetry that he passed onto his son in their home workshop. Years later when Jobs and Wozniak began producing portable computers in their garage and later in their factory, Jobs demanded perfection in every detail. The solder joints on circuit boards had to be as clean and precise deep in the interior of a device as the user would see on the exterior. Form and function had to be present at every level, even in the packaging.[11] They introduced i-devices that have become part of our essential vocabulary—iMac, iTunes, iPod, iPhone, iPad—and applications and services, including iPhoto, iMovie, and iCloud. Jobs was one of the first people to have his DNA sequenced. The lab technicians working on his sample playfully referred to his file as "iGenome." He founded the computer company NeXT, the operating language

of which became the heart of Macintosh computers. He co-founded Pixar Animation Studios, the most successful animation studio in the industry, producing *Toy Story* (1995) and *Finding Nemo* (2003). Ultimately, it was the synergy of different graphic technologies that made the final product greater than the sum of its components.

In 2005 Steve Jobs gave an unusually inspiring commencement address to the graduating class of Stanford.[12] President John Hennessy of Stanford, in introducing Jobs as the speaker, explained, "The reason the Macintosh turned out to be so good was because the people who designed it were such highly creative individuals—musicians, artists, poets and historians who happened to also be computer scientists." Jobs opened his speech by admitting this was the closest he had come to graduating from college.[13] In his talk, Jobs focused on a number of events that had defined his life. Each was an adversity: his illegitimate birth, choosing to attend a college (Reed) "almost as expensive as Stanford"; dropping out of school at thirty, "with no idea what I wanted to do with my life"; being forced out of a company that he personally co-founded; and his illness—and how he had come back each time with a vengeance, stronger and more determined than ever. Jobs regarded setbacks as the greatest motivational factors in his life. (Recall, adversity had been Beethoven's greatest motivator, especially in three periods of his life: in 1802 when he was facing deafness and wrote his Heiligenstadt Testament; again in 1812 when he had to terminate his relationship with his one love, Antonie Brentano; and in 1819 after he hit rock bottom in his personal life and career.) Jobs had the personality traits that were ideal for the Information Revolution. He displayed high intelligence, unquenchable curiosity, disdain for authority, independence of mind, drive for perfection, and even the willingness to experiment with marijuana and LSD as a member of the boomer generation. Inspired by the Beatles' 1968 trip to northern India, Jobs, after a year at Reed College, also journeyed to India, seeking enlightenment through the study of Zen Buddhism.

The overarching message of that commencement speech was "Think different . . . stay foolish," an expression he repeated again and again. In

1997, when Apple found itself at the brink of bankruptcy, it was the rival company Microsoft that stepped in and saved it. Bill Gates made a capital investment of $150 million in an enterprise run by an admired and crazy friend, convinced that "the ones who are crazy enough to think they can change the world are the ones who do."[14]

The magnanimous gesture by Microsoft to save a rival company and not to bury it drew an understated response from Jobs, memorialized on the cover of an issue of *Time* magazine: "Bill, thank you. The world's a better place." Of course, the gesture by Bill Gates was a testament to his personal decency, his business wisdom, and his patriotism. Indeed, the industry and the nation are better off with two great companies, though rivals, working in tandem in complementary components of technology—software vs. hardware. In a field barely out of its infancy, the poignant incident has become lore of epic proportions.

Steve Jobs was an American genius, but what degree of genius will depend on the test of time. He and "Woz" were largely responsible for the microcomputer revolution. The zeitgeist favored their ascent, but then they raised and deepened the zeitgeist by attracting others with similar passion and talent. He made eight appearances on the cover of *Time* magazine, seven of them solo appearances. Did Jobs possess that tincture of insanity that appears to color the behavior of individuals of genius? In 2003, Steve Jobs was given an early diagnosis of pancreatic cancer. The treatment calls for a highly effective surgical operation, albeit exceedingly complicated, known as the Whipple procedure. The stomach is largely replumbed. Had Jobs undergone the surgery earlier, he would most likely have been cured, although forced to take medication thereafter to replace the enzymes normally produced by the pancreas. Alas, convinced that he could treat himself with a regimen of holistic medicine, he refused the surgery and allowed the illness to proceed to an inoperable stage. He died eight years later in October 2011. A genius in one area rarely translates to genius in another.

In 1982 Jobs addressed the Academy of Achievement. Writer Alan Trapulionis reported Jobs spoke about maximizing intellectual potential, not by over specializing, but rather by making connections between diverse

fields, a message embracing polymaths. According to the reporting of Jessica Stillman,[15]

> A lot of [what it means to be smart] is the ability to zoom out, like you're in a city and you could look at the whole thing from the 80th floor down at the city. And while other people are trying to figure out how to get from point A to point B reading these stupid little maps, you could just see it in front of you. You can see the whole thing.

Around 2002, the number of PCs one saw in use in coffee shops and airport lounges dwarfed the number of Apple laptops. (Recent years have seen the numbers, although not reversed, at least reach a closer parity.) The celebrated Italian novelist Umberto Eco published a short essay regarding his preference in personal computers: "The Macs are the Catholics of the computer world, and the PCs are the Protestants. They [PCs] can interpret things anyway they like." Apples were more user-friendly and they were more resistant to being infected by viruses than their competitors. The essay drew a chuckle from Bill Phillips, a 1997 Nobel Prize winner and a devoted Mac user. Phillips's reaction: "When the girls [his daughters] were about to go off to college, we sat them down and admonished them, 'Date within the religion. Stay away from PC-users!'"[16] As it is with many individuals in technical fields, Phillips is adept in both the PC and the Apple platforms, but when it comes to personal preference, Apple was his choice.

Among the points to take away from our exploration of genius is that all genius begins with deep curiosity and a zeal for personal growth. Creation of vocabulary lists, to-do lists, systematic plans, and sketches defined the routine activity in the lives of just creative normal individuals, but also in those of Leonardo, Beethoven, Newton, and Einstein. (Of the "Big Five," if Shakespeare ever kept notes, sketches, or memos, they have not survived.) Without exception geniuses show a relentless passion for their subject(s). Different types of intelligence are required in problem-solving. In the sciences a left-brained analytic intelligence is required, whereas in the arts, it is the

more subjective right-brained activity that is most important. To optimize creativity, however, the entire brain, the synapses of both the left and right hemispheres need to be mobilized. A stroke that damages one hemisphere, even if it is clearly not the dominant one for an artist, is known to dramatically impair creativity. The timeless adage, "There is a fine line between genius and insanity," is not as far-fetched as one might think.

In chapter 5, while discussing Shakespeare, we posed the question, "Is it possible that for genius at this level, the insecurity derived from a lack of education fuels an insatiable drive . . . that a subconscious script has to be fully played out in his head and a certain level of accomplishment has to be attained before he could feel satisfied with his effort?" Again, none of the modern high achievers realistically compare to a Leonardo or Shakespeare in artistic or scientific creativity. But this is an entirely new class of genius, and admittedly we avoided making comparisons, taking cover behind Solon's test.

ASCENT TO IMMORTALITY

A pair of takeaway points from our investigation that need to be reiterated is first, that for genius, "nature *or* nurture" turns out to be a false dichotomy. Both ingredients are necessary for genius to flourish. We examined scores of eminent lives, many of them significant geniuses. Among them we isolated a handful of "transformative geniuses," the paragons of genius who define their fields. Early on we also listed the common traits that are seen in all geniuses, including passion, grit, intellectual acuity, originality, creativity, even some measure of lunacy that enhances the creativity.

Our investigation of the rarefied class of transformative genius commenced with the Latin inscription on the base of Newton's statue: "With his intellect he surpassed the human race." It has been the destiny of very few individuals in history, including the five exemplars in this book, to possess such manifest gifts, to appear in history at the most auspicious times and to become transformative geniuses. Their lives,

no matter how ordinary or modest at their beginnings, culminated in the invention of a significant new field or in permanently transforming their own field before dramatically influencing all of civilization. If we should doubt this, we might imagine for a moment the world without any or all of their masterpieces. No *Mona Lisa* or *The Last Supper*? No *Hamlet* or *Macbeth*? No *Fifth* or *Ninth Symphony*? No calculus or understanding of gravitation? No theory of relativity or quantum mechanics? Only when we consider their contributions from that perspective can we realize just how much the world owes to the transformative geniuses, past, present—and future. Who, we wonder, will be the next and from which country or continent?

History's milestones are their masterpieces. Scottish scholar Thomas Carlyle would have championed them as the very sparks creating cultural revolutions. But then, we have also seen that each man was a child of the prevailing zeitgeist—Leonardo in the time of the Medici, Shakespeare in the time of Queen Elizabeth I, Beethoven as a child of the Enlightenment, Einstein in bohemian Europe of the early twentieth century.

While each of them demonstrated ample levels of the common traits of genius, a peculiar phenomenon emerged, elevating them virtually to immortality. The phenomenon initially became evident in the examination of Beethoven in the chapter "A Singularity in the History of Art." Historians began to reinvent him according to the zeitgeist of their own time, rather than Beethoven's time. He became universal and entirely timeless. Beethoven, who was born in 1770 and experienced artistic rebirths in 1801 and 1819, began his reputational transformation at his death in 1827. He was reinvented on the centennial of his birth in 1870; again, on the centennial of his death in 1927; and again, on the bicentennial of his birth in 1970. His story is continually being rewritten, with 2020 marking the 250th anniversary of his birth and 2027 the bicentennial of his death. No dips, no ebbs and flows in his popularity have been seen, allowing his reputation to rise monotonically for over two hundred years.

The practice of reinventing the individual in a new and different guise also happens with Leonardo, Shakespeare, Newton, and Einstein. Not

one of them would have recognized himself centuries or even decades after his death. Even the story of the most recent, Einstein, who was born in 1879 and died in 1955, has been evolving. During his lifetime he had experienced a pair of scientific rebirths, anni mirabiles, in 1905 and again in 1915. Physicists the world over celebrated the centennial of his birth in 1979; and they celebrated again the centennial of his explosive creativity in 2005; and then the centennial of his magnum opus, the general theory of relativity, in 2015. His name, synonymous with genius, became even grander as the range of applications of general relativity began to expand. As the face of science in 1999, *Time* magazine declared him the "Person of the Century." But his rewritten story increasingly exposed his human failings, the warts along with the gifts. The popular modern perception of Einstein is that he was a brilliant, social-minded, violin-playing pacifist and lover, born on Pi Day, March 14 (3.14).

This process of ascent to immortality is the theme of Shakespeare's Sonnets 18 and 65. In the more familiar of the two, "Sonnet 18," the Bard compares the qualities of his lover with those of a summer's day, a near-perfect, dependably mild and temperate time of the year in England. The poem compares things of lasting duration, which are unchanging with things of limited or fleeting duration. During the course of the sonnet, the poet praises the qualities of his lover as being even more inviting and enchanting than the beauty of a perfect summer day. But both his lover and the summer are fleeting realities, but the art of his poem will endure far beyond both and capture the beauty of both for ages to come. Now imagine the speaker to be *any* one of our five paragons of genius while the lover is a metaphor for one of his artistic or scientific masterpieces.

> *Shall I compare thee to a summer's day?*
> *Thou art more lovely and more temperate:*
> *Rough winds do shake the darling buds of May,*
> *And summer's lease hath all too short a date;*
> *Sometime too hot the eye of heaven shines,*
> *And often is his gold complexion dimm'd;*

And every fair from fair sometime declines,
By chance or nature's changing course untrimm'd;
But thy eternal summer shall not fade,
Nor lose possession of that fair thou ow'st;
Nor shall death brag thou wander'st in his shade,
When in eternal lines to time thou grow'st:
So long as men can breathe or eyes can see,
So long lives this, and this gives life to thee.

After penning these lines, the man recognized universally as the greatest writer in history must have known that no one ever would be able to convey human feelings better or more effectively. When Beethoven, on his deathbed, raised his clenched fist at the roaring thunder outside his bedchamber and cried out, "I know I am an artist!" did he really have doubts whether he had not been a composer without peer? How about Leonardo, gazing out through Mona Lisa's eyes on her visitors, thinking, "Seek as you may, I will commune with you only so far; the rest is withheld, for it was my destiny to know things you will never know." This has to be the ultimate message in the immortal creations of each of the inscrutable transformative geniuses.

ACKNOWLEDGMENTS

It was clear from the beginning that a book with as many legs as *Beyond Genius* could benefit from discussions with specialists in a variety of fields: art, music, literature, medicine, physiology, psychology, physics, engineering, mathematics, astronomy, history, religion, and much more. Indeed, several friends and family members, whose backgrounds include one or more of these fields, read parts of the manuscript pertaining to their areas of expertise and, in several instances, the entire manuscript. They served as effective sounding boards, and frequently made suggestions that proved to be significant, while also bringing an international flavor to the project. Ultimately, any mistakes that made it through to the printing are solely my responsibility.

On Music (Beethoven)
Alan Fletcher, president of the Aspen Music Festival and School, and Doug Johnson, professor of music at Rutgers University, both helped me in understanding Beethoven. Ellen Brown, a physicist by vocation and violinist by avocation, was one of my best physics students ever, and I was one of her poorest music students. The talented trumpet virtuoso and cruise director Raphael Derkson was generous with his musical insight, especially in comparing jazz and classical music. Jamie Sample, a piano teacher in Virginia, tutored me on various aspects of music theory. Korean-born Min Kwon, Russian-born Svetlana Smolina, and Turkish-born Naki Ataman, all world-class piano virtuosos, were helpful in answering questions about musical performance.

On Literature (Shakespeare)
Emma Smith is a professor of Shakespeare studies at Oxford, and a fellow of Hertford College, where I served as a tutor in theoretical physics. She is the author of my favorite book on the Bard, *This is Shakespeare* (2019). Whit Morgan, a gifted English teacher at Episcopal High School, Alexandria, Virginia, served as an early advisor on the works of Shakespeare. Over the years, Whit taught summer workshops on Shakespeare at St Edmund Hall, Oxford.

On Technology and Engineering
Dündar Kocaoğlu trained as an engineer in Istanbul before embracing the burgeoning engineering and technology management field at the University

of Pittsburgh. Subsequently, he built a powerhouse program at Portland State University (PSU) in Oregon, establishing himself as a leader in the field. I am deeply beholden to him for the numerous discussions we have had at conferences organized by the Portland International Center for Management of Engineering and Technology (PICMET). Dündar read the manuscript and offered numerous useful suggestions. Indian-born Bala Mulloth, a professor at the Frank Batten School of Leadership and Public Policy at the University of Virginia, is also an engineer trained in technology management. I am grateful for our many conversations on artificial intelligence and future technology.

A major contribution to Leonardiana came from Norwegian artist Vebjorn Sand in 2001. Half a millennium after Leonardo proposed building a bridge in Istanbul, Sand masterminded the construction of a scaled-down version near Oslo. Although I did not know him at the time, we became friends in 2006. I journeyed to Istanbul with a proposal for an international project that would result in the construction of the full-sized bridge at Leonardo's original intended site. Unhappily, the project fell through, echoing so many Leonardo's own projects. I am grateful to Sand for our continued exchange of ideas.

André Buys is a professor emeritus of engineering at the University of Pretoria. After hearing my conjecture in 2005 that Leonardo may have designed and possibly built a reflecting telescope 160 years before Newton, André engaged in a two-year project to put the conjecture to a test. He tracked down Leonardo's drawings and descriptions of optical instrument designs, including lens and mirror grinding machinery, and built a working reflecting telescope, discussed in this book. Jamie Rogers, professor of industrial and systems engineering at the University of Texas at Arlington. She graciously read and advised me on modern entrepreneurship, the theme of the epilogue.

Again, in the area of entrepreneurs and innovators is Melissa Schilling, author of *Quirky*, an excellent survey book examining the creativity of eight "serial innovators." A professor of management and organization at NYU's Stern School of Business, Schilling is a renowned expert on innovation in technology.

On Medicine, Including Neuroscience, Psychiatry, and Cardiology

Arnold Ludwig is a distinguished psychiatrist, a lifelong academic, a prolific author, and a close friend. My thoughts were buttressed by two of his books. Investigating the connection between creativity and lunacy was primarily inspired by his work, spanning academia and treating inmates in mental institutions and prisons. Another distinguished psychiatrist and academic, Jerrold Post, founder of CIA's Center for the Analysis of Personality and Political Behavior, was also a good friend. He died of COVID-19 in 2020. Like Ludwig, he was the author of numerous books, including his last, *Dangerous Charisma*, that influenced my thoughts. Zeynel Karcioglu is an eminent ophthalmic surgeon at the University

of Virginia and an ardent art lover. We had many discussions, especially on the topic of ophthalmic disorders and how they influence painters. Christopher Tyler, psychologist, neuroscientist, passionate art lover, and friend of two decades, has made highly original contributions to the correlative process of how painters see their subjects and depict them in their works. Finally, psychologist Roy Weinstock and educator Laura Weinstock, friends who sequestered with us during the pandemic, were a continuous stream of information and discussions ranging from human psychology to religious history.

Francis Wells is a preeminent professor of cardiothoracic surgery at Royal Papworth Hospital, University of Cambridge. For two decades, Dr. Wells has carried out successful mitral valve repair on human hearts, inspired by the modus operandi of Leonardo himself. My son, Michael Atalay, is a professor of medicine at Brown University's Alpert Medical School, and a specialist in cardiac imaging with training at Johns Hopkins and Princeton. He has been a dependable resource on topics of physics and medicine.

On Fundamental Science, Mathematics, and History

Ady Mann, professor emeritus of physics at the Israel Institute of Technology (Technion) in Haifa, is an authentic polymath, a first-rate theoretical physicist and mathematician with a passion for history and the arts. We have been close friends since the early 1970s when we were young post-docs in the Department of Theoretical Physics at the University of Oxford, working under Sir Rudolf Peierls. It was my good fortune to share an office with Ady, putting us on a course to coauthor ten papers in theoretical physics. He read the entire manuscript. For his advice and wisdom, I cannot thank him enough. Teresa Larkin, a professor of physics at American University, Washington, DC, in her specialty of physics education research and in recruiting and training women in the sciences, has no rival. It was frequently in giving guest lectures to her students that I could field-test many of the book's topics. Another physicist friend who has been immensely helpful on technical issues is William D. Phillips, a recipient of the 1997 Nobel Prize in Physics. It is an understatement to describe him as an individual who has run some of the "coolest labs" in the world—at MIT, the National Institute of Standards and Technology (NIST), the University of Maryland, and Oxford. With his signature laser cooling and trapping technology, he achieved temperatures billions of times colder than the 3K of interstellar space. Martin Rees, formerly master of Trinity College, Cambridge, Astronomer Royal, and president of the Royal Society, is a distinguished cosmologist. He is also a manager of "big science" in the manner of Robert Oppenheimer. In 2010 and 2011, Lord Rees made arrangements for me to spend time in the Wren Library, examining Newton's personal books, and visiting the Royal Society in London.

For General Advice and Endorsements

According to his own description, Steve Meyers is "English by birth, American by choice." He is an entrepreneur, international management specialist, public policy advisor to governments, and one-time speechwriter for Margaret Thatcher. A graduate of the University of London and two seminaries, Rabbinical and Anglican, Steve is knowledgeable about both Church and English history. A classical music scholar by avocation, he served as Director of Classical Music for the University of Virginia radio station WTJU. He read the entire manuscript and made numerous suggestions. I am indebted to Alice Calaprice, former senior editor at Princeton University Press, and close friend Penny Dackis of National Geographic Books for invaluable advice in many areas of modern publishing.

I first met Keith Wamsley in a graduate class I taught in 2000. He is a humanities teacher at a private secondary school in Virginia but can teach any class in the secondary school curriculum and many classes at undergraduate and graduate levels. He served as the copy editor of my first book, *Math and the Mona Lisa* (Smithsonian Books, 2004). We co-authored *Leonardo's Universe* (National Geographic, 2009). Keith read the entire manuscript of the present book. He has always been a dependable consultant.

In reading the manuscript of *Beyond Genius*, Walter Isaacson emailed me, "I had a wonderful time reading this. Congratulations. It's a triumph, and I learned so much even about the characters I've chronicled myself." Mr. Isaacson happens to be the finest biographer of our time, and his books served as reference sources in my endeavors. I am immensely grateful for his generous endorsement appearing on the dust cover.

I was fortunate to engage Don Fehr, a former director of Smithsonian Books, as my literary agent, who in turn, introduced me to Jessica Case at Pegasus Books. Deputy publisher and editor at Pegasus Books, Jessica has been a joy to work with. For legal and general advice, I am deeply indebted to two lifelong lawyer friends, Marshall Meyers of Washington, DC, and Denis Murray of Crofton, MD.

Family

Ultimately, my greatest inspiration in writing this book came from my family: wife, Carol Jean; daughter, Jeannine and son, Michael and their spouses, Mike Harvey and Elizabeth Atalay. My grandchildren—Delilah, Amelia, Alexander, Isabella, Sophia, and Zachary—attended many of my talks at the National Geographic and the Smithsonian, as well as on cruise ships. They have all served as sounding boards, critics, and advisors. Between them, they have seen most of the world and have all been infected with the love of travel and the appreciation for great art and science. Most especially, I am grateful to Carol Jean, who read and re-read the manuscript, while frequently reminding me, "Less is more!" I should have listened.

NOTES

Prologue
1. Bulent Atalay, *Math and the Mona Lisa: The Art and Science of Leonardo da Vinci* (Smithsonian Books/HarperCollins, 2004). Bulent Atalay and Keith Wamsley, *Leonardo's Universe: The Renaissance World of Leonardo da Vinci* (National Geographic Books, 2009).
2. Aaron Copland, *What to Listen for in Music* (Penguin, 1957).
3. Leonard Bernstein, *The Unanswered Question: Six Talks at Harvard* (The Charles Eliot Norton Lectures, 1972–1973) (Harvard University Press, 1981).
4. Sherwin Nuland, *Leonardo da Vinci* (Penguin Books, 2002).
5. André Buys was responsible for the denuclearization of his nation following the dissolution of Apartheid in South Africa. This is the first and only time in history that a nuclear weapon program was dismantled.
6. Eugene Wigner, reprinted from *Communication Pure and Applied Mathematics*, 13, no. 1 (February 1960).
7. Subrahmanyan Chandrasekhar, *Truth and Beauty* (University of Chicago Press, 1987), lecture 3, "Shakespeare, Newton, and Beethoven, or Patterns of Creativity," 29–58.

1: Traits Positive and Negative
1. Arthur Koestler, *The Act of Creation* (Pan Books, Ltd., 1964), 708.
2. The number was thought to be over 100,000 a few years ago but has been reduced to around 20,000.
3. Dutch neuroscientist Danielle Posthuma has been spearheading some of the studies in statistical genetics. She holds the University Research Chair and Professorship in the Department of Complex Trait Genetics at the Vrije Universiteit Amsterdam.
4. Ann Gibbons, "Hundreds of New Genes May Underly Intelligence—But Also Autism and Depression," *Science Magazine*, June 25, 2018.
5. Computer architecture is a set of rules and methods that describe the functionality, organization, and implementation of computer systems.
6. Isaac Newton, *Philosophiæ Naturalis Principia Mathematica* (Royal Society of London, 1687). The work is comprised of three books. In Latin, the "c" in "Principia" is pronounced like a "k."
7. Niall Ferguson, *Civilization: The West and the Rest* (Penguin Books, 2011).
8. William Wordsworth, *Residence at Cambridge: The Prelude, or, Growth of a Poet's Mind* (1850), book 3, 57–58.
9. Arthur I. Miller, *Einstein, Picasso: Space, Time, and the Beauty that Causes Havoc* (Basic Books, 2001).
10. Banesh Hoffmann, onetime assistant to Einstein, "Except for the fact that he was the greatest physicist since Newton, one might almost say that he was not so much a scientist as an artist of science." Manjit Kumar, *Quantum: Einstein, Bohr, and the Great Debate about the Nature of Reality* (W. W. Norton, 2010), 237.
11. The Newton-Beethoven commonalities were first described in J. W. N. Sullivan, *Beethoven: His Spiritual Development* (Mentor Books, 1927).
12. Lecture by Prof. Glen Wilson, Gresham College Lecture, Sheldonian Theater. https://www.youtube.com/watch?v=Nje--J7fsfw.
13. James C. Kaufman, *Creativity and Mental Illness* (Cambridge University Press, 2014).
14. Arnold M. Ludwig, *The Price of Greatness: Resolving the Creativity and Madness Controversy* (Guildford Press, 1995).
15. Albert Rothenberg, *Creativity and Madness* (Johns Hopkins University Press, Baltimore, 1990).
16. Roger Dobson, "Creative Minds: The Links Between Mental Illness and Creativity," *Independent*, May 5, 2009, https://theeveningrednessinthewest.wordpress.com/2009/05/16/seneca-there-is-no-great-genius-without-a-tincture-of-madness/.
17. John Nash, "American Experience," PBS. http://www.pbs.org/wgbh/amex/nash/peopleevents/p_jnash.html.
18. According to Trending Post, Einstein was left-handed, and so were Benjamin Franklin, Charles Darwin, Bill Gates, and one-fourth of all astronauts: https://trendingposts.net/trending-news/left-handed-people-facts/.
19. The Eli and Edythe L. Broad Institute of MIT and Harvard is frequently referred to as "the Broad Institute," a biomedical and genomic research center, located in Cambridge, MA.
20. The huge study included almost 480,000 individuals, 408,000 from the UK Biobank and the rest from the genetic testing service "23andMe." The four markers published in the 2018 study were #7, #11, #12, and #15. The analysis is an example of a big-data technique known as "genome-wide association."

- Michael Price, "Giant Study Links DNA Variants to Same-Sex Behavior," *Science*, October 20, 2018.
- Pam Belluck, "Many Genes Influence Same-Sex Sexuality, Not a Single "Gay Gene," *New York Times*, August 29, 2019.
- Lyndsey Bever, "There's No One 'Gay Gene,' but Genetics are Linked to Same-Sex Behavior, New Study Says," *Washington Post*, August 29, 2019.

21 Akira Wiberg et al., "Handedness, Language Areas and Neuropsychiatric Diseases: Insights from Brain Imaging and Genetics," *Journal of Neurology*, September 5, 2019. https://academic.oup.com/brain/advance-article/doi/10.1093/brain/awz257/5556832.

22 C. W. Tyler, "Evidence That Leonardo da Vinci Had Strabismus," *Journal of Ophthalmology*, October 18, 2018. Christopher Tyler is a long admired friend and fellow Leonardista.

23 Nick Zagorski, "Music on the Mind," *Hopkins Medicine* (Spring-Summer 2008): 18–21.

24 James Gleick, *Isaac Newton* (Vintage Books, 2003).

25 J. Ruthsatz and J. B. Urbach, "Child Prodigy: A Novel Cognitive Profile Places Elevated General Intelligence, Exceptional Working Memory and Attention to Detail at the Roots of Prodigiousness," *Science Direct* 40, no. 5 (September-October 2012): 419-26. http://scottbarrykaufman.com/wp-content/uploads/2012/07/Ruthsatz-Urbach-2012.pdf.

26 JoAnna Klein, "How Pasteur's Artistic Insight Changed Chemistry," *New York Times*, January 14, 2017.

27 On a personal note, Barry Marshall is one of the twenty-nine Nobel Prize winners I have known. He was my gastroenterologist in 1989–1991 at the University of Virginia Medical School.

28 Kush Agrawal, "The First Catheterization," *Hospitalist*, December 6, 2006. https://www.the-hospitalist.org/hospitalist/article/123249/first-catheterization.

29 Claudia Kalb, *Spark Ignites from Child Prodigies to Late Bloomers*, (National Geographic Books, 2021).

30 Louisa Gilder, "Quantum Leap," *New York Times*, September 8, 2009.

2: Multiple Intelligences

1 Howard Gardner, *Frames of Mind: The Theory of Multiple Intelligences*, (Basic Books, 1983).

2 Howard Gardner, *Multiple Intelligence* (Basic Books, 1993).

3 Banesh Hoffmann and Helen Dukas, *Albert Einstein: Creator and Rebel* (Viking Press, 1972).

4 Banesh Hoffmann, *The Tyranny of Testing* (Collier, 1964).

5 Andrew Hodges, *Turing: The Enigma* (Walker & Co., 2000 edition) 212.

6 Arnold Ludwig, personal communication.

7 Lena Groeger, "When High IQs Hang Out," *Scientific American*, November 1, 2012.

8 Anthony Rothenberg, *Creativity and Madness New Findings and Old Stereotypes* (Johns Hopkins University Press, 1994).

9 The most prominent of the musical sons were Carl Phillip Emanuel "CPE Bach," Wilhelm Friedemann "WF Bach," and Johann Christian "JC Bach."

10 Ellis Marsalis passed away of COVID-19 during the spring of 2020. The best-known musician son is Wynton Marsalis, both a jazz and classical music virtuoso. *New York Times*, April 2, 2020.

11 Durer's self-portrait created when he was twenty-eight years old hangs in the Alte Pinakothek in Munich. An unusually good reproduction can be viewed at the following site: Jason Farago, "Seeing Our Own Reflection in the Birth of Self-Portrait," *New York Times*, September 25, 2020.

12 The parents of the two girls are good friends of the author. They are both architects.

13 Graham, Elyse, "Adventures in Fine Hall," *Princeton Alumni Weekly*, January 2018. https://paw.princeton.edu/article/adventures-fine-hall.

3: The Zeitgeist Factor

1 Letter to Miss Theodate Johnson, published in *Musical America*, September 13, 1960. Prior to the 1960 election, Johnson had sent a questionnaire to the two presidential candidates regarding their feeling about the arts.

2 The catchy phrase comes from James Gleick, *Isaac Newton* (Pantheon Books, 2003).

3 The multinational Solvay Chemicals was founded in Brussels, Belgium, by the brothers Ernest and Alfred Solvay in 1863. An extraordinary three-minute home film made with Irving Langmuir's movie camera of the participants of the 1927 conference as they exist the conference can be viewed at https://www.youtube.com/watch?v=8GZdZUouzBY followed by photo of 1911 conference: https://www.youtube.com/watch?v=ueqVVa4iA24. www.FreeScienceLectures.com.

4 Narrated by Glenn Close, *Verrocchio: Painters and Sculptors of Renaissance Florence* (National Gallery of Art, 2019).

5 The first quatrain of Sonnet 77.

6 Listen to the inaugural address of John F. Kennedy: https://upload.wikimedia.org/wikipedia/commons/d/d5/JFK_inaugural_address.org.

7 The campaign to improve civil rights of the minority proposed during the Kennedy administration were advanced in the administration of JFK's successor, Lyndon Baines Johnson. The 36th president was a master politician who had served as the Democratic majority leader in the Senate before becoming JFK's vice president. The larger-than-life Texan employed every trick available in his arsenal for effective "horse-trading," including arm-twisting, cajoling, and threatening to get the required votes.

8 Originally attributed to Emperor Tiberius by Suetonius in his book, *The Lives of the Twelve Caesars* (Loeb Classical Library, 1913). Jefferson owned a 1718 edition of Suetonius's works. Variations of Jefferson's words exist.

9 William Crawley, in a 2020 lecture, in the Great Lives series at the University of Mary Washington, Virginia.

4: A Singularity in the History of Art

1 Extrovert buildings: in times before steel beams became available, expansive flat ceilings and massive roofs had to be held up by interior walls or columns. The periphery of the interior of the Parthenon displayed a virtual forest of columns. But from the exterior, the building exhibited incomparable harmony and beauty.

2 These copies are now on display in the Archaeological Museum in Naples.

3 Herve Merliac, "Christo, Artist Who Wrapped Festoon on an Epic Scale, Dies at 84," *New York Times*, May 31, 2020.

4 Malcolm Arnold (1921–2006) was an English composer and trumpeter.

5 Nicols Slonimsky, *Slonimsky's Book of Musical Anecdotes*. (Schirmer Books, 1998).

6 *Peanuts* strip published on February 22, 1952.

7 Scott Burnham, "The Four Ages of Beethoven: Critical Reception and the Canonic Composer," in *The Cambridge Companion to Beethoven*, ed. Glenn Stanley (Cambridge University Press, 2000), 272–91.

8 Aaron Copland, *What to Listen for in Music* (McGraw-Hill, 1939).

9 Aaron Copland, *What to Listen for in Music*, 28.

10 Howard Chandler Landon (1926–2009) was an American musicologist, journalist, historian, and broadcaster in Boston. bit.ly/3kfolQh.

11 Bernstein was quoted in a blog by T. Tucker in "Leonard Bernstein: From Mahler to the Beatles," *Culture Club*, December 1, 2009.

12 The three lecturers were Ross King, author of *Brunelleschi's Dome* and *The Last Supper*; William Cook, historian and presenter for the Great Courses Company; and the author.

13 Alan Fletcher is the president and CEO of Aspen Music Festival and School. He is one of the country's most accomplished music administrators and respected composers. Before arriving at the Aspen Institute in 2006, he had served as the head of the School of Music and professor of music at Carnegie Mellon University and earlier as provost and senior vice president at the New England Conservatory. Born in 1956 in New Jersey, he earned a BA at Princeton University (1978) and an MA and PhD at Juilliard (1979 and 1983, respectively).

14 Robert Haven Schauffler, *Beethoven: The Man Who Freed Music* (Tudor Publishing Co., 1955).

15 Donald Grout and Claude Palisca, *A History of Western Music*, 4th ed. (W. W. Norton, 1968).

16 Alex Ross, "Deus Ex Musica," *New Yorker*, October 14, 2014.

17 Scott Burnham, "The Four Ages of Beethoven: Critical Reception and the Canonic Composer," in *The Cambridge Companion to Beethoven*, ed. Glenn Stanley (Cambridge University Press, 2000), Op. Cit.

18 Section laying out the principal themes, establishing the primary key, and modulating to the secondary key.

19 A middle part, usually shorter, presenting frequent modulations and thus having a less definite character. The German term *Durchführung*—Leading-through—is clearer as to what happens, since in any good piece ideas are always being developed, not just in this section.

20 "Another misleading term. The music of the Exposition returns, usually in a very dramatic way after the uncertain key areas of the Development. But the Exposition modulated and the Recapitulation must end in the home key, so things get changed around. I prefer to call this section the Return. Also, a Coda (tail) may be added to emphasize the return to the home key. The Coda of Beethoven's *Fifth Symphony*'s first movement is the most emphatic of all." A. Fletcher.

21 Edmund Morris *Beethoven: The Universal Composer*, Emminent Lives (Harper Perennial, 2020).

22 "Béla Bartok—The Golden Ratio in Music," ETH Zürich, https://bit.ly/3J67Bte.

23 "Music of the Heart," *Oxford Today*, Michaelmas term, 2015. Reporting on the revelation by Professor Peter Sleight at the British Cardiovascular Society meeting in Manchester.

24 Peter Sleight et al., "Dynamic Interactions Between Musical, Cardiovascular, and Cerebral Rhythms in Humans," *Circulation American Heart Association Journal*, June 29, 2009.
25 Beethoven's influence on other composers, Classic FM, Digital Radio 100–102 FM, https://www.classicfm.com/composers/beethoven/guides/beethoven-legacy/.
26 "Artistic Maturity (1805–1815)," *All About Ludwig van Beethoven*. http://www.all-about-beethoven.com/beethovenmature1.html.
27 Robert Greenberg, *Great Masters: Beethoven-His Life and Music*. CDs and Guidebook. Course No. 755 (2001).
28 The Violin Concerto in D opens with four gentle strikes of the kettledrums (tympani), an instrument introduced into the orchestra for the first time. It premiered in 1806, and inspired one writer to derisively label the work "Concerto for Kettledrums."
29 Leonard Bernstein's analysis of Beethoven's Ninth Symphony. YouTube: https://www.youtube.com/watch?v=n174gyZkf-U.
30 There were initially six children born to the Anglo Irish Brontë family. The two older sisters, Elizabeth and Maria Brontë, died within two months of each other at the ages of 10 and 11, respectively, in 1825. Emily and Ann died six months apart in 1848. All succumbed to tuberculosis.
31 "Ode to Joy," sung by 10,000 voices. YouTube: https://www.youtube.com/watch?v=xBlQZyTF_LY.
32 Beethoven's Expansion of the Symphonic Coda: http://wafflesatnoon.com/beethovens-expansion-of-the-symphonic-coda/.

5: King Kong versus Other Monkeys

1 William Shakespeare, *Twelfth Night*, act 2, scene 5.
2 Edwin Wilson, ed., *Shaw on Shakespeare*. http://www.halleonard.com/product/viewproduct.action?itemid=314532&.
3 Stephen Booth, *Shakespeare's Language and the Language of Shakespeare's Time* (Cambridge University Press, 1997).
4 Leo Nikolayevich Tolstoy, *Tolstoy on Shakespeare: A Critical Essay on Shakespeare & Katia* (Critical Space Publishing, 2016).
5 Letter to Vasily Botkin.
6 Michael Wood, *In Search of Shakespeare*.
7 William Shakespeare, *Henry VI*, part 3, act 1, scene 4.
8 Michael Wood, *In Search of Shakespeare*.
9 Robert McCrum, "Who Really Wrote Shakespeare?" *Guardian*, March 13, 2010.
10 Elizabeth Winkler, "Was Shakespeare a Woman?" *Atlantic Monthly*, June 7, 2019.
11 https://en.wikipedia.org/wiki/Late_string_quartets_(Beethoven).
12 Emma Smith, *This is Shakespeare* (Pelican, 2019).
13 Alex Ross, *Wagnerism: Art and Politics in the Shadow of Music* (Farrar, Straus and Giroux, 2020). Book review by John Adams, "From George Eliot to Neo-Nazi Skinheads: The Chaotic Cult of Richard Wagner," *New York Times*, September 16, 2020. https://www.nytimes.com/2020/09/16/books/review/wagnerism-alex-ross.html.
14 He was at once an applied psychologist, psychiatrist, psychoanalyst, and a psychotherapist three centuries before these fields were invented, and superior to all subsequent practitioners in these fields.
15 Jerrold Post was the founder and head of the office of psychological profiling at the CIA, a post he held for twenty-one years. The expression "dangerous charisma" is borrowed from the tile of his last book. Jerrold Post died of complications from COVID-19 on November 22, 2020.
16 "The English language owes a great debt to Shakespeare. He invented over 1700 of our common words by changing nouns into verbs, changing verbs into adjectives, connecting words never before used together, adding prefixes and suffixes and devising words wholly original." http://www.shakespeare-online.com/biography/wordsinvented.html.
17 Harold Bloom, *Falstaff: Give Me Life* (Scribner, 2017), 6.
18 S. Chandrasekhar, "Truth and Beauty," Nora and Edward Ryerson Lecture (University of Chicago Record, 1974–1975); William Shakespeare, *The Taming of the Shrew*, act 1, scene 2.
19 Sonnet 80.
20 Christopher Shea, "New Oxford Shakespeare Edition Credits Christopher Marlowe as a Co-author," *New York Times*, October 24, 2016.
21 William Shakespeare, Sonnet 18.
22 Morris Kline, *Mathematics in Western Culture* (Oxford University Press, 1964), 234.
23 John Wiltshire, La Trobe University, Melbourne. Author of *Jane Austen and the Body* (Cambridge University Press, 1992) and *Recreating Jane Austen* (Cambridge University Press, 2001).
24 Nicholas Dames, "Jane Austen Is Everything," *Atlantic Monthly*, September 2017.

NOTES 443

25 YouTube, "Emma Smith: Building the Shakespeare Brand—Marketing the Theater in the Elizabethan Period." https://www.youtube.com/watch?v=t0pfviGLOEM.
26 Mihir A. Desai, *The Wisdom of Finance: Discovering Humanity in the World of Risk and Return* (Houghton Mifflin Harcourt, 2017).
27 Brian C. Southam, *Jane Austen's Literary Manuscripts* (Clarendon Press, 1966).
28 Her illness at the time was attributed to an imbalance of bile. Subsequent decades saw speculations of Addison's disease and tuberculosis as possible culprits.
29 Helena Kelly, "The Many Ways We Are Wrong About Jane Austen," *Literary Hub*, May 3, 2017.
30 The foregoing quotations are of course from Herman Melville, *Moby Dick* (1851), and Charles Dickens, *A Tale of Two Cities* (1859).
31 There were initially six children born to the Anglo Irish Brontë family. The two older sisters, Elizabeth and Maria Brontë, died within two months of each other at the ages of ten and eleven, respectively, in 1825. Emily and Anne died six months apart in 1848. All succumbed to tuberculosis.

6: Leonardo's Model

1 Bulent Atalay, *Math and the Mona Lisa: The Art and Science of Leonardo da Vinci* (Smithsonian Books, 2004).
2 Tom L. Freudenheim, "A Portrait Both Sensible and Serene," *Wall Street Journal*, January 11, 2019.
3 The ferret has been domesticated but the ermine has not.
4 Vincent Finnan is the owner and author of this blog. Although by his own claim that he is not an art historian, he is an effective autodidact, with deep interest in art. https://www.italian-renaissance-art.com/La-Belle-Ferroniere.html.
5 Margaret Livingstone, *Vision and Art: the Biology of Seeing* (Harry N. Abrams, 2002).
6 Centerline Principle of Christopher Tyler. http://christophertyler.org/CWTyler/Art%20Investigations/EyePlacement/AncientEyePlacement/AncientEyeCenterSPIE.html.
7 Jamie Wyeth, born in 1946, is the son of the Andrew Wyeth (1917–2009), and the grandson of N. C. Wyeth (1882–1945).
8 "Leyster" as "leading star," are the words of an art critic in seventeenth-century Netherlands.
9 In her self-portrait, Gentileschi is seen holding her paint brush in her right hand. Again, there is the usual question, "Is she really right-handed, or just posing in a mirror with the brush in her left-hand?" an issue familiar to any painter who has created a self-portrait or a "selfie" with a smartphone.
10 Mary D. Sheriff, "The Woman-Artist Question," *Royalists to Romantics: Women Artists from the Louvre, Versailles, and Other French National Collections* (National Museum of Women in the Arts, in association with Scala Publishers Ltd., 2012).
11 "Frances H. Arnold: Nobel Prize in Chemistry 2018," Caltech Online. https://www.nobelprize.org/womenwhochangedscience/stories/frances-arnold.
12 "Frances H. Arnold: Nobel Prize in Chemistry 2018."
13 Frances Arnold, as the Linus Pauling Professor Chemical Engineering, Bioengineering and Biochemistry is the director of the Donna and Benjamin M. Rosen Bioengineering Center.
14 Heidi Ledford and Ellen Callaway, "Pioneers of Revolutionary CRSPR Gene-Editing Win Chemistry Nobel," *Nature* 486 (2020), 346–47. Charpentiere is presently at the Max Planck Unit for the Science of Pathogens in Berlin, and Doudna at the University of California, Berkeley.
15 Ken Kingery, "Duke Computer Scientist Wins $1 Million Artificial Intelligence Prize, A 'New Nobel,'" October 11, 2021. Duke, Trinity College of Arts and Sciences Online: https://trinity.duke.edu/news/duke-co-scientist-wins-1-million-artificial-intelligence-prize-new-nobel.

7: The Intersection of Art and Science

1 No one knows how the architects arrive at the figures of 3.5 miles (5.6 km) and 1.5 miles (2.4 km). They may have just eyeballed it, trusting their aesthetic senses.
2 In 1978 Frederick Hart (1943–1999) had completed the tympanum, including its centerpiece, "Ex Nihilo," above the western or main entrance of the National Cathedral in Washington. After that commission, he sculpted the trio of soldiers complementing Maya Lin's wall at the Vietnam Memorial.
3 Bulent Atalay, *Math and the Mona Lisa* (Smithsonian Press, 2004), 121–25.
4 Antonie Van Leeuwenhoek, "Memories of Johannes Vermeer," Federation of American Societies for Experimental Biology (FASEB), April 2006. (Referring to a letter written on December 14, 1685, and preserved in the archives of the Royal Society in London).
5 Jason Farago, "The Absolute Vermeer, in a Show More Precious Than Pearls," *New York Times*, February 10, 2023. Nina Siegal, "The Fullest View of Vermeer Still Leaves Plenty to the Imagination," *New York Times*, February 5, 2023.

8: The Universal Genius and Failed Scientific Revolution

1. Edward MacCurdy, *The Notebooks of Leonardo da Vinci* (Easton Press, 2014). The compendious volume of 1,180 pages is a collectors' edition, based on the original translated, arranged and published with the same title by Duckworth & Co., London, 1906.
2. The Battle of Cascina had been fought between Florence and Pisa in 1364 and the Battle of Anghiari in 1440 between Florence and Milan.
3. Kim Williams is co-editor in chief of *Nexus Network Journal: Architecture and Mathematics*. Springer-verlag. https://www.nexusjournal.com/eb-intro/kim-williams.html.
4. Bayezid II is known as an enlightened leader who is well-known for welcoming into the Ottoman Empire the Jews expelled by Spain in 1492. He was overthrown by a recalcitrant son, Yavuz Sultan Selim.
5. The drawing is contained in a small *Codex, Manuscript L*, in the possession of the Institut de France in Paris.
6. Another bridge in the ranking was the new Calatrava Bridge, the fourth bridge spanning the Grand Canal in Venice. *Wired*, January 2005.
7. Chandler, David L., "Engineers Put Leonardo da Vinci's Bridge Design to the Test," *MIT News*, October 9, 2019. https://news.mit.edu/2019/leonardo-da-vinci-bridge-test-1010.
8. Igor Sikorski, the Russian-born aviation pioneer, claimed to have been inspired in his design of the helicopter in first seeing Leonardo's drawing of the aerial screw (1912).
9. Edward MacCurdy, *Notebooks of Leonardo da Vinci*, 497.
10. Mark Rosheim, *Leonardo's Lost Robots* (Springer Online, 2006).
11. Bulent Atalay, *Math and the Mona Lisa*, 195.
12. William J. Broad, "A Doodle Reveals da Vinci's Early Deconstruction of Gravity," *New York Times*, February 17, 2023. https://www.nytimes.com/2023/02/17/science/leonard-da-vinci-gravity.html, Original article: Morteza Gharib, Chris Roh, and Flavio Noca, *Journal Leonardo* 56, no. 1 (2023).
13. During the late 1930s, Mussolini commissioned engineer Roberto Guatelli to re-create many of Leonardo's machines. Guatelli, using the materials Leonardo had specified, wood, leather, iron, and brass, replicated many machines. Subsequently, they were shipped to Japan for exhibition. But with the breakout of WWII, they remained trapped in Tokyo and eventually destroyed by aerial bombing. After the war, IBM hired Guatelli to build the machines again. Guatelli founded a company and enlisted his son-in-law to help manufacture multiple versions of the machines for travel exhibitions.
14. The title of this section is inspired by the great Oxford art historian Martin Kemp's foreword for the magnificent book by cardiac surgeon Francis Wells, *The Heart of Leonardo* (Springer, 2013). Op. Cit.
15. Sherwyn Nuland, *Leonardo da Vinci* (Penguin Books, 2002), 131.
16. Da Vinci Center, VCU, Richmond, VA. Announcement of the author's lecture, "VCU da Vinci Center for Innovation in Product Design and Development Presents da Vinci Day 2009," https://www.news.vcu.edu/article/VCU_da_Vinci_Center_for_Innovation_in_Product_Design_and_Development.

9: Interrogating Nature: Becoming Modern

1. Yuval Noah Harari, *Sapiens: A Brief History of Humankind* (HarperCollins, 2015).
2. Although historical evidence is much too incomplete to assign an actual date to the birth of Christ, it is believed by theologians to be in the range 6 B.C.E.–4 B.C.E. The range comes from the gospels of Luke and Matthew giving the earlier date and estimation worked out backward form the start of Jesus's ministry for the latter. Astronomers have also weighed in suggesting the occurrence of a *syzygy*, the brighter than normal appearance created in the alignment of heavenly bodies. One thing for certain is that in the Justinian Calendar, zero (0) does not exist. The year after 1 B.C.E. is 1 C.E.
3. Stephen Jay Gould, "Nonoverlapping Magisteria," *Natural History*, 1997; Stephen Jay Gould, *Rock of Ages* (Vintage Books, 1999).
4. The fifth century B.C.E. historian Herodotus of Halicarnassus (modern Bodrum) reported Thales's prediction of an eclipse. Chronicling that eclipse, modern astronomers were able to compute its exact date.
5. Freeman Dyson, "Birds and Frogs," *Notices of the AMS* 5, no. 2 (2009).
6. Freeman Dyson, "Birds and Frogs."
7. Morris Kline, *Mathematics in Western Culture* (Oxford University Press, 1964), 234. Op Cit.
8. The 1931 visit was chronicled in a lecture given in 2015 at Oxford's Christ Church by Einstein biographer Andrew Robinson, *Princeton Alumni Magazine*, December 1, 2015.
9. Ellen Carol DuBois, "Overlooked No More: Eleanor Flexner, Pioneering Feminist in an Anti-Feminist Age," *New York Times*, October 16, 2020.

10: The Newtonian Revolution

1. Alexander Pope (1688–1744). English poet and satirist of the Enlightenment. According to Wikipedia, Pope is the second most quoted author in *The Oxford Dictionary of Quotations*.
2. Prominent German physicists Philipp Lenard made the claim during the 1930s.
3. Lawrence Krauss, *The Physics of Climate Change*, (Post Hill Press, 2021). CO_2 in the atmosphere is the single most prominent culprit molecule for causing global increase in temperature. The CO_2 in the atmosphere had remained constant for thousands of years until the industrial revolution in the mid-19th century. This is based on the stratified levels of bubbles of atmosphere trapped in a mile-deep ice in Greenland and Antarctic. Beginning in the International Geophysical Year (1957–1958), the National Oceanographic and Atmosphere Administration (NOAA) has been keeping precise data on daily CO_2 concentration in the atmosphere at the Mauna Loa Observatory, Hawaii. There has been a rise of an average 1.51 parts per million (ppm) per year from 313.4 ppm in March 1958 to 421.06 ppm on June 18, 2022, then to 423.16 ppm on June 18, 2023 in a smoothly rising exponential curve. The 2022–2023 period saw 2.10 ppm rise. This is independent and beyond the effects from the degrees of freedom experienced by the earth and entirely beyond human control, including the period of precession of the earth's orbital axis (26,000 years), the nutation of the rotational axis (18.6 years), the bobbing up and down of the solar system through the ecliptic plane of the Milky Way, resulting in greater asteroid collisions, periods of extinctions of species (64 million-year); plate tectonics; the Sun's 11-year cycle of solar flares, etc. https://www.co2.earth/daily-co2#:~:text=420.73%20ppm&text=This%20table%20presents%20the%20most,Source%20%3D%20NOAA%20GML.
4. The title of an article published in 1960 by Eugene Wigner, "The Great Math Mystery," March 30, 2016. http://www.pbs.org/wgbh/nova/physics/great-math-mystery.html.
 More recently another mathematical genius Roger Penrose, recipient of the 2020 Nobel Prize in Physics, discussed "Is Mathematic Invented or Discovered?" on YouTube: www.youtube.com/watch?v=ujvS2K06dg4.
5. As of 2014, p had been computed by high-speed computers to twelve trillion places.
6. The Lucasian Chair is one of the most prestigious position in academia. The chair made famous by Newton, has also been held by Paul Dirac and Stephen Hawking.
7. Annalee Newitz, "What Social Distancing Looked Like in 1666," *New York Times*, March 29, 2020.
8. Richard Feynman, *The Character of Physical Law* (MIT Press, 1967).

11: The Relativistic Revolution

1. Sir J. C. Squire (1884–1958) was an English journalist, playwright, a leading poet of the Georgian school, and an influential critic and editor. Squire's quotation referring to Einstein is an appropriate sequel to Pope's quotation referring to Newton.
2. Sears, Zemanski, Richards, and Wehr, *Modern University Physics* (Addison Wesley, 1961).
3. Susan Quinn, *Marie Curie: A Life* (Simon & Schuster, 1995).
4. Chemist Irene Joliot-Curie and her physicist husband Frédéric Joliot-Curie shared the 1935 Nobel Prize in Chemistry for the discovery of artificial radioactivity in 1934.
5. Walter Isaacson, *Einstein: His Life and the Universe* (Simon & Schuster, 2007).
6. Special relativity deals with constant velocities. As an academic argument, we assume an instantaneous acceleration, which is of course impossible . . . except for light which has only one speed, c.
7. The unit of kilogram (kg) is in reality a unit of mass. An unhappy convention, however, sees individuals in metric countries using kg as weight. The real weight of *80 kg* would be $80kg \times g = 9.8m/sec^2 = 784$ *Newtons*. Where people use kg as weight, however, the easy conversion is *2.2 lbs* translates to *1 kg*.
8. The bothersome gap (1.4 *ms* < m < 5.0 *ms*) has now been tightened. The "light blackhole" with a mass of only 2.6 *ms* was detected by Virgo in 2019.
9. "Gravitational Waves Detected 100 Years After Einstein's Prediction" LIGO, Caltech, February 11, 2016. https://www.ligo.caltech.edu/news/ligo20160211.
10. The 2017 Nobel Prize for Physics: https://www.quantamagazine.org/ligos-rainer-weiss-kip-thorne-and-barry-barish-win-physics-nobel-20171003/.
11. "James Peebles—Facts," Nobel Media AB 2020, accessed August 26, 2020, https://www.nobelprize.org/prizes/physics/2019/peebles/facts/.
12. Lawrence Krauss, *A Universe from Nothing: Why There Is Something from Nothing* (Free Press, 2012).
13. Time running faster at the top of a building compared with the bottom was also confirmed by Pound and Rebka using the Mossbauer Effect, who won the Nobel Prize in Physics in 1961.
14. Frances Arnold, private communication, November 2020.

12: The Quantum Revolution

1. Quoted in Jeremy Bernstein, "John Stewart Bell: Quantum Engineer" (Quantum Profiles, 1991).
2. Sherwin Nuland, *Leonardo da Vinci* (Penguin Books, 2002).
3. Manjit Kumar, *Einstein, Bohr, and the Great Debate About the Nature of Reality*, (W. W. Norton, 2016).
4. "John Bell and the Most Profound Discovery of Science," *Physics World*, December 1, 1998.
5. John S. Bell, *Speakable and Unspeakable in Quantum Mechanics* (Cambridge University Press, 1987), 65.
6. Alice Calaprice, ed., *The Ultimate Quotable Einstein* (Princeton University Press, 2011), 378; Einstein's letter to Langevin, December 16, 1924, Einstein Archives 15-377.
7. Manjit Kumar, *Einstein, Bohr, and the Great Debate About the Nature of Reality* (W. W. Norton, 2016). Op. Cit. Also available in a 2009 online version: https://publicism.info/science/quantum/10.html.
8. It was experimentally confirmed that electrons could undergo interference in the manner of light waves.
9. Herbert Goldstein, *Classical Mechanics* (Addison-Wesley, 1951).
10. Freeman Dyson, "Birds and the Frogs," *Journal of the American Mathematical Society* 56, no. 2 (2009).
11. John Wheeler, "Thoughts on action-at-a-distance during the war work," Session VIII, Center for History of Physics, American Institute for Physics (AIP Oral History Series). Interviewed by Kenneth W. Ford, Princeton University (between December 6, 1993 and May 18, 1995). Online, https://www.aip.org/history-programs/niels-bohr-library/oral-histories/5908-7.
12. Sam Kean, *The Bastard Brigade: The True Story of the Renegade Scientists and Spies Who Sabotaged the Nazi Atomic Bomb* (Hodder & Stoughton, 2019).
13. Graham Farmelo, *The Strangest Man* (Basic Books, 2011) Op. Cit. 183.
14. Freelance journalist Torrill Kornfeldt interviewed Duncan M. Haldane in Stockholm following the 2016 Nobel Prize award ceremonies. Watch the interview at https://www.nobelprize.org/mediaplayer/index.php?id=2705.
15. Luisa Gilder, "Quantum Leap," *New York Times Book Review*, September 8, 2009. http://www.nytimes.com/2009/09/13/books/review/Gilder-t.html.
16. Personal communication from Sir John Eccles (1977). Australian-born Eccles was the recipient of the 1963 Nobel Prize in Medicine or Physiology.
17. William Lanouette, with Bela Silard, *Genius in the Shadows: A Biography of Leo Szilard, The Man Behind the Bomb* (Charles Scribner's Sons, 1994).
18. William Lanouette, "Ideas by Szilard, Physics by Fermi," *Bulletins of the Atomic Scientists*, December 1992, 17. Rutherford's declaration came in 1933.
19. MAUD for "Military Application of Uranium for Defense" was one of a number of acronyms. In his autobiography, Peierls offered this version as a reasonable choice. Rudolf Peierls, *Bird of Passage: Recollections of a Physicist* (Princeton University Press, 1985), 156.
20. The Presidential Medal of Freedom, awarded to Frisch and Peierls by President Harry Truman is described as "an award to recognize people who have made 'an especially meritorious contribution to the security or national interests of the United States, world peace, cultural or other significant public or private endeavors.'"
21. Jeremy Bernstein, "A Quantum Story: 1927 Solvay Conference," Institute for Advanced Study, School of Natural Sciences, 2011. https://www.ias.edu/ideas/2011/bernstein-quantum-story.
22. Lecture by Cambridge University cosmologist David Tong at the Royal Institution on February 15, 2017. "The Real Building Blocks of the Universe." https://www.youtube.com/watch?v=zNVQfWC_evg.
23. Dana Bolles, "Dark Energy, Dark Matter," NASA Science, last updated June 14, 2023. https://science.nasa.gov/astrophysics/focus-areas/what-is-dark-energy#:~:text=But%20it%20is%20an%20important,than%205%25%20of%20the%20universe.

13: Lumps, Bumps, and the Gifted Mind

1. Q. M. Q., "The Insanity of Sir Isaac Newton," *Phrenological Journal and Miscellany* 7, no. 27 (March 1831–September 1832): 342.
2. The 1984 film *Amadeus* portrayed the scene of Mozart's burial in a mass paupers' grave notwithstanding, in reality communal burials were common in Vienna in the eighteenth and nineteenth centuries. See the account by P. G. Bahn in *Archaeology*, March/April 1991, 38–41.
3. Mozart's death: https://en.wikipedia.org/wiki/Death_of_Wolfgang_Amadeus_Mozart.
4. A disparity of approximately one part per million occurs with spins-up rather than spins-down.
5. Eric Kandel, *The Disordered Mind: What Unusual Brains Tell Us About Ourselves* (Farrar, Straus and Giroux, 2018); Eric Kandel, *The Age of Insight: The Quest to Understand the Unconscious in Art, Mind, and Brain* (Random House, 2012). Kandel is a passionate art lover and displays remarkable insight into artistic creativity as a function of the brain and of the prevailing social culture.
6. Elisabeth Hertenstein et al., "Modulation of Creativity by Transcranial Direct Current Stimulation," *Brain Stimul* 12, no. 5 (September-October 2019): 1213–21. "Spark of Genius," *Economist*, June 15, 2019, 74.

NOTES

7. The subjects were given three separate tests to determine the aspects of creativity: (1) conceptual expansion (Alternate Uses Task, AUT); (2) associative thinking (Compound Remote Associate Task, CRA); and (3) set shifting ability (Wisconsin Card Sorting Task, WCST). Simultaneously, they received cathodal stimulation of the left and anodal stimulation of the right inferior frontal gyrus (IFG), the reverse protocol, or sham stimulation. Just as reversing the polarity of the source of the direct current did not help to increase creativity, using an alternating current certainly would not work.
8. S. F. Witelson, D. L. Kigar, and T. Harvey. "The Exceptional Brain of Albert Einstein," *Lancet* 353 (1970): 2149–53.
9. Eugene Wigner, personal communication.
10. "Death of Ludwig van Beethoven," https://en.wikipedia.org/wiki/Death_of_Ludwig_van_Beethoven.
11. Nick Zagorski, "Music on the Mind," 21.
12. James Gleick, *Isaac Newton* (Pantheon Books/Random House, 2003), 5.
13. L. W. Johnson and M. L. Walbarsht, "Mercury Poisoning Cause of Isaac Newton's Physical and Mental Ills," *Notes and Records of the Royal Society of London* 34, no. 1 (July 1979).
14. Lead poisoning, Mayo Clinic: https://www.mayoclinic.org/diseases-conditions/lead-poisoning/symptoms-causes/syc-20354717.
15. TJA Begg et al., "Genomic Analyses of Hair from Ludwig van Beethoven," *Current Biology*, March 23, 2023. doi: 10.1016/j.cub.2023.02.041. Online version https://www.cell.com/current-biology/fulltext/S0960-9822(23)00181-1.
16. Sarah Knapton, "Leonardo da Vinci Paintings Analysed for DNA to Solve Grave Mystery," *Telegraph*, May 5, 2016.

14: Eccentricity in Scientific Genius: A Tincture of Madness

1. Loren Eiseley (1907–1977) was an anthropologist, philosopher, and prolific science writer.
2. The expression to "break bad" is a slang phrase from the American Southwest meaning "departure from convention, to defy authority, and to skirt the edges of the law."
3. Arnold Ludwig, *The Price of Greatness* (Guilford Press, 1995), 146–47.
4. George Dyson, *Turing's Cathedral: the Origins of the Digital Universe* (Vintage Books, 2012). George Dyson, the author of the book, was the son of Freeman Dyson.
5. Richard S. Westfall, *Never at Rest: A Biography of Isaac Newton* (Cambridge University Press, 1983).
6. Richard Westfall's comments on "Sir Isaac Newton: The Gravity of Genius," *Biography Series* (A&E Network, 1995).
7. "The World Will End in 2060, According to Newton," *Evening Standard*, June 18, 2007.
8. Subrahmanyan Chandrasekhar, "Truth and Beauty."
9. Graham Farmello, *The Strangest Man: The Hidden Life of Paul Dirac, Quantum Genius* (Faber and Faber, 2009).
10. Fred Jerome, *Einstein on Race and Racism* (Rutgers University Press, 2016).
11. Andrew Robinson, *Einstein on the Run: How Britain Saved the World's Greatest Scientist* (Yale University Press, 2019).
12. Arnold M. Ludwig, *King of the Mountain: The Nature of Political Leadership* (University Press of Kentucky, 2002).
13. Bulent Atalay, "Einstein's Letter to Ataturk's Turkey," *National Geographic*, May 22, 2012. https://blog.nationalgeographic.org/2012/05/22/einsteins-letter-to-ataturks-turkey/.
14. Corbin Atlardice and Edward R. Trapnell, "The First Pile," *First Reactor* (U.S. Atomic Energy Commission, 1957).
15. William Lanouette, with Bela Silard, *Genius in the Shadows*.
16. "When Science Gets Ugly—The Story of Philipp Lenard and Albert Einstein," http://theconversation.com/when-science-gets-ugly-the-story-of-philipp-lenard-and-albert-einstein-43165.
17. Walter Isaacson, *Einstein: His Life and Works*, 34.
18. Andrew Robinson, *Einstein: A Hundred Years of Relativity*, (Metro Books, 2010). The main text is by A. Robinson, with contributions by Philip Anderson, Arthur C. Clarke, I. Bernard Cohen, Freeman Dyson, Philip Glass, Stephen Hawking, Max Jammer, Joao Magueijo, Joseph Rotblat, Robert Schulmann, Steven Weinberg.
19. Direct communication from Alice Calaprice regarding the claim that Mileva Marić was a co-founder of special relativity: "But this idea has been debunked by John Stachel [director of the Center for Einstein Studies at Boston University] and others. Einstein did indeed treat Marić badly, however, when he was having a difficult time with her, and she with him. This behavior changed after their separation and divorce, and they actually remained friendly and respectful until her death—there are many letters to prove it. But I don't know if he ever apologized to her; hopefully he had some private remorse. His

second wife was also a victim of his dalliances but learned to accept them. After he became a bachelor again in late 1936, he wasn't cheating on anyone, at least!"
20. "The Closest Friendships of Albert Einstein," http://brainathlete.com/closest-friendships-albert-einstein/.
21. Dinitia Smith, "Dark Side of Einstein Emerges," *New York Times*, November 6, 1996. http://www.nytimes.com/1996/11/06/arts/dark-side-of-einstein-emerges-in-his-letters.html.
22. For brief biographies of Einstein's sons, see http://www.einstein-website.de/biographies/print/p_eduard.html.
23. Karen C. Fox and Aries Keck, *Einstein A to Z* (John Wiley & Sons, 2004).
24. "New Letters Shed Light on Einstein's Love Life," *NBC Science News*, July 2006. After his stepdaughter Margot died in 1986 and 1,400 of Einstein's letters, including his love letters, were shipped off to Hebrew University in Jerusalem, but with explicit directions not to be made public for twenty years after her death. https://www.nbcnews.com/id/wbna13804030.
25. Sir Jacob Epstein, British sculptor (1880–1959), Campus Art, Princeton, http://artmuseum.princeton.edu/campus-art/objects/31380.
26. Stacy Conradt, "30 Fascinating Facts About Marilyn Monroe," *Mental Floss*, September 30, 2022. http://mentalfloss.com/article/19268/14-breathless-facts-about-marilyn-monroe.
27. Les Harding, *They Knew Marilyn Monroe: Famous Persons in the Life of the Hollywood Icon* (McFarland & Company, 2012).
28. Arthur I. Miller, *Einstein, Picasso: Space, Time, and the Beauty that Causes Havoc*.
29. The last resident of the Einstein household was Einstein's stepdaughter Margot Einstein, who died in 1986.
30. In accordance with Einstein's will, upon Dukas's death the papers were shipped to Israel, to be preserved in perpetuity at the Hebrew University in Jerusalem.
31. Arnold Ludwig, *Price of Greatness: Resolving the Creativity and Madness Controversy* (Guildford Press, 1995).

15: Swirls and Tortured Minds

1. Richard C. Friedman, *Male Homosexuality: A Contemporary Psychoanalytic Perspective* (Yale University Press, 1990).
2. A. Rothenberg, *Creativity and Madness* (Johns Hopkins University Press, 1990), 103–113.
3. "Jupiter" and "Juno" to the Romans.
4. Arnold M. Ludwig, *The Price of Greatness: Resolving the Creativity and Madness Controversy* (Guilford Press, 1995).
5. Massimo Viola, "Caravaggio: A Biography Through His Paintings," *HubPages*, February 7, 2019. https://discover.hubpages.com/education/Caravaggio-a-Biography-Through-His-Paintings.
6. Jonathan Jones, "More Savage than Caravaggio: The Woman Who Took Revenge in Oil," *Guardian*, October 5, 2016.
7. Letter written by Gentileschi to Cosimo de' Medici; Joanna Moorhead, "Artemisia Gentileschi, the Baroque #MeToo Heroine Who Avenged Her Rape through Art," *Guardian*, February 29, 2020. https://amp.theguardian.com/artanddesign/2020/feb/29/artemisia-gentileschi-national-gallery-baroque-heroine-female-caravaggio.
8. Joanna Moorhead, "Artemisia Gentileschi, the Baroque #MeToo Heroine Who Avenged Her Rape through Art."
9. Jonathan Jones, "More Savage than Caravaggio: The Woman Who Took Revenge in Oil."
10. Ronald De Leeuw, ed., and Arnold J. Pomerans, trans., *The Letters of Vincent van Gogh* (Penguin Classics, 1998). The passage quoted is from an 1883 letter to Theo.
11. Martin Bailey, "I met the oldest woman in the world—who shared her memories of Van Gogh in Arles," *Art Newspaper*, January 20, 2023.
12. Paul Wolf, "Creativity and Chronic Disease Vince van Gogh (1853–1890)," *Western Journal of Medicine* 175, no. 5 (November 2001). https://www.ncbi.nlm.nih.gov/pmc/articles/PMC1071623/.
13. Paul L. Wolf, "If Clinical Chemistry Had Existed Then . . . ," *Clinical Chemistry* 40, no. 2 (1994), 328–336.
14. The only painting of van Gogh sold during his lifetime was *The Red Vineyard*. The painting, created in early November 1888, sold in Brussels for 400 francs just a few months before the artist's death.
15. Jennifer Wright, *We Came First: Relationship Advice from Women Who Have Been There* (Lawrence King Publishing Co., 2019).
16. Clyde Haberman, "He's a Creep, but Wow, What an Artist!" *New York Times*, November 11, 2014. http://nyti.ms/2k3mIbk.
17. Of course, in reality the expression "Oxbridge College" refers to the colleges of Oxford and Cambridge. But the one she employs in her essay was her creation.

18 Peter Bradshaw, "The Wife," *Guardian*, September 12, 2017. https://www.theguardian.com/film/2017/sep/12/the-wife-review-glenn-close-brilliant-toronto-film-festival-tiff-2017.
19 Russell Shorto, "Jo: The Woman Who Made van Gogh," *New York Times Magazine*, April 2021.
20 Russell Shorto, "Jo: The Woman Who Made van Gogh."

16: Heroes, Rulers, and Rankings
1 Arnold M. Ludwig, *King of the Mountain: The Nature of Political Leadership* (University Press of Kentucky, 2002).
2 The full title of Post and Doucette's book is *Dangerous Charisma: The Political Psychology of Donald Trump and His Followers* (Pegasus Books, 2019).
3 Anton Antonov-Ovseyenko, *The Time of Stalin: Portrait of a Tyranny* (Harper & Row, 1981).
4 Valerie Strass and Daniel Southerl, "How Many Died? New Evidence Suggests Far Higher Numbers for the Victims of Mao Zedong's Era," *Washington Post*, July 17, 1994.
5 Atatürk appeared on the cover of *Time* in the March 24, 1923, and February 21, 1927, issues.
6 Michael Hart, *The 100: A Ranking of the Most Influential Persons in History* (A Citadel Book: Published by Carol Publishing Company, 2nd ed., 1992).
7 Francis Bacon, Joseph Devey, ed., *The Advancement of Learning* (Collier and Son, 1901).

Epilogue: Genius in the Digital Age
1 Twenty-five hundred years later, people in Anatolia repeat a maxim that has endured: "He has as much money as Croesus."
2 Accounts vary, but the three oracles are mentioned are those of Delphi, Hieropolis, and Didyma.
3 King Cyrus asks Croesus about his discussions with Solon. A Persian version of the story has the wise Cyrus releasing Croesus and allowing him to keep what is left of his kingdom.
4 In the unlikely event that you need to know, the exact number of possible moves in chess happens to be 46,783,665,034,756,288,456,012,644 or roughly 4.7×10^{25}.
5 Steven Stogatz, "One Giant Step for a Chess Playing Machine," *New York Times*, December 26, 2018.
6 Ahmed Elgammal, "How Artificial Intelligence Completed Beethoven's Unfinished Tenth Symphony," *Smithsonian*, September 24, 2021. https://www.smithsonianmag.com/innovation/how-artificial-intelligence-completed-beethovens-unfinished-10th-symphony-180978753/.
7 I recommend listening to the panelists debating the future world of artificial intelligence: https://www.youtube.com/watch?v=V79op5yuwgQ.
9 Victor Tangermann, "Elon Musk Has Reportedly Been Telling Friends About the Benefits of Shrooms and MDMA," *Futurism*, October 12, 2022. https://futurism.com/neoscope/elon-musk-shrooms-mdma.
10 Victor Tangermann, "Elon Musk Has Reportedly Been Telling Friends About the Benefits of Shrooms and MDMA."
11 Walter Isaacson, *Steve Jobs* (Simon & Schuster, 2011).
12 Full text of Tim Cook's speech: https://qz.com/1002570/watch-live-apple-ceo-tim-cook-delivers-mits-2017-commencement-speech/.
13 The full twenty-minute commencement Steve Jobs, including President Hennessy, gave at Stanford in 2005 is available on YouTube: https://www.youtube.com/watch?v=VHWUCX6osgM.
14 Catherine Clifford, "When Microsoft Saved Apple: Steve Jobs and Bill Gates Show Eliminating Competition Isn't the Only Way to Win," CNBC *MakeIt*, June 12, 2020.
15 Jessica Stillman, "All Highly Intelligent People Share This Trait, According to Steve Jobs (and Science)," *Inc.*, September 16, 2020.
16 William D. Phillips, private communication.

INDEX

A
Aaron, Hank, 32
ability, xiii, 31
absolute rest, 254
academic families, 37
acceleration, 207–208, 280–281, 283
achievement tests, 34
Achilles, 148
adagios, 82
Adams, Ansel, 12
Admiral's Men, 55
admissions tests, 32–33
adversity, 428
aeronautics, 185–186
Aeschylus, 373
aesthetics: of mathematics, 155–158; symmetry and, 328
age, xiii, 27–29
Age of Pericles, 200
Agricultural Revolution, 200
Alba Madonna (Raphael), 131
Albee, Edward, 374
alchemy, 11, 230, 332, 342
alcoholism, 338
Alexander the Great, 67, 374, 413
algorithms, 51
Ali, Muhammad, 32
Allen, Woody, 66
All Souls College, 220
All's Well That Ends Well (Shakespeare), 111
Alphabet, 426
AlphaZero, 419
Alsop, Marin, 20
Alzheimer's disease, 6, 18
Amazon, 426
ambiguity, xviii–xix, 100, 101, 119
American Revolution, 121
Ampre's circuital law, 252
Analytic Engine, 51
analytic geometry, 234
anatomical drawings, of Leonardo, 173, 174, 195–197
anatomy, 192–193, 195–197, 205–206
Anderson, Carl David, 309–310
Anderson, Marian, 32, 349
Anderson, Philip, 306
Andrea del Verrochio, 19
Angelou, Maya, 27
Anglican Church, 54–55, 56
Anguissola, Sofonisba, 142
Anne of Cleves, 54
annus horribilis, 237
annus mirabilis: of Einstein, 239, 269–270, 279–283; of Newton, 239
Antheil, George, 147
antibiotics, 26
antimatter, 28
antimatter electrons, 308–309
antisemitism, 50, 313, 353, 357
anxiety, 6, 83
Apelles of Kos, 67, 68
aphantasia, 22
aphasias, 324
Apollo Space Program, 58, 218
Apple, 425–431
Après la tempte (Bernhardt), 146
aptitude, 31
aptitude tests, 4, 34
Aquino, Corazon, 405, 409
Archimedes, xv, 9, 47, 128, 208, 231
Arden, Mary, 108
Aristarchus of Samos, 188, 203, 204
Aristotle, 3, 9, 11, 47, 168, 202, 203, 212–213, 224, 233, 236, 374, 391, 412, 413
arms races, 202
Armstrong, Louis, 32
Armstrong, Neil, 414
Arnold, Frances, xv, 151–153, 294
Arnold, Malcolm, 68
Arouet, François-Marie. *See* Voltaire
Arrhenius, Svante, 266
artificial intelligence (AI), xx, xxiv, 202, 374, 419–422
artistic ability, xiii
artistic creativity, 65–66; mental disorders and, 337–338. *See also* creativity
artists: bad behavior, 388–391; eyesight of, 18–19, 21; immortality for, 66; left-handedness in, 16. *See also specific artists*
art(s), xii, 201; communication by, 75; creative process in, xxiii; creativity in, 65–66; emotion and, 66; genres in, 67; intersection of science and, 154–170; mathematics underlying, 80–81; nature of, xxv; public support for, 46; techniques, 129–131, 154, 160–167, 376; therapeutic effects of, 201; trends in, 67
Aryabhata, 27
Ashkin, Arthur, 292
Aspect, Alain, 297
Aspen Institute, xvii
Asperger's syndrome, 23, 425
Astaire, Fred, 31
astigmatism, 21
The Astronomer (Vermeer), 170
astronomy, xxii, 166, 190, 191, 208–210, 286–287
As You Like It (Shakespeare), 111, 115
Atalay, Bulent, 74
Atatürk, Kemal, 350, 351–353, 407–410, 416
Athanadoros, 148
atherosclerosis, 196, 198
athletes, 32

INDEX

Atiyah, Michael, 305
atmospheric perspective, 128
atomic bomb, 10, 305, 310–315, 354–355
atomic clock, 293
atoms, 262–264, 272
Auden, W. H., 374
Augustus, Caesar, 412, 413
Austen, Henry, 122
Austen, James, 122
Austen, Jane, xxviii, 31, 119–124, 393
authority, aversion to, 4, 358, 366
Auticon, 22
autism, 6, 371–372; mathematical genius and, 21–23
autodidacts, 8, 50–52
automatons, 187
autopsy, 15, 196, 206, 320, 324, 326, 329–330
"Ave Maria," 82
Averroes, 47
Ayscough, William, 231, 232
Ayscough-Newton-Smith, Hannah, 229, 232

B

Babbage, Charles, 51
Babbage, George, 6
Bach, Johann Sebastian, xv, xvi, 4, 9, 31, 37–38, 68, 69, 73, 74, 77–78, 322, 415
Bach-Palestrina Model, 111–112
background radiation, 257, 288–289
Bacon, Roger, 128, 218
Bacon, Sir Francis, xxiii, 6, 44, 48, 99, 128, 199, 211–214, 219, 416
Bader, Abram, 49
Bailey, Martin, 382
Ball, Thomas, 53
ballet, 31
Balzac, Honoré de, 125
Bandaranaike, Sirimavo, 405
Baptism of Christ (Verrocchio), 176
Barbieri (Il Guercino), 18
Barish, Barry, 290
barium, 312, 353
Barrow, Isaac, 6, 234, 237–239
Bartók, Bela, 48, 49, 50, 73, 81
Barton, Catherine, 249
Basov, Nicolay, 292
Bastard Brigade, 303
Bates, John, 230
The Battle of Anghiari (Leonardo da Vinci), xxi, 129, 175
The Battle of Cascina (Michelangelo), 175
Battle of Issus, 67
Bayezid II, 178, 180–181
Bay of Pigs, 57, 58
The Beatles, 72–73
A Beautiful Mind (film), 16
beauty: Greek ideal of, 156; intrinsic, 201; subjective nature of, 66; truth and, 154–155, 285. *See also* aesthetics
Becquerel, Henri, 262
Beethoven, Johann van, 38, 77, 78, 79

Beethoven, Karl, 86–87
Beethoven, Kaspar Anton Karl van, 86
Beethoven, Ludwig van, xv–xviii, 4, 38, 65, 73, 74, 305, 415, 434; AI-created symphony of, 420; career of, 78–80; compared with Tchaikovsky, 75–76; continued popularity of, 68–69; creative style of, 71; declining health of, 329–330, 333; depression of, 84; education of, 99; Enlightenment and, 45, 59, 78; Fibonacci sequence music of, 80–81; forensic analysis of hair of, 333–334; funeral of, 331; Goethe and, 84–85; hearing loss of, 20, 78, 79, 85, 116, 330, 428; influence of, 76–77, 83–84; left-handedness of, 16; legacy of, 390; life of, 77–80; mental illness of, 87; Mozart and, 43; multiple intelligences and, 31; musical sketches of, 36; open-endedness in music of, xviii; personality of, 345–348; personal life of, 85–87; physical appearance of, 85; recognition for, 330; reputation of, 432; similarities between Newton and, xxvi, 9, 345–348, 365–366; skull of, 321; tension and release in music of, 92–93; as universal composer, 75–77; works of, 87–92. *See also specific works*
Beethoven Model, 71
Begg, Tristan, 333–334
The Beheading of St. John the Baptist (Caravaggio), 141, 378
Bell, John Stewart, xxv, 295–297, 314
La Belle Ferronière (da Vinci), 132, 133, 134, 135
Bellini, Gentile, 38, 42, 180
Bellini, Giovanni, 38, 42
Bellini, Jacopo, 38
Bell's theorem, 314
Belushi, John, 14
Benedict XVI (pope), 144
Ben-Gurion, David, 350, 355–356, 406
Bergman, Ingrid, 32
Berlin, Irving, 71, 425
Berlin Wall, 91, 409
Berlioz, Hector, 68, 90–91
Berners-Lee, Timothy, 423
Bernhardt, Sarah, xxviii, 31, 128, 144, 145, 146
Bernini, Lorenzo, 377
Bernoulli, Jacob, 248–249, 332
Bernoulli, Johann, 248–249, 332
Bernoulli family, 37
Bernoulli's aerodynamics principle, 225
Bernstein, Leonard, xviii, 72, 89, 91–92, 100
Berrill, Roland, 35
Besso, Michele, 362, 363
Bethe, Hans, 313, 338
Bezos, Jeff, 422, 424
Bhutto, Benazir, 405
Bible, 56, 116–117, 216
biblical literalists, 224
bibliotherapy, 201
Big Bang, 101, 288, 316
Bigg-Wither, Harris, 124

bilateral symmetry, 328
billionaires, 422–425
Bingen, Hildegard von, 73, 74, 144
binomial theorem, 231, 246, 277
bipolar disorder, 15
Birth of Venus (Botticelli), 67
blackbody radiation, 267–269, 271
Blackett, Maynard, 312
black holes, 282, 287, 289, 290
Blakely, Sara, 27
blank verse, 56
blood circulation, 196–198
bloodletting, 196, 219, 322, 329
blood pressure, 82–83, 201
Bloom, Harold, 107
bohemian zeitgeist, 45, 48, 366
Bohr, Aage, 37
Bohr, Niels, 37, 48, 50, 75, 221, 295, 297, 302, 312, 313, 354, 362
Bohr-Einstein debates, 296, 297
Bohr-Sommerfeld theory, 297
Boleyn, Anne, 54, 55
Bolt, Usain, 32
Boltzmann, Ludwig, 15, 339
Bonaparte, Napoleon. *See* Napoleon Bonaparte
books, 41
Booth, Stephen, 94–95
Borgia, Cesare, 184
Born, Max, 50, 296, 298, 302, 303
Bose, Satyendra Nath, 293
Bose-Einstein Condensate (BEC), 293, 294
Bose-Einstein statistics, 293
Botero, Fernando, 21
Botticelli, Sandro, 17, 53, 67, 374
Bowie, David, 17
Boyle, Robert, 44, 218, 234, 342, 343
Boyle's law, 225
brachistochrone curve, 248, 249
Bradley, A. C., 119
Bradshaw, Peter, 395
Bragg, William Henry, 37
Bragg, William Lawrence, 37
Brahe, Tycho, 209
Brahms, Johannes, 45, 68, 395, 396
brain: cerebral cortex, 323; of Einstein, 10, 326–329; functions, 323–325, 328–329; left hemisphere, 5, 23, 140, 324–326, 328; morphology of, 328; research on, 319–326, 327; right hemisphere, 5, 140, 325–326, 328
Bramante, 164–165
Brando, Marlon, 31–32
Braque, Georges, 81
breathing rates, 83
Brentano, Antonie, 86, 348, 428
Brin, Sergey, 39, 40, 424, 425
Broadway composers, 71–72
Broca, Pierre Paul, 323–324
Broglie, Louis de, 271–272
Brontë, Anne, 124

Brontë, Charlotte, 124
Brontë, Emily, 27, 124
Bronx School of Science, 33
Brookhaven National Accelerator Lab, 293
Brown, David Alan, xxii, 189
Brownian motion, 272
Bruckner, Anton, 45
Brunelleschi, Filippo, 52, 128, 160–161, 176
Bruno, Giordano, 206, 207, 210
bubonic plague, 236–237
Budapest, 48, 50
Buddha, 411
Bülow, Hans von, 68
Buonarotti, Ludovico, 385
Burnell, Jocelyn Bell, 394
Burnham, Scott, 68–69, 79
Buys, André, xxii, 187, 190–191
Byron, Lord, 51, 244, 337
Byzantine Empire, 204

C
Caesar, Julius, 374
Calaprice, Alice, 360
Calcar, Jan Stefan van, 205
calculus, 7, 231–232, 240, 246, 247–249
calculus of variations, 248–249, 332
Calculus Wars, 246–249
Callas, Maria, 14, 32, 144
Callicrates, 66
The Calling of St. Matthews (Caravaggio), 376
Calment, Jeanne, 382
Calvin, John, 216
Calvinism, 217
Cambridge University, 217, 218, 232, 314
Camelot, 56–62
camera obscura, 167–170
cannabis use, 17
cannons, 184
Cantor, Georg, 15
Cantor, Paul, 98
Capote, Truman, 374
Caprotti, Gian Giacomo. *See* Salai
Caravaggio, Michelangelo Merisi da, 13–14, 17, 129, 141, 142–143, 375–380, 389
carbon-14, 265
Cardano, Gerolamo, 51
Cardinal College, 54, 217
cardiology, 195–196
cardiovascular system, 82–83, 195–197
The Card Players (Cezanne), 388
Carlyle, Thomas, 432
Carpenter, Karen, 14
Carroll, Lewis, 16
Caruso, Enrico, 32, 144, 425
Castro, Fidel, 57, 408
Çatalhüyük, 200
cathode rays, 270, 357
Catholic Church, 54, 193, 206, 210, 323
Cavendish, Henry, 245–246, 281, 291

INDEX

Cavendish Lab, 45
Center for Talented Youth (CTY), 39–41
centerline principle, 18, 137–139
centripetal force, 244
Cepheid variables, 286–287
cerebral cortex, 323
Cerf, Vinton, 423
cesium (Cs), 293
Cezanne, Paul, 388
Chadwick, James, 264
Challenger space shuttle, 223–224, 226
Chandrasekhar, Subrahmanyan, xxvi, 37, 287–288, 305, 345, 425
Chan-Zuckerberg, Priscilla, 425
Chaplin, Charlie, xv
Charles I, 195, 219
Charles II, 219, 236
Charles III, 194–195
Charles V, 206
Charpentier, Emmanuelle, 152, 153
Chaucer, Geoffrey, 119
chemical energy, 277
chemistry, xxiii
chess-playing computers, 419
chiaroscuro, 128–129, 143, 376
Chiesa San Satiro, 164–166
Child, Julia, 27
child prodigies, 23, 27
children: familial influence on, 37–39; of smart parents, 41
China, xxvii, 200, 202, 406
chirality, 24
Christ, 200, 206, 411, 412
Christ Church, 54, 217
Christianity, 412
Christo, 67–68
Chronicles of England, Scotland and Ireland (Holinshed), 110
Chu, Steve, 294
Churchill, Lady Clementine, 139
Churchill, Sir Winston, 138–139, 406
Church of Santa Croce, 334–335
Çiller, Tansu, 405
civilization, 200
civil rights legislation, 46
Clark, Sir Kenneth, 132, 162
Clarke, William, 229–230
classical mechanics, xxiv–xxv, 7, 189, 252, 254, 257, 274, 295, 299, 341
Claudel, Camille, 386
climate change, 225
cloud chamber, 309
Codex Arundel (da Vinci), 189
Codex Atlanticus (da Vinci), xxii, 184–185, 187
Codex Windsor (da Vinci), 195
cognitive dissonance, 215
Cognitive Revolution, 200
Cohen-Tannoudji, Claude, 294
Cold War, 91, 409–410

Colleoni, Condottiero Bartolomeo, 53
colonization, 212
Columbus, Christopher, 411–412
The Comedy of Errors (Shakespeare), 111
comets, 236, 239, 347
communication, through art, 75
complementary therapies, 83
composers, 20, 36; Broadway, 71–72; careers of, 78; Fletcher's ranking of, 73–75, 402. *See also specific composers*
computer hacking, 420–421
computerized tomography (CAT scan), 324
computer programming, 51
computers, 58, 430
computer science, 202
The Concert (Leyster), 142
Condell, Henry, 114
Conduit, John, 238
Confucius, 411
connections, 4
consonance, 93
conspiracy theories, 225
Constantine the Great, 413
Cook, Tim, 421
Cooke, Alastair, 68
Copenhagen interpretation, 295, 297
Copernicus, Nicolaus, 44, 174, 187, 198, 199, 203, 204, 210, 322–323, 413
Copland, Aaron, xviii, 69–73, 75, 111, 305
Coppola, Francis Ford, 377
Cornell, Eric, 294
Cosmic Background Explorer (COBE), 288–289
cosmic microwave background radiation (CMBR), 288–289
Cotte, Pascal, 136
Coulomb, Charles-Augustin de, 250, 414
Coulomb force, 252
counterrevolutions, 199
COVID-19 pandemic, 237
Cranach, Lucas, the Elder, 38
Cranach, Lucas, the Younger, 38
Crane, Hart, 17
Crater Tycho, xxii, 191
Crawley, William, 61
The Creation of Adam (Michelangelo), 376
creativity, 4, 36–37, 431; age and, 27–29; in the arts, 65–66; brain and, 4–5, 325, 326; concept of, 4; madness and, 12–16, 34, 337–338; musical, 69–73; nurturing, 39; physical handicaps and, 18–21; in the sciences, 65–66; sexual orientation and, 372–375; source of, xi
Credi, Lorenzo di, 53
Crick, Francis, 24–25, 415
Crimean War, 96
CRISPR-Cas9, 152, 153
Crivelli, Lucrezia, 135
Croesus, 417–418
Cuban Missile Crisis, 57–58, 147
cubic equation, 51, 235

cubism, 81, 366
cultural revolutions, 156
Curie, Marie, xxviii, 12, 16, 37, 47, 128, 152, 261–262, 265–266, 291, 313
Curie, Pierre, 37, 262, 263, 265
curiosity, 4, 430
The Curious Incident of the Dog in the Night-Time (play), 161, 162
Curium, 266
curriculum vitae, 180–181
Curzon, George Nathaniel, ix

D

Dalí, Salvador, 12, 164
Dames, Nicholas, 120
dance, 31
Dangerous Charisma (Post and Doucette), 407–408
Dante Alighieri, xv, 52, 334
Darius III, 67
dark energy, 290–291, 316
dark matter, 290–291, 316
Dark Paintings (Goya), 384
Darwin, Charles, xv, 23, 75, 128, 193–194, 198, 225, 344, 412, 413, 415
David (Verrocchio), 176
David, Miles, 32
da Vinci, Leonardo. *See* Leonardo da Vinci
Da Vinci Center for Innovation in Product Design and Development, 197–198
da Vinci Surgical System, 187
Davisson-Germer experiment, 299
Dean, James, 14
de Broglie, Louis, 47, 297–298, 299
decimal system, 159–160
Declaration of Independence, 59, 61
deductive reasoning, 213–214, 215
de Duillier, Nicolas Fatio, 341
Deep Blue, 419
DeepMind, 419
De Fredis, Felice, 148
de Gaulle, Charles, 406
Dell, Michael, 424
De Magnete (Gilbert), 211
de Motu Cordis (Harvey), 195–196
Deng Xiaoping, 416
depression, 6, 15, 17, 18, 83, 84, 339, 342
de Revolutionibus (Copernicus), 204
Desai, Mihir, 120
Descartes, René, 44, 128, 141, 213, 214, 234
d'Este, Beatrice, 134, 135
Destiny Symphony. *See Fifth Symphony* (Beethoven)
destructive charismatic leadership, 408
determinism, 47
Devereux, Robert (Earl of Essex), 116
Devi, Shakuntala, 22
devil, 117, 216, 226
Diamond, Marian, 327
Dicke, Robert H., 288
differential calculus, 240, 246

Digital Age, 4, 422–425
digitalis, 383, 388
Digital Revolution, 200
Dirac, Paul Adrian Maurice, xiv, 9, 21, 27–29, 47–48, 75, 239, 279, 299–300, 304–310, 338–339, 346–347, 370
Dirac equation, 308
discoveries, preparedness and, 23–26
discrimination, 46, 58
dissonance, 93
Divina Proportione (Pacioli), xxi, 191–192, 197
DNA (deoxyribonucleic acid), 24–25, 415
dodecahedron, 164
Donatello, 53, 161
Don Giovanni (Mozart), 70
Dorati, Antal, 48, 49
Dou, Gerrit, 167
double-jointedness, 20
Doucette, Stephanie, 407–408
Doudna, Jennifer, 152, 153
Douglas, Alfred, 389
Doyle, Arthur Conan, 30, 42
Drake, Sir Francis, 55
drawing materials, 130
Dresden, Max, 298
DuBois, Ellen Carol, 222
Du Bois, W. E. B., 349
Dukas, Helen, 368–369
Duncan, David Douglas, 368
Dupin, Amantine Lucile Aurore, 125–126
Durer, Albrecht, 38, 42
Dutch School, 167
dynamic tension, 100
dysfunctional families, 346
dyslexia, 81
Dyson, Freeman, 28, 214, 299, 306, 307, 308

E

Eakins, Thomas, 377
Earth: age of, 193; density of, 246; mass of, 245–246, 291; measurement of, 203
Eban, Abba, 355–356
Ecce Homo (Caravaggio), 377
Eccles, Sir John, 307
Eco, Umberto, 430
economics, 225
eddies, 384
Eddington, Arthur, 281
Edison, Thomas, 252, 415
education, 39–41, 99
Egyptian pyramids, 200
Ehrenfest, Paul, 15, 339
eigenfunctions, 305
eigenvalues, 305
Eighth Symphony Opus 93 (Beethoven), 84
Einstein, Albert, xii, xv, xvi, xxiv, 47, 48, 75, 101, 128, 407, 424; age of peak creativity of, 27, 28; *annus mirabilis* of, 239, 269–270, 279–283; aphantasia and, 22; atomic bomb and, 354–355;

aversion to authority of, 348, 358; on Beethoven, 65; Bohr-Einstein debates, 296, 297; brain of, 10, 326–329; career of, 279, 358–359; contradictions of, 10; contributions of, 256, 269–283; creativity of, 9, 36–37; death of, 326; de Broglie and, 298, 299; eccentricities of, 368–371; education of, 358; experimentation by, 129; Flexner and, 220–221; on human stupidity, 402–403; influence of, 286–294, 412; lectures by, 307; left-handedness of, 16; legacy of, 390–391; letters of, 310, 350–356; life of, 270, 348–350, 356–365; logical reasoning of, 214; on Marie Curie, 261–262; mental illness and, 12; on Mozart, 70–71; multiple intelligences and, 31; Newton and, 42, 226–227; Noether and, 284, 286; as Person of the Century, 410, 433; photoelectric effect and, 258, 271, 297, 298, 362; quantum theory and, xxv–xxvi, 291–292, 295–297, 300; reinvention of, 432–433; Relativistic Revolution and, 256–257; reputation of, 348–349; similarities between Picasso and, 365–368; on Spinoza, 167; on technology, 422; theory of relativity of, xxv, xxvi, 225–227, 239, 256, 271–283; thought experiments by, 9, 10; value system of, 348–356; zeitgeist and, 45
Einstein, Bernhard Caesar, 364
Einstein, Eduard, 360, 363, 369
Einstein, Elsa, 360–364
Einstein, Hans Albert, 360, 363–364
Einstein Centennial, 306–307
Einstein ring, 282
Einsteinium, 266
Einstein-Podolsy-Rosen (EPR) paper, 294
Eiseley, Loren, 336
Eisenhower, Dwight D., 409
electricity, 249–251, 414, 415
electrodynamics, 252, 257
electromagnetic forces, 101
electromagnetic radiation, 277, 309
electromagnetic spectrum, 252
electromagnetic theory, 252, 254
electromagnetism, 251–252, 414, 415
electrons, 262–264, 266–267, 270, 297–299, 308–309
Elements (Euclid), 234, 235
Elgammal, Ahmed, 420
Eliot, George, xxviii, 125, 397
Eliot, T. S., 12, 221
Elisabeth of Bavaria, 354
Elizabethan Age, 3, 45, 53–56, 211
Elizabeth I, 46, 54–56, 61–62, 98, 114, 116, 211, 212
Elizabeth II, 409
Ellington, Duke, 32, 71
Ellison, Larry, 423
Ellison, Ralph, 27
emotion: communicated through art, 66; paleolithic, 404
empiricism, 212–214, 219
energy: dark, 290–291, 316; kinetic, 245, 277–279, 285; potential, 245, 277, 285; thermal, 277

energy–mass equivalence ($E = mc^2$), 10, 270, 277–278, 310
English Civil War, 195
Enlightenment, 4, 7, 45, 59, 78, 200, 409
entertainment business, 14–15
The Entombment (Caravaggio), 376
entrepreneur-innovators, 422
Ephesus, 157
epic writers, 29
epiphany, 36
Epstein, Margarete, 365
equivalence principle, 225, 280, 283
Eratosthenes of Cyrene, 203
Erdogan, Recep Tayyip, 409
Erdos, Paul, 48
erethism, 343–344
Eroica. *See Third Symphony* (Beethoven)
escape velocity, 245, 246
Essex Rebellion, 116
ether, 254, 255, 257–261
Euclid, 44, 47, 51, 234, 235, 413
Euler, Leonard, 8
eureka moments, 23–26
Evans, Mary Anne, 125
evaporative cooling technique, 294
evolution, theory of, 23, 193–194, 198, 225–226, 415
Ex Nihilo (Hart), 5
exorcism, 4
experimentation, xxiii, 102, 129, 130, 174–175, 212–213, 219, 224, 226
extraterrestrial life, 291
eyesight, 11, 18–19, 21, 168, 185

F

Fabrica (Vesalius), 205–206
Facebook, 426
familial backgrounds, 37–42
Faraday, Michael, 9, 22, 51, 75, 250–253, 413–415
Farmelo, Graham, xiv
farming, xxvii, 200, 414
Farrow, Ronan, 39
Fay, Charles François de Cisternay du, 250
female geniuses, xxvii–xxviii
Ferguson, Niall, 7
Fermi, Enrico, 313, 353
fermions, 308
Ferrari, Ettore, 207
Feynman, Richard, xiv, 27, 49, 224, 242, 244, 256–257, 300, 307, 308, 313, 342–343
Fibonacci di Pisa, Leonardo (Il Pisano), 52, 159–160
Fibonacci sequence, 80, 159
Fidelio Opus 72 (Beethoven), 84
Fields Medal, 40
Fifth Symphony (Beethoven), xvi, 87–93, 100
Finnan, Vincent, 135
First Symphony (Beethoven), 80
Fitzgerald, Ella, 32
Flamsteed, John, 347–348
Fleming, Alexander, 26, 27

Fletcher, Alan, xvii, 73–75, 80, 100, 402
Flexner, Abraham, 220–222
Flexner, Eleanor, 222
Flexner Report, 220
flight, 185–186
Florence, 45, 46, 52–53, 334–335
Florey, Howard, 26
Flourens, Marie Jean Pierre, 323
fluents, 231, 240
fluxions, 231, 240, 246
Fontana, Lavinia, 142, 144, 393
Fonteyn, Margot, 31
Ford, Harrison, 118
forensic pathology, 321–326
Forssmann, Werner, 25–26
fossils, 193, 194, 265
founding fathers, 50, 416
The Four Seasons (Vivaldi), 83
Fowler, Ralph, 304, 305, 313
Francis I, 335
Franklin, Aretha, 32
Franklin, Benjamin, 34, 128, 250
Franklin, Rosalind, 394
fraternal twins, 6
free fall, law of, 188–189, 242
Freemasons, 206
French Revolution, 78, 121, 144
Freud, Sigmund, 75, 178, 198, 350
Friedman, Richard C., 372
Frisch, Otto, 31, 311–312, 314, 353–354
Frisch-Peierls Memorandum, 310–315
frontal lobe, 323
Fukushima disaster, 187
functional magnetic resonance imaging (fMRI), 325
fundamental theorem of calculus, 247
fusion reactions, 264–265

G

Gabor, Dennis, 48
Gachet, Paul-Ferdinand, 382–383, 388
Galilean-Newtonian (G-N) transformation, 273, 274
Galileo Galilei, 3–4, 44, 75, 128, 166, 188–190, 192, 198, 207–211, 223, 234, 242, 272, 377, 412, 413
Gall, Franz Joseph, 319–320, 323
Gallerani, Cecilia, 133–134, 137
Galois, Évariste, 27, 51
game theory, 338, 339
Gandhi, Indira, 405
Gandhi, Mahatma, 96, 408, 410
Gardner, Howard, 30–31
Garland, Judy, 14
Gassendi, Pierre, 234
The Gates, 67
Gates, Bill, 16, 27, 422, 423, 429
Gates, Melinda, 409
Gauguin, Paul, 382
Gauss, Carl Friedrich, 22
general intelligence, 31

general relativity, xxv, 101, 155, 226–227, 239, 257, 271, 279–284, 286–290, 293
generators, 251
genes, 6, 17–18, 41
genetics, of mental disorders, 325
Genghis Kahn, 413
genius: autism and, 21–23; concept of, 3–4; definition of, xii–xiii, 4–5; degrees of, xiii–xv, 6–8; in Digital Age, 417–434; eccentricity and, 336–370; group, 47–50, 73, 256, 295–316, 416; mental illness and, 5, 6, 12–16, 337; mind of, 336; misunderstood, 336, 337; rankings of, 402–403; recognition of, by genius, 42–43; traits of, 3–29, 393, 431. *See also specific geniuses*
Gentileschi, Artemisia, xxviii, 38, 52, 142, 143, 371, 379–380
Gentileschi, Orazio, 38
Genzel, Reinhard, 291
geocentric model, 203, 209, 236
The Geographer (Vermeer), 170
geology, 192–195
geometry, 156, 170, 234, 240, 247, 384
George I, 217
Gericault, Theodore, 377
germ theory of disease, 24
Gershwin, George, 71, 72
Gharib, Morteza, 189
Gherardini, Lisa, 128, 136, 137
Ghez, Andrea, 291
Ghiberti, Lorenzo, 52, 160
Ghirlandaio, Domenico, 53
Giacometti, Alberto, 21
gifted education, 39–41
Giga, 35
Gilbert, William, 211
Gilot, Françoise, 386, 387–388
Ginevra d'Benci (da Vinci), 132–133, 134, 137
Ginsberg, Allen, 374
Ginsburg, Ruth Bader, 33
Giotto, 52
Girl with a Pearl Earring (Vermeer), 131, 132, 168
Gleich, Michael, 21, 22
Gleick, James, xiv, 330
globalism, 48
global positioning system (GPS), 227, 293
Globe Theatre, xix
Göbeklitepe, xxvii
God, 226. *See also* Christ; religion
Gödel, Kurt, 339
The Godfather (film), 377
gods and goddesses, 226
Goethe, Johann Wolfgang von, xv, 59, 84–85, 128
Golden Age of England, 54–56
Golden Age of Greece, 3, 155–156, 200, 203–204
Golden Age of Holland and Flanders, 140–141, 166–168
Golden Horn bridge, 181, 182
golden ratio, 133, 157–160, 164
golden rectangle, 157–158

Goldsmith, Martin, xvii
Goldwater Rule, 408
Good, Jack, 34
Gorbachev, Mikhail, 409–410, 414
Gould, Stephen Jay, 201
gout, 329
Goya, Francisco, 377, 384
Graham, Billy, 56–57
Graham, Elyse, 42
Grail Society, 35
Grandma Moses, 27
Grand Unified Theory (GUT), 101, 315
Grant, Cary, 304
gravitation, 101, 188–189, 198, 225, 226, 233, 241–246, 279–281, 342–343
gravitational collapse, 290–291
gravitational field equation, 280, 286
gravitational waves, 289–290
Great Fire of London, 237, 239
greatness, rankings of, 402–409
El Greco, 21
Greenberg, Robert, 79–80, 84, 86, 87, 348
Greene, Robert, 97–99, 106
Gregorian calendar, 228
Gresham College, 219
Groeger, Lena, 35
Grossman, Marcel, 359
group genius, 47–50, 73, 256, 416; definition of, 295; quantum mechanics and, 295–316
group theory, xxiv
Grout, Donald Jay, 76
Guatelli, Roberto, xxii
Günzberg, Sami M., 352
Gutenberg, Johannes, 411
Gymnasium 19, 49, 338

H

Habicht, Conrad, 269
Hagesandros, 148
Hagopian, Clara, 427
Hahn, Otto, 303, 353
hair analysis: of Beethoven, 333–334; of Newton, 331–332
Haldane, Duncan, 306
Hallem, Elissa, 40
Halley, Edmond, 347
Halmos, Paul, 48
Hals, Frans, 18, 141, 142, 167
Hamilton, William, 245, 299
Hamlet (Shakespeare), xvi, 102, 115, 116
Hammerstein, Oscar, 72
Hampton Court, 54
handedness, xiii, 328–329
Handel, George Frideric, 73
Harari, Yuval Noah, 200, 201
harmony, 92
Hart, Frederick, 5, 157, 412–414
Hart, Lorenz, 72
Hart, Michael H., 411

Harvey, Thomas, 326–327
Harvey, William, 195–196, 198
Hathaway, Anne, 109
Hawking, Stephen, 239, 305, 307
Haydn, Joseph, 45, 70, 71, 73, 90, 320–321, 327
al-Haytham, Ibn, 168
hearing loss: in Beethoven, 20, 78, 79, 85, 116, 330, 428; in Smetana, 20–21
heart catheterization, 25–26
Heaviside, Oliver, 251
heavy metals, 332, 333, 343
Heifetz, Jascha, 144
Heiligenstadt Testament (Beethoven), 79, 86, 116, 428
Heisenberg, Werner, 27–29, 47–48, 75, 128, 296, 298, 299–305, 312, 315, 414
Heisenberg uncertainty principle, xxv, 101–102, 225, 296, 299, 301–305, 414
Helicobacter pylori, 25
heliocentric model, 187–188, 198, 199, 203, 204, 209
Helmont, Jan Baptist van, 24
Hemings, John, 114
Hemingway, Clarence Edmonds, 13
Hemingway, Ernest, 12, 13, 391, 392
Hemingway, Margaux, 13
Hennessy, John, 428
Henry V (Shakespeare), 123
Henry VI (Shakespeare), 111
Henry VIII, 53–54, 217
Hephaestion, 374
Heraclitus, 47
Herodotus, 203, 417
Hertenstein, Elisabeth, 325
hertz, 258
Hertz, Heinrich, 257–258
hidden variables, 296
high-intelligence societies, 35
High Renaissance, 3, 50–51, 150, 162, 166, 256, 376
Hilbert, David, 284
Hildegard of Bingen, xv
Hill, Imogene "Teddy," 427
Hiller, Ferdinand, 333
Hipparchus, 203, 236
historical determinism, 47
Hitler, Adolf, 312, 315, 408, 409, 410, 413
Hobbes, Thomas, 234
Hodges, Andrew, 34
Hoffman, E.T.A., 89–90
Hoffmann, Banesh, 33
Holbein, Hans, the Elder, 38
Holbein, Hans, the Younger, 38
Holiday, Billie, 32
Holinshed, Raphael, 110
Holland, 140–141, 166–168
Holst, Gustav, 287
The Holy Family (Michelangelo), 131
Homer, 147–148, 415, 416
Homo sapiens, 200, 411
homosexuality, 61, 337, 341, 372–375, 389–390
Hooch, Pieter de, 167

Hooke, Robert, 9, 44, 128, 166, 218, 244, 245, 342–343
Hoover, J. Edgar, 349
Hotz, George, 40
House Un-American Activities Committee (HUAC), 222
Houssaye, Arsène, 335
Howard, Katherine, 54
Hubble, Edwin, 286, 287
Hubble's law, 286–287
Hubble Telescope, 282
Hudson, John, 99
Hughes, Langston, 349
Hugo, Victor, 96, 125–126
human condition, xix–xx
human flight, 185–186
humanists, 202
Humboldt, Alexander von, 128
Hume, David, 66, 242
The 100 (Hart), 411–416
Hungary, 48, 48–49
Hungerford, Margaret Wolfe, 66
Hussein, Saddam, 408
Huygens, Christiaan, 44, 128, 241, 342
hydrogen bomb, 264, 355
hydrogen maser, 293
hydrogen spectrum, 305
hypergraphia, 381
hypermobility, 20
hypotheses, xxiii, 226

I
iambic pentameter, 114
identical twins, 6
Ignatius, Paul, 421–422
Iktinos, 66
Il Pisano. *See* Fibonacci di Pisa, Leonardo
imagination, 4
immigrant parents, 40
immigrants, 424–425
"Immortal Beloved" (letter), 85–86
immortality, 431–434
Impressionism, 381
India, xxvii
inductive reasoning, 212–213, 215–218
Industrial Revolution, xxvii, 7, 121, 174, 197, 199, 204
inertial frames, xxv, 272–276
inferior parietal lobe, 327–328
infinitesimal calculus, 246, 247–249
influencers, 411–416
Information Age, 4
information technology (IT), 58
Innocent X, 379
innovators, 422–431
Inquisition, 210
insanity, 4, 6, 11–14, 337, 369, 384–385. *See also* mental disorders
insight, 4
inspiration, xi, xxiv, 36

instant gratification, 41
Institute for Advanced Studies (IAS), 220–221, 391
institutional zeitgeist, 45
integral calculus, 240
intellectual cultures, 202
intellectual honesty, 393
intelligence, 4; general, 31; genetic factors in, 6, 41; measuring, 32–35; multiple intelligences, 30–43; types of, 430–431
Intelligence Quotient (IQ), 34–35
intelligence tests, 4
intelligent design, 225–226
interferometer, 260
interventional cardiology, 26
intuition, 4
IQuadrivium Society, 35
Isaacson, Walter, 269, 327, 358
Isabella of Aragon, 135
Islam, 412
Islamic Golden Age, 168
isotopes, 31, 264, 265
Israel, 352, 355–356
Italian Baroque period, 142–143
Italian Renaissance. *See* Renaissance

J
Jackson, Michael, 14, 31
Jacobean Age, 116–117, 211
James, LeBron, 32
James, William, 47
James I, 56, 116–117, 212, 216
James Madison School, 33
Jamestown colony, 55, 212
James Webb Telescope, 282
Jandali, Abdul Fattah, 426
jazz, 32
Jeanne-Claude, 67–68
Jeans, James, 268
Jefferson, Thomas, 50, 59–61, 414
Jepson, Ursula Hemingway, 13
Jesus Christ, 200, 206, 411, 412
Jews, 49–50, 349, 351–353, 356
Joachim, Joseph, 395
Jobs, Paul, 427
Jobs, Steve, 244, 422, 423, 425–431
John, Elton, 17
John F. Kennedy Center for the Performing Arts, 46
Johns Hopkins University, 220
Johnson, Douglas, 90
Johnson, L. W., 332
Johnson, Lyndon B., 46
Joliot-Curie, Frédéric, 37
Joliot-Curie, Irène, 37, 313
Jones, James, 408
Jonson, Ben, xix, 55, 94, 112
Jordan, Michael, 32
Jordan, Pascual, 298, 302, 303, 313
Joyce, James, 12–13, 29
Joyce, Lucia, 12–13

INDEX

Joyner, Florence Griffith, 32
Judith Beheading Holofernes (Caravaggio), 379
Judith Slaying Holofernes (Gentileschi), 379
Julian calendar, 228
Julius Caesar (Shakespeare), xix, xx, 102–106, 115, 390
Julius II (pope), 148–149, 175
Jung, Carl, 12–13
Junger, Itha, 298

K

Kac, Mark, xiv
Kahlo, Frida, xxviii, 132, 143, 386–387
Kahn, Bob, 423
Kalb, Claudia, 27
Kamen, Dean, 423, 424
Kandel, Eric, 325
Kasparov, Garry, 419
Katherine of Aragon, 54
Keats, John, 98, 155
Kelvin, Lord, 255, 256, 277
Kemeny, John, 48
Kemp, Martin, 176
Kennedy, Jacqueline, 57, 62
Kennedy, John Fitzgerald, 44, 46, 56–62, 139, 218, 414
Kennedy Cultural Center for the Performing Arts, 61
Kennedy Space Center, 61
Keough, Ben, 15
Kepler, Johannes, 44, 128, 168, 209–210, 225, 245
Ketterle, Wolfgang, 294
Khomeini, Ayatollah, 408, 409, 410
Khrushchev, Nikita, 58, 409
Kiesler, Hedwig Eva Maria, 146–147
kinetic energy, 245, 277–279, 285
King, Martin Luther, Jr., 96, 408
King, Rachel, 106
King James Bible, 56, 116–117
King Lear (Shakespeare), 123
The King of the Mountain (Ludwig), 403–407
King's Men, 56, 117
Kipling, Rudyard, 119, 201
Kissinger, Henry, 421, 422
Kleppner, Daniel, 293, 294
Kline, Morris, 117, 216
Klingon Shakespeare Restoration Project, 107
Knecht, Frieda, 364
Kodály, Zoltán, 48, 49
Koestler, Arthur, 48
Koresh, David, 408
Kyd, Thomas, 55

L

Lady Gaga, 39
Lady with an Ermine (da Vinci), 132–135, 138
Lagrange's equation, 285
Lamarck, Jean-Baptiste, 193
Lamarr, Hedy, xxviii, 128, 146–147
Lamb, Charles, 12
Lamb, Willis, 305
Landon, H. C. Robbins, 71

Langevin, Paul, 265, 266, 298
Lanier, Emilia Bassano, 99
Lanza, Mario, 14
Laocoön, 147–150
Lascaux cave paintings, 154
laser cooling, 294
Laser Interferometer Gravitational-Wave Observatory (LIGO), 289–290
lasers, 292
The Last Supper (da Vinci), ix, xxi, 99, 100, 129, 162–164, 166, 175
Lauterbur, Paul, 293
Lavoisier, Antoine, 413
law of gravitation. *See* gravitation
laws of motion, xxv, 7, 155, 225, 226, 240, 244–245
lazy eye (strabismus), 11, 18–19
leadership, 45–46, 401–409, 416
lead poisoning, in Beethoven, 333, 334
Leavitt, Henrietta Swan, 286–287
Leavitt's law, 286–287
Le Brun, Elisabeth Louise Vigee, xxviii
Lee, Harper, 27
Lee, T. D., 288, 425
Lefroy, Tom, 124
left-cheek question, 139–140
left-handedness, 16, 17
Leibniz, Gottfried Wilhelm, 128, 232, 246–249
Lenard, Philipp, 270, 357–358
length contraction, 274–275
Lenin, Vladimir, 406, 412, 413
Lennon, John, 14, 72–73
Leonardo: Artist, Scientist, Engineer (exhibit), xxi–xxii, 189–190
Leonardo da Vinci, ix–x, xii, xv, xvi, 3, 9, 53, 73, 127–153, 154, 374, 434; anatomical drawings by, 173, 174, 195–197; anatomy and, 192–193; Brunelleschi and, 161; curriculum vitae, 178–181; death of, 335; education of, 99; engineering projects of, 176, 180–185; as eternal genius, 27; on evolution, 193–194; experimentation by, 129, 174–175, 226; eyesight of, 11; Fibonacci sequence and, 81; fingerprints of, 134–135; Freud on, 178; geological-paleontological subjects and, 192–195; gravitation and, 188–189; heliocentric model and, 187–188; human flight and, 185–186; influence of, 166, 197, 415–416; *The Last Supper*, ix, xxi, 99, 100, 129, 162–164, 166, 175; left-handedness of, 16; linear perspective and, 162–163; mathematics of, 191–192; missing notes and sketches of, 197; *Mona Lisa*, ix, xx–xxi, 99, 100, 132–138; multiple intelligences and, 31; natural observation by, 194; on nature, 152; as polymath, 128–129; portraits by, 132–138; postmortems by, 196; recording of ideas by, 36; reinvention of, 432–433; Renaissance and, 45; robotics and, 186–187; as scientist, xxi, 173–198; on seeing, 168; sexual orientation of, 17; stroke suffered by, 5; techniques used by,

128–134, 137; telescope of, xxii–xxiii, 189–191; tomb of, 334–335; understanding, 175–177; Vasari on, 177; *see also specific works*
Leonardo-Sand Bridge, 182–183
Leonardo's model, 128
Leoni, Pompeo, 184
Lerner, Alan Jay, 72
Les Misérables (Hugo), 96
Lewis, C. S., 371
Leyster, Judith, xxviii, 141–142, 167
Liber Abici (Fibonacci), 159–160
Library of Alexandria, 220
life, definition of, xxiv
life sciences, xxiii, xxiv
light, 252, 254, 270–272; dual nature of, 271, 297; speed of, xxv, 227, 252, 254, 255, 269, 272, 274, 275, 276, 278, 280, 281, 283, 308
lightning, 250
Limb, Charles, 20, 330
Lincoln, Abraham, 414
Lincoln University, 349
Lindbergh, Charles, 409
linear addition, 276
linear momentum, 277–279
linear perspective, 128, 160–167, 225
Lippershey, Hans, 166, 208
Lippi, Filippo, 389
Liszt, Franz, 20
literary characters, 107
literary devices, 55–56
literature, 201
The Lives of the Most Excellent Painters, Sculptors, and Architects (Vasari), 143, 177
Lloyd, Constance, 389
Lobkowitz, Prince von, 88
Locke, John, 66, 341, 343
Lockwood, Lewis, xvii
Loewe, Frederick, 72
logarithmic spirals, 158
logic, xiv
logical reasoning, 212–218
London, 218, 236–237
Lord Chamberlain's Men, 55, 56, 113–114, 117
Lorentz, Hendrik A., 47, 48, 273–274, 308
Lorentz transformations, 273–274, 276
Los Alamos Lab, 305
Louis, Joe, 32
Louvre, 135
Lovelace, Ada, 51
Love's Labour's Lost (Shakespeare), 111
Löwenthal, Max, 360, 363
Ludwig, Arnold, 12, 13, 35, 49, 338, 351, 373, 403–407
Lugosi, Bela, 48, 49
Luijten, Hans, 396
Luis of Aragon, 173
Lumiere Technology, 136
luminosity, 286–287
lunacy. *See* insanity; mental disorders
Lurie, Jacob, 40

Luther, Martin, 210, 216–217, 413
Lutheranism, 217
lysozyme, 26

M

Ma, Yo-Yo, 27, 425
Maar, Dora, 367, 368, 386
Macbeth (Shakespeare), 115
Machiavelli, Niccolò, 175, 184
Madison, James, 50
madness, 337, 388, 403. *See also* mental disorders
magic, 215
magicians, xiv
magnetic flux, 251
magnetic resonance imaging (MRI), 293, 324–325
magnetism, 211, 250–251. *See also* electromagnetism
magnet schools, 32–33
Mahler, Gustav, 45, 72, 73
male-pattern baldness, 17
malleability, 101
"Man, Machine, and God," 421–422
Mandela, Nelson, 96, 406, 408, 416
Mandl, Fritz, 147
Manet, Édouard, 377
Manhattan Project, 10, 292, 313
Mannerism, 376, 379
Manners, Sir Roger, 98
"Man of the Year" (*Time*), 409
Mao Zedong, 406, 410, 412, 413
Maradona, Diego, 32
Marciano, Rocky, 32
Marfan syndrome, 20
Maric, Mileva, 356–363, 386
Marie Antoinette, 144
Marlowe, Christopher, 55, 98, 110–113, 374
Marsalis, Ellis, Jr., 38
Marsalis, Wynton, 38
Marshall, Barry, 25
Marshall, Thurgood, 349
Marta e Maddalena (Caravaggio), 389
Martians, 48–50, 425
Marx, Groucho, 35
Marx, Karl, 412–413
masers, 292, 293
mass, 10, 270, 277–278, 310
mass-energy, 281
masterpieces, xi
mathematical genius, autism and, 21–23
Mathematical Principles of Natural Philosophy (Newton), 7
mathematics, xxvii; aesthetics of, 155–158; age of creativity in, 27–28; art and, 9; calculus, 7, 231–232, 240, 246–249, 332; geometry, 156, 170, 234, 240, 247, 384; Leonardo and, 191–192; in nature, 9–10, 101, 160, 208, 223; nature of, xxiii–xxiv; Newton and, 238; proof in, 51–52; in the sciences, 228; underlying art, 80–81, 158–160
Mathematics in Western Culture (Kline), 216
Mather, Cotton, 217

INDEX

Mather, John, 288–289
matrix mechanics, 296, 298, 300, 302, 303
matter: dark, 290–291, 316; particle-wave dual nature of, 298
MAUD Committee, 311
Maxwell, James Clerk, xv, 9, 75, 225, 251–253, 413–415
Maxwell's equations, 251–252, 273–274
Mayer, Maria Goeppert, xxviii, 425
Mayor, Michel, 290
McCarthy, Joseph, 222
McCartney, Paul, 73
McCrum, Robert, 99
Meacham, Jon, 60–61
medical imaging technology, 324–325
Medici, Cosimo di Giovanni de', 52
Medici, Giovanni di Bicci de', 52
Medici, Grand Duke Cosimo II de', 52, 143
Medici, Lorenzo de', 53, 61
Medici family, 46, 52–53
medicine, 195–197, 205–206, 220, 322
medieval era, xx, 73, 74, 128, 162, 174, 183, 203, 204
Mega, 35
Mehmed the Conqueror (Fatih Sultan Mehmet), 179–180
Meir, Golda, 405
Meitner, Lise, xxviii, 311, 312, 313, 353–354, 394
melody, 83, 225
Melzi, Francesco, 176
memory, 4
Mendelssohn, Felix, 68
Mensa Society, 35
mental disorders, 4, 6, 11–16, 18, 34, 325, 337–340, 384–385; in Beethoven, 87; in Newton, 339–344; in van Gogh, 381
mercury poisoning: in Charles II, 219; in Newton, 332, 343–344
Meres, Francis, 115
Merkel, Angela, 405, 409
Mesopotamia, 200
Messi, Lionel, 32
Methodism, 217
Metsu, Gabriel, 167
Metternich, Prince, 348
Michelangelo, xv, xvi, 3, 46–47, 53, 128, 131, 162, 376, 415; *Laocoön* statue and, 148–150; left-handedness of, 16; Leonardo and, 166, 175; *Pietà*, 145–146, 150; sexual orientation of, 17, 374; violent temper of, 385
Michelson, Albert A., 255–256, 258–261
Michelson-Morley experiment, 255–256, 258–261
Micrographia (Hooke), 166
micro-Kelvin, 294
microscope, 166
Microsoft, 426, 429
Middle Ages. *See* medieval era
Middle East, xxvii
Middlemarch (Eliot), 125
A Midsummer Night's Dream (Shakespeare), 337

military engineering projects, by Leonardo, 183–184
Miller, Arthur I., 367
Millikan, Robert A., 267
Milyukova, Antonina, 13
Mitchell, Margaret, 27
Moby Dick (Melville), 123
Mona Lisa (da Vinci), ix, xx–xxi, 99, 100, 132–138
Monet, Claude, 383
monomania, 384
Monroe, James, 50
Monroe, Marilyn, 14, 365
Montessori schools, 40
Monteverdi, Claudio, 73, 74, 75
Monticello, 60
moon, xxii, 191, 242–243
moral tales, 417–418
Moray, Sir Robert, 219
Morley, Edward W., 255, 258–261
Morris, Edmund, 81
Morrison, Toni, xxviii
Morse, Samuel, 91
Morse code, 91
Moses, 412, 413
Mother Teresa, 96
motion, laws of. *See* laws of motion
Mourou, Gérard, 292
moveable type, 411
Mozart, Franz Xaver Wolfgang, 38
Mozart, Leopold, 38
Mozart, Wolfgang Amadeus, xv, xvi, 4, 9, 31, 45, 59, 68, 122, 415; Beethoven and, 43, 78; creativity of, 70–71; death of, 322; father of, 38; in Fletcher ranking, 73; Hoffman on, 90; skull of, 321, 322, 327
Mozarteum, 321
Mozart Model, 111–112
Mozi, 167–168
Muhammad, 411
Mullis, Kary, 150–151, 152
multiple intelligences, 30–43
multiverse, 291
Munch, Edvard, 371, 384–385
Munch, Laura, 385
music, 32; blood pressure and, 82–83, 201; tension and release in, 92–93, 225; therapeutic effects of, 201
musical creativity, models of, 69–73
musicians, 36
music theory, 92–93
Musin, August Henri, 38
Musin, François, 38
Musk, Elon, 422, 424, 425
mutually assured destruction, 311
myth, 101

N

Napoleon Bonaparte, 59, 84, 87, 150, 184, 413
Napoleonic Wars, 88, 121
narcissism, 58, 407–408
Nash, John, 16, 221, 339

National Bureau of Standards (NBS), 294
National Cathedral, 157
National Endowment for the Arts (NEA), 46
National Gallery of Art, 391
National Institute of Standards and Technology (NIST), 294
National Museum for Women in the Arts, 143
natural laws, 65–66, 101, 166–167, 203, 223, 225, 226, 228
natural philosophy, 174, 202–211
natural selection, 23, 193–194
nature, 81; Leonardo on, 174; mathematics of, 9–10, 101, 160, 208, 223
nature's numbers, xviii
Nazis, 286, 302–303, 312, 313, 354, 364
Neefe, Christian Gottlob, 77–78, 427
Neuberger, Anne, 421
neuroscience, 323–327
neutron activation analysis (NAA), 331
neutrons, 263–264
New Critics, 100
New Guard, 47
Newitz, Annalee, 237
Newman, Betty, 365
New Principles of Artillery (Robins), 8
Newton, Isaac, xv, 4, 9, 27, 44, 65, 75, 128, 198, 411; age of creativity of, 27–28; *annus mirabilis* of, 239; autism of, 21; Beethoven and, xxvi, 9, 345–348; biblical timeline and, 193; birth of, 223; books of, 235; calculus and, 231–232, 240, 246–249; classical mechanics of, xxiv–xxv, 7, 189, 252, 274, 341; contradictions of, 10; contributions of, 7, 227–228, 238; education of, 229–235; Einstein and, 42, 226–227; forensic analysis of hair of, 331–332; funeral of, 330–331; gout of, 329; homosexuality of, 341; influence of, 197; law of gravitation of, 101, 188–189, 198, 225, 226, 241–246, 279–281, 342–343; laws of motion of, xxv, 7, 155, 225, 226, 240, 244–245, 278–279; lectures by, 306; left-handedness of, 16; legacy of, 390, 416; life of, 227–236; logical reasoning of, 214; mathematics and, 238; mental health of, 339–344; mercury poisoning in, 332, 343–344; multiple intelligences and, 31; over-inclusive thinking by, 34; passions of, 11; personality of, 249, 345–348; *Principia*, 238–245; recognition for, 330; reinvention of, 432–433; religion and, 233–234, 341–342, 344; scientific laws of, xxiii; Scientific Revolution and, 44–45; sexual orientation of, 17; similarities between Beethoven and, 365–366; statue of, 6–7
Newtonian physics, 7, 235, 341
Newton-John, Olivia, 50
New World, 55, 211, 212
NeXT, 427–428
Nicholas I, 408
Nicholl, Mike, 139–140
Nietzsche, Friedrich, 16
The Night Watch (Rembrandt), 141

Nijinsky, Vaslav, 144, 374
Ninth Symphony (Beethoven), xvi, xvii, 82, 87, 92, 100
Nixon, Richard, 57
Nobel laureates, xiv
Nobel Prizes, 33
Noether, Emmy, xxviii, 37, 128, 283–286, 425
Noetherian module, 283
Noether's ring, 283
Noether's theorem, 285, 286
nonlinear addition, 276
nonlinear thinking, 336
non-Western civilizations, xxvi–xxvii
novelists, 29. *See also specific novelists*
nuclear atom, 263–264
nuclear energy, 200, 277, 310
nuclear fission, 312
nuclear magnetic resonance (NMR), 292, 293
nuclear reactions, 264–265
nuclear weapons, 310–315, 349, 354–355
nucleus, 310
Nude, Green Leaves, and Bust (Picasso), 388
Nuland, Sherwin, xx–xxi, 175
Nullius in Verbe, 219
number theory, 160
Nureyev, Rudolf, 31

O

objectivity, in science, 154–155
observer effect, 302, 303
occipital lobe, 323
"Ode on a Grecian Urn" (Keats), 155
"Ode to Joy" (Schiller), 92
Oedipus complex, 343
The Officers of the St. George Militia Company (Hals), 141
Old Guard, 47–48
Oliphant, Mark, 313
Olivier, Laurence, 31, 144
Omnia Vincit Amor (*Love conquers all*) (Caravaggio), 376
one-point perspective, 161–164
On the Origin of Species (Darwin), 193–194
open-endedness, xviii–xix, 100–101, 119
open-mindedness, 4
opera, 32
operator theory, 299
Oppenheimer, J. Robert, 305
optical illusions, 137, 158, 165
optics, 238, 244, 299, 342
orbital velocity, 245, 246
ordinary geniuses, xiv, 7, 73, 74
originality, 4
O-rings, on *Challenger*, 224
Ormandy, Eugene, 48, 49, 425
orthogonals, 161
Ottoman Empire, 180–181, 408
over-inclusive thinking, 34
overthinking, 34
Ovid, 110

INDEX

Owens, Jesse, 32
Oxfordians, 98
Oxford University, 217–218, 220, 314
Oz, Mehmet, 353
Öz, Mustafa, 353
"Ozymandias" (Shelley), 416

P

Pacioli, Luca, xxi, 180, 191–192, 197
Paganini, Niccolo, 20
Page, Larry, 40, 424
painting materials, 130
painting techniques, 129–131, 154, 376; linear perspective, 160–167
pair creation, 309
paleolithic emotions, 404
paleontology, 192–195
Palestrina, Giovanni Pierluidi da, 69
Palestrina-Bach Model, 69
Panofsky, Erwin, 42
Pantheon, 161
paper, invention of, 200
parabolic curves, 189
parachute, 186
parents, influence of, 40, 41
parietal lobe, 323
Parkinson's disease, 18
Parmenides, 47
Parr, Catherine, 54
Parthenon, 66–67, 157–158
passion, 430
Pasteur, Louis, xv, 5, 24, 25, 128, 412, 413, 415
patronage, 422
pattern recognition, 4, 383
Pauli, Wolfgang, 425
Pauli exclusion principle, 225
Pavarotti, Luciano, 32
Pavlova, Anna, 31
Payne, Cecilia, 287
Peace Corps, 58
Peale, Norman Vincent, 56
Peebles, James, 288, 290
Peele, George, 106
Peierls, Sir Rudolf, 31, 297, 307, 312–315, 353, 370
Pelé, 32
penicillin, 26
Penrose, Roger, 290–291, 306
Penzias, Arno, 288, 306
Pepys, Samuel, 236–237, 341, 343
performing arts, 31–32
Pericles, 46, 61
Pernet, Jean, 358
Peron, Isabel, 405
"Person of the Century" (*Time*), 410, 433
"Person of the Year" (*Time*), 410
perspective, 160–167
Perugino, Pietro, 53
Peterzano, Simone, 375
Phidias, xv, 66–67, 128

Philip II, 206
Philips, William D., 190
Phillips, Bill, 430
Phillips, William, 294
philosophers, 3, 202–203
philosophy, natural, 202–211
phosphorescence, 262
photoelectric effect, 258, 271, 297, 298, 362
photoelectrons, 270–271
photons, 282–283, 291–292, 297
phrenology, 319–321, 323, 335
physical attributes, 11
physical handicaps, 18–21
physical laws, 273–274. *See also specific laws*
physical traits, 17
physics, xxiii, xxiv; advancements in, 255–257; of Galileo, 207–208; Golden Age of, 15; Newtonian, 7, 235, 341; Old School vs. New School, 102; quantum mechanics, xxv–xxvi, 28, 48, 50, 101–102, 225, 256, 291–292, 295–316, 414; terrestrial, 207–208
"Piano Concerto No. 9" (Mozart), 71
Picasso, Pablo, xv, 9, 12, 18, 27, 81, 138, 365–368, 387, 388, 415
Pietà (Michelangelo), 145, 146, 150
pi (π), 231
pitchblende, 262
Pixar Animation Studios, 428
plague, in London, 236–237
Planck, Max, 47, 50, 269, 271, 307
Planck's constant, 269, 283, 297
Planck's law, 268, 269
planetary motion, 209–210, 225, 236, 241, 244
Plato, 47, 202
playwrights, 29
Pliny the Elder, 38, 67, 147, 148, 250
Pliny the Younger, 38
plum pudding model, 263
Podolsky, Boris, 296
poets, 29, 338
Political Greatness Scale (PGS), 406
political leadership, 403–409
political personality profiling, 407–408
polling, 303
Polydoros, 148
polymaths, 11, 128, 144–147, 430
Pompeii, 67
The Pont Neuf Wrapped, 67
Pope, Alexander, 223
Porter, Cole, 72
Portrait of Dora Maar (Picasso), 138, 388
Portrait of Dr. Gachet (van Gogh), 388
portraits, 132–142
positron emission tomography (PET scan), 324, 325
positrons, 308–310
Post, Jerrold, 407–408
postmortems, 15, 196, 206, 320, 324, 326, 329–330
The Potato Eaters (van Gogh), 381
potential energy, 245, 277, 285

preparedness, 23–26
Presley, Elvis, 14
Presley, Lisa Marie, 15
preternatural vision, 185, 188
Prez, Josquin des, 73
Pride and Prejudice (Austen), 123–124
Prince, 14
Principia (Newton), 238–245
principle of least action, 225
principles, xxiii, 225
Principles of Quantum Mechanics (Dirac), 299–300
Pritchard, David, 294
probability, 215
problems, obsessing over, 36
problem solving, gender differences in, 405
prodigies, 23, 27
projectiles, trajectories of, 188–189, 207–208
Prokhorov, Aleksandr, 292
Protestantism, 54–56, 216
Protestant Reformation, 216–217
proto-cities, 200
protons, 264, 308
Proust, Marcel, 374
psychopathological twins, xxvi, 9, 345–348
Ptolemy, 203, 236
Public Schools System of New York, 33
Puccini, Giacomo, 82
Puech, Pierre-François, 321, 322
pulse, 83
Puritans, 216
Pythagoras of Samos, 156–157
Pythagoreans, 93, 156–157, 160, 164
Pythagorean triples, 156–157

Q

Qin Shi Huang, 200, 412, 413
quantum entanglement, 294
quantum mechanics, xxv–xxvi, 28, 48, 50, 101–102, 225, 256, 291–292, 295–316, 414
quantum theory, 271, 291–292, 297, 300
Queen Elizabeth's Men, 55, 110–111, 117
Queloz, Didier, 290

R

Rabi, Isidor Isaac, 292, 294
Rachmaninoff, Sergei, 20
radiation: background, 257, 288–289; blackbody, 267–269, 271; cosmic microwave background radiation, 288–289; electromagnetic, 277, 309; UV, 258, 262; X-rays, 261, 262, 293, 324
radioactive materials, 261–264
radium, 262–263
Rain Man (film), 372
Raleigh, Sir Walter, 55, 98
Raman, C. V., 37
Ramanujan, Srinivasa, 51–52
Ramsey, Norman F., 190, 292–293, 294, 305
Rankin, William, 277
rankings: of composers, 73–75, 402; of geniuses, 402–403; of most influential persons in history, 402, 411–416; of political leaders, 403–409; *Time* magazine, 402, 409–410; usefulness of, 402
Raphael, 3, 9, 16, 47, 129, 131, 162, 166, 334
rationalists, 193
Rátz, László, 49–50
Rayleigh, Lord (John William Strutt), 268
Reagan, Ronald, 406, 410, 414
reality, fundamental paradigm of, xxv
Rede Lecture, 202
Rees, Martin, 344, 345
Reeves, G., xxii, 191
reflecting telescope, 189–191, 198, 342
Reichardt, Johann Friedrich, 88
Relativistic Revolution, 256–257
relativity, theory of, xxv, xxvi, 28, 225–227, 239, 256, 271; general relativity, 101, 226–227, 239, 257, 271, 279–284, 286–290, 293; special relativity, xxv, 257, 271–280, 299, 360
release: in art, 149; in music theory, 92–93
religion, xii, 11, 49–50, 200, 201, 216, 226, 344, 349, 411, 412
Rembrandt van Rijn, xv, 18, 138, 140, 141, 167, 377
Renaissance, 4, 38, 45–47, 50–53, 166, 200, 374
reparative charismatic leadership, 408
revolutions, 199–202, 226
rhythm, 83
Richard II (Shakespeare), 102
Richards, I. A., 100
Riess, Adam, 40
Riess, Johanna, 86, 87
Ring Cycle (Wagner), 101
risk-taking, 17
Rivera, Diego, 386, 387
River Problem, 258–260
Robeson, Paul, 32, 349
Robins, Benjamin, 7–8, 10, 51, 296
Robinson, Andrew, 350, 360
robotics, 186–187
Rodgers, Richard, 72
Rodin, Auguste, 386
Roentgen, Wilhelm, 261, 262, 293, 324
Rogers, Ginger, 31
Roget, Peter Mark, 27
Roman Forum, 161
Roman Numerals, 159–160
Romantic era, 90
Rome, 155–156, 161, 174, 203–204
A Room of One's Own (Woolf), 392–394
Roosevelt, Eleanor, 27, 349
Roosevelt, Franklin Delano, 10, 310, 350, 354, 355, 406, 409, 410, 414
Rosen, Nathan, 296
Rosheim, Mark, 187
Ross, Alex, 76–77, 79, 87, 101
Rostand, Edmond, 145
Rostropovich, Mstislav, 425
Rothenberg, Albert, 12, 372–373
Rothmayer, Joseph, 321

Roubiliac, Louis-Francois, 6
Royal Collection, 194–195
Royal Society of London, 218, 219, 244, 247
Rózsa, Miklos, 49
Rubens, Peter Paul, 143, 377
Rudin, Cynthia, 152–153
Running Fence, 67
Ruskin, John, 377
Russell, Bertrand, 155
Russell, Bill, 32
Russia, 91
Ruth, Babe, 32
Rutherford, Ernest, 9, 75, 263, 310

S

Sacrament of the Last Supper (Dalí), 164
Sacred Band of Thebes, 373
Sadler, Hamnet, 109–110
Salai, 180
Salam, Abdus, 305
Salk, Jonas, 387
Sand, George, xxviii, 125–126
Sand, Vebjørn, 182
Sanders, Bernie, 33
Santa Croce Church, 334–335
Santa Maria del Fiore, 161
Sapiens (Harari), 200
Sappho, 373
satire, 123–124
Schauffler, Robert Haven, 76
Schieble, Joanne, 426–427
Schiller, Friedrich, 92, 128
Schindler, Anton Felix, 91
schizophrenia, 6, 13, 16, 17, 18, 34
Schmidt, Eric, 421
The School of Athens (Raphael), 47, 67, 129, 130, 131, 162
Schopenhauer, Arthur, xii, 3, 336
Schrödinger, Erwin, 28–29, 47, 75, 279, 294, 296, 298–301, 309
Schrödinger's equations, 300–301
Schubert, Franz, 9, 45, 69–70, 71
Schubert Model, 69–70, 111–112
Schumann, Clara, 393, 395–396, 398
Schumann, Robert, 73, 395–396, 398
Schumer, Charles, 33
Schütz, Heinrich, 73
Sciama, Dennis, 305, 307
sciences, xii; creative process in, xxiii–xxiv, 36, 65–66; intersection of arts and, 154–170; mathematics in, 228; in medieval period, 174; misuse of, 202; nature of, xxv; purpose of, 201; religion and, 201; in Roman era, 204; stratification in, xxiii; technology and, 7, 204; truth in, 154–155; unification in, 101
scientific determinism, 256
scientific method, 215
scientific principles, xxiii, 225
Scientific Renaissance, 256, 261

Scientific Revolution, 3–4, 24, 44–45, 56, 174, 193, 197, 199, 201–202, 204, 211, 215, 226
Scott, Sir Walter, 119, 122
Scotus, Duns, 218
The Scream (Munch), 371, 384–385, 388
sculptures, 156
second law of thermodynamics, 225
sedimentary rocks, 193
Self-Portrait Dedicated to Leon Trotsky (Kahlo), 132
self-portraits, 38, 132, 138, 140, 142, 382, 387
Seneca, 4, 11, 337
Seventh Symphony Opus 92 (Beethoven), 84
Seven Wonders of the Ancient World, 67
sexual misconduct, 388–389
sexual orientation, xiii, 17, 115, 372–375, 389–390
Seymour, Jane, 54
Sforza, Ludovico, xxi, 133–135, 178–180, 187, 191
sfumato, 128
Shakespeare, John, 108, 109, 115
Shakespeare, William, xv, xvi, 3, 94–126, 415; age of peak creativity of, 29; ambiguity in, 100; artistic rebirth of, 115–117; Austen and, 119–123; career of, 110–111, 113–114; children of, 109–110; conspiracy theories about, 97–99, 393; contributions to English language by, 106–107; critics on, 94–95, 97–98; education of, 108–109, 111; Elizabethan Age and, 45, 46, 54–56; experimentation by, 102; human condition and, xx; immortality of, 94, 107; influence of, 95; *Julius Caesar*, xix, xx, 102–106, 115, 390; life of, 107–110; on madness, 337; multiple intelligences and, 31; open-endedness in writing of, xviii–xix; plays of, 114–116; reinvention of, 432–433; relevance of, 99–100; satire in, 123–124; sexual orientation of, 17, 115, 374; "Sonnet 18," 433–434; sonnets of, 114–115, 433–434; Tolstoy on, 95–97; works of, 113–116. *See also specific works*
Shakespearean actors, 118
Shapiro, James, 99
Shaw, George Bernard, 12, 94
Shelley, Percy, 416
Sibelius, Jan, 72
Siegal, Nina, 170
Simpson, Richard, 119
Simpson, Wallis, 409
Sistine Chapel, 162, 166
situs inversis, 5
slavery, 61
Sleight, Peter, xviii, 82–83
Small, William, 59
Smetana, Bedrich, 20–21
Smith, Adam, 413
Smith, Barnabas, 229, 232
Smith, Emma, xviii–xix, 99–101, 119, 120
Smoot, George, 288–289
Snow, C. P., 202
social media, 421
social sciences, xxiii, xxiv

Socrates, 47, 202
Sofonisba, Anibal, 142
solar eclipse, 168, 203, 281
Solomon, Maynard, 86
Solon, 417–418
Solvay, Ernest, 48
Solvay Conference, 47–48, 265, 296, 309, 313
Somma, Thomas, xxi–xxii, 189
Sondheim, Stephen, 72
"Sonnet 17" (Shakespeare), 115
"Sonnet 18" (Shakespeare), 433–434
sonnets, 56, 114–115
Southhampton, Earl of (Henry Wriothesley), 113, 115, 116
Soviet Union, 91
space-time, 257, 281, 282, 289, 290
Spanish Armada, 55
specialization, 127–128, 430
special relativity, xxv, 226–227, 257, 271–280, 299, 360
Spenserian Stanza, 56
spin-down electrons, 308
Spinoza, Benedictus, 166–167
spin-up electrons, 308
spolvero, 128, 130
spontaneous generation, 24
sports, 32
spyglass, 166, 208
Squire, J. C., 255
Squirrel AI Award, 152–153
Stalin, Joseph, 406, 409, 410, 413
standardized tests, 32–35
standard model of elementary particles, 101
Stanley, Julian, 39, 41
Stark, Johannes, 357
The Starry Night (van Gogh), 132, 371, 383–384
startups, 422–423
static electricity, 250
Steen, Jan, 167
Stein, Gertrude, 374
Steinberg, Saul, 68
Step Pyramid, 200
Stern, Otto, 312
Stillman, Jessica, 430
St. John the Baptist (Caravaggio), 376
Stockfish, 419
Stokes, John, 230, 231, 232
Storer, Katherine, 230
Stowe, Harriet Beecher, 27
St. Paul, 411, 412
St. Paul's Cathedral, 218, 237
St. Peter's Basilica, 150, 164
strabismus, 11, 18–19
Strassmann, Fritz, 353
strata, 193
stratigraphy, 193
Strauss, Johann, 45
Stravinsky, Igor, 73
Streep, Meryl, 32

Strickland, Donna, 292
Strogatz, Steven, 419
strokes, 5
strong nuclear forces, 101
subjectivity, 66
Subtle, Robert, 96–97
suicide, 13, 15, 87, 234, 337–338, 339, 374, 382, 387, 392
Sullivan, J. W. N., xxvi, 345
Sumer, 200
summative geniuses, 73, 74, 75
Sumon, Luc, 387
sun, mass of, 246
superstition, 215
superstring theory, 101
supply and demand, law of, 225
surgery, 205–206
Sutherland, Graham, 18, 138–139, 377
Sutherland, Joan, 32
symmetries, xvii–xviii, 328
synesthesia, 22
Szell, George, 48, 49
Szent-Györgyi, Albert, 48
Szilard, Leo, 48, 310, 313, 338, 353, 354

T

talent, nurturing, 39
Tale of Two Cities (Dickens), 123
Tallchief, Maria, 31
Talmud, Max, 427
tanks, 184
Tartaglia, Nicolo, 51, 235
Tassi, Agostino, 379, 380
Tchaikovsky, Peter Ilyich, xviii, 13, 75–76, 100, 305, 374
teachers, inspiring, xxiv, 49–50
technology, xx; advancements in, xxvii, 204, 422; dangers of, 420–421, 422; development of, 219; science and, 7
telegraph, 91
telescopes, xxii–xxiii, 166, 189–191, 198, 208, 210, 342
Teller, Edward, 48, 49, 338
Temple, Shirley, 27
Temple of Artemis, 157
temporal lobe, 323
tenebrism, 129, 143, 376, 377
Tennyson, Alfred Lord, 6, 119
tension: in art, 149; in music theory, 92–93, 225; in poetry, 100
tension and release, 92–93, 225
Tenth Symphony (Beethoven), 420
Ter Borsch, 167
terrestrial physics, 207–208
Téry, Gustave, 266
Tesla, Nikola, 9, 22, 51, 252, 415
testing, 32–35
Thales of Miletus, xv, 3, 156, 202–203, 213
Thatcher, Margaret, 405, 410

theater, 31–32; in Elizabethan England, 55–56
theistic creation, 225–226
theme, in music, 92–93
theories, 225
Theory of Everything (TOE), 101, 315–316
thermal energy, 277
thermodynamics, second law of, 225
Third Symphony (Beethoven), 81, 87
"Third Symphony Opus 55" (Beethoven), 79–80
Thomson, J. J., 262–263, 266–267, 292, 307
Thorne, Kip, 290
Thorpe, Jim, 32
thought experiment approach, 9, 10
three-point perspective, 166
time dilation, 275
Time magazine, 402, 409–410
time measurement, 293
tincture of madness, 337
Tiresias, 372–373
Titian, 130
Titus, 148
Tolstoy, Leo, 12, 29, 31, 95–97
Tomalin, Claire, 119
tondo, 131
topographic maps, 184
TOPS Society, 35
Torrigiano, Pietro, 385
Townes, Charles, 292
trajectories of projectiles, 188–189, 207–208
transcranial direct current stimulation (tDCS), 325–326
transformative geniuses, xiv–xvi, 7, 73, 74, 75, 431–432; contradictions of, 10; education and, 99; immortality for, 390; insight of, 150; parallels between, 8–9; power of, 197. *See also specific persons*
transitional geniuses, 73, 74
Trapulionis, Alan, 429
Treves, Letizia, 380
Trinity College, 6, 8, 45, 51–52, 54, 217, 232–233, 235, 244
trochaic pentameter, 114
Trojan War, 147–148
Trotsky, Leon, 386
Truman, Harry, 354, 406, 414
truth, 154–155
Ts'ai Lun, 200, 411
Tsao, Terence, 40–41, 425
Turgenev, Ivan Sergeyevich, 126
Turing, Alan, 16, 34, 339, 374–375, 423
Turing test, 374
Turkiye, xxvii, 200, 351–353, 407, 408–409
Twain, Mark, 16, 145
Twelfth Night (Shakespeare), 115
twin paradox, 275, 280–281
twins, 6
two-point perspective, 165–166
Tycho Crater, xxii, 191
Tyler, Christopher, 18–19, 137–138, 176

U

Ukraine, 92
ulcers, 25
ultraviolet (UV) radiation, 258, 262
uncertainty principle, xxv, 101–102, 296, 299, 301–305, 414
underdrawings, 130–131, 136, 376
United States, 409, 424–425
universal gravitational constant, 245–246, 281, 291
universality, 72
universe: Big Bang, 101, 288, 316; creation of, 288; expanding, 286, 287, 316; measuring, 291
universities, 32, 45, 217–218
University of al-Qarawiyyin, 217
University of Bologna, 217
University of Cambridge, 45
University of Padua, 205
University of Virginia, 59
uranium, 31, 264, 312, 353, 354
uric acid, 329
Ussher, James, 193

V

Van Dyck, Anthony, 18, 143
Van Eyck, Jan, 18
van Gogh, Theo, 396–397
van Gogh, Vincent, 13, 132, 371, 380–384, 388, 396–398
van Gogh-Bonger, Johanna, 396–398
van Leeuwenhoek, Antonie, 132, 166, 168–169, 170
Vasari, Giorgio, 142, 143, 177
Vatican Museum, 148, 150
vector calculus, 251–252
velatura, 128, 134
Velazquez, Diego, 143
velocities, 276
Venice, 38, 180
Venizelos, Eleftherios, 408
Venus Anadyomene, 67
Venus and Cupid (Gentileschi), 143
Verdi, Giuseppe, 73, 82
Vere, Edward de, 98
Verino, Ugolino, 53
Vermeer, Johannes, 128, 131, 132, 141, 167–170, 377
Verrocchio, Andrea del, 53, 130, 176
Vesalius, Andreas, 174, 195, 205–207
Vienna, 45, 78, 86, 88, 320, 331
Vietti-Teppa, Olivier, 186
Vigée Le Brun, Élisabeth, 142, 143–144
violent temperaments, 385
Virgil, 29
Virgin of the Rocks (da Vinci), 131–132
Virginia Commonwealth University, 197–198
vision, 185
visualization, top-down vs. bottom-up, 9
Vivaldi, Antonio, 37
Vivaldi, Giovanni Battista, 37, 73, 83
Voltaire, 128, 330, 401, 416
Von Bingen, Hildegard, xxviii, 128

von Braun, Werner, 302
von Neumann, John, 48, 49, 50, 128, 338–339, 425
vortices, 241

W

Wadham College, 218–219
Wagner, Richard, 73, 74, 100–101
Wallace, Alfred Russell, 23, 44
Wallach, Eli, 365
Walter, Marie-Therese, 367
Ware, Lancelot, 35
Warhol, Andy, 374
Warren, Robin, 25
Wars of Religion, 335
Washington, George, 50, 53, 61, 413, 414
Watson, James, 24–25, 415
Watt, James, 174, 413
wave functions, 296
wave mechanics, 296, 298, 299
weak nuclear forces, 101
weapons of mass destruction, 202, 310–315, 349, 354–355
Webber, Andrew Lloyd, 72
Weber, Heinrich, 358
Weil, André, 221, 299
Weinberg, Steven, 306
Weir, Peter, 14
Weiss, Rainer, 290
Weizsacker, C. V., 303
Wellington's Victory, Opus 91 (Beethoven), 84
Wells, Francis, 194
Welsey, John, 217
Wernicke, Carl, 324
Westfall, Richard, 339–340, 341
Weyl, Hermann, 221, 298
What to Listen for In Music (Copland), 69
Wheat Fields (van Gogh), 383
Wheeler, John, 300, 307
Whitman, Walt, 17, 374
Whitney, Eli, 174
Wieman, Carl, 294
Wien, Wilhelm, 267–268
The Wife (Wolitzer), 394–395
Wigner, Eugene, xxiv, 36, 48, 49, 228, 306, 327, 338–339, 425
Wilde, Oscar, 337, 374, 389–390
Wilkins, John, 218–219
Wilkinson, David, 288
William of Ockham, 218
Williams, Kim, 175–176
Williams, Robin, 14, 15
Williams, Ted, 11, 32, 185
Williams, Tennessee, 374
Wilson, C. T. R., 309
Wilson, E. O., xix–xx, 404
Wilson, Robert, 288, 307

Wilson, Woodrow, 406
Wilson cloud chamber, 309
Wiltshire, John, 119
Wiltshire, Stephen, 371–372
Winkler, Elizabeth, 99
Winters, Shelley, 365
witchcraft, 117, 216–217
Witelson, S. F., 327
Wolbarshy, M. L., 332
Wolf, Paul, 383
Wolitzer, Meg, 394–395
Wolsey, Cardinal, 54, 217
women, xxvii–xxviii; actors, 145, 146–147; artists, 386–388; geniuses, xxvii–xxviii; as leaders, 405; painters, 141–144; plight of genius, 391–398; scientists, 150–153, 261–262, 266, 291, 313; writers, 391–394. *See also specific women*
Wood, Michael, 96, 98
Woolf, Virginia, xxvii, 12, 391–394
Wordsworth, William, 8
World War I, 200
World War II, 200, 302–303
World Wide Web (WWW), 423
Wozniak, Steve, 423, 424, 426
Wrapped Coast, 67
Wrapped Reichstag, 67
Wren, Christopher, 218, 237
Wren Library, 235, 244
Wright, Ed, 16
Wright, Frank Lloyd, 12
Wright, Orville and Wilbur, 413
writers: age of peak creativity of, 29; women, 391–394. *See also specific writers*
Wu, Chien-Shiung, 425
Wyeth, Andrew, 39
Wyeth, Jamie, 39, 139, 377
Wyeth, N. C., 39

X

X-rays, 261, 262, 293, 324

Y

Yale, Elihu, 217
Yang, C. N., 288, 425
Young Turks, 45
Yu, Lee Kuan, 416

Z

zealots, 144
Zeeman, Pieter, 308
zeitgeist, 44–62, 432; of Elizabethan Age, 53–56; of Enlightenment, 78; group genius and, 47–50; of Kennedy administration, 56–62; of Renaissance, 52–53
zero, 159
Zuckerberg, Mark, 40, 424